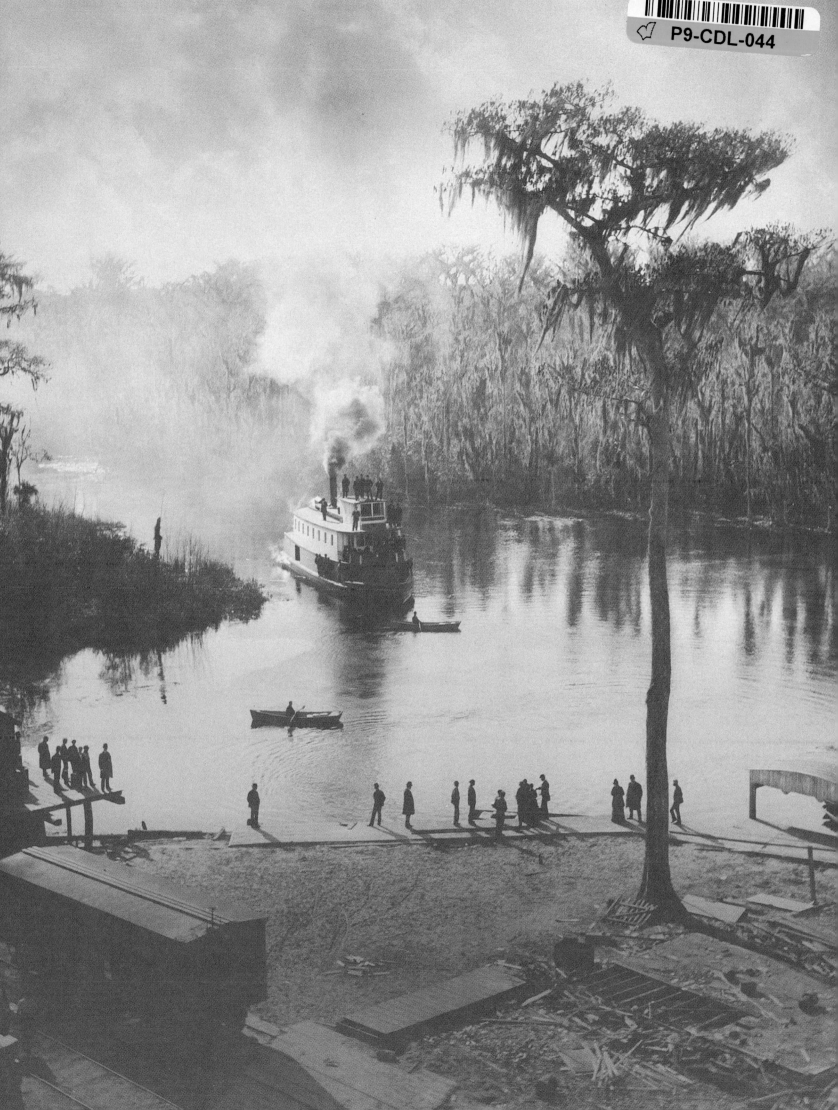

EYES OF THE NATION

Overleaf: **Thirty-six-star flag. Textile, c. 1865.**

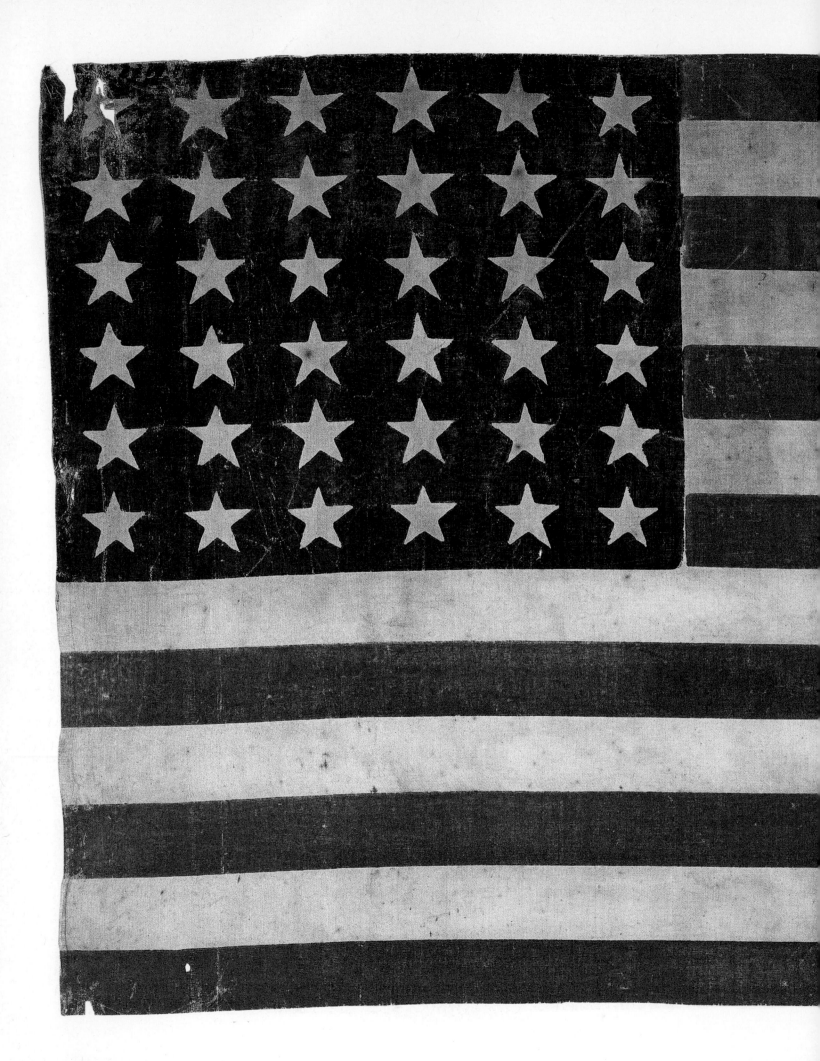

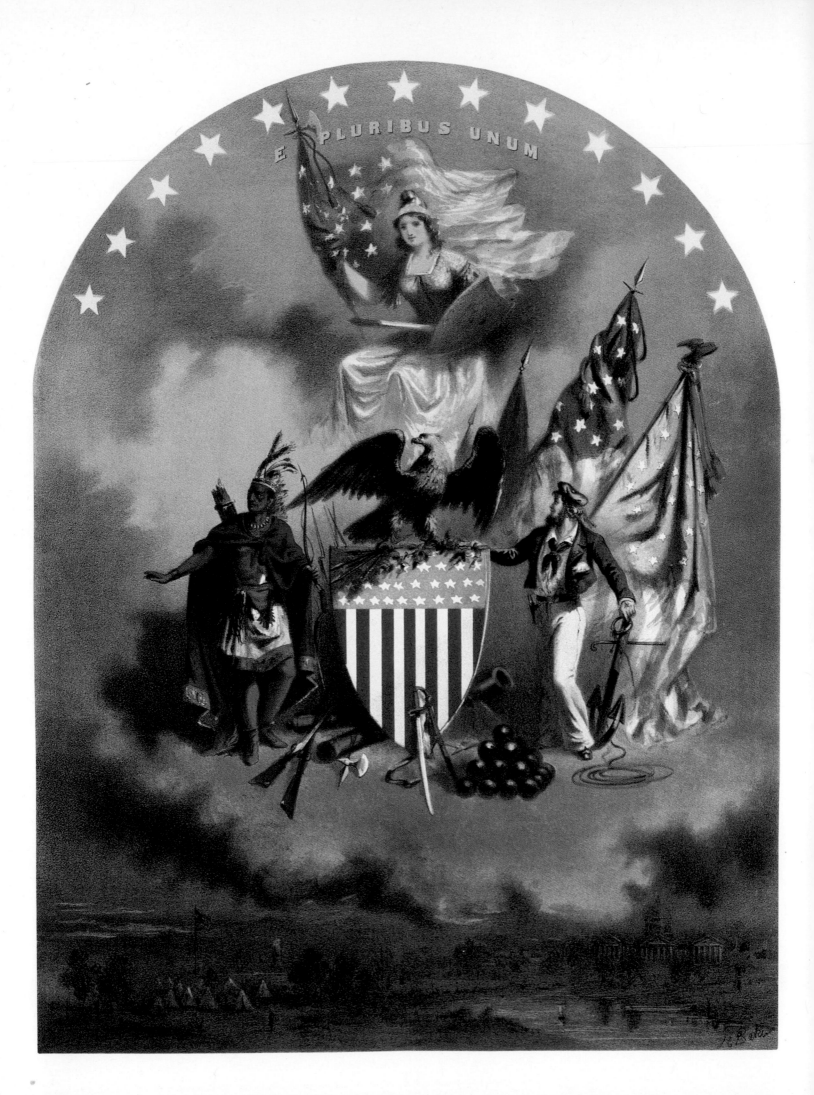

EYES OF THE NATION

A Visual History of the United States

by Vincent Virga and Curators of The Library of Congress

Historical commentary by Alan Brinkley

ALFRED A. KNOPF NEW YORK 1997

CURATORS OF THE LIBRARY OF
CONGRESS
Bernard F. Reilly, Jr., Head, Curatorial Section, Prints
and Photographs Division
Elena G. Millie, Curator, Poster Collection, Prints and
Photographs Division

Katherine L. Blood, Assistant Curator for Fine Prints,
Prints and Photographs Division
Beverly Brannan, Curator, Documentary Photogra-
phy, Prints and Photographs Division
Verna Posever Curtis, Curator, Master Photographer
Collection, Prints and Photographs Division
Ronald E. Grim, Specialist in Cartographic History,
Geography and Map Division
John R. Hébert, Senior Specialist in Hispanic Bibliog-
raphy, Hispanic Division
Carol M. Johnson, Curator, Nineteenth-Century
Photography, Prints and Photographs Division
Harry L. Katz, Curator, Popular and Applied Graphic
Art, Prints and Photographs Division
Patrick Loughney, Head, Moving Image Section,
Motion Picture, Broadcasting and Recorded Sound
Division
John McDonough, Manuscript Historian, Manuscript
Division
Jon Newsom, Chief, Music Division
C. Ford Peatross, Curator, Architecture, Design, and
Engineering, Prints and Photographs Division

FOR THE LIBRARY OF CONGRESS
Director of Publishing: W. Ralph Eubanks
Project Coordinator: Margaret E. Wagner
Editor: Sara Day

Frontispiece: J. E. Baker. *Arms of the United
States of America.* Color lithograph. Boston,
1864.

THIS IS A BORZOI BOOK
PUBLISHED BY ALFRED A. KNOPF,
INC.

Copyright © 1997 by Vincent Virga and the Library of
Congress
Historical commentary copyright © 1997 by Alan
Brinkley

Grateful acknowledgment is made to Alfred A.
Knopf, Inc., and Harold Ober Associates Inc. for
permission to reprint "The Negro Speaks of Rivers"
from *Selected Poems* by Langston Hughes, copyright
1926 by Alfred A. Knopf, Inc., and renewed 1954 by
Langston Hughes. Copyright © 1994 by the Estate of
Langston Hughes. Reprinted by permission of Alfred
A. Knopf, Inc., and Harold Ober Associates Inc.

Library of Congress Cataloging-in-Publication Data
Virga, Vincent.
 Eyes of the nation : a visual history of the United
States / by Vincent Virga and curators of the
Library of Congress : historical commentary by
Alan Brinkley.—1st ed.
 p. cm.
 Includes index.
 ISBN 0-679-44330-4 (acid-free paper)
 1. United States—History—Pictorial works.
2. United States—History. I. Brinkley, Alan.
II. Library of Congress. III. Title
E178.5.V57 1997
973'.022'2—DC21 97-36603
 CIP

Manufactured in the United States of America
First Edition

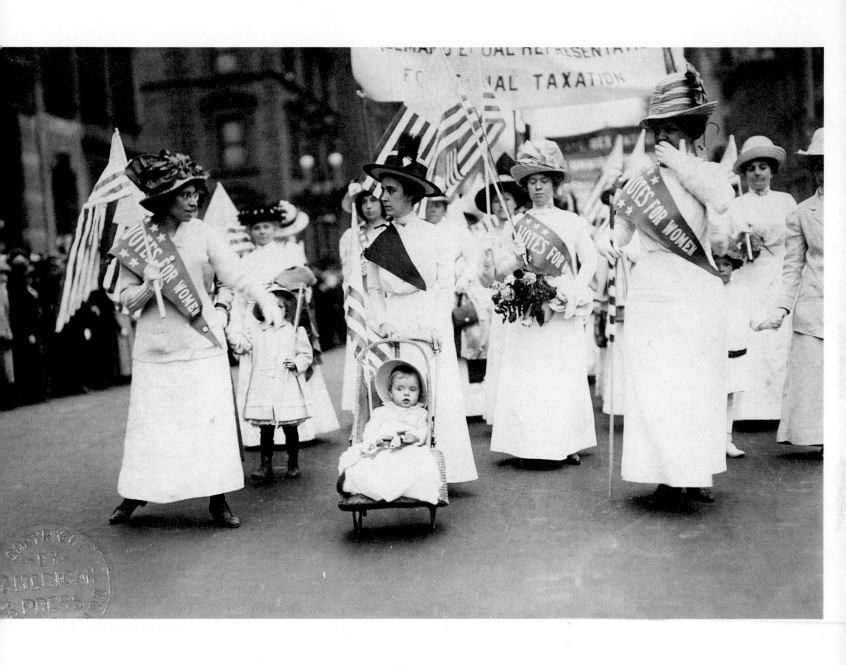

American Press Association. Suffrage parade,
New York City, May 6, 1912. Photograph.

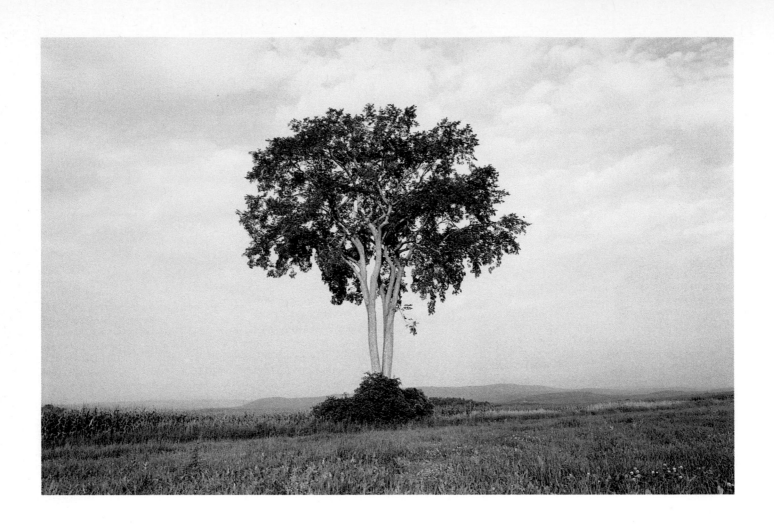

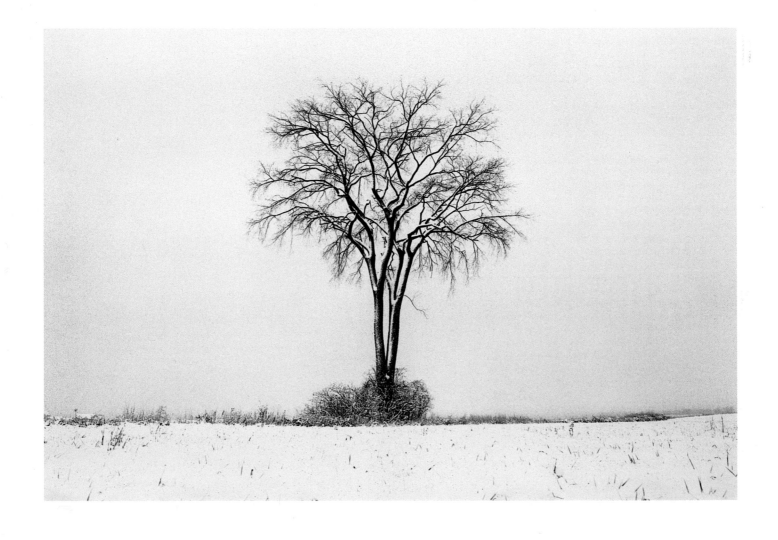

FOR YOU O DEMOCRACY

Come, I will make the continent indissoluble,
I will make the most splendid race the sun ever shone upon,
I will make divine magnetic lands,
 With the love of comrades,
 With the life-long love of comrades.

I will plant companionship thick as trees along all the rivers of America, and
 along the shores of the great lakes, and all over the prairies,
I will make inseparable cities with their arms about each other's necks,
 By the love of comrades,
 By the manly love of comrades.

For you these from me, O Democracy, to serve you ma femme!
For you, for you I am trilling these songs.

—WALT WHITMAN

Tom Zetterstrom. *American Elm, Summer, Massachusetts, 1993* and *American Elm, Winter, Massachusetts, 1994.* Gelatin silver prints from *Portraits of Trees.*

CONTENTS

PLATE XI.

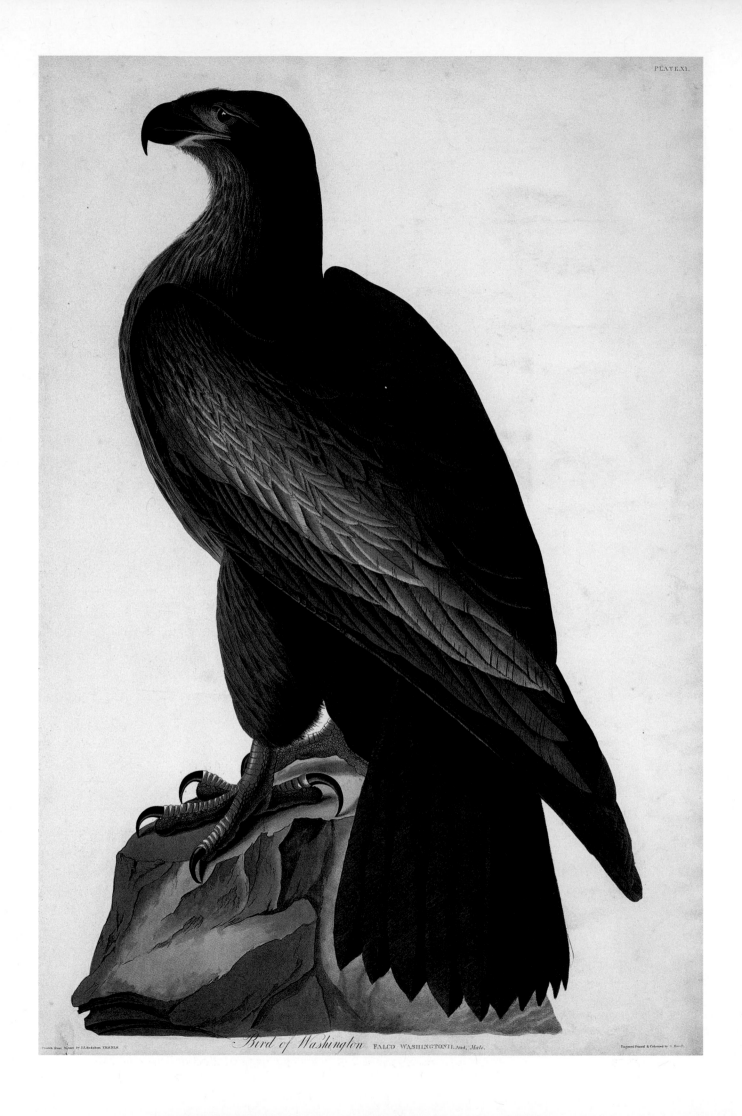

Bird of Washington FALCO WASHINGTONII, Aud, *Male.*

Drawn from Nature by J.J.Audubon. F.R.S.E.S. Engraved, Printed & Coloured by R. Havell.

PREFACE

Beginning well before that remarkable era in the late eighteenth century when the basic ideals of the United States of America were expressed in the nation's founding documents, this land has been a magnet for dreams, drawing people from all over the world to pursue their hopes for a better life. Each generation of Americans has been enriched by the infusion of new energies and new talents from abroad. Alone among the nations of the earth, the United States is at once a heterogeneous assemblage of people of various colors, religions, and national origins and a remarkably stable democratic society constantly redefining itself by the very principles upon which it was founded.

The story of the United States has its dark side: grave injustices, slavery, bigotry, civil war, hardships, violence, opportunities missed or long denied. What makes the American narrative unique is the ability we have displayed time and again to remedy our mistakes, to adjust to changing circumstances, to debate and then move on in new directions that seem better for all.

Eyes of the Nation brings this epic chronicle to life through the artful presentation of more than five hundred images of the American past—images created by those who helped build it, preserved in the collections of the Library of Congress, and painstakingly selected by the Library's curators and coauthor Vincent Virga. These vivid images, which include prints, posters, maps, manuscript pages, photographs, designs, movie stills, and cartoons, show how Americans have viewed themselves, and have been viewed by others, in the course of this great work-in-progress that is the United States.

The development of American democracy is, of course, a dramatic reflection of the power of the written word. In 1776, a small group of American leaders announced their intentions with some of the most influential words ever written: those of the Declaration of Independence. The first page of Thomas Jefferson's rough draft of the Declaration is in this book. Like each of the images in *Eyes of the Nation*, it is accompanied by a caption that describes its creation and establishes its place in the American story. Historian Alan Brinkley's narrative, introducing each chapter in the book, provides an illuminating verbal foundation for this fresh and unusual visual history of the United States.

The Library of Congress is, in many ways, "The Nation's Memory." Since it was established in 1800, with 740 volumes and three maps, it has grown into the world's largest library, holding over 111 million items in all media and in more than 450 languages. Just one hundred years ago, as the collections grew and the Library moved

W. H. Lizars, after John James Audubon. *Bird of Washington* (Bald Eagle). Hand-colored engraving from Audubon, *Birds of America*, Plate 11. London, 1827–38.

Dick de Marsico. Times Square, facing uptown. Celebrating Japanese surrender, World War II. Photograph for *New York World-Telegram and Sun,* August 1945.

from the U.S. Capitol into the first separate Library of Congress building, now named for Thomas Jefferson, the collections were sorted out and separate divisions were created for the Library's "special collections"—prints and photographs, rare books, cartography, music, and audiovisual materials. This book celebrates both that event and these valuable and still growing repositories of the American heritage.

Established to serve Congress, and continuously supported by Congress, the Library of Congress is also the *nation's* library, supplying basic cataloging data to all other libraries, providing other services to the public, and serving as a source of information and enlightenment to researchers everywhere. We work hard to make these magnificent collections ever more accessible to the public at large, and have, in recent years, received increasing private support for our efforts. We have launched a massive new electronic initiative, the National Digital Library, which is now making it possible for people around the world to "visit" our new on-line collections of American history via the Internet. We host lectures and symposia and mount exhibitions—many of which also become accessible via the Internet; and we engage in collaborative publishing projects. All these efforts are made possible by the Library's staff, the men and women who develop and preserve its collections, whose expertise helps set each item we hold in its proper context and whose dedication and joy in their work are reflected in the pages of *Eyes of the Nation.*

Inscribed upon the walls of the Library's James Madison Building, the nation's official memorial to our fourth president and chief architect of our Constitution, is a note Madison penned in 1829:

The happy union of these states is a wonder: their constitution a miracle: their example the hope of liberty throughout the world.

One hundred and sixty-eight years later, the union of our states is still happy; the sturdy constitution adopted over two centuries ago remains a miracle; and the United States continues to be the hope of liberty throughout the world. *Eyes of the Nation* shows how this has come to pass. Like the country it describes, it is a grand mixture of diverse elements. We hope you will enjoy moving through its bright and inspiring pages.

James H. Billington
The Librarian of Congress

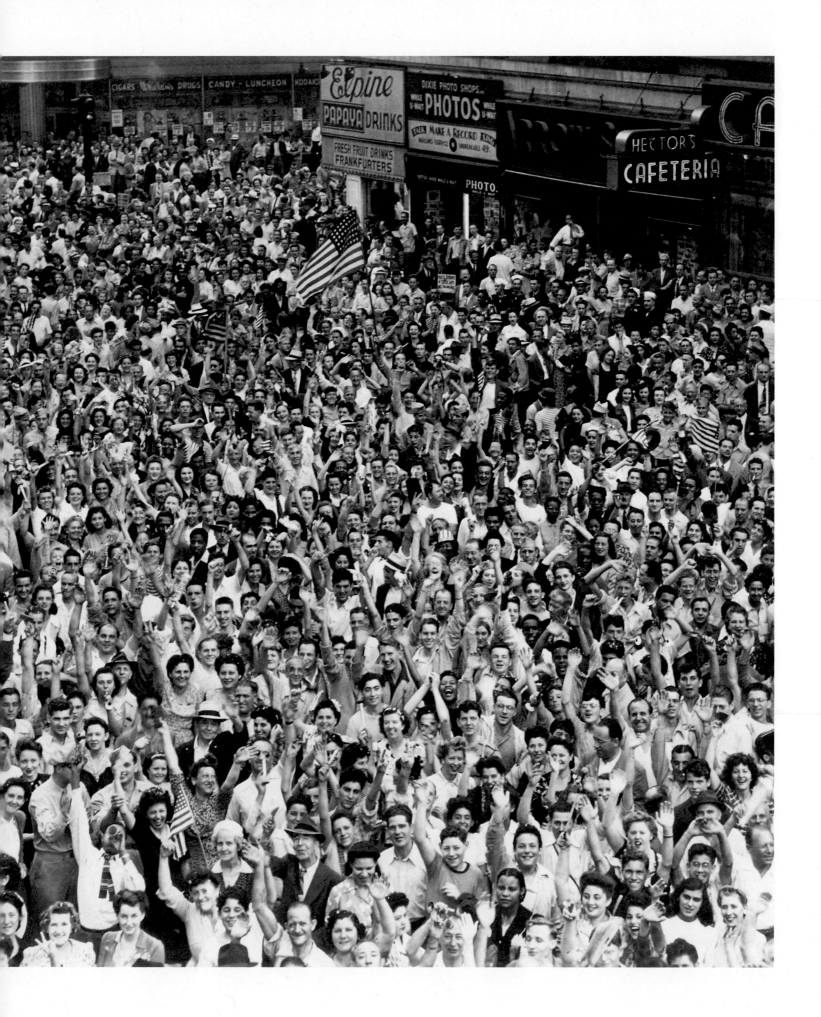

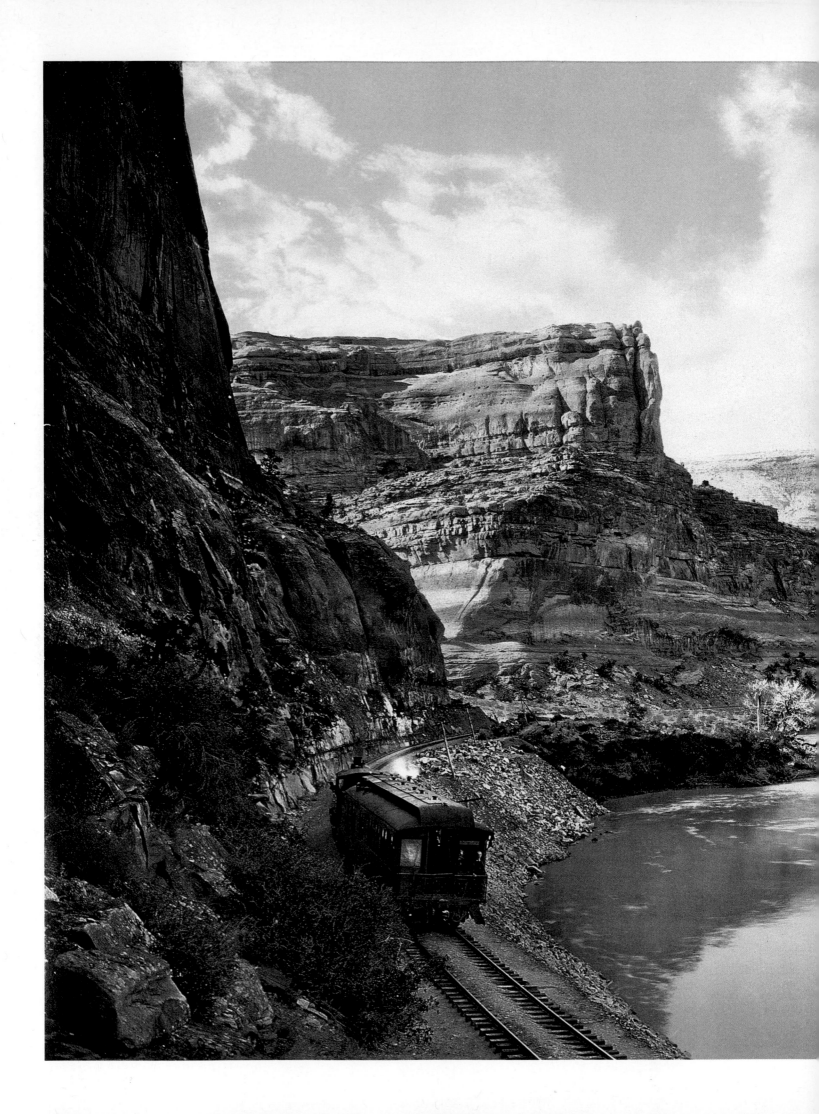

EYES OF THE NATION

William Henry Jackson. *Citadel Walls, Cañon of the Grand, Utah.* Photomechanical print, photochrom, Detroit Publishing Company, 1900.

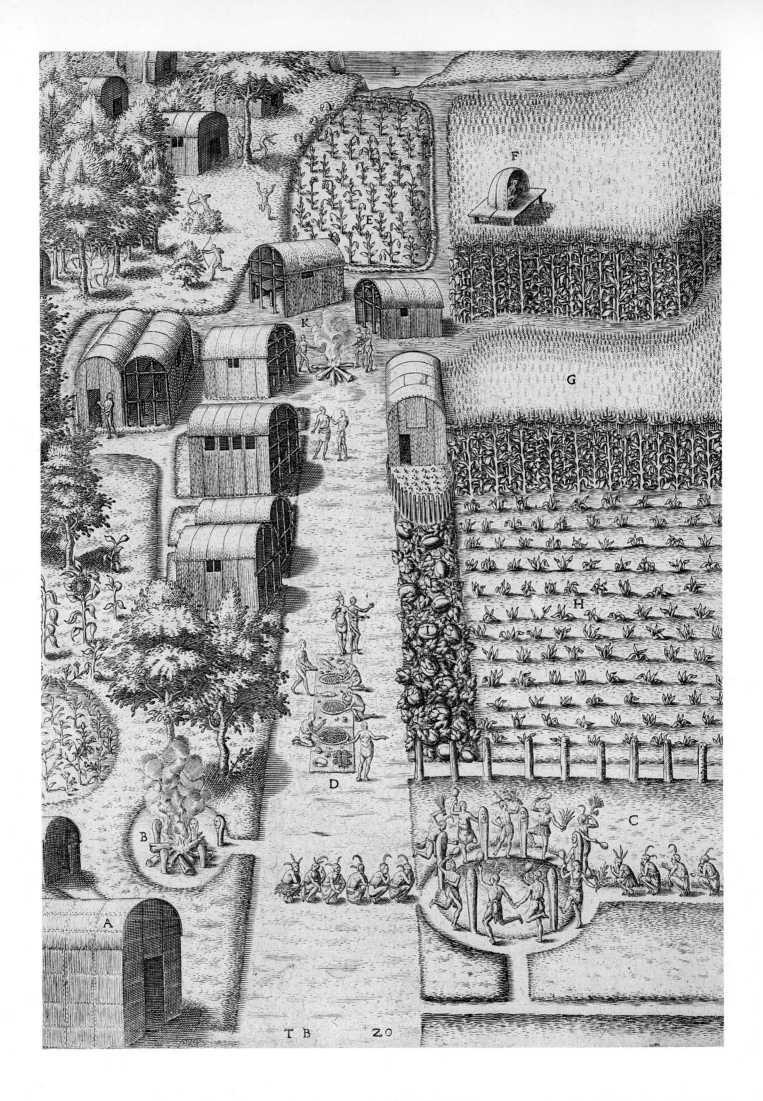

TB 20

ENCOUNTER, 1492–1600

Shakespeare wrote his last play, *The Tempest*, at a time when interest in the Americas was rapidly growing in England, and he set it on a strange and faraway island that almost certainly reflected accounts he had read of early English experiences in Bermuda and the Caribbean. It was an island peopled by strange, wonderful, and terrifying creatures: Caliban, "this thing of darkness," half man and half ogre, who could be controlled by superior power and intellect but who could never be wholly tamed; Ariel, a fairy spirit, endowed with powers that even the great Prospero, the European master of the island, could not entirely match; sprites, nymphs, and monsters, living in a half-paradise, half-purgatory, but living above all in a world unlike anything Europeans could know—a world that was both horrible and alluring.

The Tempest suggests the mixture of astonishment, excitement, and fear with which Europeans encountered what Shakespeare called this "brave new world." But the incomprehension was not, of course, all on one side. The Europeans were as bewildering to the peoples of the Americas as the Americans were to them. To the natives, the intruders were taller, bigger, fairer. They had strange ships, strange weapons, strange clothes and food and animals. Could such people really be humans? Were they not strange and, perhaps, terrible gods? And so it was throughout the long and often brutal process by which Europeans explored, colonized, and battled to control the "new world." Not even centuries of sharing the continents of the Americas—centuries in which the cultures of natives and Europeans blended and merged to produce new civilizations—would entirely remove the barriers between these very different peoples.

*

When Europeans arrived in the Americas at the end of the fifteenth century, it had been home to millions of people for hundreds of centuries. But these first Americans, too, were the descendants of immigrants. Human beings did not originate in America. They had to find it. And they did so in several great waves of immigration: the first from Asia, beginning at least 14,000 to 16,000 years ago; the second from Europe and Africa, beginning in the sixteenth century. For humans, at least, the Americas were indeed the New World that awestruck Europeans called them 400 years ago.

The first American immigrants were nomadic hunters who moved from Siberia into Alaska across an ancient land bridge that spanned the Bering Strait. It has now long since vanished. They were people of Mongol stock, not unlike that of some Asian peoples today. And they crossed into America (almost certainly without realizing that they were entering a new continent) in search of large game animals that their relatively new stone-tipped spears now made it possible for them to pursue. Year after year, a few

Theodor de Bry, after a drawing by John White. *The village of Secota.* Engraving from Thomas Hariot, *A briefe and true report of the new found land of Virginia.* Frankfurt, 1590.

Among the various types of settled communities existing in North America when the Europeans arrived was the Indian village of Secotan on Roanoke Island. This engraving (called Secota on this print) reproduces a drawing made by John White, a cartographer and draftsman who witnessed the first colonization attempt by the English in Virginia organized by Sir Walter Raleigh in 1585. White's portrayal shows a distinctly sophisticated society. The corn is in three stages of growth for three separate harvests; the settlement's crops vary, to include pumpkins, sunflowers, and tobacco. Trading occurs on the middle roadway, not only among fellow villagers, but also with outsiders. The living arrangements are dormitory-style, the deceased are entombed in mausoleums, and religious rituals are performed.

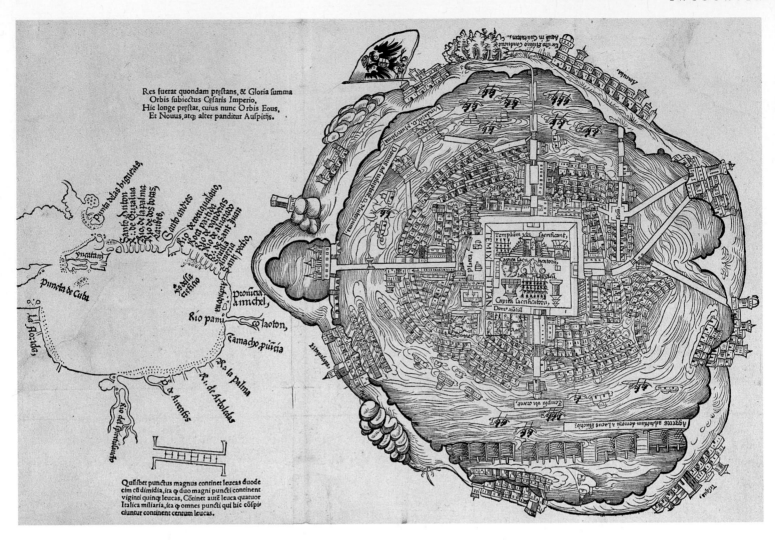

Res fuerat quondam prestans, & Gloria summa
Orbis subiectus Cesaris Imperio,
Hic longe prestat, cuius nunc Orbis Eous,
Et Nouus, atq; alter panditur Auspitiis.

Quilibet punctus magnus continet leucas duode
cim est dimidia, ita q; duo magni puncti continent
viginti quinq; leucas, Cotinet aute leuca quatuor
Italica miliaria, ita q; omnes puncti qui hic cospi
ciuntur continent centum leucas.

at a time, they moved into the new continent; little by little, they moved deeper into its heart. Gradually, this trickle of humanity became a tide. Waves of immigrants followed one another, settled, reproduced themselves, established new tribes and new societies, and spawned yet more immigrants who fanned out further into the vast and beckoning lands. By 8000 B.C., human settlement had reached the southern tip of South America. By 1492 A.D., when the first important contact with Europeans occurred, over 50 million people lived in the Americas and at least 4 million in the territory that is now the United States.

By then, Americans had created extensive and remarkable civilizations. In the Andes of South America, the Incas established a great empire radiating out from their mountaintop capital at Cuzco and encompassing much of the continent. They built roads and bridges to tie their vast lands together. They developed a complex political system and an elaborate network of oral communication (they had no written language). In what is now Mexico, the Mayans created an advanced civilization with a written language, a sophisticated numerical system, substantial cities, and a large coastal trade. Mayan civilization declined after the collapse of their great capital in the eighth century A.D. But by the fifteenth century, the Aztecs had created a new Mexican empire, centered in the city of Tenochtitlán on the site of what is now Mexico City. They established an uneasy dominion over much of the Mexican peninsula and built elaborate administrative and educational systems. They also sustained a brutal warrior culture and a violent religion that required human sacrifice on a scale hitherto unknown in history. Hundreds of thousands of people died at their hands, in rituals designed to celebrate victories and

Map of Mexico City and the Gulf of Mexico. Woodcut from Hernán Cortés, *Praeciara Ferdinandi Cortesii de nova maris Hyspania narratio*. Nuremberg, 1524.
This map—actually two separate maps on a single sheet—appeared with the second letter from Cortés to King Charles I of Spain (Emperor Charles V). To impress the royal court, Cortés also sent objets d'art and treasures. On the right is a rendering of Tenochtitlán (Mexico City) presented to Cortés as a gift from the Mexicas (Aztecs) in the 1519–21 period; on the left is the Gulf Coast region of Mexico with the southeastern part of the present-day United States, as prepared by the Mexica peoples or by a contemporary Spanish explorer.

The Pillars of Hercules. Title page engraving from Francis Bacon, *Instauratio magna.* London, 1620.
The Pillars of Hercules, as the western entrance to the Strait of Gibraltar had been known since antiquity, marked what was believed to be the end of the world, the portal to the inaccessible outer sphere of the cosmos, a great dark "Ocean Sea." This belief was firmly held by medieval Europeans, confirmed by their weightiest authorities: the genius mapmaker Ptolemy, the Bible, and the Pope. Even the intrepid Marco Polo was branded a liar for ascribing to Asia a greater eastward extension than found in Ptolemy. Francis Bacon, here poeticizing Ptolemy, was a member of Queen Elizabeth's Learned Council and has been called the "father figure of western science."

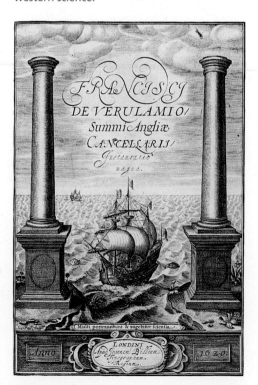

placate jealous gods. Not surprisingly, the Aztecs were despised by their rivals, some of whom later assisted European invaders in destroying them.

The peoples north of Mexico—in the lands that became the United States and Canada—developed no empires so great and no civilizations so elaborate as those to their south. But they too built substantial societies. In the northern parts of the continent, people subsisted on hunting, gathering, and—along the coasts and lake shores—fishing, sometimes living nomadically and sometimes in stable, established communities. Further south, agricultural societies emerged: the pueblo-dwellers of the Southwest, who built elaborate irrigation systems and substantial towns; the farmers who cultivated grain on the fertile lands of the Great Plains; the peoples of the heavily wooded East, who combined hunting, fishing, and gathering with small but intensive agricultural settlements.

The American tribes did not live in isolation. They were acutely aware of the societies around them, and they maintained alliances with some of their neighbors and rivalries with others. Almost all of them were convinced, too, of the existence of gods in the natural world around them—gods they associated with rivers, trees, mountains, rocks, crops, and game; with the natural landscape that formed the basis of their existence and their self-image. The world, they believed, was vast and mysterious. They knew they were only a small part of it. And there was, indeed, much of it they did not know. For as late as the end of the fifteenth century, they were completely unaware of what would soon become the most important force in their long and eventful histories. They knew nothing of the great civilizations that had emerged simultaneously across the oceans—civilizations that were destined to intrude upon, and largely destroy, their world.

*

The peoples of Europe in the late fifteenth century knew no more of the New World than the New World knew of them. Maps of the time included rough approximations of Asia and Africa, but nothing of the Americas—only a vast "terra incognita" guarded, they believed, by the mythical Pillars of Hercules in the eastern Atlantic, beyond which stretched vast expanses of ocean endlessly into the west. But whatever the world was, Renaissance Europeans had come to believe they were at the center of it. Having emerged from years of military vulnerability, economic provincialism, and devastating famines and plagues, Europe was growing rapidly. Throughout the fifteenth century, powerful nation-states began to emerge and to finance great ventures. They sent explorers and merchants to search further and further into Africa and Asia. Those

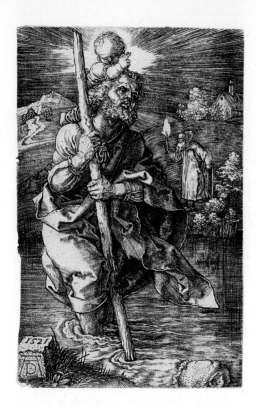

Albrecht Dürer. *St. Christopher.* Engraving. Nuremberg, 1521.

It is said that the first step toward Europe's discovery of the earth's fourth part was taken by the parents of Columbus when they baptized him in honor of Saint Christopher, who, according to popular legend, carried the Christ child across a river. Throughout his life, the explorer believed it his destiny, his mission, to carry the word of Christ across the ocean to the lands of Marco Polo. Dürer was born in Nuremberg, and was the first German artist to achieve fame outside the borders of his country. In his art Dürer introduced to northern Europe the radical discoveries of the Italian Quattrocento and its commitment to the natural world, thus opening realms of creative exploration. In the New World, a host of native craftsmen were employed by Spanish missionaries to create altarpieces, and were given prints by Dürer and his fellow engravers to use as models.

merchants established trading posts, captured slaves, and sought new riches both for their own coffers and for the glory of their nations and their sovereigns. Having once been among the world's most backward civilizations, Europe was rapidly becoming its most dynamic and adventurous.

One of the fruits of this expansion was a large and growing trade with the great civilizations of Asia. And throughout the late fifteenth century, because of that trade, explorers from the maritime nations—primarily Portugal and Spain—began seeking a sea route to the riches of the East. Most navigators assumed that any such route must include the dangerous passage through the turbulent waters at the southern tip of Africa. But a skilled Genoese sailor believed there was an alternative. If the world was indeed round, as most educated people now believed, then it should be possible to reach Asia not by sailing east around Africa, but by sailing west across the Atlantic.

Christopher Columbus took this daring proposal to the Portuguese, who scoffed at him. The circumference of the earth, they correctly argued, was about twenty-five thousand miles; a voyage to Asia would be impossibly long. But Columbus was convinced that the earth's circumference was much smaller, and that the voyage to Asia would be a manageable three thousand miles. Neither he nor his detractors were aware that anything lay between Europe and Asia.

Spurned by the Portuguese, he turned to the new Spanish monarchs, Ferdinand and Isabella, whose marriage had united the two most important Iberian kingdoms into a large and powerful nation. Isabella was impressed with his vision. She named him "Admiral of the Ocean Sea" and funded his expedition.

A strange and mystical man, Columbus considered himself an agent of God on earth, appointed to guide humankind toward the coming millennium. His explorations, he believed, were part of this divinely ordained mission. "God made me the messenger of the new heaven and the new earth," he wrote near the end of his life, "and he showed me the spot where to find it." But he was also in search of worldly success, and finding a trade route to Asia seemed a likely avenue to vast riches. Leaving Spain in August 1492, he sailed west across the Atlantic. Ten weeks later, he saw land and thought he

Inhabitants of the "New World." Title page from Giuliano Dati, *Il secondo cantare dell'India.* Rome, 1494–95.

Dati, an Italian poet, took the *Epistola* of Columbus and set it to verse as "The Songs of the Indies." His illustrations were loosely based in part on descriptions in the text, but also drew heavily upon Jean de Mandeville's *Travels,* which first appeared in French between 1350 and 1375. Mandeville's books, along with those of Marco Polo, had been sources of inspiration for Columbus. The cyclops, pygmy, bigfoot, and other creatures real and fictional described by Mandeville were soon rumored to inhabit North America as well, thanks to their inclusion in Dati's poem.

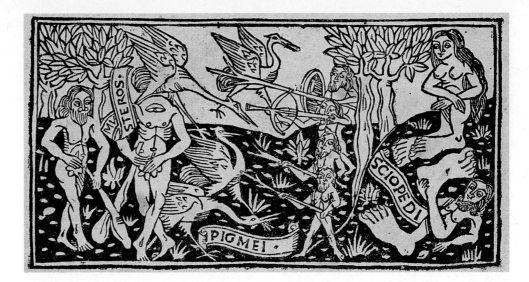

had reached his destination. In reality, he had encountered not China or Japan, but the Bahamas and Cuba. But convinced that he had reached the East Indies in the Pacific, he called the natives Indians; and convinced that the rest of Asia was only a short distance away, he launched two more expeditions—in 1493 and 1498—neither of which, of course, took him anywhere near his goal. It remained for later explorers to recognize that the lands Columbus had described were in fact part of a vast new continent far from Asia. One of them—an Italian named Amerigo Vespucci, whose vivid descriptions of the New World helped popularize that knowledge—gave the continents his name: the Americas.

*

In the century following Columbus's voyages, the worlds of America and Europe became increasingly, and often catastrophically, intertwined. The Spanish and Portuguese soon ceased to think of America as an obstacle on the way to Asia and began considering it, rather, as a new source of wealth and glory. Instead of explorers, they now sent soldiers—the *conquistadores,* or conquerors. These were men of great skill and daring. They were also men nearly consumed by greed, and they were armed in their mission with the sense that the natives they encountered were barely human. Contemporary maps and engravings of America by Europeans revealed a fantastic, *Tempest*-like world, whose denizens were exotic, menacing savages and cannibals. The waters of the Americas, the maps suggested, were teeming with mythical sea creatures; the forests were filled with strange and terrible beasts.

The natives, for their part, viewed the intruders with almost equal bewilderment—but far less assurance. As reports of the intruders began to reach the great American cities, people began looking for divine signs to help them understand this new presence. When Montezuma, emperor of the Aztecs, saw what he described as a "comet with its brilliant tail" sometime in the 1520s, he was certain it was just such a sign. He summoned a respected elder knowledgeable in interpreting omens. Many men would come to the land of the Aztecs, the old man said, men with long beards and white faces "mounted on beasts similar to deer." They would "possess the country, settle in all its cities, multiply in great numbers, and be owners of gold, silver, and precious stones."

Later, more stories reached the emperor: stories of soldiers with new weapons so powerful they could destroy a mountain or shatter a tree. Montezuma assumed the men were gods, and he sent offerings of food, soaked with the blood of human sacrifice, in hopes of placating them. But according to one Aztec chronicle, the Spaniards

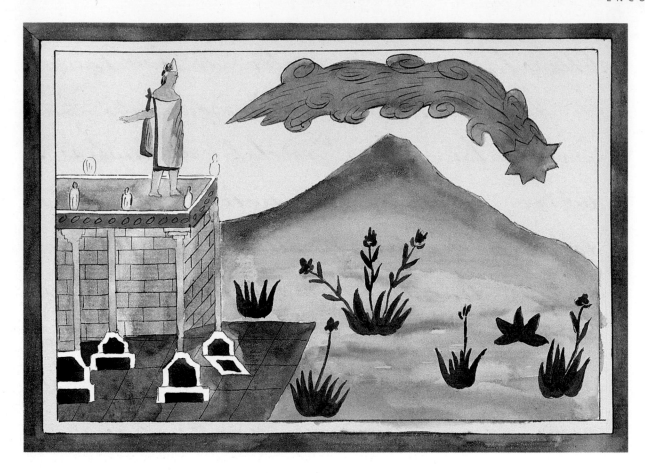

"spat . . . shut their eyes [and] shook their heads. . . . Much did [the food] revolt them." Later, as the Spanish approached Tenochtitlán, Montezuma sent more tribute, this time made of gold. The tribute only inflamed the invaders' avarice and hastened their movement toward conquest. "They picked up the gold," an Aztec chronicler wrote of the Spanish, "and fingered it like monkeys. They longed and lusted for gold. Their bodies swelled with greed, and their hunger was ravenous."

In Mexico and South America, Spanish and Portuguese conquerors gradually spread through vast new lands, constructing great empires of their own and nearly destroying the societies and peoples they encountered along the way. They conquered the natives in part with brute military strength, but in ever greater part through the inadvertent spread of terrible diseases previously unknown in the Americas—smallpox, typhus, measles, influenza—to which the unimmunized natives were tragically vulnerable. Millions died. In some areas—the island of Hispaniola, certain parts of Mexico, and others—virtually the entire native populations succumbed to these imported diseases. Almost everywhere, the indigenous societies were decimated by illness.

In the beginning at least, few of the Spanish and Portuguese settlers in the New World expected to work. They were products of a hierarchical society in which the definition of success was living like a nobleman, supported by the labor of others. They attempted to recreate that society in their new empires across the sea. To do so, they needed a labor force; and so they set out to recruit one. In areas where substantial native populations survived the plagues and wars, Europeans enslaved them and put them to work. Few European women made the perilous voyage to this rough new world, far too few to provide families for all the men who had traveled there. And so the European men intermarried extensively with native women, even as they subju-

Montezuma awaits Cortés. Drawing, watercolor, and ink from Fray Diego Durán, *La Historia antigua de la Nueva España*. Early nineteenth-century facsimile.

Diego Durán was a Spanish Dominican priest who worked to convert the Aztec, or Mexica, people to Christianity. In order to understand their culture more fully, in the 1570s he recorded the history of their society in a manuscript that was not published until the nineteenth century. This leaf from the manuscript illustrates the moment that Montezuma, having heard of white, sandy-haired men arriving on his eastern coast, reportedly saw a comet plunge to earth, a clear portent of disaster. The great leader stares uncertainly, fearing the fate of his people as the Spaniards arrive in the unknown territory.

gated them; over time the racial hierarchy of Spanish and Portuguese America became complicated and, to some degree, permeable.

In areas where there were too few natives to sustain the colonies, Europeans began importing new workers, making use of an already well-established slave trade with Africa. Slavery in the Spanish world was a somewhat more fluid institution than it would later become in the United States; and Africans, too, began intermarrying with natives and, at times, with whites. Within decades, through large areas of the Americas, new multiracial civilizations were emerging in which Europeans, Africans, and American natives joined in hierarchical, but also intimate, communities.

By the end of the sixteenth century, the Spanish empire had become one of the largest in the history of the world. Along with the great Portuguese empire in Brazil, Europeans had established a claim to virtually all the territories of South and Central America, and to the southern regions of the North. They had drawn great societies of native people, who had lived for thousands of years in isolation from the rest of the world, into an expanding global civilization centered, for the moment at least, in Europe. They had created a catastrophe perhaps unprecedented in history: the deaths of millions of people, the enslavement of millions of others. They had also laid the foundations for even larger and grander civilizations than the ones they had vanquished.

By the late sixteenth century, Spanish settlement was beginning to reach north of Mexico, into the lands that now constitute the United States. In 1565 Spanish colonists established an outpost at St. Augustine in what is now Florida. A half century later, they established another at Santa Fe in what is now New Mexico. But by then, other European powers had begun to take an interest in the New World as well. And a wholly new process of settlement, dominated by the English, had begun its own errands into the wilderness.

* * *

Panning for gold. Woodcut from Gonzalo Fernández de Oviedo y Valdés, *La historia general delas* [sic] *Indias*. Seville, 1535.

The discovery of gold in great abundance in the New World stimulated what might be called the first "gold rush" across the Atlantic by the Spanish *conquistadores* in search of power and riches. This prospecting scene is one of several woodcuts that appeared in the Spanish historian and naturalist Oviedo's great *Historia*. Oviedo introduced Europe to an enormous variety of previously unheard-of "exotica" from the newly visited Western Hemisphere—items such as the hammock, the pineapple, and tobacco. Oviedo believed that "without a doubt the eyes play a great part in the information of these things, and given that they themselves cannot be seen or touched, the image of them is a great help to the pen." While overseeing the mines on Hispaniola, Oviedo produced the first known illustrations done from life by a European traveler in the New World. This rare copy of *La historia* is signed by the author.

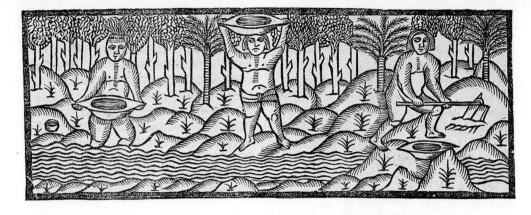

Theodor de Bry, after a drawing by Jacques le Moyne de Morgues. Scenes in Florida. Engraving from de Bry, *America*, Part II. Frankfurt, 1590.

Le Moyne was a cartographer on the 1562 French expedition to Florida, which aimed to build a colony partly as a religious refuge for the Huguenots and partly as a base for pirate attacks against the Spanish. Le Moyne's assignment was to "map the sea coast, and lay down the positions of towns, the depth and course of rivers, and the harbours; and to represent also the dwellings of the natives, and whatever in the province might seem worthy of observation." The colony was destroyed by the Spanish in 1565, and some survivors returned to France. Le Moyne's drawings, probably made from memory, were adapted and published by the Flemish engraver and goldsmith Theodor de Bry who endowed the people with the poise and proportions of classical statues and created a romance of primitive prowess. In this engraving the indigenous alligator, unknown to Europeans, is merged with the familiar African crocodile and transformed into a dragon of mythological proportions.

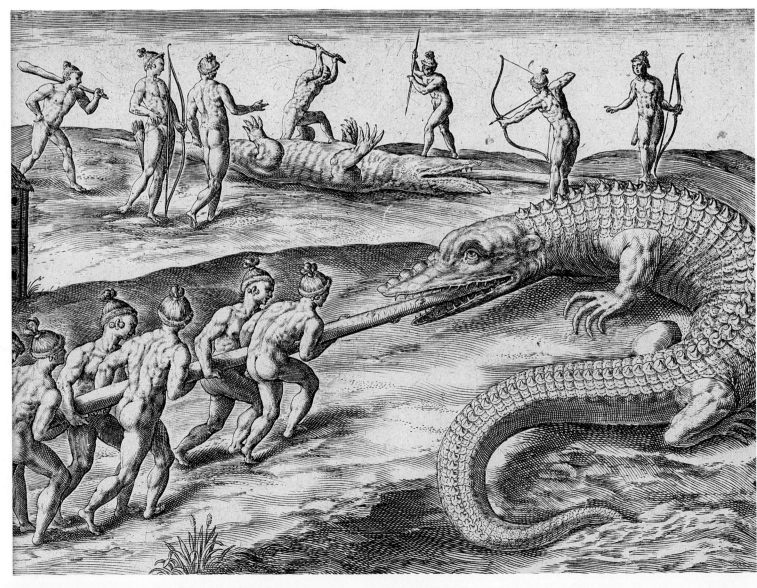

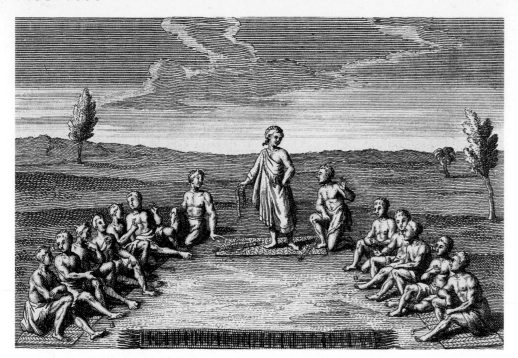

The Five Nation Confederacy. Engraving from Père Joseph François Lafitau, *Moeurs des sauvages amériquains*. Paris, 1724.

The Confederacy was a political and civic organization formed around 1570 by the five Iroquois nations—Mohawk, Cayuga, Oneida, Onondaga, Seneca—in what is now New York State and Canada. Iroquois towns and villages were autonomous, but the Confederacy influenced life from the Mississippi River to the Atlantic Ocean. While men dominated the politics of the Confederacy, it was the elder women who nominated tribal chiefs and representatives to the councils. Some have suggested that Benjamin Franklin based his vision of a democratic society on the Iroquois system. This engraving shows the use of beaded belts, called *wampum*, as aids to the memorization of tribal law. Such memory aids were widespread.

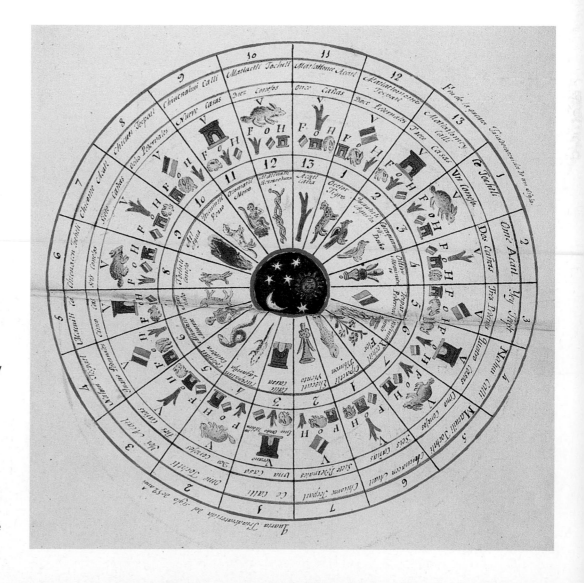

Calendar wheel, no. 7. Drawing, watercolor and ink from Mariano Fernández Echeverría y Veytia, *Historia del origen de las gentes que poblaron la America septentrional*. Early-nineteenth-century facsimile.

The *tonalpobualli*, or sacred calendar, ruled the life of each Mexica (Aztec) and was consulted on all important occasions well before the early-sixteenth-century Spanish conquest. It was made up of 260 days, or 13 months of 20 days each. The inner portions represent the symbols for the 20 days and the sun, moon, and stars.

Remmet Teuinesse Backer. Celestial map. Engraving with watercolor from Reiner Ottens, *Atlas Maior,* Vol. 1. Amsterdam, 1729. Objects of wonder in every human society, the stars have been studied and charted for thousands of years. Early Western science concentrated on the stars and the planets. The constellations were grouped to mark the path of the sun and observed not only for the mystical purposes of the zodiac, but also for the practical uses of the solstice and equinox in agriculture and the North Star in navigation and exploration. These "star pictures" comprise familiar objects, creatures, and mythological beings, perhaps to domesticate or "tame" the heavens. Ottens was one of the last of the prominent cartographers of the Dutch Golden Age (1570s–c. 1750). This 360-degree diagram of the heavens is a later example of the tradition and is part of a seven-volume series encompassing the geography of the known world.

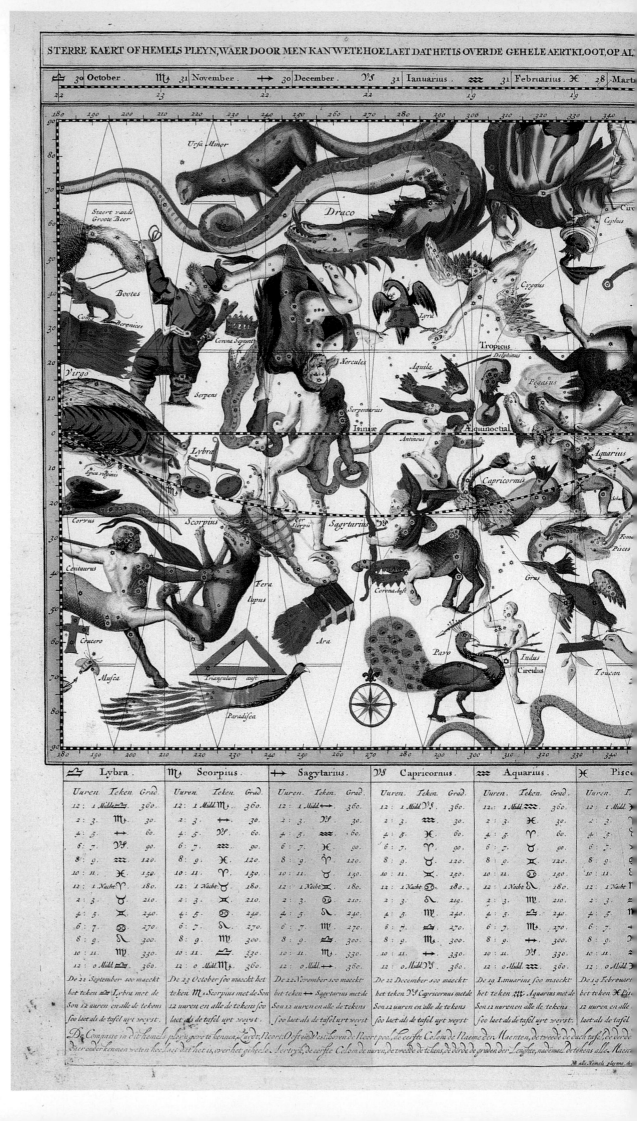

Aprilis.	♉	30 Maius	♊	31 Iunius.	♋	30 Iulius.	♌	31 Augustus.	♍	31 September	♎
20		20		21		22		23		22	

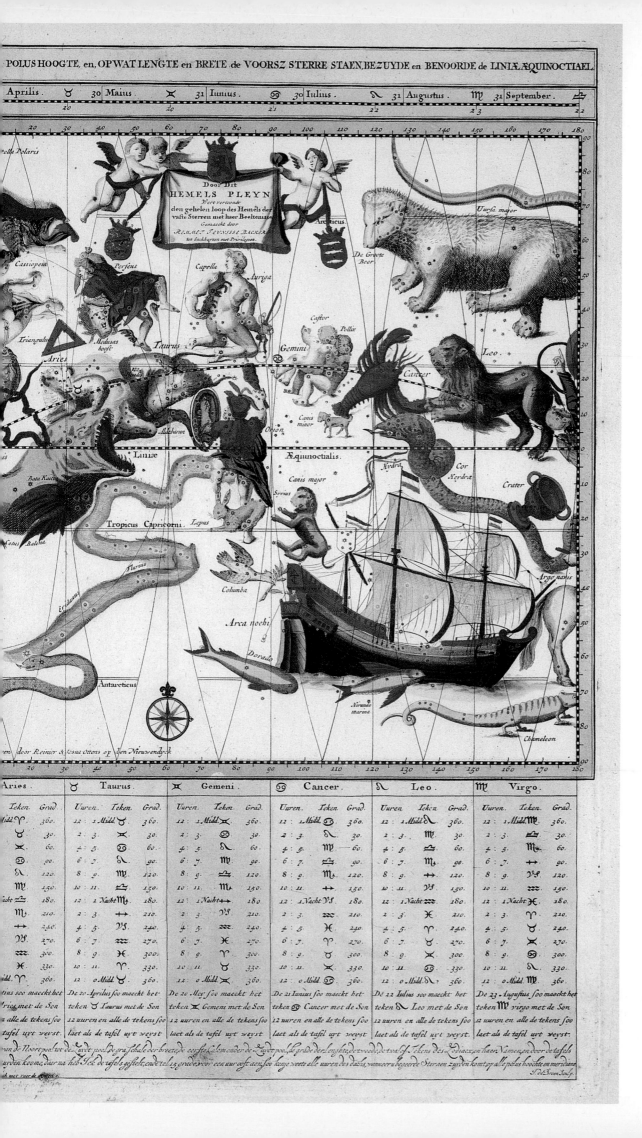

Aries.		Taurus.		Gemeni.		Cancer.		Leo.		Virgo.	
Teken. Grad.		Uuren. Teken. Grad.		Uuren. Teken. Grad.		Uuren. Teken. Grad.		Uuren. Teken. Grad.		Uuren. Teken. Grad.	
Midd ♉ 360.		12 : 1 Midd ♊ 360.		12 : 1 Midd ♋ 360.		12 : 1 Midd ♋ 360.		12 : 1 Midd ♌ 360.		12 : 1 Midd ♍ 360.	
♊ 30.		2 : 3. ♋ 30.		2 : 3. ♌ 30.		2 : 3. ♍ 30.		2 : 3. ♍ 30.		2 : 3. ♎ 30.	
♋ 60.		4 : 5. ♌ 60.		4 : 5. ♍ 60.		4 : 5. ♎ 60.		4 : 5. ♎ 60.		4 : 5. ♏ 60.	
♋ 90.		6 : 7. ♍ 90.		6 : 7. ♎ 90.		6 : 7. ♏ 90.		6 : 7. ♏ 90.		6 : 7. ♐ 90.	
♌ 120.		8 : 9. ♍ 120.		8 : 9. ♎ 120.		8 : 9. ♏ 120.		8 : 9. ♐ 120.		8 : 9. ♑ 120.	
♍ 150.		10 : 11. ♎ 150.		10 : 11. ♏ 150.		10 : 11. ♐ 150.		10 : 11. ♑ 150.		10 : 11. ♒ 150.	
♎ 180.		12 : 1 Nacht ♏ 180.		12 : 1 Nacht ♐ 180.		12 : 1 Nacht ♑ 180.		12 : 1 Nacht ♒ 180.		12 : 1 Nacht ♓ 180.	
♏ 210.		2 : 3. ♐ 210.		2 : 3. ♑ 210.		2 : 3. ♒ 210.		2 : 3. ♓ 210.		2 : 3. ♈ 210.	
♐ 240.		4 : 5. ♑ 240.		4 : 5. ♒ 240.		4 : 5. ♓ 240.		4 : 5. ♈ 240.		4 : 5. ♉ 240.	
♑ 270.		6 : 7. ♒ 270.		6 : 7. ♓ 270.		6 : 7. ♈ 270.		6 : 7. ♉ 270.		6 : 7. ♊ 270.	
♒ 300.		8 : 9. ♓ 300.		8 : 9. ♈ 300.		8 : 9. ♉ 300.		8 : 9. ♊ 300.		8 : 9. ♋ 300.	
♓ 330.		10 : 11. ♈ 330.		10 : 11. ♉ 330.		10 : 11. ♊ 330.		10 : 11. ♋ 330.		10 : 11. ♌ 330.	
Midd ♈ 360.		12 : 0 Midd ♉ 360.		12 : 0 Midd ♊ 360.		12 : 0 Midd ♋ 360.		12 : 0 Midd ♌ 360.		12 : 0 Midd ♍ 360.	

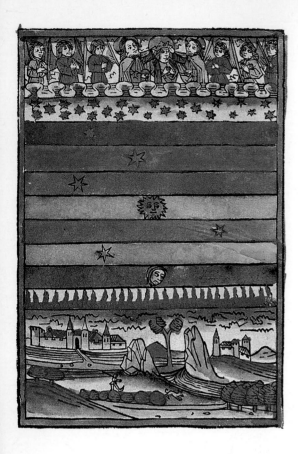

Earth and the planets. Color woodcut from Konrad von Megenberg, *Buch der Natur.* Augsburg, 1481.

Europeans in the fifteenth century considered the earth the center of the universe around which the sun, the stars, and the planets revolved. In visualizations of this scheme, like this one found in Konrad von Megenberg's encyclopedia of natural lore, *Buch der Natur*, straight horizontal bands neatly separate the world with its four elements from the moon, Mercury, Venus, the sun, Mars, Jupiter, Saturn, and the fixed stars. In an indication of the medieval union of science and Christian belief, Megenberg's artist shows God in his heaven presiding over the cosmic order. On earth, there are castles and kingdoms; it is an ordered, apparently peaceful society, not unlike Secotan. The *Buch der Natur* was compiled in Latin in the thirteenth century and was eventually printed in Germany. It was the first book to use woodcuts for scientific illustration rather than purely for decoration.

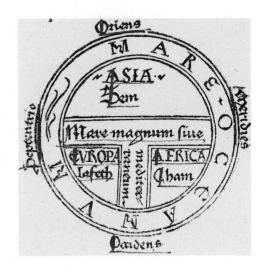

Map of the medieval world. Color woodcut from Isidor of Seville, *Etymologie.* Augsburg, 1472.

The liberation of cartography from cosmology and theology was a gradual process. Isidor's *mappa mundi* was originally drawn between 622 and 633 A.D. for the Bishop of Seville's encyclopedia; it became, with its publication in 1472, the first printed world map. By then it no longer reflected European knowledge of the world's geography, which had been expanded considerably by navigators, beginning in the twelfth century, when Europeans brought their eyes down from the heavens and began to study the earth they inhabited. Isidor's map shows the ancient view of his known world divided into three parts: Asia, Europe, and Africa. This "T" scheme represented the Don and the Nile (or possibly the Red Sea) running horizontally, the traditional separation of Europe and Africa from Asia, and the Mediterranean Sea running vertically. The "T" also stood for the "tau cross," a mystical Christian symbol placing Jerusalem— their "center of the world"—at the intersection of the horizontal and vertical axes. The "O" encircling the "T" reflected the common ancient and medieval idea of a habitable world surrounded by confining water.

The earth with the sun and the moon. Color woodcut from Joannes de Sacro Bosco, *Sphaera mundi.* Venice, 1485.

In 1220, drawing on Ptolemy and his Arabic commentators, Sacro Bosco wrote in his famous book, *Sphaera mundi:* "That the earth, too, is round is shown thus." Sacro Bosco taught at the University of Paris, and by 1231 was Europe's foremost mathematician and astronomer. The Florentine astronomer and geographer Toscanelli, working in the tradition of Sacro Bosco, turned out an astrological sailing chart that encouraged Columbus: the outer ocean was accessible and a "shorter way of going by sea to the lands of spices" possible. Toscanelli and Columbus would have known *Sphaera mundi* well, as the fundamental astronomy text of the Middle Ages. It was still being used, with commentaries, in the seventeenth century.

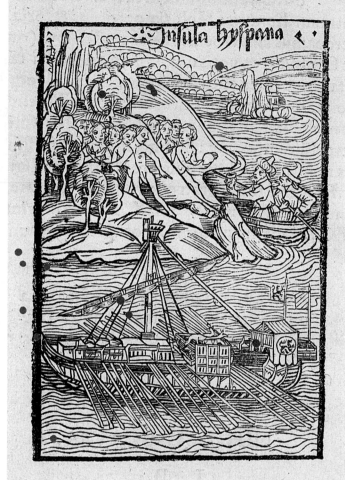

Insula Hyspana. Woodcut from Christopher Columbus, *De insulis nuper in mari Indico repertis* in Carol Verardi, *Historia baetica.* Basel, 1494.

Having dared to sail beyond the dreaded Pillars of Hercules, Columbus believed he had attained the outer reaches of Asia, east of the Ganges. He called the native people of the Bahama Islands "Indians." Not until his third voyage did he realize that he had come upon an uncharted continent between Europe and Asia five times the size of Europe. Upon his return to Spain, Columbus submitted a report of his expedition to the Spanish court. Originally published in 1493 in Rome under the title *De Insulis inventis Epistola,* Columbus's "letter" was immediately and widely reprinted. Verardi's illustrated version appeared the following year in Basel. As no images were provided by Columbus, Verardi's printer supplied this imaginative portrayal of the first encounter, with docile and cowering Indians—though the Arawak people who greeted the Europeans had no fear and considerable curiosity—and a ship with oars more suited to Mediterranean travel than to spanning vast oceans.

How the savages roast their enemies. Etching from André Thevet, *La cosmographie universelle.* Paris, 1575.

In his *Journal,* Columbus clearly reveals that he considered it one of the obligations of the "travel writer" to surprise and delight his readers with the "marvellous," one of his favorite adjectives. Forewarned by the tales of Marco Polo, and by the journals of French explorers in other parts of the "heathen" world, he was on the lookout for cannibalism during his travels but found none. This obligation was later met by André Thevet, a French Franciscan monk and royal cosmographer to the French king Henry III. Recounting his own travels in Brazil as chaplain with Nicolas Durand de Villegaignon's 1555–56 expedition, he graphically chronicled this exotic method of dealing with the spoils of war in South America.

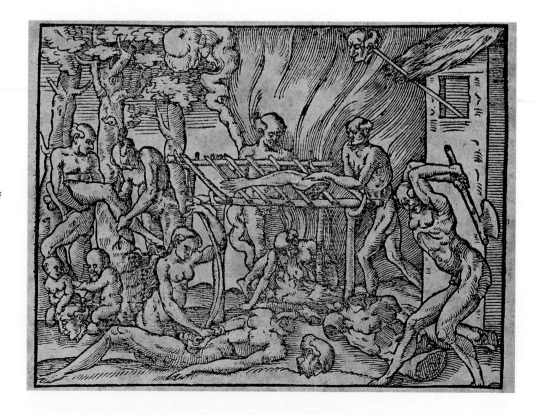

Johan Ruysch. *Universalior cogniti orbis tabula*. Engraving with watercolor from Ptolemy, *Geographia*. Rome, 1507. In a reprinting of the ancient astronomer and geographer Ptolemy's classic atlas after Columbus's first voyage, Johan Ruysch adjusted the second-century three-part worldview to include what Europeans called the "new" fourth part, America. But not knowing what to do with it, or what its unexplored western boundaries were—"this map is left incomplete for the present, since we do not know in which direction it trends"—he neatly tucked the immense fragment beneath Asia, just below the Tropic of Cancer. The West Indies and Cuba are large islands above Cancer between this terra incognita and Asia; and there is still an ocean passage to "the land of the spices." Greenland and Newfoundland (reached by John Cabot in 1497) are attached to Asia just below the Arctic Circle; and Africa is perfectly delineated from the Portuguese circumnavigation of it below the equator in 1497. It was particularly fortunate that the age of European discovery coincided with the invention of printing, which not only made maps cheaper and available to a wider audience but made them more likely to survive. Ruysch was a native of Antwerp who lived in Germany. His map is the earliest original contemporary map relating to America in the Library's collection.

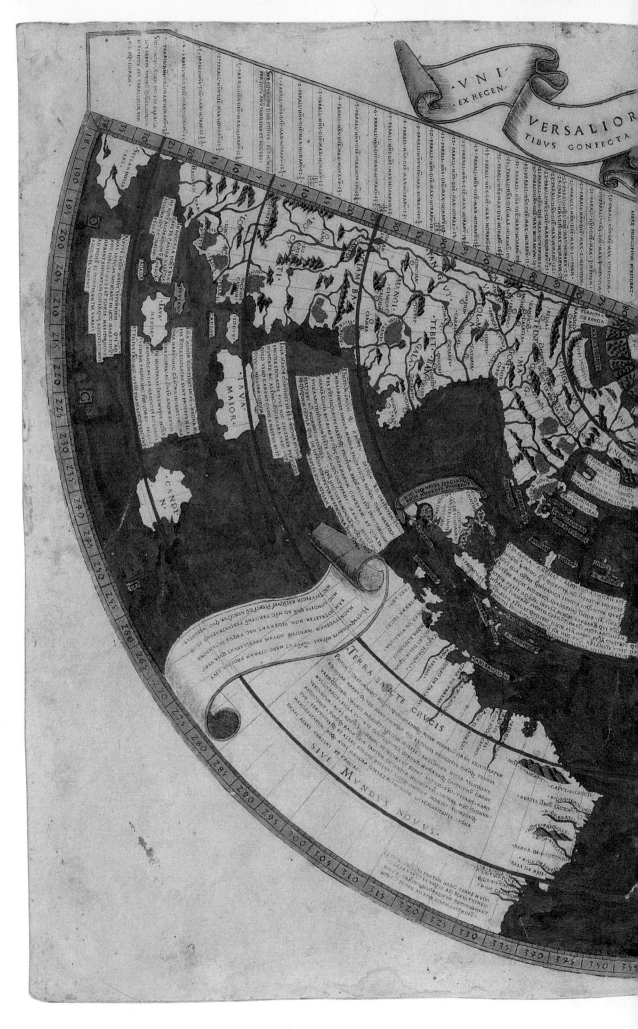

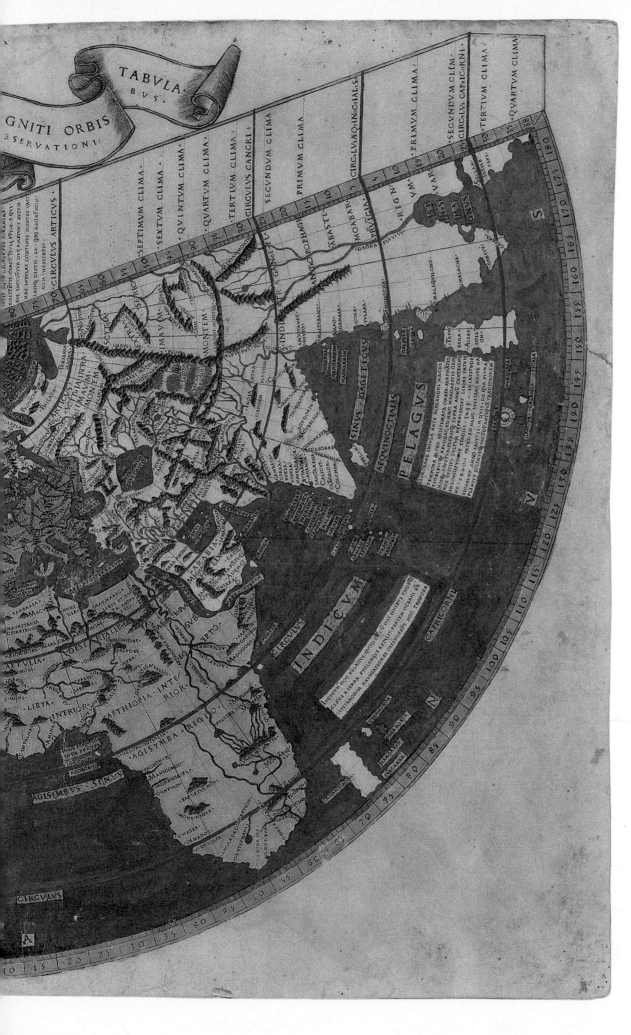

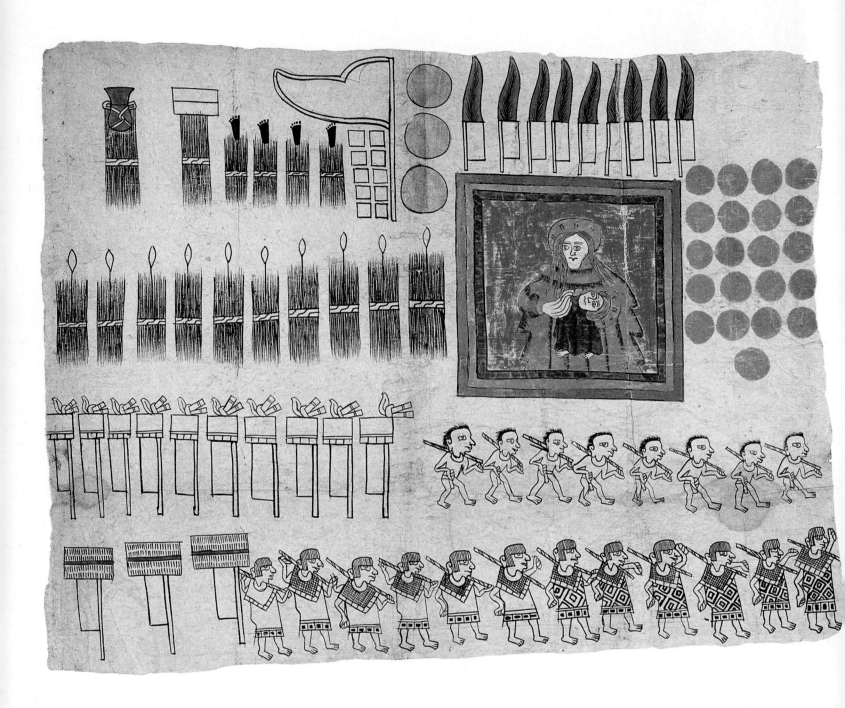

Products and services provided as tribute, including a banner with Madonna and Child. Drawing, colored inks on amate paper from *Huexotzinco Codex*, Painting V. Manuscript, 1531.

The stories of the Spanish warriors who came after Columbus recount great military daring and achievement as well as remarkable brutality and greed. The *conquistadores* concentrated on extracting surface wealth—gold and silver—rather than organizing permanent Spanish colonies in America until the middle of the sixteenth century. By the end of that century, their empire was the largest in history. Cortés had conquered the Aztecs by 1521. After a lengthy absence from his dominion, he was asked by the people of Huexotzinco (located in what is today the state of Puebla, Mexico) to initiate a lawsuit against the high court of New Spain for labor abuses and unjust taxation. The Codex is a portion of this successful legal action. It is eight sheets of handmade renderings. Painting V in the manuscript, one of the earliest native artworks, demonstrates the confluence of Spanish and Indian cultures.

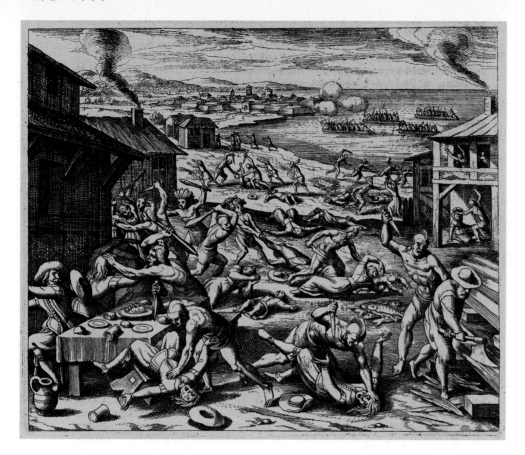

Below: Anatomical drawing. Engraving from Carol Ruini, *Dell'anatomia et dell'infirmità del cavallo*. Bologna, 1598.

The Europeans brought technologies, ideas, plants, and animals to America that would transform people's lives: guns, iron tools, and weapons; Christianity and Roman law; sugar-cane and wheat; cattle and, of course, horses. The horse was a military asset comparable in effect to the tank. It transformed warfare in America. In what has been described as "the first comprehensive monograph on the anatomy of an animal," Ruini, a Bolognese aristocrat and lawyer, described each part of the horse's body and offered advice on the nature and treatment of its diseases. The illustrations are obviously patterned after Vesalius's landmark work on human anatomy based on exploratory dissection.

Above: Theodor de Bry. *1622 Massacre in Virginia*. Engraving from de Bry, *Grandes voyages*, Part 13. Frankfurt, 1628.

Firmly entrenched in the belief—gained in colonizing Ireland—that settlements in foreign lands must retain a rigid separation from native populations, the English relent-lessly assaulted the once-friendly Powhatan Indians, who, like the Irish, retaliated. On March 22, 1622, they massacred 350 white colonists in and around Jamestown. De Bry imagined this gory confrontation as a display of primitive prowess. The colonists are being treated like crocodiles, and there is not a gun in evidence, even though the colonists owned them.

For nearly forty years, the English had been engaged in a series of failed efforts to colo-nize America above the Tropic of Cancer; all below that line was legally controlled by Spain according to papal edict. After one such attempt—a colony on Roanoke Island—was abandoned, Sir Francis Drake took the remain-ing settlers home, and wrote of them: "these men which were brought backe, were the first that I knew of that brought into England that Indian plant, which they call Tabacca and Nicotia, and use it against crudities, being taught it by the Indians. Certainly from that time, it beganne to be in great request, and to be sold at an high rate, whilst very many everywhere, some for wantonnesse, some for healthe, suck in with insatiable greedinesse the stinking smoke thereof."

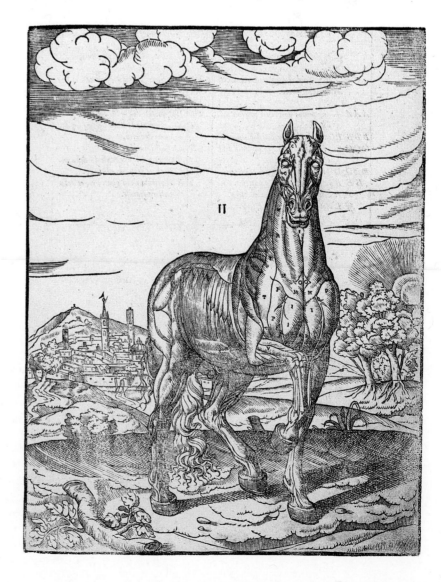

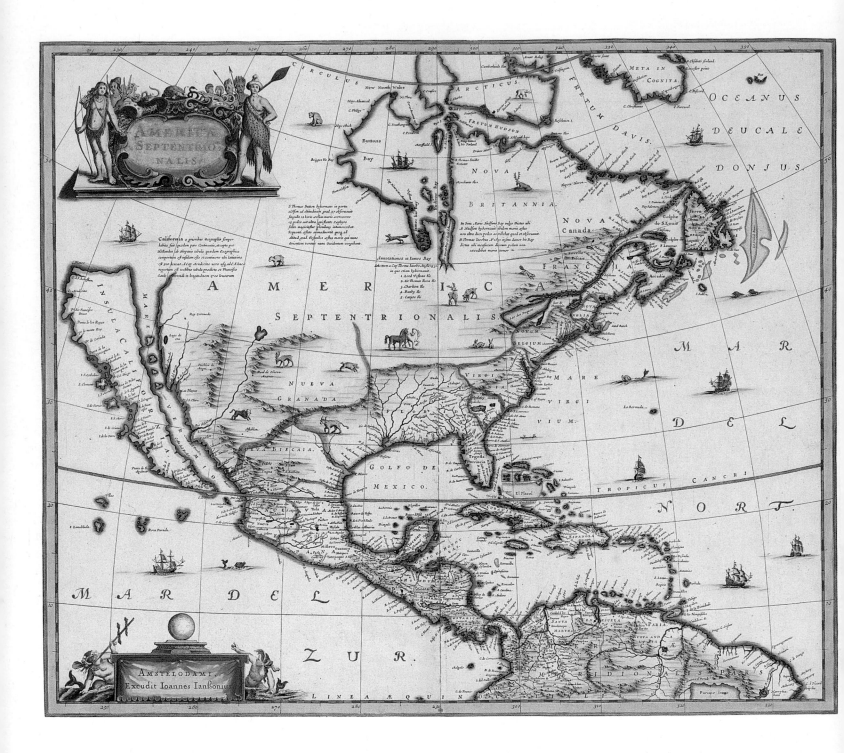

Joannes Jansson. *America Septentrionalis.*
Hand-painted engraving with opaque pig-
ment, watercolor, and gold. Amsterdam.
Until the early 1600s, California was thought
to be part of the mainland; then, legend has
it, a Spanish explorer found a watery indenta-
tion near Cape Mendocino and assumed it
opened into the Gulf of California. On his way
home, his ship was captured by the Dutch,
who took his assumptions for sightings; and
California came to be known as an island until

the Jesuit Father Kino proved otherwise
around 1701. The Caribbean is shown in best
detail because it was closest and of most
interest to the European colonists. The
cartouche has figures in native dress with
snakes, turtles, and lizards, while horses, deer,
beaver, and buffalo roam the uncharted land.
Jansson was one of the most prominent Dutch
cartographers in the tradition of Hondius and
Mercator. This engraving is undated, but it
appears in his *Nuevo Atlas* of 1653.

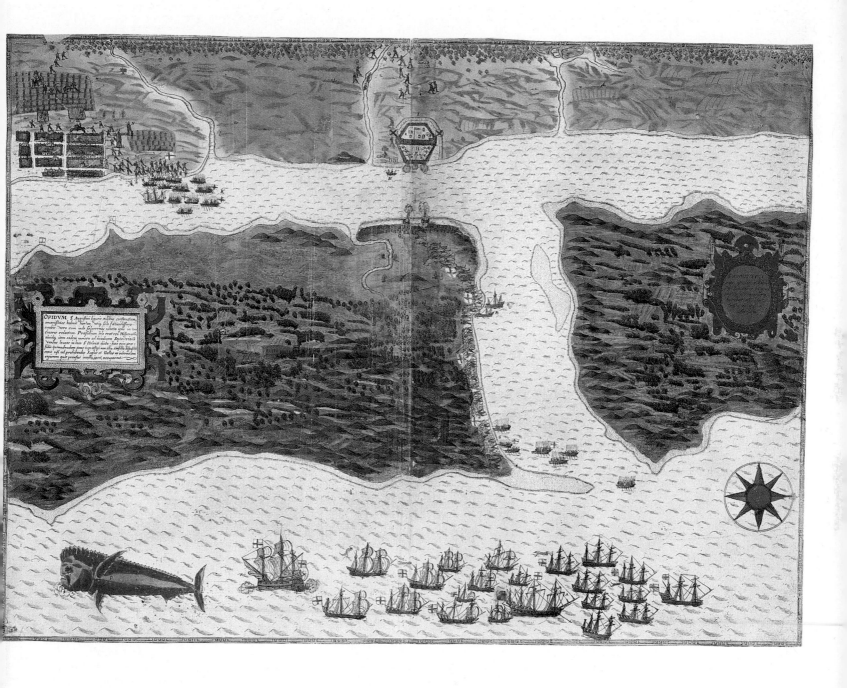

Baptista Boazio. *Augustini pars est Floridae*. Hand-colored engraving. London, 1589. The Spanish built fortifications at St. Augustine in 1565 after successfully routing the French. The English lost Calais, their last territory on the mainland of Europe, in 1558, and Sir Francis Drake conceived a plan to humble Spanish greatness and to capture "that golden Harvest which they get out of the Earth and send into Spain to trouble all the Earth." He plundered and destroyed St. Augustine in 1586, then returned to London where Boazio made an engraving of the attack from the drawings of a participant, perhaps Drake himself. The captions are in Latin with pasted-on English texts. It is the earliest printed depiction of the first town of European construction within the territory of the United States. The large dorado fish, seemingly in the lead of Drake's battalion, is the first publication—incorporated by Boazio—of a John White drawing from North America. From the moment the European rivals began fighting among themselves for territory in the Western Hemisphere, the Native Americans' dominion in their homeland, and the security of villages like Secotan, came to an end.

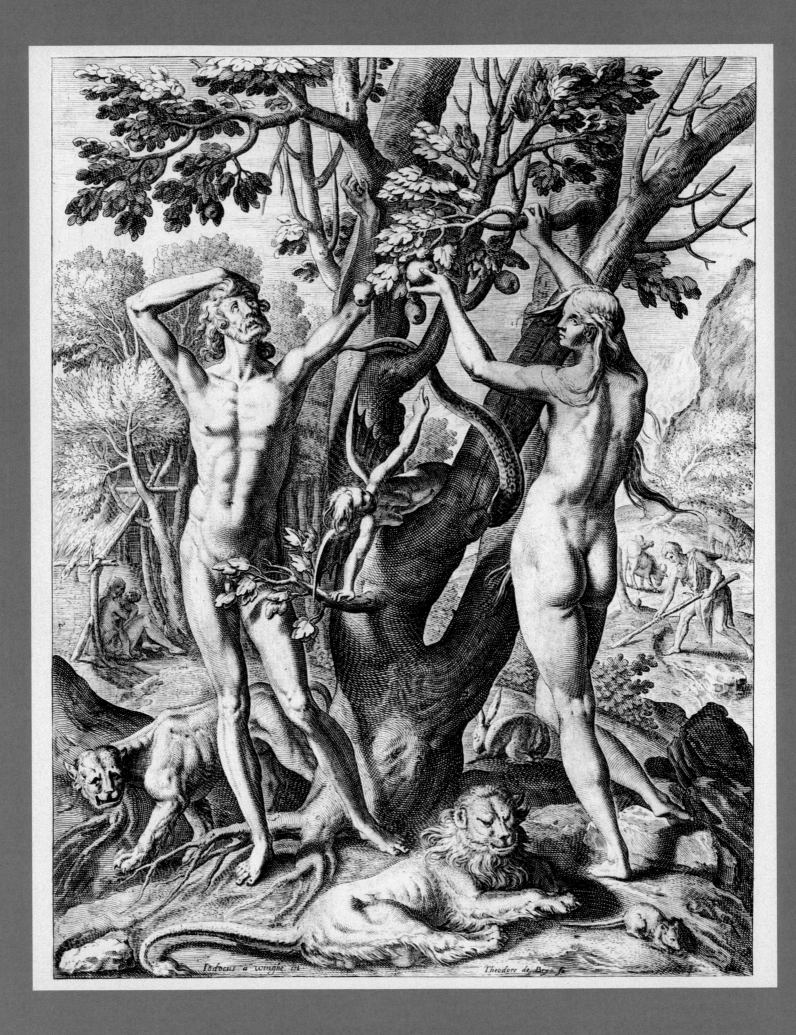

Iudocus a vvinghe in. Theodore de Bry f.

THE GARDEN

Opposite: Theodor de Bry. Adam and Eve in Virginia. Engraving from Thomas Hariot, *A briefe and true report of the new found land of Virginia* in de Bry, *America,* Part II. Frankfurt, 1590.
The idea of a New World, or "New Eden," became very popular as Europeans tried to make sense of the strange place by cloaking it in familiar notions. Most likely Columbus never accepted that he had reached a part of the world unknown to Europe, and other explorers were equally unwilling to acknowledge America's distinctiveness, misconstruing it as part of Asia or a mere impediment to the riches of China and India.

V. R. Speckle, after Füllmaurer and Meyer. *Turcicum frumentum. Türchisch korn. Blé de Turquie.* Hand-colored woodcut from Leonhard Fuchs, *Stirpium imagines.* Lyon, 1549.
By the beginning of the sixteenth century, the Renaissance had swept botany into the scientific era. With his emphasis on firsthand observation, Fuchs set a new standard for plant illustration. Corn (*zea mays*) was widely planted in the New World prior to 1492.

Gonzalo Fernández de Oviedo y Valdés. *Ananas cosmosus.* Woodcut from Oviedo, *La historia general delas* [sic] *Indias.* Book 8. Seville, 1535.
Oviedo's description and illustration of the pineapple appeared in the first work on the natural history of the New World—which, in translation, attracted the English to the Americas.

After Basilius Besler. *Flos Solis maior.* Engraving from Besler, *Hortus eystettensis.* Vol. I. Nuremberg, 1613.
The sunflower (*Helicanthus annuus*) was cultivated by Native Americans and was introduced into Europe within the first decade of Columbus's arrival in the region.

476
Turcicum frumentum
Türchisch korn
Blé de Turquie

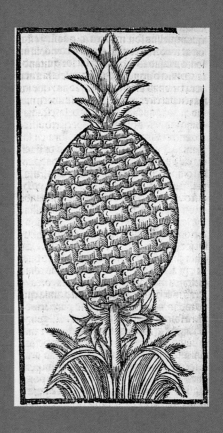

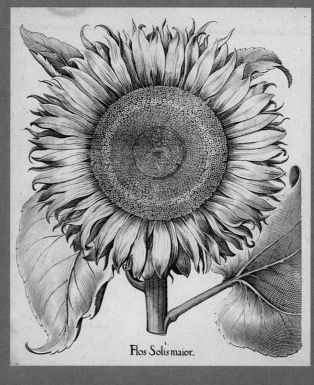

Flos Solis maior.

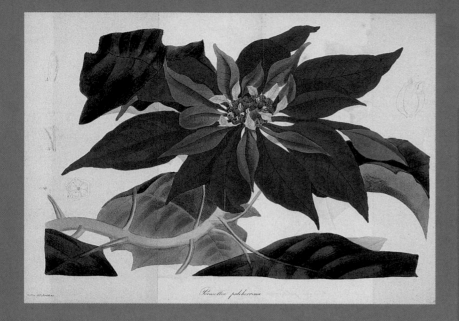

Poinsettia pulcherrima

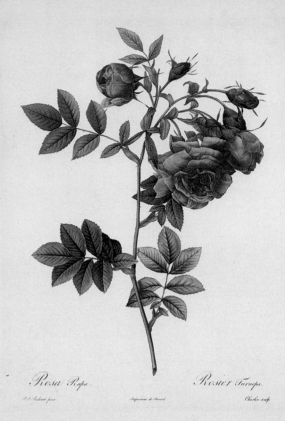

Rosa Rapa. Rosier Turneps.

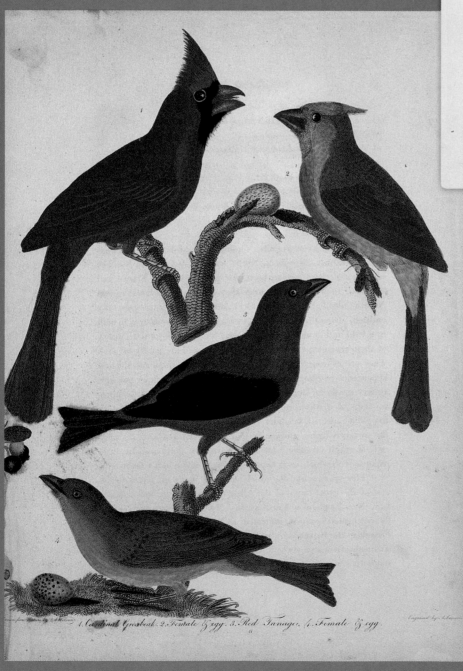

1. Cardinal Grosbeak. 2. Female & egg. 3. Red Tanage. 4. Female & egg.

Smith, after Samuel Holden. *Poinsettia pulcherrima.* Color engraving from *Paxton's magazine of botany, and register of flowering plants,* Vol. IV. London, 1834–49.
Besides beautiful illustrations, Sir Joseph Paxton's popular magazine offered plans for gardens. The *Poinsettia pulcherrima* was named for Joel R. Poinsett, the first minister to Mexico, who discovered the flower there in 1828.

Jean Louis Auguste Charlin, after Pierre Joseph Redouté. *Rosa rapa. Rosier turneps.* Color engraving from Redouté, *Les roses,* Vol. 2. Paris, 1821.
Redouté, the "Raphael of flowers," is considered the greatest flower painter of all time. The Library owns his personal copy of *Les roses,* printed on vellum.

Alexander Lawson, after Alexander Wilson. *Cardinal Grosbeak . . . Red Tanage.* Color engraving from Wilson, *American Ornithology,* Vol. II. Philadelphia, 1810.
The founder of American ornithology, Wilson preceded Audubon by nearly twenty years and certainly inspired him. The cardinal lives east of the Rockies in the wild but soon became the most popular cage bird in Europe.

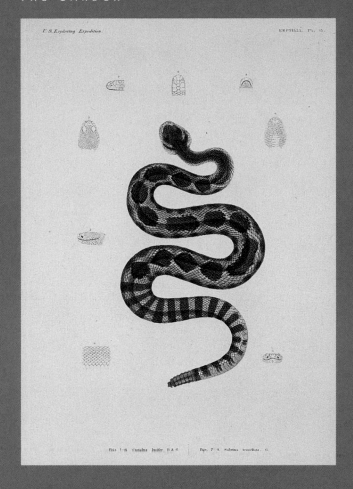

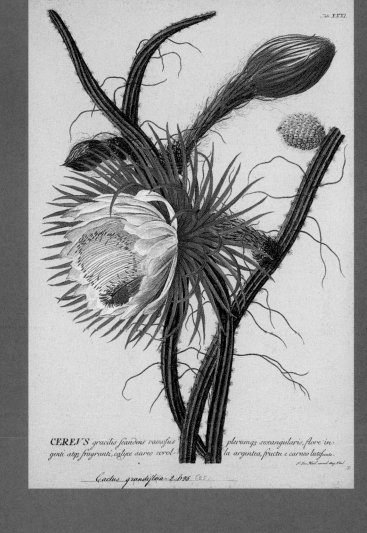

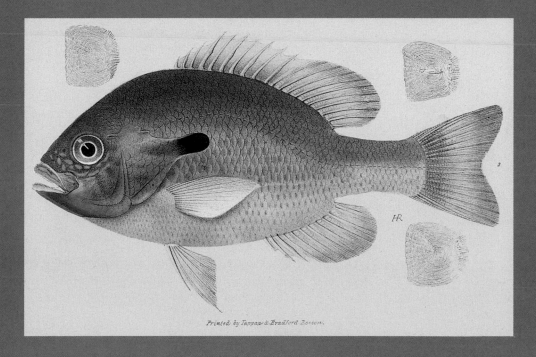

Dougal, after John H. Richard. *Crotalus lucifer.* Color engraving from Charles Frédéric Girard, *U.S. Exploring Expedition. Herpetology,* Vol. 20, atlas. Philadelphia, 1858.
The rattlesnake, found solely in the Americas, is a folkloric figure on colonial flags; the first naval ensign pairs one with the motto "Don't Tread On Me."

Johann Jacob Haid, after Georg Dionysus Ehret. *Cereus . . . Cactus grandiflora.* Color engraving from Christoph Jacob Trew, *Plantae selectae.* Nuremberg, 1750–73.
Cacti were an entirely new group of flowering plants to European botanists. The night-blooming *Cereus* is native to Jamaica, and was one of the first transported across the ocean.

John Edwards Holbrook. *Pomotis rubricauda.* Color engraving from Holbrook, *Ichthyology of South Carolina.* Charleston, 1855.
Originally intending to depict all the fish of the southern states, Holbrook focused on his own state when the project became too expensive. The habitat of the red-bellied perch extends from Mississippi to Georgia.

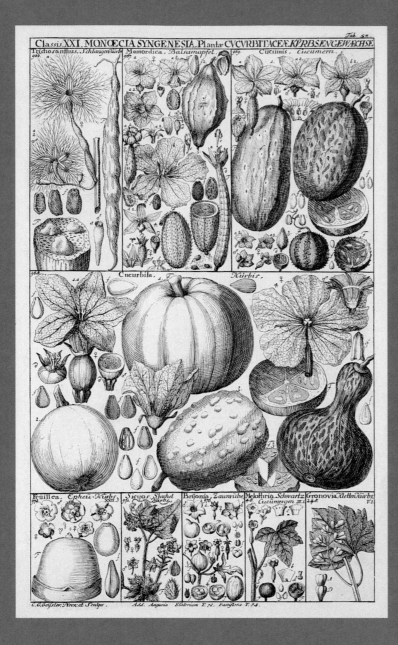

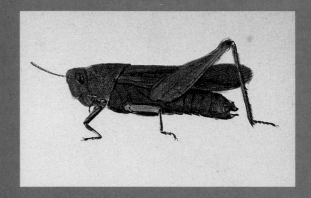

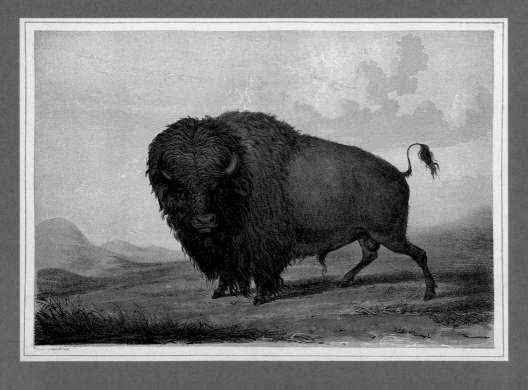

Opposite: W. H. Lizars, after John James Audubon. *Wild Turkey, Meleagris gallopavo.* Hand-colored engraving from Audubon, *Birds of America,* Plate 1. London, 1827–38.
In his classic work, Audubon, one of the first and most influential wildlife conservationists, conveyed the grand dimensions of the American continent and its birds—such as the indigenous turkey, which Benjamin Franklin nominated as the national bird.

C. G. Giesslev, after Johann Gessner. *Classe XXI. Monoecia syngenesia.* Engraving from Gessner, *Tabulae Phytographicae,* Vol. II. Turici, 1804.
Gessner's work explicates the Linnaean classes with tabular diagrams demonstrating the characteristics of each. All of these plants were cultivated by Native American farmers, and none were known to Europeans before Columbus.

John H. Richard, after Antoine Sonrel. Green-striped Locust. Color engraving from Thaddeus William Harris, *Treatise on Some of the Insects Injurious to Vegetation.* Boston, 1862.
Swarms of ravenous locust species were legendary on the prairie. This one was drawn from nature under the supervision of Louis Agassiz, one of America's foremost educators and scientists.

McGahey, after George Catlin. *Buffalo Bull Grazing.* Hand-colored lithograph from Catlin, *North American Indian Portfolio.* London, 1844.
Catlin painted three tribes of Plains Indians that depended on parts of the ubiquitous buffalo for survival: its flesh for food, its hide for clothing and lodging, and its bones for weapons and eating utensils. Between 1872 and 1874, over 4 million buffalo were slaughtered by white sportsmen and hunters working for the leather industry.

PLATE I

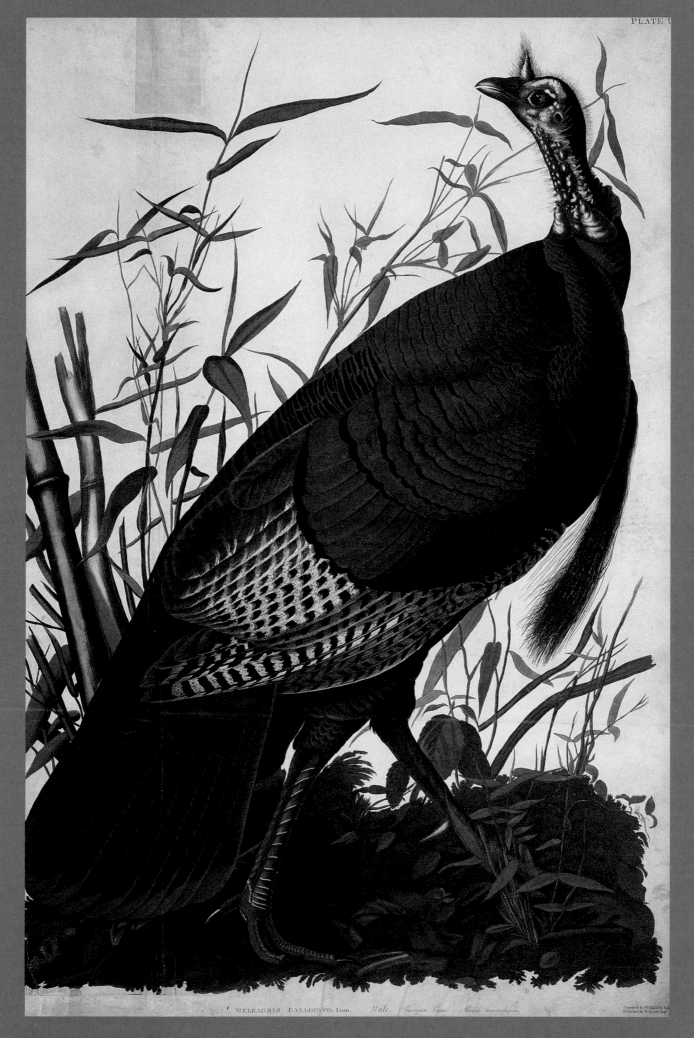

MELEAGRIS GALLOPAVO, Linn. *Male.* American Cock. Magna americanus.

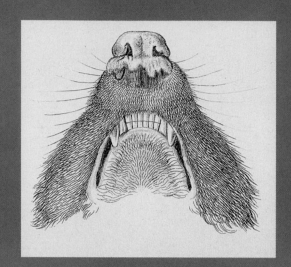

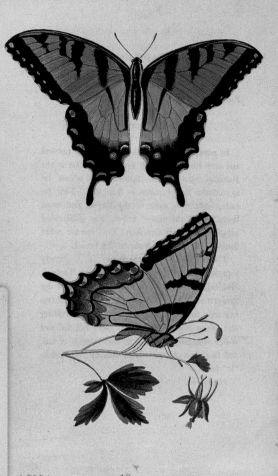

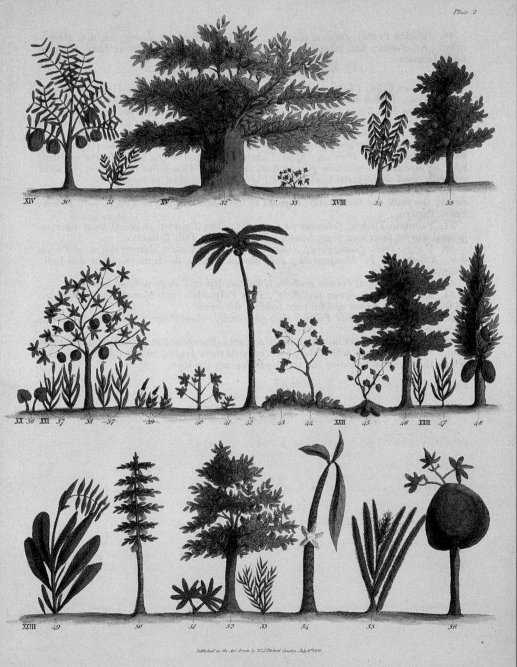

John H. Richard, after R. Metzeroth. *Mephitis mesoleuca. White-backed skunk.* Engraving from Spencer F. Baird, "Mammals" in *General Report upon the Zoology of the Several Pacific Railroad Routes.* Washington, D.C., 1857.
This view from below of a white-backed skunk's muzzle was drawn from the specimen gathered in West Texas during a War Department survey for a railroad route from the Mississippi to the Pacific. Baird was Assistant Secretary of the Smithsonian Institution.

C. Tiebout, after Titian Ramsey Peale. *Papilio turnus. Aquilegia canadensis.* Color engraving from Thomas Say, *American Entomology,* Vol. III. Philadelphia, 1828.
Say, the self-taught father of American entomology, began his great project to describe the butterflies of America in 1816. The Eastern Tiger Swallowtail is found throughout the regions east of the Rockies.

After William Jowit Titford. Trees of seven classes and corn. Color engraving from Titford, *Sketches toward a Hortus botanicus americanus.* London, 1811–12.
The Jamaican-born Titford, who studied botany at New York's Columbia University, artfully demonstrated the economic importance of American plants to world trade.

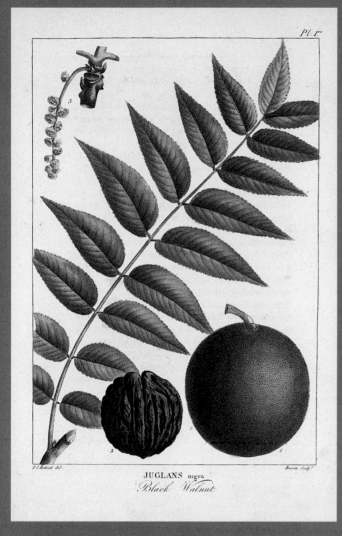

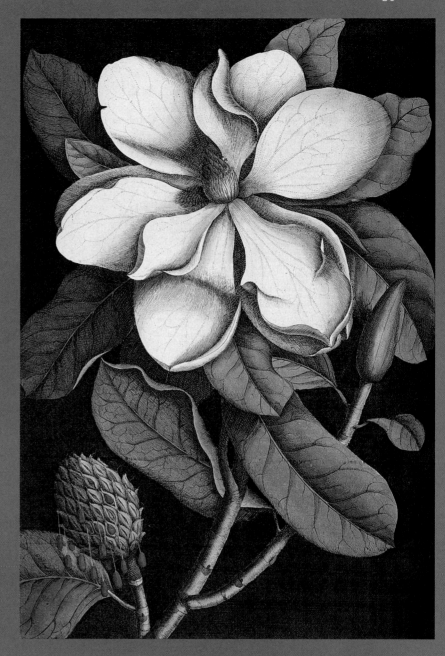

Bessin, after Pierre Joseph Redouté. *Juglans nigra. Black Walnut.* Color engraving from François André Michaux, *Histoire des arbres forestiers de l'Amérique septentrionale,* Vol. I. Paris, 1810–13.
Michaux helped to introduce American trees into European fine art and commerce. Redouté's close-up drawings captured the particular beauty of each specimen.

Georg Dionysus Ehret, after Mark Catesby. *Magnolia altissma* [grandiflora]. Hand-colored engraving from Catesby, *The natural history of Carolina, Florida and the Bahama Islands.* London, 1731.
Once known as the "Laurel Tree of Carolina," the magnolia enthralled many early explorers. It was the first American tree planted in London's Kew Gardens and it lent its form to a decorative order for the entrance gallery to the Senate Chamber in the new nation's Capitol (the columns were later eliminated when the chamber was enlarged).

Leonard Baskin. *Lucannus cervus.* Etching from Baskin, *Horned Beetles and Other Insects.* Northampton, Massachusetts, 1958.
Baskin, one of America's finest printmakers and book artists, has done much to advance our appreciation of the natural world.

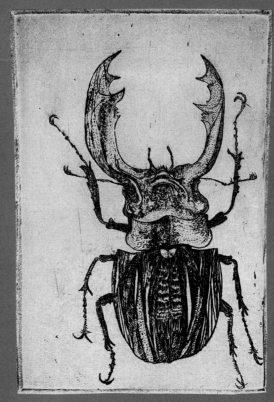

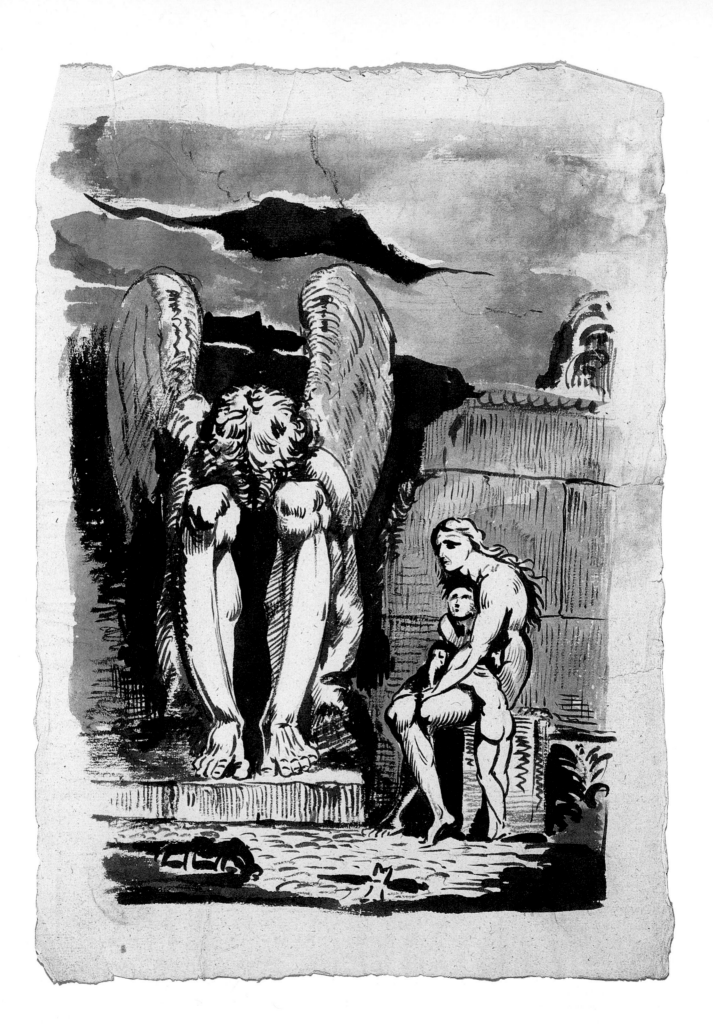

2

THE WORLD TURN'D UPSIDE DOWN, 1600–1800

William Blake. Frontispiece for his *America: A Prophecy.* Drawing, watercolor and ink. London, 1793.
For English poet William Blake, as for other liberals of the eighteenth century, the American Revolution appeared to be the dawn of the millennium. Shaken by the upheaval and regicide of the French Revolution, however, the English government was bent on exterminating subversive or antimonarchical thought. The resulting emigration of Blake's friend Thomas Paine to the colonies may also have convinced him that a symbolic approach to the subject of America's triumph was far safer than a realistic one. In his illustrated poem *America: A Prophecy,* Blake infused the historical events with mythical significance by portraying Albion's (i.e., England's) angel as a winged giant blocking a breach in a massive wall with his body and burying his head mournfully between his legs.

In the spring of 1630, a small fleet of ships set sail from Southampton, England, carrying nearly a thousand people to a world they had never seen. Aboard the flagship, the *Arabella*, was a pious, imperious man—the son of landed gentry—who had already been chosen governor of the unborn community he and his fellow voyagers planned to create. Despite affluence and social connections, John Winthrop had grown deeply disillusioned with life in England. Like many other men and women who considered themselves Puritans, he looked with despair at what he believed was the growing corruption and sinfulness of his homeland. And like others, he left in search of an alternative in America.

Sometime during the voyage, Winthrop wrote a description of what he hoped the new society would be. He called his essay "Christian Charity, A Model Hereof." It became one of the most celebrated documents in American history. "We must be knit together in this work as one man," he wrote,

> we must entertain each other in brotherly affection . . . we must delight in each other, make others' conditions our own, rejoice together, mourn together, labor and suffer together, always having before our eyes our commission and community in the work. . . . We shall find that the God of Israel is among us . . . when he shall make us a praise and glory that men shall say of succeeding plantations: "the Lord make it like that of New England." For we must consider that we shall be as a city upon a hill: The eyes of all people are upon us.

Not all the Europeans who came to America considered themselves part of a religious mission. Some came in search only of wealth, glory, or adventure. Others were escaping harsh conditions at home: poverty, landlessness, religious or political persecution. But many of these new Americans, and many of their descendants, came to share Winthrop's sense of being part of an unusual experiment in human civilization. Three centuries later, some Americans—even some who knew nothing of John Winthrop—would still talk of their society as a "city upon a hill," a model to the world. A sense of mission was part of American history almost from the moment Europeans began to establish themselves in the New World.

*

The European settlement of North America in the seventeenth century was not an English enterprise alone. French explorers in the early seventeenth century laid the basis for a large empire in Quebec, north of New England, and gradually moved into the interior of the continent, where they formed close relationships with Indian tribes and established themselves as intrepid fur traders. Settlers from the Netherlands

founded a colony at the mouth of the Hudson River, at what would later become New York. The Spanish established northern outposts of their great empire in what are now Florida and New Mexico. But it was the string of English colonies along the Atlantic Coast that would shape most decisively the future of what would be the United States.

How strange the new land must have seemed to these early English settlers, coming as they did from a small, densely settled, rigidly hierarchical country in which land was scarce and people were plentiful. In America, land seemed limitless, people were few, and conventional hierarchies were difficult to recreate. Primeval forests stretched beyond the horizon, unbroken except by trails the Indians had blazed and small fields they had cleared for planting in the woodlands.

How strange, too, must have seemed the Indian tribes, whose civilization the English were soon to disrupt. The English came to North America not as *conquistadores* determined to subjugate and destroy the natives. But they came clad with certainty in the superiority of their customs, their religion, their culture. The English colonists tried, although without complete success, to maintain a rigid separation between their communities and those of the surrounding tribes; unlike the Spanish and the French, the English seldom lived or intermarried with natives. (The famous marriage of the Powhatan princess Pocahontas with John Rolfe in Virginia was a conspicuous exception to this practice.) But the English also confronted the Indians with a combination of ethnographic curiosity and missionary zeal.

After several failed efforts, the English established their first permanent colony in the early seventeenth century in the region of the Chesapeake: a settlement they named Jamestown, after their king. There—after several decades of starvation and death, and after twice coming perilously close to abandoning the enterprise altogether—English men and women stabilized the first of several flourishing new societies based on the cultivation and sale of tobacco. They carved large farms, which they called plantations, out of the wilderness, some of which became nearly self-sufficient communities. Desperate for labor, tobacco growers relied at first on white indentured servants from England. But the supply of indentures dwindled as the seventeenth century neared its end, and planters turned increasingly to another source of workers: the African continent.

European slave traders bought thousands of black men and women in Africa, most of them captured and sold by rival tribes, and transported them from their homelands to the Americas under conditions so horrible and so terrifying that some ("preferring death to such a life of misery," as one African prisoner later claimed) jumped together,

Peter Pelham. *Cottonus Matherus.* Mezzotint. Boston, 1728 (1860 restrike).

In 1684 Protestant divine Cotton Mather is reputed to have used the term "American" to describe European colonists for the first time. Mather published nearly five hundred works, including *Magnalia Christi Americana: or the Ecclesiastical History of New England from its First Planting* and *Memorable Providences, Relating to Witchcraft and Possessions,* a case study of a witch trial, which included detailed instructions for recognizing witchcraft and provided inadvertent fodder for the subsequent Salem histrionics that led to the deaths of nineteen innocent people. As a testament to his celebrity, the *Boston Gazette* began running announcements for the forthcoming portrait print only six days after his death. Although the mezzotint process was in wide use in Europe by 1700, Pelham's is believed to be the first use made of it in America. It involved abrading a copper plate so when inked it would print a deep and velvety black, and then creating the desired image by burnishing areas of the roughened surface back to smoothness, sometimes applying engraving to bring out details and to approximate the look of original drawings.

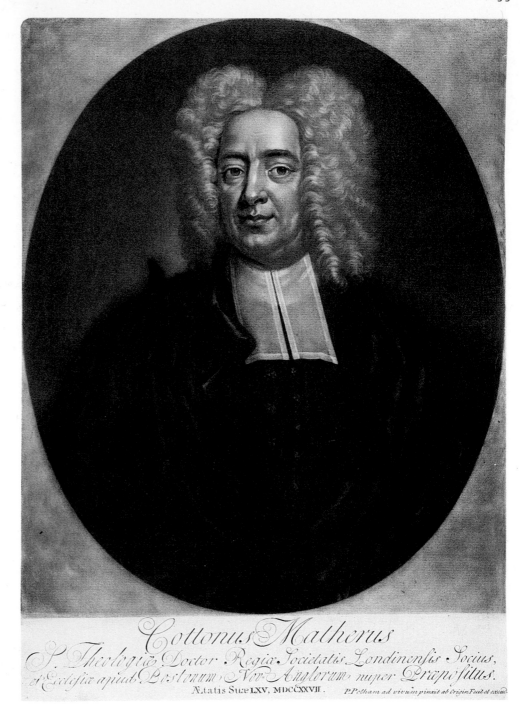

in chains, into the sea. Those who survived the voyage were again sold, now to work on plantations cultivating tobacco, rice, sugar, and later cotton. In much of the Caribbean and some areas of the South, they soon constituted a majority of the population. Their presence, and the bondage that whites imposed on them, would shape the American future as decisively as any other single thing.

The Puritan migrations began a few years later and populated colonies in New England—colonies that were based less on commercial ambitions, at least at first, than on religious ones. A first group of Puritans, known as the Pilgrims, settled in Plymouth; Winthrop's much larger wave came a few years later and established the town of Boston in Massachusetts Bay, a town they hoped would become a godly community in the "vast and empty chaos" of North America.

The new society, many English settlers hoped, would be an inspiration not only to the peoples of Europe, but also to the "heathen" of America—the native peoples who,

as one early settler described them, "do but run over the grass, as do also the foxes and wild beasts . . . [and] are not industrious." It was with great dismay that these European evangelizers discovered that the Indians had little interest in their culture or their faith. As the Puritan theologian Cotton Mather lamented in 1721:

> Tho' they saw a people Arrive among them, who were clothed in Habits of much more Comfort & Splendour than what there was to be seen in the Rough Skins with which they hardly covered themselves; and who had Houses full of Good Things, vastly outshining their squalid and dark Wigwams; And they saw this People replenishing their Fields, with Trees and with Grains, and useful Animals, which until now they had been wholly Strangers to; yet they did not seem touch'd in the least, with any Ambition to come at such Desireable Circumstances, or with any Curiosity to enquire after the Religion that was attended with them.

<p style="text-align:center">*</p>

As Mather's sermon suggested, religious piety and material success were closely intertwined in early America. Prosperity and worldly accomplishment, many settlers believed, were signs of God's grace. But as colonial society grew, and as American commercial life became more vigorous and complex, confidence in the compatibility of faith and wealth was sometimes difficult to sustain. Throughout the seventeenth and eighteenth centuries, wave after wave of emigrants poured into the colonies the English had established along the Atlantic coast of North America—a string that stretched north and south from the original outposts in Virginia and Massachusetts and gradually formed a continuous line of non-Indian settlement from what is now Maine to Georgia—and contributed to their rapid economic growth. The settlers came not only from England and Africa, but also from Ireland, Scotland, Germany, France, and elsewhere, bringing new kinds of skills and different social and cultural values. The early coastal towns—Boston, Newport, New York, Philadelphia, Baltimore, Charles Town, and others—gradually became substantial cities. They were thriving centers of trade, commerce, and industry; they were also breeding grounds for diverse, secular ideas.

Ministers in virtually all the colonies lamented the decline of piety that seemed to accompany these changes, the "declension" of communities once presumably governed by the laws of God into ones governed by the laws of commerce. Some clerics joined with other anxious settlers in parts of New England to accuse their neighbors—often those who seemed most conspicuously at odds with the Puritan vision of a godly community—of witchcraft. Later, beginning in the 1730s, colonists throughout North America sought to reverse the fading religious ardor of their world by joining in a vast

Praevalebit aequior. Cover woodcut from *The American Magazine and Monthly Chronicle.* Philadelphia, March 1758.

During the French and Indian War, part of the last and most important in a series of wars between England and France, both combatants were aware that control of North America would be determined in part by the allegiance of the native tribes. This magazine cover, whose title means "grease takes precedence," reflects British envy of French relations with Ohio Valley Indian nations: the Frenchman offers a tomahawk and flintlock, while the Englishman offers a Bible and bolts of cloth. Though in fact the English plied the Indians with better goods, the French existed far more compatibly with them. Tolerance, rather than a liberal dispensing of weapons, was the key to France's alliances with the Iroquois Confederacy and to their conversion of thousands to Christianity.

Periodicals like *The American Magazine* provided a mix of political and scientific news, as well as contemporary literature, to the upper classes of colonial American society.

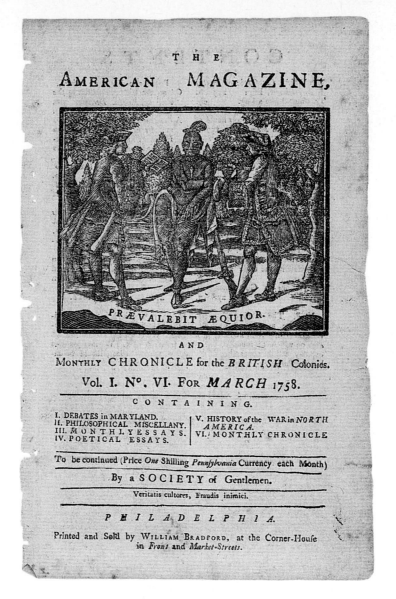

revival, the first of many in American history, known as the Great Awakening. The great theologian Jonathan Edwards traveled widely through the colonies, arousing congregants everywhere through his stern warnings about their helplessness in the face of God's vengeance, their hopelessness in the absence of active faith. "What is the strength of man, who is but a work, to support himself against the power of Jehovah, and against the fierceness of his wrath," he asked.

But nothing could stop the growing commercialization and diversification of American society. Nothing could prevent the development of distinct classes of wealthy and poor; the importation of European notions of elegance and style; the challenges to traditional patterns of deference; the emergence of independent women and, occasionally, rebellious slaves; the creation of values and attitudes shaped by the world of commerce more than by the world of faith. It was for this new, more secular society that Benjamin Franklin, in his famous autobiography, enumerated a group of virtues that he believed would be appropriate to the American civilization of the future: "Lose no time. Be always employ'd in something useful. . . . Avoid extreams. . . . Tolerate no uncleanness. . . . Imitate Jesus and Socrates."

As the agricultural regions along the eastern seaboard filled up with Europeans and Africans, new settlers pressed ever deeper into the continent in search of new land. In so doing, they established a pattern that would repeat itself over centuries of American history. Westward-moving Europeans were not carrying civilization into empty

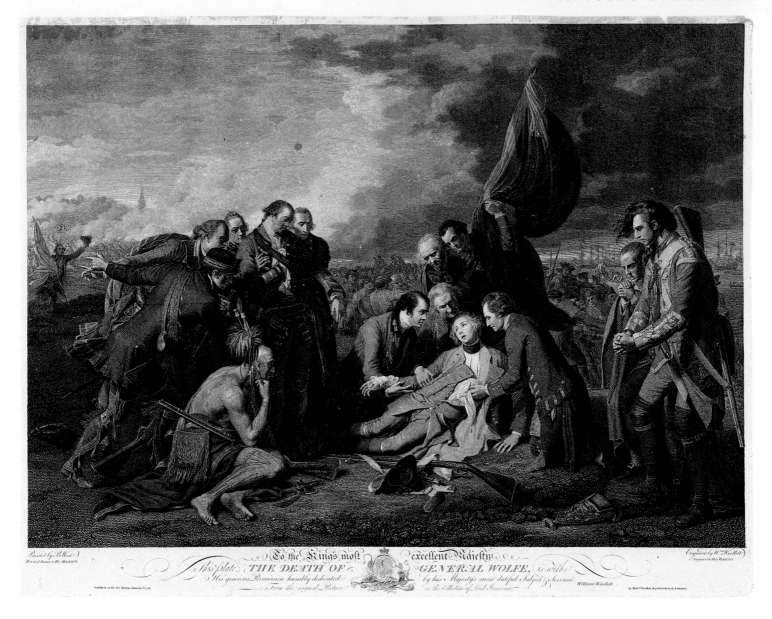

THE DEATH OF GENERAL WOLFE

William Woollett, after Benjamin West. *The Death of General Wolfe.* Engraving. London, 1776.

The American painter Benjamin West, then residing in London, precipitated an artistic revolution when he chose to depict the great English general dying at the Siege of Quebec in 1759 in contemporary military costume rather than classical toga. At the close of the French and Indian War, the Treaty of Paris (1763) ceded French control of Canada and everything east of the Mississippi to victorious Great Britain; everything west of the river went to Spain.

This engraving (after West's painting) was published, not fortuitously, in 1776 when British attention was once again focused on America, with a war for independence underway. Twenty years earlier, the British preoccupation with the French threat had forced its colonies to act in unison for the first time against a common foe. They had learned the lesson well.

lands, as they often chose to believe. They were intruding into existing civilizations, that they would attempt, usually successfully, to supplant. A series of Indian wars erupted along the western frontier, conflicts so brutal (and so expensive to quell) that colonial administrators, following policies established in London, sought at times to limit further expansion. But the expansion continued despite those policies, bringing the migrants into battle not just with the tribes but, at times, with their own authorities in the East.

In the mid-eighteenth century, conflicts with Indians along the frontier became linked to a larger conflict with France, which began in Europe but soon spread to North America, where English and French settlers (each allied with various tribes) were already competing for supremacy in the rich lands of the Ohio Valley. The result was the French and Indian War, the first great colonial conflict in North America, which raged for nine years, engaged the energies and resources of almost all the English colonies, and drove thousands of white settlers off their lands and back to the relative security of the East. Finally—in 1763—it came to an end, on terms highly favorable to Great Britain. France ceded almost all its lands in North America to Britain. The Indian tribes of the Ohio Valley, most of which had allied themselves with the French, emerged from the war greatly weakened; their battle to defend their lands against Eu-

ropean encroachments would continue, but on increasingly unequal terms. And the English colonists in North America faced a significantly altered world as well.

<p style="text-align:center">*</p>

The British Empire, of which the American colonies were a part, was a vast and in many ways informal association of lands. During the first century and a half of English settlement in North America, imperial authority had usually seemed remote. The colonists had become accustomed to governing themselves and resolving their disputes largely on their own. But after the end of the great war with France, the British government—its terrain suddenly expanded and its treasury badly depleted—began trying to exert a new form of authority over its colonies. That effort would stumble through one disastrous experiment after another for more than a decade and would ultimately help produce the American Revolution.

The new imperial policies had three related aims: first, to solidify London's control over its often recalcitrant colonies; second, to make English settlers in America pay some of the costs (and reduce some of the debt) of the Empire of which they were a part; and third, to limit wars with the Indians by restricting further English incursions into the interior of the continent. The colonists resisted all these efforts. They ignored Britain's Proclamation of 1763, forbidding settlement beyond the Appalachian Mountains. They rebelled against the Stamp Act of 1765, which required colonists to purchase stamps in order to conduct all manner of transactions—a broad-based tax imposed not by the colonial legislatures but by the distant Parliament. The Stamp Act Congress, which met in New York with delegates from nine colonies, announced a principle that would become increasingly important as tensions between America and Britain grew: "That the only representatives of the people of these colonies are persons chosen therein by themselves, and that no taxes have ever been, or can be constitutionally imposed on them, but by their respective legislatures."

As colonial resistance grew, so did the British government's insistence on enforcing its will. Parliament disbanded colonial assemblies, closed harbors, levied new duties on imports (distinct from "taxes," the British government unpersuasively argued), and tried to tighten the regulation of colonial commerce. Bitterness accumulated on both sides.

One of the many British policies that Americans resented was the stationing of British troops in colonial cities. That resentment rose as the Redcoats, who were themselves underpaid and poorly treated, began to compete with colonists for work on docks and construction projects. On March 5, 1770, a skirmish between Boston dock-

workers and British soldiers ended in gunfire, which left seven colonists dead and four wounded. Local resistance leaders quickly transformed this murky incident, almost certainly the result of panic and confusion, into the Boston Massacre—a symbol of British oppression and brutality, its victims memorialized in popular literature and in a famous engraving by Paul Revere. The incident greatly heightened American animosity toward England.

By the early 1770s, relations between the colonists and the British government had become so poisoned by mutual suspicion and resentment—so clouded by each side's misunderstanding of the other's motives and beliefs, so entangled with images of conspiracy and corruption on both sides—that virtually any action by either party fueled the conflict further. In 1773, Parliament passed the Tea Act, a relatively innocuous bill designed to help the troubled British East India Company by giving it the right to import tea to the American colonies free of the duties that colonial merchants were obliged to pay. To the Americans, it was more evidence of tyranny. Throughout the colonies, a boycott of imported tea began, led in part by an organization of colonial women known as the Daughters of Liberty (a name derived from the more famous network of men active in resistance, the Sons of Liberty). The women proclaimed "that rather than Freedom, we'll part with our Tea." The success of the boycott aroused popular enthusiasm for more direct forms of resistance. And on the night of December 16, 1773, more than a hundred men disguised as Indians boarded cargo ships in Boston Harbor, broke open crates of tea waiting to be unloaded, and dumped the contents into the harbor. As news of the Boston Tea Party spread throughout the colonies, other patriots staged similar incidents in other ports.

By now, many American colonists had become accustomed to thinking of themselves as defenders of liberty against a British government that had abandoned its traditions and fallen victim to despotism. And over the next several years, they formed intercolonial resistance organizations known as "committees of correspondence." In 1774, the committees met in Philadelphia as the First Continental Congress and, in effect, declared economic war against Parliament by calling for a series of efforts to stop all trade with England. Some hoped such actions would persuade the British government to change its ways, but others were pessimistic. "I expect no redress, but, on the contrary, increased resentment and double vengeance," John Adams of Massachusetts wrote to Patrick Henry of Virginia. "We must fight." Henry replied, "By God, I am of your opinion."

A year later, almost by accident, resistance turned to revolution. British troops in

Paul Revere. *A View of the Obelisk.* Engraving. Boston, 1766 (restrike, printed after 1839). Through oratory, diplomacy, physical intimidation, and civil disobedience, Americans and English sympathizers convinced Parliament that the Stamp Act was ill advised. It was repealed in March 1766, but news of the repeal reached colonial cities only in May. Illuminated obelisks, made of oiled paper stretched on a wooden frame and lit from within by candles, were often created as centerpieces of celebrations such as those the repeal inspired. American activist and engraver Paul Revere apparently helped design the illuminated obelisk erected on Boston Common, which explains why he was able to offer a copperplate engraving of it on the night it was presented. Decorated with patriotic imagery and portraits of English statesmen who aided the American cause, the obelisk was destroyed by fire hours after it was erected. The Revere engraving is the only surviving visual record of this important but ephemeral form of communication in revolutionary America.

Boston, alerted to the existence of weapons and ammunitions stockpiled by colonial activists outside the city, marched to the town of Lexington to destroy the rebel stronghold. Hastily assembled volunteer militias, warned of the advance by the famous "midnight rides" of Paul Revere and Charles Dawes, gathered to meet them. Unaware that they were participating in a pivotal moment in history, the two "armies" faced each other on Lexington Green on the morning of April 19, 1775. Someone (no one knows whether a colonist or a Redcoat) fired a shot—and began the first battle of the American Revolution.

*

News of the bloody encounter in Massachusetts spread quickly through the colonies, electrifying the many Americans who had come to oppose British policies and who now called themselves Patriots. Communities everywhere formed militias. State assemblies met in emergency sessions to contemplate the uncertain future. The Continental Congress convened again in July and adopted a "Declaration of the Causes and Necessity of Taking Up Arms." For ten years, the Declaration proclaimed, we "incessantly and ineffectually besieged the throne as supplicants; we reasoned, we remonstrated with parliament in the most mild and decent language." But to no avail. The British had thus aroused "the indignation of a virtuous, loyal, and affectionate people," who had become "reduced to the alternative of chusing an unconditional submission to the tyranny of irritated ministers, or resistance by force. —The latter is our choice."

But what were the Americans fighting for? At first, the answer to that question was

not clear. Then, in January 1776, Thomas Paine, a recent emigrant from England, published *Common Sense,* an electrifying pamphlet that helped clarify the way many Americans thought about the war. There was no point in hoping for a reconciliation with Britain, Paine insisted, for "not a single advantage is derived" by Americans from their membership in the Empire. "Wherefore, since nothing but blows will do, for God's sake let us come to a final separation." Six months later, on July 4, 1776, Congress adopted the Declaration of Independence:

> We . . . declare that these united colonies are, and of right ought to be, free and independent states: that they are absolved from all allegiance to the British Crown, and that all political connection between them and the state of Great Britain is, and ought to be, totally dissolved. . . . [To] the support of this declaration . . . we mutually pledge to each other our lives, our fortunes, and our sacred honor.

The war to achieve that independence continued for five more years—fitfully, inconclusively, at times savagely, pitting makeshift bands of volunteers against the mightiest army in the world. By the time of the Declaration of Independence, the British had recognized that what they had at first considered a local uprising around Boston was, in fact, a larger, intercolonial conflict that required a concerted strategy. For the next two years, they focused their efforts in the Mid-Atlantic states: New York, New Jersey, and Pennsylvania. They won most of the battles in which they managed to engage Patriot forces (organized under George Washington as the Continental Army), but they were never able to bring the war to a real conclusion. And then the Americans won a great victory at Saratoga in October 1777. News of it echoed throughout the new nation—and in Europe as well, emboldening the French (who were eager to see their great rival, the British empire, humbled) to offer aid to the young United States.

In 1778, the British moved their operations into the South, hoping to arouse what they believed was a large population of Americans loyal to the king to help them put down the insurrection. Instead, they found themselves engaged in a war they did not know how to fight—a kind of combat that in later times would become known as a guerrilla war. A large, cumbersome, traditional army faced smaller, more mobile forces capable of outmaneuvering and surprising them. What had been a reasonably conventional colonial war now became a genuinely "revolutionary" struggle, for the fighting mobilized and energized large segments of the American population who had previously been relatively apolitical but who were now aroused with an ardor to defend their homes and their communities.

Slowly, the tide of battle turned against the British, until finally the English com-

Charles Balthazar Julien Fevret de Saint-Memin. Thomas Jefferson. Medallion engraving. Washington, D.C., c. 1804.
Scientist, author, farmer, linguist, lawyer, governor, diplomat, legislator, musician, inventor, architect—Thomas Jefferson became, even during his lifetime, an icon of the Enlightenment. In 1804 President Jefferson sat for Saint-Memin, perhaps America's most meticulous and elegant portraitist during the Federal period. He posed at the behest of his daughters Martha and Maria, who wrote, "If you did but know what a source of pleasure it would be to us while so much separated from you to have so excellent a likeness of you you would I think not refuse us."

mander, Lord Cornwallis, found himself trapped on a peninsula near Yorktown, Virginia, surrounded by American and French forces and with little choice but to surrender. As a military band played the old English song "The World Turn'd Upside Down," members of the great British army lay down their weapons before the leaders of a new and as yet only half-formed nation. "Many of the soldiers manifested a sullen temper, throwing their arms on the pile with violence," an American army doctor who witnessed the scene later wrote. It was, he said, "to us a most glorious day, but to the English, one of bitter chagrin and disappointment" as "that vindictive, haughty commander" and his "army, who by their robberies and murders have so long been a scourge to our brethren" faced the reality of defeat.

*

The military victory over the British did not complete the process of creating the United States. It remained for the victorious Patriots to decide on the shape of their national community. Even during the war itself, the new state governments were drafting constitutions that expressed some of the emerging political assumptions of American democracy: that the executive and the legislature should be separate from one another, that there should be an independent judiciary, that the constitutions themselves should be formally written down (as opposed to the English Constitution, which was an informal, unwritten understanding of the way government should operate). In the mid-1770s, the "representatives of the good people of Virginia" had adopted a "declaration of rights," which stated (even before the Declaration of Independence echoed it) that "all men are by nature equally free and independent, and have certain inherent rights . . . namely, the enjoyment of life and liberty, with the means of acquiring and possessing property, and pursuing and obtaining happiness and safety." Such sentiments, compromised though they were by the continuing allegiance of their authors to the institution of slavery, echoed through state legislatures and constitutional conventions for the next decade.

At first, the new nation experimented with a relatively weak central government, established by the Articles of Confederation and led by a Congress in Philadelphia that was the primary—indeed virtually the only—institution of national authority. And despite its subsequent reputation as a weak and ineffectual experiment, the government of the Articles was not without substantial achievements. Most notable was the 1787 Northwest Ordinance, which organized the western lands north of the Ohio River into a Northwest Territory and made provisions for distribution of property and eventual admission to statehood of the areas within it. Congress divided the territory into neat

rectangular townships, establishing a grid pattern that would become an enduring feature of the American landscape. It also sought to prevent the Indian tribes who already lived there from becoming obstacles to the rapid settlement and development of the region by whites. But despite a series of lopsided treaties imposed on the tribes, conflict between natives and transplanted Europeans in these western lands, as in other western lands to follow, continued for many years.

Although it achieved occasional successes, the Congress's limited authority (for example, its inability to raise taxes except through the consent of state governments) gradually generated substantial sentiment for reform. Indeed, so unpopular and ineffectual had the Confederation Congress become by the mid-1780s that it began to lead an almost waiflike existence. In 1783 its members timidly withdrew from Philadelphia to escape the clamor of army veterans demanding back pay. They took refuge for a while in Princeton, New Jersey, then moved to Annapolis, Maryland, and in 1785 settled in New York. Through all of this, the delegates were often conspicuous largely by their absence.

Particularly alarming to many nationalists was the 1786 uprising in western Massachusetts by a group of disgruntled, indebted farmers led by the rebellious, phlegmatic Daniel Shays. Shays's Rebellion, as it was called, attempted to prevent debts from being collected, courts from meeting—indeed, the government itself from functioning. Congress proved unable to act in the face of this insurrection. The rebellion was finally quelled, with great difficulty, by the Massachusetts militia.

When news of Shays's Rebellion had reached General George Washington, hero of the Revolution, at his stately home on the Potomac River, he exclaimed, "There are combustibles in every State which a spark might set fire to. I feel infinitely more than I can express for the disorders which have arisen. Good God!" Similar fears swept throughout the colonies, hastening the movement toward reform. In 1787, finally, delegates from all thirteen states assembled in Philadelphia—after elaborately orchestrated maneuvers led by Alexander Hamilton of New York and James Madison of Virginia, two of the leading advocates of change—for a constitutional convention. George Washington agreed to preside over the meeting, giving it immediate credibility.

In the course of the sweltering summer, the delegates struggled over several momentous questions they were unable to resolve. What should they do about slavery, which many white Americans were coming to consider a blight on their democracy? The delegates finally decided, after considerable debate, that the Constitution could not interfere with the institution without damaging its chances of acceptance in the

Charles Willson Peale. Portrait of James Madison. Watercolor on ivory, with gold frame. Philadelphia, 1783.
Miniature paintings were a popular commodity for the affluent in America, and Charles Willson Peale's portrait of James Madison is one of the highest achievements in that delicate art. Raised in a family that was, by his own account, "in independent and comfortable circumstances," Madison was a moody, sensitive youth who found purpose in the colonies' political struggle with England. Peale painted this portrait in Philadelphia during Madison's last year as delegate to the Continental Congress. Later, during the Constitutional Convention, Madison helped assuage the fears that a strong central government would be tyrannical by arguing that it would derive its power not from the states but from the public at large, and his influence was such that he has been described as the "master builder of the Constitution."

South. What would be the status of the Indian tribes? Again, the delegates remained largely silent. Instead, they concentrated on creating a structure that would, they believed, resolve or at least contain the many disagreements that they assumed would arise again and again in the nation's future. There would be a Congress with two Houses, one popularly elected, the other chosen by state legislatures. There would be a president, chosen by an electoral college and with authority distinct from the legislature. There would be an independent judiciary. This "separation of powers" within the government—the creation of "checks and balances" between the legislative, executive, and judicial branches, no one of which would be wholly sovereign—was, in the end, the Constitution's most distinctive feature. The array of forces within the government would constantly compete with (and often frustrate) one another.

As the convention neared its close, the delegates still uncertain as to the wisdom of their work, the aging Benjamin Franklin spoke to his younger colleagues and urged them to support the constitution they had drafted. He was astonished, he said, that an imperfect convention so riven with disagreement could have produced something "so near to Perfection as it does. . . . Thus I consent, Sir, to this Constitution, because I expect no better, and because I am not sure it is not the best." Later he confessed that he had wondered at times throughout the proceedings whether the carved sun that decorated the back of Washington's ceremonial chair had been rising or setting. Now, he said, he was certain it marked the beginning, not the end, of the new nation's day.

*

The debate over ratification of the Constitution, which raged for over a year after the adjournment of the Philadelphia convention, suggested the outlines of basic disagreements that would survive into the early years of the new republic. On one side were the supporters of the Constitution, who called themselves the Federalists and who marshaled impressive arguments on behalf of a strong central government capable of tempering the factional disputes that everyone knew would arise within a large and diverse nation. Three leading Federalists—James Madison, Alexander Hamilton, and John Jay—published a series of powerful essays in support of the Constitution. They were widely distributed throughout the nation and became known as the Federalist Papers. "The influence of factious leaders may kindle a flame within their particular States," Madison wrote in the tenth (and perhaps the most important) of them. But in a large and united nation, he insisted, such flames "will be unable to spread a general conflagration through the other States." Just as a representative government divided into separate branches would provide a check against popular passions, so would the

extent of the new nation protect against dangerous faction. Thus, Madison concluded, "In the extent and proper structure of the Union . . . we behold a republican remedy for the diseases most incident to republican government."

Opposing such arguments were a group of Americans known as the Anti-Federalists, who feared that the new government would create the same centralized tyranny that the Revolution had been fought to abolish. "Is there not a formidable combination of power thus created in a few?" protested Richard Henry Lee of Virginia, one of the most articulate foes of the Constitution. "Or, will any sensible man say that great power, without responsibility, can be given to rulers with safety to liberty?" Particularly troubling to the Anti-Federalists was the absence in the Constitution of any specific enumeration of the people's rights. "The rights of conscience, trial by jury, liberty of the press, all your immunities and franchises, all pretensions to human rights and privileges, are rendered insecure, if not lost, by this change," Patrick Henry lamented. "Is this tame relinquishment of rights worthy of freemen?"

In the end, both sides could take some solace in the result of the battle. The Constitution was ratified, and the new government—under the leadership of the unanimously elected first president, George Washington—began operating in New York in 1789. But among its first acts was the passage of ten amendments to the Constitution, specifically protecting the rights of which Henry and other Anti-Federalists had spoken: the Bill of Rights, among the most cherished (and oft-contested) of all American political documents.

*

The first years of the federal government were almost as fraught with conflict as the last years of the Confederation had been. At the heart of the controversies was the same basic difference in philosophy that had driven the debate over the Constitution. On one side stood a powerful group that believed America required a strong, national government: that the country's mission was to become a genuine nation-state, with centralized authority, a complex commercial economy, and a lofty place in the world. Like the defenders of the Constitution, they called themselves Federalists; and they gravitated to the leadership of Alexander Hamilton. On the other side stood another group—a minority at first, but one that steadily gained strength as the Federalists overreached themselves—that envisioned a more modest central government, a society that would remain predominantly rural and agrarian, a nation prudently insulated from the byzantine politics of Europe. They called themselves Republicans, and they gathered behind James Madison and Thomas Jefferson.

The Federalists and the Republicans were capable at times of compromising, as when Hamilton and Jefferson struck a bargain that moved the nation's capital from New York to a new city to be built on the banks of the Potomac (near the President's estate at Mount Vernon) and to be called Washington. The government moved there at last in 1800. But on the basic issues dividing the two parties, compromise could seldom be found. Indeed, so profound did both sides consider the issues dividing them that politics in the early republic became as acrimonious as at any time in American history. Debates in Congress were often so bitter that physical violence seemed imminent. On one occasion, at least, two members actually came to blows on the House floor—one of them wielding fire tongs from the Chamber's fireplace, the other a cane, both of them eventually wrestling on the floor until pulled apart by their colleagues.

As the Federalists grew more confident, and more imperious, in their use of national power, the popularity of the Republicans grew. And finally, in the election of 1800, their leader and champion Thomas Jefferson—after surviving what remains the most unsavory political campaign in American history—won the presidency and with it the chance to reshape the nation's development. The Jeffersonians were jubilant. They called their victory "the Revolution of 1800." But the new century that began with Jefferson's triumph was not to be kind to his vision of a simple, agrarian republic.

* * *

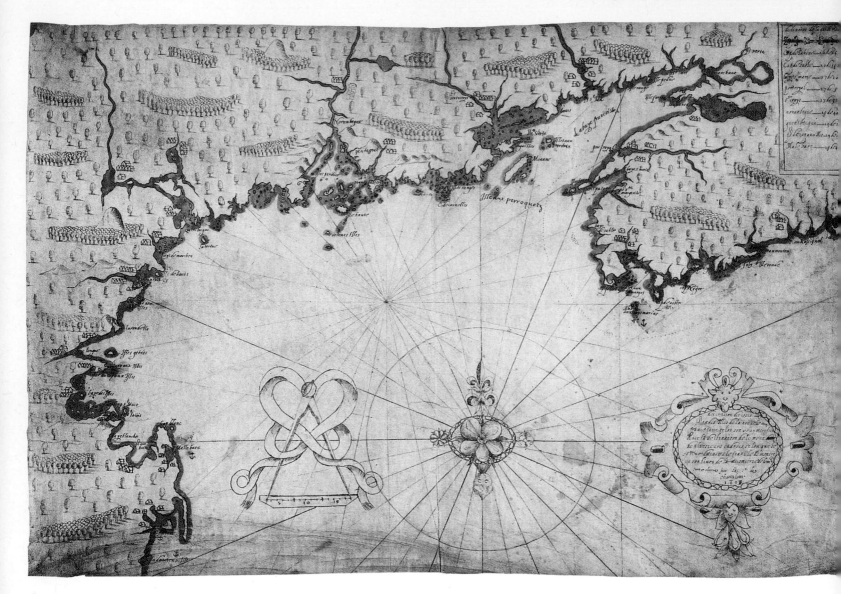

Samuel de Champlain. *Descrision des costs, pts, rades, Illes de la nouuele france.* Drawing, ink and wash on vellum. Manuscript map, 1607.

This thorough delineation of the coast from Cape Sable to Cape Cod was personally executed by the explorer and founder of New France, Samuel de Champlain, and was intended for presentation to the King of France. Between 1603 and 1607, Champlain explored the St. Lawrence River and other parts of what would become Canada and New England. His map, aside from being the first guide to coastal waters and features, indicates the numerous French settlements and Indian villages that dotted the coastline prior to the landing of the Pilgrims at Plymouth in 1620. The French exercised an influence in North America disproportionate to their numbers because of their close relationship with the Indians: traders formed partnerships with them and often joined their societies.

Mr. de la Barre's camp. Engraving from Louis Armand de Lom d'Arce, baron de Lahontan, *Nouveaux voyages de Lahontan, dans L'Amérique Septentrionale.* London, 1703. This is one of the earliest representations of the "Calumet of peace," or peace pipe, in a schematic portrayal of a solemn meeting between the Iroquois and French emissary Isaac de la Barre to discuss recent Indian attacks on people friendly to the French. The pipe stands upright in its porcelain collar. It had a four- to five-foot-long feathered stem and might or might not include a pipe bowl. Borne by the Grangula, an Indian leader or emissary, it was a sign of truce and a symbol of the authority of his mission. The French officer's large retinue included interpreters, troops, and other officers; the Grangula was attended by a smaller group, who, in the words of the author, "set Squat upon their tails."

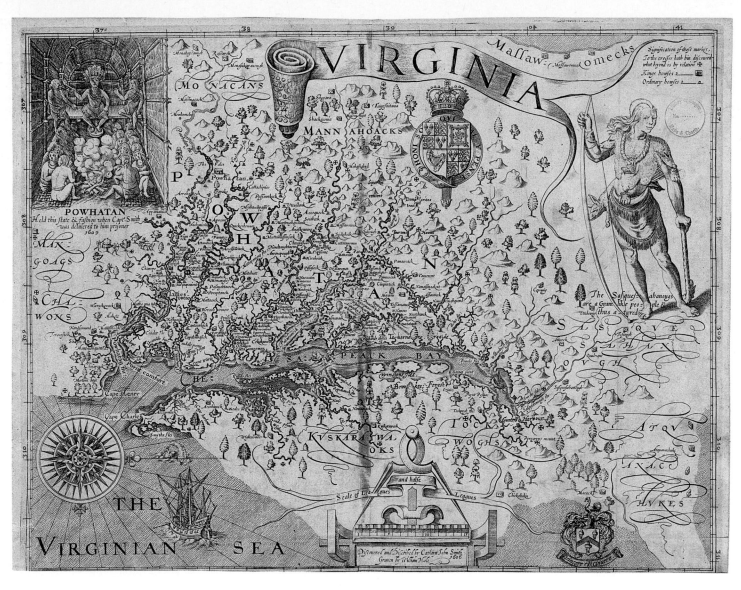

William Hole, after John Smith. *Virginia, discovered and discribed by Captayn John Smith, 1606.* Engraving from Smith, *The generall Historie of Virginia.* London, 1624. An adventurer with a talent for self-promotion, John Smith was indispensable to the early English colony established by the Virginia Company. On several occasions, through his good relations with the Indians, he was able to procure corn to prevent the colonists from starving. Smith's map of Virginia, the first accurate survey of the Chesapeake, drew upon not only his own explorations of the Potomac and Rappahannock Rivers during the summer of 1608, but also descriptions of the territory obtained from the Native Americans. As Smith himself put it, "To the crosses hath been discoverd / what beyond is by relation."

To add interest to the map, the engraver inset in the upper left a view of the Indian leader Powhatan's court showing Smith when he was, by his own account, captured and then saved from death by the intercession of Pocahontas in 1607.

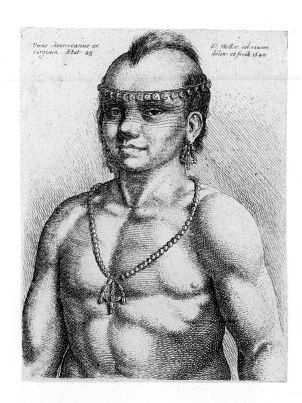

Wenceslaus Hollar. *Unus Americanus ex Virginia.* Etching (Aetat 23). Antwerp, 1645. The inscription above this early etching of a twenty-three-year-old Virginia Algonquian states that the portrait was taken *ad vivum,* "from life." Possibly Hollar first sketched his subject while working in London, where envoys of Native American tribes and nations occasionally traveled on diplomatic missions or as guests of the English allies. The straightforward, frontal presentation of the subject, and the inclusion of a generic description rather than his name, transform the sitter into a scientific specimen.

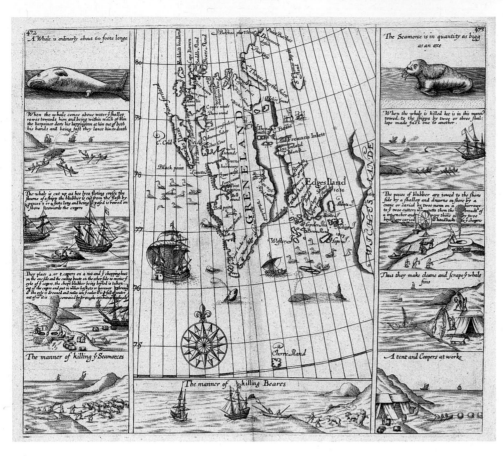

Samuel Purchas. *A Whale is ordinarily about 60 foote longe.* Engraving from *Purchas his Pilgrimage.* London, 1625.

The waters off New England and Canada have been a source of livelihood to the region's more intrepid inhabitants since its earliest settlement. This seventeenth-century map details the maritime industries in their infancy, showing the manner of hunting whales, polar bears, and seals as far afield as Greenland. The Dutch were the first to organize whaling as an industry. Centered at first on Long Island and Cape Cod, it shifted to Nantucket and then New Bedford, the greatest whaling port in the world until the industry's decline in the 1850s.

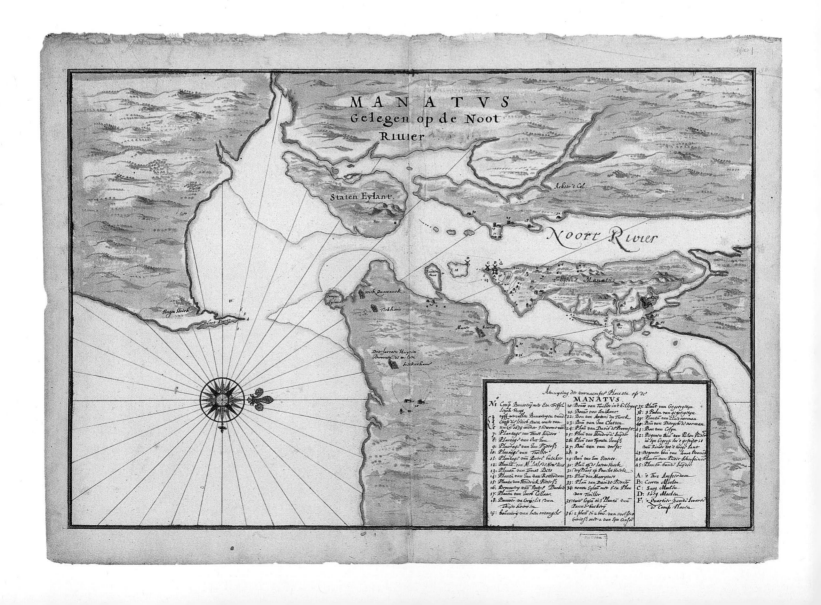

At Portsmouth in Her Maj:ties Province of New Hampshire, in New England the 28th Day of July in the thirteenth Year of our Sovereign Lady ANN, by the Grace of God of Great Britain, France & Ireland Queen, Defender of the faith &c.

The Severall Articles, of the foregoing Sheet after a long Conference, with the Delegates of the Eastern Indians, were Read to them, & the Sense & meaning thereof Explained by two faithfull Sworn Interpreters, and accordingly Signed by every of the Sachems, and Delegates, that were not present, & had not Signed the last Year. In Presence of his Excellency the Governour & his Excellency Generall Nicholson, & the Gentlemen of Her Maj:ties Councills of the Provinces of the Massachusetts Bay & New Hampshire, & other Gentlemen.

Signed Sealed & Delivered in presence of us

Indian treaty signed at Portsmouth, New Hampshire, July 28, 1714. Ink on vellum. On July 13, 1713, the "Eastern Tribes," long allied with the French, submitted to the governments of Massachusetts and New Hampshire following the end of Queen Anne's War (1702–13), one of the many colonial wars fought between Great Britain and France in the late seventeenth and the eighteenth centuries. The delegates and sachems of the tribes met at Portsmouth a year later with representatives of the provinces to sign this treaty. Both pictographs and English and French names were used by the Indian signatories. The treaty brought peace to the northern frontier for thirty years.

Pierre Fourdrinier, after Peter Gordon. *A View of Savanah* [sic] *as it stood the 20th of March, 1734.* Engraving. London, c. 1735. Georgia was the last English colony, established in 1733 on the southern border of England's American territory as a military barrier against the Spanish Empire below it. This grand and sweeping view of the newly laid-out town of Savannah—just a year after its founding by Governor James Edward Oglethorpe—was engraved and circulated in England to promote investment and emigration to the settlement. More than a hundred houses, a church and parsonage, storehouses, and a fort and battery had already risen in the midst of pine, cypress, and oak forests on the banks of the Savannah River. The drawing on which this engraving was based was made by Peter Gordon, an artist who served as the town's first bailiff.

Opposite: *Manatus, Gelegen op de Noot Riuier.* Drawing, ink and wash. Manuscript map, c. 1665, after Johannes Vingboons, 1639. This is the earliest known map of Manhattan and its environs, and may well have been drawn by the cartographer for the Dutch West India Company to encourage settlement. It covers what is now Manhattan Island, Staten Island, a part of Long Island, and the adjacent mainland. Pictorial symbols depict Fort Amsterdam, windmills, plantations, and Indian villages; the names and locations of some forty-five "boweries" or farms are also given. The Dutch encouraged settlement by all comers regardless of race, nationality, or religion. By 1639 this was America's most populous and most diverse region, though the Dutch community remained relatively small. By 1674 it was lost for good to the English.

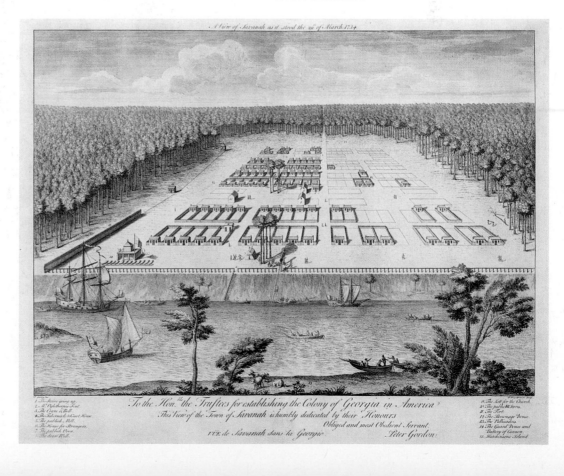

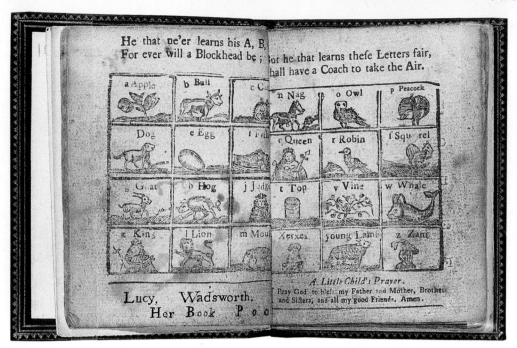

He that ne'er learns his A, B, C. Woodcuts from *The New England Primer Enlarged.* Boston, 1779.

New England settlers strove to inculcate a high standard of learning and moral conduct in their children. Primers were used in the "dame schools," so named because the teachers were invariably women. These small books served to teach spelling and reading through a combination of proverbs, fables, pictures, and historical and moralizing texts. Great emphasis was placed on memorization. The books linked the letters of the alphabet to picture emblems, as this one does. It belonged to a young Connecticut girl, Lucy Wadsworth. In keeping with the stern ethic of Puritan society, it warns of the consequences of illiteracy, "He that ne'er learns his A, B, C, For ever will a Blockhead be."

The Anatomy of Man's Body as govern'd by the Twelve Constellations. Woodcut from Benjamin Franklin, *Poor Richard's Almanack.* Philadelphia, 1750.

A wide range of information, self-improvement advice, and wisdom—practical, religious, and scientific—was available to American farmers and townsmen in almanacs, which were small, ephemeral pamphlets generally issued annually. One of the most widely circulated was Benjamin Franklin's *Poor Richard's Almanack*; initially published in 1732, it was a prodigious success, selling nearly ten thousand copies a year. The work made Franklin's a household name and gave homespun flavor to American humor. As this page indicates, eighteenth-century popular lore still clung to the ancient belief that the functioning and welfare of parts of the human body were influenced by the movements of the planets and the positions of the constellations.

Benjamin Franklin. *Join, or Die.* Woodcut from *The Pennsylvania Gazette*. Philadelphia, May 9, 1754.
Franklin was perhaps the first person in America to use the printing press for the molding of public opinion. His famous warning to the various English colonies, whose frontier settlements were being raided by the multiple Indian allies of the French, is considered the earliest American political cartoon. It was produced as part of his unsuccessful campaign to unite the colonies in a "general government" that would manage relations with the Indians. Each portion of the segmented snake represented a colony. The snake later became the symbol of colonial union with the motto: "Don't Tread On Me."

Benjamin Franklin. Page from a letter to Jan Ingenhousz. Pen and ink. Philadelphia, August 1777.
In a letter to a Dutch physician and friend, the eternally inquisitive Franklin states his theory of the conductivity of heat and demonstrates that metals will expand, melt, or explode according to their composition, thickness, and intensity of the electrical charge. Franklin describes a simple experiment that involved passing an electrical charge from a large Leyden jar through various objects and materials, including the links of a brass chain and a tapered piece of tinfoil. Franklin observes how the foil, at its narrowest point, was "reduc'd to Smoak by Explosion." His experiments establishing the "sameness of lightning with electricity" made him an international celebrity; his scientific reputation would play a major part in enrolling French assistance during America's fight for independence.

er, the Quantity of Fluid passing, being the same, and the Quantity of Matter less that is acted upon.

7. Thus the Links of a Brass Chain, with a certain Quantity of Electricity passing thro' them, have been melted in the small Parts that form their Contact, while the rest have not been affected.

8. Thus a Piece of Tin Foil cut in this Form, inclos'd in a Pack of Cards,

and having the Charge of a large Bottle sent thro' it, has been found uncharg'd in the broadest Part between a. and b. melted only in Spots between b. and c, totally melted between c and d. and the Part between d. and e, reduc'd to Smoak by Explosion.

9. The Tinfoil melted in Spots between b and c, and that whole Space not being melted, seems to

George Washington. *A Plan of my Farm.* Drawing, ink, and wash. Manuscript map, 1766.

The future commander of American revolutionary forces and first president of the United States drew this map of his plantation on the Potomac River near Alexandria, Virginia, with characteristic exactitude. The plat covers the lands Washington had recently purchased adjacent to his ancestral home of Mount Vernon. He had begun his career as official surveyor for the western Virginia county of Culpeper, a duty that familiarized him with what would later become his theater of operations when the colony's militia, under his command, challenged French expansion in the Ohio Valley.

James Peake, after a painting by Paul Sandby, from a design by Thomas Pownall. *A Design to represent the beginning and completion of an American Settlement or Farm.* Etching from *Scenographia Americana.* London, 1761.

The English landscape painter Paul Sandby no doubt romanticized military governor Thomas Pownall's original rendering of a colonial farm. Yet the log cabin, its rude outbuildings and mill, and the proud manor house with its neatly landscaped grounds, standing bravely amid the still wild environs, give a sense of the challenge that American colonists faced in clearing the vast forests of North America.

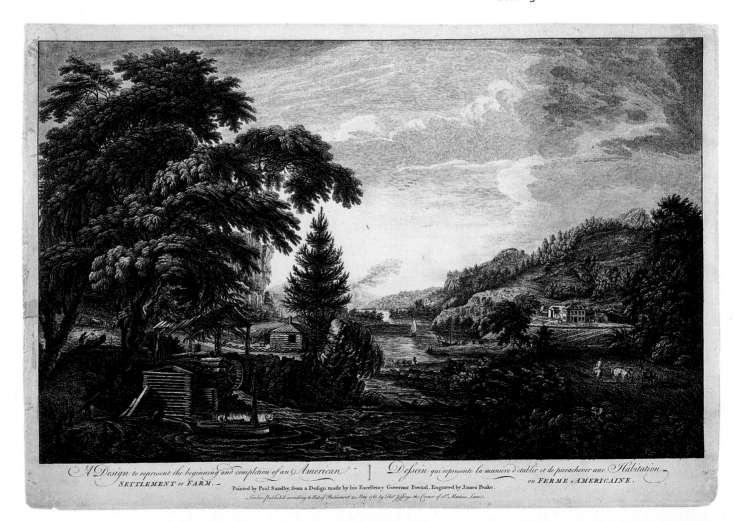

Paul Revere. A music party. Frontispiece engraving and title page from William Billings, *The New England Psalm-Singer.* Boston, 1781.

The development of music in the British colonies was closely linked with Protestant liturgy and its vocal accompaniment. William Billings, one of the first American-born composers, was an itinerant singing master who traveled from town to town tutoring the young of the more affluent families. To augment his teaching wages, he sold his own books of musical compositions for the voice, such as this manual introduced by Paul Revere's illustration of a music party. Revere's plate is one of the few surviving graphic representations of people making music in eighteenth-century America, where, wrote Elizabeth Shaw, Abigail Adams's sister, verse and music existed to "render us better qualified for Business & things of a much higher nature."

Scipio Moorhead. *Phillis Wheatley, Negro Servant to Mr. John Wheatley, of Boston.* Frontispiece engraving from Wheatley, *Poems.* Boston, 1773.

Editions of contemporary poetry were published infrequently in the colonies. When they were, they normally featured the poet's portrait as frontispiece, such as this of the African-born Wheatley in an attitude of poetic contemplation. At eight years of age she was kidnapped, brought on a slave ship to Boston, and purchased by John Wheatley, a prosperous tailor, as a servant for his wife. Having quickly mastered the English language, then the classical languages and literature, she became a sensation among Boston intellectuals. Her verse was later used by abolitionists to discount the argument that blacks were innately inferior to whites.

Wheatley praises the creative talents of the black painter Scipio Moorhead, servant to the Rev. John Moorhead, in one of her poems.

(279)

Anno quinto

Georgii III. Regis.

CAP. XII.

An Act for granting and applying certain Stamp Duties, and other Duties, in the *British* Colonies and Plantations in *America*, towards further defraying the Expences of defending, protecting, and securing the same; and for amending such Parts of the several Acts of Parliament relating to the Trade and Revenues of the said Colonies and Plantations, as direct the Manner of determining and recovering the Penalties and Forfeitures therein mentioned.

WHEREAS by an Act made in the last Session of Parliament, several Duties were granted, continued, and appropriated, towards defraying the Expences of defending, protecting, and securing, the British Colonies and Plantations in America: And whereas it is just and necessary, that Provision be made for raising a further Revenue within Your Majesty's Dominions in America, towards defraying the said Expences: We, Your Majesty's most dutiful and loyal Subjects, the Commons of Great Britain in Parliament assembled,

4 Q 2 have

5

An Act for granting and applying certain Stamp Duties. Pamphlet. London, 1765.
Chief among the "long train of abuses" cited by Thomas Jefferson in the Declaration of Independence as leading to the separation of the colonies from the mother country was the Stamp Act. In a desperate effort to wring new revenue from the colonies and retire the enormous debt incurred through its wars with France in Europe and America, the British government decided to tax virtually all paper products and official and legal documents. This first direct tax levied by England on America took effect in November 1765 and immediately met stiff resistance. Representatives from nine colonies met at Albany, New York, to inform Parliament boldly that it had no constitutional right to tax them without the authorization of the provincial assemblies. Many historians consider the Stamp Act protest to be the opening round of the American Revolution.

Robert Sayer and John Bennett. *A Society of Patriotic Ladies.* Mezzotint engraving. London, 1775.
As a prelude to revolution and confederation, the First Continental Congress adopted trade sanctions against England in October 1774. Americans took these sanctions seriously and began to boycott such British goods as tea and fabrics. When a group of American women, the principal consumers of tea, publicly pledged in Edenton, North Carolina, not to purchase English products any longer, the London print publishers, Sayer and Bennett, issued this satire ridiculing their action. It was women such as these, however, who formed the Daughters of Liberty which, like the Sons of Liberty, was committed to agitating against British policies. In Boston, tea was dumped from British ships; other seaports staged similar "tea parties."

A SOCIETY of PATRIOTIC LADIES,
AT
EDENTON in NORTH CAROLINA.
London, Printed for R. Sayer & J. Bennett, N.º 53 in Fleet Street, as the Act directs 25 March 1775.

Plate V.

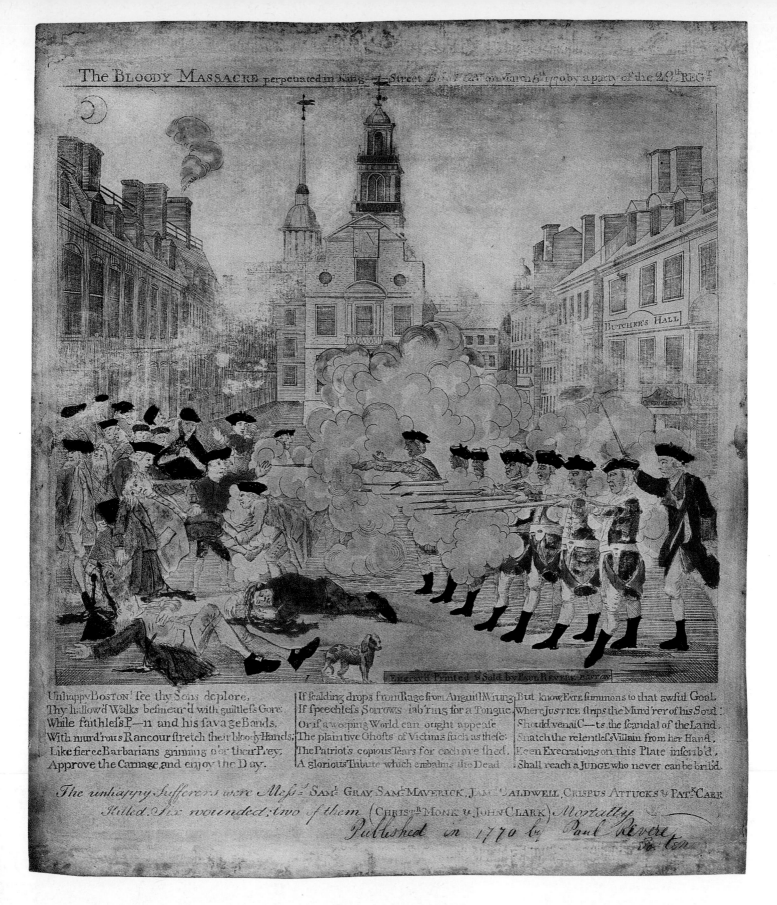

Paul Revere, after Henry Pelham's design. *The Bloody Massacre perpetrated in King Street, Boston on March 5th 1770.* Engraving with watercolor. Boston, 1770.

Both Samuel Adams, the most effective radical in the colonies, and Paul Revere, a master propagandist, seized the opportunity to foment public outrage in the wake of the Boston Massacre, when British soldiers opened fire on a mob, killing five. Revere was shown a preliminary sketch for a print depicting the deadly scuffle by fellow artist and engraver Henry Pelham, and saw a way to support Adams's speeches and turn a profit at the same time. His engraving (after Pelham's design) was issued on March 28, 1770, and was quickly reproduced throughout the colonies. The day after the print appeared, an indignant Pelham protested the piracy of his design in a note to Revere that concluded, ". . . [I] find myself in the most ungenerous Manner deprived not only of any proposed Advantage but even of the expence I have been at, as truly as if you had plundered me on the highway. If you are insensible of the Dishonour you have brought on yourself by this Act, the World will not be so." Pelham published his own version of the print one week later, but it is Revere's earlier effort that has endured as one of the most influential works of graphic propaganda in American history.

Last Thursday was hung up by some of the lower class of inhabitants, at New Brunswick, an effigy, representing the person of Mr. Rivington. Wood-engraving from *Rivington's New-York Gazetteer.* New York, April 20, 1775.

Though freedom of the press had been strengthened in the colonies by the 1735 jury acquittal of Peter Zenger—found not guilty of libel by reason of having printed the truth—James Rivington's "Open and Uninfluenced Press" fared less well forty years later. Patriots bitterly resented that his columns were filled with Tory arguments as well as anti-British opinion. In one of the earliest tabloid illustrations, he reports being hanged in effigy in New Brunswick. When his Royalist sympathies became more apparent, the Sons of Liberty mobbed and nearly destroyed his office, demolished his press, and carried away his type, forcing closure of the paper which he reestablished after British troops occupied New York in September 1776.

Carl Guttenberg. *The Tea-Tax Tempest, or the Anglo-American Revolution.* Engraving. Nuremberg, 1778.

In this satire expressing a Continental European view of the American Revolution, Father Time employs a magic lantern to project the image of a teapot exploding among frightened British troops as American troops advance through the smoke. Figures representing world opinion look on: an Indian for America, a black woman representing Africa, a woman holding a lantern symbolizing Asia, and a woman bearing a shield for Europe. The cartoon clearly takes the American side of the seven-year conflict, which officially began with a skirmish at Lexington, Massachusetts, on April 19, 1775.

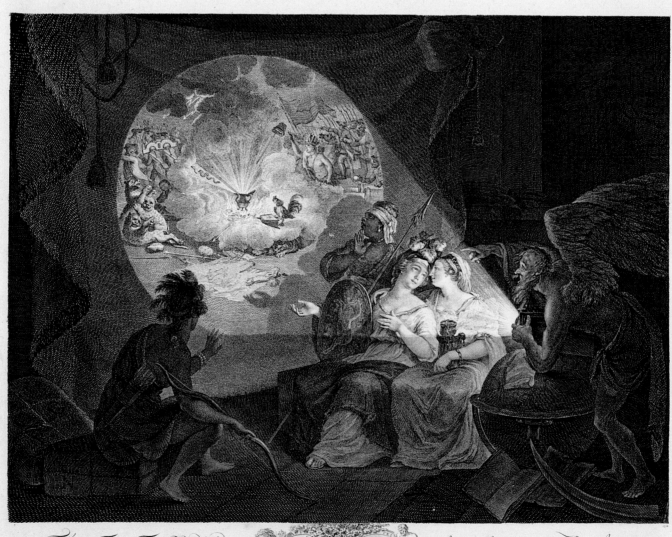

The Tea-Tax-Tempest, or the Anglo-American Revolution.
Ungewitter entstanden durch die Auflage auf den Thee in America.
Orage causé par l'Impôt sur le Thé en Amerique.

Charles Willson Peale. *His Excel: G: Washington Esq.* Mezzotint engraving. Philadelphia, 1787.

George Washington assumed command of the Continental Army on July 3, 1775, and led it throughout the war. Printed portraits of him were ubiquitous in America during and after his lifetime, but few displayed the artistry and technical skill of this elegant oval mezzotint. Charles Willson Peale was a gifted artist, printmaker, promoter, entrepreneur, and patriarch of the most prominent and accomplished family in the history of American art. This portrait of Washington was issued in September 1787 at the culmination of the Constitutional Convention, over which Washington presided. The president must have been pleased, for a framed impression Peale gave him hung in the music room at Mount Vernon until his death.

Thomas Hyde Page. *Plan of the Action which happened 17th June 1775, at Charles Town N. America.* Drawing, ink and watercolor. Manuscript map.

This rough sketch map of the disposition of British troops and supporting naval craft and of the movement of the American provincial irregulars (the Rebel Army) at Bunker Hill was drawn shortly after the siege by the aide-de-camp of the English commander General William Howe. It depicts the first premeditated battle of the American Revolution. The Patriots suffered severe casualties, but inflicted even greater losses on the Redcoats—the heaviest casualties they suffered during the entire war—and the battle led to their eventual evacuation of Boston for Halifax with hundreds of Loyalist refugees on March 17, 1776.

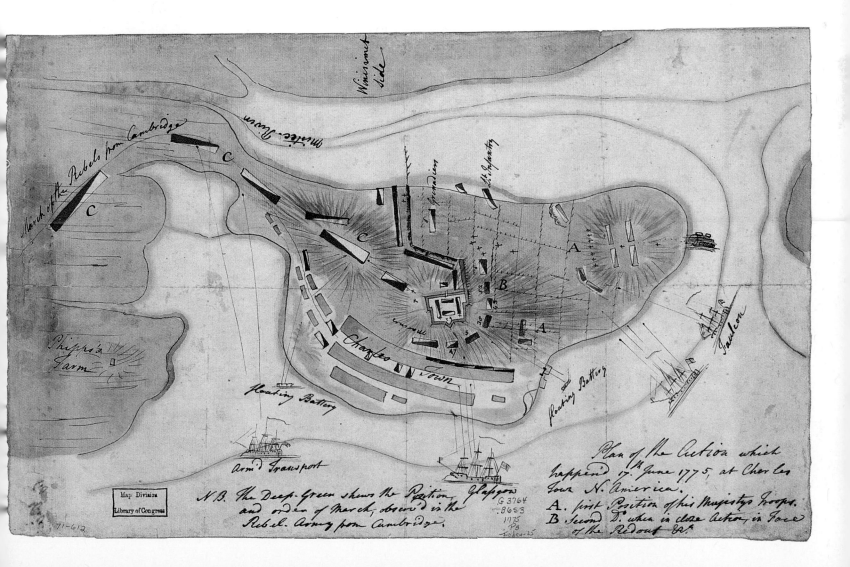

An EAST PROSPECT of the CITY of PHILADELPHIA; taken by GEORGE HEAP from the JERS...

A DESCRIPTION OF THE SITUATION, HAR...

PHILADELPHIA, the Capital of Pennsylvania, is situate on the West side of the River Delaware, on a high and pleasant Plain, the City is laid out in form of an Oblong, two Miles in length, and one in breadth, bounded on the East by Delaware River, and on the West by the River Schaylkill, the Streets are all strait and parallel to the sides of the plan, and consequently cut each other at right Angles, none of which are less than 50 and the widest 100 feet in breadth, the Houses are built with Brick, and are from two to three and four Stories high; the Buildings are extended on Delaware Front a considerable distance North and South

beyond the Verge of the City the depth of several Streets to the Westward. The Harbour is one of the safest & ... that is known, where Ships of the greatest Burthen may safely Anchor in seven or eight Fathom at low Water, & ma... the Wharfs without the least Danger, & as this Harbour is at least thirty Miles above Salt Water, it must consequente... Ship Worm. The Tides rise and fall here seven or eight feet, and flow up the River thirty Miles above the Town ... of Philadelphia from the Sea adds much to its Security, as the Channel is intricate & long, and is a natural Fortifica...

1. Christ Church. 2. State House. 3. Academy. 4. Presbyterian Church. 5. Dutch Calvinist Church. 6. The Court House. 7. Quakers Meeting House.

A PLAN of the CITY of PHILADELPHIA.

Thomas Jefferys, after George Heap and Gerard Vandergucht. *An East Prospect of the City of Philadelphia.* Engraving. London, 1756. Philadelphia, rebel capital and site of both Continental Congresses, was occupied by the British under General William Howe during the winter of 1777–78. Urban development in eighteenth-century America was nowhere as advanced as in Philadelphia, and the British enjoyed their stay immensely, while Washington's army suffered near starvation at freezing Valley Forge. This is one of the few authentic

, under the Direction of NICHOLAS SCULL Surveyor General of the PROVINCE of PENNSYLVANIA.

OF THE CITY AND PORT of PHILADELPHIA.

THE BATTERY

THE STATE HOUSE

Engrav'd & Publish'd according to Act of Parliament, by T. Jefferys, near Charing Cross.

portraits of an American city before the Revolution; it was produced under the direction of Nicholas Scull, surveyor-general of the province of Pennsylvania. The spires and buildings of the wealthy, cosmopolitan city rise beyond the waterfront, and the Delaware River teems with sailing vessels of every variety. The work satisfied the desire of Thomas Penn, proprietor of Pennsylvania, for an image to rival existing large-scale engravings of the competing ports of New York and Boston.

Thomas Jefferson. First draft of the Declaration of Independence. Pen and ink. Philadelphia, June 1776. Jefferson's initial draft of the Declaration was written during the Second Continental Congress. It contained an attack on the slave trade, even though he himself was a slaveholder; the delegates from the South opposed it and succeeded in having this part of the text deleted. His harsh language against the people of Great Britain and King George III was also softened in the final draft, but like Franklin's "Join, or Die," the Declaration was a powerful brief supporting American nationhood.

In May of 1776, Abigail Adams wrote to her husband, John, who was on the committee to draft the declaration: "I cannot say that I think you are very generous to the ladies, for whilst you are proclaiming peace and good-will to Men, Emancipating all Nations, you insist upon retaining an absolute power over Wives. But you must remember that Arbitrary power is, like most other things which are very hard, very liable to be broken—and we have it in our power not only to free ourselves but to subdue our masters, and without violence, throw both your natural and legal authority at your feet."

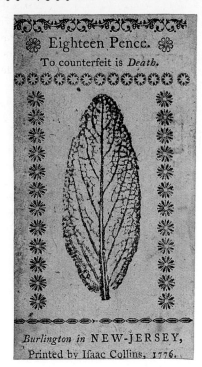

Isaac Collins. *Eighteen Pence.* Leaf-print with letterpress and type ornaments. Continental currency. Burlington, New Jersey, 1776. After Bunker Hill and the Declaration of Independence, the issuance of currency to finance the revolution was authorized by the Continental Congress. When the relatively crude early banknotes were counterfeited by disloyal colonists, the authorities responded with stern warnings ("To counterfeit is Death") and with printing techniques designed to frustrate imitation, such as incorporating impressions of the unique vein structures of leaves and other natural objects.

John Cadwalader. Plan of Princeton, New Jersey, December 31, 1776. Drawing, pen and ink. Manuscript map.

The British regrouped quickly after their retreat from Boston. Immediately following the Declaration of Independence, hundreds of British ships and 32,000 soldiers arrived in New York under General Howe. A royal pardon was offered the colonists; it was rejected, even though Washington had only 19,000 inadequately armed and poorly trained soldiers and no navy at all. The British camped in New Jersey for the winter. This hand-drawn intelligence map was sent by General John Cadwalader to Washington only days before his surprise attack on the British. After crossing the icy Delaware River on Christmas night, 1776, he defeated the unprepared Hessian troops first at Trenton and, on January 3, 1777, at Princeton, shattering Howe's notion of a quick triumph. The strategic intent of the map for the American infantry is reflected in Cadwalader's notation at lower right: "This Road leads to the back part of Prince Town, which may be entered anywhere on this side—the Country cleared, chiefly, for about 2 miles . . . few Fences."

François Godefroy, after Fauvel. *Saratoga.* Drawing, ink and wash. Paris, 1783–84. The surrender of British commander General John Burgoyne to American forces under Horatio Gates at Saratoga, New York, on October 17, 1777, effectively ended the bungled English effort to cripple the rebellion by cutting the colonies in two after Howe captured Philadelphia. Saratoga convinced the French that America had a real chance of winning; they became an indispensable ally through the intervention of Ben Franklin, who had gone there to lobby for aid and diplomatic recognition right after the signing of the Declaration of Independence. This drawing of the surrender was produced by a French artist for an engraved portfolio published in Paris after the war's conclusion. While it reflects the sublime sense of triumph that the Americans and their French allies must have felt at this development, the portrayal, complete with coconut palm trees, is entirely imaginary.

ARTICLES

OF

CONFEDERATION AND PERPETUAL UNION,

BETWEEN THE COLONIES OF

NEW-HAMPSHIRE,
MASSACHUSETTS-BAY,
RHODE-ISLAND,
CONNECTICUT,
NEW-YORK,
NEW-JERSEY,
PENNSYLVANIA,

THE COUNTIES OF NEW-CASTLE,
KENT AND SUSSEX ON Delaware,
MARYLAND,
VIRGINIA,
NORTH-CAROLINA,
SOUTH-CAROLINA, AND
GEORGIA.

ART. I. THE Name of this Confederacy shall be "THE UNITED STATES OF AMERICA."

ART. II. The said Colonies unite themselves so as never to be divided by any Act whatever, and hereby severally enter into a firm League of Friendship with each other, for their common Defence, the Security of their Liberties, and their mutual and general Welfare, binding the said Colonies to assist one another against all Force offered to or attacks made upon them or any of them, on Account of Religion, Sovereignty, Trade, or any other Pretence whatever.

ART. III. Each Colony shall retain and enjoy as much of its present Laws, Rights and Customs, as it may think fit, and reserves to itself the sole and exclusive Regulation and Government of its internal police, in all matters that shall not interfere with the Articles of this Confederation.

ART. IV. No Colony or Colonies, without the Consent of the United States assembled, shall send any Embassy to or receive any Embassy from, or enter into any Treaty, Convention or Conference with the King or Kingdom of Great-Britain, or any foreign Prince or State; nor shall any Colony or Colonies, nor any Servant or Servants of the United States, or of any Colony or Colonies, accept of any Present, Emolument, Office, or Title of any Kind whatever, from the King or Kingdom of Great-Britain, or any foreign Prince or State; nor shall the United States assembled, or any Colony grant any Title of Nobility.

ART. V. No two or more Colonies shall enter into any Treaty, Confederation or Alliance whatever between them, without the previous and free Consent and Allowance

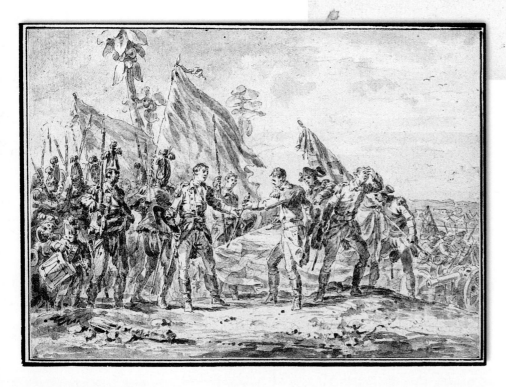

Opposite: *Articles of Confederation and Perpetual Union between the States.* Letterpress with pen and ink annotations by Thomas Jefferson. Pamphlet. Philadelphia, 1775.

For a time, Americans were not sure whether they wanted a national government; virtually everyone considered the individual colonies the real centers of authority. Jefferson annotated this copy of Benjamin Franklin's proposed Articles of Confederation, which were read in Congress on July 21, 1776. It constituted the points of agreement that first formally joined the colonies. The articles were adopted in 1777, and superseded by the Constitution in 1789.

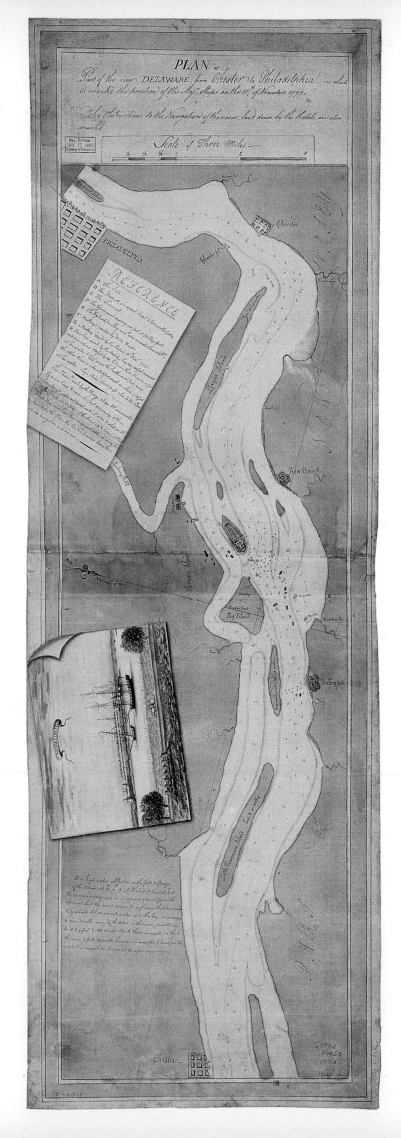

John Hunter. *Plan of part of the River Delaware from Chester to Philadelphia, in which is marked the position of His Majesty's ships on the 15th of November 1777.* Drawing, ink and watercolor. Manuscript map, June 1778.

One British strategy was to undermine the Revolution from within by rallying Loyalists and slaves to their cause. It was a dismal failure. After defeat in the North, British forces spent three years (from 1778 to 1781) moving through the South fighting many battles but also paradoxically politicizing large sections of the local populations and mobilizing them to fight for independence. This plan of a fifteen-mile stretch of the Delaware below Philadelphia belonged to English Admiral Richard Howe. It includes the "Obstructions to the Navigation of the river laid down by the Rebels," and shows the location of fortifications, such as Mud Island, Red Bank, and Billingsgate. These defenses failed to prevent British occupation of Philadelphia in 1777. Many Revolutionary War maps are distinguished by decorative as well as cartographic detail.

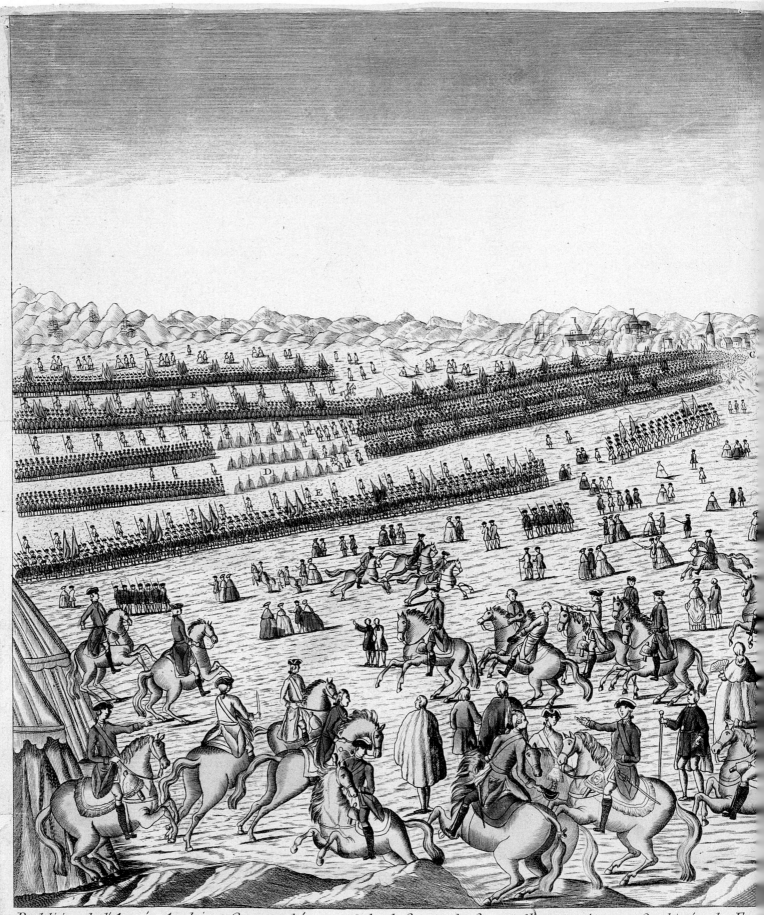

Reddition de l'Armée Angloises Commandeé par Mylord Comte de Cornwallis aux Armées Combineés des Eta et Glocester dans la Virginie. le 19 Octobre 1781. Il s'est trouvés dans ses deux postes 6000 hommes de troupes regleés An 40 Batimens dont un Vaiseau de 50 Canons qui a eté Brulé 20 Coules Bas ; Ce jour a jamais memorables pour les É.

71-2365

A. Yorck Towwn C. Armeés Angloise sortant de la place E Armeé Francoise
B. Glocester D. Les Armes des ennemis poseé en Faiseeaux F Armeé Ameriquaine

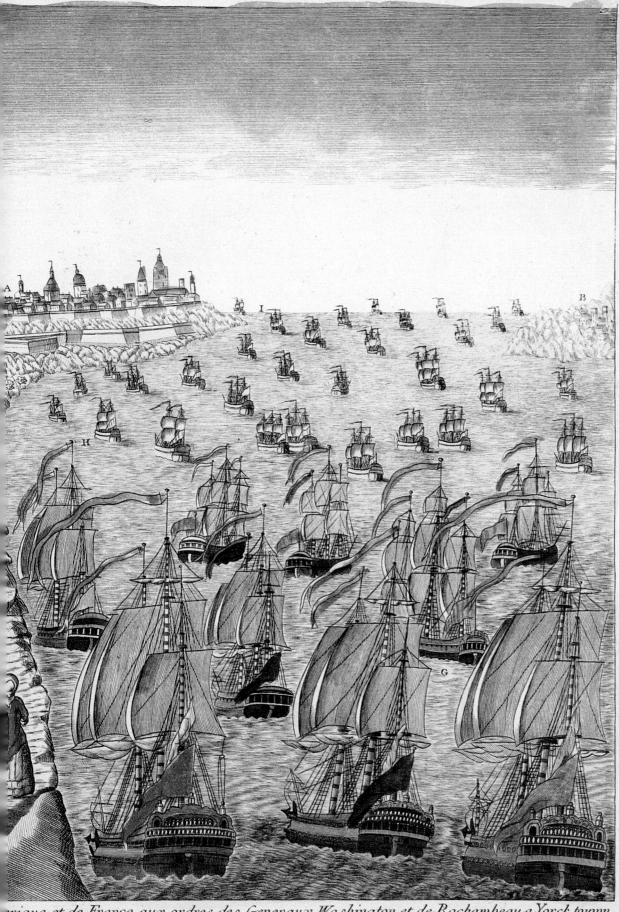

rique et de France aux ordres des Generaux Washington et de Rochambeau a Yorck towwn
ses et 22 Drapeaux 1500 Matelots 160 Canons de tout Calibre dont 75 de Fonte 8 Mortiers
nuil assura definitivement leurs independances
le France aux Ordres du Comte de Grace
apeack I Riviere d'Yorck.

A Paris chez Mondhare rue St. Jean de Beauvais près celle des Noyé

Reddition de l'Armée Angloises Commandée par Mylord Comte de Cornwallis. Etching with watercolor. Paris, 1781.
The British commander in the South, Cornwallis, was caught between land and sea at Yorktown, Virginia. His surrender on October 17, 1781, marked the effective end of the Revolution. The American victory was hailed in Europe by the French and other enemies of the British Empire. This imaginary view portrays the small Virginia tobacco port of Yorktown as a fortified European city. It was fabricated by a French engraver from verbal accounts, and features the French fleet under Admiral de Grasse arriving from the Chesapeake Bay while Cornwallis surrenders his army of seven thousand. On that day, a military band played the old tune "The World Turn'd Upside Down."

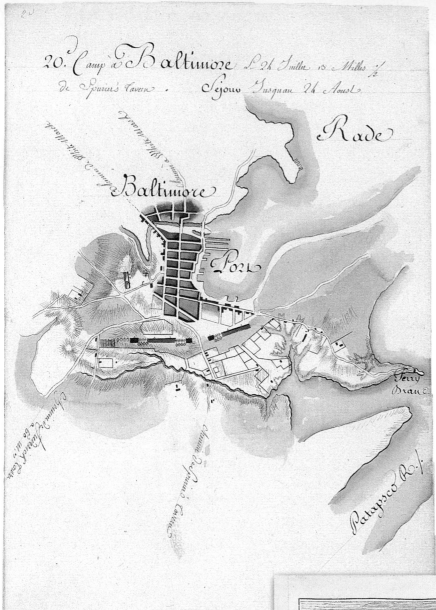

Jean Baptiste Donatien de Vimeur, comte de Rochambeau. *Camp à Baltimore.* Drawing, ink and watercolor. Manuscript map from *Amérique campagne, 1782, Plans des différents camps occupés par l'armée aux ordres de Mr. le comte de Rochambeau.* Manuscript atlas.
After Rochambeau's army assisted the American colonists in defeating the British at Yorktown, his troops marched north through the new country to Boston, where they departed for France. This map of Baltimore is one of forty-five manuscript maps prepared by the engineers accompanying the French army to record each site where they camped on their return march. Although the French stayed near Baltimore for a month, from July 24 to August 24, it is interesting to note the amount of detail on these beautifully colored maps since they stayed in most locations only one night. This small atlas provides a unique vista of major towns in the northeastern part of the country; much of the French route is retraced by today's U.S. Route 1 and Interstate 95.

James Gillray. *The American Rattle Snake.* Etching. London, 1782.
James Gillray was the most influential satirical artist in England during the Revolution. He lampoons the British war effort in this piece, published on the day peace negotiations commenced in Paris between the United States and Britain, by portraying America as a rattlesnake coiled around the British armies under Generals Burgoyne and Cornwallis. The snake speaks: "Two British Armies I have thus Burgoyn'd And room for more I've got behind." Over a vacant third coil the snake's rattle supports a sign advertising, "An Apartment to Lett for Military Gentlemen." The verse printed below the image reflects the widespread sympathy in England with the Americans:

Britons within the Yankeean Plains,
Mind how ye March & Trench,
The Serpent in the Congress reigns,
As well as in the French.

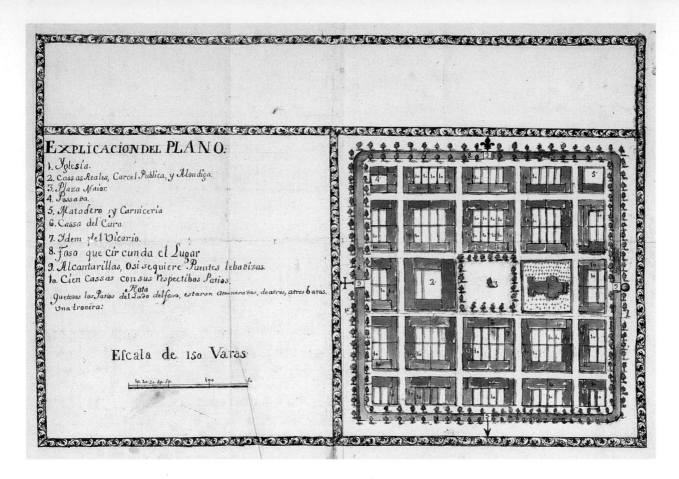

EXPLICACION DEL PLANO:

1. Yglesia.
2. Cassas Reales, Carcel Publica, y Mondiga.
3. Plaza Maior.
4. Jossaêa.
5. Matadero y Carniceria
6. Cassa del Cura.
7. Ydem del Vicario.
8. Foso que circunda el Lugar
9. Alcantarillas, Osi sequiere Puentes lebadizas.
10. Cien Cassas consus respectibos Patios.

Nota
Quetodos los Patios del Lado delfano, estaran Atrineraôos, deatres, atres 6 aras.
Una Tronéra:

Escala de 150 Varas

Juan Augustan Morfi. Plan of San Antonio, Texas. Drawing, ink and watercolor, from *Memorias para la historia de Texas.* Manuscript, 1780.

Well outside the geographical sphere of what was imagined as the United States following the war of independence, the Spanish administration in the same America was continuing to build colonial communities according to a 1573 Spanish ordinance that prescribed a particular layout for towns. This precise form of development has left an historical imprint on many regions of the country. Historian Juan Augustan Morfi's plan of San Antonio illustrates the long-lived ordinance. The focal point of the plan is formed by the church (*iglesia*) and government buildings (*cassas reales*) that face each other across a large central plaza. The plan also indicates a prison and other public structures, a slaughterhouse and meat market, and the patioed houses of its ordinary citizens.

S. Smith, after John Webber. *A View of the Habitations in Nootka Sound.* Engraving from James Cook, *A Voyage to the Pacific Ocean . . . performed under the direction of Captains Cook, Clerke, and Gore . . . 1776, 1777, 1778, 1779, and 1789.* Atlas, London, 1784.

Ironically, while the Revolution raged on the East Coast, this British naval expedition was exploring and charting the West Coast, identifying resources that would eventually provide the incentive for Americans to claim the entire breadth of the continent as their "manifest destiny." Sailing under the British flag, with the goal of locating the western entrance to the fabled Northwest Passage, James Cook devoted his attention on this third and final voyage to the Pacific basin, visiting, for the first time, Hawaii and the northwest coast of North America from Oregon to Alaska. Representative of the illustrations in his three-volume account of the voyage is this view of the native "habitations" on Vancouver Island in present-day British Columbia.

When the Revolution began, only a few thousand whites had lived west of the Appalachian divide; by 1790 their numbers had increased to 120,000, thanks in part to the Northwest Ordinance of 1787.

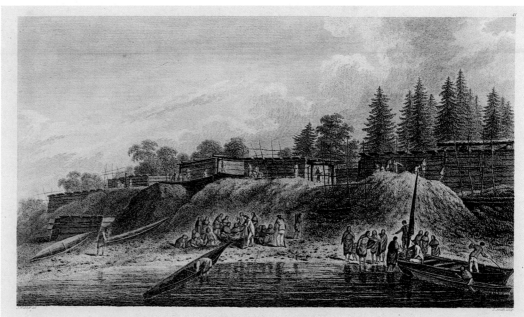

A View of the HABITATIONS in NOOTKA SOUND.

John Mitchell. *A Map of the British and French Dominions in North America.* Engraving. London, 1755. John Mitchell of Virginia was a distinguished physician and botanist and the maker of a single map. It was compiled for the Lords Commissions for Trade and Plantations to show the extent of British and French settlements. Called by one historian "the most important map in American history" because of its geographic accuracy and comprehensiveness, it was the cartographic document consulted in 1782 and 1783 by official representatives of Great Britain and the confederated states when in Paris negotiating the treaty that terminated the Revolutionary War. Colored bands represent the claims to western lands made by the individual states beyond their official boundaries.

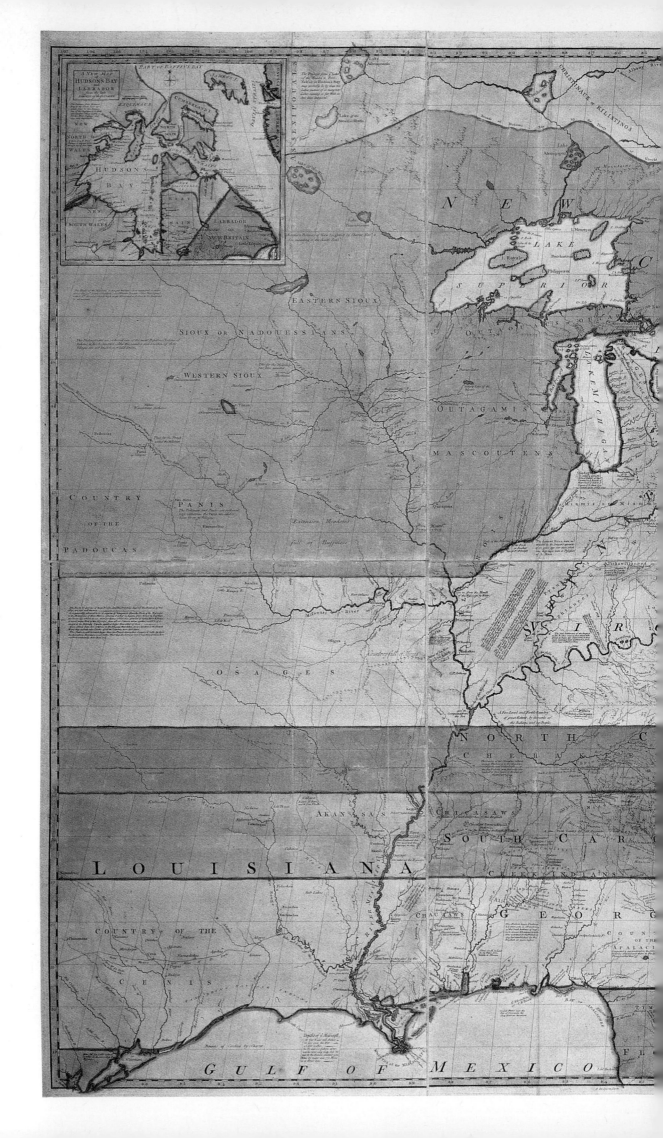

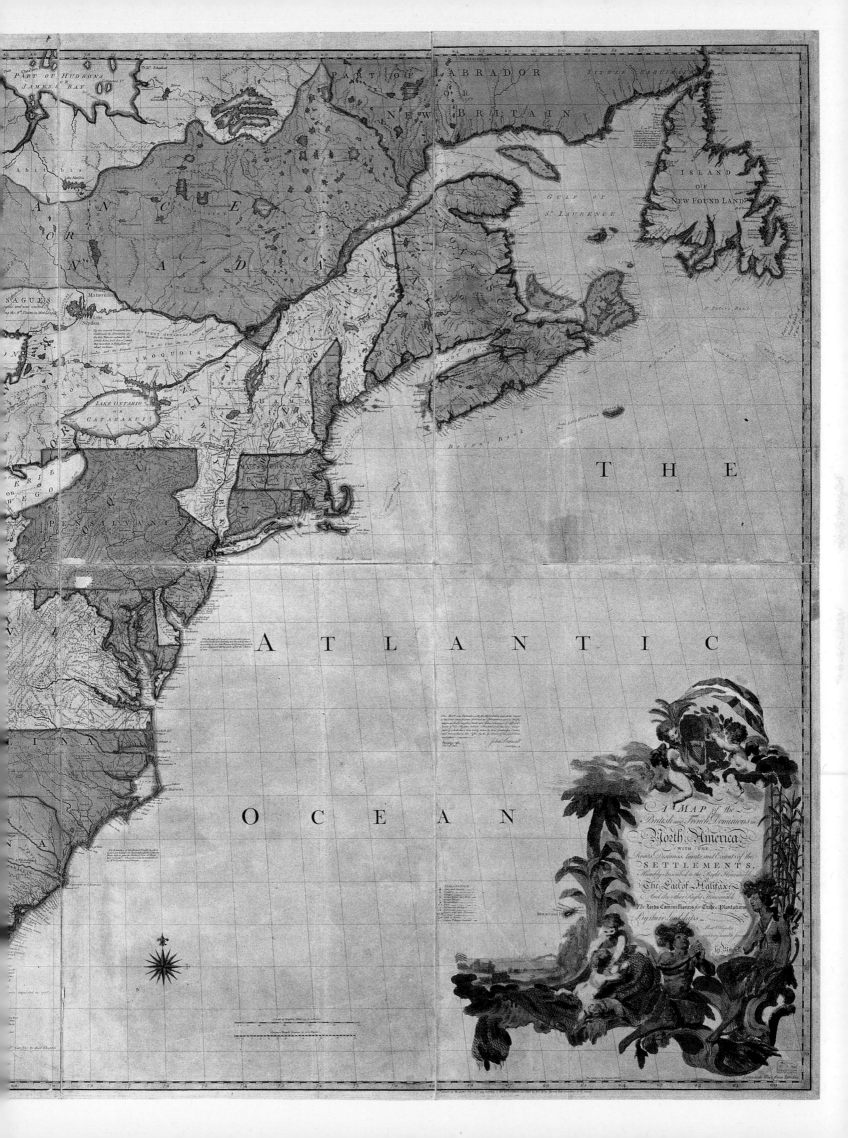

as finally agreed to by the Convention

Constitution of U.S.

WE, the People of the United States, in order to form

a more perfect union, eſtabliſh juſtice, inſure domeſtic tranquility, provide for the common defence, promote the general welfare, and ſecure the bleſſings of liberty to ourſelves and our poſterity, do ordain and eſtabliſh this Conſtitution for the United States of America.

ARTICLE I.

Sect. 1. ALL legiſlative powers herein granted ſhall be veſted in a Congreſs of the United States, which ſhall conſiſt of a Senate and Houſe of Repreſentatives.

Sect. 2. The Houſe of Repreſentatives ſhall be compoſed of members choſen every ſecond year by the people of the ſeveral ſtates, and the electors in each ſtate ſhall have the qualifications requiſite for electors of the moſt numerous branch of the ſtate legiſlature.

No perſon ſhall be a repreſentative who ſhall not have attained to the age of twenty-five years, and been ſeven years a citizen of the United States, and who ſhall not, when elected, be an inhabitant of that ſtate in which he ſhall be choſen.

Repreſentatives and direct taxes ſhall be apportioned among the ſeveral ſtates which may be included within this Union, according to their reſpective numbers, which ſhall be determined by adding to the whole number of free perſons, including thoſe bound to ſervice for a term of years, and excluding Indians not taxed, three-fifths of all other perſons. The actual enumeration ſhall be made within three years after the firſt meeting of the Congreſs of the United States, and within every ſubſequent term of ten years, in ſuch manner as they ſhall by law direct. The number of repreſentatives ſhall not exceed one for every thirty thouſand, but each ſtate ſhall have at leaſt one repreſentative; and until ſuch enumeration ſhall be made, the ſtate of New-Hampſhire ſhall be entitled to chuſe three, Maſſachuſetts eight, Rhode-Iſland and Providence Plantations one, Connecticut five, New-York ſix, New-Jerſey four, Pennſylvania eight, Delaware one, Maryland ſix, Virginia ten, North-Carolina five, South-Carolina five, and Georgia three.

When vacancies happen in the repreſentation from any ſtate, the Executive authority thereof ſhall iſſue writs of election to fill ſuch vacancies.

The Houſe of Repreſentatives ſhall chuſe their Speaker and other officers; and ſhall have the ſole power of impeachment.

Sect. 3. The Senate of the United States ſhall be compoſed of two ſenators from each ſtate, choſen by the legiſlature thereof, for ſix years; and each ſenator ſhall have one vote.

Immediately after they ſhall be aſſembled in conſequence of the firſt election, they ſhall be divided as equally as may be into three claſſes. The ſeats of the ſenators of the firſt claſs ſhall be vacated at the expiration of the ſecond year, of the ſecond claſs at the expiration of the fourth year, and of the third claſs at the expiration of the ſixth year, ſo that one-third may be choſen every ſecond year; and if vacancies happen by reſignation, or otherwiſe, during the receſs of the Legiſlature of any ſtate, the Executive thereof may make temporary appointments until the next meeting of the Legiſlature, which ſhall then fill ſuch vacancies.

No perſon ſhall be a ſenator who ſhall not have attained to the age of thirty years, and been nine years a citizen of the United States, and who ſhall not, when elected, be an inhabitant of that ſtate for which he ſhall be choſen.

The Vice-Preſident of the United States ſhall be Preſident of the ſenate, but ſhall have no vote, unleſs they be equally divided.

The Senate ſhall chuſe their other officers, and alſo a Preſident pro tempore, in the abſence of the Vice-Preſident, or when he ſhall exerciſe the office of Preſident of the United States.

The Senate ſhall have the ſole power to try all impeachments. When ſitting for that purpoſe, they ſhall be on oath or affirmation. When the Preſident of the United States is tried, the Chief Juſtice ſhall preſide: And no perſon ſhall be convicted without the concurrence of two-thirds of the members preſent.

Judgment in caſes of impeachment ſhall not extend further than to removal from office, and diſqualification to hold and enjoy any office of honor, truſt or profit under the United States; but the party convicted ſhall nevertheleſs be liable and ſubject to indictment, trial, judgment and puniſhment, according to law.

Sect. 4. The times, places and manner of holding elections for ſenators and repreſentatives, ſhall be preſcribed in each ſtate by the legiſlature thereof; but the Congreſs may at any time by law make or alter ſuch regulations, except as to the places of chuſing Senators.

The Congreſs ſhall aſſemble at leaſt once in every year, and ſuch meeting ſhall be on the firſt Monday in December, unleſs they ſhall by law appoint a different day.

Sect. 5. Each houſe ſhall be the judge of the elections, returns and qualifications of its own members, and a majority of each ſhall conſtitute a quorum to do buſineſs; but a ſmaller number may adjourn from day to day, and may be authoriſed to compel the attendance of abſent members, in ſuch manner, and under ſuch penalties as each houſe may provide.

Each houſe may determine the rules of its proceedings, puniſh its members for diſorderly behaviour, and, with the concurrence of two-thirds, expel a member.

Each houſe ſhall keep a journal of its proceedings, and from time to time publiſh the ſame, excepting ſuch parts as may in their judgment require ſecrecy; and the yeas and nays of the members of either houſe on any queſtion ſhall, at the deſire of one-fifth of thoſe preſent, be entered on the journal.

Neither houſe, during the ſeſſion of Congreſs, ſhall, without the conſent of the other, adjourn for more than three days, nor to any other place than that in which the two houſes ſhall be ſitting.

Sect. 6. The ſenators and repreſentatives ſhall receive a compenſation for their ſervices, to be aſcertained by law, and paid out of the treaſury of the United States. They ſhall in all caſes, except treaſon, felony and breach of the peace, be privileged from arreſt during their attendance at

the

First page of a working draft of the Constitution of the United States. Letterpress with handwritten annotations by James Madison. Broadside. Philadelphia, September 1787.

The U.S. Constitution derived many of its principles from the state documents that had preceded it. A national convention was called by Alexander Hamilton to overhaul the Articles of Confederation and the weak central government it had created. Once the specific provisions were resolved after a two-month-long debate at Philadelphia, they were sent to the Committee on Style. The Committee was charged with preparing the document's language. This, their printed draft, was emended by Madison during the final debates leading to the adoption of the Federal Constitution on September 17, 1787, by the thirty-nine delegates to the Convention. It was then sent to the states for ratification.

The Federal Edifice. Woodcut from The [Massachusetts] Centinel. Boston, August 2, 1788.
Although cartoons were rare in the eighteenth century, this depiction of the Federal Edifice shows New York becoming the eleventh state to ratify the Constitution. When thirteen pillars were in place, the structure would be complete and the Union cemented.

James Madison. Notes on Debates on the Bill of Rights (excerpt). Pen and ink. Manuscript. New York, 1789.
Wary of the potential hazard to individual liberties posed by the new Constitution's strong central government, five of the state ratifying conventions called for immediate amendments. Accordingly, Madison synthesized the numerous states' demands and used these notes in delivering a speech in Congress on June 8, 1789, calling for specific amendments to the federal Constitution. Congress approved twelve, but only ten were ratified by the states to form the Bill of Rights.

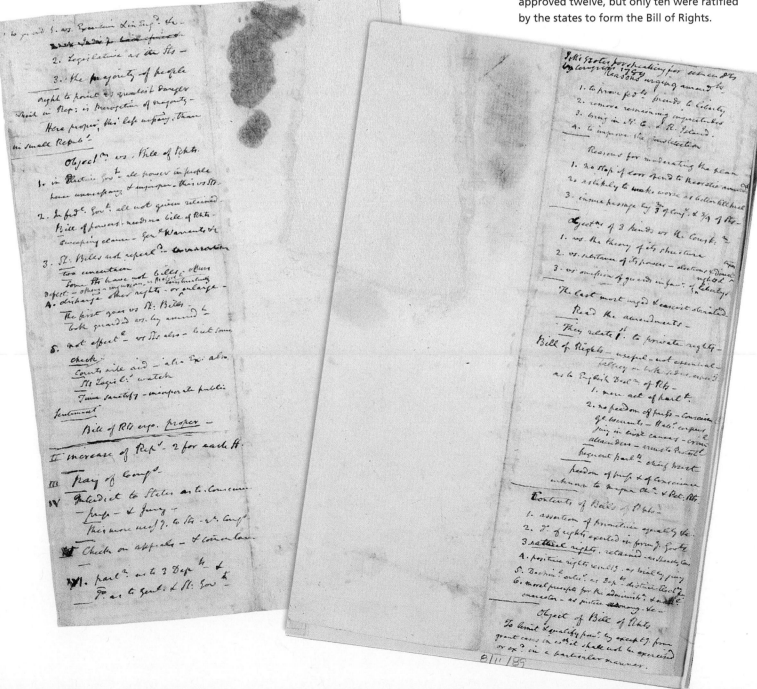

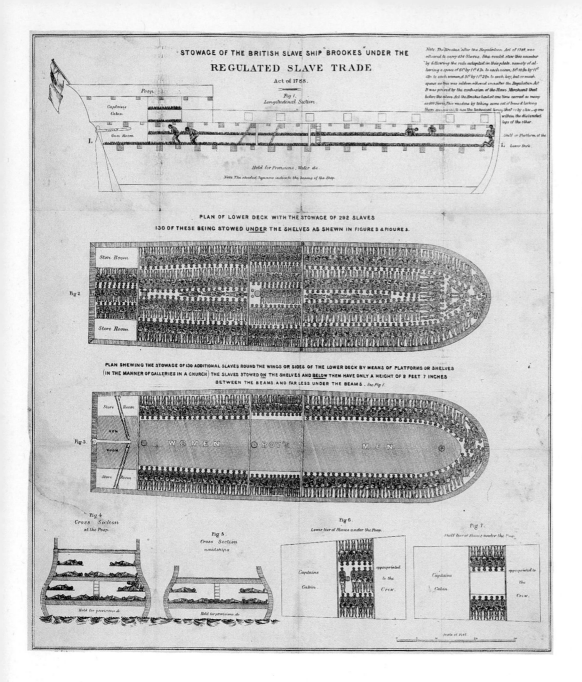

Figure 1: Longitudinal Section

STOWAGE OF THE BRITISH SLAVE SHIP "BROOKES" UNDER THE REGULATED SLAVE TRADE
Act of 1788.

PLAN OF LOWER DECK WITH THE STOWAGE OF 292 SLAVES
130 OF THESE BEING STOWED UNDER THE SHELVES AS SHEWN IN FIGURE B & FIGURE 5.

PLAN SHEWING THE STOWAGE OF 130 ADDITIONAL SLAVES ROUND THE WINGS OR SIDES OF THE LOWER DECK BY MEANS OF PLATFORMS OR SHELVES (IN THE MANNER OF GALLERIES IN A CHURCH) THE SLAVES STOWED ON THE SHELVES AND BELOW THEM HAVE ONLY A HEIGHT OF 2 FEET 7 INCHES BETWEEN THE BEAMS AND FAR LESS UNDER THE BEAMS. See Fig 1.

Stowage of the British Slave Ship "Brookes" Under the Regulated Slave Trade Act of 1788. Etching. London, c. 1790.

In order to accommodate the interests of both the northern and southern states, the Declaration of Independence and the Constitution ignored the questions of slavery and the slave trade. Slave ships like the notorious *Brookes* became floating coffins for many of the Africans kidnapped and sold for transport into slavery in North America and the West Indies. This deck plan of the vessel was issued under the auspices of British antislavery advocate Thomas Clarkson; it protested the leniency of the Act passed in 1788 to regulate the British slave trade. Under the Act, ships were permitted to sail with their human cargo packed in claustrophobic density. Carrying 454 slaves, the *Brookes* allowed 6' x 1'4" for each adult male; 5'10" x 11" for each woman; and 5' x 1'2" for each boy. Horrifying in its straightforward, almost clinical presentation of Middle Passage conditions, this became one of the most widely circulated items in the graphic arsenal of American abolitionists.

John Raphael Smith, after Joseph Wright. *The Widow of an Indian Chief.* Mezzotint. London, 1789.

Very little was done to resolve the "Indian question" within the new federal structure. The relationship between the tribes and the United States remained to be determined by a series of treaties, agreements, and judicial decisions that have continued to pile up for more than two centuries. America's view of its indigenous peoples became influenced by the Enlightenment philosopher Jean-Jacques Rousseau, who held that natural man, living apart from society, was inherently virtuous and unspoiled. This image of the "noble savage" underlies Smith's mezzotint of a Native American woman in mourning for her husband. Velvety tones underscore the romanticism of the image, whose composition has been traced to *The History of the American Indians,* published in 1775 by James Adair.

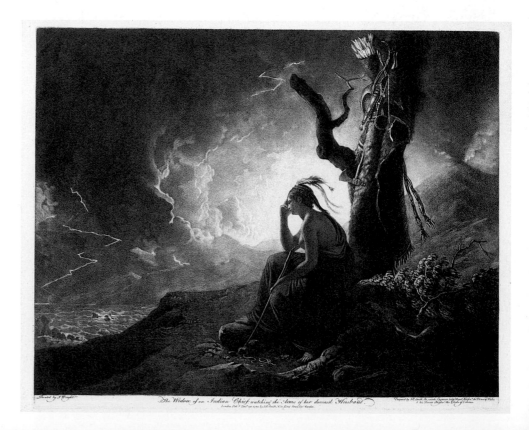

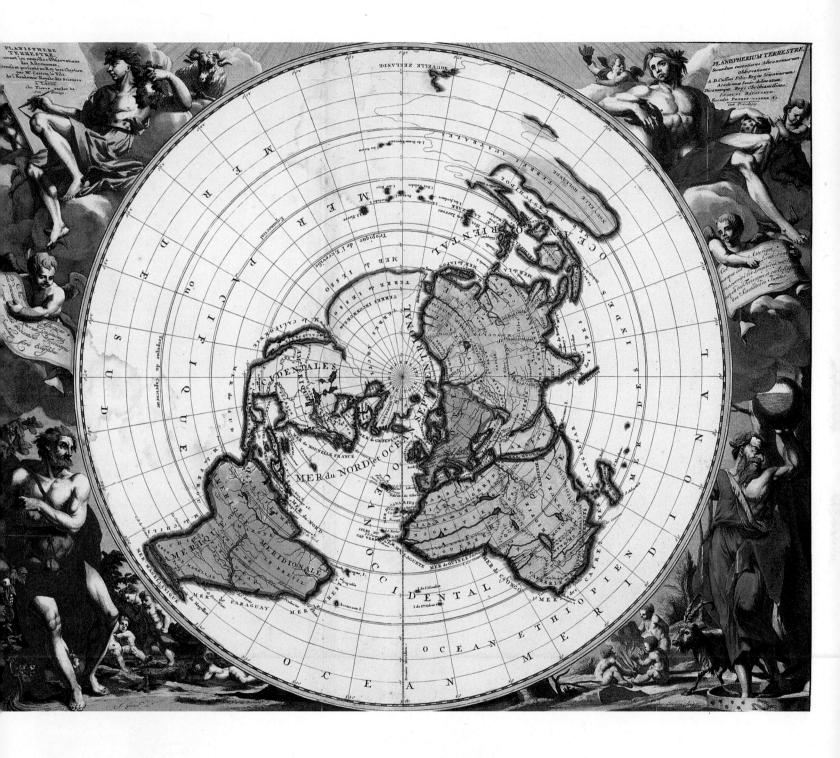

Pieter van der Aa. *Planisphere Terrestre.*
Hand-colored engraving from Reiner Ottens,
Atlas Maior, Vol. I. Amsterdam, 1729.
The Scientific Era no longer considered
Jerusalem the center of the earth. The global
perspective presented in this polar-oriented
projection indicates that by the end of the
eighteenth century Europeans had encom-
passed the world, exploring and colonizing

most of its inhabited portions (including
California, which was already known not to be
an island). Although this beautifully deco-
rated, circular world map was prepared by a
Dutch cartographer and later published in a
Dutch atlas, it is based on prolonged scientific
observations made at the French Academy of
Sciences during the 1670s and 1680s. A new
world order was definitely in place.

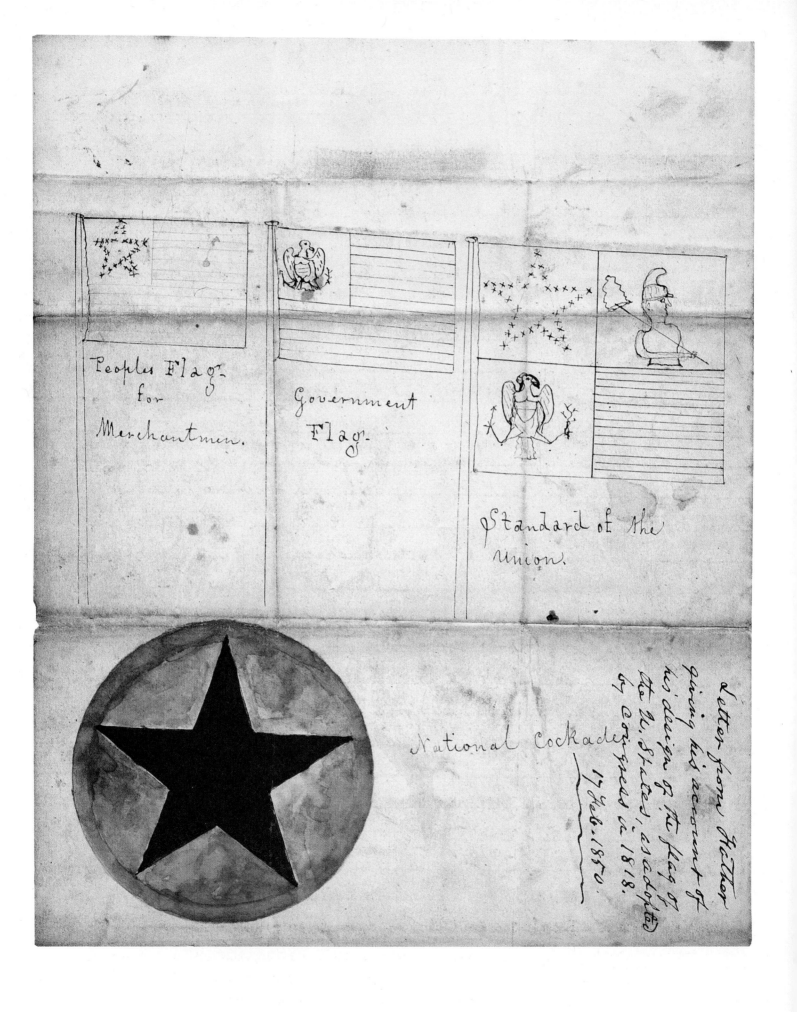

Peoples Flag.
for
Merchantmen.

Government
Flag.

Standard of the
Union.

National Cockade.

Letter from Hollow
giving his account of
his design of the flag of
the U. States, as adopted
by Congress in 1818.
17 Feb. 1850.

3

WESTWARD THE COURSE OF EMPIRE, 1800–1850

"Great joy in camp," William Clark wrote in November 1805, in the diary he and Meriwether Lewis kept of their famed expedition into the American West. "We are in view of the ocian (in the morning when the fog cleared off just below the last village, first on leaving this village, of Warkiacum) this great Pacific Ocean which we been so long anxious to see, and the roreing or noise made by the wave brakeing on the rockey shores (as I suppose) may be heard distinctly."

The Lewis and Clark expedition was one of the most fabled events of American history, in part because of the courage of the intrepid travelers forging their way across a vast and uncharted continent; but partly, too, because it tapped popular dreams of national grandeur. Lewis and Clark wrote exultantly of their first glimpses of sights "which had never yet been seen by civilized man" (even though Indian guides, Indian roads, and Indian villages had sustained them all along the way). In doing so, they were suggesting, to themselves and to others, that their own civilization—a civilization now well established along the eastern coast of the United States and already straining at its western boundaries—would expand across the continent and bend the land to its will.

The first half of the nineteenth century was indeed notable for the expansion and development of the new civilization of the United States. Thomas Jefferson, who purchased the great Louisiana territory and dispatched Lewis and Clark to explore it, became president in 1801 still promising to preserve the simple, agrarian character of the American republic. But Jefferson himself helped consign that dream to oblivion—not just by approving the Louisiana Purchase but by making his own passion for progress and improvement part of the spirit of his age.

Throughout the first decades of the century, white Americans pushed further and further into the continent's heart: into the fertile agricultural regions of the "Old Northwest" (now the Midwest) and the "Southwest" (now the lower regions of the Deep South), and gradually (although still in small numbers) beyond, into the Plains States, into California and Oregon, even into the semiarid regions of Oklahoma, Texas, New Mexico, and Arizona, which English-speaking Americans had previously dismissed as The Great American Desert. The nation's agriculture, once largely the means by which small farmers sought to feed and clothe themselves and their families, became increasingly a great commercial enterprise, sending wheat, corn, cotton, rice, sugar, timber, and other staples to coastal entrepôts and from there out into the world. To serve this vast new agricultural kingdom, the nation built a complex transportation system—turnpikes, canals, steamboats, and ultimately railroads—capable of bringing

crops and raw materials to market and taking finished goods back to the farms. The once-modest cities of the coasts, and the even more modest villages of the interior, grew rapidly to serve this growing commerce. Boston, Philadelphia, Baltimore, Charleston, and New Orleans; later St. Louis and Chicago; above all—once the Erie Canal connected it to the Great Lakes in 1821—New York: all became major centers of commerce. They also, gradually, became centers of industry as well.

The industrial revolution that swept across the nation in the middle third of the nineteenth century was relatively modest by the standards of the twentieth century, when the scale of manufacturing (and the corporate institutions that came to control it) became immense and overpowering. But the industrial growth of the early republic was rapid and substantial nevertheless. In the first years of the new republic, American manufacturing was so limited and so primitive that Alexander Hamilton felt it necessary to write plaintively, in his celebrated 1791 Report on Manufactures, of the advantages industry would provide the nation in response to those many "respectable patrons of opinions unfriendly to manufactures." By 1850, although some Americans remained unfriendly to industry, the growth of manufacturing was so firmly established that it was no longer possible to imagine the nation without it. Textile mills throughout New England were transforming cotton into finished goods. Shoe factories and glove factories were mass-producing their wares for a far-flung market. Iron and then steel mills were making the rails that permitted the great train routes to stretch across the continent. New technologies were emerging rapidly, transforming the processes of production. Great corporations were emerging, capable of amassing large sums of capital and investing it in still larger manufacturing enterprises.

Steadily, then, the great "untamed wilderness" that Lewis and Clark, among others, had so adventurously explored became the agricultural frontier of the expanding republic—peopled by farmers and merchants and teachers and clergymen and other agents of the new American civilization. Steadily, the cities and towns of the East became the centers of an increasingly advanced commercial and industrial economy. And steadily, too, many Americans began to see themselves as a great nation capable of rivaling the established powers of Europe. America, some now dreamed, would not be simply the new Athens, the seat of a noble democratic experiment. It might also become the new Rome.

The extent of the nation's aspirations—and the limits of its achievement of them—were especially clear in the character of the new capital under construction throughout the nineteenth century in the city of Washington, on the banks of the Potomac

John Lewis Krimmel. *Barroom Dancing.* Watercolor. Pennsylvania, 1820. The sons and daughters of German farmers on the Pennsylvania frontier often found their recreation in rural taverns and stagecoach waystations. A watercolor by the German-American genre painter John Lewis Krimmel portrays this practice, considered perfectly respectable even for ladies in country society. While the black fiddler, the flirting couple, and the coachman smoking a clay pipe are stock characters in Krimmel's works, the scene includes some telling and authentic details of rustic life: the almanac hanging on the tavern-keeper's stall at right, the flintlock over the door, and the patriotic prints of George Washington and of a War of 1812 naval encounter. The vast majority of German immigrants had some savings and belonged to family groups, or were single men to whom the western agricultural frontier was both accessible and attractive, as opposed to the Irish—the other largest group of newcomers—who were mostly penniless women requiring urban employment.

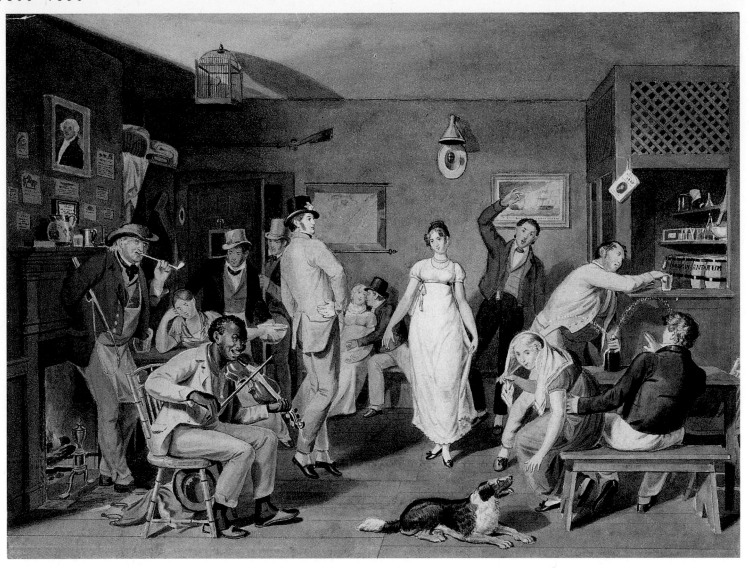

River between Maryland and Virginia. The formal plan for the city, created by the French urbanist Pierre L'Enfant and modeled after Paris, called for great boulevards and imposing public buildings, a city of nearly imperial splendor. The reality, for many years, was a humid, marshy, bedraggled village dotted with a few incongruously grand buildings—the White House, the Capitol, and several others; a city so raw and unfinished that few government officials actually lived there. Most rented rooms in boarding houses during the relatively brief terms of Congress and the courts, then returned to their homes as quickly as possible. But year by year, decade by decade, the city of Washington rose upward from its swampy site—never a city to rival Paris, London, Rome, or New York—but a steadily growing and ever grander testament to the nation's ambitions.

As a popular "Poem on the Rising Glory of America" had revealed even before the Revolution, Americans had long believed that their "happy land" was destined to become the "seat of empire" and the "final stage" of civilization, with "glorious works of high invention and of wond'rous art." The United States, another eighteenth-century writer had proclaimed, would serve as "the last and greatest theatre for the improvement of mankind." And as the nation grew and flourished in the first decade of the nineteenth century, it seemed to many Americans that they were actually fulfilling those exuberant predictions. John L. O'Sullivan, an influential Democratic editor and champion of national expansion, gave voice in 1845 to sentiments that many Americans by then shared—that the nation's claim to new territory "is by the right of our

manifest destiny to overspread and to possess the whole of the continent which Providence has given us for the development of the great experiment of liberty and federative self government entrusted to us. It is a right such as that of the tree to the space of air and earth suitable for the full expansion of its principle and destiny of growth."

<p style="text-align:center">*</p>

But the first half of the nineteenth century was not just a time of growth, progress, and development; not simply an age of national exuberance and "manifest destiny." It was also an age that revealed the many prices the nation had paid—and would continue to pay—for its dramatic progress. American territorial expansion came, as it always had, at the expense of the native peoples of the continent. In the 1830s white Americans had forcibly dislodged all but a few of the remaining Indians from the lands east of the Mississippi River to unoccupied and relatively infertile lands to the west, a process of removal so tragic for the tribes that they remembered their brutal westward journey to the arid lands to which they would henceforth be confined as the Trail of Tears.

Also in the 1830s the new factory system began to draw large numbers of immigrants—people deserting the countryside both in America and in Europe—into its often cruel embrace. Men, women, and children labored long, arduous hours for minimal wages to sustain the new industrial economy. Class divisions grew starker, and mistrust between old-stock Americans and the new immigrants from Ireland, Germany, and other nations grew more savage. A new political party—the so-called Know Nothings—emerged in the 1840s and gave voice to a rising anti-immigrant sentiment that would continue almost unbroken into the twentieth century.

The dramatic growth of the American economy created social and cultural dislocations almost everywhere, but nowhere more so than in the regions where development was most rapid. In the areas of upstate New York where the Erie Canal was being constructed in the 1820s, for example, the pressures of change produced a wide range of powerful religious revivals—revivals of such frequency and intensity that the region came to be known as the Burnt-Over District. Among the products of this religious ferment was Mormonism, whose founder, Joseph Smith, lived only miles from the rapidly lengthening canal before conceiving a new religion and leading his followers on a long, forlorn pilgrimage that would, after Smith himself was murdered, take them finally to Utah.

In American politics, the tension between the dream of a simple agrarian republic and the vision of a proud and growing nation—the tension that in the 1790s had created vicious battles between the followers of Jefferson and the followers of Hamilton—gave way to new battles over who would have the opportunity to share in the fruits of

The Tory Mill. Woodcut on green paper. [Hanover, New Hampshire, 1834–40.] An unidentified Whig humorist used the metaphor of a cider mill to portray the spoils system notorious under the Democrats, or Tories as they were labeled by their opponents. A uniformed Andrew Jackson works the crank of the mill, as young men urged on by Satan ascend its steps at left. Coins from the U.S. Treasury pour into the mill from above, and at right newly minted officeholders emerge, bearing various patronage plums. Jackson helped fix the spoils system firmly upon American politics.

"Experiment" was the derisive term applied by Jackson's critics to his redistribution among state banks of federal funds that had been held in a national, central bank until 1833. His victorious war against this monopoly was the most celebrated episode of his presidency. It reflected one of the cornerstones of the Jacksonian philosophy: that the key to democracy was an expansion of economic opportunity.

Opposite: Benjamin Henry Latrobe. Magnolia order, Gallery of the entrance of the Senate Chamber, north wing, United States Capitol. Drawing, graphite, ink, and watercolor. Washington, D.C., 1809.
The beginnings of a distinctly American architecture can be seen in this drawing by Latrobe for a short column in the gallery of the original Senate Chamber. The previous year, he had produced a design for the Library of Congress in the north wing of the Capitol, across the vestibule from the Senate Chamber, in an Egyptian Revival style that recalled the great Library of Alexandria, one of the wonders of the ancient world. The Egyptians modeled their columns after such native plants as papyrus and lotus. Inspired by this tradition, Latrobe chose three American plants for columns in the Capitol. The magnolia was selected for the original Senate chamber, which was destroyed when the Capitol was burned in 1814; corn for the entrance vestibule of the Senate wing and the old Supreme Court Chamber; and tobacco for the rebuilt vestibule in the Senate wing. The magnolia was the first American tree to be planted at the Royal Botanical Gardens at Kew in London in 1740.

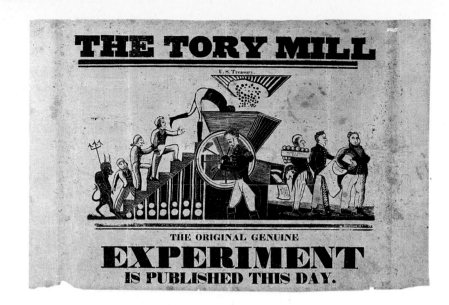

THE TORY MILL

THE ORIGINAL GENUINE
EXPERIMENT
IS PUBLISHED THIS DAY.

the new economy. In the late 1820s ambitious westerners joined forces with skilled artisans in eastern cities and aggressive planters in the burgeoning regions of the Deep South to repudiate the nation's established elite and raise to the presidency their own champion: Andrew Jackson, whom they claimed would inaugurate a new "era of the common man." Jackson did battle against the eastern establishment on many issues, most famously in his long and successful effort to destroy the powerful Bank of the United States. But his victory was less on behalf of the "common man" than on behalf of rising aristocrats of the newer regions of the country—men like himself who wanted the same access to power and wealth that the older aristocrats of the East had, they believed, long monopolized.

Twice in the first half of the nineteenth century, America's quest for national glory led to war. The continuing struggle to displace Indian tribes and make room for white settlement combined with a long-simmering naval rivalry with Great Britain to produce the War of 1812, which brought British troops once again into American territory. In August 1814 the British fleet sailed up the Potomac River and put a brigade of soldiers ashore near Washington. The Redcoats dispersed the frail militia defending the capital, marched into the city, and set fire to the Capitol, the White House, and other public buildings—revenge for the earlier burning by American troops of the Canadian capital city, York. The fleet then laid siege to the port of Baltimore. During a nighttime bombardment of the port's defenses, a young American lawyer, on board a British ship to try to win the release of an American prisoner, wrote his impressions of the battle on the back of an envelope: a poem he entitled "The Star-Spangled Banner" that was soon set to music and over a century later proclaimed the national anthem. The War of 1812 ended with no clear victor a few months later.

In 1846 the pressures for expansion and national self-assertion led to war again—this time against Mexico. Expansionists in the United States had spent several years agitating for a conflict that they hoped would add the Mexican territories of New Mexico and California to the United States. But the war they finally succeeded in provoking proved much more difficult than they had predicted, and highly unpopular. American forces eventually prevailed, and the United States finally annexed California and New Mexico. But the controversy over the war gave way to a much larger and ultimately more dangerous controversy over what to do with the new territories. In particular, it produced a great debate over slavery.

Of all those who paid a price for the rapid growth of the United States in the first half of the nineteenth century, none paid a higher one than the millions of African Americans living in bondage in the American South. In the first years of the century, many white Americans had begun to view slavery as a dying institution. In the North, slavery had been abolished very early in the life of the new nation. In the most populous area of the South, the Tidewater region, where once-fertile land was becoming exhausted, some found it possible to believe for a time that slavery had become archaic and unnecessary. But whatever doubts white Southerners had about the economic viability of what they called their "peculiar institution" vanished rapidly in the 1820s and 1830s as ambitious planters moved westward into the rich lands of Alabama, Mississippi, Louisiana, and other areas of the Southwest and created a booming new cotton economy.

The Cotton Kingdom, as it soon became known, emerged in part because of a single invention—Eli Whitney's cotton gin, which made it possible to remove seeds easily from the tough bolls of short-staple cotton grown in the black soil of the new plantations. It emerged, too, because of the energy, talent, and greed of a new generation of planters—many of whom rose from modest circumstances to great wealth in a generation or less. But most of all, it emerged because white Southerners had a plentiful labor force over which they could exercise near-total control. The rise of the Cotton Kingdom consolidated the grip of slavery on the South, revived the domestic slave trade, and inspired dreams among many Southern whites of extending their own civilization even further into the American continent—particularly into the new western lands the nation was acquiring.

Most white Southerners considered plantation slavery a benign, even a generous system, providing a secure and comfortable life for workers incapable of flourishing on their own. The writer John Pendleton Kennedy, for example, wrote in 1832 of the slaves he had seen on a Virginia plantation: "The air of contentment and good humor and kind family attachment, which was apparent throughout this little community, and the familiar relations existing between [the slaves] and the proprietor struck me very pleasantly. . . . I am quite sure [the Negro people] never could become a happier people than I find them here."

But to the African Americans themselves, the institution of slavery was notable above all for the absence of freedom—for the inability of slaves to change or challenge their conditions effectively, no matter how harsh they might be. Solomon Northrup, a free black kidnapped into slavery in Louisiana in the 1840s, wrote an account of his experiences in which he described the character of fieldwork in the cotton South:

Am I Not a Man and a Brother? Woodcut, with J[ohn] G[reenleaf] Whittier, *Our Countrymen in Chains!* Broadside. New York, 1837. The image circulated most widely by antislavery men and women in the United States was the supplicant slave, originally adopted as the seal of the Abolition Society of England. His appeal here to heaven and humanity is amplified in the verses of the Quaker poet and antislavery advocate, John Greenleaf Whittier:

What! mothers from their children riven!
What! God's own image bought and sold!
AMERICANS to market driven,
And bartered as the brute for gold!

Although the abolitionists were a small minority even in the North, they developed an extraordinarily sophisticated system for spreading their message, from antislavery fairs and festivals to a network of offices and reading rooms in various northern cities. Copies of this broadside with Whittier's verse were sold at the New York Anti-Slavery Office ("Two cents single; or $1.00 per hundred") and by mail through such abolitionist newspapers as the *Charter Oak* and William Lloyd Garrison's *Liberator*. But the opposing forces seemed for the time unbeatable. "What argument, what eloquence can avail," the philosopher Ralph Waldo Emerson asked Whittier, "against the power of that one word *niggers*? The man of the world annihilates the whole combined force of all the antislavery societies of the world by pronouncing it."

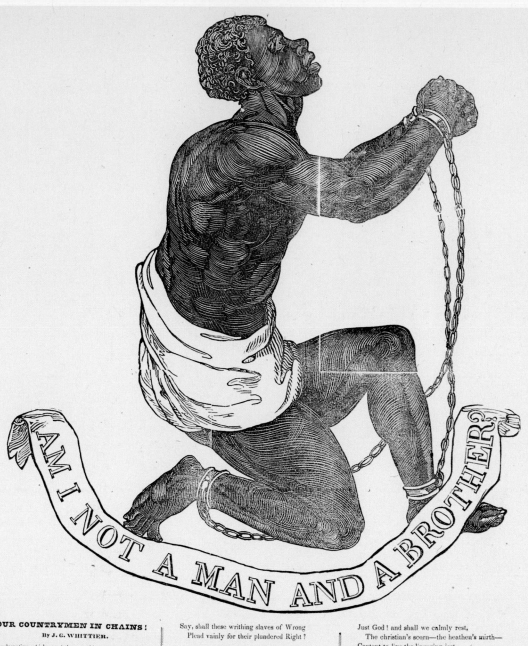

AM I NOT A MAN AND A BROTHER?

OUR COUNTRYMEN IN CHAINS!
By J. G. WHITTIER.

'The despotism which our fathers could not bear in their native country is expiring, and the sword of justice in her reformed hands has applied its exterminating edge to slavery. Shall the United States—the Free United States, which could not bear the bonds of a king, cradle the bondage which a king is abolishing? Shall a Republic be less free than a Monarchy? Shall we, in the vigor and buoyancy of our manhood, be less energetic in righteousness, than a kingdom in its age?'—*Dr. Follen's Address.*

Genius of America! Spirit of our free institutions—where art thou? How art thou fallen, oh Lucifer! son of the morning—how art thou fallen from Heaven! Hell from beneath is moved for thee, to meet thee at thy coming!—The kings of the earth cry out to thee, Aha! Aha!—ART THOU BECOME LIKE UNTO US?'—*Speech of Rev. S. J. May.*

OUR FELLOW COUNTRYMEN in CHAINS!
 SLAVES—in a land of light and law!—
SLAVES—crouching on the very plains
 Where rolled the storm of Freedom's war!
A groan from Eutaw's haunted wood—
 A wail where Camden's martyrs fell—
By every shrine of patriot blood,
 From Moultrie's wall and Jasper's well!

By storied hill and hallowed grot,
 By mossy wood and marshy glen,
Whence rang of old the rifle shot,
 And hurrying shout of Marion's men!—
The groan of breaking hearts is there—
 The falling lash—the fetter's clank!—
SLAVES—SLAVES are breathing in that air
 Which old De Kalb and Sumpter drank!

What, ho!—*our* countrymen in chains!—
 The whip on WOMAN's shrinking flesh!
Our soil yet reddening with the stains,
 Caught from her scourging, warm and fresh!
What! mothers from their children riven!—
 What! God's own image bought and sold!—
AMERICANS to market driven,
 And bartered as the brute for gold!

Speak!—shall their agony of prayer
 Come thrilling to our hearts in vain!
To us—whose fathers scorned to bear
 The paltry *menace* of a chain;—
To us whose boast is loud and long
 Of holy liberty and light—

Say, shall these writhing slaves of Wrong
 Plead vainly for their plundered Right?

What!—shall we send, with lavish breath,
 Our sympathies across the wave,
Where manhood on the field of death
 Strikes for his freedom, or a grave?—
Shall prayers go up—and hymns be sung
 For Greece, the Moslem fetter spurning—
And millions hail with pen and tongue
 Our light on all her altars burning?

Shall Belgium feel, and gallant France,
 By Vendome's pile and Schoenbrun's wall,
And Poland, gasping on her lance,
 The impulse of our cheering call?
And shall the SLAVE, beneath our eye,
 Clank o'er *our* fields his hateful chain?
And toss his fettered arm on high,
 And groan for freedom's gift, in vain?

Oh say, shall Prussia's banner be
 A refuge for the stricken slave;—
And shall the Russian serf go free
 By Baikal's lake and Neva's wave;—
And shall the wintry-bosomed Dane
 Relax the iron hand of pride,
And bid his bondmen cast the chain
 From fettered soul and limb, aside?

Shall every flap of England's flag*
 Proclaim that all around are free,
From 'farthest Ind' to each blue crag
 That beetles o'er the Western Sea?
And shall we scoff at Europe's kings,
 When Freedom's fire is dim with us,
And round our country's altar clings
 The damning shade of Slavery's curse?

Go—let us ask of Constantine
 To loose his grasp on Poland's throat—
And beg the lord of Mahmoud's line
 To spare the struggling Suliote.
Will not the scorching answer come
 From turbaned Turk, and fiery Russ—
'Go, loose your fettered slaves at home,
 Then turn and ask the like of us!'

Just God! and shall we calmly rest,
 The christian's scorn—the heathen's mirth—
Content to live the lingering jest
 And by-word of a mocking earth?
Shall our own glorious land retain
 That curse which Europe scorns to bear?
Shall our own brethren drag the chain
 Which not even Russia's menials wear?

Up, then, in Freedom's manly part,
 From gray-beard eld to fiery youth,
And on the nation's naked heart
 Scatter the living coals of Truth.
Up—while ye slumber, deeper yet
 The shadow of our fame is growing—
Up—While ye pause, our sun may set
 In blood, around our altars flowing!

Oh rouse ye—ere the storm comes forth—
 The gathered wrath of God and man—
Like that which wasted Egypt's earth,
 When hail and fire above it ran.
Hear ye no warnings in the air?
 Feel ye no earthquake underneath?
Up—up—why will ye slumber where
 The sleeper only wakes in death?

Up now for Freedom!—not in strife
 Like that your sterner fathers saw
The awful waste of human life—
 The glory and the guilt of war:
But break the chain—the yoke remove
 And smite to earth oppression's rod,
With those' mild arms of Truth and Love,
 Made mighty through the living God!

Prone let the shrine of Moloch sink,
 And leave no traces where it stood
Nor longer let its idol drink
 His daily cup of human blood:
But rear another altar there,
 To truth and love and mercy given,
And Freedom's gift and Freedom's prayer
 Shall call an answer down from Heaven!

He that stealeth a man and selleth him, or if he be found in his hand, he shall surely be put to death. Exod. xxi. 16.
* ENGLAND has 800,000 Slaves, and she has made them FREE. America has 2,250,000!—and she HOLDS THEM FAST!!!

Sold at the Anti-Slavery Office, 144 Nassau Street. Price TWO CENTS Single; or $1.00 per hundred.

When a new hand, one unaccustomed to the business, is sent for the first time into the field, he is whipped up smartly, and made for that day to pick as fast as he can possibly. At night it is weighed, so that his capability in cotton picking is known. He must bring in the same weight each night following . . . [or] a greater or less number of lashes is the penalty.

The growth of the slave system troubled many white Americans outside the South. Some felt moral revulsion and joined the rapidly expanding abolitionist movement, whose zealous leader, William Lloyd Garrison, preached an uncompromising opposition to slavery whatever the cost. "Look at the slave," the abolitionist Theodore Dwight Weld wrote in 1839, "his condition but little, if at all, better than that of the brute; chained down by the law, and the will of his master; and every avenue closed against relief . . . —must not humanity let its voice be heard?" Other Northern whites opposed slavery not because of its effects on the slaves, but because of what they feared might be its effects on them. If the South succeeded in its avowed aim of extending slavery into new territories, what opportunities would there be for free white laborers there? How could America remain a fluid society, in which every free individual would have a chance to advance? The plantation elite—the "slavocracy," as some Northerners began to call it—was a threat to the freedom not just of blacks, but also of whites.

By the late 1840s the issue of slavery was moving to the center of American social and political life. New territories in the West were beginning to clamor for admission to the Union: Nebraska, Kansas, Oregon, California (suddenly booming as vast numbers of new settlers flooded into the territory after the discovery of gold in 1848), and others. But leaders from the North and the South were drawing sharp lines about the status of slavery in these new regions.

In 1820, in the midst of a bitter debate over whether to permit slavery in the newly organized territory of Missouri, Speaker of the House Henry Clay had steered a bill through Congress that many hoped would settle the issue forever. It became known as the Missouri Compromise. All land in the area of the Louisiana Purchase north of the southern boundary of Missouri would be considered "free" territory; all land south of that boundary would be open to slavery. Clay's "great compromise" kept the issue of slavery relatively contained for nearly three decades. But the spirit of compromise was fading in the face of rapid national expansion in the 1840s; and by the end of the decade new voices were emerging—harsher, less conciliatory, more singleminded of purpose—demanding a reconsideration of slavery's future. The white South, fearful that it would soon be outnumbered and overshadowed by the briskly developing

North, was becoming ever more committed to its labor system, ever more convinced that it was not only efficient but just and that no impediments should stand in the way of its expansion. The white North, convinced by its dramatic growth that its own labor system must become the model for the nation, was becoming increasingly hostile to slavery in any form and adamantly opposed to its expansion. And abolitionists, black and white, argued heatedly for the immorality of slavery—angering many of their fellow Northerners, who were uncomfortable with their radicalism, and frightening many white Southerners, who feared that the abolitionists were speaking for a larger portion of Northern opinion than in fact they were.

<p align="center">*</p>

Through much of the first half of the nineteenth century, a vigorous nationalism seemed to dominate the life of the United States. Every year on the Fourth of July, joyous celebrations commemorated the birth of American independence and reinforced the sense of nationhood that the Revolution had helped produce. When the Marquis de Lafayette, the French general who had aided the United States during the Revolution, traveled through the country in 1824, cheering, frenzied crowds greeted him everywhere he went—North, South, and West—expressing a shared pride in America's history and its ideals. And on July 4, 1826—the fiftieth anniversary of the adoption of the Declaration of Independence—an event transpired that seemed to many Americans to confirm that the United States had a special destiny in history. For on that notable day, two of the greatest of the country's founders and former presidents—Thomas Jefferson, author of the Declaration, and John Adams, "its ablest advocate and defender" (as Jefferson had said)—died within hours of each other. Jefferson's last words, those at his bedside reported, were "Is it the Fourth?" And Adams comforted himself and those around him moments before his death by saying, "Thomas Jefferson still survives."

Widely shared sentiments of nationhood, what Abraham Lincoln later called "mystic chords of memory," steered the United States through a period of remarkable growth and progress. But they could not forever obscure the profound injustices on which much of that growth and progress had rested, or the deep divisions they were creating. The United States at midcentury was standing on the brink of the most turbulent era in its history—staring, even if largely unaware, into an abyss of acrimony and war that would both shatter and redeem the nation.

<p align="center">* * *</p>

Thomas Jefferson. Design for a Mouldboard Plow. Drawing, pen and ink. Charlottesville, Virginia, c. 1790.
Jefferson's detailed plan of the mouldboard plow reflects the practical, agricultural interests of the Virginia planter and author of the Declaration of Independence. His plow sup-

planted the essentially medieval method of tilling the soil by hoe, and allowed cultivation of hilly terrain in regions like his native Piedmont. The design was the result of extensive consultation with other scientific farmers and field tests by his own overseers and slaves, as well as by those of his son-in-law, Thomas

Mann Randolph, Jr. In the early nineteenth century the plow became the symbol of the ascendant Republican faction in American politics. Led by Jefferson and Madison, the Republicans envisioned a primarily agrarian American society under the jurisdiction of a modest central government.

John Fitch. *A Draft of our Present Air Pump and Condenser 1792*. Drawing, pen and ink. Philadelphia.
Opposing the Republicans during our nation's early years were the Federalists, led by Washington and Alexander Hamilton. They envisioned a more urban society with a strong central government, founded upon commerce, manufacturing, and technology. This steam engine, sketched in embryonic form by John Fitch, was the virtual heart of their society. It eventually powered the mills and moved the ships and locomotives of the young nation.

In 1787 Fitch had built the first successful steam-powered vessel in America and given free rides to delegates to the Constitutional Convention. By 1790, he was operating a ferry between Burlington and Trenton, New Jersey, but passengers were few because the stagecoach was faster and the sailboats cheaper. This later drawing details what is usually called an atmospheric steam engine, in which boiling water expands explosively into steam and then condenses back into water to create a vacuum. Although Fitch built several improved versions (like this one) of his first steam engine, they were all large, ungainly mechanisms operating with low pressure and very little power.

Christopher Colles. *From Annapolis (65) to Alexandria*. Engraving from Colles, *A Survey of the Roads of the United States of America.* New York, 1789.

Irish-born engineer and surveyor Christopher Colles created what is considered the first road map or guide book to the burgeoning transportation network uniting the new nation. Using a format familiar to modern travelers, he made each plate with two to three strip maps arranged side by side, covering approximately twelve miles. Publication began in 1789 on a subscription basis, with advertisements promising a total of one hundred maps. By 1792, however, having received relatively few subscriptions, Colles brought the project to an end with only eighty-three plates covering approximately one thousand miles from Albany, New York, through New York City, Philadelphia, Wilmington, Baltimore, and Alexandria to Yorktown and Williamsburg, Virginia.

Colles's guide focused on the major north-south artery through the middle states, a route comparable in part to today's U.S. Route 1 and Interstate 95. This page illustrates a portion of the road paralleling the Potomac River from Georgetown, Maryland, to Alexandria, Virginia, an area that would eventually be set aside for the nation's capital. His prospectus for the project touted its practical value: "A traveller will here find so plain and circumstantial a description of the road, that whilst he has the draft with him it will be impossible for him to miss his way; . . . [and] if his horse should want a shoe, or his carriage be broke, he will by the bare inspection of the draft be able to determine where he must go backward or forward to a blacksmith's shop."

Colles was a creative but restless individual, and none of his many projects brought him wealth. He had eleven children, one of whom, Eliza, assisted on his various atlas projects; she, most likely, qualifies as the first American female map engraver.

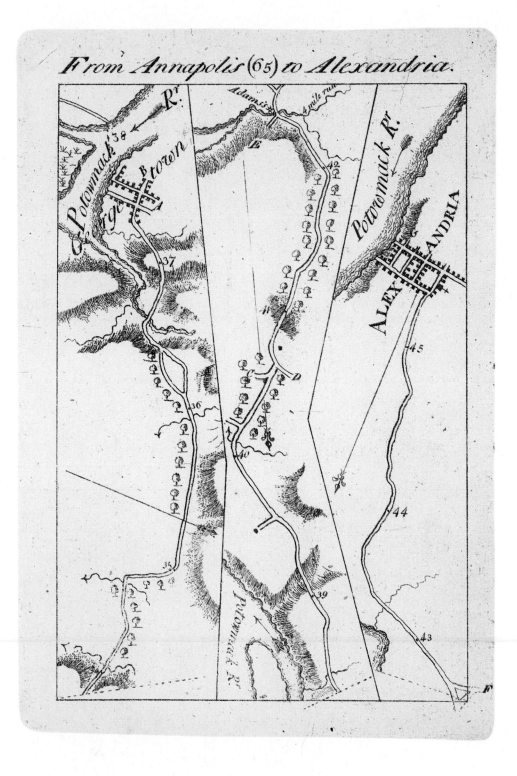

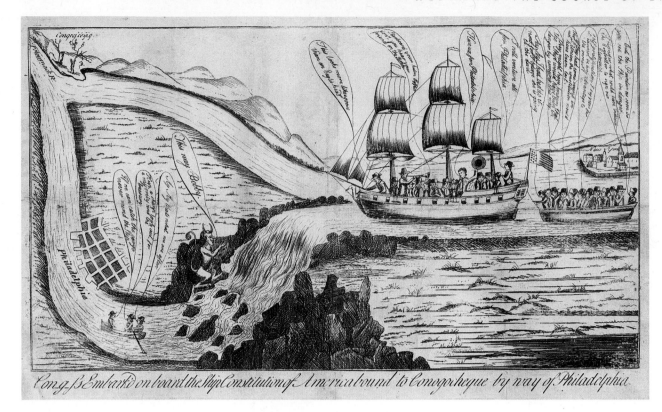

Cong_ss Embark'd on board the Ship Constitution of America. Etching. [New York?], 1790.
The decision to move the nation's capital south from New York to Conogocheque, a creek that empties into the Potomac, inspired an unidentified satirist (probably a disgruntled New Yorker) to issue this crude commentary on the intrigues surrounding the move—undertaken to appease Virginia—and the opportunity for Philadelphians to profit by the capital's temporary relocation to their city. A devil lures the Ship of State toward the lower fork in the river, which falls precipitously in a rocky cataract. Below, three men in a dinghy await the prize and comment: "If we can catch the cargo never mind the Ship," and "Keep a sharp look out for a majority and the treasury."

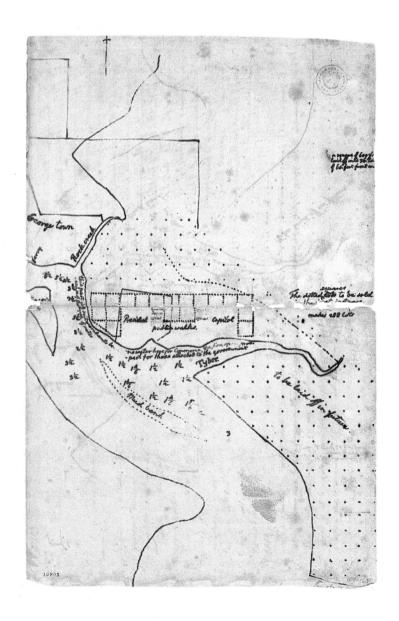

Thomas Jefferson. Plan for the city of Washington. Drawing, pen and ink (press copy). [Philadelphia], c. March 1791.
Jefferson drew this layout for the new capital city during the early stages of planning. As Secretary of State, he was deeply involved in the relocation of the national government to the District of Columbia.

In 1823 Jefferson wrote that it was "the duty of every good citizen to use all the opportunities, which occur to him, for preserving documents relating to the history of our country."

Benjamin Henry Latrobe. Looking glass frame, President's House. Elevation drawing, graphite, ink, and watercolor. Washington, D.C., 1809. Immediately upon occupying the White House, President and Mrs. James Madison enlisted Latrobe to design an elegant suite of reception rooms. Boldly executed in the latest Grecian style, the rooms were completed in December 1809 and changed forever the char-acter of presidential entertainment. Latrobe wrote: "Mr. Jefferson is a man out of a book. Mr. Madison is more a man of the world." The interiors and most of their furnishings were destroyed by invading British troops in 1814, only hours after Dolley Madison fled the city in her carriage with important government papers and the velvet window curtains that Latrobe had designed.

Benjamin Henry Latrobe. *View of the East Front of the President's House [White House] with the addition of the North and South Porticos.* Drawing, graphite, ink, and watercolor. Washington, D.C., 1807.
Jefferson appointed Latrobe "Surveyor of the Public Buildings," which included the Capitol and the White House. A brilliant designer and consummate draftsman, Latrobe is considered the father of both the architectural and engineering professions in the United States. In this drawing, he proposes the sophisticated transformation of the White House from the simple rectangular block erected by James Hoban, the previous Surveyor, to the porti-coed building we know today.

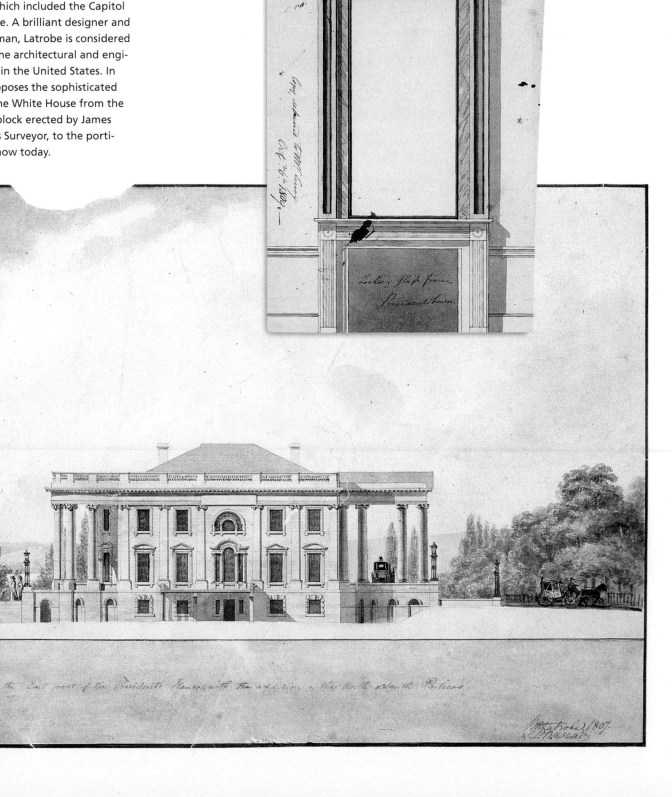

THE GERRY-MANDER.

A new species of *Monster*, which appeared in *Essex South District* in Jan. 1812.

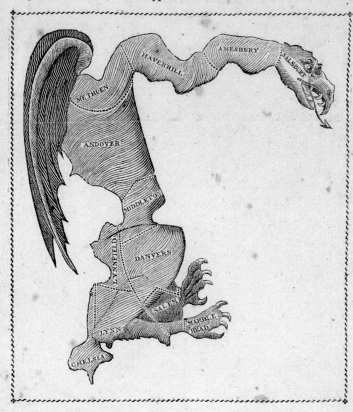

" O generation of VIPERS *! who hath warned you of the wrath to come ?"*

THE horrid Monster of which this drawing is a correct representation, appeared in the County of Essex, during the last session of the Legislature. Various and manifold have been the speculations and conjectures, among learned naturalists respecting the *genus* and origin of this astonishing production. Some believe it to be the real *Basilisk*, a creature which had been supposed to exist only in the poet's imagination. Others pronounce it the *Serpens Monocephalus* of Pliny, or single-headed *Hydra*, a terrible animal of pagan extraction. Many are of opinion that it is the *Griffin* or *Hippogrif* of romance, which flourished in the dark ages, and has come hither to assist the knight of the rueful countenance in restoring that gloomy period of ignorance, fiction and imposition. Some think it the great Red Dragon, or Bunyun's *Apollyon* or the *Monsirum Horrendum* of Virgil, and all believe it a creature of infernal origin, both from its aspect, and from the circumstance of its birth.

But the learned Doctor Watergruel who is famous for peeping under the skirts of nature, has decided that it belongs to the *Salamander* tribe, and gives many plausible reasons for this opinion He says though the Devil himself must undoubtedly have been concerned, either directly or indirectly in the procreation of this monster, yet many powerful causes must have concurred to give it existence, amongst which must be reckoned the present combustible and venomous state of affairs. There have been, (says the Doctor) many fiery ebullitions of party spirit, many explosions of democratic wrath and fulminations of gubernatorial vengeance within the year past, which would naturally produce an uncommon degree of inflammation and acrimony in the body politic. But as the Salamander cannot be generated except in the most potent degree of heat, he thinks these malignant causes, could not alone have produced such diabolical effects. He therefore ascribes the real birth and material existence of this monster, in all its horrors, to the alarm which his Excellency the Governor and his friends experienced last season, while they were under the influence of the Dog-star and the Comet—and while his Excellency was pregnant with his last speech, his libellous message, and a numerous litter of new judges and other animals, of which he has since been happily delivered. This fright and purtarbation was occasioned by an incendiary letter threatening him with fire-brands, arrows and death : (if his proclamation is to be credited) which was sent to him by some mischievous wight, probably some rogue of his own party, to try the strength of his Excellency's mind. Now his Excellency being somewhat like a tinder-horn, and his party very liable to take fire, they must of course have been thrown into a most fearful panic, extremely dangerous to persons in their situation, and calculated to produce the most disastrous effects upon their unborn progeny.

From these premises the sagacious Doctor most solemnly avers there can be no doubt that this monster is a genuine Salamander, though by no means perfect in all its members ; a circumstance however which goes far to prove its illegitimacy But as this creature has been engendered and brought forth under the sublimest auspices, he proposes that a name should be given to it, expressive of its genus, at the same time conveying an elegant and very appropriate compliment to his Excellency the Governor, who is known to be the zealous patron and promoter of whatever is new, astonishing and erratic, especially of domestic growth and manufacture. For these reasons and other valuable considerations, the Doctor has decreed that this monster shall be denominated a *Gerry-mander*, a name that must exceedingly gratify the parental bosom of our worthy Chief Magistrate, and prove so highly flattering to his ambition, that the Doctor may confidently expect in return for his ingenuity and fidelity, some benefits a little more substantial than the common reward of virtue.

That astute naturalist Lucricostus however in the 26th section of his invaluable notes upon the Salamander, clearly shews that this word is a corruption of the Latin Salimania, expressing the characteristic dislike and almost hydrophobic antipathy of that animal for sea salt : " Oweinge (to use the words of the author) to the properties and virtues of the sayde " mineralle, as is well knowen to moste folke, in dampeinge the heate of that elemente of fyre, wherein the sayde beaste " doth abide, so that if a piece of salt, or any marine thinge be placed neare it, it dothe fret it sorely, and enrage it to such " madnesse that it dothe incontinently throw from its mouthe a venomous spittle, which dothe tarnishe and destroy all that " is of worth or value that it fallethe upon. A further and most manyfest proofe of which deadlie hatred appearethe in " that, whereas, on and neare the renouned salt mountayne, so called, amydst alle the marvells and wonders with which " it dothe abounde, not any of this Lizarde species hath been discoverable thereyne." We therefore propose, with the utmost deference to the ingenious Doctor's opinion, that the term *Gerry-mania* be substituted for Gerry-mander, as highly descriptive both of the singular ferocity of the monster in question, and the influence which the moon at certain periods, more especially on the approach of April, is supposed to exert over it.

A friend of ours has further suggested that there is a peculiar felicity at the present time in adopting the term Gerry-mania, as according to his definition, Gerry is derived from the French Guerre, or the Italian, Guerra, (war) and that it therefore possesses the double advantage of expressing the characteristic ferocity of this monster, and that magnanimous rage for war which seems to have taken such possession of our worthy Chief Magistrate and his friends. But we mention this merely as an ingenious speculation, being well convinced ourselves, notwithstanding appearances, of the truly pacific sentiments of that great man, whose *mild* and *charitable* denunciations of his political opponents have had such a wonderful effect in convincing their reason, allaying the spirit of party, and in reconciling all conflicting opinions.

Elkanah Tisdale. *The Gerry-mander.* Woodcut. Broadside. Salem, Massachusetts, January, 1812.

The engraver is credited with creating one of the most famous images in American political history by adding fangs, wings, and claws to a map of the new voting districts in Essex County, Massachusetts, where county lines were redrawn solely to assure Republican dominance over Federalists in the state senate. The term is a hybrid of "salamander" and the last name of the governor, Elbridge Gerry, who forced the partisan bill through the Massachusetts legislature. The word has come to describe any arbitrary redistricting for political purposes—a common practice in American electoral politics ever since.

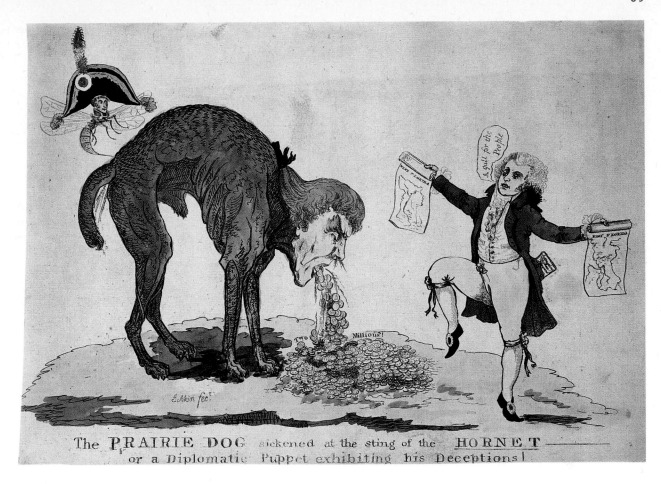

The PRAIRIE DOG sickened at the sting of the HORNET —
or a Diplomatic Puppet exhibiting his Deceptions!

James Akin. *The Prairie Dog sickened at the sting of the Hornet.* Etching with watercolor. [Newburyport, Massachusetts, c. 1804.] In Akin's earliest-known signed cartoon, the scrawny prairie dog is Thomas Jefferson, stung into coughing up "Two Millions" in gold coins by a hornet with the head of Napoléon Bonaparte, who had sold the entire Louisiana Territory to the United States in 1803. The artist reflects public indignation over the revelation that the president had sought a secret appropriation from Congress for covert negotiations to purchase the West Florida territory from Spain in 1804, which Jefferson's critics feared could lead indirectly to war with Britain. A negative portrayal of Jefferson like this one is not common.

Robert Fulton. Sighting mechanism for the "plunging boat" or submarine. Drawing, graphite, ink, and watercolor. [London],1806. French emperor Napoléon Bonaparte subsidized American inventor Robert Fulton's development of the first practical submarine. Successful tests of the *Nautilus* were carried out at the port of Le Havre in the winter of 1800–01, when Fulton and three mechanics descended to a depth of twenty-five feet. The machine later destroyed a heavy brig in trials for the interested British near Deal, England, in 1804. Fulton returned to the United States in 1806, the same year this drawing was made, and in August of 1807 his commercially viable steamboat *Clermont* made her famous voyage from New York to Albany, opening new chapters in human transportation, commerce, and warfare.

HIEROGLYPHICS of John Bull's overthrow:

DOLL, the Landlady. Split-Foot. Bonapart. John Bull.

Kill him Bona, kill him, 'tis what we're all after. *Drive the business Split-foot, it's an ill wind that blows nobody down.*

Doll, we'll win any way. *Kill him Bona, I want to smoke him eternally.*

Johnny, Master's coming. *You old tyrant, I'll hew you to pieces before my Master.*

You little Corsican Sergeant, I'll put you into my snuff-box.

Since money is plenty and millions are lending,
If I get a few shillings pray don't be offended,
I love to see soldiers repair to the northward,
And teamsters transporting their stores from the southward.
There's good pay by the month, and abundance of rations,
Which keeps up the money in good circulation,
I have excellent rum, wont you come in and smoke?
(Now this is put in for to humor the joke.)

Since Cain was a boy I've delighted in fighting,
And to further the business my scribes are now writing,
And since we've got Bona & Johnny together,
I want he'd do with him as Cain with his brother:
For since he's got old, he is not worth keeping,
And I want him below, where I'll keep him from sleeping;
Then add this new service unto the old score,
And I'll pay altogether when time is no more.

My name it is Bona, the terror of nations,
Give Quebec up to James, or I'll hew you to pieces,
This makes me to laugh like a man that is frantic,
For then I'll be able to cross the Atlantic.
If uncle Sam needs, I'd be glad to assist him,
For it makes my heart bleed we live at such a distance,
If he calls me to Quebec, I'll lead on the van,
And for Johnny Bull we'll not leave him a man.

My name is John Bull, it strikes Bona thunder,
If I meet with old Rodgers, I'll make him wonder,
He talks of his ship being swift in her mot
But I'll let him know I am king on the oc
My old British subjects who claim his protec
I want to take home to the house of correc
If the right to search him is the question in
I'll stick to that text while my name is JO. BULL,

ON GOVERNMENTS.

From the creation of the world, down to the flood, including a term of 1656 years, and for several generations following, there was no civil government among men, which we have any account of, except *patriarchal;* which consisted in the authority that the head of a family had over his dependants. Consequently about one third part of the world's age ran down without any government, which the other two thirds have made such a bustle about.

Nimrod the great grandson of Noah, had more ambition and address than his cotemporaries, by which means he established a supremacy over them. He was a mighty hunter before the Lord. He hunted men and reduced them to his will; and by force and fraud, turned the mild patriarchal governments into a consolidated, energetic *monarchy,* and fixed his emporium at Babylon, several years before a like government was founded in Egypt.

On the first introduction of monarchy, the spirit ran with such velocity, that a king was found in almost every village. Joshua destroyed above 30 of them; and Adonibezek cut off the thumbs and great toes of 70 more.

In the midst of this rage for empireal dignity, the Almighty God set up a government on earth, over the Israelites, unlike all which had been on earth before.

This government we call a *Theocracy,* because God *(Theo)* was the sole founder of it. This government was founded in the 25th century, and was an *ecclesiastica political* institution. The subjects of this government received all their laws, both civil and religious, directly from God. The Israelites, however, by their apostacy, had their *Theocracy* turned into a qualified monarchy: next split and formed two kingdoms: and after passing thro' many changes, were driven from their land, and became extinct, as a body politic, about 1600 years after this establishment. It is nevertheless concluded that 8 millions of their descendants are still in existence, in the various parts of the world. And some also suppose that the *ten tribes* are yet existing in some unknown parts of the earth.

While the Israelites were passing thro' their various changes, other nations were not idle. As far as the cruelty of monarchs—the fraud of demagogues—the din of war—and other evils would admit of, the nations were laboring to find out that *scheme* of government, which would give legislators and magistrates power enough to *do good,* and yet have the power so counterpoised, that those in the possession of it could *do no harm.* For this purpose, monarchies, aristocracies and republics were all put to the experiment, and passed thro' their rises, advances, full glories, declines & overthrows.

From the destruction of *Troy,* a few fugitives, with *Eneas* at their head, fled to Tiburn, and laid the foundation of that government, (Rome) which, in time, gave law to the world. The Chaldean, Medo-Persian, and Grecian empires, one after another became prostrate, and Rome (having passed thro' six or seven changes in her form of government) rose to the summit of empireal dignity, with Augustus Cæsar at her head; in whose reign the *Hebrew Boy* was born, who was to rule all nations. *In the days of those kings, the God of heaven set up a kingdom, which will stand for ever.*

Let the kingdom of Christ be called a *Christocracy,* which is radically different in its structure from the governments that ever were on earth.

The laws of Christ extend to the heart and take cognizance of every mental exercise. The laws of state do not.

The government of Christ admits of the sufferings of an innocent person for the guilty. Not so with other governments.

In the Christocracy, the resurrection of the dead and the forgiveness of sins, are discovered and secured; which philosophy and state policy could never bring to view.

In this divine government (thro' a vicarious atonement) the penitential criminal is pardoned, while the impenitent is punished. Quite otherwise with the laws of men.

The kingdom of Christ is not bounded by territorial limits—oceans—or lines of latitude—but it includes all the pious saints in all parts of the world; who, nevertheless, are not freed from their allegiance to the respective governments where they reside; but are under obligation to all the just laws thereof, and exposed to all their penalties, if they transgress.

On the ascension of Christ, he left some authority with his disciples, to exercise among themselves; which extends no farther than a declaration of *who* and *what* they fellowship, and *who* and *what* they do not.— He has not left any power among the saints to *impose fines* or *inflict corporeal punishments* on any man, though the most abandoned. The claim of the Pope, therefore, and of all diocefon or other religious courts, to dethrone kings or punish heretics, is criminal usurpation.

JOHN BULL in a pe

I cannot get these impud Yankees out of my head.—— The Guerrier gone! The Ma donian taken! The Java funk The Frolic and Peacock both f to Davy Jones's locker! It is p all endurance! What! a fet of lows that do not own in the wh world one single ship of the line, brave and defy my whole navy! take three of my best frigates in pen fight, and trounce me with more ceremony forsooth, than were a Dutchman or a Spania A set of fellows too, that I had aff ted to despise as beneath my notic " whose affembled navies could lay siege to a single sloop of war." those seamen about which they m so much clamour, have broken ice, and I am afraid I shall be fc to the bottom. I have made th feel their strength already, and shrewdly suspect that they will m me feel it in all my bones. And th there are your French and your R fians; they too will profit by example, and learn to despise vaunted superiority... Oh! tha could hear of a single vessel of min taking one of the Yankees on a thing like equal terms. The we of their frigates would be an acc table offering. It would be " *most grateful service*" which captain " can render to the service I would certainly knight him for spendid achievement.

View of the Northern Expedition in Miniature.

mes War. Tom Patriot. John Adams. John Rogers:

Bona, I'll ada.

Here comes No. 1. Let me at him Bona & I'll take him down

Kill him Bona, & I'll pay all damages.

Let me at him Bona, and I'll blow him to atoms.

Columbia, to glory arise,
o the north, make Canada a prize,
ine to command, it is your's to obey,
nds make ready to seize on the prey.
r to the northward, sick close by the

too far in those northerly climes,
inter sets in, to Greenbush we'll

our long pipes by the side of the

Starvation's the fate of the British empire,
My destructive machine will soon make them
 expire,
Methinks I will make them come under my
 thumb,
With my little bark that mounts only one gun,
I will bring them to terms by the force of this
 measure,
Then we'll go abroad & return home at pleasure,
We'll sail to sweet France, & in ev'ry direction,
And no British tyrant demand our protection.

My name is Taxation—in my introduction,
Some people I vext, to prevent their destruction,
Had I in the place of some others been sitting,
I'd built me a navy to cope with Great Britain.
But now I'm retir'd, sees the states in a bustle,
And all I'm afraid, paid too dear for the whistle,
One caution I'd give you before that I leave
 you,
I'd send Barlow to Bona, and borrow a navy.

My fleet to John Bull no true homage will pay,
Though his orders in council forever should
 stay;
He talks of a right for to search for his slaves,
Before I grant that I shall sink in the waves:
He had better be silent and send me no threat,
Les I catch his fish in my old yankee net,
He builds on the Indians that's now with him
 join'd,
But if Uncle Sam lives, they will all be Bur-
 goyn'd.

BATTLE OF QUEENSTOWN.

ALO, October 20. 1812.
esday morning last, just be
light, in conformity to pre-
rangements, Colonel Solo-
in Renfselaer, aid-de-camp
Van Renfselaer, at the head
olunteer militia, from the
giment, and Col. Christie,
D regular troops, the whole
e immediate command of
n Renfselaer, crossed the riv-
wiston in 17 boats, with the
storm the enemy's works
eights or mountain above
on. The militia and regu-

lars moved forward with the great
est intrepidity and gallantry, and
carried the enemy's works with but
a small lofs and poffessed themselves
of the enemy's battery. In this af-
fair, Col. Van Renfselaer was severe-
ly wounded in the leg, thigh & fide,
and was carried back to the Ameri-
can fide of the river. Gen. Brock
and his aid, Col. M'Donald, of the
British forces, were killed in this
engagement.
 General Wadfworth then crossed
over with the refidue of his brigade,
confisting of detachments from Cols.

Allen's Bloom's Stranahan's and
Mead's regiments, and Col. Fen-
vick with the light artillery, a-
mounting in all to about 700 men.
The command was transferred to
Gen. Wadfworth, who commanded
in the subfequent operations of the
day. After a line had been formed
on the heights, our troops were at-
tacked in the rear, by the Indians
and Militia, in the direction from
Chippawa, and were repulfed and
driven back, with great flaughter,
and our men remained a fecond time
in quiet poffession of the field. At

this period General Van Renfselaer
ordered over Col. Scott, of the ar-
tillery, and Lieut. Totten, the engi-
neers, to lay out a plan of a fortified
camp—and immediately after, the
General and Maj. Mullany, crossed
the river. From the heights, the
General obferved a strong reinforce-
ment of the enemy from Fort George,
marching up under the command of
Gen. Sheaffe, who fucceeded Gen.
Brock in command, amounting to
about 6 or 700 men.
 As this force, in co-operation with
the force of the enemy yet hanging
near our flanks, would inevitably
overpower our brave troops now fa-
tigued with feveral hours hard fight-
ing, the General was prevailed to
recrofs the river, in the hope of in-
ducing the militia to crofs to the re-
lief of our brave countrymen; not a
man of whom could be prevailed up-
on to crofs over. The British mili-
tia and Indians, being reinforced by
the troops from Fort George, made
a vigorous attack, and although op-
pofed by frefh troops, superior in
discipline and numbers, yet our men
maintained the unequal conflict with
a determination, bordering upon
desperation, for a confiderable time,
when all hope of relief being cut off,
they capitulated to a superior force,
and were conducted prisoners of war
to Fort George. Our lofs in prifo-
ners and wounded was as follows:
 Wounded. Of the regulars 62, 2
fince dead, 6 dangerous. Of the
militia 20, 9 dangerous.
 Prisoners. Regulars 336, militia
373 befides officers.
 There was a brifk exchange of
cannon fhot during the whole day
at the different fortification along the
the river. The jail & a brewery at
Newark, were fired by hot fhot from
Fort Niagara and confurned.
 The corps of General Brock and
Col. McDonald, were conveyed to
Newark, and interred near the Fort
with martial honors. Gen. B. was
53 years of age, a real gentleman,
and one of the beft generals in the
British provinces.

G. Thompson. *The Taking of the City of Washington in America*. Wood engraving. London, 1814.

At about 8:00 p.m. on the evening of August 24, 1814, British troops under the command of General Robert Ross marched unimpeded into Washington, D.C., after routing hastily assembled American forces at Bladensburg, Maryland, earlier in the day. Encountering neither resistance nor any United States government officials—President Madison and his cabinet had fled to safety—the British quickly put the nation's most notable public buildings to the torch. They burned the White House, the Capitol (which then housed the Library of Congress), the navy yard, and several American warships. Most private property, however, was left untouched. (In 1815 Congress approved the purchase of Thomas Jefferson's library to replace the one lost in the fire.)

A celebratory image, this large, dramatic wood engraving of the capital in flames was printed in London just weeks after the event. Bringing a print quickly to market increased sales in the highly competitive world of English publishing.

Amasa Trowbridge. *A view of the capture of Fort George*. Drawing, pencil and ink. Manuscript sketch. Fort George at Newark (now Niagara-on-the-Lake), Canada, 1813.

This is a firsthand account of the crucial struggle between America and Britain for control of the Great Lakes during the War of 1812. Captain Isaac Chauncey and General Henry Dearborn led combined American naval and military forces on May 7, 1813, to capture Fort George on the Niagara River, connecting Lakes Erie and Ontario. Trowbridge, a surgeon serving in the U.S. infantry, sketched this disposition of the American vessels and the principal features of the British stronghold. A few days earlier, on April 27, these same forces had burned the public buildings at the capital city of York (now Toronto), Canada, providing the British with a precedent for the burning of Washington the following year.

Francis Scott Key. "The Star-spangled banner." Autograph lyric in ink. Washington, D.C., October 21, 1840.

During the closing months of the War of 1812, the British drive northward was stopped at the city of Baltimore. There, the determined defense of Fort McHenry turned back and, ultimately, ended the British invasion. Francis Scott Key, an emissary to the British, watched the bombardment of the fort from an enemy vessel in the harbor. In the flush of excitement at daybreak, when he saw the American flag still aloft over the fort, Key dashed off much of the poem that became the text for a patriotic song. (The tune was taken from a popular English drinking song, "To Anacreon in Heaven.") In 1931, Congress officially established it as the national anthem. This is one of several copies made by Key some years after writing the poem.

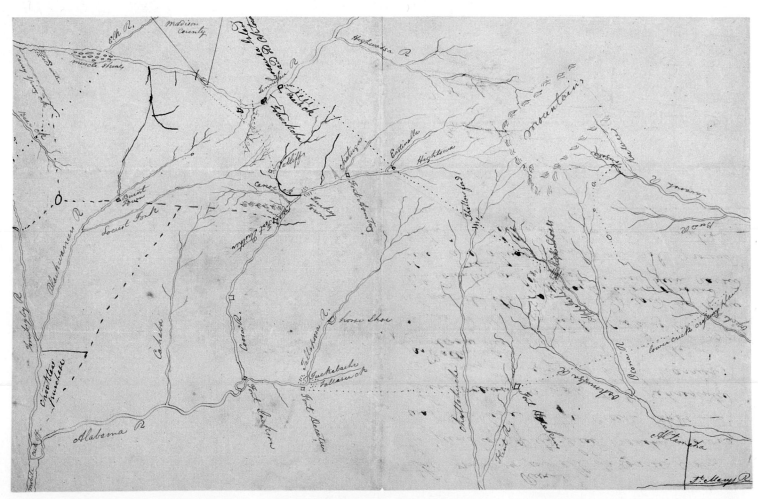

John Coffee. *Map by which the Creek Indians gave their Statement at Fort Strother on the 22nd. Jany. 1816.* Drawing, pen and ink. Manuscript map.

This rough sketch map identifying sites associated with Andrew Jackson's military campaign to subdue the Creek Indians in the present state of Alabama was drawn by Jackson's chief subordinate in the campaign, General John Coffee. Jackson's suppression of the Creek threat to white settlers along the Florida border earned national attention for the wealthy planter and general in the Tennessee state militia. His forces massacred the Creek warriors, along with women and children, at the Battle of Horseshoe Bend in March 1814. Eleven manuscript maps document Jackson's military operations in the southeastern United States, particularly along the lower Mississippi River Valley and the Gulf Coast during the War of 1812, as well as his campaign against the Creek (1813–14).

The verso of the map bears an annotation signed by Coffee, recording the statement of Thokehajo, a Creek Indian, in which he described the extent of the Creek lands. Coffee notes that Thokehajo, "after deliberating [over the map] for some time, drew his finger all along the whole course of the Tombigby, crossing the Black warrier at its mouth, and said he knew that Country well, it was his beloved ground, that he had been raised there, and always hunted on that ground and that it belonged to him and his nation."

City of CHARLESTON S Carolina

Looking across Cooper's River.

William James Bennett. *City of Charleston, S Carolina, Looking across Cooper's River.* Engraving and aquatint with watercolor. New York, 1838.
Prior to photography, topographical artists created popular images of cities, towns, and rural landscapes. Bennett portrayed many major American cities accurately and elegantly during a period of peace and relative prosperity. As artist and master engraver, he helped to establish an American school of city-view makers when the international art market, in pursuit of the "picturesque," had a growing interest in foreign scenery.

Opposite: Charles Willson Peale. *The Accident in Lombard Street.* Etching. Philadelphia, 1787.
Peale's portrayal of a maid's mishap in his own Philadelphia neighborhood is a rare glimpse of everyday life in a young American city. It is also the first street scene by an American printmaker. The story unfolds in verse:

The pye from Bake-house She had brought;
But let it fall for want of thought;
And laughing Sweeps collect around
The pye that's scatter'd on the ground.

The renowned painter's residence and studio are on the left, in a building that also housed his famous museum of art and natural history. Peale was an early and ardent advocate of art galleries and instructive displays, such as fossils and stuffed animals, for public edification. While American artists were often keen observers of nature, mundane urban dramas such as this one were unpopular subjects at the time. Common folk seldom figured in American prints, which favored formal portraits of gentry or statesmen, allegories, historical scenes, etc. Yet, in spite of their low stature in society, sweeps performed the indispensable function of keeping chimneys in the multitude of wooden buildings of early American cities free of inflammable debris.

Benjamin Henry Latrobe. View of the house from the stage. Interior section from the album *Designs of a Building to be erected at Richmond in Virginia, to contain a Theatre, Assembly-rooms, and an Hotel*. Drawing, graphite, ink, watercolor, and wash. Richmond, Virginia, 1797–98.

In this unexecuted plan for the first multiuse building in this country, Latrobe brings the building process alive by showing, on the upper balcony, the architect himself. He is directing workmen in applying the finishing touches to the elegant theater, meant to accommodate nine hundred patrons. Religious prejudice excluded theaters from the early colonies; the first appears to have been built in Williamsburg, Virginia, in 1715.

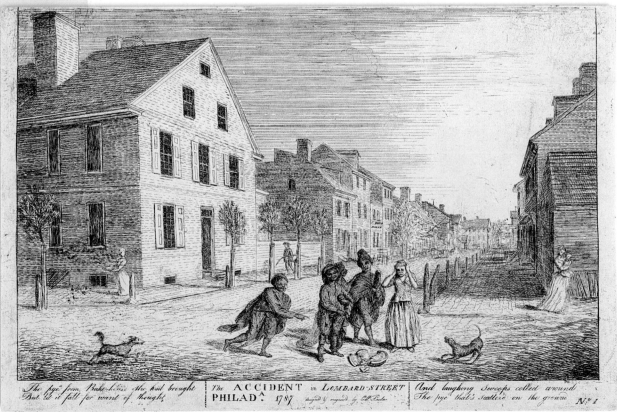

John Rubens Smith. *Philadelphia Association for the Relief of Disabled Firemen.* Watercolor, ink wash, and opaque white. Certificate. Philadelphia, 1830–40.

In eighteenth- and nineteenth-century cities, the fire companies—most of them consisting of volunteers—symbolized both the self-reliance and mutual interdependence that many Americans believed characterized their society. The intrepid members of these companies would risk all to combat fires that raged through the wooden buildings of the period and devoured entire city blocks. Firemen's benevolent associations were founded to provide aid and support to the many disabled firemen and their families, and to the widows and children of deceased firemen. Aid would take the form of firewood and coal, modest pensions, food, and shoes for the children.

In his numerous allegorical designs for bank notes, political banners, and certificates such as this one, John Rubens Smith replaced traditional iconographic symbols derived from mythology, and largely unchanged since the Renaissance, with images of modern machines and contemporary American men and women, like the ubiquitous fireman.

James Brown. *Dancing for Eels.* Lithograph with watercolor. New York, 1848.

Perhaps the most celebrated fireman of the era was the theatrical character of Mose, a self-assured street tough, here perched on a barrel wearing his signature stovepipe hat. Mose was the central character in the play *New York As It Is,* which opened to wild success in April 1848 at the Chatham Theatre. The play was something new on the American stage, reported the *New York Herald,* "so different from the hacknied [*sic*] round of the usual farces of the day." It offered a medley of humorous and musical vignettes drawn from the lives of New York City's lower-class rakes and rogues: the "b'hoys," especially of the Bowery environs, who volunteered as firemen in gangs that fought each other to reach the fire first, sometimes allowing buildings to burn in favor of the ruckus. The play, and its many spinoffs, became a star vehicle for the young actor Francis S. Chanfrau, himself a child of the Bowery tenements. The *Herald* noted that Chanfrau's characterization of Mose was such a hit that "lithographers are multiplying his likeness throughout the city. The boys in the street have caught his sayings."

New York As It Is had obvious local appeal, but it also had national connotations. A wave of nativist sentiment swept America during the 1840s, stirring xenophobic and anti-intellectual passions. But at the same time, interest in city life grew as European immigrants and rural workers seeking jobs swelled urban populations. The b'hoy Mose gained a mythic stature almost equal to Paul Bunyan and Davy Crockett; by the late 1840s, he had become the most prominent figure in American humor, as well as a major component of Walt Whitman's persona in *Leaves of Grass.*

PRINCESS'S THEATRE,

J. M. MADDOX, Sole Lessee and Manager, Duchess Street, Portland Place.

FOURTEENTH APPEARANCE IN THIS COUNTRY

OF THE CELEBRATED

NEW ORLEANS ETHIOPIAN SERENADERS!

SANFORD, BURK, OLE BULL, JUN. J. C. RAINER, SWAINE,

Whose Performances elicit shouts of laughter and applause.

This Evening the Free List will be entirely suspended

This Evening, TUESDAY, March 16th, 1847,

The Performances will commence with

BELLINI's CELEBRATED OPERA, in Three Acts,

LA SONNAMBULA

Conductor. — **Mr. LODER.**

Leader of the Band, Mr F. EAMES, Chorus Master, Mr DUGGAN.

Count Rodolpho, Mr. BODDA,

Elvino, - - - - **Mr. ALLEN,**

Alessio, - **Mr. S. COWELL,**

Notary, **Mr. HONNER,**

VILLAGERS.

Messrs. Brennan, Benedict, Braithwaite, Berkely, Bowtell, Bologna, Chambers, Davies, Elmore, Foster, Franks, Gaynor, Healey, Henry, Hill, Howlett, Josephs, Knight, Larpent, Murray, Marshall, Nadin, Oliver, &c.

Liza, (First Time) **Miss GEORGIANA SMITHSON,**

Teresa, - **Mrs. FOSBROKE,**

AND

Amina, — **Miss BASSANO.**

FEMALE VILLAGERS.

Misses Burbidge, Barton, Brady, Cuthbert, Charlton, Day, M. Day, Faucit, Fairbrother, Hincks, Hodson, Laporte, Lacy, A. Lacy, Millar, L. Marshall, Mears, Mildenhall, Robertson, Simmonds, Smithyes, Steward, Taylor, &c.

ACT I.

A VILLAGE IN SWITZERLAND

Lisa's INN & PAVILION adjoining,

With the WIDOW's MILL, and DISTANT COUNTRY.

ACT II.

Summer Pavilion in Lisa's Inn, and Moonlit Village.

ACT III.

SUBURBS of the VILLAGE & ROMANTIC DELL

The Mill Stream and Mill of Teresa.

WITH DWELLING, DILAPIDATED WALL, and VILLAGE PASS.

New Orleans Ethiopian Serenaders! Woodcut. Broadside. [London], 1847.

The minstrel show, inspired by the music and dances of plantation slaves, was one of the most popular forms of American entertainment between 1840 and 1870. The New Orleans Ethiopian Serenaders—actually whites performing in blackface—were the premier ensemble, consisting of founder James Buckley, his three sons, and Samuel Sanford. This broadside shows the performers with instruments typical of minstrelsy during this period: the fiddle, the double fiddle combination (played by child virtuoso Frederick), the banjo, the tambourine (played by Sanford, who also performed many specialty dances), and the bones (played by Swayne).

As part of its repertoire, the troupe began to parody operas, such as Vincenzo Bellini's *La Sonnambula.* Before the Civil War, there was a fluid exchange between different cultural idioms; classical and popular music often shared the same audiences.

Phiz (Hablot K. Browne). Cover engraving from Charles Dickens, *The Life and Adventures of Martin Chuzzlewit,* Vol. VII. London, July 1843.

The vibrant and bustling piers of Mose's New York—"belted round by wharves as Indian isles by coral reefs," says Melville's Ishmael—greeted Martin Chuzzlewit on his arrival in America. The tale of Dickens's fictional hero's travails in England, and his quest for fortune in the United States, was issued monthly between January 1843 and July 1844. America waited breathlessly for each of the nineteen illustrated installments.

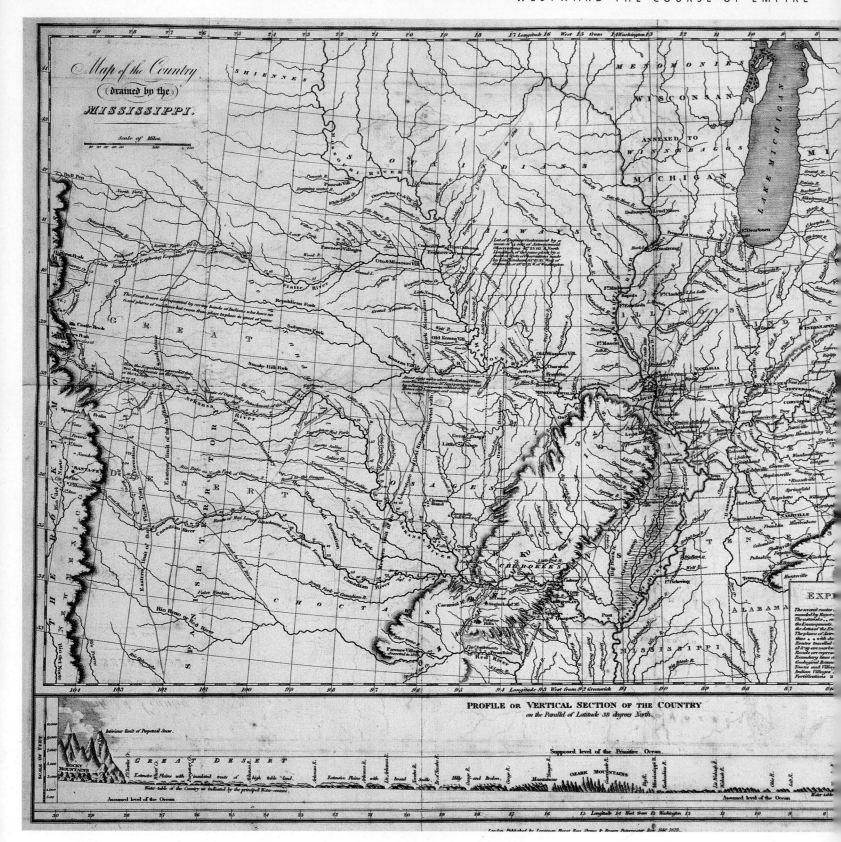

Major Stephen H. Long. *Map of the Country drained by the Mississippi.* Engraved map from Edwin James, *Account of an expedition from Pittsburgh to the Rocky Mountains performed in the years 1819, 1820 . . . under the command of Major Stephen Long.* London, 1823.

Long's map misidentifying the region between the Mississippi and the Rocky Mountains as the "Great Desert," or "almost wholly unfit for cultivation," had considerable impact on potential settlers' perception of the region, and influenced the Jackson administration to assign it to the Indians. In the 1830s the issue of Indian removal probably occupied more time in Congress than any other; and by 1837 the expenses connected with it consumed approximately half of the national budget. James Fenimore Cooper relied heavily upon Long's report for his novel *The Prairie.*

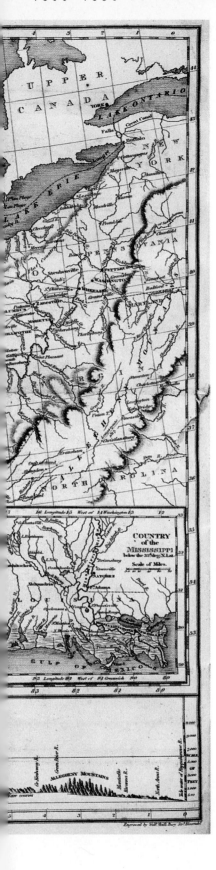

The Savages conveying Mrs. Lewis and her Three Children into captivity. Woodcut from Lewis, *Narrative of the Captivity and Sufferings of Mrs. Hannah Lewis.* Boston, 1817. In the early nineteenth century, white Americans' attitudes toward Native Americans deteriorated from the earlier Jeffersonian ideal of "noble savages." Sensational and often fictional accounts of Indian captivities, published in pamphlet form, proliferated in popular literature after the War of 1812. Mrs. Hannah Lewis's first-person account details the murder of her husband and abduction of herself and her three children from their homestead near St. Louis in May 1815; the unspeakable cruelty of their captors; and her escape with her son two years later. While the diminutive tomahawks brandished by the Indians look unthreatening in this rendition accompanying the pamphlet, the artist has embellished the captors with a rather fierce red coloring to make up for it.

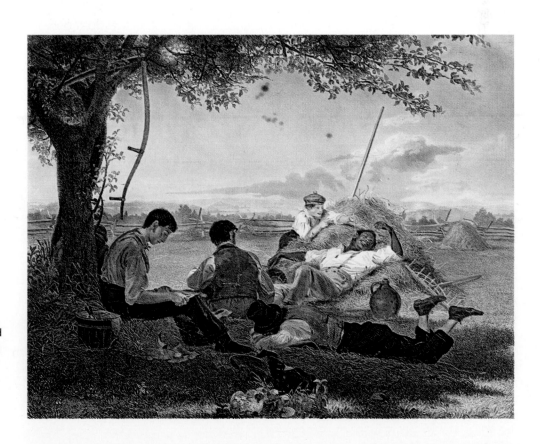

Alfred Jones, after William Sidney Mount. *Farmers Nooning.* Engraving. New York, 1843. The Long Island painter Mount immortalized a typical moment in this 1836 painting of field hands at midday rest. The reclining black man was one of the many freedmen who worked the farms of Stony Brook and eastern Long Island where Sag Harbor figured as an important stop on the underground railroad.

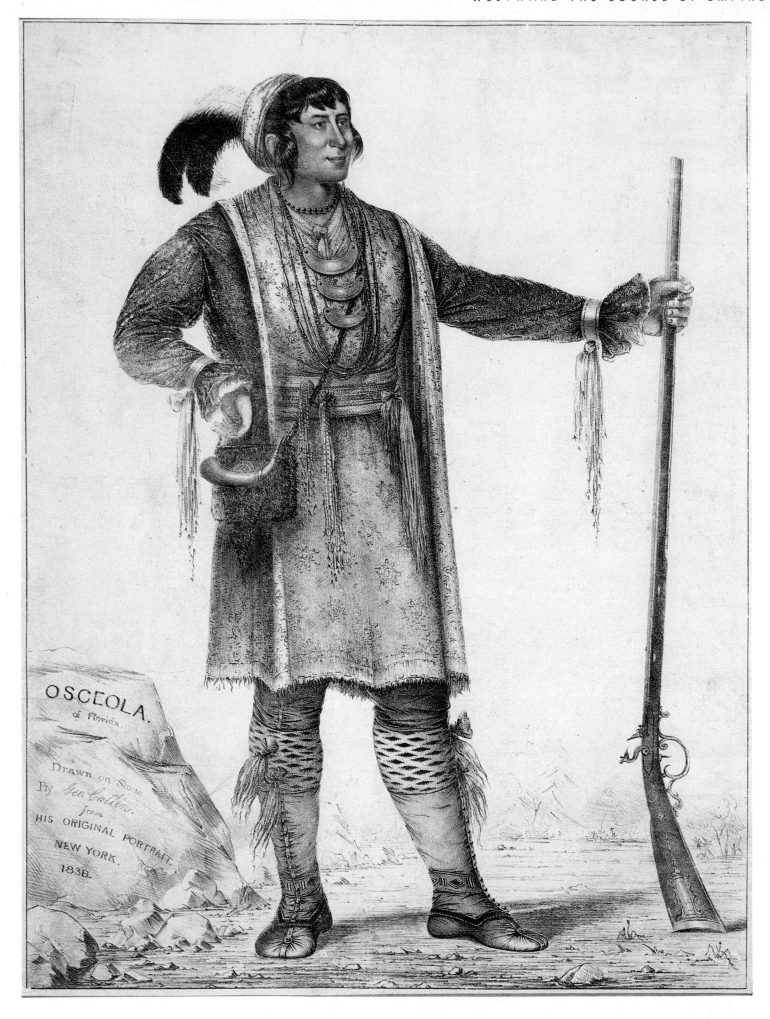

OSCEOLA.
of Florida.

Drawn on Stone
By Geo. Catlin.
from
HIS ORIGINAL PORTRAIT.
NEW YORK.
1838.

James Ackermann, after George Catlin. *Ball Players.* Color lithograph from Catlin, *North American Indian Portfolio.* New York, 1845. In his lavishly produced volume on "hunting scenes and amusements of the Rocky mountains and prairies of America," George Catlin described an early form of lacrosse, which was common to the forty-eight tribes he had studied. The three players shown here were among the most accomplished: Tul-lock-Chish-Ko (He Who Drinks the Juice of the Stone), a Choctaw; Wee-Chush-Ta-Doo-Ta (The Red Man), a Sioux; and Ah-No-Je-Nahge (He Who Stands on Both Sides), a Sioux from the Missouri. Resettled on the plains, the Indians attempted to resume their normal lives—until white settlers discovered that the "Great American Desert" was really a fecund prairie.

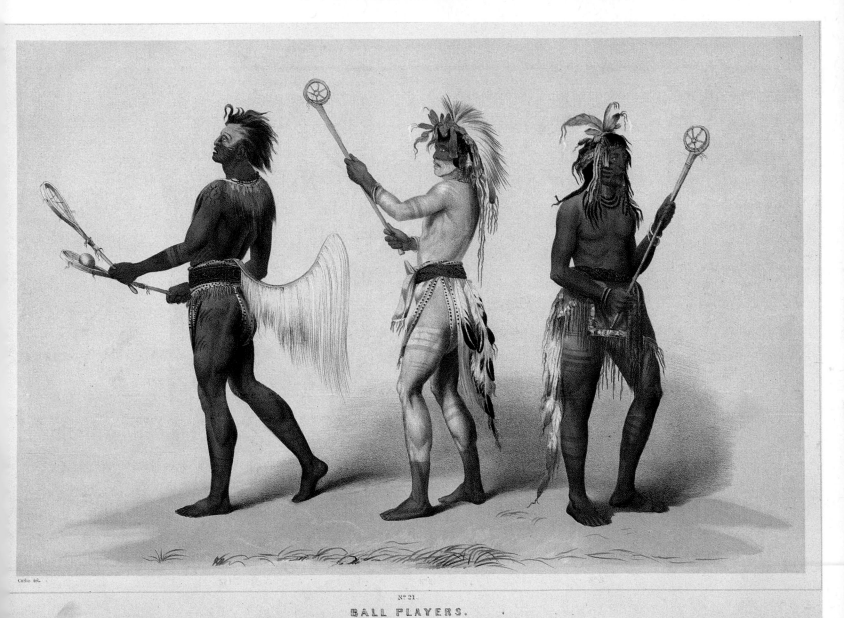

Nº 21.

BALL PLAYERS.

Published at James Ackerman's Lithographic rooms, 3d, Broadway, N. Y.

Opposite: George Catlin. *Osceola of Florida.* Lithograph. New York, 1838.
A substantial Seminole minority balked at removal to the plains and staged an uprising. Osceola was their charismatic and valiant leader, the Tiger of the Everglades, and a formidable opponent of the American troops. The war dragged on for years and became the costliest ever waged against the Indians; but by 1842, most (though not all) Seminoles had been killed or moved west. George Catlin, the foremost antebellum artist of the Indians and the West, published this monumental but humanizing portrait in the wake of Osceola's death in a South Carolina federal prison after he was tricked into surrendering under a truce flag.

By the end of the 1830s, virtually all the important Indian societies east of the Mississippi had been removed. According to a report by the Commission of Indian Affairs, the Choctaws of Mississippi and western Alabama, the Creeks of eastern Alabama and western Georgia, the Chickasaws of northern Mississippi, the Cherokees of Georgia, and the Seminoles of Florida—52,570 Native Americans in all— were forced to leave their ancestral farmlands. An epidemic of smallpox, along with starvation and exposure, took thousands of lives on what became known as the Trail of Tears.

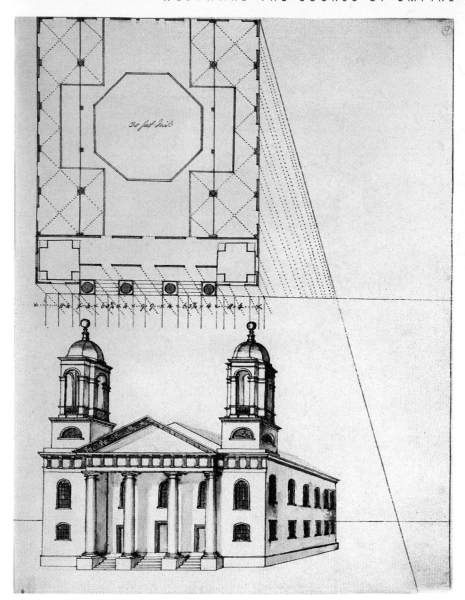

Below: Kennedy & Lucas, after Alexander Rider. Camp meeting. Lithograph. Philadelphia, 1829.

Between 1800, when the first planned camp meeting took place on the Gasper River in Kentucky, and the 1840s, when attendance began to decline due in part to the increasingly settled frontier communities, thousands of Americans found spiritual and religious guidance, physical and emotional release, and social intercourse by attending backwoods revivals. Dominated and fully developed by the Methodists (although Presbyterians and Baptists were common participants), camp meetings featured impassioned, often apocalyptic sermons by itinerant preachers, and responses from the audience that were emotionally charged and often physically violent. In *Domestic Manners of the Americans,* the English writer Frances Trollope recorded her impressions of an Indiana camp meeting in 1829, the year this lithograph was published:

> . . . above a hundred persons, nearly all females, came forward, uttering howlings and groans, so terrible that I shall never cease to shudder when I recall them. They appeared to drag each other forward, and on the word being given, "Let us pray," they all fell on their knees; but this posture was soon changed for others that permitted greater scope for the convulsive movements of their limbs; and they were soon all lying on the ground in an indescribable confusion of arms and legs.

Charles Bulfinch. Hollis Street Meeting House, Boston, Massachusetts. Plan and perspective drawing, pen and ink, wash and graphite. Boston, 1787–88.

America's first native-born architect of distinction, Charles Bulfinch, designed and built the Hollis Street Meeting House soon after his return from a tour of study in Europe. The new church was part of the refurbishment of Boston, which had been devastated and impoverished by British occupation forces during the American Revolution. Its plan is very close to that of the Church of St. Stephen Walbrook, which Bulfinch had carefully studied and drawn while in London. This drawing, which appears in a sketchbook with a number of others, is one of the earliest and finest American perspective drawings. It also marks the beginning of the career of one of the nation's greatest architects of churches and public buildings.

Das neue Jerusalem. Pennsylvania German fraktur woodcut with watercolor. Nineteenth century.

The term "fraktur" refers to manuscript and printed folk art on paper produced by the largely German- and Swiss-born residents of Pennsylvania and Ohio. These peoples preserved their original language, culture, and customs from the colonial era forward in such enclaves as Bethlehem, Easton, Ephrata, and Lancaster. Fraktur took the form of baptismal or wedding certificates, memorial remembrances, academic rewards of merit, illuminated alphabets, mottoes, hymns, or biblical excerpts. They chronicled the progress of individuals through life from the cradle to the grave, and were generally created for private reflection. This hand-colored woodcut by an unknown artist, however, was clearly intended for public consumption. It depicts the divergent paths toward heaven and hell, good and evil, in an effort to both warn and instruct members of the Pennsylvania Dutch community.

Diagram of the South part of Shaker Village, Canterbury, N.H.

G. N. Fasel, after C. G. Crehen. *Martyrdom of Joseph and Hiram* [sic] *Smith in Carthage Jail, June 27th 1844.* Color lithograph. New York, 1851.

Members of the Church of Jesus Christ of Latter-day Saints, commonly referred to as Mormons, were persecuted for their radical religious doctrines—including polygamy, the surrender of individual liberty to a rigid form of social organization, and an intense secrecy. The murder of Joseph Smith and his brother Hyrum by a mob in Carthage, Illinois, and increasing hostility to Mormons in the East, prompted their exodus over the Rocky Mountains to Utah in 1846. Led by Smith's successor, Brigham Young, twelve thousand people—one of the largest group migrations in American history—managed to found their "New Jerusalem" in what is now Salt Lake City.

This portrayal of the Smiths' assassination was issued in 1851, shortly after Young ordered Mormons to evacuate the state of Iowa, where they were suspected of trying to dominate the state's politics. The print was dedicated to the Reverend Orson Hyde, editor of the *Frontier Guardian.*

MARTYRDOM OF JOSEPH AND HIRAM SMITH
in Carthage Jail, June 27th 1844.

Opposite: Peter Foster. *Diagram of the South part of Shaker Village, Canterbury, NH.* Drawing, ink and watercolor. Manuscript map, 1849.

The Shaking Quakers, or Shakers, derived their name from a unique religious ritual, a sort of dance in which members of the congregation would "shake" themselves free of sin while chanting loudly. The first English Shakers arrived in New York in 1774 and eventually attracted a large following, establishing more than twenty communities, like this one at Canterbury. Emphasizing the importance of inner, spiritual "vision," and striving to redefine traditional gender roles, the Shakers tried to create a society protected from the chaos and disorder that they believed had come to characterize American life as a whole. In that, they were much like other dissenting religious sects and utopian communities of their time.

Foster confesses in the upper left corner of this sheet that he "drew this diagram not being acquainted with any rules of drawing" and hopes "it will be sufficient apology for the imperfection which may be found."

Ladies Whipping Girls. Woodcut from George Bourne, *Picture of Slavery.* Middletown, Connecticut, 1834.

Illustrated almanacs and tracts such as George Bourne's were potent weapons in the American antislavery arsenal, so effective that Southern states sought to force the federal government to prohibit their dissemination via the mails. Among the most inflammatory images was this woodcut of a slaveowner's wife whipping a female slave. Whipping was one of the accepted methods for the plantation mistress, who lived in constant dread of insurrections and poisonings, to vent her rage at the ostensible "immorality" of the slave women who were actually victims of sexual exploitation by white plantation masters.

Peter S. Duval, after Alfred Hoffy. *Mrs. Juliann Jane Tillman. Preacher of the A.M.E. Church.* Lithograph. Philadelphia, 1844.

In a portrait from life, this early woman of the cloth, a minister of the African Methodist Episcopal Church in Philadelphia, exhorts the viewer to prepare for the second coming of Christ in verses from the Book of Revelations:

Behold he comes in clouds of Glory;
Ev'ry eye shall see him nigh;
Prepare to tell the pleasing story;
Of redemption through the sky.

During the nineteenth century, many African-American women achieved positions of influence within the evangelical Christian community. Denied civil rights and social or economic opportunity elsewhere in society, women like Juliann Jane Tillman flourished among the Methodists, with their emphasis on universal salvation through personal repentance, conversion, and good works. Some reached a wider congregation through prints such as this one.

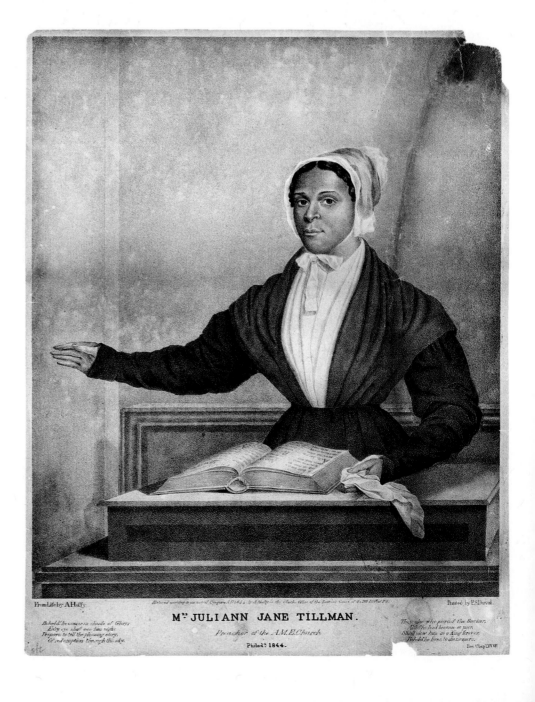

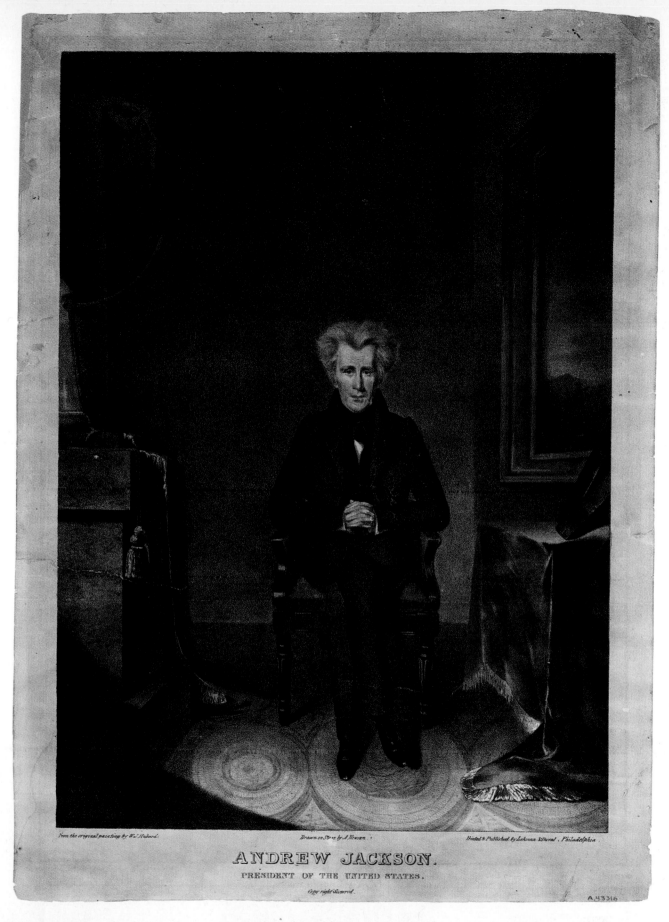

ANDREW JACKSON.
PRESIDENT OF THE UNITED STATES.

Albert Newsam, after William James Hubard. *Andrew Jackson. President of the United States.* Lithograph with watercolor. Philadelphia, 1830.

This portrait of the aging hero of the War of 1812 was made at Jackson's Tennessee estate. It is deceptively tranquil. Newsam's print was no sooner issued than the Jackson administration was rocked by the Peggy Eaton Affair. Vice President John Calhoun and other cabinet members, provoked by their wives, refused to accept Peggy Eaton—the new wife of Secretary of War John H. Eaton and a woman they considered of dubious morals—into their social world. Jackson, who believed his own wife had died as a result of public slander, defended Mrs. Eaton and insisted that the Cabinet wives accept her. That led to a mass resignation that the press portrayed (wrongly) as the downfall of his administration. Martin Van Buren, a widower, befriended the Eatons and ingratiated himself with Jackson, who would choose him as successor and destroy Calhoun's dream of achieving the White House.

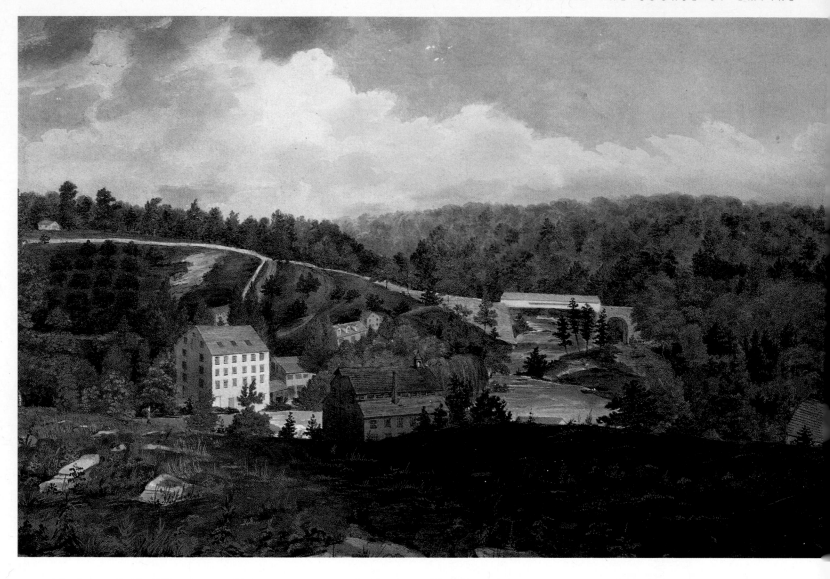

John Rubens Smith. *Mill on the Brandywine*. Watercolor. Philadelphia, 1830.
This delicate watercolor of a paper mill complex and its scenic environs on the Brandywine River suggests the fragile harmony between nature and technology achieved in America during the first decades of the Industrial Revolution. Between 1810 and 1840, the painter and printmaker John Rubens Smith traveled the eastern seaboard, creating a vivid "life portrait" of the young republic. He sketched cities and towns, rivers, roads, bridges, and mills, capturing the spirit and energy of the new nation during a period of momentous change and optimism.

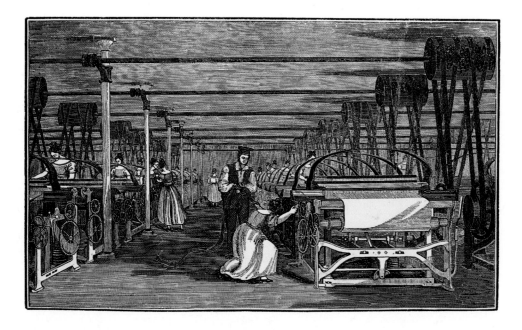

Power Loom Weaving. Wood engraving from George Savage White, *Memoir of Samuel Slater*. Philadelphia, 1836.
With the introduction of the power loom about 1815, America's cotton cloth became competitive in foreign markets with that of England. A woodcut in White's worshipful biography of the English-born Slater, the first American mill builder, shows a factory staffed almost exclusively by women—but most of his workers were children. Although this image seems quaint and almost genteel, it depicts the essence of a revolution that would both broaden employment opportunities for women and transform an agrarian and handicraft economy into one dominated by machine manufacture and heavy industry at a greater rate in the United States at midcentury than in any other country in the world.

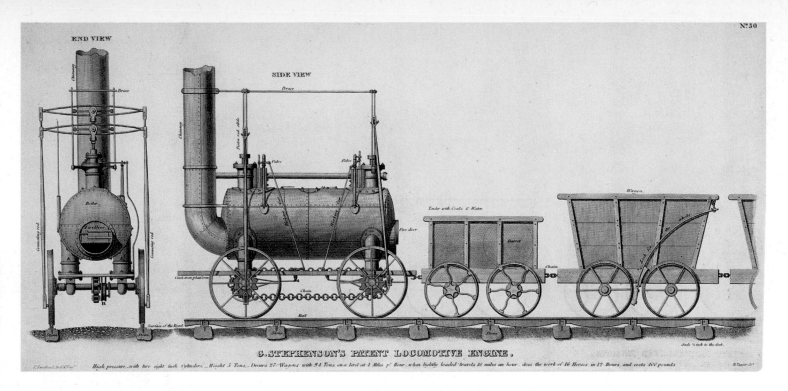

C.STEPHENSON'S PATENT LOCOMOTIVE ENGINE.

Benjamin Tanner, after William Strickland.
C. Stephenson's Patent Locomotive Engine.
Engraving with watercolor from Strickland,
*Report on Canals, Railways, Roads, and other
Subjects, made to the Pennsylvania Society for
the Promotion of Internal Improvements.*
Philadelphia, 1826.
Only a year after the first railroad to carry
general traffic opened in England, American
architect and engineer William Strickland pub-

lished this steam engine and tender, which
could pull twenty-seven wagons loaded with
ninety-four tons at four miles per hour on a
level grade. The engraving was issued, to-
gether with others about gas lighting, calico
printing, road and bridge building, steel cast-
ing, and a range of technologies, so as to
"awaken and animate the citizens of Pennsyl-
vania, to promote and adopt those great and
certain sources of national wealth and pros-

perity." Strickland's careful and precise
renderings of locomotives, rails, trackbeds,
and other specifics were meant to serve as
patterns for construction and fabrication. Rail-
roads would become the primary transporta-
tion system for the United States and remain
so until the construction of interstate high-
ways in the mid-twentieth century.

State of Pennsylvania. Union Canal Lottery.
Wood engraving. Ticket. Philadelphia, March
1825.
The immediate success of New York's Erie
Canal, the first and most ambitious of Ameri-
can inland waterways, prompted other states
to follow suit. The enormous expense involved
led to myriad funding ventures, such as lotter-
ies, which had been a popular money-raising
scheme since the settlement of Jamestown
was financed in part by one.

Orlando Metcalfe Poe. Erie Canal lock. Plan,
elevation, and sections drawing, ink and
watercolor. West Point, New York, 1855–56.
Begun in 1817 and opened in 1825, the Erie
Canal was one of America's earliest and great-
est construction projects. Covering over 543
miles altogether, its eighty-four locks accom-
modated a total rise and fall of 692 feet, sur-
passing all earlier works in Europe. New York
City became America's largest metropolis
partly because of the unrivaled access to the
interior it gained through the canal. By the
1850s drawings for the canal were being used
to train student engineers at the United States
Military Academy at West Point, where Cadet
Orlando M. Poe, who went on to have a dis-
tinguished career as a civil engineer, drew this
lock. One of the immediate results of such
new transportation routes was increased
white settlement in the Northwest.

Meriwether Lewis, after David Thompson. *Bend of the Missouri Long. 101í 25–Lat. 47í 32 by Mr. Thomson* [sic] *astronomer to the N.W. Company in 1798.* Drawing, pen and ink. Manuscript map.

One of the reasons for the success of the Lewis and Clark expedition in crossing the northwestern portion of North America and reaching the Pacific Ocean was the explorers' meticulous compilation of the best cartographic sources available at the beginning of the nineteenth century. This map, transcribed by Lewis from one prepared by David Thompson, an explorer and cartographer for the Hudson Bay and North West companies, was used during the planning stage of the expedition. The original map is based on Thompson's astronomical observations in January 1798, providing critical and accurate information about the

Great Bend of the Missouri River in what is today central North Dakota. This sketch map focuses on the Mandan Indian villages, where Lewis and Clark spent their first winter on the expedition, gathering information from the Indians about the geography of the area that they were about to traverse.

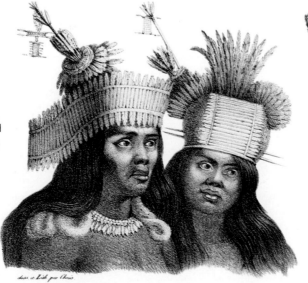

Charles de Langlumé, after Louis Choris. *Coiffures de danse des habitans de la Californie.* Lithograph from Choris, *Voyage pittoresque autour du monde.* Paris, 1822.

Drawn by scientific curiosity and, perhaps, imperialistic interest about the newly accessible Pacific territories, a Russian scientific expedition under Otto von Kotzebue ventured to the Marshall Islands, Bering Strait, and parts of the California coast from 1815 to 1818. The artist who accompanied the exploring party depicted members of several of the tribes encountered at Spanish missions on the Sacramento River, at San Francisco, and in other parts of northern California. In reality, the Indians were usually more helpful than dangerous to explorers and white pioneers.

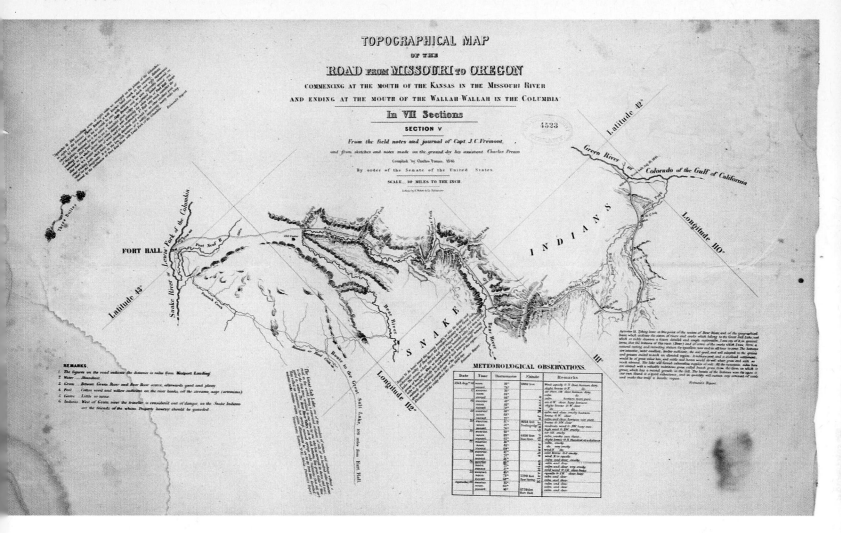

Charles Preuss. *Topographical Map of the Road from Missouri to Oregon . . . from the field notes and journal of Capt. J. C. Frémont.* Printed map, Sheet V. Washington, D.C., 1846.
During the 1840s and early 1850s, John C. Frémont, a noted western explorer renowned for his active role in the conquest of California during the Mexican War, made four expeditions with his cartographer Charles Preuss throughout the western United States. Preuss's seven-sheet map of the two-thousand-mile Oregon Trail was published as a congressional document in 1846. Section V covers a portion of the trail in present-day southwestern Wyoming and southeastern Idaho. The marginalia include Frémont's observations about the Great Salt Lake, "one of the wonders of nature, and perhaps without a rival in the world." Migrants relied heavily upon this series of maps.

Horse-tracks at ordinary speed. Wood engraving from Randolph B. Marcy, *Prairie Traveler: A Handbook for Overland Expeditions.* New York, 1859.
This how-to guide contains maps and minutely detailed itineraries of the principal routes between the Mississippi and the Pacific, as well as a wealth of practical advice for the traveler—such as exact instructions on packing a Conestoga wagon with provisions for the lengthy trip, remedies for rattlesnake bites (primarily large doses of "ardent spirits"), and clues for distinguishing the tracks of white Americans' horses from Indians' (invariably smaller and unshod). Marcy notes, "I have in the following cut represented the prints made by the hoofs at the ordinary speed of the walk, trot, and gallop, so that persons, in following the trail of Indians, may form an idea as to the probability of overtaking them, and regulate their movements accordingly."

Pendleton's Lith. *Dr. Spurzheim: Discussions of the Origins of Phrenology Marked Externally.* Lithograph. Boston, 1834.

Phrenology, the science of reading the human personality from the shape of the cranium, attracted a wide following in the United States largely through the writings of Johann Gaspar Spurzheim, who asserted that a person's innate propensities and character traits were revealed in the formation of the skull. He believed that the brain inside its telltale case, rather than presiding over the range of mental functions as a single homogeneous organ, was actually composed of multiple organs, each governing a particular characteristic or faculty, such as amativeness, destructiveness, benevolence, and so forth. Though now wholly discredited, phrenology reflected a growing exploration of the brain by scientists of the nineteenth century.

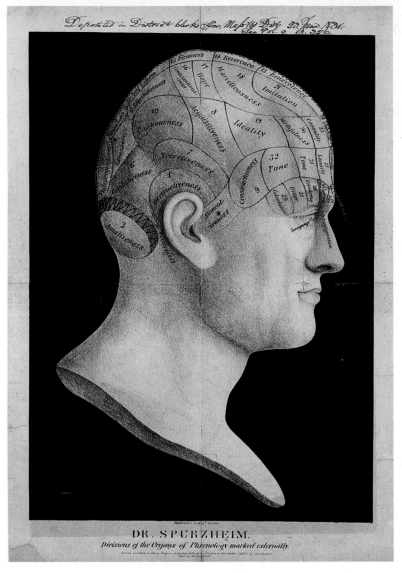

DR. SPURZHEIM.
Divisions of the Organs of Phrenology marked externally.

Draper & Co. *Swaim's Panacea.* Steel engraving. Label. Philadelphia, 1846.

Legislation regulating the patent medicine industry was still sixty years away when manufacturer John Swaim put his portrait on every bottle of his cure-all, Panacea. Beginning in the 1840s, improvements in literacy, printing, transportation, and postal rates, along with a lack of consensus on the medicinal value of Red Jacket Stomach Bitters or Dr. Keeler's Infant Cordial, contributed to the growing national market for patent medicines. Packaging was often the key to selling them, and manufacturers vied to produce the most colorful and compelling labels. Borrowing security techniques developed for bank notes and other financial documents, engraving companies embellished the labels with attractive and often exceedingly complex decoration impervious to counterfeiters. To further protect their niche, manufacturers rarely patented recipes; this not only would have required the disclosure of potentially harmful or spurious ingredients, but also would have limited the life of the patent monopoly to seventeen years. It was far more common for proprietors like John Swaim to register the name of the product as a trademark and copyright the label design. He linked his kindly features with the product's good intentions and cemented his personal relationship with the buying public by putting his likeness on the label.

Samuel F. B. Morse. *What hath God wrought?*
Ink and embossing on paper. Telegraphic tape.
Baltimore, May 24, 1844.
This first telegraphic message was sent over a
wire from the Supreme Court chamber in the
Capitol to the railroad depot in Baltimore,
Maryland. Words were encoded in dots and
dashes and embossed into a length of paper
tape at the prompting of a short or long elec-
trical impulse. The message was then deci-
phered by the receiving operator. The phrase
"What hath God wrought?" was chosen for
Morse's initial demonstration by the inventor's
"much loved friend," Annie Ellsworth, the
daughter of the U.S. Commissioner of Patents.

John Plumbe, Jr. The United States Patent Of-
fice. Half-plate daguerreotype. Washington,
D.C., 1846.
The commercial benefits of American ingenu-
ity and technology were protected by the U.S.
Patent Office, housed in this grand building,
which was appropriately among the first in
the nation's capital to be recorded by the rela-
tively new medium of photography (the da-
guerreotype process was invented in 1839).
John Plumbe, Jr., the first professional photog-
rapher in Washington, D.C., operated a studio
in the mid-1840s. An enterprising business-

man, he also maintained studios in Boston,
New York, New Orleans, Philadelphia, and
Paris. This is one of seven Plumbe architectural
views of the Washington metropolitan area
discovered by a California photography collec-
tor at a flea market near San Francisco in the
early 1970s.

To achieve wider distribution of his da-
guerreotypes of famous people and well-
known buildings and monuments—each a
unique, unreproducible image—Plumbe is-
sued hand-drawn lithographs based on them,
which he called *Plumbeotypes.*

A Desperate Contest with a Great Black Bear. Woodcut from *Davy Crockett's 1837 Almanack of Wild Sports in the West.* Nashville, Tennessee, 1836.

The real Davy Crockett was a frontiersman, hunter, scout, and Indian fighter who served in the Tennessee legislature and the United States Congress and died in the Texans' defense of the Alamo against Mexican forces in 1836. The legends that grew up around him, even during his own lifetime, became the stuff of southern and western folklore. Much of this legend was generated by the Crockett almanacs "of wild sports in the West," filled with outrageous, comic yarns of his exploits in the backwoods.

Edward Weber & Company. *General Harrison's Log Cabin March & Quick Step.* Lithograph. Baltimore, 1840.

The Log Cabin campaign of 1840 demonstrated how fully the ethos of party competition had established itself in America. This illustrated sheet music portrays the Whig William Henry Harrison, hero of the War of 1812, as a farmer residing in a log cabin on the north bend of the Ohio River. Although both parties presented themselves as the party of the common people, the log cabin was particularly potent as a foil to the prevailing image of the elegant White House of the Democratic incumbent, Martin Van Buren, who was ultimately defeated.

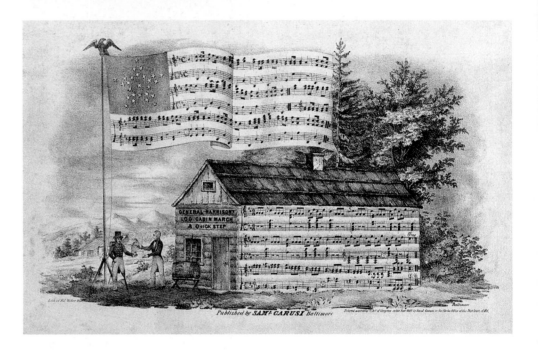

Fanoli, after Richard Caton Woodville. *Politics in an Oyster-House.* Lithograph. Paris, c. 1851.

One of the sixty or so oyster houses or "caves" that dotted Baltimore's wharf in the late 1840s serves as a forum for two citizens engaged in political discourse. Woodville's debaters, painted in 1848, must have been particularly animated by the presidential election year and the burning issue of how to admit new states to the Union, slave or free, without upsetting the balance.

Historian Francis S. Grubar has pointed out that this work seems consciously to illustrate Charles Dickens's comments in his 1842 *American Notes*: ". . . of all eaters of fish, or flesh, or fowl, in these latitudes, the swallowers of oysters are not gregarious; but subduing themselves as it were to the nature of what they work in, and copying the coyness of the thing they eat, do sit apart in curtained boxes, and consort by twos, not by two hundreds."

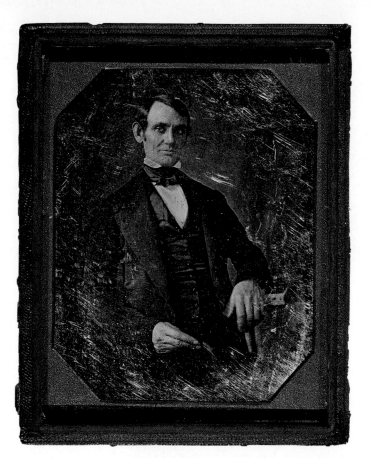

Nicholas Shepherd. *Abraham Lincoln*. Quarter-plate daguerreotype. Springfield, Illinois, c. 1846.

In 1937 Abraham Lincoln's granddaughter, Mary Lincoln Isham, donated to the Library this photograph, which had been handed down through several generations of her family. It is the earliest known photographic portrait of the Great Emancipator. Lincoln presumably sat for it in 1846 or 1847, soon after he won his first seat in the House of Representatives. The thirty-seven-year-old future president strikes the pose of a determined, aspiring lawmaker, certainly not the backwoods lawyer his 1860 presidential campaign would make him out to be.

Alfred Jones, after Richard Caton Woodville. *Mexican News*. Etching and engraving. New York, 1851.

One of the gravest crises faced by Lincoln and the other members of the incoming Congress in 1846 was the increasingly tense dispute with Mexico over American annexation of Texas—an expression of Manifest Destiny, the idea, fueled in large measure by the "penny press," that the United States was destined by God to span North America. The determinedly expansionist Polk administration soon embroiled American troops in hostilities with Mexico.

In his painting *Mexican News*, completed shortly after the Treaty of Guadalupe Hidalgo, when Mexico ceded California and New Mexico and acknowledged the Rio Grande as the Texas boundary, Richard Caton Woodville portrays the receipt of intelligence from the front at the American Hotel, doubling as rural post office and distribution point for newspapers. On its porch, citizens react, presumably, to reports of a recent triumph by American forces on their drive toward Mexico City. Woodville gives credence to Alexis de Tocqueville's observations on newspapers' vital role in American society, and the avidness with which Americans consumed them.

The painting was shown extensively in the United States at a time when art exhibition venues were relatively few. It was engraved in an edition of fourteen thousand impressions.

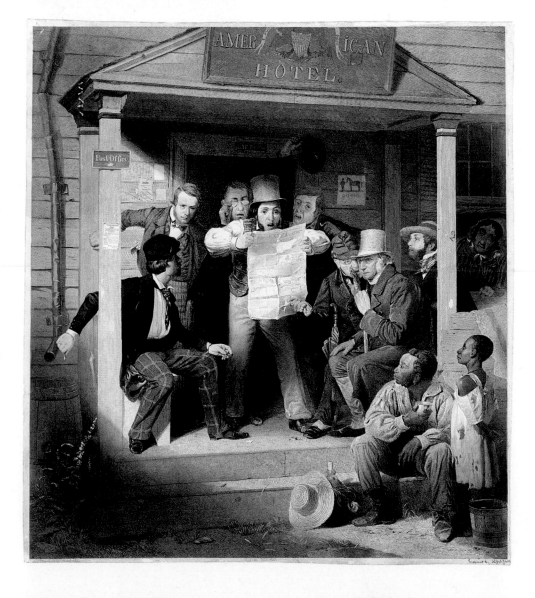

Charles Parsons, after Daniel Powers Whiting. *Bird's-eye View of the Camp of the Army of Occupation, Commanded by Genl Taylor Near Corpus Christi, Texas, from the North, Oct. 1845.* Lithograph with watercolor from Whiting, *Army Portfolio No. 1*. New York, 1847. Stirring written accounts of the Mexican War fueled demand in the United States for equally compelling graphic illustrations. Although newspapers rarely reproduced images at the time, commercial publishers generated hundreds of engravings, lithographs, and woodcuts of battlefields, encampments, and principal figures of the war for books and for people to hang on their walls. Few portrayals, however, had the authenticity of the drawings by Daniel P. Whiting, who served as an officer under American commander Zachary Taylor in the conflict.

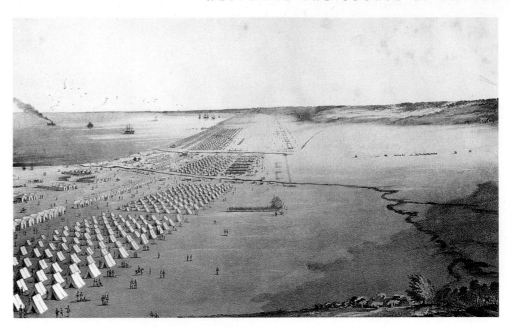

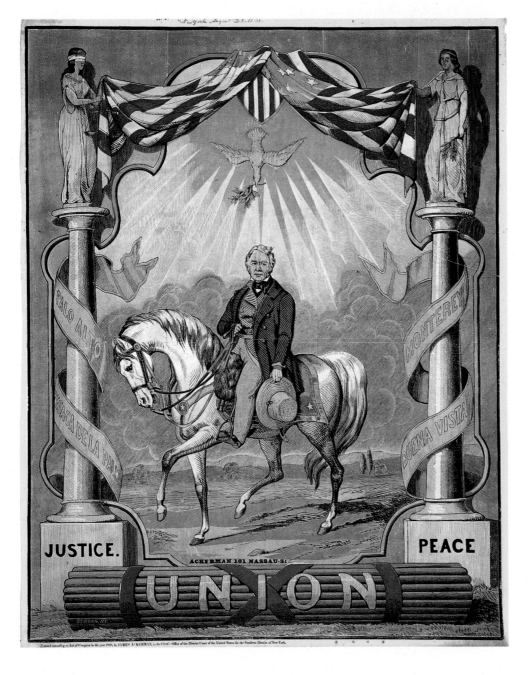

Thomas W. Strong. *Union*. Color woodcut. Poster. New York, 1848.
While Winfield Scott directed the victorious American assault on Mexico City that ended the war, Zachary Taylor's early victories in the field covered him in glory. He returned a hero and a viable presidential contender. The creators of Taylor's campaign posters seem to have borrowed a leaf from the circus publicists' book in their employment of colorful, oversized images printed from large woodblocks. The Whig presidential nominee sits astride his white charger. The names of his Mexican victories—"Palo Alto," "Buena Vista," etc.—wind about columns at right and left. Above, a dove of peace descends toward him. His fame made it unnecessary for them to mention him by name.

Nathaniel Currier. *Congressional Scales, a True Balance.*
Lithograph. New York,1850.

During his brief presidency, Zachary Taylor maintained a
precarious balance between Southern and Northern in-
terests on the issue of slavery. Here he stands atop a pair
of scales, with a weight in each hand. On the left is the
"Wilmot Proviso"—an act introduced in 1846 prohibit-
ing slavery in lands acquired through the Mexican
War—and on the right is "Southern Rights." Below him,
the scales are evenly balanced with members of Con-
gress representing their states. Taylor quips, "Who said I
would not make a No Party president? I defy you to
show any party action here." The question of extending
slavery into the territories became increasingly divisive
in the following years.

Theodor Kaufmann. *Effects of the Fugitive-Slave-Law.*
Lithograph. New York, 1850.

One of the measures that sought to bridge the great
sectional divide over slavery was the Compromise of
1850, which included the Fugitive Slave Act, odious to
Northern antislavery interests. (Mobs formed to prevent
its enforcement.) The Act provided for the appointment
of federal commissioners empowered to issue warrants
for the arrest of alleged fugitives and to enlist the aid
of posses, and even civilian bystanders, in this effort.
Here, Theodor Kaufmann, a painter now chiefly known
for his mentoring of the young Thomas Nast, envisions
the potentially tragic outcome of the Act: four black
men—probably freedmen—are ambushed and shot by a
posse of whites in a Northern cornfield.

The work is unusually well drawn and composed for a
political print of the period.

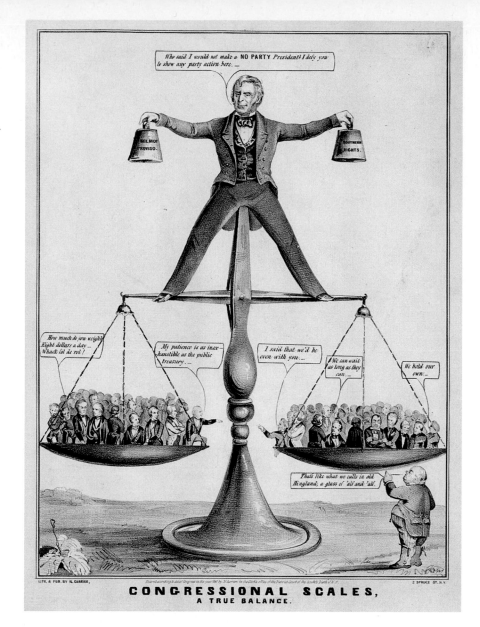

CONGRESSIONAL SCALES,
A TRUE BALANCE.

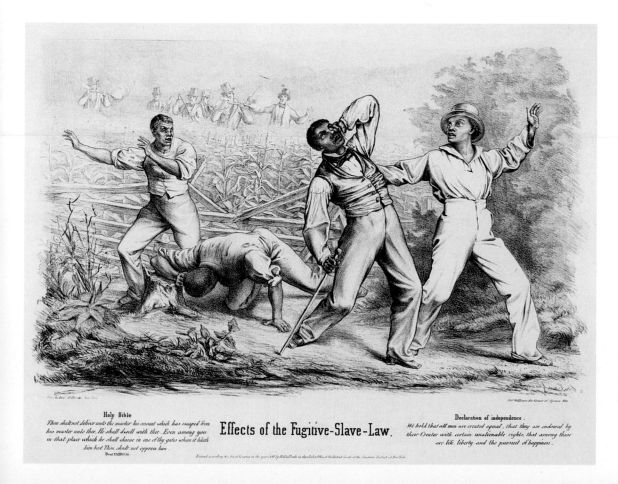

Effects of the Fugitive-Slave-Law.

Charles R. Parsons, after George V. Cooper. *Sacramento City Ca.* Color lithograph. New York, 1850.

The rapid rise of Sacramento from hinterland settlement to state capital began with the discovery of gold in January 1848, some fifty miles northeast at John Augustus Sutter's sawmill. Situated at the confluence of the Sacramento and American Rivers, Sacramento City became the gateway to the California gold fields. To capitalize on national interest in this phenomenal development, print publishers all around the country quickly produced views of the nascent city, both to encourage more visitors and simply to sell prints of a popular place. It is likely that the local businesses depicted in the image or listed on the margin—saloons, theaters, hotels, grocers, and dry goods merchants—supported production of the print by paying an advertising fee to the publisher.

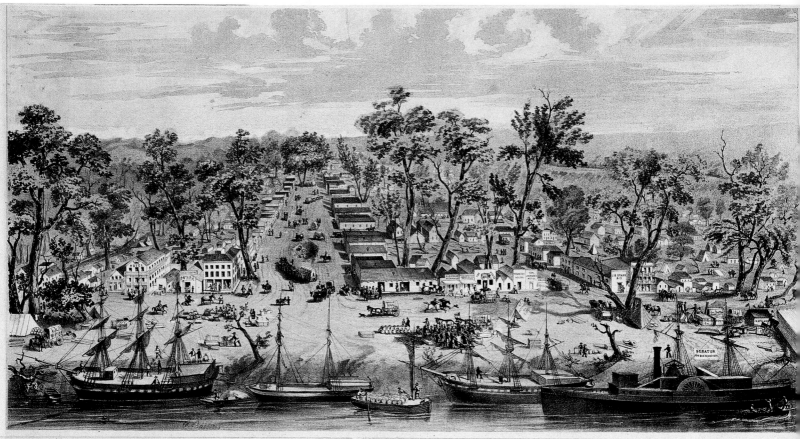

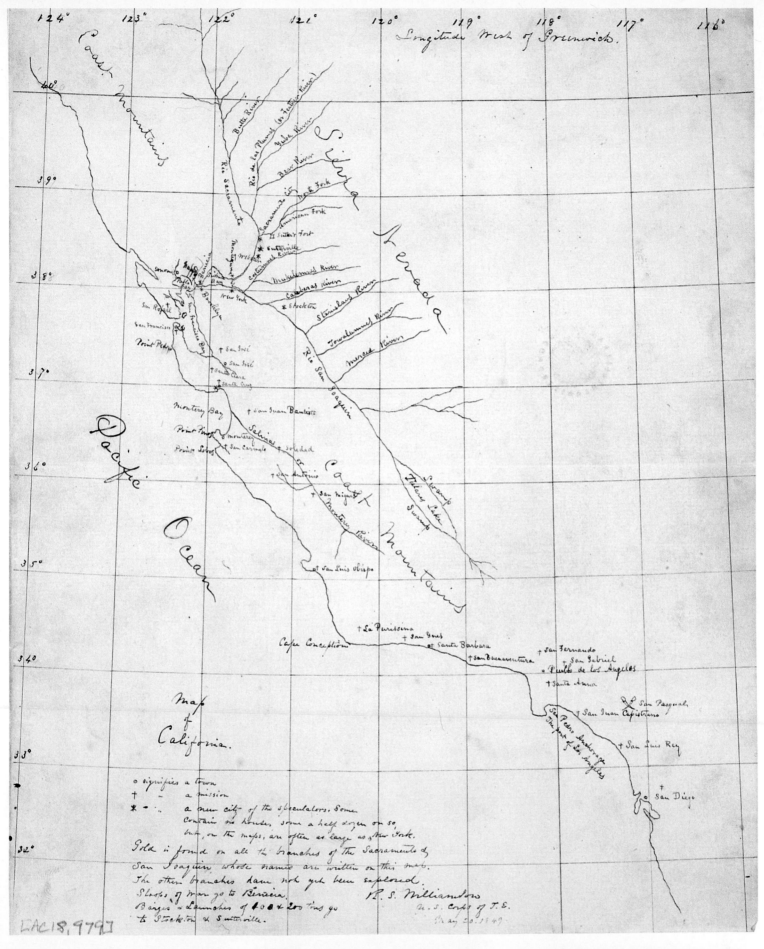

Robert Stockton Williamson. *Map of California*. Drawing, pen and ink. Manuscript map. May 20, 1849.

Williamson's sketch is an authentic treasure map of the California gold regions. He included it in a letter East of August 23, 1849, when he was in the forefront of the 1849 gold rush. The rush drew thousands of Americans and Europeans—more than eighty thousand in 1849 alone—to the streams and fields around the Sacramento River. By the end of the year, California's population was roughly a hundred thousand, enough to qualify for statehood.

W. E. Tucker, after J. Drayton. *Pine Forest, Oregon.* Wood engraving from Charles Wilkes, *Narrative of the United States Exploring Expedition, 1838–1842.* Philadelphia, 1844.

Both Britain and the United States claimed sovereignty in the rich Oregon territory, which included the present states of Oregon, Washington, and Idaho, as well as parts of Montana, Wyoming, and British Columbia. The 1840s saw escalating tensions between the two countries, intensified by the enormous influx of American settlers into the territory. Many of them traveled overland along the Oregon Trail, averaging fifteen miles a day and facing great dangers and hardships during the five- or six-month journey (from May to November).

PINE FOREST, OREGON.

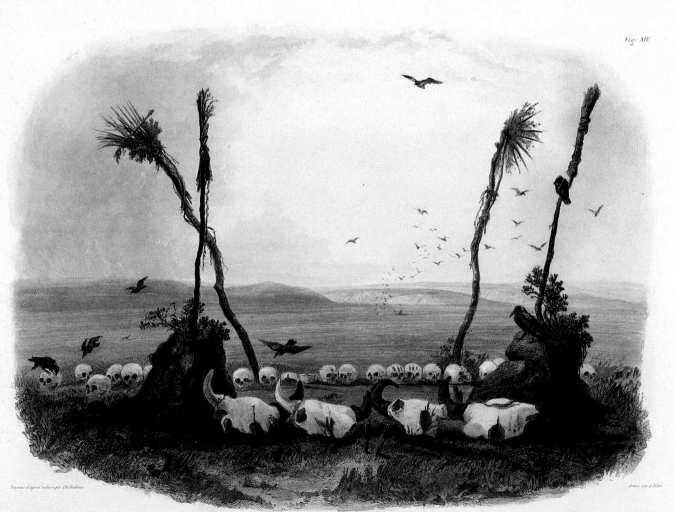

OPFER DER MANDAN INDIANER. | OFFRANDE DES INDIENS MANDANS.

OFFERING OF THE MANDAN INDIANS.

Emmanuel Leutze. Waving figure from "Westward the Course of Empire Takes its Way." Graphite drawing, 1861–62.

In a mural for the west staircase of the House of Representatives conceived in 1854, Emmanuel Leutze, the German-born painter of *Washington Crossing the Delaware,* sought "to give in condensed form a picture of western emigration." This drawing from a notebook of preparatory sketches clearly prefigures the mural's robust pioneer waving triumphantly from the top of a craggy pinnacle when his party gains its first view of the Pacific. The title of the vast work comes from a poem by Bishop George Berkeley.

Opposite: L. Weber, after Johann Karl Bodmer. *Offering of the Mandan Indians.* Engraving with watercolor from Maximilian von Wied-Neuwied, *Reise in das Innere Nord-America in den Jahren 1832 bis 1834.* Koblenz, 1839.

The German prince Maximilian von Wied-Neuwied, accompanied by the Swiss artist Bodmer, led an expedition up the Missouri River in 1832–34. Maximilian sought information and specimens for an eager German scientific community then initiating the study of anthropology. Bitter weather forced the prince's party to bivouac at Fort Clark on the eastern side of the Rocky Mountains during the winter of 1833 and provided them a rare opportunity to study the nearby Mandan tribe. The expedition bore fruit in a monumental, two-volume publication of Maximilian's report with luxuriously colored illustrations after Bodmer's watercolors. This image encapsulates the experience of the pioneers, confronted with countless extraordinary and enigmatic sights on their way west.

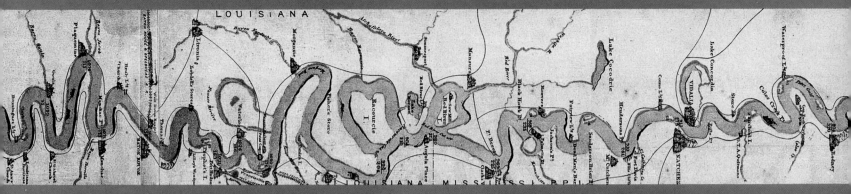

THE RIVER

Across the top: *The Mississippi, Alton to the Gulf of Mexico*, as seen from the deck of the *Hurricane Deck*. Color lithograph. Map. New York, 1861.
Designed as a souvenir for passengers on a Mississippi River steamboat, the *Hurricane Deck*, this scroll map, measuring four inches by nearly ten feet, uses pictorial symbols to highlight important towns and sites along the entire length of the river south of its juncture with the Missouri.

Opposite, center: Thomas J. Brennan. Interior of a steamboat cabin at dinner [noon] time. Silver printing-out photograph, c. 1890s.
Many steamboats were opulent floating palaces with dining rooms, parlors, and saloons in which travelers on the interior waterways could meet and socialize.

Opposite, bottom: Detroit Publishing Company. A Mississippi River Landing, Memphis, Tennessee. Modern gelatin silver print (from dry plate negative, c. 1906).
At the time of this photograph Memphis was among the busiest ports on the Mississippi. Steamboat traffic had peaked in the early 1890s, and began to decline later in the decade as railroads proliferated, but was still very much in evidence in the early twentieth century.

This page: *A New Map of the Cherokee Nation . . . Engrav'd from an Indian Draught by T. Kitchin.* Engraving from *London Magazine*. London, 1760.
On this mid-eighteenth-century printed map Cherokee settlements are located in an ill-defined region between the headwaters of the Savannah River and tributaries of the Mississippi, in what is today the southeastern United States.

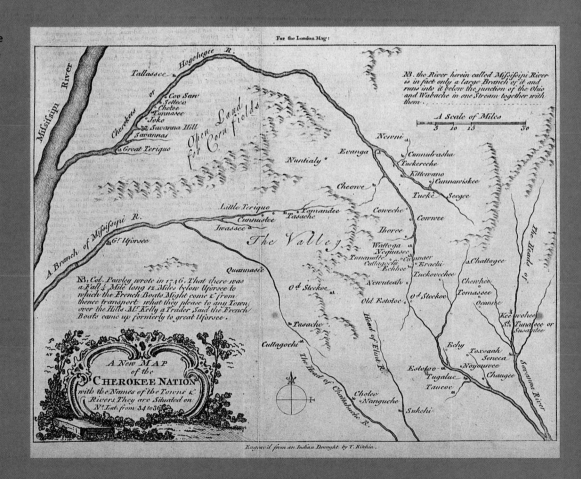

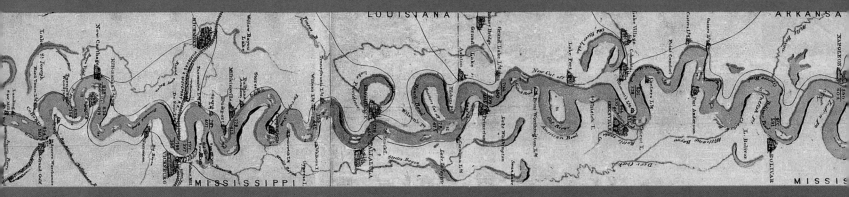

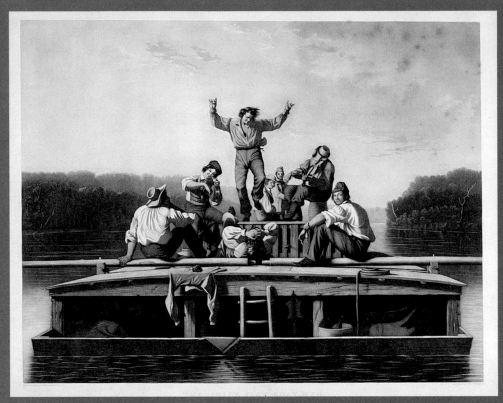

T. Doney, after George Caleb Bingham. *The Jolly Flat Boat Men.* Mixed-method mezzotint. New York, 1840.
George Caleb Bingham's paintings and prints immortalized the fur traders of the Missouri and Mississippi, in an age when they were a vanishing breed.

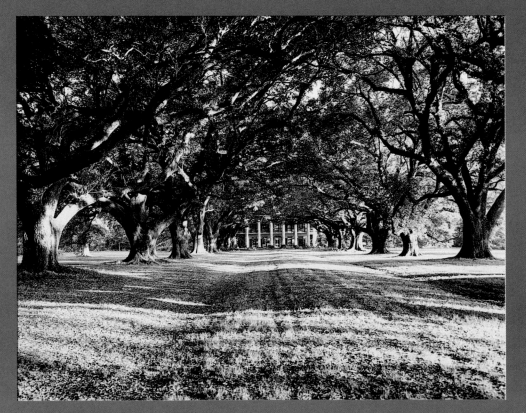

Frances Benjamin Johnston. Oak Alley (originally Bon Séjour) Plantation House. Carnegie Survey of the Architecture of the South. Gelatin silver print. Vacherie, Louisiana, c. 1938.
Although the romantic image of the great colonnaded plantation house belied the human realities of the slave economy that supported it, its power to stir the imagination remains undiminished. Two Library collections, the Carnegie Survey and the Historic American Buildings Survey, provided important source material for those designing the sets for *Gone With the Wind* in the late 1930s.

Opposite: Democrat Lithography and Printing Co. *The Bridge at St. Louis.* Color lithograph. St. Louis, Missouri, 1874.
James Buchanan Eads used cantilever supports and a new alloy, steel, to create the longest span arches of any bridge yet built, linking east and west over the turbulent river at St. Louis. In 1879, five years after its completion, Walt Whitman wrote: "I have haunted the river every night lately, where I could get a look at the bridge by moonlight. It is indeed a structure of perfection and beauty unsurpassable, and I never tire of it."

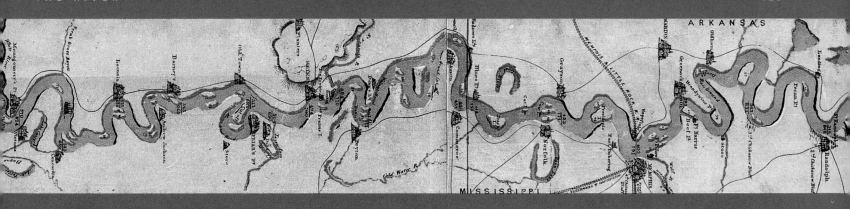

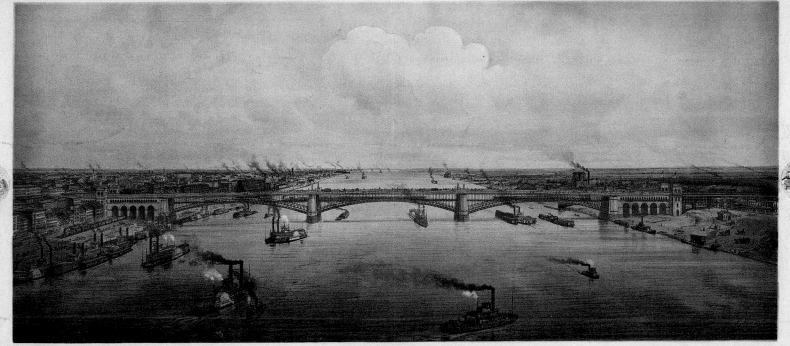

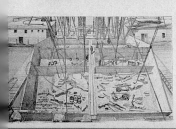 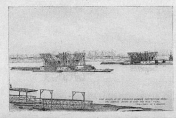 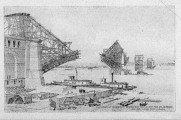

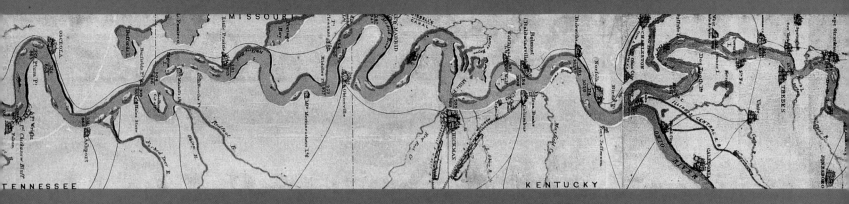

Chapter XII.

MUST a been close onto one o'clock when we got below the island at last, and the raft did seem to go mighty slow. If a boat was to come along, we was going to take to the canoe and break for the Illinois shore; and it was well a boat didn't come, for we hadn't ever thought to put the gun into the canoe, or a fishing-line or anything to eat. We was in rather too much of a sweat to think of so many things. It warn't good judgment to put *everything* on the raft.

If the men went to the island, I just expect they found the camp fire I built, and watched it all night for Jim to come. Anyways, they stayed away from us, and if my building the fire never fooled them it warn't no fault of mine. I played it as low-down on them as I could.

When the first streak of day begun to show, we tied up to a tow-head in a big bend on the Illinois side, and hacked off cotton-wood branches with the hatchet and covered up the raft with them so she looked like there had been a cave-in in the bank there. A tow-head is a sand-bar that has cotton-woods on it as thick as harrow-teeth.

We had mountains on the Missouri shore and heavy timber on the Illinois side,

MISSOURI

THE MISSISSIPPI

ILLINOIS

Opposite, clockwise:
E. W. Kemble. *On the raft.* Opening to Chapter XII from Mark Twain, *Adventures of Huckleberry Finn.* New York, 1885.
Twain's biographer Justin Kaplan observes: "Much of this great book's power to offend as well as endure derives from a commitment to truth-telling and to a frequently brutal, painful realism." *Finn* raised American vernacular speech to the level of literature.

Makoto Wada. Louis Armstrong. Watercolor. Japan, 1968.
By age thirteen the legendary jazz virtuoso Louis "Satchmo" Armstrong was playing in marching bands, at picnics, in clubs and bars throughout New Orleans, and on the riverboats. He lit up the world with his brilliant trumpet trills, dazzling vocals, and incandescent smile.

Jerome Kern and Oscar Hammerstein II. "Ol' Man River." Autograph score in pencil, 1927.
Although many believe it to be an American folk song, "Ol' Man River" is the original work of composer Kern and lyricist Hammerstein. It was first sung by Paul Bledsoe, but the great baritone Paul Robeson, who sang it in the London premiere of *Show Boat* in 1928, made it his own.

Carl Van Vechten. William Faulkner. Gelatin silver print. New York, December 11, 1954.
Faulkner set many of his novels and short stories in the fictional county of Yoknapatawpha in his home state of Mississippi. Faulkner won the 1950 Nobel Prize for literature; in his acceptance speech he said: "It is the writer's privilege to help man endure by lifting his heart."

This page: Earth Observation Satellite Company. Satellite views of St. Louis, Missouri, and vicinity, July 4, 1988 (center) and July 18, 1993 (bottom). Remote sensing images. Lanham, Maryland. These two images, derived from Landsat satellites, depict the confluence of the Missouri and Mississippi Rivers just north of St. Louis in the drought year of 1988 and during the height of the 1993 floods.

4

A MORE PERFECT UNION, 1850–1870

The Thirty-first Congress convened in Washington in December 1849 to debate the most momentous question of the day: What should be the status of slavery in the new western lands, where white settlement was accelerating and where a clamor for admission to the Union was steadily rising? Members were already deeply divided over a proposal that had first appeared more than three years earlier, when Representative David Wilmot of Pennsylvania had introduced his famous proviso calling for slavery to be prohibited from all territory acquired in the war with Mexico.

A bitter dispute in the House of Representatives over the election of a new Speaker revealed something of the depths of the divisions. "If these outrages are to be committed upon my people," a representative from Virginia insisted when it appeared a deal was in the works to pass the Wilmot Proviso, "I trust in God, sir, that my eyes have rested upon the last Speaker of the House of Representatives." A Northern representative challenged him. Tempers flared. Bedlam followed. The usually staid reporter for the official *Congressional Globe* found it impossible to keep his composure, even in print. "Indescribable confusion followed," he wrote, "threats, violent gesticulations, calls to order, and demands for adjournment were mingled together. The House was like a heaving billow. . . . The Sergeant-at-arms . . . took the mace in his hand, and descending among the crowd of members held it up on high. Cries of 'Take away the mace; it has no authority here.'"

And so commenced not only a new session of Congress, but a long season of acrimony that would end, sixteen years later, when an exhausted army of Americans from the South surrendered to an almost equally exhausted army of Americans from the North after what remains the bloodiest war in the history of the nation.

*

The sectional crises that consumed the nation in the 1850s and 1860s were not a departure from the pattern of dramatic national growth of the previous half-century. They were its product. Early in the nineteenth century, when the United States had been a collection of small, relatively self-reliant communities, economic, cultural, and political differences among the regions had been easy to ignore. The nation remained highly decentralized. The national government was largely irrelevant to the lives of most people. When sectional tensions arose, as they occasionally did, it was much easier for the great statesmen of the day to craft compromises to calm them. The United States in the 1850s and 1860s was not yet the great industrial power it would soon become. But neither was it any longer a loose collection of semi-independent communities and regions. Much had changed to draw the nation together.

George Housman Thomas. Sheet of sketches for an illustrated edition of *Uncle Tom's Cabin*. Pencil, pen and ink. London, 1852.
Harriet Beecher Stowe's antislavery novel *Uncle Tom's Cabin*, first published in 1851, was one of the most influential books in American history and a phenomenal success on both sides of the Atlantic. In 1852 London publisher N. Cooke issued an edition illustrated by George Thomas, for which these preparatory sketches were made. Thomas, an English artist who had traveled and worked in the United States, reportedly had seen the slave trade firsthand, and was sensitive to the subject. Remarkably for the period, he depicts Simon Legree and some of the book's other central characters as individuals, not as caricatures.

A vast network of railroads—thirty thousand miles by 1860, three times what it had been a decade earlier—helped knit together the economies, and the cultures, of the different regions. Great feats of engineering, visionary experiments in corporate organization, lavish government subsidies, and harsh exploitation of low-wage immigrant workers ensured the triumph of the rails. New lines crossed the Appalachian Mountains, linking the Northeast to what was then known as the Northwest (Ohio, Indiana, Michigan, Illinois, Wisconsin). Chicago—served by fifteen lines and a hundred trains a day—became the railway center of the region, surpassing St. Louis as the premier city of the West. In the past, these great grain-producing states had sent their crops to market down the Mississippi River to New Orleans; they had been economic allies of the South. The rails now tied their economies firmly to the East.

And early in the 1860s, despite the terrible war raging only a few miles from the Capital, Congress authorized the construction of a transcontinental railroad—a line that would permit uninterrupted travel by rail from the Atlantic to the Pacific. By the end of the decade, it was finished—an epic achievement by thousands of Irish and Chinese workers laboring under unimaginably arduous conditions, and of two ambitious, hard-driving companies. In the spring of 1869, the two lines—one built west from Nebraska (where the existing rails had once ended), the other east from California—met at Promontory Point, Utah, and were joined by a golden spike, a dramatic symbol of the rapid consolidation of the nation, which had already been far advanced when the project began.

The construction of the railroads was the greatest economic venture in American history to that point. And it made possible a host of other changes. Throughout the Northeast, and through much of the Northwest, a substantial industrial economy was emerging, aided by new technologies and new forms of corporate organization—and crucially dependent on the railroads to transport manufactured goods to distant markets. Gradually, large, disciplined factories were replacing small, independent, artisanal shops—producing more goods, and producing them more cheaply, than the older economy had done. Those factories also shattered a way of life for many men and women, by taking people who had lived and worked independently and subjugating them to the discipline of an organized, hierarchical economy. "It is useless for us to disguise from ourselves the fact that, under the present arrangement of things, there exists a perpetual antagonism between labor and capital," a group of journeymen printers proclaimed during a meeting in New York in 1851. "The toilers are involuntarily pitted against the employers: one side striving to sell their labor for as much, and

Three railroad workers with crank handcar. Sixth-plate daguerreotype, c. 1855. Railroads were not only faster than prior transportation but more flexible: while canal routes had to be located near water, railroads could be built almost anywhere. In laying over six thousand miles of track between the late 1820s and 1848, construction inspectors and work crews would have to travel distances of up to three to six miles daily to their worksites on handcars. This photograph is especially valuable because it is one of the few in which a worker is identified. A note accompanying the image reads: "Jacob Lewis Davis, my dear father. Taken when he worked on the railroad. He is the tall man with a beard standing on the left."

Truthful portrayals of the antebellum laboring class are uncommon; outdoor depictions are even more rare. Working outdoors, the daguerreotypist had to have a portable darkroom, or work close to his studio, because the plates had to be developed immediately after being exposed in the camera.

John H. Manning. *Fetridge & Co.'s Periodical Arcade, Washington and State Streets, Boston.* Wood engraving from *Gleason's Pictorial.* New York, July 31, 1852.

Gleason's was the first pictorial weekly in the United States, and soon nineteenth-century America was flooded with inexpensive illustrated journals proposing to provide cultural polish, give the latest news, enrich morals, and sharpen the intellect. This advertisement shows men, women, and children thronging to purchase such periodicals. In larger cities, the emergence of great arcades and department stores helped transform buying habits and turned shopping into a more alluring and glamorous activity, as women became the dominant consumers. Shopping was an acceptable diversion for unchaperoned ladies.

John H. Manning is known to have collaborated on illustrations with wood engraver Frank Leslie, whose career culminated in the ubiquitous *Frank Leslie's Illustrated Newspaper.*

the other striving to buy it for as little, as they can." In a modern market economy, many workers were discovering, labor—like the goods labor produced—was becoming a commodity.

*

The South was tying itself to a national (and international) market, too. In the 1840s and 1850s its booming cotton economy expanded deep into the Southwest, and its most successful planters, like the industrialists of the North, were selling wares throughout the nation and the world; accruing great fortunes; and steadily expanding their enterprises. But in other respects the South was becoming increasingly unlike the North. It was almost wholly without industry. It had few significant cities. Its railroads were relatively undeveloped. What made the South most distinctive, of course, was its "peculiar institution": slavery. By the early 1850s white Southerners had become tautly defensive about their labor system in the face of a rising chorus of attacks from abolitionists and other antislavery forces in the North. Planters had an enormous economic stake in the survival of slavery because, for many, slaves represented their largest single investment. They gradually developed a philosophical and cultural stake in it as well. Slavery was not a necessary evil, John Calhoun had told his fellow Southerners in the 1830s. It was "a good—a positive good." Over the next two decades, white Southerners embraced that view and developed an elaborate argument to support it. Africans were inferior beings, they insisted, and it was the duty of white society to protect them, nurture them, and help them make the most of their limited capacities.

"The negro slaves of the South are the happiest, and, in some sense, the freest people in the world," the proslavery writer George Fitzhugh wrote in 1857. "The children and the aged and the infirm work not at all, and yet have all the comforts and necessaries of life provided for them. They enjoy liberty, because they are oppressed neither by care nor labour. . . . The free labourer [in the North] must work or starve, he is more of a slave than the negro."

In defending slavery, white Southerners were also defending a way of life: a distinctive civilization that unlike the rapidly developing North, was, they believed, stable, orderly, steeped in tradition and nobility. "The masses of the North are venal, corrupt, covetous, mean, and selfish," one polemical Southerner wrote. The South, by contrast, was a seat of gentility and culture. And its defenders looked on with alarm as the expanding American union increasingly isolated the region. Should the North recreate itself in the new lands to the west, the South would, they feared, become a powerless minority within a vast and largely hostile nation.

To others, of course, the South looked very different. Few of the millions of enslaved African Americans who lived there had opportunities to express their own dismal views of Southern society, but those who did minced no words. "We have drank to the dregs the bitter cup of slavery," the former slave Frederick Douglass wrote in 1847, after he had become an internationally renowned abolitionist. In a passage addressed to those who remained in bondage, he said, "We have sighed beneath our bonds, and writhed beneath the bloody lash;—cruel mementoes of our oneness are indelibly marked on our living flesh. We are one with you under the ban of prejudice and proscription—one with you under the slander of inferiority—one with you in social and political disfranchisement." White Northerners, too, were becoming increasingly critical of slavery—not always out of concern for the plight of African Americans (whom many Northern whites also considered inherently inferior), but often out of concern for themselves. Slavery, they believed, was a threat to the freedom and mobility that formed the basis of their society. Most of America was dynamic, growing, filled with opportunities for advancement—a bastion of "free soil, free labor, and free men." The South, they believed, was its antithesis: closed, static, backward, undemocratic, controlled by an entrenched aristocracy. And most menacing of all, this decadent society was attempting to expand its influence—to put its stamp on the new lands that beckoned to the west.

*

The sectional crisis was the natural, perhaps inevitable, result of the dramatic expan-

sion of these two very different economies and cultures—each convinced of its own righteousness, each increasingly suspicious of the other, neither able any longer to exist in quasi-isolation. Time and again in the 1850s, men of both idealistic and practical bent sought to ease the tensions that were driving deeper and deeper wedges between the North and South. Time and again they failed. In 1850 the old lions of the Union—Henry Clay, Daniel Webster, John C. Calhoun—tried to collaborate in a great settlement that would calm the sectional controversy as the Missouri Compromise had done twenty years before. But the Compromise of 1850—which admitted California to the Union as a free state and placated the South with a new and more stringent law requiring the return of fugitive slaves to their owners—was not the "final and irrevocable" solution to the nation's problems that President Millard Fillmore called it. It simply papered them over for a time.

Four years later, in the Senate, Stephen Douglas of Illinois steered through Congress the Kansas-Nebraska Act, which rested on the new concept of "popular sovereignty." The residents of each territory would decide for themselves whether to permit slavery within their borders. Opposition to the act (which was, among other things, a repudiation of the Missouri Compromise) was widespread and powerful—so much so that it helped spearhead the formation of the new Republican Party that same year out of a coalition of the unsuccessful critics of the bill. In Kansas, whose fate the act was designed to resolve, a fierce and violent battle erupted between proslavery and antislavery forces, earning that territory the unhappy title of "Bleeding Kansas." Among the fervent partisans in the Kansas struggle was a zealous abolitionist named John Brown, who gathered his sons and a few others one night and murdered five proslavery settlers who had recently moved into the territory. Later, in 1859, Brown and his sons—with encouragement and financial support from prominent Northern abolitionists—seized a government arsenal at Harpers Ferry, Virginia, in an unsuccessful attempt to start a slave uprising. Brown was captured by the state militia and hanged less than two months later—but not before he had become a martyr to antislavery leaders, and a symbol to the South of the threat they believed Northerners posed to them.

In 1857 the Supreme Court tried to bury the sectional controversy with the most sensational decision in its history. In *Dred Scott* v. *Sanford*, it ruled that no person of African descent could be a citizen of the United States; that slaves were, in the eyes of the law, simply property; and that Congress, therefore, had no authority to interfere with slavery in the South or in the territories, because to do so would be to infringe on the sacred right of property. White Southerners were understandably elated. Anti-

slavery Northerners reviled the decision as "entitled to just as much moral weight as would be the judgment of a majority of those congregated in any Washington bar room." It had, they argued, made the Constitution "nothing better than the bulwark of inhumanity and oppression." But Frederick Douglass may have assessed the impact of *Dred Scott* more accurately than anyone else when he wrote: "This very attempt to blot out forever the hopes of an enslaved people may be one necessary link in the chain of events preparatory to the complete overthrow of the system."

<div style="text-align:center">*</div>

One year after the *Dred Scott* decision—a year in which passions had intensified in both North and South, in which the prospects for a peaceful solution to the sectional crisis had steadily dimmed—an extraordinary contest occurred in Illinois. Stephen A. Douglas, author of the Kansas-Nebraska Act and the dominant political figure of the age, was campaigning for reelection to the United States Senate. His opponent was an Illinois lawyer with little political experience and an even smaller national reputation, a member of the new Republican Party. In a series of debates up and down the state, the short, stout, aristocratic Douglas and the tall, gangly, awkward-looking Abraham Lincoln sparred on the central issue of their time: the future of slavery. Douglas continued to defend "popular sovereignty" as the only democratic solution. But Lincoln, looking back over the nearly five years since Douglas's policy had been enacted ("initiated with the avowed object and confident promise of putting an end to slavery agitation"), concluded—correctly—that "agitation has not only not ceased, but has constantly augmented." And it would not cease, he predicted, "until a crisis shall have been reached and passed." There was, in short, scant room left for compromise. "A house divided against itself cannot stand," Lincoln said at the beginning of the campaign. "I believe this government cannot endure permanently half slave and half free."

Lincoln lost the Senate election that year. But he emerged from the debates as the leading Republican in his state, perhaps even his region. Two years later, widely respected but still largely unknown, he found himself the party's nominee for president in a four-way race in which Douglas, again, was his principal opponent. With the opposition divided, he won easily.

Lincoln was not an abolitionist in 1860. He mounted no challenge to slavery where it already existed; and he did not yet believe that African Americans could be absorbed into society as free men and women. But he did consider slavery both a moral blight and an obstacle to the healthy growth of a free society. He was determined to prevent it from expanding and was, as such, the first man openly opposed to slavery to become

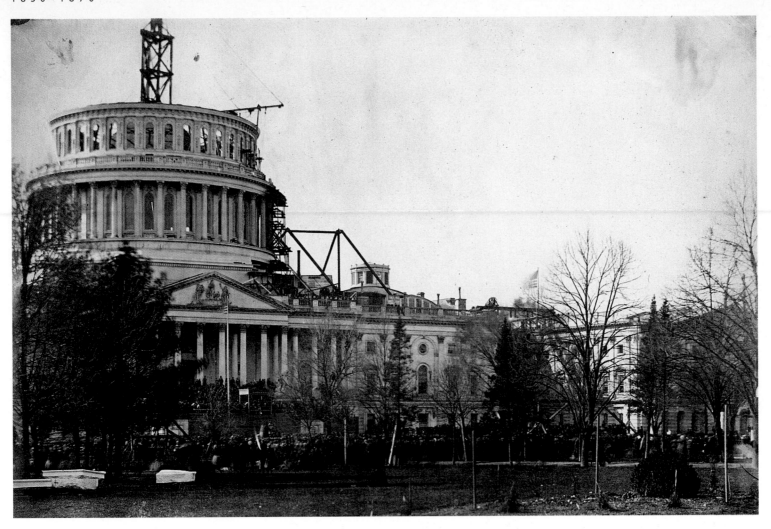

4 March 1861, Inauguration of Mr. Lincoln.
Salt print. Washington, D.C., 1861.
Abraham Lincoln's first inauguration was a
somber occasion, as six Southern states had by
that time seceded from the Union and formed
the Confederate States of America. Moreover,
South Carolina, the first state to secede, was
threatening to seize Fort Sumter, a federal
military outpost in Charleston Harbor. Deter-
mined to strengthen the national presence
symbolically as well as militarily, Lincoln
ordered the continuation of the Capitol's
expansion, then in progress for several years.
In this photograph, the building's mammoth,
half-completed dome rises behind the small
crowd of onlookers in attendance as Lincoln
is sworn in.

president. News of Lincoln's election terrified the South. One by one, the slave states
began to secede from the Union. By the time of the presidential inauguration in March
1861, seven states had withdrawn.

In his brief and generally prosaic inaugural address, Lincoln insisted that no state
had the right to secede and that the federal government would defend the sanctity of
the Union, peacefully if possible, forcefully if necessary. "We are not enemies but
friends," he closed plaintively. "Though passion may have strained, it must not break,
our bonds of affection. The mystic chords of memory, stretching from every battle-field
and patriot grave all over this broad land, will yet swell the chorus of the Union when,
again touched, as surely they will be, by the better angels of our nature."

But Lincoln was speaking to a nation now so blinded by anger, resentment, and fear
that it could not heed his words. A few weeks later, soldiers of the new Confederate
States of America opened fire from Charleston on a United States naval vessel trying
to resupply Fort Sumter, a federal installation off the coast of South Carolina. The Civil
War had begun.

*

No words can describe the horror the Civil War visited upon the people of the sun-
dered nation. It began, as most wars begin, with bursts of patriotism and pride and op-
timism on both sides. Young men rushed to sign up to fight—amateur soldiers led by
amateur commanders, joining the militias that cities, towns, and villages cobbled to-
gether in every state, North and South. The recruits put on shiny new uniforms of blue
or gray, strode down the streets of their hometowns behind brass bands and before

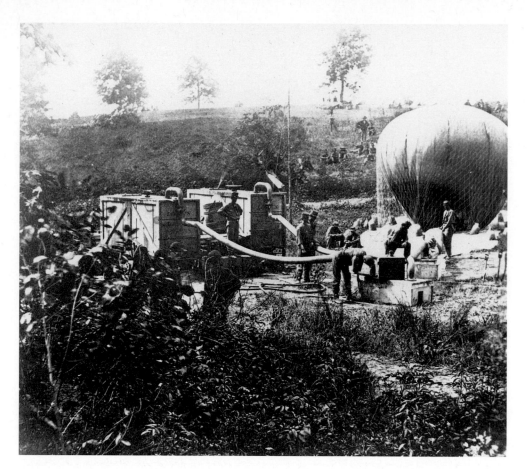

Mathew Brady Studio. *Inflation of Professor Thaddeus S. Lowe's balloon, Gaines's Mill, Virginia, June 1, 1862.* Silver gelatin print (from glass plate negative), before 1910. Lowe invented the mobile gas generator that made it possible to inflate balloons in the field. In October 1861 he established the first American Army Balloon Corps, served as the Chief Aeronaut of the Army of the Potomac, and introduced the first American use of balloons for reconnaissance. In this photograph, the balloon *Intrepid* is being inflated at Gaines's Mill to reconnoiter the Battle of Fair Oaks, just outside Washington, D.C. One of a series of battles on the Virginia peninsula from March to July in 1862, it pitted McClellan against Lee, placed at the head of a major army for the first time. The Peninsular campaign became known as the Seven Days; and though he won all but one of the battles, the faint-hearted McClellan retreated down the peninsula to the safety of the gunboats on the James River. McClellan's reputation foundered; Lee's soared.

cheering families and friends, and marched off to battle. Four years later, when the fighting finally shuddered to a close, over 600,000 of them were dead and more than a million more maimed and wounded—more casualties than in all of America's other wars, before and since, combined. As a proportion of the U.S. population, the casualties made the Civil War one of the bloodiest conflicts in human history. It shattered the economy of the South. And in the North, although there was substantial economic growth, the war produced such savage internal conflict and such vicious dissent that the region's social fabric was also forever altered. Little wonder, then, that when the war was over, a gaunt, exhausted North Carolina soldier—stacking his arms in surrender—turned to a comrade and said, "Damn me if I ever love another country."

Men and women on both sides of the rift had come to love their countries deeply—enough to make great sacrifices and to fight with extraordinary bravery in battle after battle during the long, enervating war. Bold commanders—among them Robert E. Lee, Stonewall Jackson, and P. G. T. Beauregard in the South; and Ulysses S. Grant, William T. Sherman, and George C. Meade in the North—fought each other to a standstill time and again, in battles distinguished both by innovative, often brilliant, tactics and by appalling, unprecedented casualties. At Shiloh, Tennessee, in April 1862, twenty-four thousand soldiers fell in two days of fighting. At Antietam that September, there were twenty-three thousand casualties in a single day. In neither battle did either side win a decisive victory. Yet still the armies struggled on.

The Confederates dominated the first two years of the war, using their home soil advantage and constantly frustrating the efforts of a succession of timid or incompetent Union commanders to force a decisive engagement. As an aspiring new nation in a primarily agrarian land, the Confederacy lacked both an experienced government and many of the material resources necessary for waging a large, modern war. But it prof-

ited at first from the great fervor for the cause among most of its white population and from the brilliance of its best generals.

Gradually, however, the natural material advantages of the Union—its superior transportation system, its vastly greater industrial capacity, its much larger population, its more experienced government—began to make themselves felt. So, too, did the North's superior leadership. The Confederate president, Jefferson Davis, was a stiff, pompous, inflexible man, unable either to delegate authority or to exercise it effectively. Lincoln was both a gifted leader and a brilliant politician. He was an inveterate compromiser, often criticized for inconstancy. He was derided by the political elite for his prairie twang and for his constant, often irritating, delight in telling stories and jokes. He was prone to deep fits of melancholy and self-doubt. But while Lincoln vacillated on many issues and many principles, he was unwavering in his central purposes: to preserve the Union, whatever the cost, and gradually, as the war dragged on and his resolve hardened, to end slavery everywhere and forever. "All the revolutionary vigor is with the enemy," a Confederate official once wrote in evaluating Lincoln and Davis. "With us timidity—hair splitting."

Lincoln recognized incompetence, and at great political cost he removed the arrogant and indecisive George McClellan from command of the Army of the Potomac. He also recognized talent. He elevated the once lightly regarded Ulysses S. Grant to command of the Union armies, understanding (as Grant did) that in a war of this scale tactical finesse mattered less than sheer, bullheaded determination to apply the Union's superior force unrelentingly until it prevailed. Grant, an observer once noted, "habitually wears an expression as if he had determined to drive his head through a brick wall, and was about to do it." That was, in fact, an apt description of Grant's military philosophy. "The art of war is simple enough," he once said. "Find out where your enemy is. Get at him as soon as you can. Strike at him as hard as you can and as often as you can, and keep moving on." Lincoln came to rely, too, on William Tecumseh Sherman, whose philosophy of battle was much the same. "War is all hell," he once said, by which he meant not that war is a terrible thing to be avoided, but that it should be made as brutal and costly as possible for the enemy. When the people of Atlanta implored him not to burn their conquered city in 1864, he told them: "War is cruelty, and you cannot refine it. . . . You might as well appeal against the thunderstorm as against these terrible hardships of war. They are inevitable." The city burned.

After Union armies rebuffed the bold Confederate campaign into Pennsylvania in the summer of 1863—at the great Battle of Gettysburg, perhaps the most important sin-

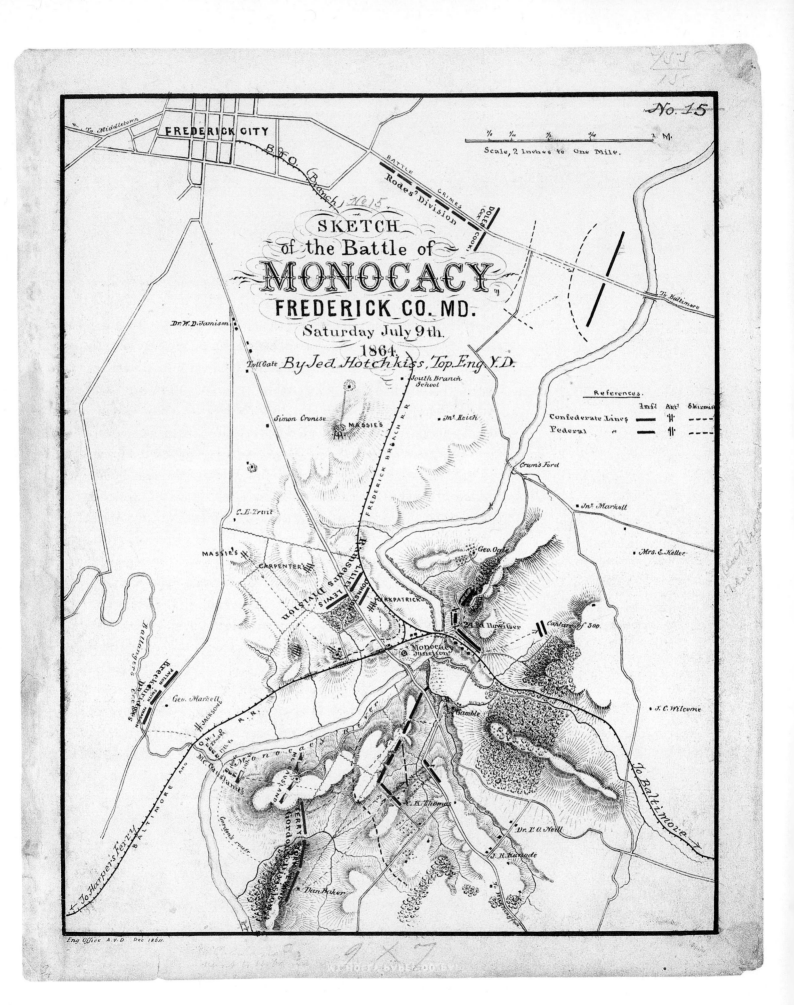

SKETCH
of the Battle of
MONOCACY,
FREDERICK CO. MD.
Saturday July 9th.
1864.
By Jed. Hotchkiss, Top. Eng. V.D.

Scale, 2 Inches to One Mile.

References.
Confederate Lines
Federal

Jedediah Hotchkiss. *Sketch of the Battle of Monocacy,* from his unpublished *Report of the Camps, Marches and Engagements of the Second Corps, A.N.V. and the Army of the Valley Dist., of the Department of Northern Virginia: during the Campaign of 1864.* Black lead and colored pencils. Manuscript map. Of the few maps that were readily available at the war's beginning, many were out of date or lacked crucial information. As the Confederate General Richard Taylor observed, ". . . we were profoundly ignorant of the country, were without maps, sketches, or proper guides, and nearly as helpless as if we had been suddenly transferred to the banks of the Lualaba." Both Union and Confederate governments, therefore, devoted significant resources to producing suitable maps. The North was relatively rich in mapmaking materials and printing equipment, and was able to build on existing units such as the Army's Corps of Engineers. The South had no comparable agencies or trained personnel in place, and throughout the war faced shortages of printing equipment, paper, and ink. Hotchkiss was the finest topographical engineer to serve in the Confederate Army. Though not a trained mapmaker, his knowledge of geography and geology resulted in beautiful and accurate maps.

gle engagement of the war—the tide slowly turned toward the North. In the western theater, Union forces consolidated control over the Mississippi River, dividing the Confederacy and occupying some of its most important ports. Grant's long siege of Vicksburg, the last important Confederate stronghold along the river, ended victoriously the day after Lee's defeat at Gettysburg. In the East, where Grant took command soon after, the Union launched a series of bloody assaults on Lee's armies in Virginia that produced few great victories but that gradually wore down the ability of the Confederate forces to continue. Slowly, Grant closed in on the Confederate capital at Richmond, while Sherman—moving from the west—rolled across Georgia (in his famous "March to the Sea"), leaving a swath of devastation in his wake. On April 9, 1865, cut off from the rest of his troops and without either the manpower or the munitions to continue, Robert E. Lee surrendered what remained of his army to Grant at Appomattox.

A few days earlier, on April 4, President Lincoln had traveled to Richmond, which Union forces had occupied at last. A tall, solitary figure in a long black coat and tall black hat, he walked solemnly through the devastated city accompanied by his son Tad. Two years before, he had signed the Emancipation Proclamation, which declared that "all persons held as slaves" within the Confederacy "shall be then, thenceforward, and forever free." Now, some of the men and women his Proclamation had touched emerged from the ruins of their city to watch him pass. "No triumphal march of a conqueror could have equalled in moral sublimity the humble manner in which he entered Richmond," a black soldier serving with the Union army later wrote. "It was a great deliverer among the delivered. No wonder tears came into his eyes." One woman, when told that she was looking upon the man who had liberated her, clasped her hands and said, "Glory to God. Give Him the praise for his goodness," and shouted "until her voice failed her." Lincoln stopped on the steps of the Confederate capitol before he left and spoke to a crowd of former slaves. "God has made you free," he said, ". . . and if those that claim to be your superiors do not know that you are free, take the sword and the bayonet and teach them that you are."

Two weeks later, Abraham Lincoln was dead.

*

No issue in American history has inspired more controversy and mythology than the tortured effort to reconstruct the nation after the close of the Civil War. To white Southerners, Reconstruction was a vindictive effort by Republican extremists to punish and impoverish the region and bend it to the North's self-interested will. To Northern Republicans, it was a determined effort to prevent the unrepentant South from restoring

the backward, aristocratic, racist world that the Civil War had been fought to eradicate. To the millions of African Americans attempting to adjust to life after emancipation, it was a small, if ultimately inadequate, first step toward freedom and economic independence. When Reconstruction finally came to an end in the 1870s—because of strenuous and at times violent resistance by white Southerners, and because of flagging will among its erstwhile defenders in the North—the once-prostrate South had rebuilt itself into something both familiar and new.

In Washington, Reconstruction was above all an exercise in high politics—pitting the new and painfully inept president, Andrew Johnson, against militant Republican majorities in Congress. Johnson was no friend of the Old South aristocracy. But he was a proud, petulant, intemperate man; and he increasingly chafed against the Republican "Radicals" in Congress who largely ignored him as they sought to impose fundamental change on the South (and, not incidentally, to strengthen the Republican party there). Thaddeus Stevens, one of the fieriest of the Radicals, expressed both the moral and political urgency with which militant Republicans faced their task: "Unless the rebel States, before admission, should be made republican in spirit, and placed under the guardianship of loyal men, all our blood and treasure will have been spent in vain. . . . I am for negro suffrage in every rebel State. If it be . . . a punishment to traitors, they deserve it."

The impasse between the president and Congress continued for more than two years, culminating in a (barely) unsuccessful effort to impeach Johnson in 1867. Gradually, however, Congress stripped the president of almost all authority over Reconstruction and implemented an ambitious plan of its own. It also introduced three new amendments to the Constitution, all of them eventually ratified and all among the most important in American history: the Thirteenth, which abolished slavery; the Fourteenth, which declared "all persons born or naturalized in the United States" to be citizens (thus negating the *Dred Scott* decision) and which guaranteed to all Americans "the equal protection of the laws"; and the Fifteenth, which promised the right to vote to all male citizens, regardless of "race, color, or previous condition of servitude."

The Reconstruction laws—and the federal troops stationed in the South to help enforce them—had many visible effects on the region. They created, for a time, a sizable black electorate while simultaneously (if briefly) barring many former white Confederates from the franchise. A large number of African Americans were thus elected to public office. White Southerners (and some white Northerners) complained loudly of what they called "Negro rule" and went to great lengths to ridicule African-American

Mercer Brown. *Radical Members.* Albumen silver print on printed mount. Photomontage. Baltimore, 1876.
After the war, Radicals urged that civil and military leaders of the late Confederacy be punished, large numbers of Southern whites be disenfranchised, and the property of wealthy white Southerners who had aided the Confederacy be confiscated and distributed among the freedmen. Some Radicals favored granting suffrage to the former slaves, and this was eventually achieved by the Fifteenth Amendment in 1870. South Carolina was readmitted to the Union in 1868. Approximately one-fourth of the state's white males were excluded at first from voting or holding office; and this produced a radical victory and a black majority in the electorate.

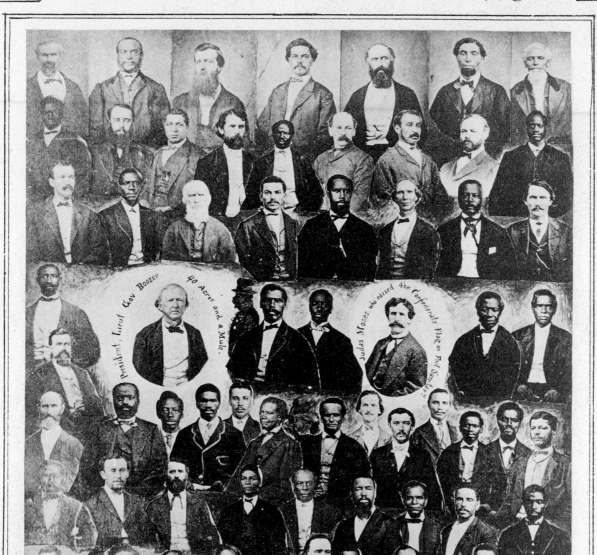

RADICAL MEMBERS

OF THE FIRST LEGISLATURE AFTER THE WAR

SOUTH CAROLINA

Dusenberry	Mayes	Demars	Rivers	Miteford	Smith	Swails
McKinlay	Jillson	Brodie	Duncan	White	Pettengill	Perrin
Dickson	Lomax	Hayes	BOOZER	Barton	Hyde	James
Wilder	Jackson	Cain	Smythe	Boston	Lee	Johnston
Hoyt	Thomas	Maxwell	Wright	Shrewsbury	Simonds	Wimbush
Randolph	Webb	Martin	MOSES	Mickey	Chesnut	Hayes
Harris	Bozeman	Cook	Sancho	Henderson	McDaniel	Farr
	Tomlinson	Miller	Sanders	Howell	Williams	Meade
	Wright *		Nuckles	Hayne	Gardner	Thompson
				Mobley		Rainey
				Hudson		
				Nash		
				Carmand		

* Afterwards associate Justice of the Supreme
Court of the State

officials. "The Speaker is black, the Clerk is black, the door-keepers are black, the little pages are black, the chairman of the Ways and Means is black, and the chaplain is coal-black," a Northern observer, James S. Pike, wrote scornfully of the South Carolina legislature in 1873. "At some of the desks sit colored men whose types it would be hard to find outside of the Congo."

In reality, African Americans never dominated any state government in the South. Only once—and only briefly—did they establish a majority in even one chamber of a state legislature (the South Carolina House of Representatives, which Pike mocked). A few black men served in Congress. None was ever elected governor. Most of those who did hold office—some of them in the face of vicious abuse, intimidation, and violence—did so responsibly, ably, and usually far from radically. "I plant myself on the broad principle of the equality of all men as the basis of true republicanism," an African-American delegate to the 1868 South Carolina convention said in opposing a provision that would make school attendance compulsory for children; "and to compel any man to do what this section provides is contrary to this principle." Reconstruction governments created public schools in states that had always had many fewer of them than the rest of the country. They invested in roads, bridges, and other public works. They made some of the region's first attempts at poor relief. And like governments in all parts of the nation in this age of rapid economic expansion, they accumulated debts and at times experienced graft and corruption.

But the most important changes in the South occurred outside the province of governments. They were the result of efforts by emancipated slaves to craft new lives in freedom. Many black men and women had liberated themselves from their former masters before the law intervened to help them. Even before the war was over, slaves began leaving their owners and moving off in search of work elsewhere—a great and, at times, aimless migration across the South of thousands of self-liberated men and women, most of them with nowhere to go. After the war ended, the former slaves rebelled as well against the old gang-labor system of the plantations. They insisted on at least physical independence from the white landowners; and because few had the resources to buy land of their own, most who chose to remain in the countryside worked as tenants—usually paying for the use of the land they farmed with a share of the crops they raised, hence the term "sharecropper." Tenantry soon imposed enormous debts on these landless farmers, debts that many could never hope to pay and that became another form of bondage—less total, but for many no less inescapable, than slavery. Other former slaves moved to towns and cities, where they formed new black commu-

nities (or expanded existing ones) and supported themselves with what were usually menial jobs. In both town and countryside, blacks formed their own churches, established fraternal societies, and—when they could secure even modest capital—created new businesses.

But Reconstruction fell well short of assuring black Americans anything approaching real freedom. At its end, hardly less than at its beginning, they remained economically dependent on white Southerners, who owned virtually all the land and controlled virtually all the capital in this now impoverished region, and who—while they conceded that slavery was dead—remained fervently committed to maintaining what they now began to call "white supremacy." Even before federal protections were withdrawn in the 1870s, rigid patterns of segregation were visible throughout the South: separate schools, white-only hotels and restaurants and railroad cars and theaters. Ku Klux Klan terrorists attacked, and often murdered, those African Americans who dared to challenge white supremacy. Robin Westbrook, a proud black Republican in the little town of Demopolis, Alabama, was one of many who paid for his convictions with his life. Klansmen burst into his house one night and (in the words of his wife) "put two loads of a double-barreled gun in his shoulders." One Klansman said " 'Kill him, God damn him,' and took a pistol and shot him down. He didn't live more than an hour."

Frederick Douglass, looking back on Reconstruction after its conclusion, judged the experiment a tragic failure. "What is your emancipation?" he asked his white readers. "When you turned us loose, you gave us no acres. You turned us loose to the sky, to the storm, to the whirlwind, and, worst of all you turned us loose to the wrath of our infuriated masters." But white Southerners, who had struggled successfully to cripple Reconstruction, also had some reason to question the value of their victory. They had ensured their dominance over the former slaves and had preserved at least the remnants of the former white aristocracy. But they had done so at the cost of economic progress—stifling commercial and industrial growth in all but a few areas of the South and condemning the region to decades of poverty, isolation, and backwardness.

And yet Reconstruction is not only notable for its failure. For during it, a proud people—the millions of African Americans now loosed from generations of bondage—carved out of harsh and often malignant conditions at least a semblance of freedom. They could say at its end, even if little else, that after more than two centuries in America they were slaves no more.

* * *

Arthur Joseph Stansbury. *The original sketch of Mr. Adams, taken when dying by A.J.S. in the Rotunda of the Capitol at Washington.* Pencil drawing. Washington, D.C., 1848.
On February 21, 1848, John Quincy Adams suffered a stroke at the Capitol during his ninth successive term as congressman from Massachusetts. This sketch was made while he lay unconscious in the Rotunda before he was carried to the Speaker's room, where he died two days later without having regained consciousness. Adams's severe, uncompromising political style had won him few friends during his single presidential term (1825–29) or at the Capitol, yet he was widely admired for the force of his intellect and independent nature. Congressional reporter Arthur J. Stansbury softened the memory of Adams with this tender deathbed sketch. Sarony & Major, a New York lithographic firm that produced some of the finest American historical prints of the nineteenth century, issued a highly successful commercial lithograph after this drawing.

African-American group. Salt print from Larkin J. Mead, Civil War album. Hand-made album. Virginia, 1861 or 1862.
This photograph was found tucked into the pocket album of photographs and sketches kept by the engraver and sculptor Larkin Mead during the year and a half he spent in Virginia as an illustrator for *Harper's Weekly* newspaper. Mead was a member of New England's pre–Civil War intellectual elite who, thanks to abolitionist tracts and literature, were well aware of the inhumanities of slavery and were enraged by the Supreme Court's *Dred Scott* decision that denied blacks Constitutional rights. Numbers of them went South after the first successes of the Yankee blockade to assist the newly released slaves. Educated but not always wealthy, many of these activists were committed to utopian socialism, abolition, and full citizenship rights for women. Mead may have used this photograph as a model for his own newspaper illustrations.

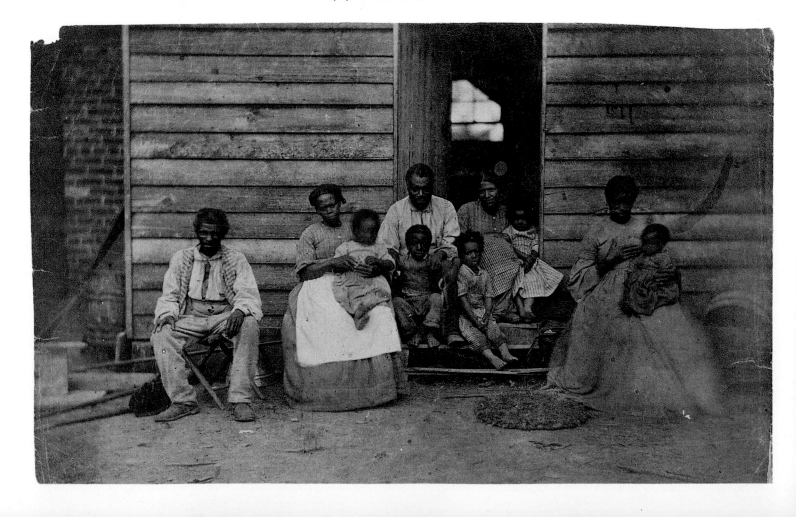

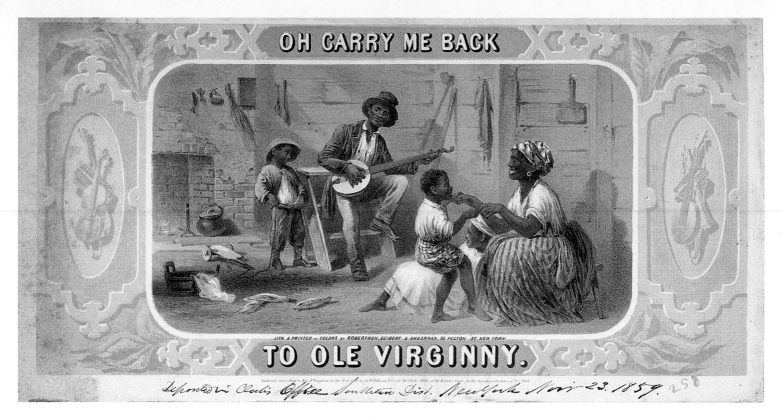

Robertson, Seibert & Shearman, after Eastman Johnson. *Oh Carry Me Back to Ole Virginny.* Color lithograph. New York, 1859.

This tobacco label's central vignette of a banjo player, a young woman, and three youths was appropriated directly from a painting entitled *Negro Life at the South* by Eastman Johnson. A popular and critical success that landed Johnson in the prestigious National Academy of Design, *Negro Life* depicted an African-American family relaxing in the yard of a dilapidated urban residence (actually, the house of the artist's father in Washington, D.C.). That the label portrays the family group with such affection and dignity is not surprising; the pre–Civil War tobacco industry was dominated by Southern manufacturers determined to preserve slavery and present an engaging and sentimental image of black life in the South.

The label's title refers to a folk song from the early nineteenth century, not the more famous, onetime state anthem of Virginia by James A. Bland, the first African American to enjoy major success in the popular music field.

Rufus Anson. *Joseph Jenkins Roberts, President of Liberia.* Sixth-plate daguerreotype, c. 1851.

Born in Virginia to free parents, Joseph Jenkins Roberts emigrated to Liberia in 1829 under the auspices of the American Colonization Society, a private philanthropic organization established in 1817 for the purpose of relocating freeborn and emancipated blacks to Africa. Colonization as an alternative to integration appealed to a small percentage of blacks and whites. Approximately twelve thousand blacks had moved to Liberia by 1861, when the outbreak of the Civil War greatly reduced emigration. Roberts established a successful export business between Africa and the United States before holding a series of political offices including lieutenant governor, chief of state, and governor of Liberia. When the country declared its independence in 1847, he was elected its first president.

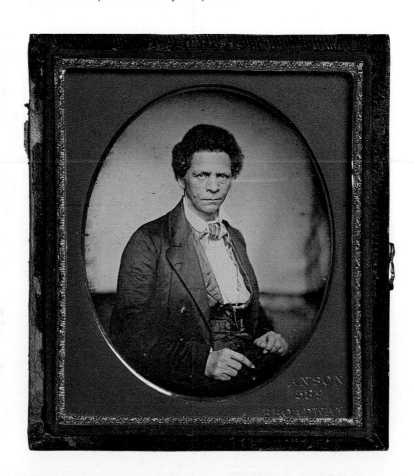

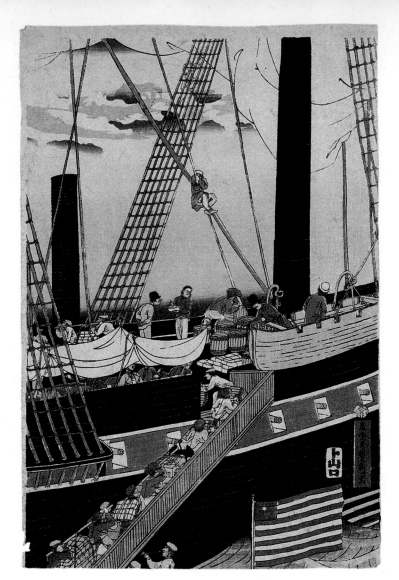

Sadahide Utagawa. *Yokohama koeki seyojin nimotsu unso no zu.* Color woodcut. Yokohama, Japan, 1861.

In 1854 Commodore Matthew Calbraith Perry engineered the Treaty of Peace and Amity, opening Japanese ports to American traders for the first time in two centuries and paving the way for further trade agreements between Japan and England, France, Russia, and the Netherlands. The subsequent exchanges of material, culture, technology, and ideas inspired both Western and Eastern artists. The Japanese artist Sadahide recorded this view of cargo being loaded onto an American ship at Yokohama at a moment when Western trade with Japan had reached full stride. Yokohama prints were often issued in sets of five to symbolize the five treaty nations; this image is one of five woodcut panels illustrating Western trading ships at the thriving seaport. Noted for his firsthand observations, Sadahide related having borrowed a pencil from a foreigner to finish the sketch for this scene, after dropping his paintbrush in the water.

Charles Parsons, after J. B. Smith & Son. *The Clipper Ship "Red Jacket."* Hand-colored lithograph. New York, 1855.

During the 1850s, the rush to mine gold in California and Australia and an increasingly open trade with the Far East spurred the development and construction in America of the fast, seaworthy vessels known as clipper ships. Larger, longer, and faster than the coastal "Baltimore" clippers that inspired their design, American clippers outraced their British competition and delivered gold and tea to London from Melbourne and Hong Kong, and passengers and provisions from Boston and New York to San Francisco. Fast sailing times led to increased profits and publicity, and like great racehorses, the fastest clippers were celebrated in newspapers, magazines, and popular prints for their beauty, speed, and record-setting runs. In 1854 *Red Jacket* broke the record from New York to Liverpool, crossing the Atlantic in thirteen days and one hour, a pace of 413 nautical miles per day.

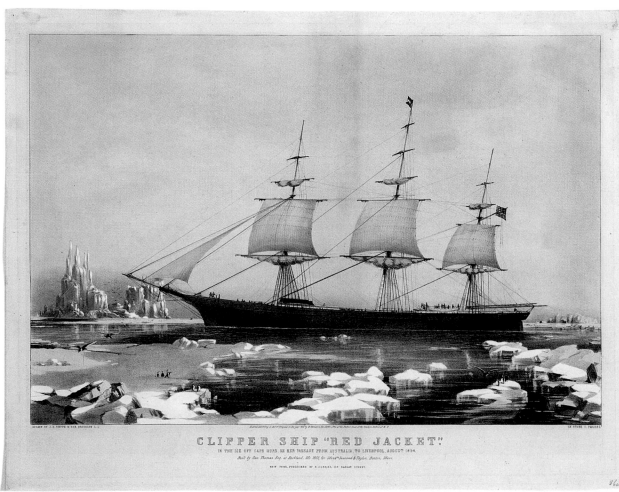

CLIPPER SHIP "RED JACKET"
IN THE ICE OFF CAPE HORN, ON HER PASSAGE FROM AUSTRALIA TO LIVERPOOL, AUGUST 1854.

Mathew Brady Studio. *Horace Greeley.* Half-plate daguerreotype. New York, c. 1850.
The eccentric editor of the *New York Tribune* personified the ebullient spirit of American politics in the 1850s. A founding member of the Republican Party, passionate in his belief that all Americans should be politically and economically free, he spoke out against monopolies, in support of labor unions and experiments in "constructive democracy," and against slavery. Here he presents himself for Mathew Brady's camera, wearing his characteristic hobnail boots, stovepipe hat, and long coat. Brady's gallery on Broadway in New York was de rigueur for public figures and celebrities in the 1840s and 1850s, and his corpus of daguerreotype portraits, preserved in the Library of Congress, is a veritable "who's who" of antebellum America.

George Wevill, after Henry Louis Stephens. *Vanity Fair!* Color woodcut. Poster. New York, 1861.
Vanity Fair was one of the most popular of a growing breed of comic weeklies published in the United States before the Civil War. True to the claims of its advertisers, the magazine offered "good art and spicy comments on affairs." Henry Louis Stephens, creator of most of the fine woodblock cartoons and caricatures for the magazine, also created this poster. It is an early example of the large, graphically bold images designed for outdoor display to engage the attention of passersby in a bustling urban environment.

Stephens's poster refers to the great influx of Chinese between 1830 and 1870, when thousands were lured to America by false promises of high wages in the gold mines and on construction of the transcontinental railroad. Eventually, daunted by minimal pay and deplorable living conditions, the majority of Chinese settled in California and New York where they formed the first Chinatowns.

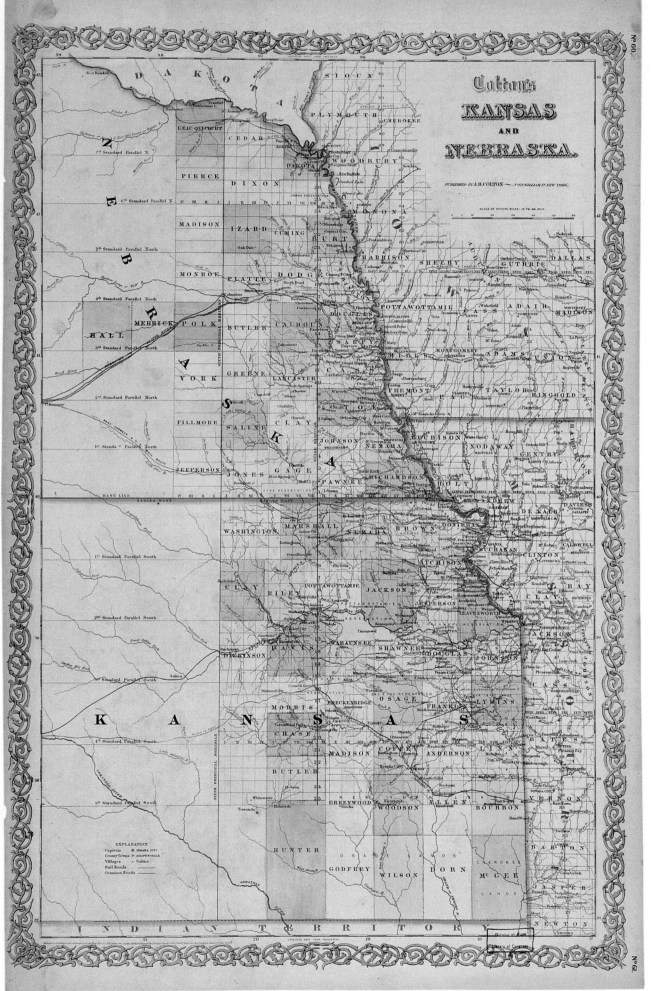

J. H. Colton. *Colton's Kansas and Nebraska.* Lithograph with watercolor. [New York], 1855.

Interest in a northern route for the transcontinental railroad led to the reclaiming of the fertile area beyond the Missouri River previously ceded to the Indians. Two states were to be carved from this "Nebraska Territory": Kansas and Nebraska, with the final decision on slavery to be decided by popular sovereignty. In the mid-1850s agitators on both sides of the slavery question, goaded and financed by New England abolitionists on the one hand and Southern slaveholders on the other, perpetrated raids, murders, kidnappings, and other forms of terrorism in the border counties shown here. This is the initial survey of the territory by the General Land Office, noting the townships and the earliest eastern settlement. J. H. Colton was a major cartographic publisher, whose map was intended for general reference as well as for prospective settlers of the area.

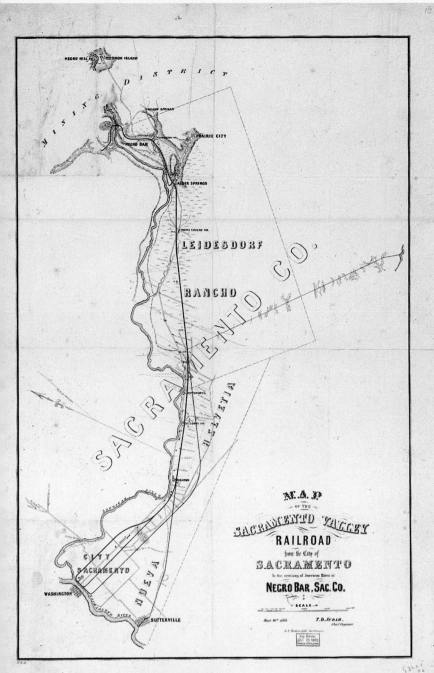

T. D. Judah. *Map of the Sacramento Valley Railroad.* Lithograph. San Francisco, 1854.

Long before 1869, when the rails of the Central Pacific and the Union Pacific were joined to form the transcontinental railroad, the "iron horse" provided a relatively fast and economical means of conveying goods and people within regions such as northern California. This is the official survey map for the first California railroad, showing the rail line that linked the gold fields of Negro Bar and Mormon Hill with the state capital and river transport to the coast. T. D. Judah laid out the town of Folsom at Negro Bar, which was named after the first black gold miners who settled there in 1849. Later he was the guiding spirit in building the Central Pacific Railroad across the Sierra Nevada Mountains.

Los Angeles. Lithograph from Lieutenant R. S. Williamson, *Report . . . upon the routes in California to connect with the routes near the 35th and 32nd parallels.* House Executive Document, No. 91, 33rd Congress, 2nd Session, Serial Set 795, Vol. 5, Pl. X. Washington, D.C., 1857.

Lieutenant Williamson, of the Corps of Topographical Engineers, made this report as part of the *Explorations and Surveys* authorized by Congress in 1854–55, under the direction of the Secretary of War, "to ascertain the most practicable and economical route for a railroad from the Mississippi River to the Pacific Ocean." Such reports detail terrain, botany, animal life, and Indian communities met on the trails. Williamson writes: "About 21 miles southeast of San Fernando is the Pueblo de los Angeles, formerly the capital of California, when under Mexican rule. This place is celebrated for its delightful climate and fertile soil. Large quantities of grapes are exported to San Francisco, and considerable wine was formerly produced. The accompanying view (Plate X) was taken from a hill near the city."

**Edwin Forbes. *Lagonda Agricultural Works.*
Color lithograph. New York, 1859.**
In 1862 the Homestead Act permitted any
citizen or prospective citizen to claim 160
acres of public land and to purchase it for a
small fee after living on it for five years.
(Congress eventually raised the allotment to
1,280 acres at little cost.) This act promoted
the rapid development of the West, and
American farmers reaped benefits from the
Industrial Revolution as technological ad-
vances—building on Jefferson's plow—
changed the way their produce was planted,
harvested, refined, and sent to market. As
increasingly large and mechanized farms
emerged, however, to provide for the nation's
military needs during the Civil War and for its
burgeoning urban populations after the war,
the small farmer's way of life began to slip
away.

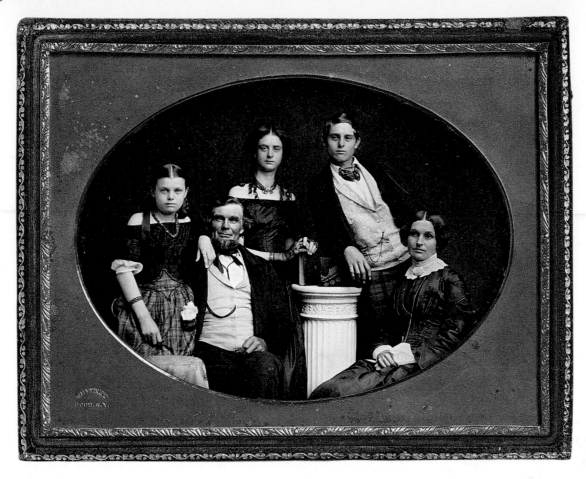

Edward Tompkins Whitney. Benjamin Family group portrait. Half-plate daguerreotype. Rochester, New York, c. 1850.
Industrialization led to profound changes in family life at the beginning of the nineteenth century. Men worked outside the home and were able to purchase a wide range of consumer goods. Women, the prime partici- pants in the "cult of domesticity," assumed the day-to-day responsibilities of raising well- mannered children, maintaining a secure and nurturing household, and infusing the home with a moral and religious atmosphere. These qualities were highly valued, for they were thought to strengthen society in general.

This daguerreotype was donated to the Library by Frances Benjamin Johnston, a successful woman photographer who worked during the first half of the twentieth century. Johnston's maternal grandfather, Zina Ben- jamin—the prosperous boatbuilder pictured here—launched many craft, including steam tugs, into the waters of the Erie Canal. Johnston's mother, Frances Antoinette Clark, stands in the middle of the group.

Seamstress. Sixth-plate daguerreotype, c. 1853.
The seamstress was one of the few female wage workers accorded dignity by the cham- pions of domesticity. Earlier in the nineteenth century, work in textile factories had been considered appropriate for New England farm girls prior to marriage, but the drive for profits undermined working conditions until these increasingly harsh jobs became socially and economically unacceptable for all but recent immigrants. This portrait of an uniden- tified sewing-machine operator may suggest solemn dignity and seclusion, but actually she is seated at an 1853-model Grover and Baker industrial sewing machine and was most likely engaged in the production of an umbrella or a coat lining. Whether made for a proud member of the emerging class of skilled industrial workers or by a manufacturer for advertising purposes, the photograph care- fully presents sewing and the use of sewing machines as part of a respectable middle-class lifestyle.

Temperance advocate. Sixth-plate daguerreotype, c. 1851.

The evils of alcohol, along with the evils of slavery, were among the first social issues to motivate women to participate in public life in the nineteenth century, leading directly to their fight for suffrage. Members of the Sons of Temperance, a fraternal society founded in 1842 in New York City, pledged never to make, buy, sell, or imbibe any spirituous or malt liquor, wine, or cider. The unidentified subject of this daguerreotype holds a copy of the *Sons of Temperance Offering for 1851,* a volume of short stories and poems issued annually during the society's heyday that included many contributions from women. Membership in the Daughters of Temperance, a sister organization to the all-male Sons, peaked in 1848 with thirty thousand women. Society benefits included assistance to those whose husbands were unable to provide for their families due to illness or death. In 1852, when the Daughters were denied equal participation at a convention organized by the Sons, their walkout led to the formation of the Women's New York State Temperance Society.

Richard Upjohn. Designs for a wooden church. Drawing, graphite, ink, and watercolor. [New York], c. 1850. Founder and first president of the American Institute of Architects, Richard Upjohn was a key figure in the Gothic Revival that determined the form and appearance of American ecclesiastical buildings for almost a century. Upjohn's work for the Episcopal Church during its great flowering of the 1840s and 1850s patterned houses of worship throughout the country. Bountiful forests made his widely published designs for wooden churches eminently practical for congregations in smaller towns and rural areas. As a former carpenter, he was especially inventive in his use of simple "board and batten" cladding, shown here.

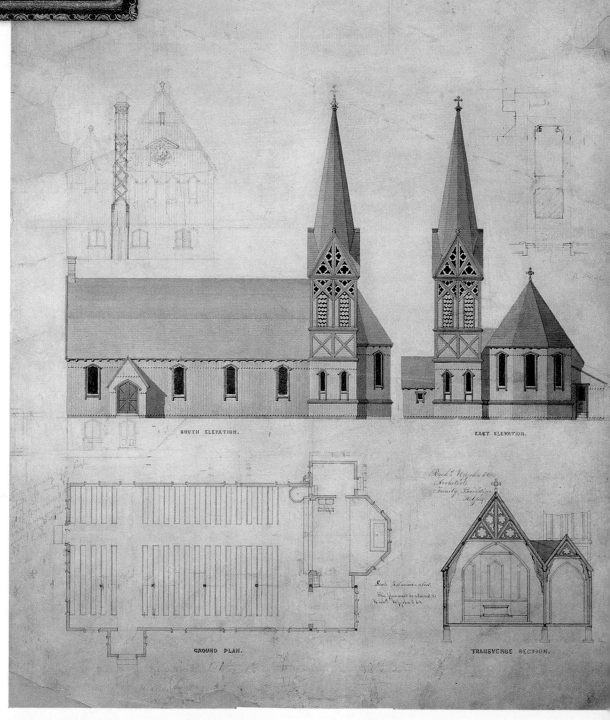

SOUTH ELEVATION.

EAST ELEVATION.

GROUND PLAN.

TRANSVERSE SECTION.

Walt Whitman. Trial title page with author's annotations for *Leaves of Grass.* **New York, 1891–92.**

Later known as the "deathbed edition," this is the last edition of Whitman's poetry that he personally saw through the publication process. It was his habit to involve himself at every step: designing title pages, proofreading, revising publicity copy. Since July 4, 1855, when *Leaves of Grass* was first published, Whitman had been renouncing previous versions every time a new, "authoritative" one appeared. Two months before his death,

he prepared this announcement for the *New York Herald:* "Walt Whitman wishes respectfully to notify the public that the book *Leaves of Grass*, which he has been working on at great intervals and partially issued for the past thirty-five or forty years, is now completed, so to call it, and he would like this new 1892 edition to absolutely supersede all previous ones. Faulty as it is, he decides it is by far his special and entire self-chosen poetic utterance." With the joy of a troubadour, Whitman helped liberate verse from restrictive convention.

Platt Babbitt. *Niagara Falls.* **Whole-plate ambrotype, c. 1854.**
The awe-inspiring scenery of Niagara Falls has attracted tourists since the early 1800s. Capitalizing on the area's natural beauty, Platt Babbitt established the first photographic studio at the falls in 1853 and obtained the exclusive right to operate at Point View, later known as Prospect Point. Taken from a fixed vantage point, Babbitt's images are nearly identical, the only variables being the people and the atmospheric conditions. By 1860 at least ten photographers had studios at the falls, and before the close of the century, Niagara Falls had become the most photographed site in the nation.

By the mid-1850s the daguerreotype had been largely replaced by the ambrotype, a faster and less expensive photographic process that used a glass plate rather than polished metal.

Carleton E. Watkins. Cathedral Rocks, Yosemite. Albumen silver print. California, c. 1861.
Word of the majestic beauty of seven-mile Yosemite Valley spread quickly after Anglo-American military ventured into it to remove the Ahwani tribe from their ancestral lands in 1851. When Carleton Watkins visited the area ten years later with his mammoth plate camera, the valley already had its first hotel. Rendered in meticulous detail thanks to his consummate skill with the awkward wet-plate medium, Watkins's views inspired many American painters and induced Congress to pass a bill in 1864 requiring the state of California to protect Yosemite forever from private development. Through the subsequent efforts of landscape designer Frederick Law Olmsted, whose personal collection (now at the Library of Congress) contained this print, and at the urging of naturalist John Muir, Yosemite was proclaimed a national park in 1890. A native of Oneonta, New York, who had traveled during the Gold Rush, Watkins returned to photograph his beloved Yosemite at least five times over a period of twenty years.

Calvert Vaux. Ink survey and conceptual sketch plan for Prospect Park, Brooklyn, New York. Manuscript map, January 9, 1865.

Writing in 1893 of his professional partner, Calvert Vaux, Frederick Law Olmsted asked the reader to "consider that he and I were one. I should have been nowhere but for his professional training." Vaux's initiative was critical to the firm's securing of two of its most important and influential commissions: New York City's Central Park and Brooklyn's Prospect Park. The city of Brooklyn (the nation's third most populous in the 1850s) spent more than $11 million over seven years on the acquisition and improvement of the park. By the summer of 1871 over 250,000 people were visiting it each month.

The founding of the firm of Olmsted and Vaux in 1858 marked a key point in the evolution of the profession of landscape architecture and in the nation's commitment to managed care of its natural environment.

S. W. Chandler & Bro. *Walden Pond. A reduced Plan. 1846.* Lithograph from Henry David Thoreau, *Walden, or Life in the Woods.* Boston, 1854.

On July 4, 1845, Henry David Thoreau took up residence at a pond on the property of Ralph Waldo Emerson, the most influential teacher and lecturer of his day, and engendered a sacred place in American intellectual history. Thoreau was an advocate of civil disobedience and an apostle of transcendentalism, which taught that each individual should strive to transcend the limits of the intellect and allow the emotions, or the soul, to create an "original relation to the Universe." For more than two years Thoreau remained at Walden Pond in Concord, Massachusetts, seeking a retreat for philosophical meditation and "a simpler, hardier, and healthier life." Thoreau drew this schematic plan of the pond to accompany his journals from this period, published as *Walden, or Life in the Woods.*

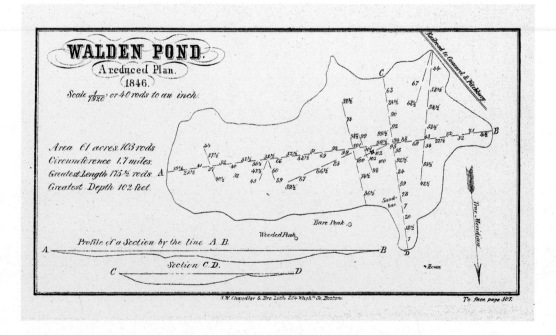

Mathew Brady Studio. Charlotte Cushman as Meg Merrilies in *Guy Mannering*. Contemporary gelatin silver print (from glass plate negative). New York, c. 1855.
Among the great and notorious whose likenesses were captured by Brady's photographers was Charlotte Cushman, America's foremost actress during her lifetime and an international star. Cushman moved audiences through her skill, expressive genius, intellect, and powerful voice, rather than by beauty or sex appeal. She played both male and female roles, and besides Romeo, Queen Katherine, and Lady Macbeth, one of her most popular roles was Meg Merrilies, of which the critic William Winter wrote: "Her voice . . . had in it an unearthly music that made the nerves thrill and the brain tremble."

Charlotte Cushman. *Guy Mannering.* Annotated prompt book, 1850.
As leading player in the Broadway Theater's 1850 production of a play based on Sir Walter Scott's 1815 novel, Cushman assumed directorial duties. This was her prompt book, which helped the management to prepare the production. During actual performances, prompt books would orchestrate entrances, exits, props, technical cues, and line cues at a time when most actors had copies only of their own parts. For stars like Cushman, who toured the country extensively, these detailed books were indispensable to mounting productions with short rehearsal periods and companies who had never before worked with her or with the play. This spread shows light and setting changes, with a design and property list for the grove scene in which Meg makes her entrance.

Mathew Brady Studio. *Edwin Forrest.* Albumen silver print mounted on card. Carte de visite. New York, 1862.
Edwin Forrest was the first American-born actor to achieve international fame, and a boon for native playwrights. His work was bold and large, devoid of subtlety, and marked by electrifying climaxes of passion. At the height of his career, he became embroiled in a rivalry with the English actor William Macready. When an angry mob of Forrest's fans—seeing him as a symbol of democracy—attacked the Astor Place Opera House in New York during Macready's 1849 farewell American engagement, twenty-two people were killed and thirty-six wounded. Forrest's reputation was tarnished by the episode, but his fame endured.

The carte de visite, as its name suggests, was a variation on the traditional calling card, a staple of Victorian social etiquette. Between 1857 and 1900, it quietly effected a cultural revolution by placing the photographic image on a par with the printed word. Millions were sold each year, and the format survived into the 1920s.

Joseph Morse. *Five Celebrated Clowns Attached to Sands, Nathan Co's Circus.* Color woodcut. Poster. New York, 1856.

The circus flourished in the United States from its earliest manifestations—traveling animal acts, jugglers, tightrope dancers, and clowns—to become one of the most spectacular and popular forms of entertainment. This mammoth woodcut advertisement, larger than 11 feet by 9 feet, was created by Joseph Morse, a New York wood-engraver and innovator of early poster design. By gluing several pine planks together, he increased the surface area of the wooden printing block, enabling him to print large-scale advertising bills.

One of the largest overland circuses of the era, Sands, Nathan Company was distinguished for its pair of performing elephants (named Victoria and Albert) and for presenting, during the 1850s, one of the first steam calliopes.

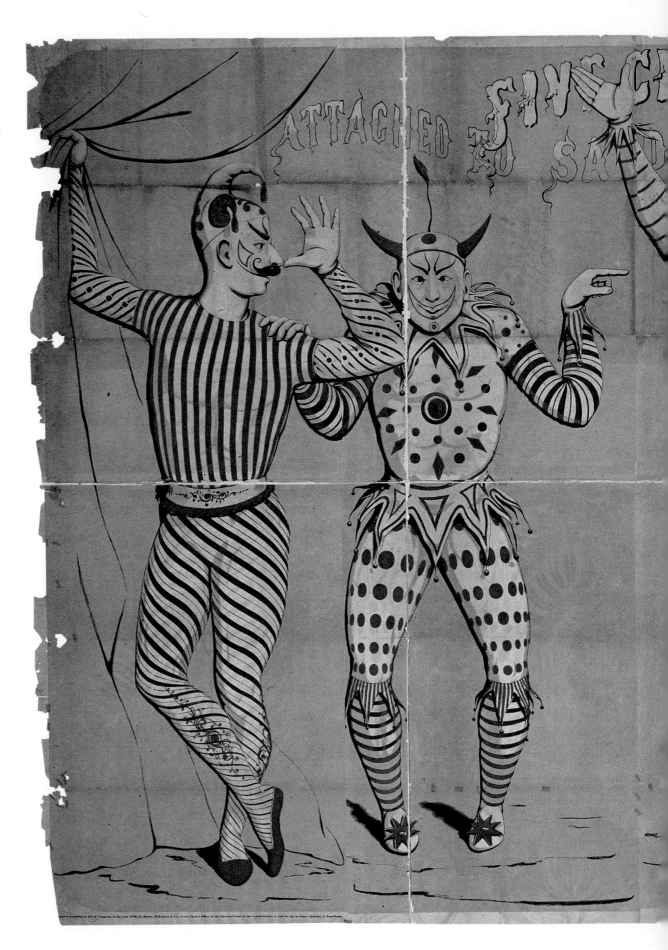

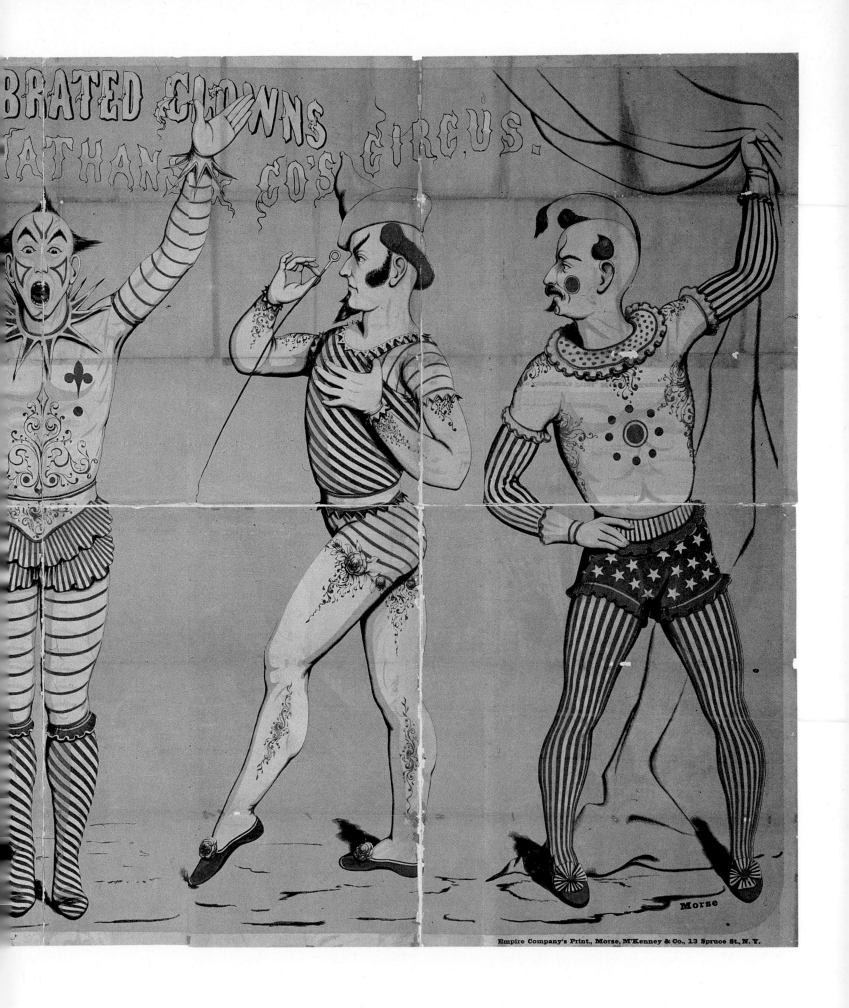

Empire Company's Print., Morse, McKenney & Co., 13 Spruce St., N.Y.

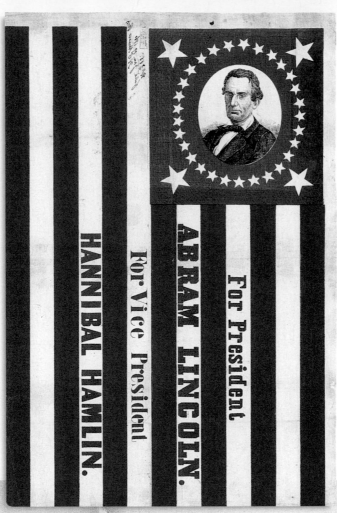

H. C. Howard. *For President Abram Lincoln.*
Color woodcut or lithograph printed on
muslin. Banner. Philadelphia, 1860.
Use of the graphic arts to further political
aims has a strong tradition in American
history, and the 1860 presidential campaign—
pitting Republican Abraham Lincoln against
Constitutional Unionist John Bell and Demo-
crats John Breckinridge and Stephen Douglas,
who split their party's vote—was no excep-
tion. Bold, brightly colored banners, outra-
geous political cartoons, sentimental sheet
music covers, patriotic portraits, and visually
stirring certificates of membership in rival
political clubs were printed to sway individual
voters and popular opinion. Banners like this
one were not unique to Lincoln's campaign,
and the Library has in its collections an almost
identical banner promoting John Bell from
the same Philadelphia printing shop of
H. C. Howard.

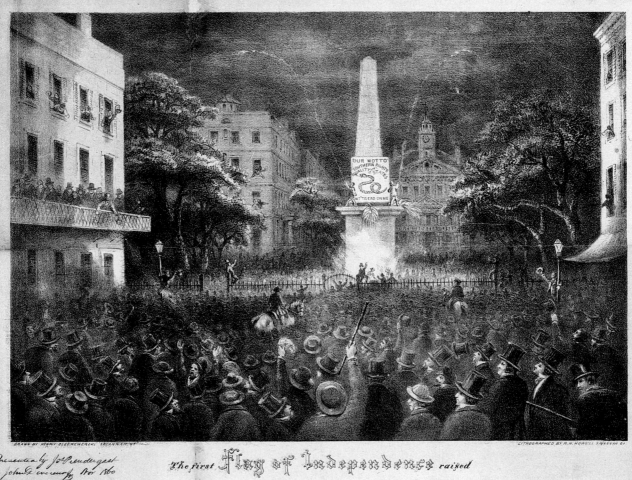

The first Flag of Independence raised
in the South, by the Citizens of Savannah, Ga. November 8th, 1860.

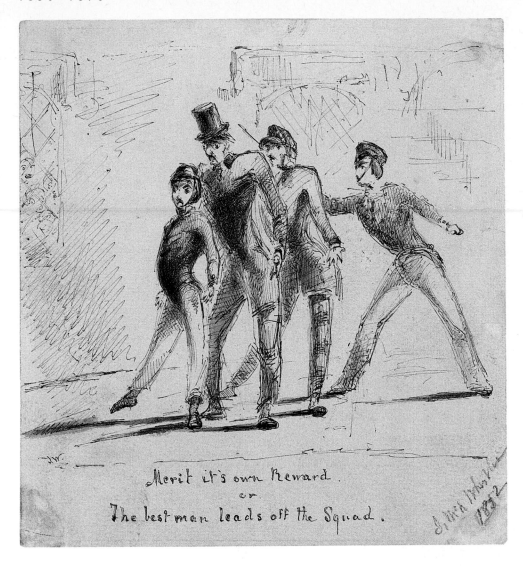

James McNeill Whistler. *Merit its own Reward, or The best man leads off the Squad*. Drawing, pen and black ink with wash. West Point, New York, 1852.

Before becoming one of the most celebrated and controversial artists of his era, James McNeill Whistler tried his hand briefly at a military career. Robert E. Lee was superintendent of West Point Military Academy the year Cadet Whistler made this satirical sketch. Whistler proved to be patently unsuited to the military profession and left in 1854 under the weight of a failed chemistry exam. He would later sally, "If silicon had been a gas, I would have been a general!"

Unidentified Union soldier. Sixth-plate ambrotype, c. 1863–65.

The families of countless infantrymen who fought, and fell, in the Union and Confederate ranks during the Civil War nurtured the memory of their loved ones through affordable ambrotype and tintype portraits. This example attests to the black military presence in the war. By its end, more than 180,000 African Americans had enlisted, creating a ratio of one black soldier to every eight white soldiers. This man's uniform with kepi (cap) identifies him as a private.

Opposite: R. H. Howell, after Henry Cleenewerck. *The first Flag of Independence raised in the South*. Lithograph. Savannah, Georgia, 1860.

In Savannah, Georgia, angry citizens responded to Lincoln's 1860 victory with a public rally on the night of November 8 calling for a state convention to ratify secession. The rally was held in Johnson Square, a public plaza dominated by an obelisk draped for the event with a banner reading "Our Motto Southern Rights, Equality of the States, Don't Tread On Me." First used by Americans during the Revolutionary War, the phrase "Don't Tread On Me" in conjunction with a coiled snake signals the militant mood of Southern secessionists five months before war broke out.

Shortages of capital, equipment and spare parts, and paper and ink made commercial print publishers in the South—already scarce prior to the war—virtually extinct. The few popular prints that survive date from the early years of the conflict and glorify the Confederate cause and its leaders.

Mathew Brady Studio. *The Fifth Vermont Infantry at Camp Griffin, Virginia.* Salt print from Larkin J. Mead, Civil War album. Hand-made album. Virginia, 1861.

The Fifth Vermont took part in the massive mobilization to defend the capital, after the neighboring state of Virginia joined the Confederacy. Lieutenant-Colonel L. A. Grant sits on his horse to the right; Major Redfield Proctor is to the left. *Harper's Weekly* engraver Larkin Mead kept this photograph tucked into a small album of sketches and photographs from his Civil War stint as a newspaper illustrator. A loyal Vermonter, he had good reason to prize this picture: in 1861 Camp Griffin received a visit from Julia Ward Howe, who reviewed these troops with other dignitaries and was inspired to write "The Battle Hymn of the Republic."

Women's roles changed dramatically during the war. Many volunteered to make clothing for the troops and worked for relief agencies. The nursing profession, formerly a male domain, employed over three thousand women; and some women, disguised as men, enlisted and fought.

J. B. Elliott. *Scott's Great Snake.* Color lithograph. Cincinnati, Ohio, 1861.

As commander of the Union forces, General Winfield Scott conceived a strategy early in the war to crush the Confederacy with a blockade of its shipping combined with a major offensive down the Mississippi. The strategy was sometimes referred to as the Anaconda Plan. This cartoon map expressed Northern optimism about the prospects for a rapid victory, soon to be dashed by the debacle at Bull Run. Scott was unprepared for the magnitude of the conflict; he retired in 1861 and was replaced by proud, arrogant George B. McClellan, who had a wholly inadequate grasp of strategy. But Scott's plan was never wholly abandoned.

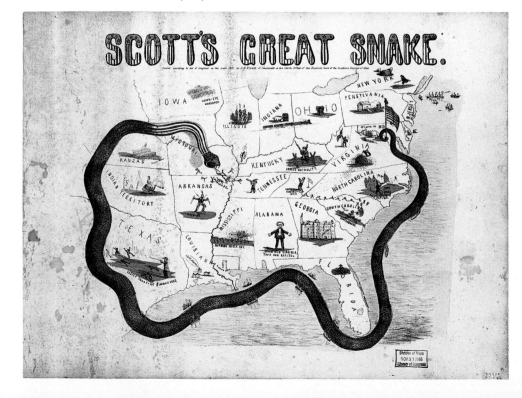

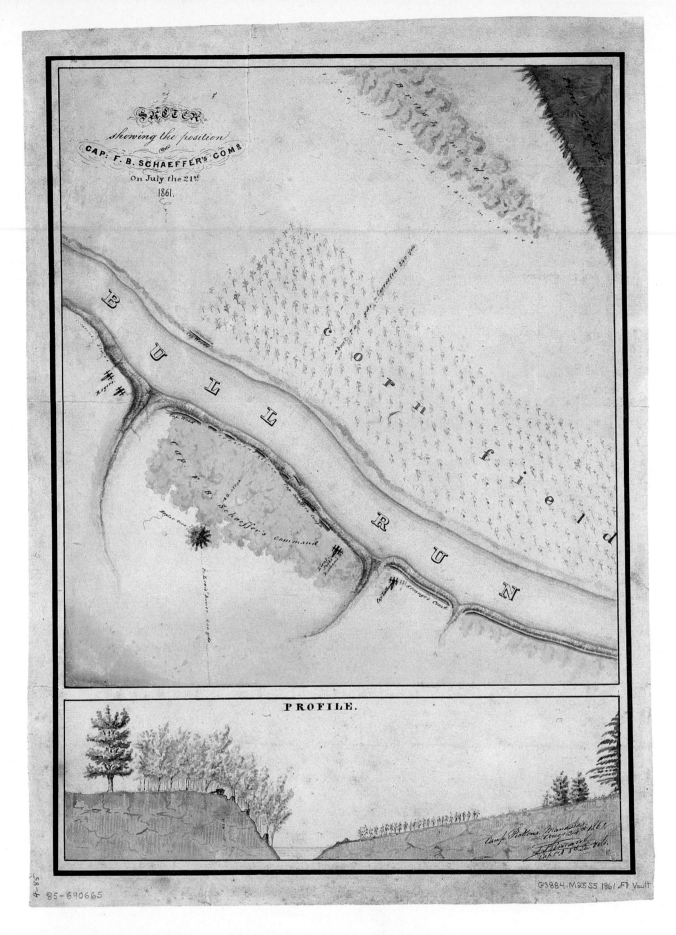

Leon J. Frémaux. *Sketch showing the position of Cap F. B. Schaeffer's Comd on July the 21st 1861.* Drawing, ink and watercolor. Manuscript map, August 24, 1861.

This manuscript map was executed a month after the first Battle of Bull Run—called "First Manassas" by the victorious Confederates. It was a jarring setback for the North, and for the widespread belief that the price of war would be slight. Through the use of a profile, the draftsman demonstrates that the height of the corn, the depth of the creek, and other features of the site influenced the course of the battle.

Alfred Waud. *Sutler's Cart at Bailey's Cross Roads.* Graphite drawing. Virginia, 1861.
The best and most prolific of wartime newspaper sketch artists was Alfred Waud, one of the few to remain in the field for virtually the entire war. His surviving sketches for *Harper's Weekly,* more than one thousand of which are preserved at the Library, represent a remarkably comprehensive and candid view of life in and around the Northern Army of the Potomac.

A perceptive journalist as well as artist, Waud published this drawing in *New York Illustrated News* (his pre-*Harper's* employer)

together with a written account of the "handsome young woman attended by a quiet negro, driving her own team, and selling her wares in person with a pistol buckled to her waist . . . Cider, apples, pies, cakes, and tobacco, seemed to be her staple,

and although perfectly good humored, and occasionally showing her white teeth in a charming smile, there was an air about her which told plainly that any impertinence would be apt to draw the fire of her little pistol upon the culprit."

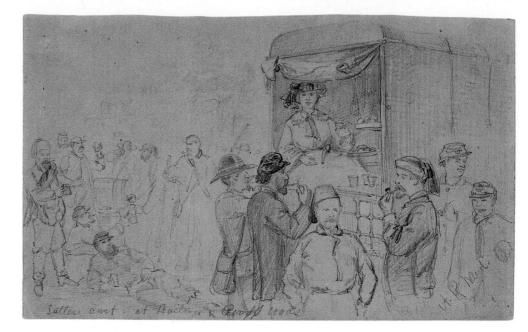

Mathew Brady Studio. *Ninth Massachusetts Infantry Camp near Washington, D.C.* Albumen silver print, 1861.
An Irish-American regiment and its chaplain pause to be photographed before celebrating Mass on a quiet Sunday morning at Camp Cass, Virginia. With the outbreak of the rebellion, New York–based photographer Mathew Brady—no doubt inspired by British photographer Roger Fenton's gripping documentation of the Crimean War a few years earlier—dispatched a dozen photographers to the field. Bulky equipment and long exposure times required Brady's photographers to record static moments, like the Sunday Mass, rather than battlefield action.

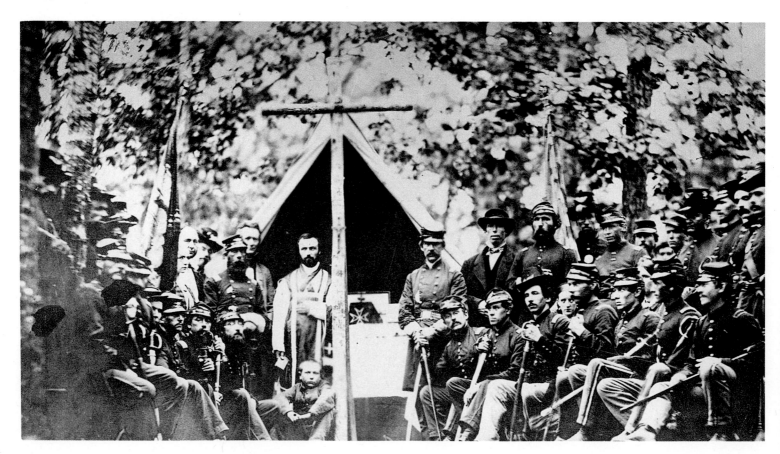

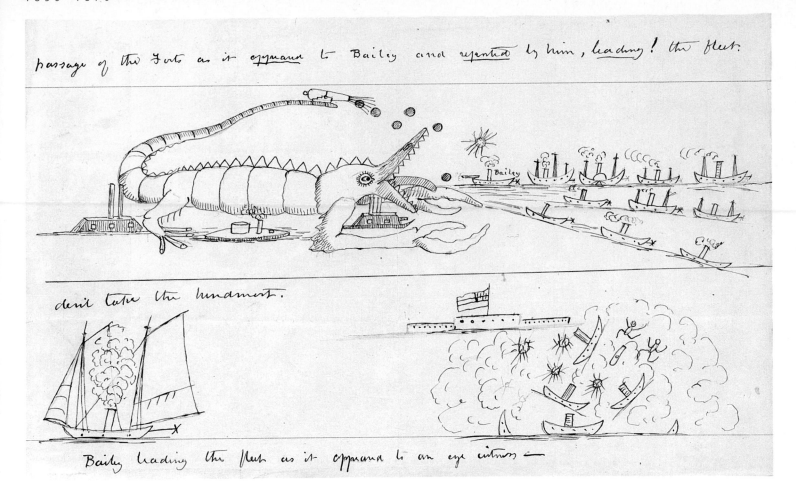

passage of the Forts as it appeared to Bailey and reported by him, leading! the fleet.

don't take the hindmost.

Bailey leading the fleet as it appeared to an eye witness —

David Dixon Porter. *Bailey leading the fleet as it appeared to an eyewitness.* **Drawing, pen and ink. [New Orleans], 1862.**

Thanks to an overwhelming advantage in naval power, the Union captured New Orleans early in the war to gain control of the mouth of the Mississippi. It was the first major Union victory and one of the decisive military engagements in the West. This sketch portrays, in imaginative terms, the "passage" of Forts Jackson and St. Philip below New Orleans on April 24, 1862. Porter had done much of the preliminary planning for this expedition and was in direct command of a mortar flotilla. His drawing gives two points of view: Theodorous Bailey, second-in-command under Union Admiral David Farragut, sees a giant beast—a hybrid of the indigenous alligator and crayfish—protecting the Confederate ironclads while he leads the fleet into its lair; and an "eye witness" sees Bailey demolish the Confederate fleet with little effort.

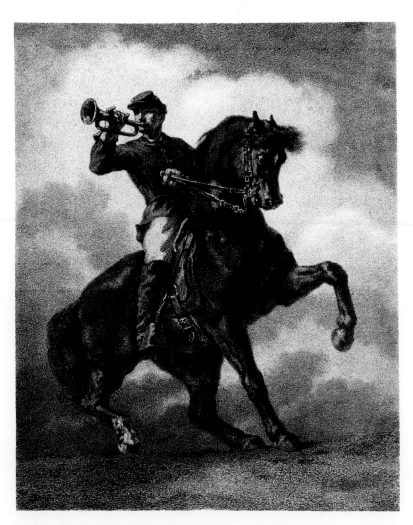

Dominique C. Fabronius, after William Morris Hunt. *The Bugle Call.* **Lithograph. Boston, 1863.**

Only the uniform places this subject in time. Otherwise, *The Bugle Call* administers a universal dose of patriotic fervor. The Olympian proportions of the horse and rider suggest an unflinching moral force. The Boston painter William Morris Hunt was, at thirty-eight, too old to serve in the army; this image was his offering to the Union effort. The composition was translated to the lithographic stone by the Belgian-born printmaker Fabronius.

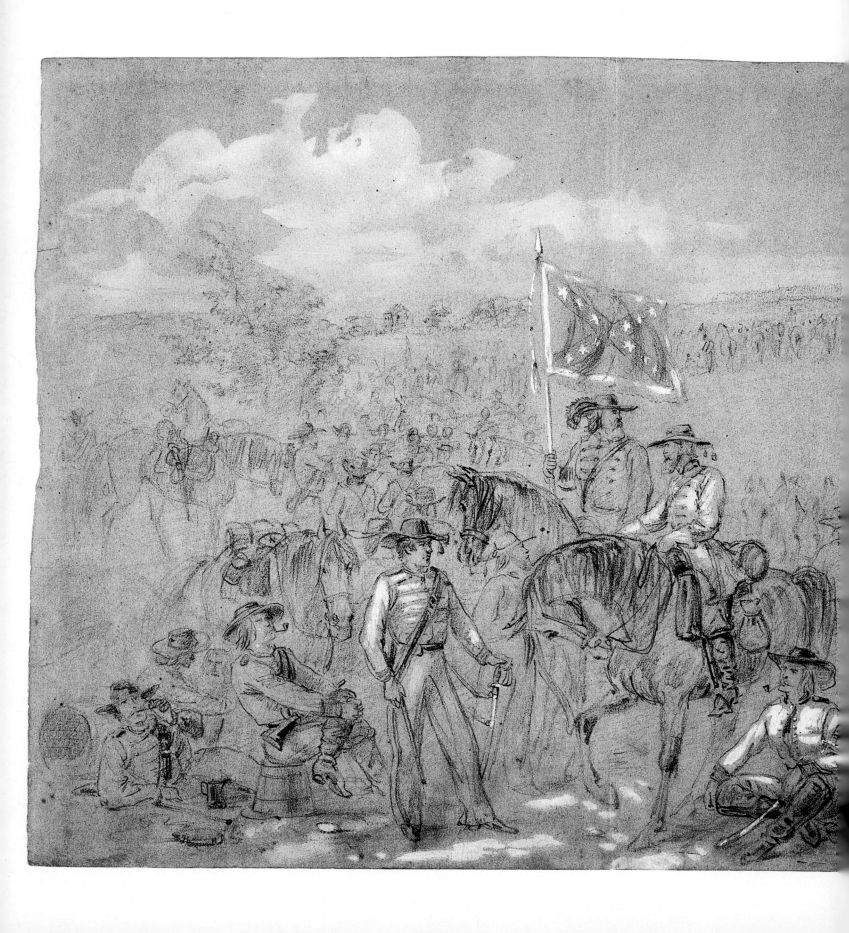

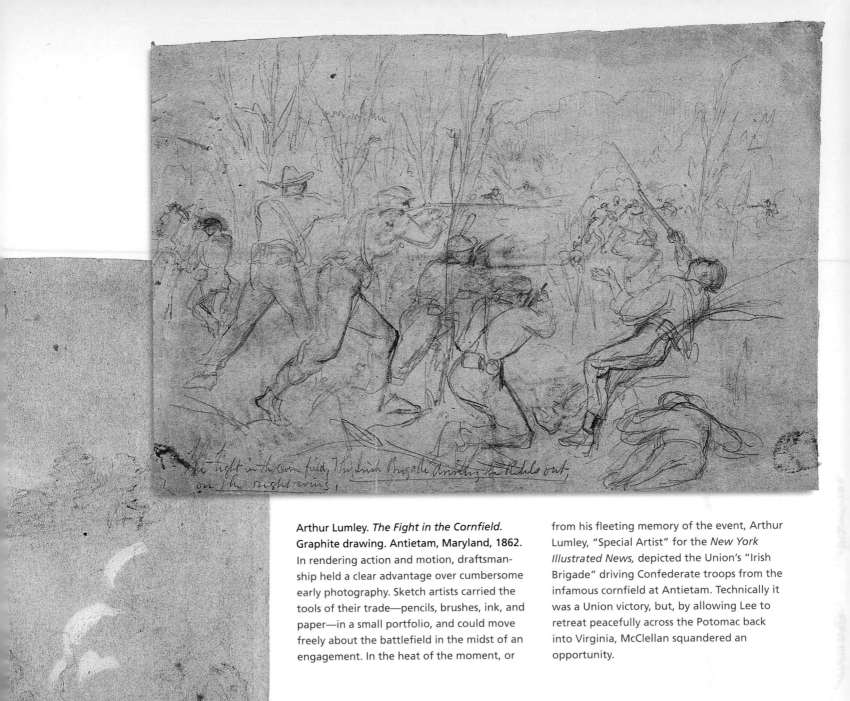

Arthur Lumley. *The Fight in the Cornfield.*
Graphite drawing. Antietam, Maryland, 1862.
In rendering action and motion, draftsman-ship held a clear advantage over cumbersome early photography. Sketch artists carried the tools of their trade—pencils, brushes, ink, and paper—in a small portfolio, and could move freely about the battlefield in the midst of an engagement. In the heat of the moment, or from his fleeting memory of the event, Arthur Lumley, "Special Artist" for the *New York Illustrated News,* depicted the Union's "Irish Brigade" driving Confederate troops from the infamous cornfield at Antietam. Technically it was a Union victory, but, by allowing Lee to retreat peacefully across the Potomac back into Virginia, McClellan squandered an opportunity.

Alfred Waud. *1st Virginia Cavalry.* **Drawing, pencil and opaque white, c. September 1, 1862.**
The weeks just before the bloody battle of Antietam, with General Robert E. Lee on the move through western Maryland, were a high point in the Southern war effort. Bearing a pass signed by a Confederate captain from Georgia, *Harper's Weekly* sketch artist Alfred Waud went behind enemy lines and captured, if only with pencil and brush, members of the First Virginia Cavalry. In a brief description accompanying the published drawing Waud wrote: "They seemed to be of considerable social standing, that is, most of them—FFV's [First Families of Virginia], so to speak, and not irreverently: for they were not only as a body handsome, athletic men, but generally polite and agreeable in manner. . . . Their carbines, they said, were mostly captured from our own cavalry, for whom they ex-pressed utter contempt—a feeling unfortu-nately shared by our own army. Finally, they bragged of having their own horses, and, in many cases of having drawn no pay from the Government, not needing the paltry remuner-ation of a private."

Waud's drawing of this elite regiment must have sent a chill through every Union encamp-ment and Northern parlor, and thrilled the many Southerners who saw it.

July 22, 1862

In pursuance of the sixth section of the act of Congress entitled "An act to suppress insurrection and to punish treason and rebellion, to seize and confiscate property of rebels, and for other purposes" Approved July 17. 1862, and which act, and the Joint Resolution explanatory thereof, are herewith published, I, Abraham Lincoln, President of the United States, do hereby proclaim to, and warn all persons within the contemplation of said sixth section to cease participating in, aiding, countenancing, or abetting the existing rebellion, or any rebellion against the government of the United States, and to return to their proper allegiance to the United States, on pain of the forfeitures and seizures, as within and by said sixth section provided—

And I hereby make known that it is my purpose, upon the next meeting of Congress, to again recommend the adoption of a practical measure for tendering pecuniary aid to the free choice or rejection, of any and all States which may then be recognizing and practically sustaining the authority of the United States, and which may then have voluntarily adopted, or thereafter may voluntarily adopt, gradual abolishment ~~adoption~~ of slavery within such State or States— that the object is to practically restore, thenceforward to be maintain, the constitutional relation between the general government, and each, and all the States, wherein that relation

Abraham Lincoln. The Emancipation Proclamation. Pen and ink. Manuscript. Washington, D.C., July 1862.
Lincoln read this earliest surviving draft of the proclamation to his Cabinet on July 22, to gauge public reaction prior to issuing a preliminary version in September 1862, five days after the Battle of Antietam, where six thousand died and seventeen thousand were wounded. Lincoln's final proclamation went into effect in January 1863. It freed slaves only in those states hostile to the Union, and was intended both to strengthen the North's moral resolve in the face of Antietam's immense losses and to elicit English support for the Northern cause.

is now suspended, or disturbed; and that,
for this object, the war, as it has been, will
be, prosecuted. And, as a fit and necessa-
ry military measure for effecting this object,
I, as Commander-in-Chief of the Army and
Navy of the United States, do order and de-
clare that on the first day of January, in the
year of our Lord one thousand, eight hundred
and sixty three, all persons held as slaves with-
in any state or states, wherein the constitution-
al authority of the United States shall not
then be practically recognized, submitted to,
and maintained, shall then, thenceforward, and
forever, be free.

Herman Melville.

Inscription
For the Dead
At Fredericksburgh.

A dreadful glory lights an earnest end;
In jubilee the patriot ghosts ascend;
Transfigured at the rapturous height
Of their passionate feat of arms,
Death to the brave's a starry night,—
Strewn their vale of death with palms.

Herman Melville

Herman Melville. *Inscription for the Dead at Fredericksburgh* [sic]. Pen and ink. Autograph manuscript. New York, 1863.

This unique early version of a poem by Herman Melville, author of *Moby-Dick,* honors the 12,600 Union casualties (1,284 died) in General Burnside's ill-conceived assault on Marye's Heights, overlooking the town of Fredericksburg. The loss in December 1862 halted the Union army's drive toward Richmond, the Confederate capital. Burnside, who had replaced McClellan as Lincoln's commanding general after Antietam, was himself replaced by "Fighting Joe" Hooker after Fredericksburg.

Melville submitted the poem to Alexander Bliss, a Union officer who was compiling an anthology of poetry with John Pendleton Kennedy. When *Autograph Leaves of Our Country's Authors* appeared in 1864, it included a revision of this poem entitled "Inscription for the Slain at Fredericksburgh." A period replaced the semicolon and "Strewn" became "Strown."

Adalbert Volck. *Offering of the Bells to be Cast into Cannon.* Etching. Baltimore, 1863.

This somewhat melodramatic portrayal of a Southern clergyman donating the church bells of his parish to be melted down for Confederate cannon was one of a series of anti-Union prints issued covertly in Baltimore. The city was occupied and closely watched by the Union throughout the war. Volck's work glorified the Confederacy and bitterly criticized Abraham Lincoln.

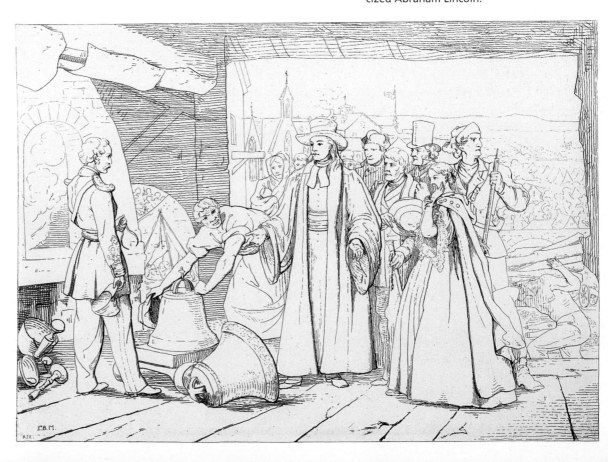

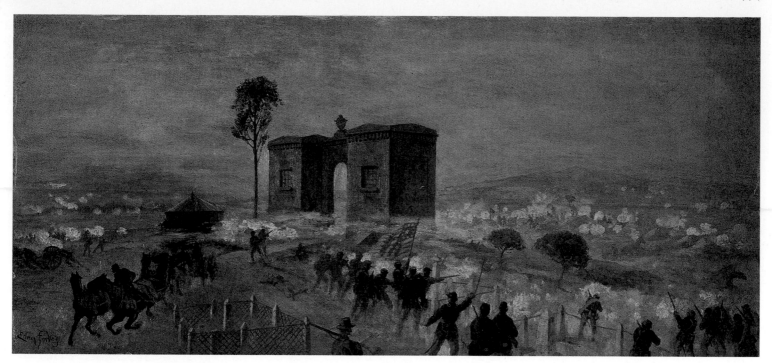

Edwin Forbes. *Charge of Ewell's corps on the Cemetery Gate.* Oil on canvas, after his eye-witness drawings. [Brooklyn, New York, c. 1866–70.]

After being driven through the town of Gettysburg, Pennsylvania, the Federals rallied on Cemetery Hill, their lines extending south along Cemetery Ridge. The next day, July 2, 1863, is pictured here: Union forces are shaken when a battery on their right flank is captured by members of General Richard Ewell's Corps (though one of their guns is being driven to safety at extreme left). Despite such setbacks, the three-day battle ended in Confederate retreat; it was a turning point of the war. Never again were the weakened Confederate forces able seriously to threaten Northern territory. Four months later, President Lincoln spoke briefly at the dedication of Gettysburg's National Cemetery and delivered one of the most famous orations in American history.

Forbes worked for *Leslie's Illustrated Newspaper* and typically depicted battle scenes from afar to show troop movement.

Charles Wellington Reed. *Dear Mother.* Pen and ink. Manuscript. Centreville, Virginia, June 20, 1863.

Reed, an artist and soldier, wrote detailed letters to family members during the Civil War, many illustrated with his splendid drawings. This example of June 20, 1863, shows the Ninth Massachusetts Battery leaving Centreville, Virginia, for its rendezvous at Gettysburg. On July 2, the nineteen-year-old Reed fought in the Peach Orchard during the famous siege and "such a shrieking, hissing, seathing I never dreamed was imagineable." He was later awarded the Congressional Medal of Honor for gallantry in that action.

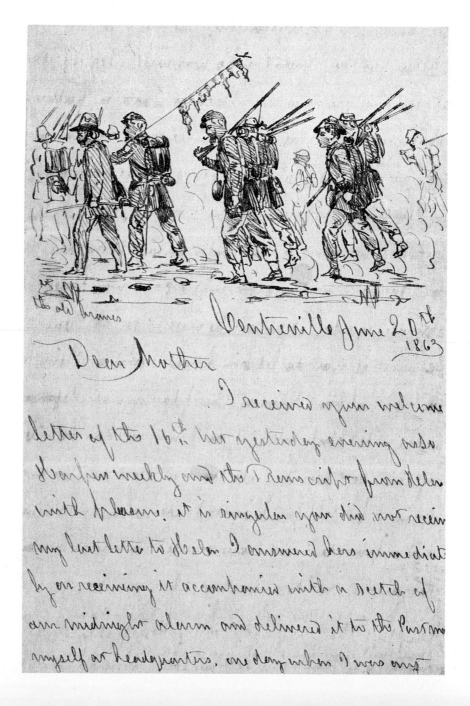

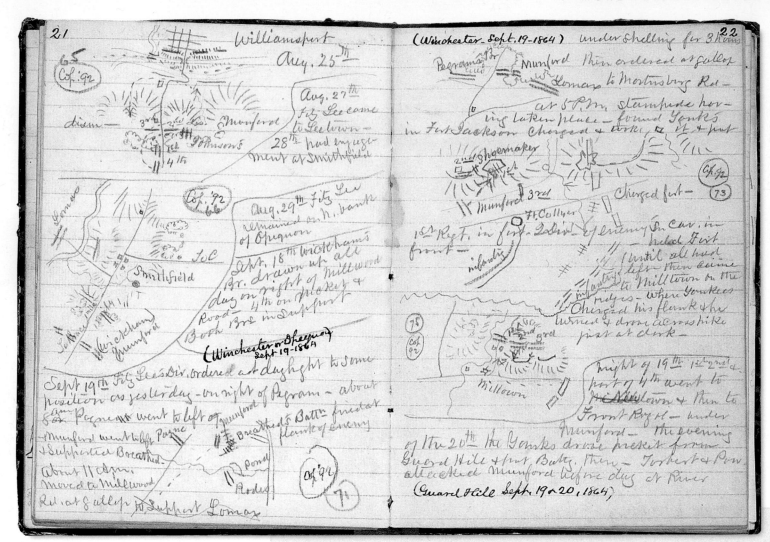

Jedediah Hotchkiss. Pages from *Sketch book of the Second Corps, A[rmy] of N[orthern] V[irginia] in engagements of 1864–5.* Pen and ink, pencil, and watercolor. Manuscript.

An outstanding topographical engineer serving with the Confederate army, Jedediah Hotchkiss mapped much of the Shenandoah Valley and the adjacent territory, a vital theater of Confederate operations throughout the war. Hotchkiss provided indispensable geographic intelligence for Thomas J. "Stonewall" Jackson, Robert E. Lee, Richard Ewell, Jubal Early, and John B. Gordon. He would note, often hurriedly on horseback, features of terrain and vegetation that would later adorn his very detailed, beautiful maps. He made these particular notes and sketches en route to Winchester from Williamsport, August 25 to September 19, 1864.

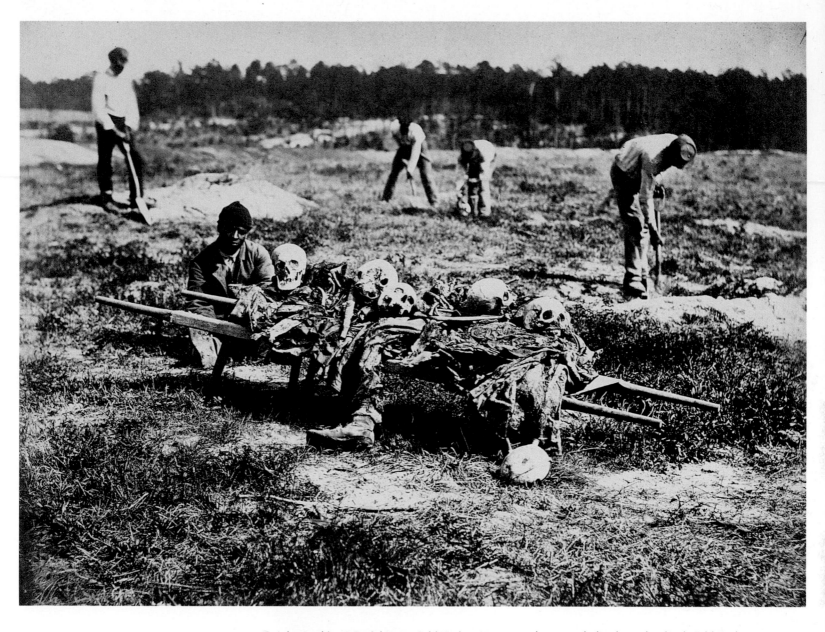

Opposite: Jarvis. Ulysses S. Grant and his war horse Cincinnati. Albumen silver stereograph half. Cold Harbor, Virginia, June 4, 1864.
By 1864 Ulysses S. Grant had distinguished himself as a tenacious and aggressive military leader in the western theater by gaining control over Mississippi communications and forcing the Confederate army to evacuate Kentucky and half of Tennessee. After Grant's victory at Chattanooga, Lincoln appointed him to command all the Union armies. Here Grant stands with his horse Cincinnati at Cold Harbor, Virginia, the day after his attack on Lee's Army of Northern Virginia. While hoping to capture Richmond, Grant lost almost seven thousand men in less than one hour and was obliged to withdraw. Eventually, however, his plan to fragment the Confederate forces with simultaneous attacks did bring about the Union victory.

John Reekie. *A Burial Party, Cold Harbor, Va.* Albumen silver print #94 from Alexander Gardner, *Gardner's Photographic Sketch Book of the War*, Vol. II. Washington, D.C., 1865–66.
There is no more graphic a representation of Civil War carnage than this image of an African American—probably a freed slave—pausing beside a stretcher loaded with human remains. Cold Harbor lay just northeast of Richmond, and was one of many places where the fallen were abandoned and left unburied, as in this case, for nearly a year. After the battle, nearly five acres were piled thick with bodies. For three days and three nights, the two armies had sat in stunned silence, neither Grant nor Lee willing to call a truce to collect the wounded or bury the dead. Cold Harbor was a horrible failure for the Union and the final triumph in the field for General Lee. In total, more than 618,000 died in the Civil War, more than in all other American wars combined through Vietnam.

Alexander Gardner, a Scottish immigrant, was the manager of Mathew Brady's Washington, D.C., gallery. He is credited with the idea of sending a private photographic corps into the field to provide extensive coverage of the war. Gardner left Brady's employ in 1863 to start a rival firm, having contributed greatly to Brady's epoch-making enterprise in photography.

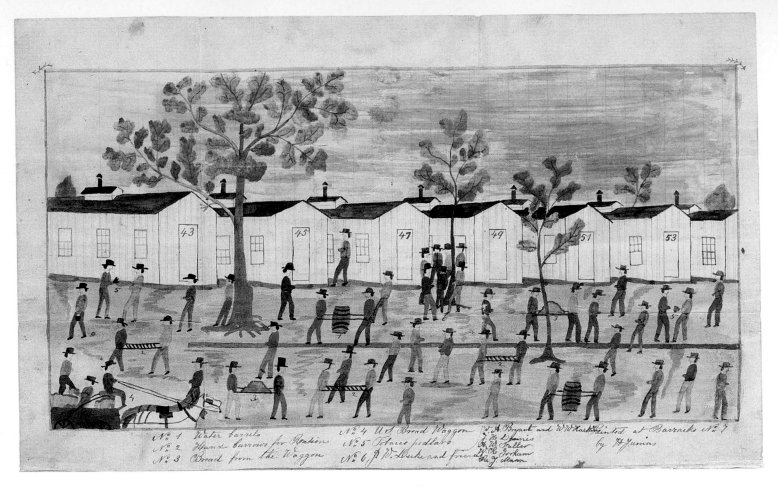

James W. Duke. *Picture of our row of Barracks with a limited portion of the prison.* Drawing, watercolor and ink. Rock Island, Illinois, August 1864.
This drawing was enclosed in a letter from a captured Confederate soldier to his "Dear Cousin" Charles Buford, a resident of the town of Rock Island, Illinois. Located on an island in the Mississippi River, the prison at various times held between five thousand and eight thousand Confederate prisoners, and the death rate has been estimated at 28 percent. Buford and some of his fellow townsmen attempted to alleviate, to some degree, the severity of conditions within the prison.

The difficulties of prisoner exchange and release were such that no enduring plan could be devised. Official reports show that the Union took 215,000 captives and the Confederates nearly 195,000. Mismanagement and congestion led to chaos and perhaps the greatest cruelties of the war. The commandant of the most infamous prison, in Andersonville, Georgia, was tried and publicly executed for murder.

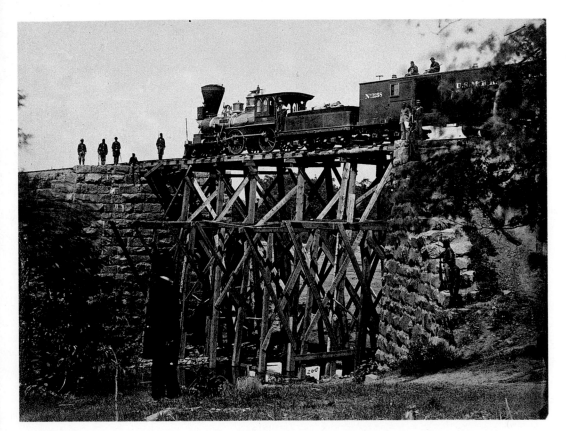

A. J. Russell. *Bridge on Orange & Alexandria Railroad.* Albumen silver print. Virginia, 1865.
In April 1862, Secretary of War Stanton had appointed the brilliant engineer and inventor Herman Haupt to be chief of construction and transportation for the U.S. military railroads. Without adequate supplies and ignoring "all the rules and precedents of military science as laid down in books," some of which he had written himself, Haupt and his men worked feverishly throughout the war to rebuild a number of railroad bridges demolished by Confederate forces. These reconstructions amazed President Lincoln, who described one, built in nine days, as "the most remarkable structure that human eyes ever rested upon. That man Haupt has built a bridge across Potomac Creek, about four hundred feet long and nearly one hundred feet high, over which loaded trains are running every hour, and, upon my word, gentlemen, there is nothing in it but beanpoles and cornstalks."

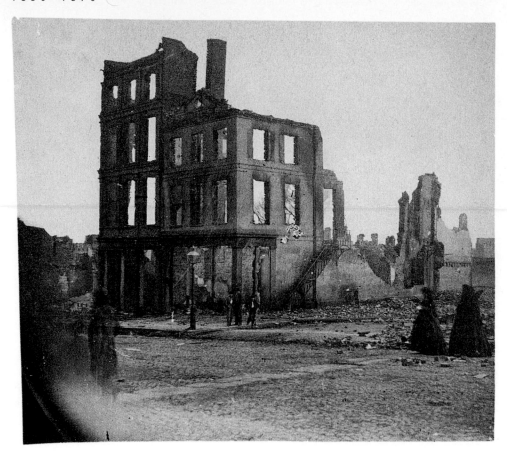

View in the Burnt District, Richmond, Virginia, April, 1865. Albumen silver print.

The "Burnt District" in Richmond was a pitiable sight for the various photographers who scrambled to record the Confederate capital in the last days of the Civil War. As the government collapsed and people rioted, the fires—meant to destroy the arsenal, bridges, and anything of military value—spread to a large part of the city's prime commercial districts. Richmond's weary and long-suffering inhabitants searched for missing friends and relations and combed the ashes for what could be saved. Photographs such as this, of two women in black approaching the ghostly shell of a building, serve as a reminder to posterity of the terror and devastation of war. Northern forces, including an African-American infantry brigade, entered burned-out Richmond on April 3, 1865. On the following day, President Lincoln, who had been reelected in 1864, entered the city.

The First E-flat cornet (leader's) part of *The Star Spangled Banner.* Pen and ink. Manuscript. *Port Royal Band Books.* South Carolina, 1863–64.

The Third New Hampshire Regimental Band, also known as the Port Royal Band, had spent much of the war out of harm's way at the Hilton Head Garrison in Port Royal, South Carolina, but played at the ceremony marking the close of the Civil War when the United States flag was raised over Fort Sumter, where the conflict had begun, on April 14, 1865. A notation in the drummer's part book indicates that the brass band used these part books on that occasion. General Lee had surrendered to General Grant in Appomattox Courthouse, Virginia, on April 9, ending four years of war.

SURRAT. BOOTH. HAROLD.

War Department, Washington, April 20, 1865,

$100,000 REWARD!

THE MURDERER

Of our late beloved President, Abraham Lincoln,

IS STILL AT LARGE.

$50,000 REWARD

Will be paid by this Department for his apprehension, in addition to any reward offered by Municipal Authorities or State Executives.

$25,000 REWARD

Will be paid for the apprehension of JOHN H. SURRATT, one of Booth's Accomplices.

$25,000 REWARD

Will be paid for the apprehension of David C. Harold, another of Booth's accomplices.

LIBERAL REWARDS will be paid for any information that shall conduce to the arrest of either of the above-named criminals, or their accomplices.

All persons harboring or secreting the said persons, or either of them, or aiding or assisting their concealment or escape, will be treated as accomplices in the murder of the President and the attempted assassination of the Secretary of State, and shall be subject to trial before a Military Commission and the punishment of DEATH.

Let the stain of innocent blood be removed from the land by the arrest and punishment of the murderers.

All good citizens are exhorted to aid public justice on this occasion. Every man should consider his own conscience charged with this solemn duty, and rest neither night nor day until it be accomplished.

EDWIN M. STANTON, Secretary of War.

DESCRIPTIONS.—BOOTH is Five Feet 7 or 8 inches high, slender build, high forehead, black hair, black eyes, and wears a heavy black moustache.

JOHN H. SURRAT is about 5 feet, 9 inches. Hair rather thin and dark; eyes rather light; no beard. Would weigh 145 or 150 pounds. Complexion rather pale and clear, with color in his cheeks. Wore light clothes of fine quality. Shoulders square; cheek bones rather prominent; chin narrow; ears projecting at the top; forehead rather low and square, but broad. Parts his hair on the right side; neck rather long. His lips are firmly set. A slim man.

DAVID C. HAROLD is five feet six inches high, hair dark, eyes dark, eyebrows rather heavy, full face, nose short, hand short and fleshy, feet small, instep high, round bodied, naturally quick and active, slightly closes his eyes when looking at a person.

NOTICE.—In addition to the above, State and other authorities have offered rewards amounting to almost one hundred thousand dollars, making an aggregate of about **TWO HUNDRED THOUSAND DOLLARS.**

$100,000 Reward! **Broadside with attached albumen silver prints. Washington, D.C., April 20, 1865.**

The assassination of President Abraham Lincoln in Ford's Theater just weeks after Lee's surrender profoundly shocked the nation. The suspicion that John Wilkes Booth had acted as part of a conspiracy of Southern sympathizers reignited Northern rancor and helped doom Lincoln's plans for a relatively generous peace. This was one of the earliest "Wanted" posters to bear a fugitive's photograph. Hastily assembled and issued during the few days Booth was at large, the work incorporated carte de visite photographs of the conspirators, including one of Booth that had been produced, in better times, as a publicity photograph for the famous actor. Gardner's subsequent photographs of the captured conspirators, and of their executions, were the most complete documentation of a news story by the camera up to that time.

Opposite: Thomas Nast. *Andrew Johnson's Reconstruction and How it Works.* **Wood engraving. New York, 1866.**

Thomas Nast was the most influential political cartoonist in nineteenth-century America. His editorial cartoons for *Harper's Weekly* had helped inflame Union sentiment during the Civil War, and afterward he became one of the most visible and voluble critics of the inadequacies of Reconstruction, initiated by Lincoln and carried out with a seemingly conciliatory attitude toward the South by his intemperate and tactless successor, Andrew Johnson. To the dismay of Nast and the Radical Republican Congress devoted to liberty and progress, the Johnson administration permitted the former ruling class in the South to reemerge and allowed the economic position of the 4 million African Americans emerging from bondage to worsen. Nast believed Johnson had betrayed the freedmen in their fight for civil rights, and inspired by Shakespeare's *Othello,* he here caricatures the President as deceitful Iago, who betrayed the dark-skinned Othello.

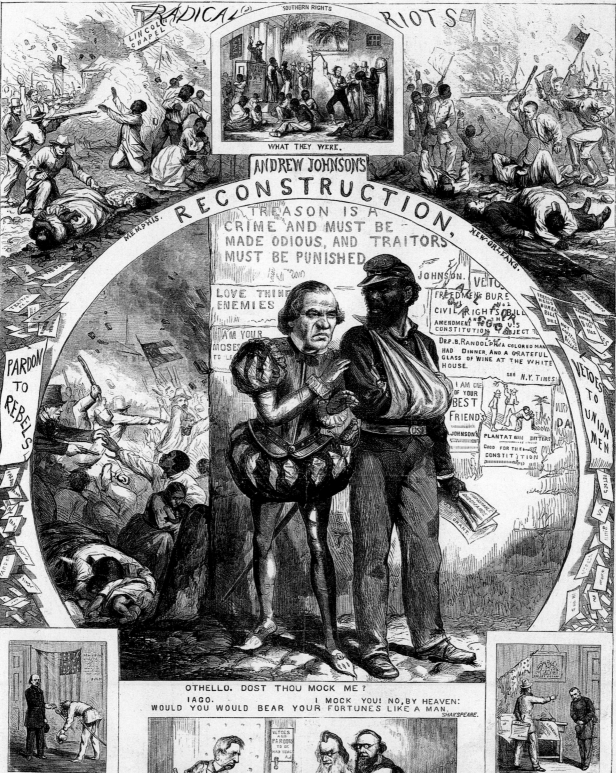

ANDREW JOHNSON'S RECONSTRUCTION, AND HOW IT WORKS.

Th. Nast

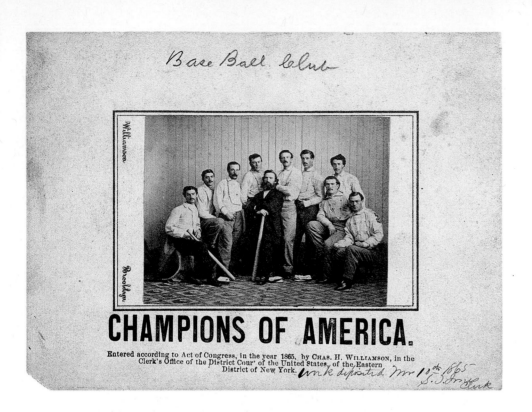

Charles H. Williamson. *Champions of America.*
Albumen silver print mounted on card.
New York, 1865.

Though already America's national pastime by 1857, baseball became even more popular during and after the Civil War. Young men learned the game behind the battle lines and carried it back to their communities, colleges, and workplaces. The Brooklyn Atlantics (pictured here) won championships in 1861, 1864, and 1865. Their season continued throughout the winter, when the team donned skates and played on frozen ponds.

Baseball cards as we know them did not become commonplace until the 1880s. This early prototype is actually an original photograph mounted on a card. At the start of the 1865 season, the Atlantics had presented opposing teams with framed photographs of the "Champion Nine." Charles H. Williamson, born in Scotland, operated a photographic studio in Brooklyn from 1851 until his death in 1874.

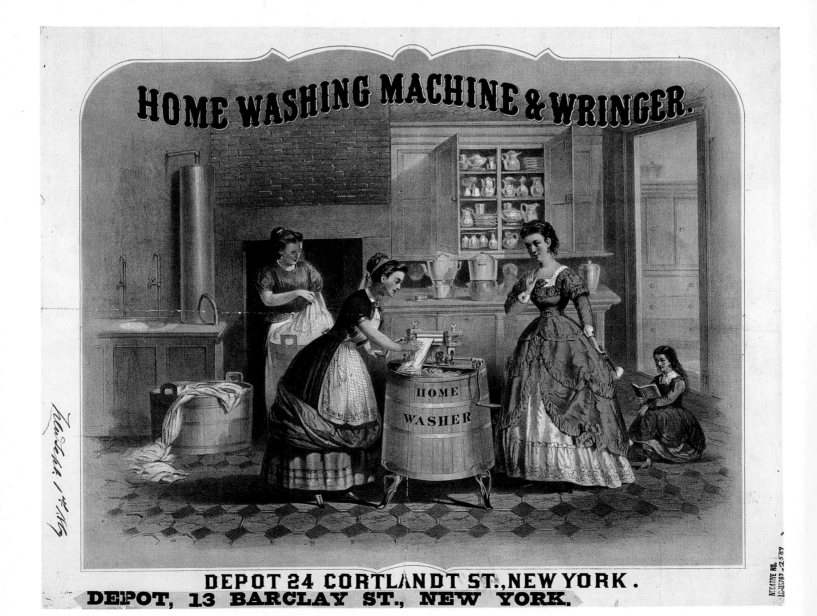

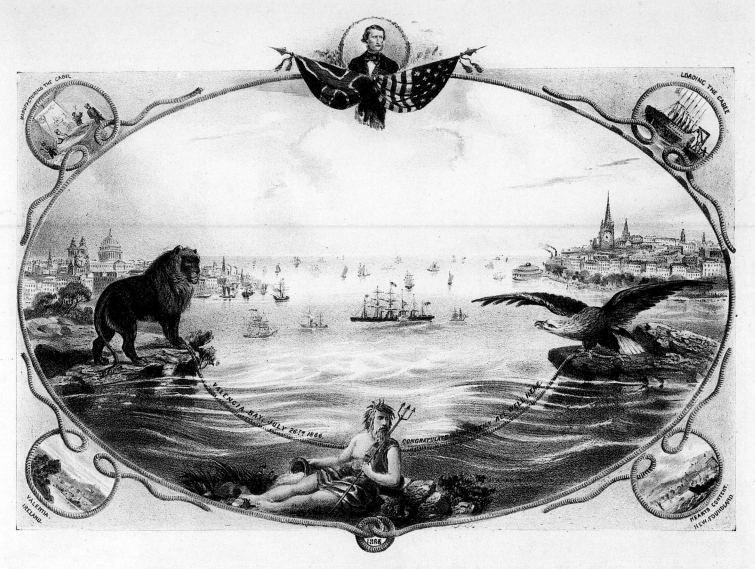

THE EIGHTH WONDER OF THE WORLD.

THE ATLANTIC CABLE.

"*Heart's Content, July 27th 1866.*
I hope that it will prove a blessing to England, and the United States,
and increase the intercourse between our Country & the Eastern Hemisphere."
Your faithfully
Cyrus W. Field.

PUBD BY KIMMEL & FORSTER, 254 256 CANAL St N.Y.

Washington, July 29th 1866.
To Cyrus W. Field, Heart's Content:
May the Cable under the sea tend to promote harmony between the Republic
of the West and the Governments of the Eastern Hemisphere.
Andrew Johnson

Kimmel & Forster. *The Eighth Wonder of the World. The Atlantic Cable.* Color lithograph. New York, 1866.
International communications took a giant step in the summer of 1866 when a two-thousand-mile copper cable linking the United States (the eagle) to Great Britain (the lion) was successfully laid. The accomplishment was made possible as much by the indomitable optimism and ability of a single person as by any scientific advances. From its beginnings in 1854, Cyrus Field's proposal for an Atlantic cable met every technical and financial adversity, including a setback in 1858 after it had carried messages successfully for three weeks, then failed. The results of Field's perseverance won him praise from around the world, a gold medal from Congress, and celebratory prints like this one bearing his portrait above Neptune.

Opposite: *Home Washing Machine & Wringer.* Color lithograph. New York, 1869.
Emancipation through technology is the message of this 1869 advertisement in which low-tech drudgery is contrasted with state-of-the-art housekeeping. The older woman might expect to labor for the better part of a day with tub and washboard, while the next generation bends serenely over the home washer with the promise of leisure time implicit in the woman's glamorous dress and the immaculate child reading nearby. In actuality this early mechanical washer offered a slim improvement over the manual process; the concept didn't really catch on until the twentieth century when electric power was added to the equation.

Lith. of Sarony, Major & Knapp, 449 Broadway, N.Y.

Opposite: Thomas Kelly, after James C. Beard. *The Fifteenth Amendment. Celebrated May 19th 1870.* Lithograph with watercolor. New York, 1870.

The Fifteenth Amendment to the U.S. Constitution, ratified and enacted in early spring of 1870, gave male citizens the right to vote regardless of race, color, or previous condition of servitude. This lithograph was issued to commemorate the grand celebratory parade held in Baltimore on May 19. Surrounding a central vignette of the parade passing the city's Washington Monument are portraits of Abraham Lincoln, President Ulysses S. Grant, Vice President Schuyler Colfax, and such notable black leaders as Frederick Douglass and John Brown, as well as scenes of African Americans participating freely in the cultural, economic, religious, political, and military life of the nation.

Sarony, Major, and Knapp. *Architectural Iron Works.* Frontispiece from Daniel D. Badger, *Illustrations of Iron Architecture.* Color lithograph. New York, 1865.

In the mid-nineteenth century, cast-iron architecture changed the face of main streets all across America. Affordable, of high quality, and easily shipped by rail, it initiated the era of modular construction from standardized building parts sold through illustrated catalogs. Once numerous, such catalogs are now quite rare. Only six copies survive of Daniel D. Badger's catalog of the Architectural Iron Works in New York, including two in the Library.

Ferdinand Mayer & Sons. *Proposed Arcade Railway under Broadway, view near Wall Street, 1869.* Color lithograph. New York, c. 1868.

The dramatic growth of American cities in the second half of the nineteenth century demanded entirely new solutions to transportation problems. In 1867 a special commission appointed by the New York State Senate issued a report recommending the construction of "underground railroads" as the best means of reducing New York City's congestion. (London had one by 1863.) A prototype was built, but its failure resulted in the formulation of many schemes, including the one illustrated here, where Broadway has been elevated in order to segregate pedestrian, vehicular, and mass rail transportation. Elevating the railroad at first proved more feasible than going underground, and the first practical line opened in 1876. America's first "subway" was running in Boston in 1897. New York's followed in 1904.

PROPOSED ARCADE RAILWAY.
UNDER BROADWAY.
VIEW NEAR WALL STREET.

THE FIFTEENTH AMENDMENT

PUBLISHED & PRINTED BY THOMAS KELLY 17 BARCLAY ST. N.Y.

1 Reading Emancipation Proclamation
2 Life Liberty and Independence
3 We Unite the Bonds of Fellowship.
4 Our Charter of Rights the Holy Scriptures.
5 Education will prove the Equality of the Races.
6 Liberty Protects the Marriage Alter.
7 Celebration of Fifteenth Amendment May 19th 1870
8 The Ballot Box is open to us.
9 Our representive Sits in the National Legislature
10 The Holy Ordinances of Religion are free
11 Freedom unites the Family Circle.
12 We will protect our Country as it defends our Rights.
13 We till our own Fields
14 The Right of Citizens of the U.S. to vote shall not be denied or abridged by the U.S. or any State on account of Race Color or Condition of Servitude 15th Amendment

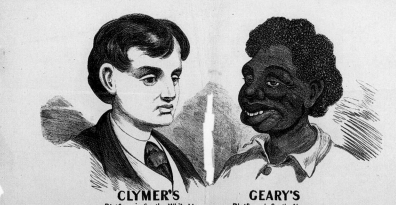

The Two Platforms. Woodcut. Broadside. [Philadelphia?], 1866.

A number of racist posters were issued in 1866 as part of a smear campaign against Pennsylvania Republican gubernatorial nominee John White Geary, and as a wider attack on postwar Republican efforts to pass constitutional amendments granting citizenship to everyone born in the United States and enfranchising blacks. This poster specifically proclaims Democratic candidate Hiester Clymer's platform as being "for the White Man" and represents it with the idealized head of a young man, while a stereotyped black head represents Geary's platform. Despite such conservative efforts, the voters returned an overwhelming majority of Republicans, most of them Radicals, who ensured that Southern states could not be readmitted to the Union without ratifying the new amendments (as the bottom line of the poster makes clear).

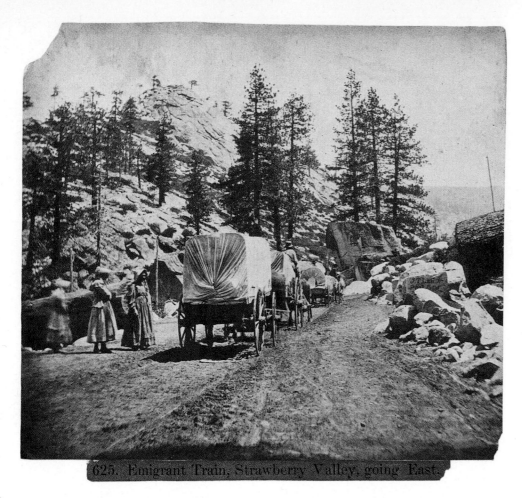

625. Emigrant Train, Strawberry Valley, going East.

George S. Lawrence and Thomas Houseworth. *Emigrant Train, Strawberry Valley, going East.* Gold-toned albumen half-stereograph. California, c. 1866.

The lower Sierra Nevada mountains attracted large populations when gold was discovered at Sutter's Mill in 1848. California grew so popular that by 1866 the San Francisco photographers Lawrence and Houseworth had issued three editions of *Gems of California Scenery*, a set of 860 stereographs with accompanying catalog.

The emigrants pictured here were traveling from the West Coast eastward into the higher elevations, where timbering, ranching, and fruit-growing were the principal economic options. Women and children stood aside to lighten the load as men drove the small chuck wagons through a narrow passage, where someone named J. T. Lee left his mark on a rock in the foreground. Their trek contributed to the transition of the western United States from wilderness to more permanent settlements.

C. C. Kuchel, after Grafton T. Brown. *Virginia City, Nevada Territory.* Lithograph. San Francisco, 1861.

Accurate panoramic mapping of urban centers from a high oblique angle was unique to North America in the post–Civil War era. Most of these "bird's-eye views" were published independently, not as plates in books, and made popular wall hangings. The development of an estimated 2,500 towns and cities and their architecture was recorded in panoramic maps.

In 1861, when Kansas became a state, the rest of the Kansas–Nebraska Territory was divided into smaller units, including Nevada. Waves of white settlers penetrated the lands supposedly guaranteed to the tribes, resulting in incessant fighting. Miners from California flocked to Nevada in 1859 when silver was discovered there. By the end of the 1860s, Nevada and Nebraska had become states.

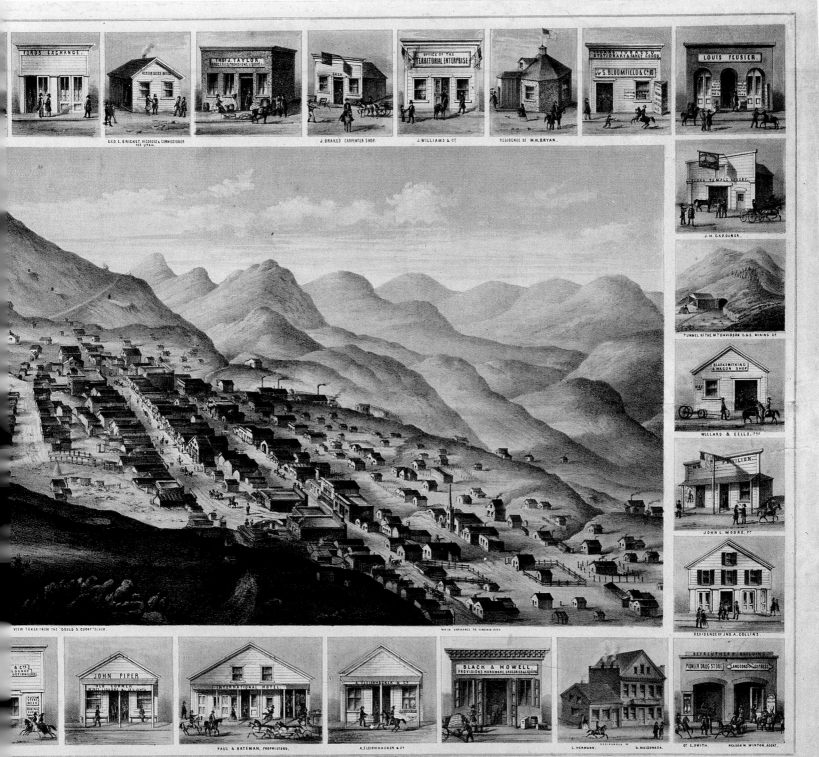

VIRGINIA CITY,

NEVADA TERRITORY.

1861.

PUBLISHED BY GRAFTON T. BROWN.

Detroit Publishing Company. *Mulberry Street, New York City.* Photochrom print. New York, c. 1900.

Mulberry Street, on Manhattan's Lower East Side, was a bustling market and a popular destination for immigrants at the turn of the century as living conditions deteriorated in southern and eastern Europe. Thousands settled in New York, their port of arrival, alarming older-stock Americans with their poverty and unfamiliar customs. Much reform work was directed at assimilating this new population into American society.

The Photochrom process combined photography with lithography to produce a color image. A minimum of four lithographic stones were required for each print, one for each color, and occasionally as many as fourteen. Photographer William H. Jackson's Detroit Publishing Company used this process to make picture postcards that immigrants could send to family and friends in the "Old Country."

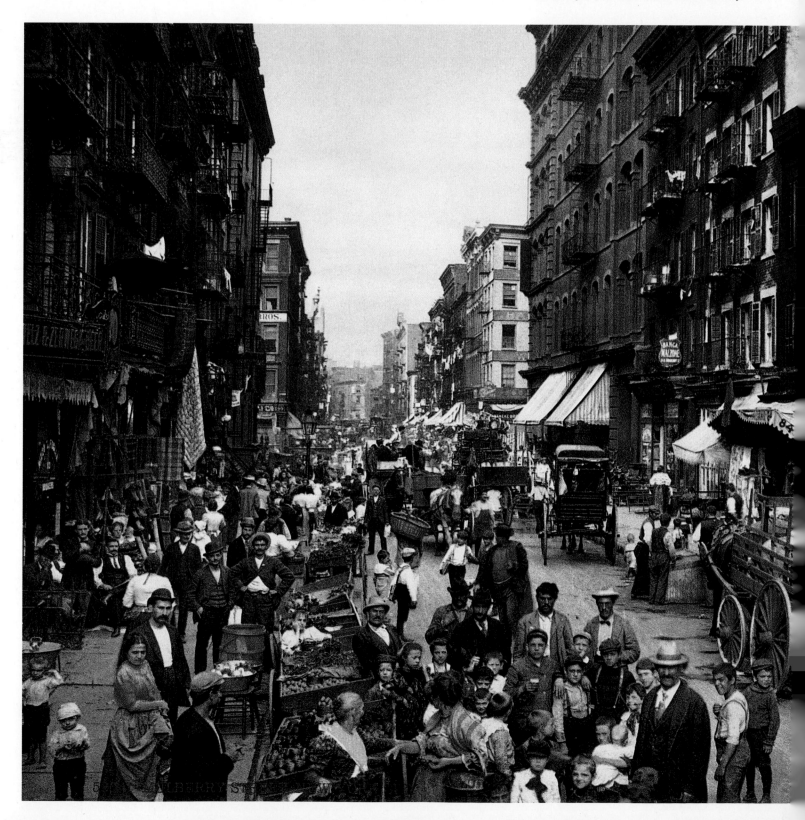

YEARNING TO BREATHE FREE, 1870–1920

"The tendencies of the times," wrote Ralph Waldo Emerson shortly before the Civil War, "favor the ideal of self-government, and leave the individual . . . to the rewards of his own constitution." Emerson was expressing one of the central faiths of his age, and one of the central hopes of his own life and work: that everyone could, through individual effort, carve out a truly independent life; that the individual could experience the world in highly personal terms. "If the single man plant himself indomitably on his instincts and there abide," Emerson once said, "the huge world will come around to him."

Seven decades later, shortly after the end of World War I, the sociologist Charles Horton Cooley offered another, very different assessment of the temper of his era. "In a truly organic life," he wrote, "the individual is self-conscious and devoted to his work, but feels himself and that work as part of a joyous whole. He is self-assertive, just because he is conscious of being a thread in the great web of events." Cooley was also celebrating individualism, to be sure, but not at all as Emerson had done. In the modern world, he said, individuals find fulfillment through their imbeddedness in society. It was no longer realistic to expect "the single man to plant himself indomitably on his instincts and there abide." He (or she) must find a place within the "joyous whole," must accept the role of being a "thread" in a great web that no one person could ever hope to control, or even fully know. And in that profound change in the relationship of the individual to society lies a key to the larger transformation of America in the late nineteenth and early twentieth centuries.

Even in Emerson's time, the forces of industrialization—the most powerful engine of change in modern history—were beginning to transform the American landscape. But no one in the 1850s could have imagined how vastly different their society would look at the end of the century from how it appeared at its midpoint. In the decades after the Civil War, the factory system spread across large areas of the United States, transforming cities, states, and regions with startling suddenness. The modern corporation—a national organization capable of mobilizing vast sums of capital, controlling far-flung activities, and exercising enormous power—was emerging as the characteristic form of economic life. Tocqueville in the 1830s had been struck, in surveying the variety of American enterprise, "not so much [by] the marvelous grandeur of some undertakings, as [by] the innumerable multitudes of small ones." The nation would have appeared very different to him in 1900, when independent businesses lived everywhere in the shadow of great national organizations; when even the smallest enterprise was critically dependent on an integrated capitalist economy that tied all regions of Amer-

ica increasingly together; when the great industrial city was replacing the village and the town as the dominant economic and cultural force in the nation.

"Many are not aware that we are living in extraordinary times," the Congregationalist minister and social critic Josiah Strong wrote in 1885. "There are certain great focal points of history toward which the lines of progress have converged, and from which have radiated the molding influences of the future. Such was the Incarnation, such was the German Reformation of the sixteenth century, and such are the closing years of the nineteenth century, second in importance to that only which must always remain the first: . . . the birth of Christ."

*

The impact of modern industrialization was visible even in those regions that seemed, at first, to be the least touched by it. In the post–Civil War South, still an overwhelmingly agrarian region (and the poorest area in the United States), there were strenuous and enthusiastic, if only modestly successful, efforts to promote industrial and commercial growth. Before the war, many Southerners had been harshly critical of what they considered the crass materialism of the North. But by the 1880s, prominent Southern intellectuals were arguing that it was the South's failure to adapt to Northern ways, its failure to promote industry and commerce, that was responsible for the region's backwardness. "We are a new people," a New Orleans writer boasted. "Our land has had a new birth . . . commercial evolution unparalleled in the annals of American progress." Or as a Mississippi newspaper argued at about the same time: "We are in favor of the South from the Potomac to the Rio Grande being thoroughly and permanently Yankeeized."

It would be many years before this new commercial/industrial mandate would come fully to dominate the region. It remained primarily agricultural until the mid–twentieth century, and it continued to support a social system that rested on the exploitation and subjugation of African Americans; indeed, white Southerners greatly strengthened that system in the 1890s with a harsh new legal regime of segregation and disenfranchisement. The South remained the poorest and most isolated part of the United States. But the late nineteenth century saw the allure of industrialization, and the reality of the factory system, begin to stamp itself even on what was once the nation's most anti-industrial region.

In the West, too, the new economic order transformed both landscape and society. White Americans fanned out through the sparsely settled region by the millions in the decades after the Civil War—drawn there, even if they were not fully aware of it, by the

T. L. Dawes. *Mining on the Comstock*. Lithograph. Gold Hill, Nevada, 1877.
Mining was an early stage of white settlement in the Far West. Between 1859 and 1882, gold and silver ore worth hundreds of millions was extracted from the mines along the Comstock Lode in the Nevada Territory. Unlike California, where the ore lay in streams or shallow mines, here it lay hundreds or even thousands of feet below the earth's surface. Deep shafts and heavy equipment called for large mining operations, and by the 1880s, the era of the independent prospector had virtually ended in the West.

Mark Twain describes the mines in *Roughing It* (1872): "The great 'Comstock lode' stretched its opulent length straight through the town from north to south, and every mine on it was in diligent process of development. One of these mines alone employed six hundred and seventy-five men. . . . The 'city' of Virginia . . . claimed a population of fifteen thousand to eighteen thousand. . . . Often we felt our chairs jar, and heard the faint boom of a blast down in the bowels of the earth under the earth."

John McArthur, Jr. Competition for the main exhibition building, Philadelphia Centennial Exhibition. Drawing, graphite, watercolor, and gouache. Philadelphia, 1873.

Had this design won the competition, it would have been one of the most remarkable structures in the history of architecture and engineering. Projected to cost over $10 million, its great cast-iron arches would have spanned more than twenty acres of exhibition space, and its great central tower would have ranked, at five hundred feet, as the tallest edifice in the world. The architect John McArthur based his secular cathedral on Joseph Paxton's magnificent Crystal Palace at the Great Exhibition of 1851 in London, and his partner, the engineer Joseph M. Wilson, contributed the latest technology from one of his specialties, the construction of wide-span sheds for train stations.

opportunities the new urban-industrial economy had created for them. Cattlemen and sheepherders poured into relatively arid regions of the Southwest and Great Plains, taking advantage of broad, unbroken expanses of grassland to graze their herds and making use of transient, part-time workers—the celebrated and much-romanticized cowboys. Their herds produced meat, leather, and wool to meet the growing demand from the urbanizing, industrializing East. Miners flocked to California, Colorado, the Black Hills of South Dakota, and other areas where there were large deposits of gold and silver; but the more enduring mines in the West produced iron and copper and other materials valuable to the industrial economy. Railroads branched through the landscape, both to bring settlers into the region and to carry goods back to the great urban markets in the East. Most of all, farmers spread out across the fertile (and even semi-fertile) lands of the West, planting crops not to feed themselves or their neighbors, but to meet the needs of the densely populated industrial regions of the nation and the world.

This post–Civil War settlement of the West was a catastrophe for the region's Indian tribes. As in the past, the insatiable appetite for land spurred by the growing American economy came into conflict with the nation's commitments to Native Americans, many of whom had been promised permanent control over the territory they occupied. White settlers, aided by the federal government, elbowed the tribes out of the way—in some cases simply by seizing land that the tribes considered theirs, and in others by fighting

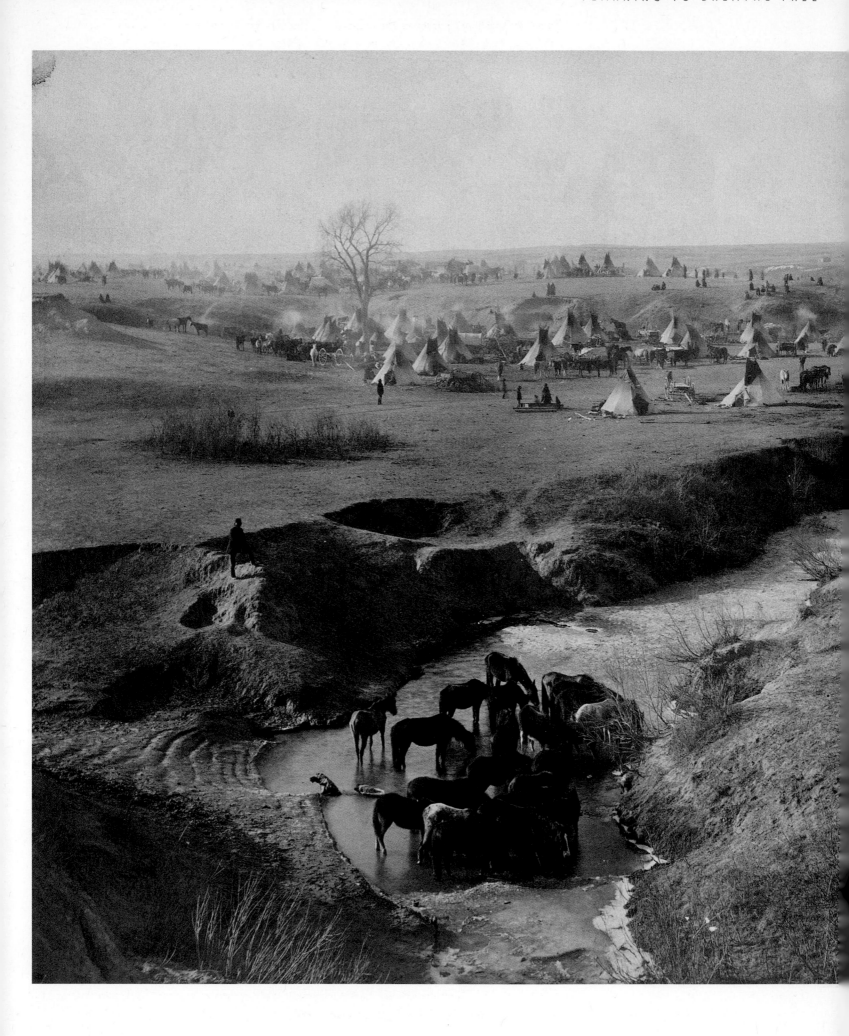

John C. H. Grabill. *Villa of Brule. The Great Hostile Indian Camp on River Brule near Pine Ridge, South Dakota.* Albumen silver print, 1891.

This disarmingly peaceful scene is close, in both time and place, to the climactic final days of the Sioux as a warrior nation, and of Indian resistance on the Western plains. The events at Wounded Knee and the death of Sitting Bull on December 29, 1890, had added to long-standing discontents, driving an estimated four thousand people from their cabins on the Pine Ridge and Rosebud reservations to this camp on White Clay Creek—not "River Brule," as labeled. The date is a few days after the surrender (on January 15, 1891) of the fugitive Oglalas and Brules, who were forced back on to the reservations. Grabill left some of the finest photographs of various phases of late frontier life.

a series of bitter "Indian Wars" in the 1870s and 1880s. Native Americans won some substantial victories, most notably the annihilation by Sioux Indians of an entire regiment under the command of George Armstrong Custer at Little Bighorn, Montana, in 1876. But the tide of battle moved inexorably against them. A year after Little Bighorn, the Nez Percé leader known to whites as Chief Joseph—having failed in a dramatic effort to lead his people into Canada to escape forced relocation—announced to the remnants of his once mighty tribe: "I am tired of fighting. The old men are all dead. . . . The little children are freezing to death. . . . Hear me, my chiefs. From where the sun now stands, I will fight no more forever."

By 1890 the tribes were effectively vanquished—relegated finally to small, scattered reservations on especially undesirable land, encouraged by the government to "assimilate" and become like the white Americans who had destroyed their culture. And Sitting Bull, the great Sioux chieftain who had led the tribe to triumph over Custer, after watching his people languish on the reservation, joined Buffalo Bill's Wild West Show and traveled the country for a time representing what was, to most white Americans, an exotic world that had ceased to exist and was rapidly passing into legend.

*

Despite the rapid rise of industrialism in the late nineteenth century, most Americans continued to live in rural areas and to participate in the agricultural economy. American agriculture as a whole had expanded dramatically in the 1870s and 1880s, as southerners rebuilt their shattered agrarian economy and others flocked into newly cultivated areas of the West. But drought, infestations, wildly fluctuating national and international prices for agricultural goods, and other problems drove many farmers off their land and others deeply into debt. Agricultural production increased steeply, making food plentiful and cheap in the cities but driving down the prices of farm goods. While great farm tycoons, who accumulated vast expanses of land and hired many workers, could amass large profits, many farmers experienced impoverishment, growing bitterness, and, increasingly, a readiness to join in movements of protest.

Through organizations such as the Grange and the Farmers' Alliances, hundreds of thousands of small farmers voiced a wide range of grievances and articulated a vision of economic life sharply at odds with the new capitalist order that they believed was oppressing them. They attacked the railroads, the banks, the local political oligarchies, and—increasingly, to the great alarm of conservatives in the East—the gold standard, which they held responsible for an inadequate money supply that made it difficult for them to pay their debts. Some populists combined these economic grievances with cul-

tural ones: hostility to cities, elites, intellectuals, and Europe. Others boldly embraced interracial harmony and gender equality. But all shared the fear that the agrarian world—once the core of American life, the bedrock of independence and individualism—had become a weak and exploited appendage of the new industrial economy.

In the early 1890s, aroused farmers formed a new political party—the People's Party, whose members were commonly known as populists—which articulated their grievances, promoted their agenda, and nominated candidates for national, state, and local offices. The new party performed impressively in the 1892 and 1894 elections, actually displacing one or both of the major parties in some communities and electing many members to state and local offices. And in 1896, partly in response to the populists' successes, the Democratic Party embraced one of their most controversial ideas. The young Nebraska congressman William Jennings Bryan electrified the party's national convention when, in one of the most famous speeches in American political history, he denounced the gold standard and called for an expansion of the currency through the monetization of silver. "Having behind us the producing masses of this nation and the world," he concluded, "supported by the commercial interests, the laboring interests and the toilers everywhere, we will answer their demand for a gold standard by saying to them: 'You shall not press down upon the brow of labor this crown of thorns; you shall not crucify mankind upon a cross of gold.'" The convention went on to endorse the "Free Silver" platform and to nominate Bryan for president. The People's Party, after considerable internal debate, followed suit and nominated him, too. But this apparent populist victory was actually a considerable defeat. Bryan went on to lose decisively to William McKinley in an election characterized by nearly hysterical attacks on the Democrats by alarmed conservatives, and one that established the Republican Party as nationally dominant for the next four decades. And the populists, after their "fusion" with the Democrats, soon vanished as a significant political force. Never again would American farmers unite so successfully to defend their interests. And never again would so large a group of Americans raise so fundamental a challenge to the character of the modern economy.

*

The effects of industrial expansion were most visible, of course, in the heart of the new manufacturing economy—in the great cities and factory towns of the Northeast and the Midwest. And they were nowhere clearer than in Chicago, the throbbing metropolis that by the late nineteenth century had emerged as America's second-largest city and the economic fulcrum of the Midwest. As with other booming cities, a ring of indus-

trial sites was forming around Chicago—steel mills, stockyards, oil refineries, railroad car plants, cordage factories, breweries, distilleries, and many others—and a complex transportation network was developing. Chicago was a hub for railroad lines from all over the nation, a port for the growing commerce of the Great Lakes, and a community with its own web of internal transportation—trolleys, elevated trains, and eventually subways.

Like other industrial centers, Chicago had a rapidly growing and rapidly changing population, as great waves of immigrants from eastern and southern Europe—and later from the American South—poured into the city, searching for jobs and homes, all but overwhelming the older population, building whole new neighborhoods and introducing what were, to Chicago, new religions, new languages, new cuisines, new customs. At the turn of the century, nearly 90 percent of the Chicago population consisted of recent immigrants. And in Chicago, as in other cities, a variety of new urban cultures emerged—some of them dazzling, some of them squalid and desperate, most of them strange to older-stock Americans.

The industrial economy created a growing, and increasingly prosperous, middle class, whose members lived in elegant neighborhoods in cities and in the new suburbs springing up around their boundaries and whose affluence changed the urban landscape. The new department stores, of which Chicago's Marshall Field was among the first, emerged to flaunt the lavish array of consumer goods the economy was producing—new kinds of fashions, mass-produced household goods and conveniences. Middle-class people had, in addition to more money, large blocks of leisure time. They attended the theater, concerts, sporting events, and—beginning in the early twentieth century—movies. Working-class men and women also saw their wages rise and their leisure time increase, and they, too, flocked to new forms of entertainment: professional baseball games, amusement parks (such as New York's Coney Island), parks, and playgrounds.

But for many other urban residents—and for those in some of the new immigrant neighborhoods in particular—the fruits of the new consumer culture seemed alien and all but unobtainable. Such men and women remained wholly immersed in the ethnic cultures of their homelands, creating neighborhoods with their own newspapers and theaters and food stores and social organizations. Crowded into tenements or row-houses or triple-deckers, many lived in conditions of almost unimaginable squalor. Sewage systems were completely inadequate; in poor neighborhoods, there was often no plumbing at all, only outdoor privies crammed into alleys and backyards. Rivers in large cities filled up with unprocessed sewage, often polluting the drinking water.

Garbage disposal was rudimentary, and refuse simply piled up in streets, alleys, and yards. One of the most common descriptions of nineteenth-century cities was their smell, an overpowering stench that at times pervaded even the affluent neighborhoods. These sanitation problems made cities prey to great epidemics, which periodically decimated large urban areas. And they contributed to the acute sense of alarm with which middle-class Americans greeted the new urban world.

The sociologist Charles Horton Cooley wrote in 1899:

Our cities, especially, are full of the disintegrated material of the old order looking for a place in the new: men without trades, immigrants with alien habits and traditions, country boys and girls who have broken loose from their families and from early ties and beliefs, college graduates ignorant of the intellectual progress of the past fifty years, young theologians whose creeds the world has ceased to believe, and so on.

The city, Cooley believed, was where all the crises and maladjustments of the new society converged. It was the place where, as a well-known Protestant evangelical explained in the 1880s, "the dangerous elements of our civilization are each multiplied and concentrated." It became, therefore, something of a metaphor for the whole process of economic development and its discontents.

*

The "city with big shoulders," the poet Carl Sandburg later called Chicago—a city that displayed the drive and dynamism and gritty optimism of late-nineteenth-century America, a city that contained all the raging forces that the new industrial economy had unleashed, a city that was swiftly becoming a symbol of the nation's transformation. And so it was appropriate, perhaps, for Chicago to be chosen in 1893 as the site of a great world's fair to commemorate the four hundredth anniversary of Columbus's arrival in America. On the shore of Lake Michigan, where landfill had supplanted water and swamp, arose the World's Columbian Exposition. Its centerpiece was a remarkable complex of buildings known as the Great White City. There, in the midst of a city of factories and stockyards and slums, stood a gleaming complex of buildings of uniform neoclassical design, pristine white (plaster façades pasted onto iron and steel frames), arranged in perfectly symmetrical patterns around an artificial lagoon. The contrast with the sprawling, grimy, sooty city around it could hardly have been starker; and the contrast was by design. For the exhibit was meant not to represent, but to predict; not to re-create the city as it was, but to suggest the city that might be. It was a vision of a stable, harmonious society set against the chaos of the new industrial world.

Frances Benjamin Johnston. Palace of Mechanic Arts, World's Columbian Exposition, Chicago. Silver gelatin photoprint, 1893. No event had a greater impact on the form and appearance of the American city than this great public exhibition, which inspired the White City movement. Throughout the country, train stations, banks, and city halls all came to resemble these elegant buildings. The monumental classicism of the artificial city created under the guidance of the great planner Daniel Burnham was as significant as his famous dictum: "Make no little plans." On the strength of her documentation of this ephemeral grandeur, Johnston went on to become a leading architectural photographer. She opened her first studio in Washington, D.C., in 1890.

The Great White City evoked an almost religious enthusiasm from the millions of Americans who came to see it. Owen Wister, one of the most popular novelists of the age, described his own reaction to the exhibition: "Before I had walked for two minutes, a bewilderment at the gloriousness of everything seized me . . . until my mind was dazzled to a standstill." Some estimates suggest that more than 10 percent of the American people visited it before it closed.

Only a few miles away from the Columbian Exposition, on the edge of Chicago, stood another community, also constructed according to a precise and ordered plan, also designed as an idyllic vision of the future. It was Pullman, Illinois, an industrial suburb of Chicago and home to the Pullman Palace Car Company, which made the sleeping and parlor cars for most American railroads. George M. Pullman, the owner of the company, had built what he considered a model town for his workers—an orderly community of attractive cottages, with gardens, trees, fountains, and winding streets, a town that at first glance had much the same effect on visitors as the Great White City.

But this vision of order, stability, and rational planning was not simply an exhibit at a fair. It was a real community housing real people. And in 1894 it became the starting point for one of the most bitter labor conflicts in American history—a strike (prompted by wage cuts) marked by violent clashes between employees and company guards, by the burning of railroad cars, and by the departure of many workers from the town of Pullman itself. The strike ultimately spread far beyond Pullman to much of the nation's railroad system. Before ending in failure, defeated by federal intervention to ensure prompt delivery of the mails, it had become one of the largest labor actions in American history to that point.

It seemed strange to some who had visited and admired the town of Pullman that such a vast and ugly labor confrontation would begin there. But to the workers, the people who actually lived in this model community, it did not seem strange at all. To them, Pullman—neat, attractive, and comfortable as it may have been—was something

like a prison, stifling and restrictive. It was a place where every aspect of a worker's existence seemed to come under the scrutiny and control of the employer, in which the opportunities for individual expression—even in so simple a matter as choosing a color for one's house—were carefully and meticulously suppressed. The economist Richard Ely visited the town and soon recognized the flaws beneath the surface. "The citizen," he said, "is surrounded by constant restraint and restriction and everything is done for him, nothing by him." It was, he said, "benevolent well-wishing feudalism." And the result, he said, was that "nobody regards Pullman as a real home." In fact, one of the great badges of achievement among Pullman workers was to earn enough money to move out of the town of Pullman and into a tenement in one of the working-class neighborhoods nearby. Eugene V. Debs, the head of the Socialist Party, described Pullman after the strike as a place "where every prospect pleases and only man is wretched."

In the reactions to these two model communities in Chicago—the Great White City and Pullman—we can discern one of the central tensions of the age: in the celebration of the Great White City, a vision of order, organization, and harmony, of the unity of the "large joyous whole," the "great social web" that Cooley described; in the rebellion at Pullman, the survival of a vision of individual freedom and autonomy, a persistent resistance to regimentation and control, the continuing appeal of Emerson's ideal of the independent, self-reliant man.

Such tensions were exploding all over the country. In 1893 the United States descended into the worst economic depression in its history to that point, a depression so severe that it traumatized a generation and produced widespread social unrest. The nation was, the *New York Herald* reported in 1894, "fighting for its very existence." The great Pullman strike was only one of many labor conflicts in those grim and difficult years—conflicts in which workers, organized in bold but not often powerful unions, were usually crushed by the allied forces of employers, government, and powerful private "detective" agencies whose members stopped at nothing to sabotage unions and beat back strikes. The populist revolt of the short-lived People's Party exposed the anger and fear of millions of farmers as their land and their prospects slipped away from them. An upsurge of lynchings and proliferating Jim Crow laws in the South expressed the anxieties of white men and women in economic difficulties, desperate to buttress a system of segregation and oppression that might otherwise erode in the face of the crisis.

And in cities like Chicago, in addition to labor unrest and, at times, harsh racial and

ethnic confrontations, there was the specter of poverty and homelessness. In the winter of 1894, there were about 100,000 "tramps" roaming the streets of Chicago, approximately 15 percent of the population. "What a spectacle!" wrote the reporter Ray Stannard Baker. "What a human downfall after the magnificence and prodigality of the World's Fair, which has so recently closed its doors! Heights of splendor, pride, exaltation in one month; depths of wretchedness, suffering, hunger, cold, in the next."

<div align="center">*</div>

After the crises of the 1890s, it was hard for most Americans to regard their society complacently. Both the achievements and the failures of the new industrial economy had created enormous challenges. And for a growing number of men and women who came to think of themselves as, first, "reformers" and, later, "progressives," the events of the late nineteenth century had demonstrated how urgent it was to address the instability and disorder of this brave and terrifying new world.

One of the first efforts to do so was a short, messy war that had its roots almost entirely in the domestic social and political concerns of the time. In 1898 Spain was struggling to preserve Cuba, its most important Caribbean colony, against a militant independence movement. Sensationalized stories about Spanish brutality in the relatively "yellow press"—the newspapers of Joseph Pulitzer and William Randolph Hearst, which lured a mass readership with vivid, even lurid, reporting; an unexplained explosion in Havana Harbor that destroyed the battleship USS *Maine*, killing more than 250 Americans; skillful agitation by Cuban émigrés living in the United States; and an inflammatory letter from the Spanish minister in Washington (stolen and leaked to the press) calling President William McKinley "a bidder for the admiration of the crowd"— all combined with the eagerness of many Americans to prove their nation's power (and their own virility) and produced the Spanish-American War. It lasted less than four months and, despite the almost comical incompetence of much of the American military effort, produced a relatively easy victory—notable for, among other things, a bold if militarily insignificant charge in the Battle of San Juan Hill by a volunteer regiment commanded by Theodore Roosevelt, until recently the assistant secretary of the navy (and one of the officials instrumental in maneuvering the United States into the conflict in the first place).

The war may have emerged out of the nation's internal anxieties, but it ended with the United States suddenly in possession of a substantial colonial empire—not just Cuba, which the Spanish now abandoned, but also Puerto Rico, Guam, and the Philippines. The nation's goal in accepting these possessions, President McKinley explained

in recounting what he claimed was his anguished decision to support annexation of the Philippines, was "to take them all and to educate the Filipinos and Christianize them, and by God's grace do the very best we could by them." But many of the people of the Philippines were less sanguine about American intentions, and they soon launched a prolonged and bitter war with their new colonizers, a war far longer and far more costly to the Americans (who lost 4,300 men in the struggle) than the much more celebrated Spanish-American War. After four years of increasingly brutal tactics, the Americans ultimately prevailed. But not before the struggle had intensified what was already a strong anti-imperialist movement in the United States and sapped whatever momentum had been building to extend America's overseas possessions.

*

A more enduring response to the crises of the late nineteenth century was the broad array of reform efforts undertaken to rescue American society from the chaos that industrialization had thrust upon it. Those efforts came in many forms. There were the earnest endeavors of religious men and women, crackling with virtue, to turn theology into an instrument of uplift and reform—a movement known as the Social Gospel. There were the attempts by tough, enterprising journalists—the "muckrakers," Theodore Roosevelt once contemptuously called them—to expose corruption and injustice in city governments, in large corporations, in state legislatures, and anywhere else they could find it. There was the movement, borrowed from England, to send educated middle-class men and women into immigrant neighborhoods to live in settlement houses, teach, provide social services, and, above all, help the new ethnic poor to assimilate to the norms of American life. There were crusades to impose morality and order on presumably disordered urban communities: to stop the consumption of alcohol, by persuasion if possible, by law if necessary; to stamp out prostitution; to tighten divorce laws; to restrict immigration. There were initiatives to improve conditions in dangerous factories, to protect women and children who worked, to create a system of compensation for people injured on the job. And most of all, perhaps, there were efforts to reform or regulate the two great institutions that, in the industrial era, everyone realized would be the major centers of power in the nation's life: the government and the corporation. Reforming politics and government was important, progressives believed, because only through government could society hope to curb the power of corporations, prevent the creation of giant trusts, and protect citizens from the arbitrary power of a new class of industrial titans. Slowly, inexorably, that led the progressives to look to Washington.

Opposite: Woodrow Wilson in Paris, January 1919. Gelatin silver print.
Wilson arrived at the peace conference in Paris determined to forge a lasting peace among European nations. The great creative accomplishment of the conference—the League of Nations—resulted primarily from Wilson's leadership, but he could not persuade the Senate, concerned with issues of national autonomy, to ratify the peace treaties and join the League. Bent on winning popular support for his ideal of a cooperative association of nations, the president set out on a tour of the country, but the strain caused a catastrophic breakdown of his health. In December 1920 Wilson was awarded the Nobel Peace Prize.

The federal government had been a relatively insignificant force in the lives of most Americans prior to the twentieth century. But the social and political pressures of the time combined with the activist inclinations of two remarkable leaders to alter Washington's role in important ways. Theodore Roosevelt used his office as what he once called a "bully pulpit," exhorting Americans to balance their own interests against those of the nation, denouncing labor radicals and corporate conservatives with nearly equal fervor—as "anarchists" and "economic royalists," promoting "mob rule" and "plutocracy"—both threats to the broad and consensual nationalism he sought to create. Roosevelt oversaw a series of modest reforms in his eight years as president, but the most important change he introduced was less legislative or institutional than cultural: a change in popular expectations of the government and, in particular, of the presidency.

The real beneficiary of that change was not Roosevelt himself—who left the presidency in 1909 and tried in vain to regain it four years later. It was Woodrow Wilson, who defeated Roosevelt (and Roosevelt's forlorn successor William Howard Taft) in 1912 and became the most successful legislative president of the first third of the twentieth century. On the surface, he could hardly have been more different from Theodore Roosevelt. "I never met a man who gave such an impression of quietness inside," the journalist John Reed wrote in 1916, "a principle, a religion, a something, upon which his whole life rests. . . . Wilson's power emanates from it. Roosevelt's sprang from an abounding vitality." But Wilson's quiet, intense moralism was, for a time, a potent political asset that produced some impressive triumphs. He lowered tariffs, reformed the banking system, devised important new tools for regulating corporate behavior, won approval of a constitutional amendment permitting an income tax, and sought to prohibit child labor and promote education via the government's taxing and spending authority. By the time he was done, the federal government had become a more efficient instrument of economic and social power than it had ever been before.

<div align="center">*</div>

The promise of progressivism was that purposeful human effort could improve the lives of individuals and the character of society. The industrial era might have begun harshly and chaotically, but it could be transformed into an age of progress and order. That faith, which much of a generation embraced, faced a severe test beginning in 1914 when Europe and, ultimately, the United States became embroiled in the most terrible war in human history to that point: the Great War, as it was known to a generation unaware that another, greater war would soon follow.

Americans recoiled with horror at first from the savage fighting in Europe: fighting that dragged on month after month, year after year, with no prospect of victory on either side; fighting that employed horrible new weapons of mass destruction; fighting that became almost inconceivably murderous—claiming the lives of more than six million soldiers, and of many civilians as well. But when, in 1917, the United States finally joined Britain and France and entered the war itself—responding to what most Americans considered an escalating series of provocations by Germany—there were many who came to view the conflict as a vehicle for advancing progressive ideals. One of them was Woodrow Wilson, who justified American intervention by saying that the war would make the world "safe for democracy" and who enunciated a set of broad principles of international conduct that the United States was, he insisted, fighting to enshrine. When the bloodshed ended—a little more than a year after American forces entered the conflict, decisively shifted the balance of power, and broke the stalemate at last—Wilson sailed to Europe convinced that his own vision of a peace based on democratic principles would prevail. "There is a great wind of moral force moving through the world," he said as he left for Paris, "and every man who opposes that wind will go down in disgrace."

Above all, Wilson hoped, the end of the war would produce a new international organization—a League of Nations—capable of stabilizing relations among countries and preventing future wars. And while the final treaty negotiated in Paris in 1919 fell well short of his largest hopes, it did contain provisions for the creation of his cherished League. Presenting the agreement to the Senate for ratification, he asked, "Dare we reject it and break the heart of the world?" But a combination of principled objections to Wilson's brand of internationalism, frustrated partisan ambitions, and the president's own rigidity doomed the treaty to defeat in the United States. Even epic political exertions on Wilson's part—which ended when he was felled by a devastating stroke—failed to save it. And with the defeat of the Versailles Treaty came, in effect, an end not just to Wilson's dreams of a democratic peace, but also—at least temporarily—to the broad and optimistic effort by Americans of all regions, classes, and races to reshape their society through broad public action. Theodore Roosevelt had once called on Americans to fight on in the public arena "for the good of mankind; fearless of the future; unheeding our individual fates; with unflinching hearts and undimmed eyes." In the years after World War I, such words would for a time seem a relic of a moment already past.

* * *

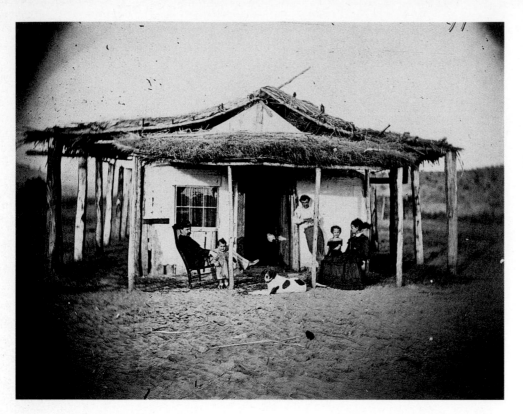

Charles Gentile. *Commanding Officers Quarters at Camp Colorado.* Albumen silver print no. 175 from *Series of Photographic Views and Portraits of Arizona Indian Tribes.* Handmade photograph book. Arizona Territory, c. 1870.

This photograph of an officer relaxing with his family on the makeshift porch of his simple grass-roofed dwelling belies the incessant friction between Native Americans and the early white settlers of the West. From 1869 to 1871 those stationed at Camp Colorado, located near Parker, Arizona, enforced the government's policy of concentrating Native Americans on reservations.

The Italian-born Gentile began his career as an itinerant, photographing remote parts of Vancouver Island and British Columbia in the early 1860s; then, based in San Francisco, exploring California and the Arizona Territory.

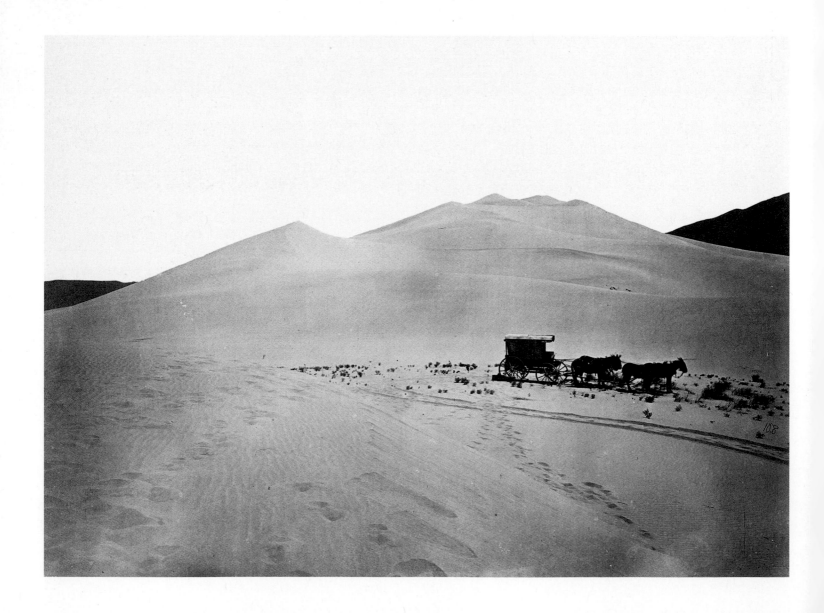

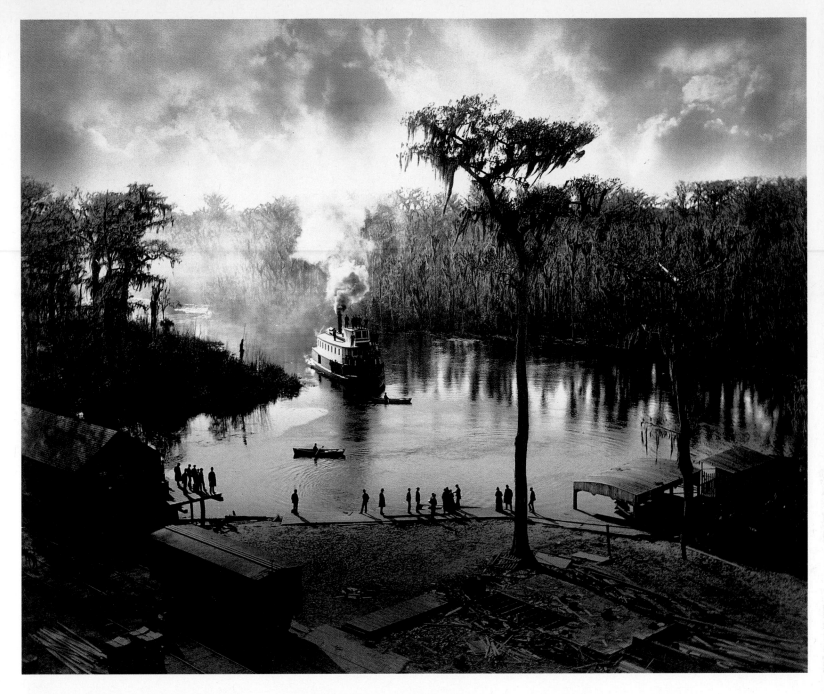

George Barker. *Silver Springs, Florida, From the Morgan House, Steamboat Approaching Dock.* Albumen silver print, 1886.
Tourists discovered Florida's tropical foliage and mild, sunny climate in the 1870s. Before train travel, visitors to Silver Springs in the state's north-central region began their overnight journey by steamboat from the town of Palatka, south of Jacksonville, on the St. Johns River. They entered the tannin-colored waters of the Ocklawaha River and proceeded through a dense swamp forest to the crystal clear waters of the eight-mile "run" that ended at the famous springs. By the 1880s a large hotel accommodated visitors, many of whom explored the un-spoiled setting in rented rowboats.

George Barker was a prominent landscape photographer who traveled to northern Florida in the 1880s to record the lush land-scapes and expanding tourist trade on glass plate negatives as large as sixteen by twenty inches.

Opposite: Timothy O'Sullivan. *Sand Dunes, Carson Desert, Nevada.* Albumen silver print, 1867.
The geologist Clarence King, called the "best and brightest mind of his generation" by writer and historian Henry Adams, led the first of the great government-sponsored explo-rations of the West after the Civil War. The two-year project to record geology, geogra-phy, and natural resources from the crest of the Sierra Nevadas to the western slope of the Rockies was essential to lucrative mining prospects, to further settlement, and to a proposed line of the Central and Union Pacific Railroads.

King could not have chosen for his team a more qualified field photographer, or more consummate artist, than O'Sullivan. Tiring of photographing the mountains toward the end of the first year, O'Sullivan and his party made a detour to a desolate area one hun-dred miles south of Carson Sink. This image of the fragile tracings of man's presence in that stunning wasteland powerfully describes the intrepid exploration of a vast and forbidding continent.

Underwood & Underwood. Theodore Roosevelt and John Muir on Glacier Point, Yosemite Valley, California. Stereograph, silver printing-out paper, c. 1906.

During the nineteenth century, North America's wilderness had seemed inexhaustible. Early in this century, Theodore Roosevelt, the first president born in a large city, brought public attention to the nation's dwindling forests, mountains, and other sites not yet touched by civilization. Here he stands on a vista of Yosemite National Park with John Muir, another early champion of the movement to conserve natural resources.

Originating in the mid–nineteenth century, stereographs were at the height of their popularity in the late 1890s. Typical middle- and upper-class families collected and viewed them as entertainment with a stereoscope that brought the images together for a 3-D effect.

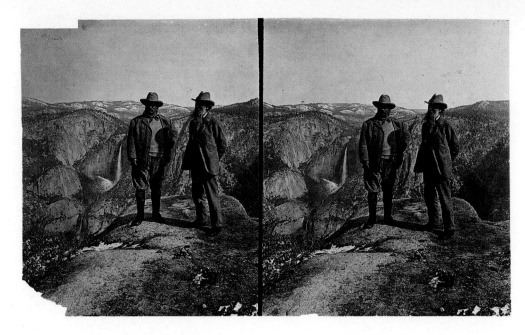

John C. H. Grabill. *Round-up Scenes on Belle Fouche* [sic]. Albumen silver print, 1887. Shortly before the arrival of a railroad line that would make South Dakota's Belle Fourche (French for "beautiful fork") the busiest cattle-shipping point in the world, Grabill captures cowboys eating dinner in front of two chuck wagons during a roundup. Held at least twice each year, once in the spring to brand unmarked cattle and again in the fall to drive them to market, cattle round-ups brought together cowboys from many ranches. After mining, cattle ranching spurred the second great wave of white settlement of the Far West, and the cowboy was transformed remarkably quickly into a powerful and enduring figure of myth. Grabill operated photographic studios in Deadwood, Lead City, and Sturgis, South Dakota.

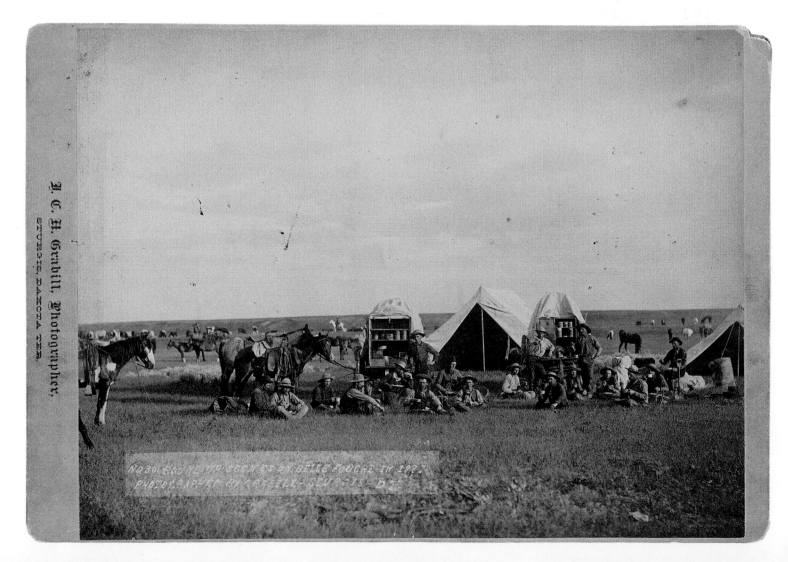

F. Holland Day. Girl with white collar. Gum bichromate print. Hampton, Virginia, 1905. Virginia's Hampton Normal and Agricultural Institute (now Hampton University) was founded in 1868 to educate freed slaves for elementary school teaching and other independent occupations. Day, the master photographer from Boston, was an adviser to the distinguished Camera Club, or Kiquotan Kamera Klub, whose name both recognizes the region's first Native American settlers and mocks the white supremacist Ku Klux Klan. This portrait of a young girl at Hampton's affiliated elementary school conveys a special warmth and human sympathy for the child's hopeful future, despite discrimination in the new urban South.

Frances Benjamin Johnston. Classroom at the Carlisle Indian Industrial School. Cyanotype. Carlisle, Pennsylvania, 1901–1903.
The Carlisle Indian Industrial School gathered many tribes with different languages for the purpose of molding them into "one people, speaking one language," in the words of its founder and longtime superintendent, Army Captain Richard Henry Pratt. Having overseen the education of Indian prisoners from the Red River War in St. Augustine, Florida, in 1875, Pratt then convinced the government to donate the army barracks at Carlisle for the first elementary and secondary-level boarding school off the reservation. This mathematics lesson captures its practical orientation; the word problems on the blackboard relate to farming. It also shows the total immersion in white culture Pratt deemed necessary for assimilation and to foster white settlement on the reservation lands.

Some of Johnston's school photographs were featured at the 1900 Universal Exposition in Paris. As a delegate, she proved an able ambassador and advocate for women photographers at a time when 90 percent of all professional women were teachers.

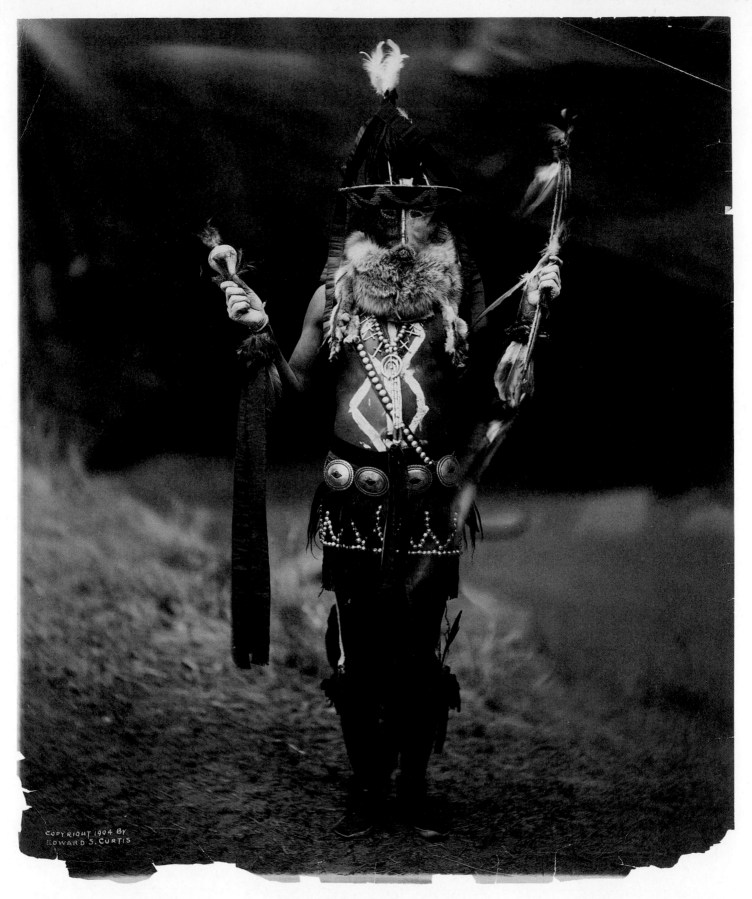

COPYRIGHT 1904 BY
EDWARD S. CURTIS

Edward Curtis. *Zahadolzha, Navaho* [sic].
Gelatin silver print. Southwest United
States, 1904
From the 1890s to the 1930s Edward S. Curtis
photographed approximately eighty different
Native American groups, including their
traditional clothing, crafts, and homes. His
twenty-volume life's work, *The North Ameri-
can Indian,* reflects the romantic notions he
and other white Americans held about the
vanquished Indian. This image dates from a
1904 visit he made among the Navajo and
Apache in the Southwest. The Yebechai
dance, a nine-day ritual combining religion
and medicine, is still practiced today and is so
sacred that Curtis is unlikely to have pho-
tographed the actual ceremony; this is proba-
bly a recreation, to which he frequently
resorted. He identifies this figure as Za-
hadolzha (Fringe Mouth), a water-dwelling
deity from the Night Chant.

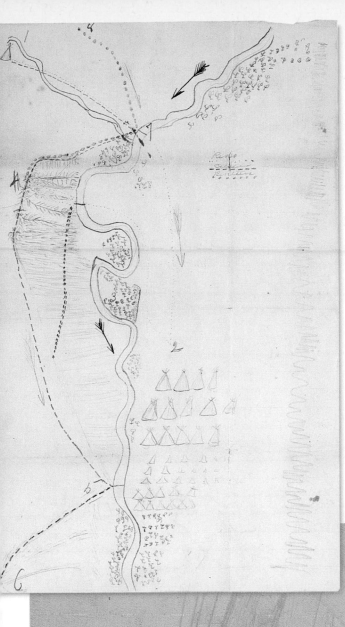

Lt. Robert Patterson Hughes. Map of the Battle of the Little Big Horn. Drawing, pen and ink. Manuscript map, June 30, 1876.

The more the military became involved in removing Indians from land desired by white settlers, the more the tribes began to focus their attacks on soldiers. On June 25, 1876, George Armstrong Custer and 264 men of the 7th U.S. Cavalry died along the banks of the Little Bighorn River in southeastern Montana. The one-sided battle with the Teton Dakota/Sioux and Cheyenne made headlines across the nation and sounded the death knell for the independence of Plains Indians. Although Custer's conduct is still in dispute, the map shown here and an accompanying eight-page letter by Lieutenant Robert Patterson Hughes, aide-de-camp to the expedition's commander, Major General Alfred H. Terry, strongly support the theory that Custer acted recklessly and contrarily to accepted military practice. Not only did he disobey orders by engaging the enemy before Terry's arrival, but he split his command into thirds in the face of overwhelming odds.

Merritt and Van Wagner. *Wild West on Voyage from New York to London.* Albumen silver print, c. 1887.

By the 1880s, Americans were already nostalgic for the rapidly disappearing wilderness and its mythologized inhabitants. The wild west show, the brainchild of frontier adventurer William F. "Buffalo Bill" Cody in 1883, appealed both to this nostalgia and to the Victorian taste for pageants, circuses, and historical tableaux. While bareback riders and lifelike battle scenes were undoubtedly entertaining, the show perpetuated the stereotype that all Indians lived in tepees, spoke in sign language, wore buckskin and feather headdresses, rode painted ponies, and hunted buffalo like the Plains Indians.

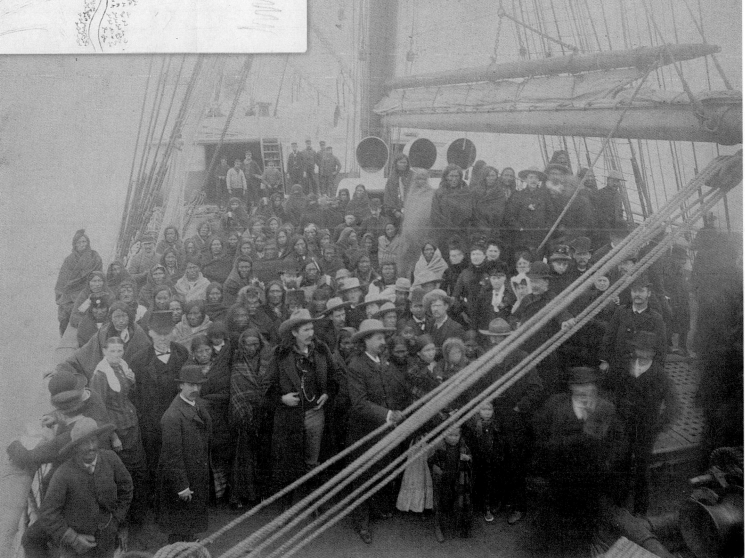

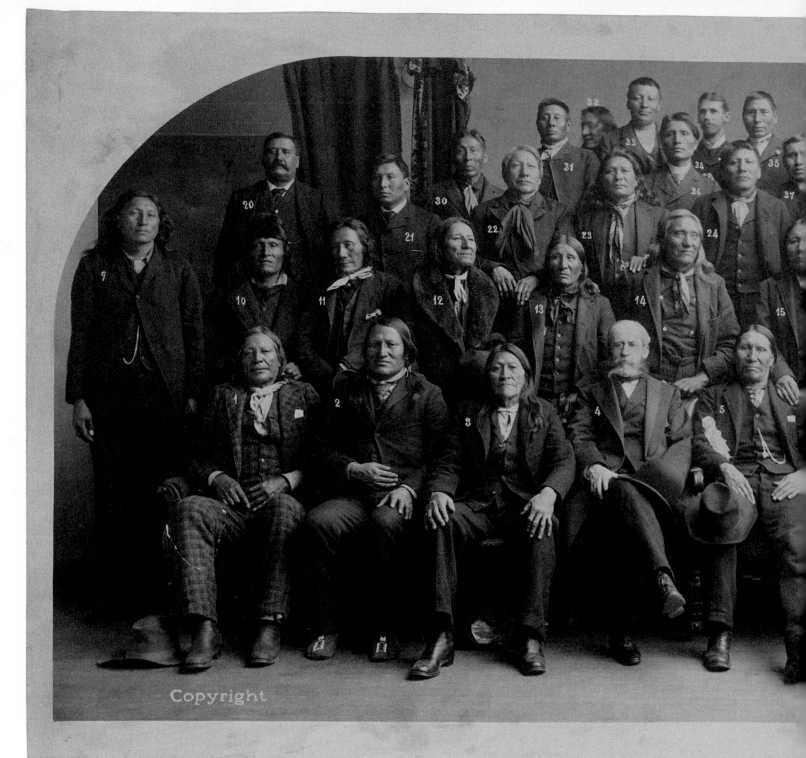

FULL DELEGATION OF SIOU

No. 1. FIRE LIGHTNING.
2. JOHN GRASS.
3. TWO STRIKE.
4. COM'R T. J. MORGAN.
5. AMERICAN HORSE.
6. HIGH HAWK.
7. HIGH PIPE.
8. YOUNG-MAN-AFRAID-OF-HIS-HORSES.
9. HOLLOW HORN BEAR.
10. CRAZY BEAR.

No. 11. MEDICINE BULL.
12. WHITE GHOST.
13. QUICK BEAR.
14. LITTLE WOUND.
15. FAST THUNDER.
16. SPOTTED HORSE.
17. SPOTTED ELK.
18. GRASS.
19. DAVE ZEPHIER.
20. LOUIS RICHARDS.

No.

Photographed and Copyrighted by C. M. BELL, V

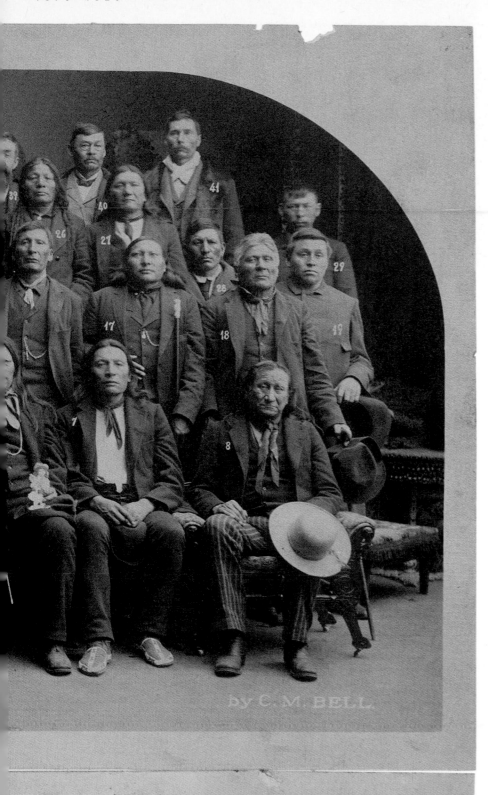

DIANS, 1891.

REE STARS.

WITH

n, D. C., February, 1891.

No. 31. NO HEART.
32. MAD BEAR.
33. STRAIGHT HEAD.
34. F. D. LEWIS.
35. MAJ. SWORD.
36. TURNING HAWK.
37. ROBERT AMERICAN HORSE.
38. REV. LUKE WALKER.
39. BAT POURIEAU.
40. ALEX. RECONTREAU.
41. LOUIS SHANGRAU.

Charles M. Bell. *Full Delegation of Sioux Indians.* Albumen silver print. Washington, D.C., 1891.

This portrait was taken in February 1891, less than two months after the massacre of the Sioux at Wounded Knee in the Dakota Territory. With the breakup and land loss of the Great Sioux Reservation west of the Missouri River by an 1889 act of Congress, the survival of the Plains Sioux was threatened. This delegation, on an official trip to Washington in the company of the tribe's government agents, was probably participating in a new pattern of politics called lobbying, in which individual interests organized to influence government directly rather than operating through party structures. Pictured are T. J. Morgan, Commissioner of Indian Affairs (1889–93), and leaders of different bands of Sioux, including Hump of the Miniconjou Sioux, who had clashed with whites in the Dakota Territory, and American Horse, an Oglala Sioux who had helped to defuse the hostilities. Bell's studio was conveniently located not far from the Capitol. From the late 1850s into the twentieth century, there was a lively trade in images of the native delegations who passed through the nation's capital to negotiate agreements with the federal government.

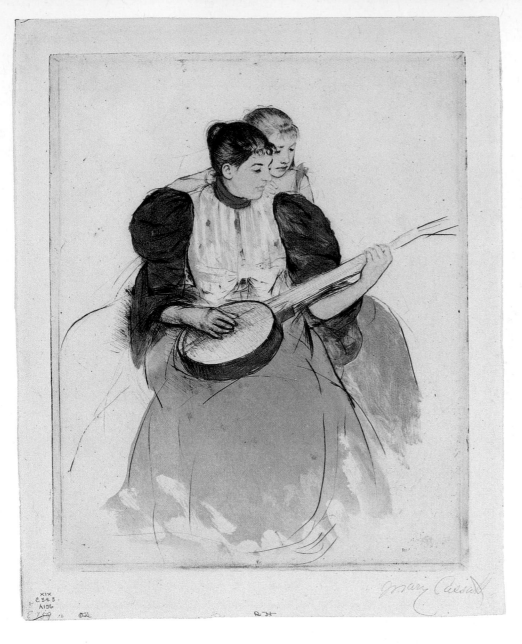

Mary Cassatt. *The Banjo Lesson.* Color drypoint and aquatint with hand coloring. Fourth state. [Paris], c. 1893.

Mary Cassatt was the only American among the core group of French Impressionists in the mid-1870s. Her wealth afforded her comparative autonomy, and after studying at the Pennsylvania Academy of Fine Arts, she joined the number of American artists in Paris, then a major artistic center.

The Banjo Lesson weds a quintessentially American subject with the tender, introspective portrayal of women and children for which she is well known. The low, almost horizontal angle of the instrument suggests Japanese woodcuts of musicians plucking the *shamisen* or *biwa*. But, as Thomas Jefferson wrote, "The instrument proper to them [African Americans] is the Banjar, which they brought hither from Africa, and which is the original of the guitar. . . ." Cassatt painted certain details, such as the dots on the player's skirt, directly on the plate for each printing, making every impression unique.

Scott Joplin and Scott Hayden. *Something Doing.* Sheet music cover. St. Louis, 1903. With the advent of ragtime at the turn of the century, African-American syncopated styles entered the mainstream of American music. "Something Doing," written in 1903 by Scott Joplin and the otherwise obscure Scott Hayden, is a classic rag: its description as a "cake walk march" pays homage to an earlier style of syncopated music. This cover for the sheet music suggests that what's "doing" is a new interest from white society in black social and aesthetic activities. The cover artist has tried (not entirely successfully) to avoid earlier stereotypical images of black Americans. Joplin was born into a musical family and studied music at the George Smith College in Sedalia, Missouri. He was a noted pianist as well as a teacher and composer.

William Glackens. *A Ford in the River Guamas marks the commencement. . . .* Drawing, ink wash, opaque white, and pencil. Cuba, 1898. Despite its enduring reputation in the American popular imagination as "a splendid little war," the Spanish-American War of 1898 was a brief but vicious campaign in which 240 American soldiers were killed and 1,400 wounded. Many of those casualties were inflicted by Spanish snipers concealed in this jungle at a bend in the Guamas River, where Teddy Roosevelt's famous charge up San Juan Hill outside Santiago was delayed for hours.

Best remembered for his association with "The Eight," an innovative group of painters who introduced contemporary urban themes into the rarefied world of American art, Glackens brought considerable journalistic integrity and artistic ability to his Cuban assignment for *McClure's* magazine. Published at a time when photographers had made documentary sketch artists virtually obsolete, Glackens's sketches represent an apotheosis in American graphic journalism.

Strohmeyer & Wyman. *Interior Santa Ana Church.* Albumen silver print. Stereograph. Philippines, 1899.

The role of the United States as an emerging world power solidified during the Spanish-American War. What began as a war to free Cuba became a war to strip Spain of its colonies. When the peace protocol led to the U.S. occupation of Manila, President McKinley offered to purchase the Philippines, Guam, and Puerto Rico from Spain for $20 million. Spain reluctantly agreed, but Filipino insurgents attacked U.S. troops, provoking a war that is the least remembered, but one of the longest and most ferocious, in American history. For over two years U.S. military efforts were hampered by poor organization and a lack of supplies. Wounded soldiers were treated at primitive medical facilities, as shown in this stereograph of a church converted to a field hospital.

Interior Santa Ana Church—our Field Hospital during the fight—Philippines
Copyright 1899 by Underwood & Underwood.

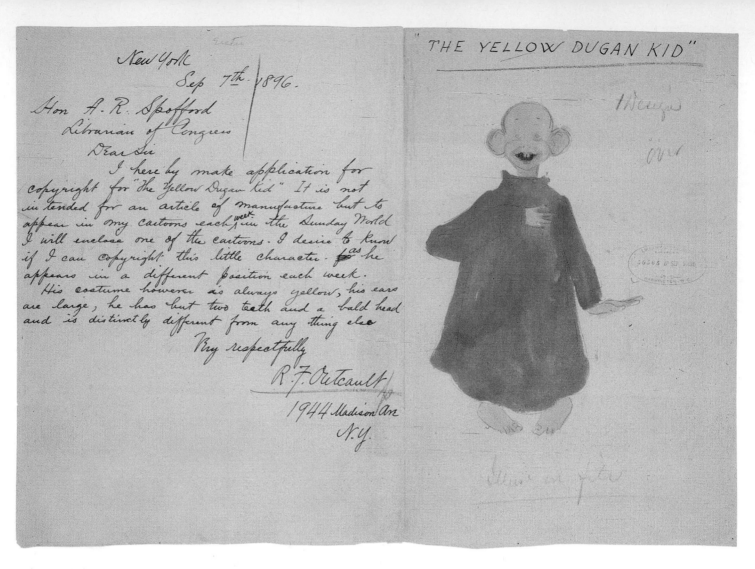

Richard Felton Outcault. *"The Yellow Dugan Kid."* Drawing, ink, pencil, watercolor, and blue pencil. New York, 1896.

On Sunday, May 5, 1895, *New York World* readers were treated to something entirely new: *At the Circus in Hogan's Alley,* by staff cartoonist Outcault. Across the page in one colored panel appeared a boisterous cast of interacting characters and an unprecedented explosion of activity. Over the next several months, one recurring character, a big-eared, gap-toothed youth named Mickey Dugan, caught readers' eyes. By summer 1896, *Hogan's Alley* was a household name, and Americans were obsessed with this goofy-looking fellow they came to call "The Yellow Kid"—whom Outcault described in his copyright registration as "distinctly different from anything else."

Outcault later introduced the further innovation of serial balloons and, by October 1896, all of the essential ingredients for the modern newspaper comic strip were in place.

Alphonse Mucha. *Exposition universelle & internationale de St. Louis (États-Unis).* Color lithograph. Poster. Paris, 1904.

In 1904, St. Louis was host city to both the third modern Olympiad and the largest World's Fair to date, celebrating the one hundredth anniversary of the purchase of the Louisiana Territory in 1803. Officially known as the Louisiana Purchase International Exposition, it attracted over twenty million visitors and emphasized the latest industrial and technological advances: a display of one hundred automobiles popularized this new private mode of transportation.

Alphonse Mucha, a celebrated Czech painter, designer, and lithographer, lived and worked in France. He was one of the foremost proponents of the turn-of-the-century Art Nouveau style. His poster invites "French citizens to make the trip to the St. Louis Exposition—six days by steamer and one day by rail." The United States is depicted as a young girl protected by an Indian; man's achievements are symbolized in the circle at the right.

Alexander Graham Bell. Design sketch of the telephone. Drawing, pen and ink. Boston, c. 1876.

Drawn by Bell himself, this sketch relates the essentials of his dramatic new invention. During the summer of 1876, he gave it to his cousin, Frances Symonds: "As far as I can remember these are the first drawings made of my telephone—or 'instrument for the transmission of vocal utterances by telegraph.'" The middle sketch perhaps best describes the system; it may be a rough draft of the drawing submitted by Bell for his 1876 patent. On the left, a person is shown speaking into the wide end of a cone that focuses the sound vibrations onto a membrane at its narrower, opposite end; there a listener hears a true reproduction of the original utterance. This unique piece of communications history was given to the Library by Bell's grandson, Melville Bell Grosvenor.

Eadweard Muybridge. *The Horse in Motion.* Albumen silver print. San Francisco, 1878.

As the technology of still photography steadily improved, it was natural for photographer/inventors in Europe and America to begin tinkering with devices to record "motion" pictures. Muybridge achieved international fame when he arranged still cameras to capture this galloping horse in sequence. In 1882 the French scientist Etienne-Jules Marey invented a camera with a magazine of photographic plates capable of recording the sequential motion of birds in flight. Building on the ideas of Muybridge, Marey, and others, Thomas Edison, revered inventor of the lightbulb and the phonograph, declared in 1888 that he would develop "an instrument which does for the eye what the phonograph does for the ear, which is the recording and reproduction of things in motion. . . ."

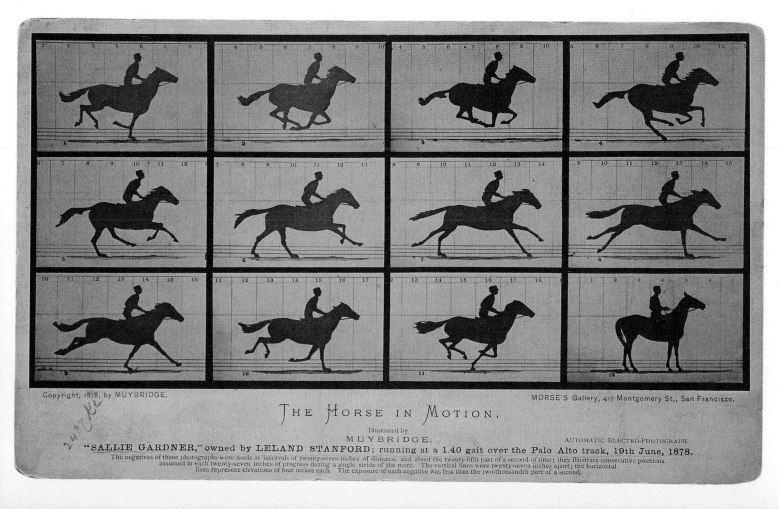

Copyright, 1878, by MUYBRIDGE.

MORSE'S Gallery, 417 Montgomery St., San Francisco.

THE HORSE IN MOTION.

Illustrated by
MUYBRIDGE.

AUTOMATIC ELECTRO-PHOTOGRAPH.

"SALLIE GARDNER," owned by LELAND STANFORD; running at a 1.40 gait over the Palo Alto track, 19th June, 1878.

The negatives of these photographs were made at intervals of twenty-seven inches of distance, and about the twenty-fifth part of a second of time; they illustrate consecutive positions assumed in each twenty-seven inches of progress during a single stride of the mare. The vertical lines were twenty-seven inches apart; the horizontal lines represent elevations of four inches each. The exposure of each negative was less than the two-thousandth part of a second.

W. K. L. Dickson. Dickson tips his hat. Frame enlargements. Edison Manufacturing Company, Orange, New Jersey, June 1891.
Edison assigned major responsibility for turning his ideas on motion photography into practical machinery to his main assistant Dickson who, during the next two years, worked to develop both a camera and a projector. By late November 1890, he had made experimental films and was able to give a studio demonstration of them. These frames are from Dickson's fourth known film, which was made around June 1891; they show him moving his hat in a greeting motion. It is one of the movies that Edison liked to show visitors touring his laboratory in 1892.

W. K. L. Dickson and William Heise. *Annabelle Butterfly Dance.* Frame enlargements. Edison Manufacturing Company, Orange, New Jersey, 1895.
Annabelle Whitford became famous in 1893 for her dancing at Chicago's Columbian Exposition. Integral to her performances was the use of colored gels on the spotlights, an effect that was reproduced for Edison's Kinetoscope peep show by hand-coloring every black-and-white 35-mm print, frame by frame, in his studio. Color motion pictures were an early innovation and became a requisite part of the moviegoing experience.

W. K. L. Dickson and William Heise. *Edison Kinetoscopic Record of a Sneeze.* Starring: Fred Ott. Series of film frames contact-printed from motion picture negative on albumen silver paper. Edison Manufacturing Company, Orange, New Jersey, 1894.

By early 1893 Dickson had surmounted all the technical challenges of motion pictures. Edison named the new motion picture camera, the Kinetograph, and the free-standing peephole viewer, the Kinetoscope. Their success as a photographic novelty was immediate. A novelty they remained, however, as did motion pictures in general, for as long as public viewing was confined to one person at a time. Fred Ott obliged with the famous sneeze, and Dickson wrote the copyright information on the card himself.

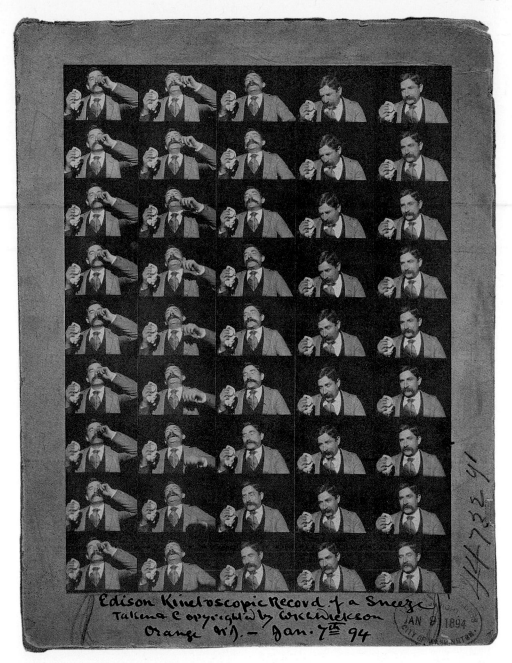

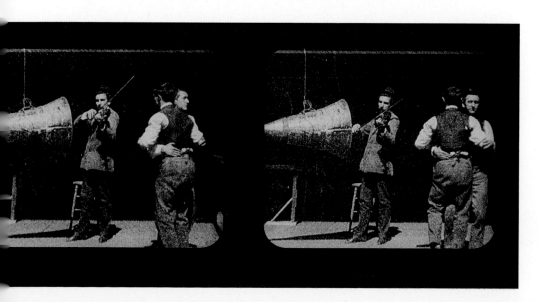

W. K. L. Dickson. *An Early Experiment in Sound Motion Pictures.* Frame enlargements. Edison Manufacturing Company, Orange, New Jersey, January 1895.

One of the many experiments conducted by Dickson under Edison's direction was this effort to record and synchronize sound with motion pictures, a goal not fully realized until the 1920s. This series of frame enlargements shows Dickson playing the violin into a large acoustical recording horn connected to an off-camera cylinder recording machine, while two of his colleagues dance to the music. Edison and Dickson hoped to create the Kinetophone, a machine that would combine movies and sound in a single cabinet. Though good results were achieved in the laboratory, the invention was never successful.

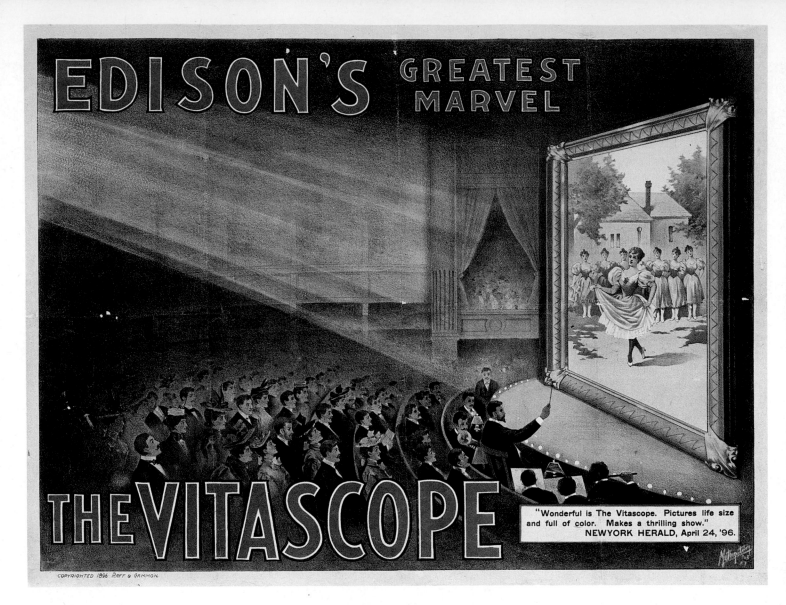

Metropolitan Print Company, for Raff & Gammon. *Edison's Greatest Marvel—The Vitascope.* Color lithograph. Poster. New York, 1896.

Historians mark the end of the "peep show" era and the beginning of the modern motion picture industry in America with the showing of projected movies before a paying audience at Koster and Bial's Music Hall in New York on April 23, 1896. Featured on a bill of live acts were six short films; the hit was called *Gaiety Girls.* From that day forward, movies were commonly incorporated into programs by vaudeville and variety theaters across the country; eventually they replaced the live acts and established the American moviegoing tradition.

The Vitascope—vita from the Latin for "life" and scope from the Greek for "see"—was a modification of the Phantoscope, a machine invented by C. Francis Jenkins and Thomas Armat of Washington, D.C. The manufacturers of Edison's Kinetoscope came to an agreement with the inventors of the Phantoscope, and the new projector was distributed under the eminent Edison's name.

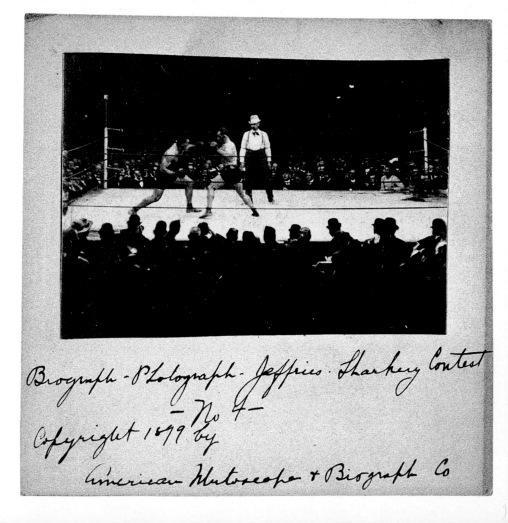

Edwin S. Porter. *The Great Train Robbery.*
Frame enlargements. Edison Manufacturing
Company, Orange, New Jersey, 1903.
As the novelty of moving pictures wore off
after their first decade, many producers
abandoned non-narrative subjects ("actuali-
ties") and began experimenting with comic
and dramatic story lines to revive interest.

Directors soon discovered how to communicate
stories effectively in pictures without dialogue.
In 1903 Porter's western masterpiece *The Great
Train Robbery* pointed the way toward longer
films with complex plots. By 1907, when D. W.
Griffith first entered the film business as an
actor and writer for the Edison company,
actualities were marginalized to newsreels.

Opposite: *Biograph-Photograph Jeffries-
Sharkey Contest.* Frame enlargement on
copyright card. American Mutoscope and
Biograph Company, New York, 1899.
Films of boxing matches were among the
most popular and important made by Ameri-
can film producers in the era before dramatic
and comic genres became dominant. On
November 3, 1899, champion Jim Jeffries
fought Tom Sharkey in a twenty-five-round
contest that Jeffries won by decision. This
filmed record of the bout was released
seventeen days later. Insufficient lighting had
foiled all previous attempts to film indoors,
so four hundred arc lamps were rigged over
the ring. In its advertising campaign, the
production company boasted that the amount
of film needed to record the match exceeded
seven miles in length.

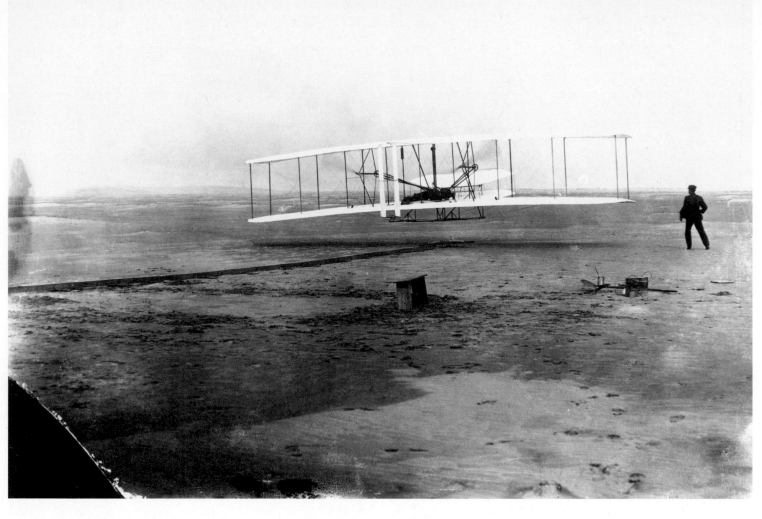

Orville Wright and John T. Daniels. *First Flight, December 17, 1903. Distance, 120 feet. Time, 12 seconds. Orville Wright at controls.* Modern gelatin silver print (from original glass plate negative). Kitty Hawk, North Carolina.
This, the most remarkable photograph in aviation history, was taken at the exact moment of liftoff and shows the world's first powered, controlled, and sustained flight. Wilbur and Orville Wright were aware of the importance of photography to their work—both scientifically and historically—and their use of it was consistent with their deliberate experimental methods.

Orville is lying at the plane's controls with his hips in the movable cradle, operating the wing-warping mechanism; Wilbur has just finished running alongside the machine to steady its ride down the wooden rail and has released his hold on the wing. Daniels was recruited by Orville, who had preset the camera and instructed him when to squeeze the rubber bulb, tripping the shutter.

Arnold Genthe. *John D. Rockefeller, Sr.* Gelatin silver print. Tarrytown, New York, 1918.
By the 1880s Rockefeller was the foremost symbol of monopoly in America. As the founder of Standard Oil Company, he controlled 90 percent of the nation's refined oil. He and other industrialists saw consolidation as a way to cope with "cutthroat competition," and he pioneered the "trust." This unusual portrait of the legendary titan of American industry shows his wit and charm at age seventy-nine. His close friend, the architect Welles Bosworth, arranged for Genthe to photograph him and his country house Kijkuit ("lookout" in Dutch) in Tarrytown, New York.

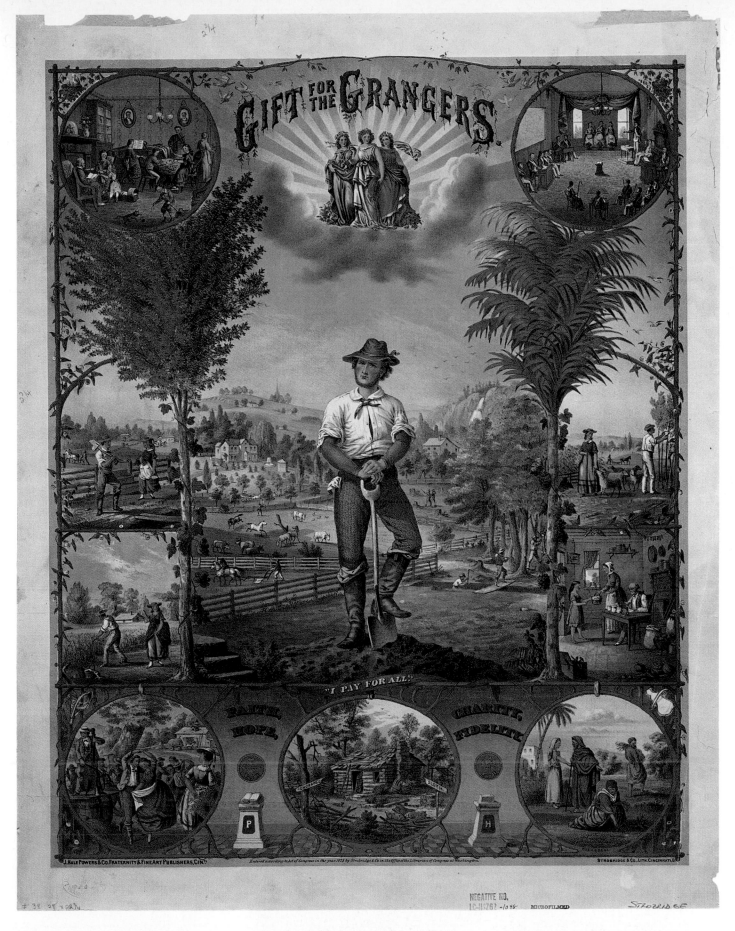

Strobridge Lithographic Company. *Gift for the Grangers.* Chromolithograph. Cincinnati, Ohio, 1873.

The first national labor unions were formed just after the Civil War, and farmers were among the first to organize. In 1867 the Department of Agriculture established the Order of Patrons of Husbandry, or National Grange, to assert the vital economic role of farmers and to oppose railroad policies that, initially, had spurred the growth of farming communities in the Midwest and West but soon became their nemesis with exorbitant toll charges and storage fees. By 1875 there were Grangers in virtually every state and territory, though their strength lay in the Midwest and South. They created cooperatives to distribute their produce, and successfully promoted legislation regulating the railroads. The Grange was succeeded by the Farmers' Alliances, and in 1891 the People's Party was founded by delegates from farm and labor organizations.

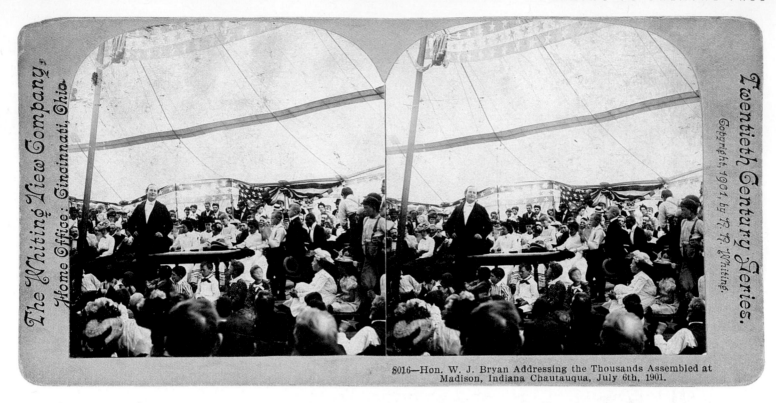

8016—Hon. W. J. Bryan Addressing the Thousands Assembled at Madison, Indiana Chautauqua, July 6th, 1901.

R. R. Whiting. *Hon. W. J. Bryan addressing the Thousands.* Silver printing-out paper print. Stereograph. July 6, 1901.

In the era before radio and television, "Chautauquas" satisfied a nationwide hunger for popular instruction and cultural debate. Originating as a series of lectures on religious issues in a summer tent encampment at Lake Chautauqua, New York, they expanded to include literature, music, morality, the arts, and history. Here William Jennings Bryan, the period's most famous orator, addresses a Chautauqua in Madison, Indiana, in 1901. He became the first presidential candidate to stump the country, systematically visiting villages and hamlets; in 1896 he was the nominee of both the Democratic and People's parties. His loss to McKinley, along with rapidly rising farm prices, helped dissolve the populist movement, which remains the most forceful protest ever raised against the nature of the industrial economy in America.

Robert La Follette on a whistle-stop tour in his campaign for Governor of Wisconsin in 1900. Gelatin silver print.

Robert La Follette was the most celebrated state-level reformer and, along with Theodore Roosevelt and Woodrow Wilson, one of the leading political voices of the Progressive Era. In his efforts to curb trusts, urban bosses, corporate moguls, unfair taxation, and corrupt elected officials, he helped turn Wisconsin into "a laboratory of Progressivism." He was elected governor in 1900. "Fighting Bob" later left the governorship to become a U.S. Senator. He ran for president on the Progressive Party ticket in 1924.

"*You ought to be ashamed of yourself!*"

William Wallace Denslow. *"You ought to be ashamed of yourself!"* Color woodcut from Lyman Frank Baum, *The Wonderful Wizard of Oz.* Chicago and New York, 1900.

Oz is the American farm made magical. Baum revamped old traditions by creating a bright new fairyland—"to bear the stamp of our own times"—where, as befits the Progressive Era, technology is right at home. In this rural utopia, good motives, ingenuity, and trust in oneself always win out, although the road to victory is often rough. Denslow, who first achieved recognition as a poster artist, endowed his twenty-four full-page color illustrations with the elegance and control of Art Nouveau. Before the *Wizard,* few children's books had tipped-in color plates, and none had such an elaborate color scheme.

The story has been read as a parable on populism: the Lion as politician (William Jennings Bryan); the Tin Woodman as eastern industrial worker (Dorothy finds him in the eastern lands of the Munchkins); the Scarecrow as farmer; Dorothy's magical silver shoes as the proposed silver standard (championed by Bryan); the Yellow Brick Road as gold (the standard of world trade and finance); and the fraudulent Wizard as President McKinley, whom the group approaches for relief from their problems.

Albert Randolph Ross. Carnegie Library, Taunton, Massachusetts. Elevation drawing, graphite and watercolor. New York, c. 1903.
In 1901 Pittsburgh's Andrew Carnegie sold his steel company to J. P. Morgan for $480 million. By 1917 he had forever altered the nation's cultural landscape for the better by helping to fund the construction of 1,679 libraries. Specializing in library design, Ross had completed buildings in at least twelve cities by 1906—including Nashville, Atlanta, San Diego, Washington, D.C., and Columbus, Ohio. This design demonstrates his ability to achieve monumental effect in a structure of modest size. "Free to All" is inscribed over its doorway, a reminder of the importance of the public library movement in the early twentieth century.

West Coast Art Company. Copper Flat,
Nevada. Panoramic gelatin silver print.
Ely, Nevada, 1909.
Mining, which had been the backbone of
Nevada's early economy, went into decline in
1873 owing to low silver prices. Then, the
discovery of copper in the hills outside of Ely
in 1900 brought a second boom. Extracting it
from the mountainsides severely scarred the
landscape by creating raw terraces around a
large open pit; it also provided vast private
fortunes. In time, the pit would measure more
than a mile in diameter with a depth of
almost one thousand feet.

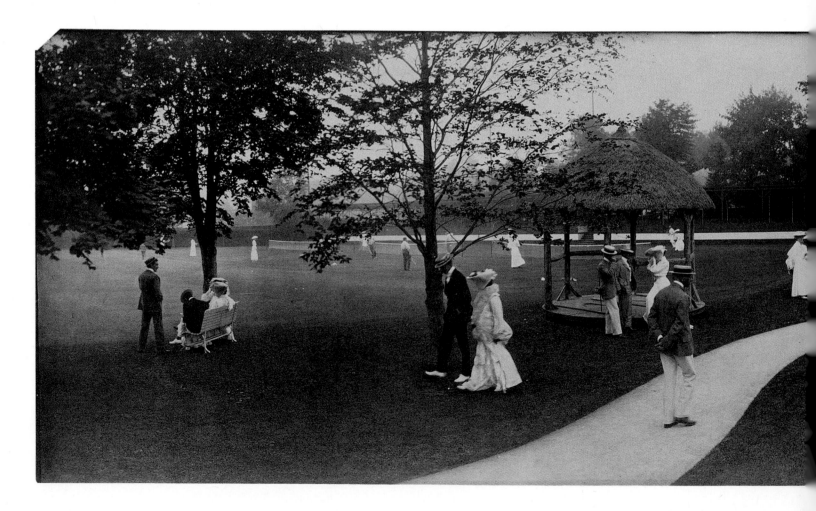

Benjamin J. Falk. *Interior of Casino Grounds, Newport, Rhode Island.* Panoramic silver printing-out paper print, 1902.

The social capital for wealthy industrialists and robber barons at the turn of the century was Newport, Rhode Island. Designed by McKim, Mead & White and built by James Gordon Bennett, Jr., editor of the *New York Herald Tribune,* the Newport Casino was America's first private suburban country club. It provided an opulent environment and many stylish entertainments for rich socialites of the Gilded Age, who summered extravagantly on the Atlantic coast in castles called "cottages." Every August from 1881 to 1914, the casino hosted the National Men's Singles Tennis Championships. Falk operated a fashionable photographic studio in New York's Waldorf-Astoria Hotel.

William Henry Jackson. *Hotel del Monte, Monterey, California.* Panoramic Photochrom print, 1898.

Hotel del Monte, an exclusive seaside resort on the northern neck of California's Monterey Peninsula, opened in June 1880. The original hotel suffered a devastating fire in 1887, only to be immediately rebuilt, larger and more splendid than before. The new hotel could accommodate seven hundred guests and resembled both a Swiss chalet and many of its visitors' homes. The grounds, occupying over one hundred acres, included landscaped gardens, a cypress hedge maze, a racetrack, polo grounds, and multiple swimming pools.

Jackson was the official photographer for the Hayden Survey of the Territories, and the expedition album, *Yellowstone's Scenic Wonders,* motivated the establishment of Yellowstone as a national park in 1872. A canyon and a mountain now bear his name.

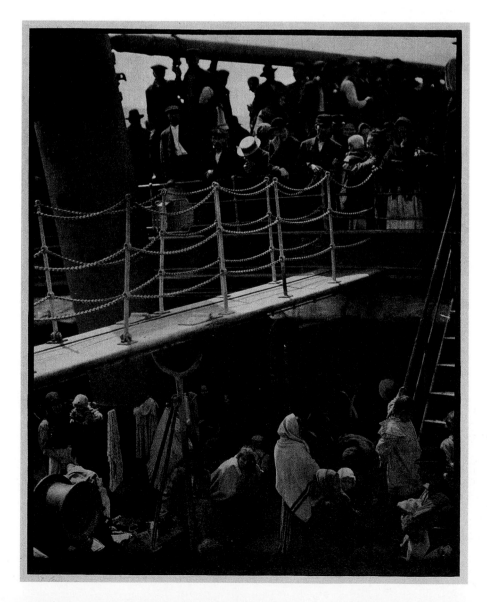

Alfred Stieglitz. *The Steerage.* Photogravure. New York, 1907.

Alfred Stieglitz's long and fruitful career spanned the international pictorialist movement in the 1890s, when photographers first asserted their aesthetic (as opposed to documentary) intentions, through modernism in the 1930s. *The Steerage,* his most famous photograph, dates from a 1907 trip to Europe. Although it has come to be identified with immigration to America, in fact it depicts a colorful and crowded scene on a Le Havre–bound passenger ship. It was first published in his landmark *Camera Work* in October 1911.

Detroit Publishing Company. *Campus Martius, Detroit, Michigan.* Panoramic Photochrom print, c. 1900.

In the 1890s, when large residences lined its wide avenues and the pristine shore of Lake Ontario, Detroit was known as "the most beautiful city in America." Its prosperous industrial economy churned out stoves, tobacco products, railway freight cars, and pharmaceuticals. Not yet a major industry in 1900, its automobile factories manufactured only eighty cars a day. In this photograph, City Hall and the Majestic Building face Campus Martius, a public square in the center of Detroit's business district. A bird's-eye view of the city could be had from the Majestic's fourteenth story for ten cents.

William Whetten Renwick. Wall elevation with study for mural depicting the "Adoration of the Magi." Drawing, graphite ink wash and pastel on grey paper. New York, 1901.
The Renwick family played a large role in the development of American church architecture. William's first architectural task was to design one of the towers of New York's St. Patrick's Cathedral, for which his uncle, James, was the architect. This rendering of St. Aloysius Roman Catholic Church on 132nd Street in New York attests both to his architectural training and to his study of sculpture and painting at the École des Beaux-Arts in Paris. The mural's glowing colors and open composition are inspired by the work of the English Romantics and the French Symbolists.

Thornton Oakley. *Ironworkers.* Drawing, charcoal and white gouache. New York, 1904.
Oakley was a prominent member of the Brandywine school of book illustrators led by Howard Pyle, who encouraged his pupils to "make real things, real surroundings, real backgrounds" at a time when historical themes were dominant in American popular fiction. Pyle's students were renowned for their dramatic compositions replete with evocative period details. Oakley absorbed and practiced these teachings, but often ventured beyond his mentor's fictional world of pirates and princesses to record the contemporary scene. This sketch of ironworkers hums with the vibrancy of life in a burgeoning modern metropolis and reflects America's confidence in industrialization prior to the world wars.

Winslow Homer. *Saved.* Etching, 1889. After his apprenticeship in a lithographer's studio, Homer established himself as a freelance illustrator, covering the Civil War intermittently from the front lines for *Harper's Weekly.* While his wood engravings brought current events into American homes, his paintings, often on the same subjects, were exhibited and acclaimed within the traditional art milieu of studios and academies.

Saved is based on Homer's eyewitness account of a shipwreck rescue, probably off Atlantic City, New Jersey, in 1883, where he interviewed members of the salvage crew and examined the breeches buoy to which the lifeline is attached. Viewers are virtually hurled into the frame; nothing stands between them and the danger of the moment but the courage of the rescuer, who was made anonymous and elemental by a scarf blown across his face.

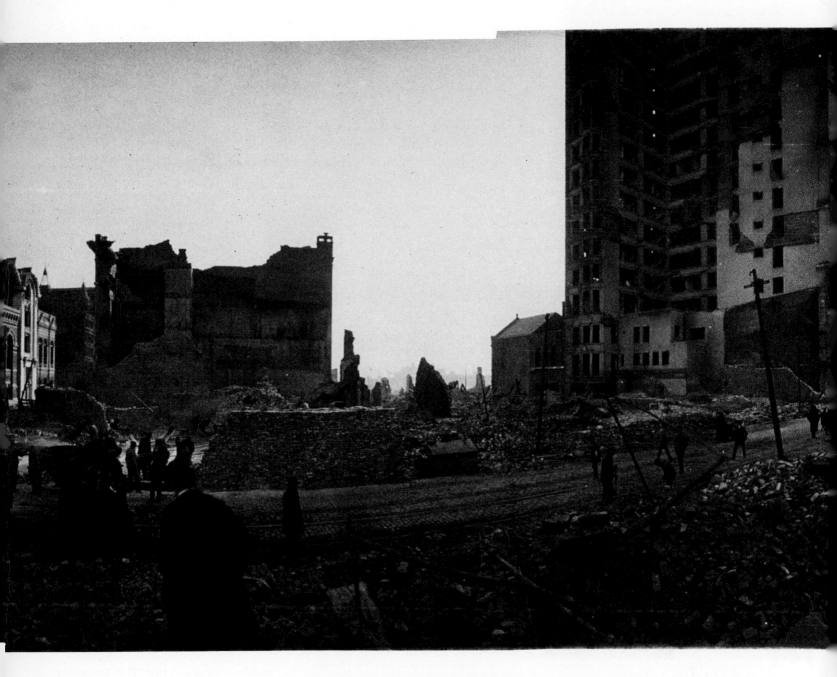

Frederick W. Mueller. *Cycloramic View of the Burned Area of Baltimore's Big Fire.* Panoramic silver gelatin print, 1904.

Throughout the nineteenth and early twentieth centuries, cities were plagued by devastating fires. In February 1904 a blaze spread through downtown Baltimore and took thirty hours to extinguish. More than fifteen hundred buildings in eighty-six city blocks were destroyed, with $150 million in damages; but miraculously, not one life was lost. This photograph, taken near Baltimore Street between Calvert and South Streets, encompasses a view of over 360 degrees—note the distant burned-out church dome at the extreme right and left. The Continental Trust Company building (center) was then the tallest in Baltimore and supposedly fireproof. City Hall (at right) and the Post Office and Custom House (behind ruins, right-center) were spared by a sudden change in wind direction.

Currier & Ives. *The Great East River Suspension Bridge.* Color lithograph. New York, 1874.

The world's longest suspension bridge—connecting the largest and third-largest cities in the United States, New York and Brooklyn—was erected between 1869 and 1883 over the East River by John and Augustus Roebling. Popularly known as the Brooklyn Bridge, it is one of the greatest engineering achievements of the nineteenth century. Even as it was being built, the bridge became a powerful symbol of American progress, ingenuity, industry, and commerce. This print by the well-known firm of Currier & Ives was published six years before the completion of the bridge.

Cass Gilbert. *Study for Woolworth Bldg. N.Y.* Graphite sketch elevation, December 31, 1910.

On the evening of April 24, 1913, President Woodrow Wilson pressed a button in Washington, D.C., and illuminated the more than five thousand windows of a new building in New York City—a triumph of technological and architectural prowess. The Woolworth Building reigned as the world's tallest until the completion of the Chrysler Building in 1930.

Frank Winfield Woolworth launched his retail empire in 1879 in Utica, New York, and by 1912 operated more than a thousand "five-and-ten-cent" stores. His building, which still serves as the company's headquarters, was paid for in full with no mortgage. Gilbert's modified Gothic design for the skyscraper began with this tiny sketch. He is also known for the U.S. Supreme Court Building, but this "Cathedral of Commerce" remains his greatest work. It instantly became an international symbol of New York City and America's can-do spirit.

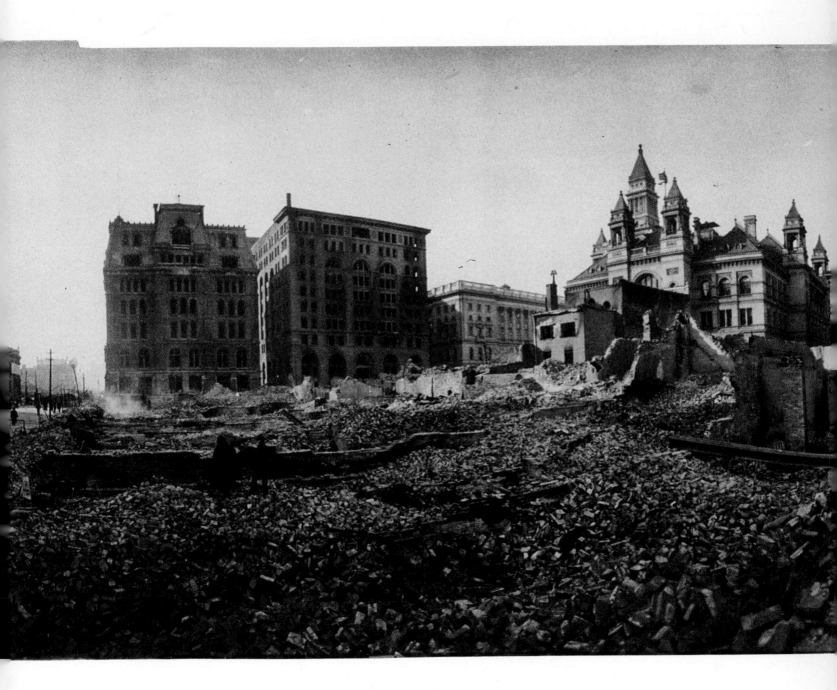

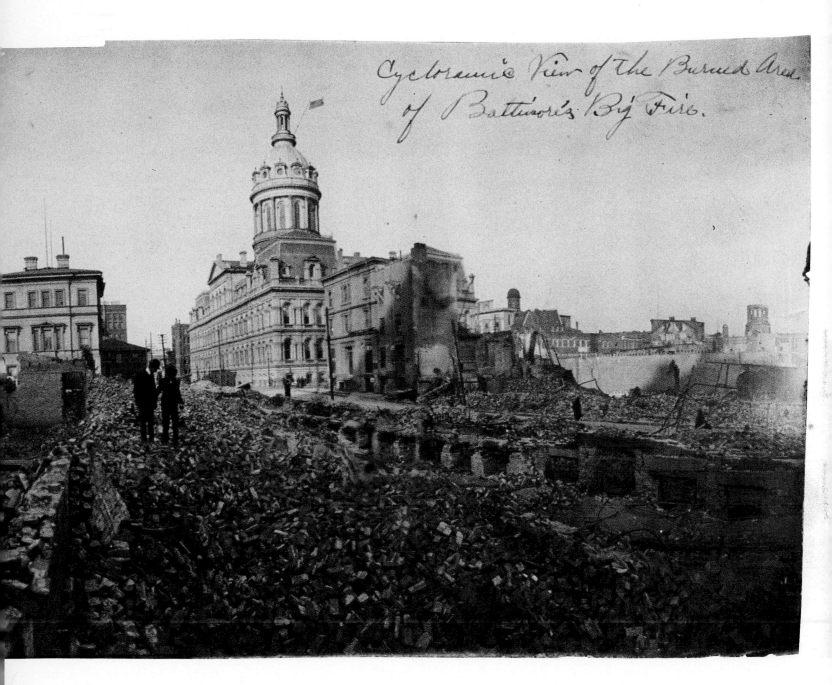

Cycloramic View of the Burned Area of Baltimore's Big Fire.

Marvin Dement Boland. Stadium Day, May 29, 1913. Panoramic silver gelatin print, Tacoma, Washington, 1913.
One of the first stadiums on the West Coast, the Stadium Bowl was built in 1910 next to Tacoma High School on a bluff overlooking Commencement Bay. The school had been initially designed in 1891 as a Beaux-Arts hotel by McKim, Mead & White, one of the period's most celebrated architectural firms; but the depression of 1893 suspended construction until 1905, when Frederick Heath reconfigured the project as Tacoma High School.

The annual field day at renamed Stadium High School was part of a Memorial Day celebration that also marked the end of the school year. Nearly thirteen thousand children participated in 1913, and in the course of the day, the U.S. cruiser St. Louis nosed its way into Tacoma's harbor. America's newfound self-confidence at the turn of the century made panoramic photography very popular— every corner of the country clamored for visual representation, and it best captured the expansive landscape, the vast industrial growth, and the complex social history.

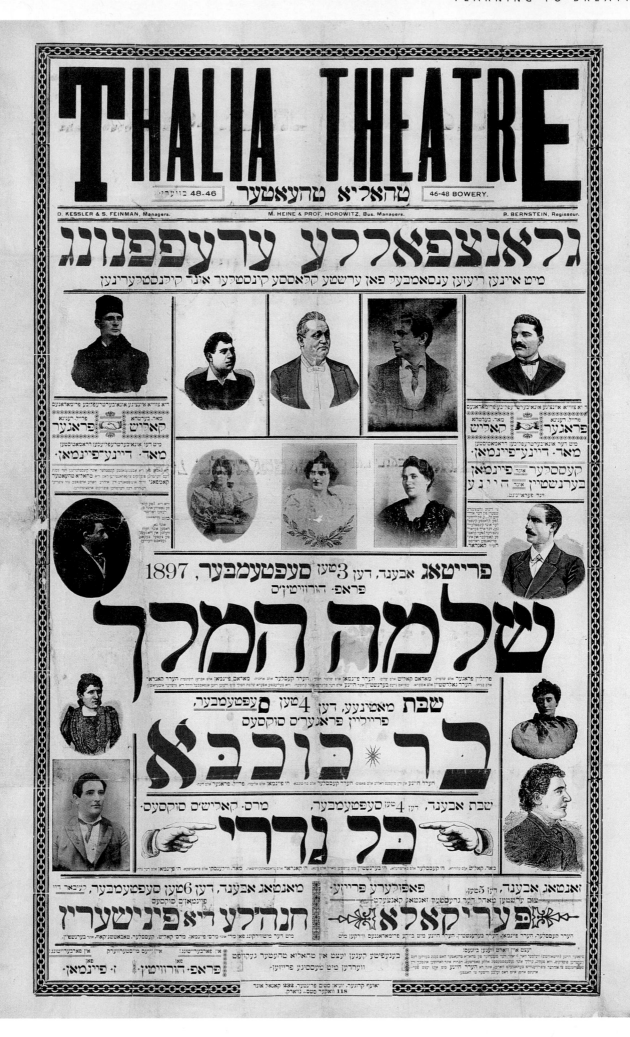

Vic Arnold. *Under the Gaslight.* Lithograph. Poster. New York, 1879.
Nineteenth-century Americans would travel for hours to the nearest town with a stage in order to see plays such as *Under the Gaslight* (1867) by Augustin Daly, a celebrated producer and playwright. In the larger cities, such "meloes" were staged with spectacular climaxes—involving waterfalls, fires, earthquakes, and huge pieces of machinery—to thrill the masses (not necessarily proficient in English). This one featured a locomotive steaming across the stage and a heroine who saves the life of the hero. The last line proclaims: "Victory! Saved! And these are the women who ain't to have the vote!"

Byron Photographic Firm. Minnie Maddern Fiske in *Hedda Gabler.* Silver printing-out paper print. New York, 1914.
This scene from the Manhattan Theater's November 1914 production of Henrik Ibsen's *Hedda Gabler* shows the great actress Minnie Maddern Fiske seated opposite George Arliss. In 1904 she had toured the country for thirty-seven weeks, offering this play sixty-two times in twenty-two states. She introduced the revolutionary social dramas of the Norwegian Ibsen to an American public accustomed to formulaic melodrama, and employed a naturalistic style of acting far removed from the overwrought handwringing of the day.

Mrs. Fiske and her husband, Harrison Grey Fiske, waged a long battle against the powerful theatrical syndicates and were among the first to oppose the trust controlling showbooking rights across the country.

Opposite: Josef Kruger. *King Solomon.* Lithograph with halftone portraits. Poster. New York, 1897.
Among the various playhouses, vaudeville halls, and beer gardens on the immigrant-crammed Lower East Side, the Thalia Theatre was renowned for stellar *Daytshmerish* (German-style) Yiddish theatricals. A gala evening was hosted there in 1896 to celebrate the twentieth anniversary of Yiddish theater in America and to pay tribute to its founding father, Abraham Goldfaden. Moshe Isaac Halevy Horowitz became manager of the Thalia the following year, and opened his first season with a series of lavish "great stars" productions that included *King Solomon.* This unusually large and elaborate poster was made for the theater's facade. Among those depicted are the three "prima donnas": Regina Prager, Bertha Kalish, and Dina (Adler) Feinman.

Joseph Pennell. *Dinner Time, Gatun Locks.* Lithograph. Panama, 1912.

The dream of a canal between the Pacific and Atlantic Oceans dated back to the early sixteenth century, when Vasco Nuñez de Balboa crossed the narrow isthmus separating them. Four centuries later, under treaty with the Republic of Panama, the United States finally brought it to fruition. Construction on such a scale was without precedent in world history. Working ten-hour days in sweltering heat, many thousands of men spent ten years on the project, completed in 1914. For the eminent American printmaker Pennell, the project provided the ultimate expression of his lifelong fascination with the "wonder of work." This lithograph is his document of a modern American epic.

Lewis W. Hine. *Little Spinner in Globe Cotton Mill, Augusta, Georgia.* Silver gelatin print, January 1909.

Hine worked as an investigator and photographer for the National Child Labor Committee, a progressive advocacy organization, from 1906 to 1921. Crisscrossing the country with his camera, flash equipment, and tripod, he sometimes resorted to subterfuge in order to enter the sweatshops and factories and to document the human costs of the economic system. The work of this educator-and-sociologist-turned-photographer resulted in the most comprehensive photographic record of the working class over such an extended period of time; and his touching portraits of young, mostly immigrant children (like this spinner in Georgia) contributed to the tightening of child labor laws in the early part of this century.

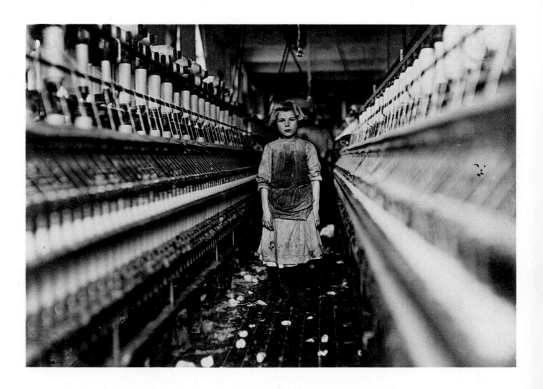

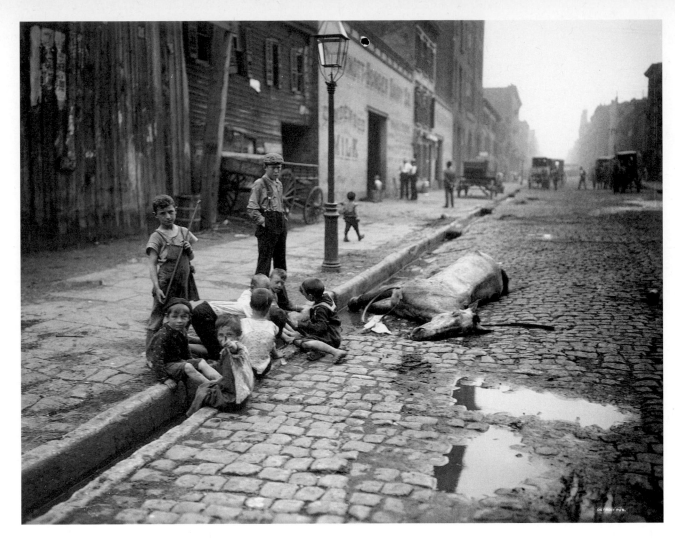

Byron Photographic Firm, for the Detroit Publishing Company. *The close of a career in New York.* Contemporary gelatin silver print (from original glass plate negative). New York, 1900–06.

As the country gradually shifted from an agricultural to an urban-industrial economy, the needs of its citizens shifted as well. Social reformers listed sanitation, child welfare (including education), and animal abuse in their agenda for American cities. Here, raggedly clothed children play on a street curb next to a dead horse, one that presumably—from the photo's caption—used to pull a work cart or trolley car. The Children's Aid Society developed a placing-out system that resettled at least 200,000 destitute urbanites in rural households. The migration of children became known as orphan trains, though many were neither orphaned nor homeless. Some found loving providers; others became the equivalent of slave labor.

Leon Barritt. *The Commercial Vampire.* Chromolithograph from *Vim.* New York, July 20, 1898.

During the last quarter of the nineteenth century, low postal rates, national advertising campaigns, improved printing technologies, and an increasingly large and literate readership fostered a boom in magazine publishing. Illustrated satirical journals, which had first appeared in the 1840s, came of age. Such weeklies as *Puck* and *Judge* had circulations approaching one hundred thousand.

Vim appeared for only ten weeks during the summer of 1898. Here, staff cartoonist Barritt attacks the growth of department stores at the expense of small shop owners. The vampire bat motif was probably inspired by Bram Stoker's *Dracula* (1897), but the sinister bat's unmistakably Jewish features reflect anti-Semitic attitudes common in America at the turn of the century.

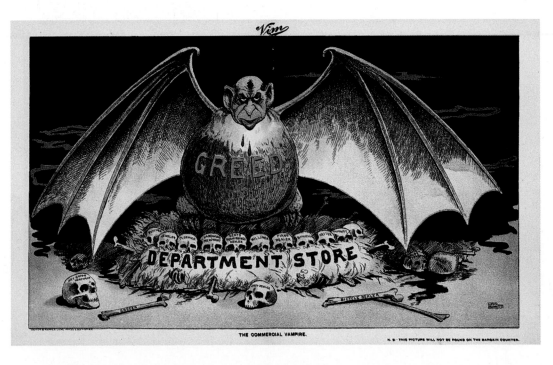

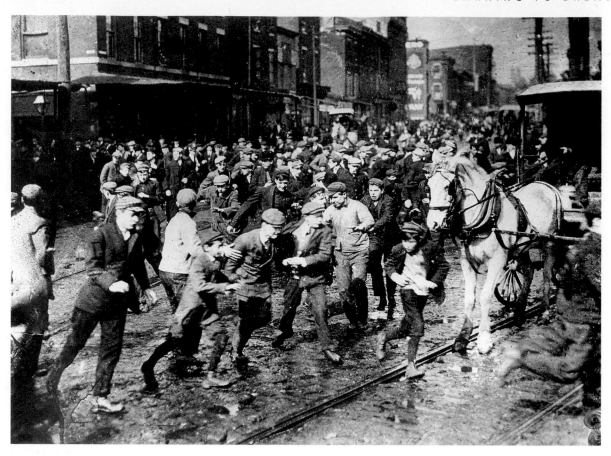

Bain News Service. *Philadelphia Streetcar Strike, Rioters charging a car on Kensington Avenue. The car was wrecked. February 21, 1910.* Contemporary gelatin silver print (from glass negative). New York.
Philadelphia Rapid Transit (PRT) held a monopoly on the city's public transportation and had a long history of exploiting its employees. Group action was one of the workers' few recourses, and when the PRT refused to abide by settlement terms after a 1909 strike, men and boys turned violent, ripping apart trolley cars while women and girls cheered. Police sympathized with the crowds. After nearly a week of bloody skirmishes, officers from outlying areas with few personal ties to the rioters were called in to restore order. Newspaper articles ran with photographic evidence of the violence and working conditions, leading President Theodore Roosevelt to praise the muckrakers for exposing social ills and priming the public for reform and regulatory legislation.

The halftone process, introduced in the late nineteenth century, allowed images like those from George Grantham Bain's news photo service to be inexpensively reproduced. Bain pioneered syndicated news photojournalism.

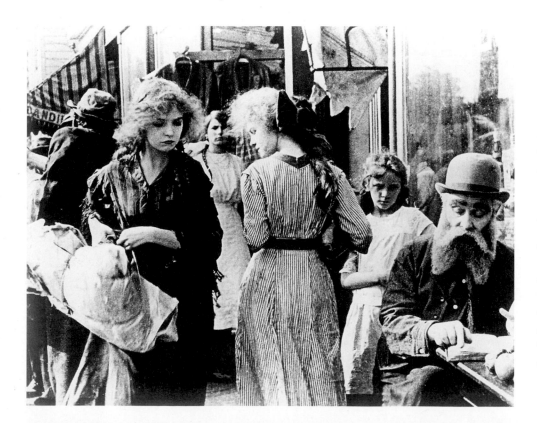

D. W. Griffith. *The Musketeers of Pig Alley.* Cinematographer: G. W. Bitzer. Starring Lillian Gish. Film still. Biograph, New York, 1912. This story of a family attempting to avoid corruption in sordid surroundings against heavy economic odds was filmed on location in New York City slums. The recent emergence of immigrant gangster mobs figures in its plot, and its theme is urban degradation. The first film companies were founded in large cities, and early movies usually reflected the urban landscape—in opposition to the idyllic country life envisioned by Jefferson when he designed his plow over a century earlier. Griffith's masterful intimate realism was like Lewis Hine's photographs dramatized and brought to life.

Frank Lloyd Wright. *American System-built Houses.* Photo lithograph. Spring Green, Wisconsin, c. 1916.

Wright revolutionized the American house by stretching out its roofs and windows horizontally and creating new spaces that engendered new ways of living. The modern ranch house owes much to Wright's early prairie houses and subsequent schemes, such as this one for mass-produced housing by the Richards Company of Milwaukee, Wisconsin. For many established city dwellers and new immigrants, Wright's vision focused their American Dream.

Bain News Service. *Hauling flag—Ebbets Park* [sic], *April 14, 1914.* Contemporary gelatin silver print (from original glass plate negative). New York.

After the Civil War, baseball went professional, with teams in most major cities. Team names often reflected local identity, and with local identities at stake, fans grew heated in their support. By the turn of the century, leagues were formed to rid the game of rowdyism, gambling, and drunkenness.

This group of men is raising the American flag on opening day of the second baseball season at Brooklyn's Ebbets Field—the start of a half-century love affair between the borough and its team. Named "The Robins" in 1914 for their coach, Wilbert Robinson, but affectionately known as the "trolley dodgers," the team officially became "The Dodgers" in 1932. Fans loved the intimacy of the small ballpark, smack in the center of their neighborhoods—games could be watched from apartment roofs. The shared Dodgers experience helped prevent Brooklyn's ethnically and racially diverse communities from splitting into isolated enclaves.

Henry Bacon. Lincoln Memorial, Washington, D.C. Graphite on tracing paper. Chicago, 1917. Dedicated in 1922, the Lincoln Memorial is one of the most popular works of American architecture. It won its architect, Henry Bacon, the Gold Medal of the American Institute of Architects, his profession's highest honor. This original sketch is one of a series that shows his critical role in the evolution of the design, scale, and placement of the statue, created by Daniel Chester French for the building's interior.

D. W. Griffith. *Intolerance.* Scenario: D. W. Griffith. Cinematographer: G. W. Bitzer. Set designer: Walter L. Hall. Cast: Robert Harron, Mae Marsh, Margery Wilson. Frame enlargements. Wark Producing Corp., Los Angeles, 1916.

In this epic three-hour movie, Griffith masterfully interwove three historical examples of intolerance—fall of Babylon, crucifixion of Jesus, massacre of St. Bartholomew—and one contemporary story of a wrongly condemned man, and concluded with an allegorical plea for the end of the appalling slaughter taking place on Europe's battlefields. Stung by the

outrage and controversy evoked by the inherent racism of his 1914 epic, *The Birth of a Nation,* and by its inaccurate portrayal of events during Reconstruction, Griffith attempted to prove with *Intolerance* that movies could be the most powerful force for good ever invented—could even bring about world peace. *Intolerance* accomplished less than he hoped, but it remains a monumental work of silent cinema. With these movies, Griffith perfected the balance of humor, drama, and narrative tension essential to cinematic melodrama and also established the motion picture as a proper evening's entertainment.

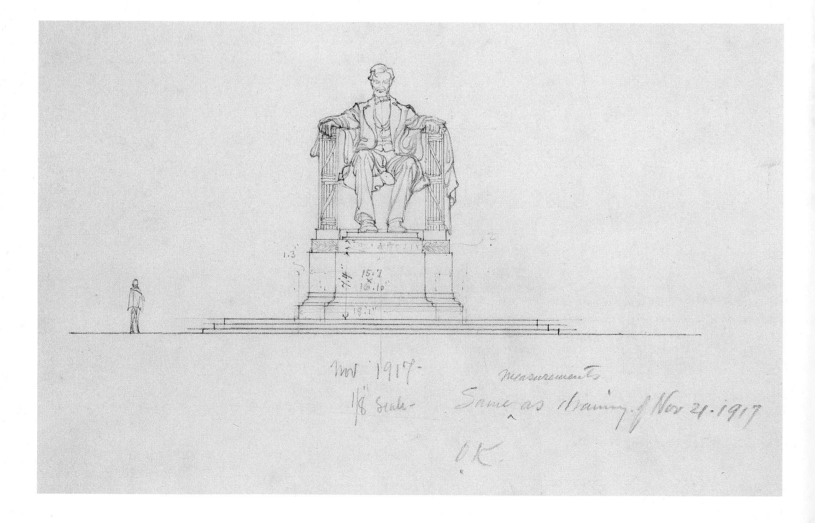

National Association for the Advancement of Colored People. *Onlookers with the burned body of Jesse Washington, 18-year-old African American, Waco, Texas, May 15, 1916.* Gelatin silver print.

On Monday, May 15, 1916, Jesse Washington, a mentally impaired eighteen-year-old African American, was sentenced to death for the murder of his employer's wife. The courtroom crowd dragged him outside to the site of a previous lynching where he was stabbed, beaten, mutilated, hanged, and burned.

In 1916, the six-year-old National Associa-tion for the Advancement of Colored People (NAACP) began a campaign to raise public awareness about lynchings—nearly 75 percent of which involved whites against blacks. Jesse Washington's case was one of the first to be investigated. After the Civil War, lynchings had increased, particularly in the South, from a handful to more than a hundred annually. Although no federal law was ever passed, the NAACP's campaign was so intense and relentless that lynchings occurred less and less frequently until they ceased almost entirely in the 1950s.

Joseph Pennell. *Lest Liberty Perish from the Face of the Earth.* Watercolor sketch for poster. New York, 1918.

The Division of Pictorial Publicity was part of the Committee on Public Information, America's central propaganda agency during World War I. Painters and illustrators were urged by director Charles Dana Gibson, the eminent illustrator of the Gilded Age, to contribute their work to build support for the war at home and to raise money to pay for it. Ultimately, more than seven hundred different poster designs were produced. For the Fourth Liberty Loan Drive of 1918, Pennell conjured up this image of New York City "bombed, shot down, burning, blown up by an enemy." Since the aircraft of the day were unable to cross the Atlantic, his scenario was implausible; but his design was unanimously accepted, and approximately 2 million copies were produced. This original watercolor drawing carries a slightly different title from the printed version, which would borrow from Lincoln's Gettysburg Address: "That Liberty Shall Not Perish From The Earth Buy Liberty Bonds." Of the five bond drives, the fourth was the most successful, with over 22 million subscribers and almost $7 million in pledges.

John Sloan. *"After the War a Medal and Maybe a Job."*
Charcoal drawing. New York, 1914.

The years prior to World War I marked a period of intense political activism among American artists. Radical art and politics met in the pages of *The Masses,* a socialist journal that appeared on newsstands from January 1911 through December 1917. As Europe moved inexorably toward militarism and war in 1914, John Sloan contributed this cartoon damning the capitalist "fat cats" made fatter by war. Such visceral and disturbing images led to the temporary suppression of the journal during World War I, when the U.S. Post Office used the new Espionage Act (1917) to ban its distribution. The act outlawed any public expression of opposition to the war and allowed officials to prosecute anyone who criticized the president or the government. In all, more than fifteen hundred people were arrested in 1918 for the crime of criticizing the government, and citizens' groups rooted out disloyalty by prying into the activities of their neighbors, opening mail, and tapping telephones.

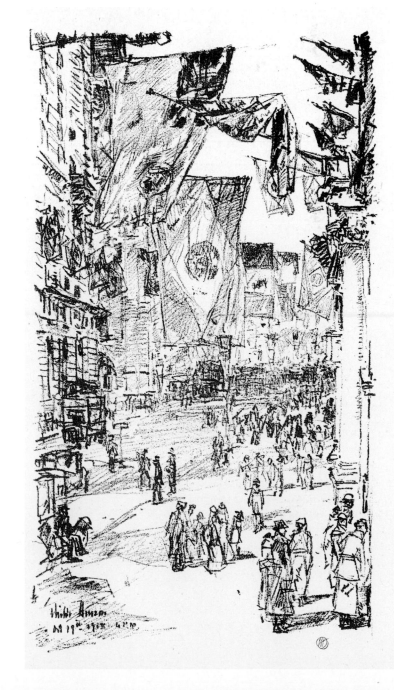

Childe Hassam. *Avenue of the Allies.* Lithograph. New York, 1918.
Hassam cited the Preparedness Day Parade of 1916 as a key impetus for his flag series. It may have been his first glimpse of Fifth Avenue festooned with flags, which would become a familiar sight during World War I. When the United States entered the war in 1917, after nearly three years of attempting to affect the outcome without becoming embroiled in it, Hassam saw the Stars and Stripes join the flags of the Allied nations on Manhattan's skyscrapers. He initially made his reputation as one of "The Ten," Paris-trained American Impressionists, but by the time he recorded this street scene, New York was very much his community, and the work glows with a sense of pride.

Woodrow Wilson. Pencil shorthand draft of "The Fourteen Points" Address. Washington, D.C., 1918.

In an address to Congress on January 8, 1918, President Wilson presented fourteen tenets for which he claimed the nation was fighting: eight recommendations for adjusting postwar boundaries, five general principles to govern future international conduct, and a proposal for a League of Nations. Even before the armistice, he was preparing to lead the fight for what he considered to be a democratic postwar settlement. His vision of a new world order came to enchant not only much of his own generation but generations to come. Britain and France, however, were in no mood for a benign and generous peace, having suffered terrible losses.

"Road scene, 30 Division on way to the front." Gelatin silver print. Pershing Papers photo. France, September 29, 1918.

Not until the spring of 1918 were significant numbers of Americans available for battle. (Eight months later, the war was over.) On September 26, under the command of General Pershing, this American fighting force advanced against the Germans in France's Argonne Forest as part of a two-hundred-mile attack that lasted nearly seven weeks. By the end of October, they had helped push the Germans back toward their own border and had cut the enemy's major supply lines to the front. German military leaders began to seek an armistice, which went into effect on November 11, 1918.

Buck Row 1. Ella Swett 3 Mamie Hilyer Dr. Frye A. F. Hilyer 5. Annie King 7 Dr. Foy 11 Evelyn Shaw 13 Lottie Grimke 24 Lula Love
3 32 Miss Chase 34 Mrs. Douglass 35 Mrs. Chas Douglass • Mrs Shippen 44 Mallie Bush Mrs. John F. Cook
46 Mrs. Frederick Douglass 47. Mrs Michaux Mrs. L. H. Hawkes 90 Mrs. Sara Fleetwood 54 Miss Grant 58 Mrs John Smith
6. Dr. Foy 047 Mrs. J. Pierre 14 Miss Alice Jackson 00 Katey Moten 052 Mrs Jordan
Right of 000 Mrs. John Smith

Luke C. Dilton. Colored Women's League of Washington, D.C. Silver printing-out paper print, c. 1894.
In 1869 Sara Iredell, a registered nurse, married the Civil War hero Christian A. Fleetwood, who had received the Congressional Medal of Honor. She was the first African-American superintendent of the Freedman's Hospital Training School for Nurses and a founder of this league in 1892 dedicated to "racial uplift." Composed primarily of teachers, it established day nurseries, an evening school for adults, and worked to improve moral and social conditions in the District of Columbia. Accompanied by husbands and supporters, the league gathered on the steps of Cedar Hill, Frederick Douglass's home in Anacostia, Washington, D.C., for this group picture. Sara I. Fleetwood is far right in the second row.

The women's club movement raised few overt challenges to prevailing assumptions about the proper role of women in society, but it did represent an important effort by women to extend their influence beyond the traditional sphere of home and family.

Wladyslaw Theodor Benda. Women in various occupations. Charcoal drawing. New York, c. 1915.
The Polish-born illustrator W. T. Benda brought a fluid Art Nouveau line and a penchant for exotic styles and settings to New York following his professional training in Warsaw and Vienna. He became noted for his glamorous treatment of women, and the elegant Benda Girl took her place alongside the popular idealizations of Charles Dana Gibson, Harrison Fisher, James Montgomery Flagg, and others. Such visions of passive American womanhood were competing with other images between 1911 and 1920, however, as women entered the nation's workforce in great numbers, took industrial jobs, and competed successfully with men for skilled office positions.

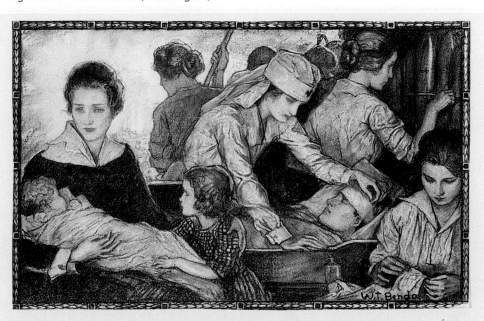

George Bellows. *The Drunk.* Lithograph. New York, 1923–24.

Prohibition and the fight for women's rights were closely allied from the mid–nineteenth century on. The Eighteenth and Nineteenth Amendments, outlawing alcoholic beverages and ensuring nationwide suffrage for women, were ratified within one year of each other—in 1919 and 1920, respectively. Bellows's wrenching image appeared in the May 1924 issue of *Good Housekeeping,* with an article titled "Why We Prohibit," by Mabel Potter Daggett. Although Bellows didn't exhibit with the group of artists known as "The Eight," his work added its unique muscle and spirit to the Ashcan style with which they were associated.

Bain News Service. *Miss Louise Hall and Mrs. Susan Fitzgerald putting up a billboard poster. Cincinnati, Ohio, May 1912.* Contemporary gelatin silver print (from original glass plate negative). New York.

The controversial activist Alice Paul took the battle for equal rights to the streets by advocating "civil disobedience." Women chained themselves to the White House fence and became their own publicists in the struggle to become "real citizens." Here, two women undertake the "unladylike" task of promoting a public meeting of the Ohio Woman Suffrage Association. Although the issue lost by a wide margin in the Ohio referendum of 1914, the association stated that the opposition was "1485 less than the number who voted against us two years ago." Their eventual success marked not the beginning of a reform era, but the end of one.

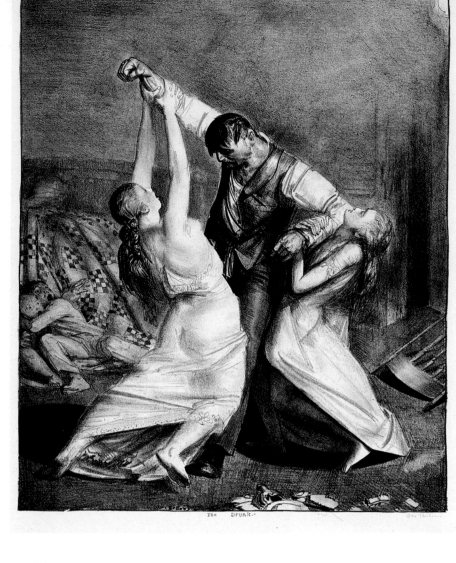

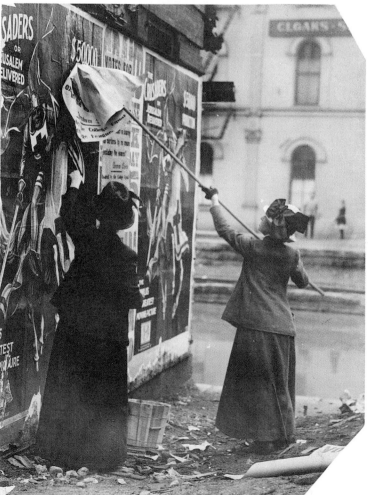

Opposite: Mary S. Anthony. Inside front cover of her scrapbook. Rochester, New York, 1892–1901.

Susan B. Anthony's younger sister shared her sister's dedication to the suffrage movement, perhaps the largest single reform movement of the Progressive Era. Mary kept scrapbooks of newspaper clippings, magazine articles, convention programs, other contemporary accounts, and portraits of some leading figures in the movement, many of whom displayed comparable commitments to other reform initiatives, including abolitionism, temperance, prison conditions, and labor relations. That historians know as much as they do about the suffrage campaign is due in large part to the women's own efforts to record their history.

Susan B. Anthony also assembled thirty-three scrapbooks of similar material from the 1850s to the early 1900s. She wrote this inscription inside the last volume: "But that future generations of women may see and learn of the struggles that the pioneers went through—I give these *scrap-books* and all they contain that is *false* as well as *true*—to The Library of Congress."

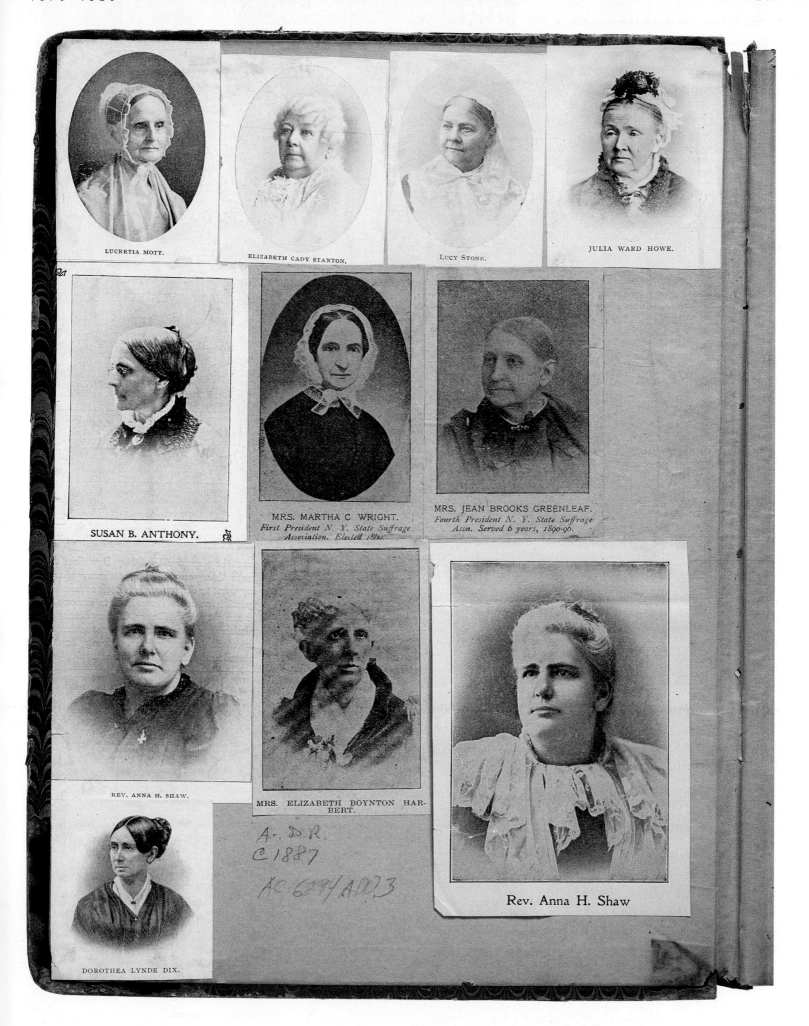

LUCRETIA MOTT.

ELIZABETH CADY STANTON.

LUCY STONE.

JULIA WARD HOWE.

SUSAN B. ANTHONY.

MRS. MARTHA C WRIGHT.
*First President N. Y. State Suffrage
Association. Elected 1869.*

MRS. JEAN BROOKS GREENLEAF.
*Fourth President N. Y. State Suffrage
Assn. Served 6 years, 1890-96.*

REV. ANNA H. SHAW.

MRS. ELIZABETH BOYNTON HAR-
BERT.

Rev. Anna H. Shaw

DOROTHEA LYNDE DIX.

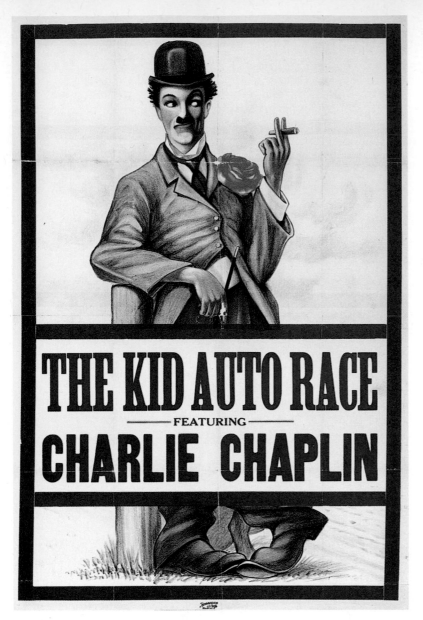

Opposite: Washington Gates. *California Automobile Tours*. Map. Oakland, California, 1913.

In 1895 there were only four cars on America's roads; by 1917, there were nearly five million. With the rapid improvement of the nation's road system, demand grew for guidebooks and road maps to assist motorists in planning their excursions. This early illustrated single-sheet map delineates the California portion of the Lincoln Highway, the first marked and named transcontinental automobile route, completed in 1913. Also shown are five routes of local interest: Yosemite, Old Missions, Sportsmans, Lake Tahoe, and Lake Country. Although provided free of charge by a hotel (Tahoe Tavern in Tahoe, California), maps became one of the primary advertising strategies of the major gasoline companies in the 1920s and 1930s.

Hennegan & Company. *The Kid Auto Race*. Color lithograph. Poster. Cincinnati, Ohio, 1914.

Directed by Henry Lehrman and produced by Mack Sennett's Keystone company, this was Charlie Chaplin's second film, shot in forty-five minutes during a soapbox derby in Venice, California. In it he reportedly introduced his trademark tramp character: the little guy driven to strike out against the social forces that crush the human spirit. Chaplin was the first stage-trained performer to understand that he needed to restructure his live comedy act to focus it directly toward an imagined audience on the other side of the camera lens. His great popularity rested on his being both a film star and a personality.

Edward Penfield. Preliminary design for a Pierce-Arrow automobile advertisement. Drawing, pencil, ink, and watercolor. New York, c. 1915.

The automobile gave Americans unprecedented personal mobility and freedom. Whether practical like a Ford Model T or elegant like a Pierce-Arrow, automobiles quickly became a central feature of American life. Like the clothes people wore or the houses they lived in, cars revealed America's social and economic status and aspirations.

American advertising came of age after 1900 as national manufacturers vied for the services of talented illustrators. Penfield established his reputation with a series of posters designed for *Harper's* magazine during the 1890s. Inspired by the bold outlines, simple compositions, and broad fields of vivid color found in Japanese prints and the work of such celebrated French graphic artists as Toulouse-Lautrec and Eugène Grasset, he developed a strong, recognizable commercial style that exerted a powerful influence on the illustrators of the day.

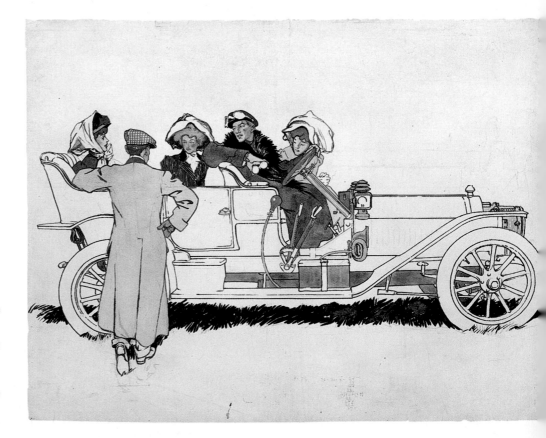

CALIFORNIA AUTOMOBILE TOURS

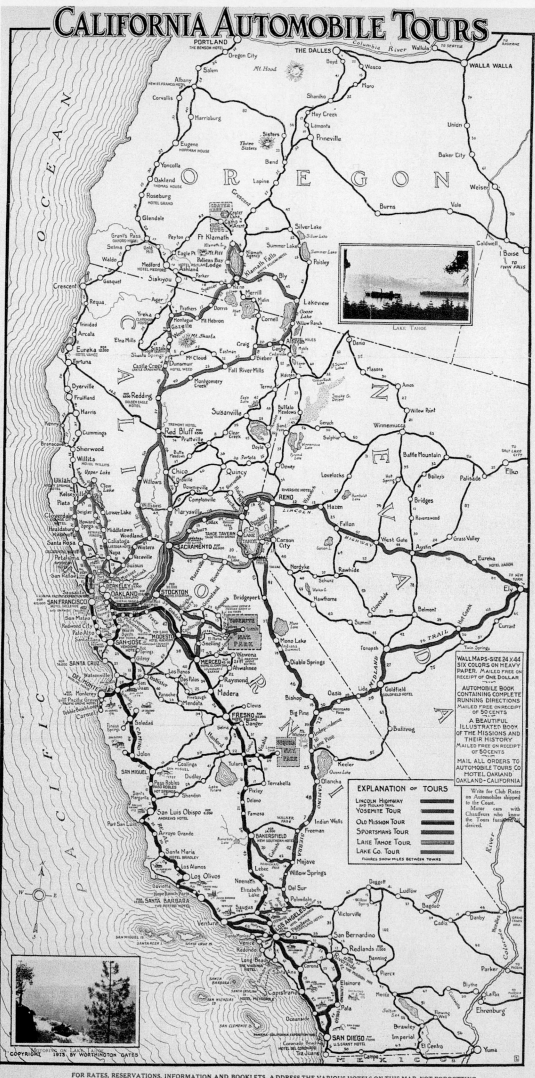

TAHOE TAVERN
ON LINE OF LINCOLN HIGHWAY
Open May 15th to October 15th

A beautiful house amid beautiful surroundings. Capacity for 400 guests. Rates $4.00 per day and upward. American plan. Special rates for chauffeurs and maids. Modern garage, machine shop, supplies. Write for descriptive folders.

LAKE TAHOE FROM TAHOE TAVERN

COMPLIMENTS OF TAHOE TAVERN Tahoe, Cal.

DUPLICATE COPIES MAILED FREE

PUBLISHER'S NOTE

Copyrighted April, 1914.

Address all orders to
California Automobile Tours Co.
Worthington Gates, General Manager,
Hotel Oakland, Oakland, Cal.

FOR RATES, RESERVATIONS, INFORMATION AND BOOKLETS, ADDRESS THE VARIOUS HOTELS ON THIS MAP, NOT FORGETTING TO MENTION THE CALIFORNIA AUTOMOBILE TOURS FOLDER

THE CITY

Opposite: Jack Delano. *In a working-class section of Pittsburgh, Pennsylvania. January 1941*. Gelatin silver print. Farm Security Administration (FSA).
Muckraker and editor Lincoln Steffens once wrote of Pittsburgh, "It looked like hell, literally." By World War II, few industries would locate there because of the city's substandard housing, raw sewage in its rivers, and air blackened by coal dust from its factories and exhaust fumes from the traffic clogging its antiquated roads. In the 1950s, smoke control, urban renewal, and highway construction programs were launched. Pittsburgh is now considered one of the most livable cities in America.

Reynold Henry Weidenaar. Pittsburgh People. Etching. Pittsburgh, Pennsylvania, and Grand Rapids, Michigan, 1942.
While waiting for a connecting train, Weidenaar sketched this Pittsburgh neighborhood east of the railroad station. The resulting etching turns a satirical eye on slope houses, or "clingers." Industrial success came at the cost of one of America's most superb natural environments: trees were cut down and imposing cliffs ripped apart and sown with these hovels, while the steel mills and factories below covered everything with dense black smoke.

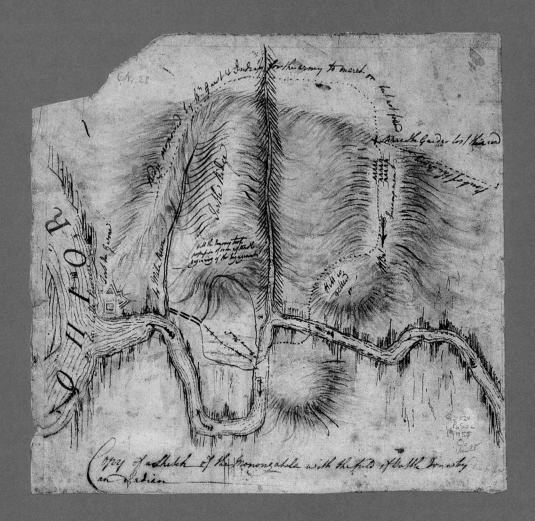

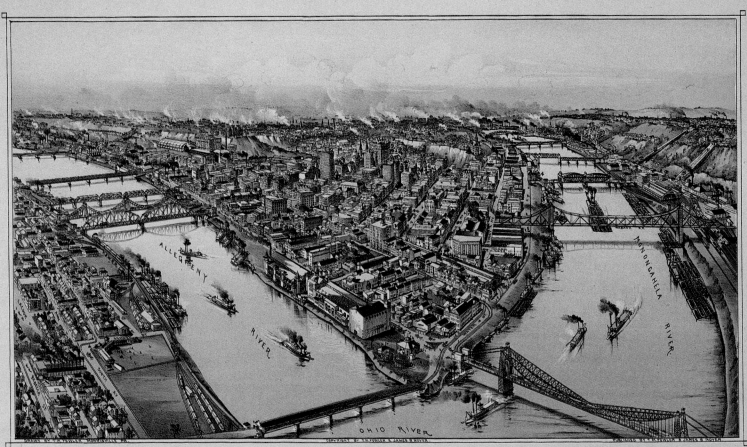

Opposite, top: *Copy of a Sketch of the Monongahela with the field of battle, done by an Indian.* Manuscript map, c. 1755.
This military map, prepared by an Indian during the French and Indian War, demonstrates the strategic importance of France's Fort Duquesne that arose from its access to western lands. Built on the site of the Delaware Indian town of Shanopin, the fort was renamed Pitt by the British. When the city of Pittsburgh was incorporated in 1816 it encompassed the area shown on the map.

Opposite, bottom: Thaddeus M. Fowler. *Pittsburgh, Pennsylvania.* Color lithograph. Morrisville, Pennsylvania, 1902.
As a port of embarkation with east/west outlets, Pittsburgh prospered when the Northwest Territory was opened. This bird's-eye perspective accentuates its position at the confluence of the Allegheny and Monongahela Rivers—imperative for gathering large reserves of industrial raw materials.

James S. Devlin. *McClure & Co. Connellsville Coke.* Color lithograph. Pittsburgh, 1886.
Pittsburgh was the capital of the steel world. Coal and coke, essential to the production of steel, were transported to the city's blast furnaces from nearby coalfields—such as the McClure mines in Fayette County, about thirty-five miles away—on tributary rail lines shown on this map of the Connellsville coal and coke regions.

Carnegie Steel and Black Diamond Steel Companies mills. Color lithograph from Sanborn-Perris Map Company, *Insurance Maps of Pittsburg* [sic], *Pennsylvania,* Vol. 2. New York, 1893.
This fire insurance map shows the precise layout of the Carnegie and Black Diamond Steel Companies, as well as the close proximity of workers' homes (indicated by the letter "D" for dwelling).

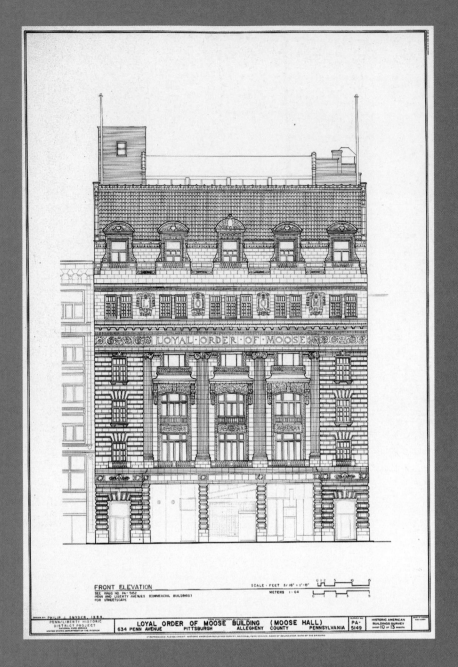

Bob Thall. Stairhall, Allegheny County Court House. Silver gelatin print. Pittsburgh, Pennsylvania, c. 1975.
In 1884 Allegheny County offered a commission to one of America's most talented architects, Henry Hobson Richardson, who aspired to a "quiet and monumental" effect in this, his most ambitious project. The building's massive masonry construction expresses the central and powerful role of the court house in our public affairs and private lives.

Philip J. Snyder. *Loyal Order of Moose Building (Moose Hall), Pittsburgh, Pennsylvania.* Drawing, ink on polyester film. Historic American Buildings Survey (HABS). Washington, D.C., 1984.
Moose Hall was the headquarters of Pittsburgh Lodge No. 46 of the Loyal Order of Moose, a social and entertainment center for non-members as well as its 8,500 members. In 1918, it was the site of the signing of the Pittsburgh Pact, which ratified the creation of Czechoslovakia.

Robert Minor. Pittsburgh. Drawing, lithographic crayon and India ink. New York, 1916. Minor used the fluid, gestural power of his lithographic crayon to condemn the brutal suppression of labor during a 1916 steel strike in the city synonymous with American industry. Unions demanded eight-hour days, a living wage, and reform of conditions under which more than five hundred workers a year died.

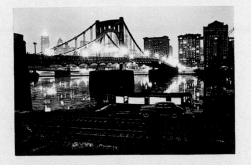

W. Eugene Smith. Title page and two pages from *A City Experienced: Pittsburgh, Pa.*, Vol. 1. Gelatin silver contact prints. Handmade photograph book, 1955–56.
This handmade three-volume study—a collaboration between Smith, who had pioneered the modern photo-essay at *Life* magazine, and picture editor Stephan Lorant—is a vivid and detailed portrait of an industrial city in its postwar rebirth, which began with the enforcement of smoke control laws in 1945. The right-hand page above shows a photograph rejected by the photographer.

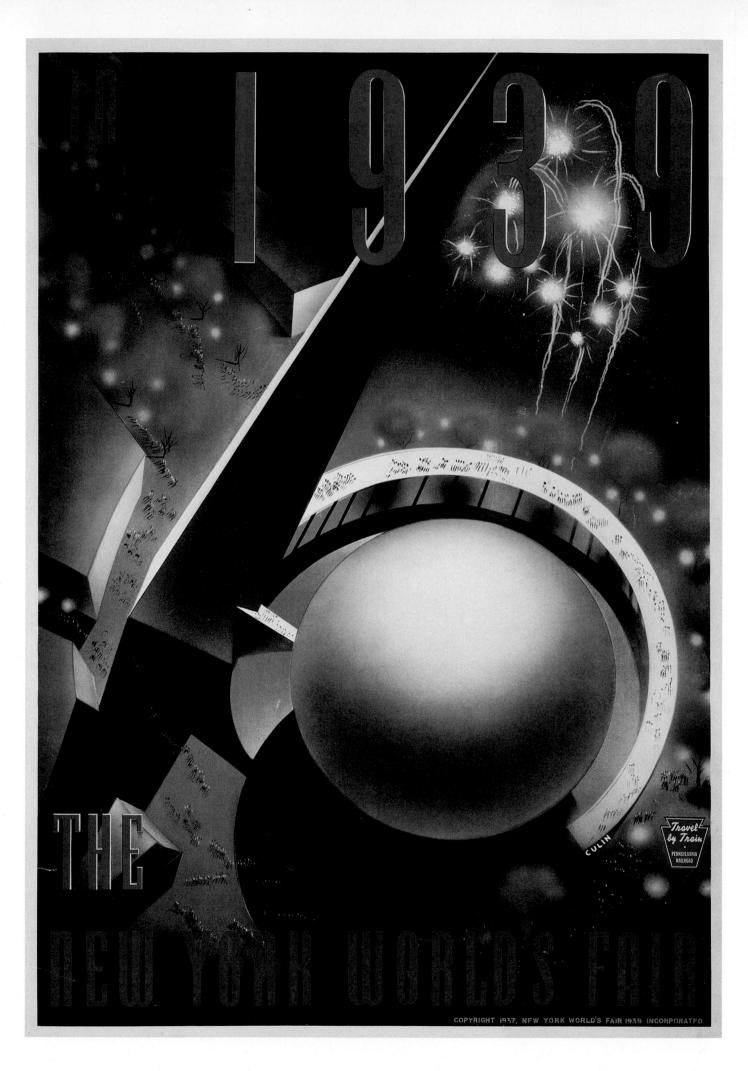

6

RENDEZVOUS WITH DESTINY, 1920–1945

Alice Mumford Culin. *The New York World's Fair.* Offset lithograph. Poster. New York, 1937.
The 1939–40 World's Fair, held in Flushing Meadows, New York, was opened by Franklin Roosevelt on the 150th anniversary of the inauguration of George Washington as president. Alice Culin, bronze-medal winner for her paintings at the Pan American Exposition in 1915, incorporated the fair's two symbols—the Trylon and the Perisphere—into this striking depiction of "The World of Tomorrow." Featured at the fair were television—seen by many for the first time—and prototypes of futuristic aerodynamic automobiles.

In 1925, a successful advertising executive named Bruce Barton published *The Man Nobody Knows*, a small book that purported to introduce modern Americans to the truth about Jesus and His life.

Jesus was not, Barton claimed, the reserved and pious ascetic—"the man of sorrows"—that so many theologians described. He was, rather, "a young man glowing with physical strength and the joy of living," a man who had "our bounding pulses, our hot desires,"—not to mention "perfect teeth." "If there were a world's championship series in town, we might look for Him there," Barton wrote. He was attractive to women. He was the most popular dinner guest in Jerusalem. "He did not come to establish a theology, but to lead a life." And that, Barton argued, was Jesus' most important contribution to the world: spreading the message of personal fulfillment. He was, in the end, not just a prophet of self-realization, but a great salesman and advertiser of it. "He picked up twelve men from the bottom ranks of business," Barton claimed, "and forged them into an organization that conquered the world." The parables, he said, were "the most powerful advertisements of all time." Jesus, he suggested, had pointed the way to the modern consumer culture.

Barton's portrait of Jesus would have seemed preposterous, even blasphemous, to most Americans a generation earlier. In the 1920s, it became a great bestseller. For nothing was more apparent in the United States in the years after World War I than the rise of consumerism and the cult of personal fulfillment that rose along with it. If the late nineteenth and early twentieth centuries had seen a dramatic increase in the nation's industrial capacities, the middle third of the twentieth century was notable for the rapid expansion of popular markets for the products of the new economy. "Mass production requires mass consumption," the auto maker Henry Ford once said. In the 1920s, mass consumption became a hallmark of American culture.

The rise of mass consumption was a result in part of the remarkable performance of the American economy in the 1920s. The United States in those years enjoyed a new kind of prosperity, a prosperity that had no precedent in history and that improved living standards, and raised the expectations, of a large proportion of the population. The fruits of this growth were, to be sure, unevenly shared. Most farmers, workers, and minorities realized only small gains, or none at all, despite the boom—a problem that would gradually undermine the economy and help bring it crashing down. But for members of the middle class, and for many others, the 1920s magnified their incomes and hence greatly increased their purchasing power.

A burgeoning mass culture that both reflected and promoted the new consumer

economy helped reshape the values and habits of middle-class Americans as well. Movies—which had been gaining popularity for more than a decade before World War I—emerged as the primary form of entertainment for millions of Americans. Hollywood spun fantasies and illusions, but by the mid-1920s it had also begun to avoid controversy, hew to a strict code of middle-class morality, and convey images of the "good life" to which a growing number of Americans could now realistically aspire. Likewise, radio, which began its commercial life in 1920 and soon penetrated almost all American households, drew the nation into a web of instantaneous shared experiences—experiences that were similarly mediated by a cautious, middle-class sensibility and reflected the economic appetites of a prosperous nation. A newly aggressive advertising industry trumpeted new consumer products—not just by describing the virtues of the products themselves, but by attempting to associate them with the image of a way of life to which consumers aspired. "Man has been called the reasoning animal," one theorist of modern advertising wrote, "but he could with greater truthfulness be called the creature of suggestion." And through suggestion, advertisers believed, they could transform desire. "Sometimes advertising supplies a demand," an industry proselytizer explained, "but in most cases it creates demand for things that were beyond even the imagination of those who would be most benefited by them."

Nothing, perhaps, better symbolized the new culture of consumption than the automobile, which became in the 1920s a central element of the nascent "American way of life." There were 6 million cars on the U.S. roads in 1919 (up from 4,000 twenty years earlier). By 1929, there were more than 23 million. The automobile industry exploited Americans' enormous appetite not just for transportation but for style. By the late 1920s, the unveiling of new models had become a major cultural event. When Henry Ford (one of the great popular heroes of his day) introduced his new Model A in 1927, a crowd reported at nearly a million stormed his New York showrooms to see it. Police had to move in to control eager throngs in cities across the country. "We'd rather do without clothes than give up the car," a resident of Muncie, Indiana, told the sociologists Robert and Helen Lynd in the mid-1920s.

The middle-class culture of the 1920s was not only materialistic but increasingly secular. Most Americans continued to believe in God and to belong to churches. But religion began to play a smaller—and markedly different—role in many lives. Fewer people than in the past observed the Sabbath, prayed in their homes, read the Bible, or discussed theology. For many, religion came to occupy a safe, rigidly compartmentalized place in a predominantly secular life. Bruce Barton's portrayal of Jesus as an apostle of

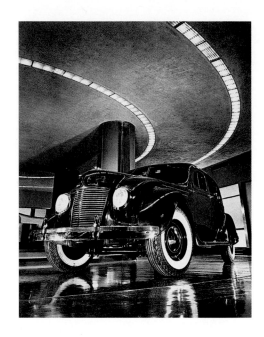

F. S. Lincoln. 1937 Chrysler Airflow four-door sedan in the showroom of the Chrysler Building, New York City. Gelatin silver print. New York, 1937.

Lincoln, an acknowledged master of commercial photography, composed this seductive image of the sleek, glamorous, and audacious Chrysler Airflow inside the "automobile salon" designed by L. Andrew Reinhard and Henry Hofmeister, the architects of Rockefeller Center. The car rests on a revolving turntable beneath curving tracks of recessed lighting and is surrounded by polished, reflective surfaces to evoke the speed, movement, and excitement of the highway. Unseen in this photograph, the Chrysler Building, itself a modern temple to the automobile, towered above as additional advertisement, embellished with hubcap friezes and radiator-cap gargoyles.

abundance was only the most celebrated example of a broad trend within American Protestantism. The eminent theologian Harry Emerson Fosdick, for example, argued in his 1926 book *Abundant Religion* that Christianity should "furnish an inward spiritual dynamic for radiant and triumphant living," and that individuals should test every religious belief against the question "does it contribute to man's abundant life?"

The new culture created new roles for many people—for those who swelled the ranks of "middle managers" in the multiplying corporate hierarchies; for those who moved from farms and small shops onto factory assembly lines; for African Americans who left the South for the city to take menial jobs on the edges of the industrial economy; for Mexicans who crossed the border in Texas and California to do the same. And it created new roles, too, for many American women. Small but highly visible numbers of women moved into the professional world as teachers, nurses, journalists, editors, and fashion designers—even as doctors, lawyers, corporate executives, and academics. Some who tried to articulate a "new feminism" for their time pointed to these professionals as evidence that women could, indeed, successfully combine family and career. "Truly modern" women, wrote one advocate of the new feminism, "admit that a full life calls for marriage and children as well as career. . . . They are convinced that they will be better wives and mothers for the breadth they gain from functioning outside the home." The real "new women" of the 1920s, however, were not the committed professionals but the low-paid secretaries, salesgirls, or clerks—later known as "pink collar" workers—whose status and pay were little better than those of factory laborers. And for the middle class, it was the housewives and mothers who abandoned the subdued and matronly style of the past and sought to introduce more glamour and romance into their lives: who socialized publicly with their husbands; and who became the most important consumers in the new economy. As one popular advice columnist explained:

> The old idea used to be that the way for a woman to help her husband was by being thrifty and industrious by . . . making over her old hats and frocks. . . . But the woman who makes of herself nothing but a domestic drudge is not a help to her husband. She is a hindrance. . . . The woman who cultivates a circle of worthwhile people, who belongs to clubs, who makes herself interesting and agreeable . . . is a help to her husband.

<div align="center">*</div>

At one point in Sinclair Lewis's famous 1922 novel *Babbitt*, its eponymous hero, George F. Babbitt, makes a speech to the Real Estate Board of Zenith (the mythical city in which the novel takes place, apparently modeled on Cincinnati):

I tell you Zenith and her sister-cities are producing a new type of civilization. There are many resemblances between Zenith and these other burgs, and I'm darn glad of it! The extraordinary, growing, and sane standardization of stores, offices, streets, hotels, clothes, and newspapers throughout the United States shows how strong and enduring a type is ours.

To Babbitt, this standardization was the great accomplishment of his age, because it represented the ascendancy of a common, national, middle-class culture and world-view; a reorientation of interest among middle-class people away from their local communities and toward national issues, events, and institutions. But to Babbitt's creator, and to many other Americans, it was the great failure of their time, because it represented the triumph of a crass, superficial, and (some believed) immoral new outlook.

To writers and artists such as Sinclair Lewis, the culture of the 1920s was alarming because it rested on a shallow conformity and substituted artificial material cravings for deeper and more enduring values. Many intellectuals felt so alienated from their culture, in fact, that they withdrew from it altogether and lived abroad, or in remote areas of the United States. Others remained within it as bitter skeptics, debunking almost everything around them. H. L. Mencken, the celebrated "sage of Baltimore," was so contemptuous of ordinary American life that he came to refer to the middle class as the "booboisie" and to reject democracy because it gave power to the cretinous hordes.

Other artists recoiled from the prevailing culture in different ways. In the South, still largely cut off from the benefits of the new economy, a group of white writers and intellectuals known as the Agrarians emerged to chronicle (and at times celebrate) the very different values and culture of their region and its ambiguous relationship to the larger experience of the nation. In some African-American communities, artists sought inspiration in their own distinct experiences as members of an oppressed race in America and in their more distant heritage in Africa. The most important concentration of such artists occurred in New York, the site of a cultural flowering known as the Harlem Renaissance—an explosion of literature, poetry, music, and painting that cultivated a sense of pride in black culture, a sense of place, a sense of the past, a sense of self-worth. The poet Langston Hughes probed the depths of the black experience in "The Negro Speaks of Rivers":

I've known rivers:

I've known rivers ancient as the world and older than the flow of human blood in human veins.

Charles Dana Gibson. *Like the moth, it works in the dark.* Charcoal drawing. New York, 1923.

Illustrator Gibson's glamorous, winsome "Gibson girls" set the standard for female beauty in turn-of-the-century America. During World War I, however, his work turned increasingly serious and political. After the war, as racial tensions intensified and the Ku Klux Klan's membership grew to unprecedented levels, he warned of the covert threat to civil rights posed by that white-supremacist organization with a dark allegory depicting a pale, white moth devouring the fabric of an American flag.

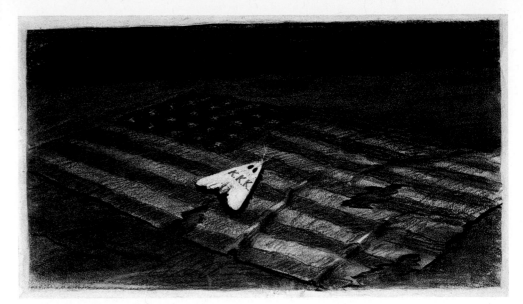

My soul has grown deep like the rivers.

I bathed in the Euphrates when dawns were young.
I built my hut near the Congo and it lulled me to sleep.
I looked upon the Nile and raised the pyramids above it.
I heard the singing of the Mississippi when Abe Lincoln went down to New Orleans,
 and I've seen its muddy bosom turn all golden in the sunset.

I've known rivers:
Ancient, dusky rivers.

My soul has grown deep like the rivers.

<p style="text-align:center">*</p>

The broadest revolt against the new secular, consumer society was the work of larger groups of white Protestants—many but by no means all of them rural men and women—who both feared and resented the cultural changes they believed threatened their traditional world and who rallied to a cluster of movements that sought to preserve an older morality. From the ranks of these traditionalists came the most spirited defenders of prohibition—the ill-fated ban on the manufacture and sale of alcoholic beverages, a ban widely flouted throughout the 1920s and ultimately abandoned in 1933. To many supporters of the "Noble Experiment," prohibition was a legitimate effort to discipline immigrants in the industrial cities and to curb the loose, corrupt, and drunken behavior prohibitionists associated with them. To rural Protestants, it was also a weapon against the urban middle class and the hedonistic immorality that seemed to characterize it.

Other traditionalists flocked to the new Ku Klux Klan—founded in 1915 in Atlanta (after the premiere of D. W. Griffith's racist classic, *The Birth of a Nation*) and ostensibly modeled on the Reconstruction-era organization that had used terror to preserve white supremacy. The second Klan, however, resembled the first in little more than its name and some of its rituals. Its principal targets were not African Americans, whose inferiority was already well inscribed into law and custom. Members of the new Klan were more concerned with other "aliens," ambassadors of the new, urban-industrial

world: immigrants, Catholics, Jews, and even Protestants who transgressed traditional community standards by committing adultery, getting divorced, or blaspheming. Among its purposes, official manuals proclaimed, were protecting "the sanctity of the home . . . the most sacred of human institutions" and shielding "the chastity of womanhood." But the Klan was also an expression, for many members, of cultural estrangement—of their exclusion from a glittering, cosmopolitan world. "We are a movement of the plain people," wrote Klan leader Hiram Evans,

> very weak in the matter of culture, intellectual support, and trained leadership. We are demanding, and we expect to win, a return of power into the hands of the everyday, not highly cultured, not overly intellectualized, but unspoiled and not de-Americanized, average citizen of the old stock. . . . The opposition of the intellectuals and liberals, who hold the leadership and from whom we expect to wrest control, is almost automatic.

The Klan soon had upwards of 5 million members, many in the South but many also in such northern cities as Cleveland, Chicago, Boston, and, perhaps above all, Indianapolis, where the organization came to dominate state and local politics. In 1924, a battle over the Klan paralyzed the Democratic National Convention. In 1926, Klansmen staged an enormous march down Pennsylvania Avenue in Washington, D.C., as if to demonstrate their political muscle. At its peak, the Klan was one of the era's most powerful forces.

But the most overt challenge to the new secular order came from men and women determined to preserve the tenets of traditional religious belief—Protestant fundamentalists who resented the accommodations that modernist theology had made with the consumer culture and who struggled to preserve a bedrock faith rooted in a literal interpretation of the Bible. At a great conclave in 1918, the World's Christian Fundamental Association issued a call to arms against the rising tide of secularism. "The Great Apostasy," its leaders warned, had spread "like a plague through Christendom. Thousands of false teachers, many of them occupying high ecclesiastical positions, are bringing in damnable heresies, even denying the Lord that brought them." It was time, they insisted, for fundamentalists to fight back, to reclaim the culture from the godlessness that threatened to consume it. Part of that crusade focused on the teaching of evolution in the public schools, and in 1925 Tennessee became the first state to pass an anti-evolution law.

A young biology teacher named John T. Scopes volunteered to allow himself to be arrested for teaching evolution so as to challenge the new law in court. The result was

Clarence Darrow at the Scopes evolution trial. Gelatin silver print. Dayton, Tennessee, July 1925.

Darrow's painstaking preparation for trials, forceful presentations, and brilliant case summations made him one of America's most influential trial lawyers. Pursuing his personal convictions, he defended such labor leaders as Eugene V. Debs as unions sought to gain a stronger voice in American industry, and fought vigorously—and successfully—against the death penalty in dozens of instances. His passionate devotion to freedom of thought led him to the courtroom pictured here, in which he is seen leaning back against the defense table during the trial of John Thomas Scopes. Scopes had been charged with teaching in public schools theories of the origin of humanity that contradicted accepted interpretations of the biblical story of creation.

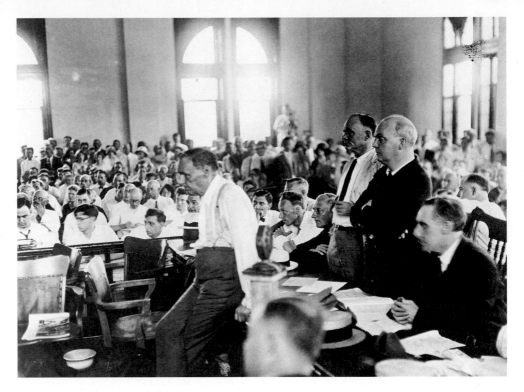

one of the great trials of its day—a national spectacle that attracted believers and skeptics alike, and that was all the more intriguing because it took place in the sweltering courthouse of the small Tennessee town of Dayton. The prosecution enlisted William Jennings Bryan, the three-time Democratic presidential candidate and former secretary of state who in his waning years had become an energetic crusader for religious purity. In 1922, he had written in "The Menace of Darwinism" that the doctrine of evolution "is obscuring God and weakening all the virtues that rest upon the religious tie between God and man." It was with the certitude of a true believer that he sought to convict Scopes. Joining the defense was Clarence Darrow, the great trial lawyer well known for his hostility to religion and to what he considered provincialism. The prosecution of Scopes, he believed, was a product of the narrow-minded bigotry Darrow had spent much of his life combatting.

The trial resulted in a conviction for Scopes (later overturned on a technicality). But the proceedings in Dayton did not end until Darrow had humiliated Bryan on the stand, cross-examining him as an "expert on the Bible" and trapping him into a series of damaging admissions that made the one-time "Boy Orator of the Platte" look like an addled fool. Bryan died in Tennessee only a few days later, and the fight against the teaching of evolution largely died with him, at least for a time. "Looking at it as an event now passed," pronounced the modernist *Christian Century* in a 1926 evaluation of the impact of the Scopes trial,

> anybody should be able to see that the whole fundamentalist movement was hollow and artificial. . . . If we may use a biological term, fundamentalism has been a spore (a mutant growth), an accidental phenomenon making its sudden appearance in our ecclesiastical order, but wholly lacking the qualities of constructive achievement or survival. . . . It is henceforth to be a disappearing quantity in American religious life, while our churches go on to larger issues.

But, of course, fundamentalism did not disappear, even if it became, for a while, less visible in public life. It survived for decades as the vital and active faith of millions of Americans who were not prepared to accept the looser, more relativistic world of the

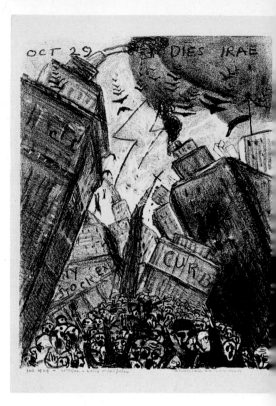

James N. Rosenberg. *Oct 29—Dies Irae.*
Lithograph. [New York], 1929.
The most severe and prolonged economic
depression in American history lasted in one
form or another for a decade. It came as a
particular shock because the "New Era" of the
1920s had seemed to be performing a series
of economic miracles. Rosenberg created an
expressionist nightmare of teetering skyscrap-
ers, suicidal stockbrokers, storm clouds, and
maddened crowds to convey the sense of
panic that overwhelmed Wall Street in the last
days of October 1929, a time he refers to as a
Day of Wrath.

secular, consumer culture; and ultimately it resumed its public, political battles against that culture.

<p style="text-align:center">*</p>

The Great Depression, which began in late 1929 and lasted for more than a decade, would have been a difficult experience under any circumstances. But that it came suddenly and unexpectedly on the heels of a period of dramatic economic growth that many had assumed was now the normal condition of American life made it deeply traumatic. In 1937, Robert and Helen Lynd described its impact on an Indiana town:

> The city had been shaken for nearly six years by a catastrophe involving not only people's values but, in the case of many, their very existence. Unlike most socially generated catastrophes, in this case virtually nobody in the community had been cushioned against the blow; the great knife of the depression had cut down impartially through the entire population, cleaving open the lives and hopes of rich as well as poor. The experience had been more nearly universal than any prolonged recent emotional experience in the city's history; it had approached in its elemental shock the primary experiences of birth and death.

Indeed, few were spared the hardships of this great economic crisis. Wealthy Americans saw much of their savings disappear in the collapse of the stock market. Many middle-class people lost their homes and farms to banks when they could no longer keep up the mortgages, or lost their assets as the banks themselves collapsed. Above all, people lost their jobs. Unemployment ranged from 15 to 25 percent of the workforce—a statistic that did not include the millions of men and women whose wages fell (sometimes dramatically) and whose working hours were reduced. The nation's gross national product declined by more than a fourth in the first three years of the Depression. New investment ceased altogether. Someone once asked the great British economist John Maynard Keynes if he was aware of any period in history comparable to the Depression. He answered: "Yes, it was called the Dark Ages and it lasted four hundred years."

Some Americans were radicalized by the Great Depression: It shattered their faith in the capitalist economy, in the political system, and in the culture that had supported them both. The American Communist Party, for example, transformed itself in the 1930s from an obscure enclave of immigrants to a potent (if never large) movement on behalf of radical social change. It had significant constituencies among African Americans in both the North and the South; among workers and within unions; and among the same artists and intellectuals who had so scorned American culture (and even the American people) a few years earlier. The literary critic Malcolm Cowley wrote years later of the

Dorothea Lange. *Broke—baby sick—car trouble. Tracy (vicinity), California, February 1937.* Gelatin silver print. Farm Security Administration (FSA).

In the summer of 1935, in the midst of the Great Depression, the Resettlement Administration (RA) launched a photographic unit known as the Historical Section to win support for its public assistance programs. The RA was succeeded by the Farm Security Administration (FSA), which continued to document both the need for and benefits from government assistance. Both Historical Sections were directed by Roy Stryker, who hired top-caliber photographers like Lange to produce an almost comprehensive record of American daily life—the cornerstone of twentieth-century documentary photography.

This 1937 photograph sums up the fears of the decade. A woman stranded on a lonely highway with her young children (one of them sick); a broken-down vehicle loaded like a Conestoga wagon, with all her worldly possessions; a husband who has gone for help and no one else in sight. Her fate, and that of her family, hangs in the balance. Strong statements like this characterized the documentary photography of the New Deal.

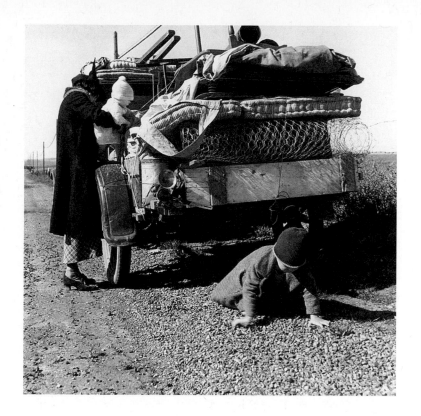

way the Depression had shattered his own faith and the faith of many of his friends in things as they were and had inspired dreams of the "golden mountains" that might be. "Under capitalism," he said, "everything had been going downhill; less and less of every vital commodity was being distributed each year." But under communism in the Soviet Union, he claimed, "everything was climbing dizzily upward; each year there was more wheat, more steel, more machinery, more electric power, and there was an unfailing market for everything that could be produced. Nobody walked the streets looking for a job. Under communism, it seemed that the epic of American pioneerism was being repeated, not for the profit of a few robber barons, but for the people as a whole."

Most disillusioned Americans had no interest in communism. But many sought nevertheless to articulate a critique of the materialistic, individualistic culture that they associated with capitalism and, thus, with the economic disaster that had so damaged their lives. Some embraced an image of community, of a caring society in which people of good will rejected selfishness and banded together to make things right. This vaguely folkish vision of informal, spontaneous neighborliness—a vision rooted in an imagined American past—found expression in many places. It could be seen in the films of Frank Capra—*Mr. Smith Goes to Washington, Mr. Deeds Goes to Town, Meet John Doe, It's a Wonderful Life*—in which decent people rallied together against wealthy plutocrats and learned to help themselves out of trouble. It could be seen in the novels of John Steinbeck, particularly in his epic story of the Dust Bowl migration, *The Grapes of Wrath,* in which the Joad family learned from their ordeal the importance of community—not community defined in traditional, geographical terms, not the community of a neighborhood, town, or region, but a community of the human spirit, for which the only real model was the family. And it could be seen as well in some aspects of the great political experiment launched by the Depression: the New Deal.

Few would have predicted in 1932, when Franklin Roosevelt was elected president of the United States, that he would later be remembered as one of the great world leaders of the twentieth century. To his contemporaries at the time, he seemed a pleasant,

optimistic man; an appealing alternative to his lugubrious predecessor Herbert Hoover; a spokesman for cautious progressivism leavened with fiscal conservatism; someone who had battled polio and courageously overcome it (even though, in reality, he remained completely paralyzed from the waist down and orchestrated an elaborate series of deceptions to convince the public he could walk); an appealing man but one not likely to move very far from established patterns. Roosevelt was indeed a patrician of moderate instincts. But he was also a brilliant politician who did not allow ideology to stand in the way of what circumstances demanded. And circumstances helped him oversee the most dramatic transformation of the role of the federal government in American history.

By the time the New Deal was over, a government that only a decade earlier had been small, limited in its purposes, and largely irrelevant to the lives of ordinary people had become a central force in American life. It had helped landowners and homeowners save their property by offering them low-interest loans. It had helped farmers sustain a decent price for their crops by limiting production and participating in marketing cooperatives. It had guaranteed a minimum wage and a maximum workweek to working people. It had regulated the stock market, the airwaves, the aviation industry, and many other areas of economic life. It had sustained the labor movement's great drive for recognition of trade unions. It had built great dams, hydroelectric plants, highways, harbors, and airports to spur the economic development of much of the nation. It had provided pensions to the elderly, insurance to the unemployed, and welfare to the indigent.

And the New Deal—in at least some of its programs—had tried as well to convey an image of America as a community, to temper the harshness of the acquisitive, industrial culture and to suggest an alternative. It created an iconography for its time—not the gleaming vision of consumer success that had dominated the 1920s, but one of cooperation, citizenship, work, and compassion. This idealized conception of strong working men and sturdy domestic women could be seen in the murals and paintings funded by the Works Progress Administration, the New Deal's most important relief agency; in the pictures of ordinary people and their ordinary problems captured by photographers hired by the Farm Security Administration; in the narratives of everyday life collected by participants in the Federal Writers' Project; and in the documentary films funded and produced by government agencies, which sought to convey a new ethic of mutual obligation to replace the rugged individualism of the past. Hopeful experiments in community-building included the camps for unemployed youths con-

Newman. *A monthly check to you.* Lithograph. Poster. Social Security Board, Washington, D.C., c. 1935.
The 1935 Social Security Act was the most important single piece of social legislation in American history. Its framers envisioned a system of "insurance," not "welfare," with contributions from participants and benefits available to all retired people sixty-five years of age or older. The act also provided, however, considerable direct assistance based on need and it would be expanded by later generations to dimensions that its planners had neither foreseen nor desired.

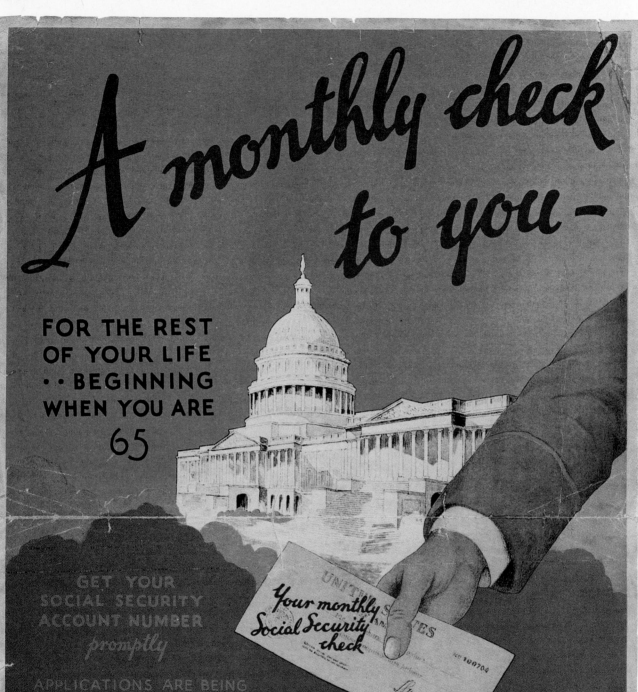

structed by the Civilian Conservation Corps; the experimental communities of the Tennessee Valley Authority and other agencies; and the communal way stations established in the West for migrant workers.

*

The spirit of community was only one part, and a small one at that, of the New Deal. And it was only one of the ways in which Americans came to terms with the Great Depression. The most powerful response to hard times, in fact, was probably not a reconsideration of older American values, but a reaffirmation of them. In popular culture, most people preferred entertainment and escapism to social commentary and instruction. The most popular novels of the day were primarily nostalgic fantasies such as *Anthony Adverse* and *Gone with the Wind*—only occasionally such socially conscious works as *The Grapes of Wrath*. The most popular movies were light comedies and splashy musicals, whose principal gesture toward the Depression was to make fun of characters trying to strike it rich: the Marx brothers, always trying to wheedle money out of wealthy people; the musical extravaganza *Easy Money*, showcasing ordinary people suddenly showered with great wealth.

The Depression also convinced some Americans of the importance of conformity. If failure was, as many middle-class people believed, the result of an individual's personal inadequacy, the best way to compensate for that inadequacy was by clinging more tightly than ever to the values of the group. Conformity meant freedom from the demands and reproaches of one's own consciousness, from humiliation and guilt and fear. And perhaps that was why the best-selling book of the 1930s, indeed a milestone in publishing history, was Dale Carnegie's *How to Win Friends and Influence People*, a paean to the positive value of conformity. The way to get ahead, Carnegie argued, is to adapt yourself to the world as it is. Those who hope to succeed must subordinate their own feelings and impulses to the expectations of others. They must make other people feel important. They must smile, flatter, fit in, behave. They must develop skills and talents that "interest and serve other people." This had been one of the most common prescriptions for success in the 1920s. Sinclair Lewis had satirized it in the character Babbitt, whose conformity was complete and pathetic. The Great Depression, if the popularity of Dale Carnegie is any indication, did not challenge the preoccupation with conformity. In the end, it strengthened it.

*

Most Americans gradually learned to cope somehow with the Great Depression—in their politics, their culture, and their efforts to survive. But they could not overcome it. The

Thomas Hart Benton. *Back Him Up! Buy War Bonds.* Offset lithograph. Poster. Washington, D.C., 1943.
Benton was one of the prominent artists of the regionalist movement of the 1930s who donated artwork to the war effort. As the "Arsenal of Democracy," the United States bore the brunt of the enormous cost of the war, which was financed in part through a series of bond drives.

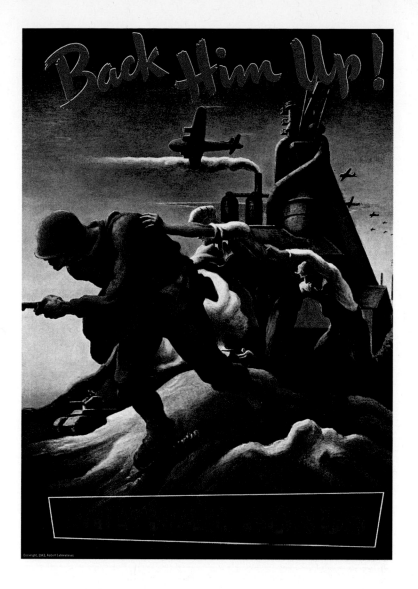

hard times stretched on and on, year after year, with no end in sight—until finally some men and women came to assume that life would never return to the conditions of the 1920s. It was the nation's perverse fate to be rescued at last from this economic catastrophe by a far greater catastrophe: the most terrible war in human history. The outbreak of World War II in Europe in 1939 produced a tremendous new era of economic growth in America. It also produced unprecedented mayhem throughout the world, mayhem into which the United States found itself slowly and inexorably drawn.

The bombs that rained down on Pearl Harbor in December 1941 stilled a long and bitter debate over America's relationship to the war and committed the nation firmly to the defense of Great Britain and the defeat of Germany and Japan. A buoyant, if deceptive, sense of national unity sprang up. "By reason of Pearl Harbor," a congressman from Virginia said within days of the attack, "our very souls became so inflamed with righteous wrath, so fired with patriotism, that our differences and divisions and hates melted into a unity never before witnessed in this country."

There was genuine unity in support of the war effort itself—and in support of the millions of American men and women who joined the armed forces and fought for victory both at home and abroad. That terrible struggle—waged on two fronts for nearly four years, at the price of more than 300,000 American lives—did indeed fire Americans with patriotism, just as it fired many soldiers and sailors with great bravery.

But in other respects, the war did much less to create unity than to unsettle conventions and accentuate divisions. American women, for example, were drawn in

Gordon Parks. *Women welders at the Landers, Frary and Clark Plant. New Britain, Connecticut. June 1943.* Gelatin silver print. Office of War Information (OWI).

In October 1942, Roy Stryker's Historical Section was moved to the Office of War Information. By then, the government's photographic agenda had shifted from agricultural to war-related documentation. Staff photographer Parks toured New England recording changes in the workforce—minorities, members of ethnic groups, and women acquired skills previously monopolized by white males, now off at war. Parks's six-decade career has encompassed poetry and nonfiction writing, music, and filmmaking, as well as every aspect of twentieth-century photography.

unprecedented numbers into the workplace to fill the jobs of the many men who had left for the war. In the absence of fathers, brothers, husbands, and boyfriends, many women lived, worked, and traveled alone for the first time in their lives. Some joined unions. Others wore uniforms—as members of the WAACs and WAVEs and other female military organizations. For many, it was a transforming experience of unprecedented freedom; and as a female aircraft worker later recalled, "It really opened up another viewpoint on life."

And yet for many American men, especially those at the front, the war strengthened more traditional expectations. Fighter pilots gave their planes female names and painted bathing beauties on their nose cones. Sailors pasted pinups inside their lockers, and infantrymen carried them (along with pictures of wives, mothers, and girlfriends) in their knapsacks. The most popular female icon was the actress Betty Grable, whose picture found its way into the hands of more than 5 million fighting men by the end of the war. Grable appealed to servicemen less for her sexiness than for her portrayals of wholesome, innocent young women, the kind any guy would want to marry. She was a reminder at the front of the modest, genteel girlfriend or wife many ser-

vicemen expected to find on their return. That was, in fact, one of the things many GIs believed they were fighting for: a world of healthy, heterosexual love, a world in which supportive, nurturing women were waiting to make a home for them.

For African Americans, many of whom were similarly drawn into the industrial workforce by the wartime labor shortage, the conflict strengthened their determination to fight for justice within the United States. Many black men and women talked openly of the "Double V," which stood for simultaneous victory over the Axis abroad and over racism at home. "If we could not believe in the realization of democratic freedom for ourselves," one black journalist wrote, "certainly no one could ask us to die for the preservation of that ideal for others." To engage in the struggle for freedom in the world while ignoring the struggle for freedom at home was to make a mockery of both. And yet to many white men and women, and to white southerners in particular, the war meant something very different: they were fighting to preserve the world they knew, the world of white supremacy.

And among those who tried to envision America's future as a world power after the war, there was division as well. Some warned of the dangers of excessive pride. The theologian Reinhold Niebuhr, for example, wrote ominously of the "deep layer of Messianic consciousness in the mind of America" and warned of the nation's "inability to comprehend the depth of evil to which individuals and communities may sink, particularly when they try to play the role of God in history." In the aftermath of the deaths of millions in battles and bombings and famines, in the aftermath of the unspeakable crime of the Holocaust, it was particularly important to keep in mind humanity's capacity for evil. All people, Niebuhr said, would do well to remember that "no nation is sacred and unique. . . . Providence has not set Americans apart from lesser breeds. We too are part of history's seamless web." But many others saw in the great and victorious struggle—a struggle in which it was hard for most Americans not to view their nation as a great force for democracy and justice against unprecedented tyranny and evil—a mandate for economic, political, military, and even moral leadership in the postwar world. As the most terrible war in history shuddered to its close in the spring and summer of 1945, the United States faced a future clouded by the memory of six years of horror and by the frightening new powers of destruction that atomic weapons had given it—but also a future brightened by victory, prosperity, and the enduring vision of America as a "city on a hill."

* * *

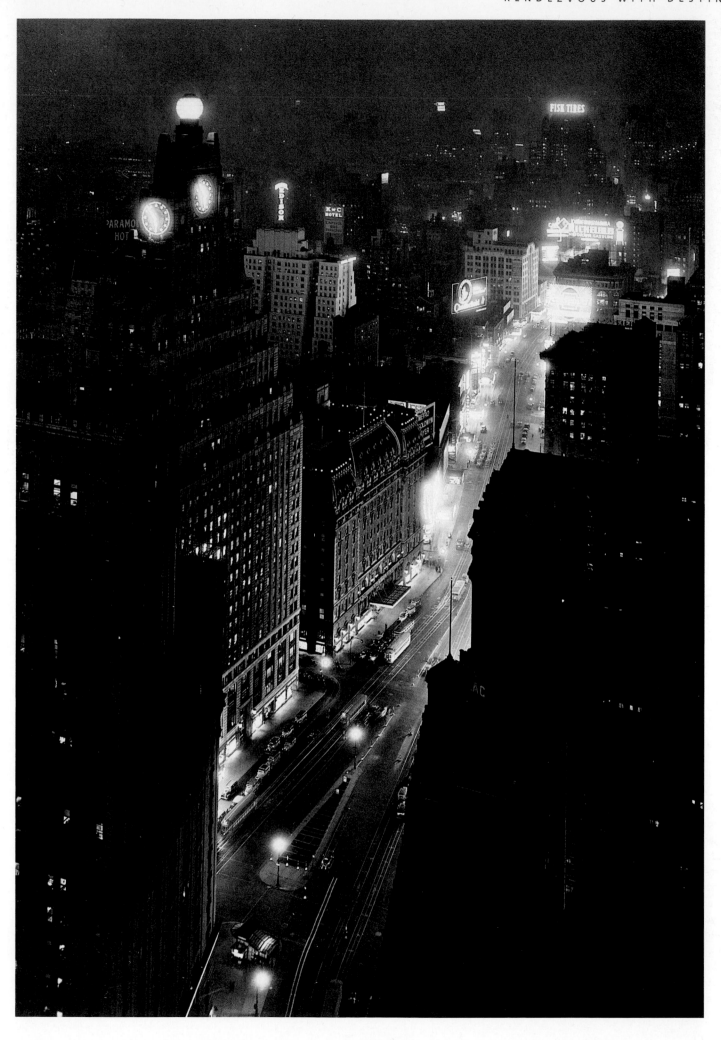

Fred Newmeyer, Sam Taylor. *Safety Last.*
Cinematographer: Walter Lundin. Cast: Harold
Lloyd, Mildred Davis, Mickey Daniels. Frame
enlargement. Hal Roach Studios, Los Angeles,
1923.
After World War I, America enjoyed a period
of rapid business expansion fueled by unbri-
dled boosterism. In the early 1920s, after an
apprenticeship with the master comic Mack
Sennett, Lloyd created for the screen a brash
character who both celebrated and satirized
the go-getter spirit of the day. This young
man refuses to be defeated by a series of
outrageous obstacles on the road to fortune
and true love. *Safety Last* is the best remem-
bered of Lloyd's many great films, in part
because it contains the most spectacular of
the death-defying stunts that were the
hallmark of his unique cinematic style.

Opposite: Samuel Gottscho. *Times Square
from Above.* Silver gelatin photoprint. New
York, February 16, 1932 (printed from original
negative, c. 1940).
Though inspired by the pioneering nighttime
photography of Alfred Stieglitz and Edward
Steichen early in this century, the moody
shadows and shimmering highlights of this
image also recall the nocturnes of Whistler.
Broadway—"The Great White Way" cele-
brated repeatedly in American popular song—
here slashes through a looming black canyon
of buildings. During the 1920s, the Times
Square theater district boomed with over sixty
playhouses and motion-picture palaces, and
blazed with over 1 million lightbulbs. New
York City dominated the nation's cultural life.
About the lights of Broadway, Will Irwin
wrote in 1927: "All other American cities
imitate them; but none get this massed effect
of tremendous jazz interpreted in light."

William A. Wellman. *Wings.* Cinematographer:
Harry Perry, E. Burton Steene, Russell Harland.
Story: John Monk Saunders. Cast: Clara Bow,
Charles "Buddy" Rogers, Richard Arlen. Frame
enlargement. Paramount, Hollywood, 1927.
Though the 1920s were a time of significant,
even dramatic, social, economic, and political
change, they are often associated with
affluence, conservatism, and cultural frivolity.
No one better personified the lifestyle of the
liberated "modern woman" of the Roaring
Twenties than the vivacious Clara Bow, the

"It" girl. She was the quintessential F. Scott
Fitzgerald flapper, who danced, drank,
smoked, wore seductive clothes and makeup,
and went to wild parties. One of her greatest
silent films was the anti-war drama *Wings,*
winner of the first Academy Award for Best
Picture in 1928. For her entrance, Wellman
puckishly satirized the "It" girl image with a
close-up of her bloomers hanging on a line
which she raises in curtain-like fashion to
reveal her face to the audience.

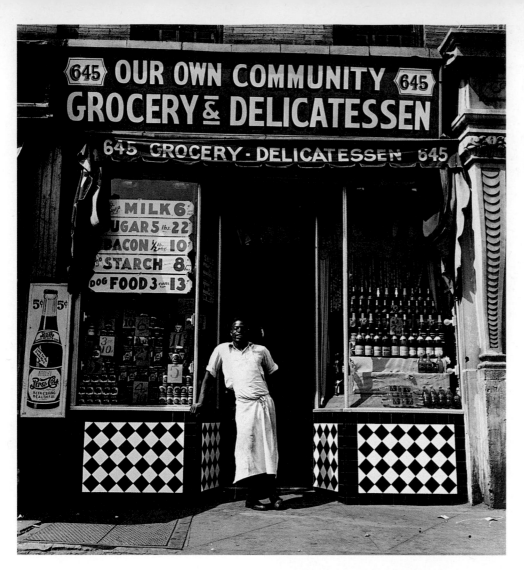

Aaron Siskind. Grocery store, Harlem. Gelatin silver print. New York, 1940.

The man in the doorway of this community grocery and delicatessen exudes ease and pride. In 1940 *Look* magazine crowned Harlem, a 202-square-block area, "the Negro capital of America." During the Great Migration, which began in 1914 and peaked during World War I, nearly half a million African Americans had moved north from the rural South, transforming the nation's racial demographics. Siskind was not interested in the imagined exotic city-within-a-city of the 1920s, but in the realities of Harlem for its quarter of a million inhabitants—northern racism, poverty, overcrowding, and disease, as well as religion and recreation. He was a guiding member of the Photo League, a center for social documentation which from 1938 to 1940 produced a series called *The Harlem Document*. The League flourished in New York City from 1936 to 1951.

Lisette Model. *Running Legs.* Gelatin silver print. New York, 1940–41.

In her native Vienna, Model initially studied piano and voice, and took lessons in theory from the great modernist composer Arnold Schoenberg. In 1926 she emigrated to Paris, and in 1933 she abandoned her music for photography. Six years later she emigrated for the second time, to Manhattan. *Running Legs* expresses the enthusiasm and excitement with which she greeted her new home, a creative refuge from the political turmoil in Europe. With a vantage point radically low to the ground, she caught the dynamic silhouettes of bustling Manhattanites on crowded pavements. The fragments of legs function as a visual shorthand for the perpetual rhythm of city life.

James Latimer Allen. Children at work on soap models, Harlem Art Workshop. Gelatin silver print. New York, 1933.
In 1922, real estate magnate William E. Harmon established the philanthropic Harmon Foundation. During the Harlem Renaissance, a period of creativity that both revealed and stimulated great confidence and racial pride, the foundation became a key sponsor for a number of African-American artists. Through a series of juried, traveling exhibits, their work was brought to a national audience for the first time. The block prints draped over the table and hung in the background of this photograph were created by children during a workshop sponsored by the Harmon Foundation. Allen's photographs appeared in *Opportunity, Crisis,* and the *Record.* He was the only photographer to participate in the film *A Study of Negro Artists,* which showcased the achievements of Foundation artists.

Isabel Bishop. *At the Noon Hour.* Etching. New York, 1935.
Known variously as a social realist, urban realist, and romantic realist, Bishop aimed her etching needle at the anonymous working-class people she could see from her Union Square studio in Manhattan. Frequently selecting "pink collar" women as her subjects, Bishop captured the beauty in ordinary acts: struggling into an overcoat, repairing lipstick in a mirror, taking a lunch break. This image emphasizes the intimacy between the two women as they pause from their work, at a time when professional opportunities for urban women remained limited by society's negative assumptions about their capabilities.

Edmund Goulding. *Dark Victory.* Cinematographer: Ernest Haller. Screenplay: Casey Robinson. Score: Max Steiner. Cast: Bette Davis, George Brent, Humphrey Bogart, Geraldine Fitzgerald, Ronald Reagan. Frame enlargement. Warner Bros., Burbank, 1939. More than 90 million movie tickets were sold weekly in 1930, as compared to 40 million in 1922. Women were a powerful box office component, and the studios responded to this fact with a genre known as women's melodrama—sometimes cynically dismissed as "women's weepies"—that dealt with the daily human experiences of love, death, disease, and poverty. Created to showcase the dramatic talents of the great female stars, the best of them, like *Dark Victory,* proved popular with both men and women. In this frame, Ann King (Geraldine Fitzgerald) suddenly realizes that her friend, Judith Traherne (Bette Davis), is going blind and has but a short time to live.

Leo McCarey. *Belle of the Nineties.* Cinematographer: Karl Struss. Screenplay: Mae West. Costumes: Travis Banton. Music: Arthur Johnston. Lyrics: Sam Coslow. Cast: Mae West, Roger Pryor, John Mack Brown, Katherine DeMille, and Duke Ellington's Orchestra. Film still. Gelatin silver print. Paramount Pictures, Hollywood, 1934.
From her birth in 1892 to her death in 1980, from burlesque to video, West defined the arc of American popular entertainment—albeit mostly in satirical counterpoint to the mainstream. She wrote the plays and screenplays that made her a star, and her phenomenal success saved Paramount from bankruptcy. More than a survivor in a male world, she was absolutely triumphant; her weapons were self-confidence, humor, vulgarity, deadly satire, and sex. On screen, she was *the* liberated woman and—to wickedly make her point—she dressed up as the Statue of Liberty in this moment from one of her best films. Her work as a performer and writer offers a primer in American censorship history. West's major film career was effectively ended in the late thirties when the Hays Office, seeking to ensure moral conduct on-screen, managed to sever her connections with Paramount.

Leo Rackow. *Greater Macy's.* Tempera on board. Poster. New York, c. 1926–28.
With a population of approximately 750,000 and merchandise arriving at its ports from all over the world, New York was the largest city in America and dominated the wholesale dry-goods market when Rowland Macy opened his first store on Fourteenth Street in October 1858. To promote it, he took out large news-paper advertisements and within fifteen years had expanded into eleven adjoining stores. The first to use a trademark identifying his goods, he was also the first to price in dollars and cents rather than even dollars. Macy's became the largest and most successful retail operation in the history of the United States.

Rackow became art director for the mam-moth Macy's in 1925, after regularly winning its monthly poster contests.

Paul Outerbridge. Telephone. Platinum print, 1923.
The first commercial version of Alexander Graham Bell's revolutionary invention was introduced in 1877. By 1881, more than 100,000 telephones had been purchased and most cities with over ten thousand inhabitants had an exchange. By 1900, more than 1.4 million were in use. By the time of this photo-graph, the telephone had evolved into an everyday utilitarian device, its working parts encased in compact, safe, durable, and com-fortably molded forms, reduced to the basic elements necessary for hearing and speaking.

Outerbridge chose to monumentalize the mundane objects of modern industrial design and mass production. He was a proponent of precisionism, which sought out the clarity and simplicity in geometric shapes. Later he would use these skills to advantage in the field of ad-vertising, which came of age in the twenties, partly as a result of techniques pioneered by wartime propaganda.

Raymond Loewy with the prototype of the Pennsylvania Railroad's S-1 locomotive. Contemporary gelatin silver print (from gelatin negative), 1937.

One of the most dynamic and influential figures in twentieth-century design, Loewy defined the form and identity of hundreds of products and corporations and helped forge the new profession of industrial design. His mastery of the art of public relations can be seen in this famous image from his office files: Self-cast in the role of heroic form-giver, a confident and dapper Loewy stands atop the 6,000-horsepower, 120-mile-per-hour S-1, the world's largest steam locomotive, which he had subjugated and transformed with a streamlined casing of welded steel and chrome.

Hawaii By Flying Clipper. Pan American Airways System. Offset lithograph. Poster. c. 1938.

By the mid-1930s, competition among airlines for airmail routes and passengers was stiff. Travelers on these early flights were adventurous and had to cope with erratic schedules and long flights with many stopovers. Juan Terry Trippe, the force behind the mail-carrying Pan American flying boats, orchestrated the inaugural flight of the Pacific Clipper on November 22, 1935, between San Francisco Bay and Honolulu, and followed up with the first commercial flight between the United States and China on October 23, 1936. The four-engine Boeing 314, or Clipper, was considered the finest flying boat ever built, and was the largest commercial plane to fly until the arrival of the jumbo jets thirty years later.

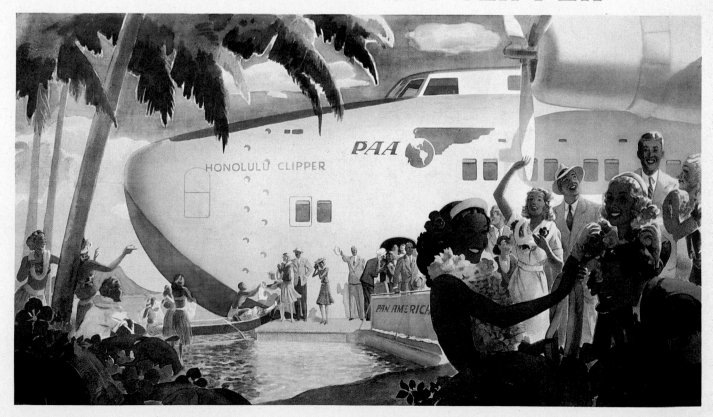

Frank Lloyd Wright. Project for the Nakoma Country Club, near Madison, Wisconsin. Perspective drawing, graphite and colored pencil on tracing paper. Spring Green, Wisconsin, 1923–24.

The country club, a peculiarly American institution for the promotion and enjoyment of outdoor sports, began to develop at least a decade before the introduction of golf from Scotland in the 1880s, but by 1900 more than a thousand golfing clubs had sprung up nationwide, and during the boom years of the 1920s, clubhouses grew increasingly large and extravagant. Nakoma was a 225-acre residential development with street and building names recalling the area's Winnebago heritage. For this clubhouse, Wright followed that example: tentlike pyramidal roofs echo the forms of tepees and are joined by strong horizontal elements which embrace and unify the green and gently rolling hills of Wisconsin.

Henry A. Botkin. *G. Gershwin Folly Beach.* Watercolor. South Carolina, 1934.

George Gershwin's jazzy syncopations, exuberant metrical somersaults, and poignant blue-note melodies and harmonies produced the archetypal sound of the legendary Jazz Age. Here he's shown composing *Porgy and Bess* during the summer of 1934 at a house that he shared with his cousin, the painter Henry Botkin, in Folly Beach, South Carolina. Ten miles from Charleston, it placed him near the Gullah people, whose music and dialect provided inspiration for the inhabitants of the opera's Catfish Row.

George Stevens. *Swing Time.* Cinematographer: David Abel. Choreographer: Hermes Pan. Screenplay: Howard Lindsay, Allan Scott. Music: Jerome Kern. Lyrics: Dorothy Fields. Cast: Fred Astaire and Ginger Rogers. Film still. Gelatin silver print. RKO Pictures, Los Angeles, 1936.

Glamour and romance in the city were epitomized by the courtship dancing of the characters played by Fred and Ginger—a duo as American as the magical music they sang and danced to by George Gershwin, Cole Porter, Jerome Kern, and the other geniuses of American popular song.

Miguel Covarrubias. *Impossible Interview: Sigmund Freud vs. Jean Harlow.* Gouache. New York, 1935.

Born in Mexico City in 1904, Covarrubias arrived in New York in 1923; within two years he was one of the principal caricaturists for the ultra-sophisticated *Vanity Fair.* One of his features for the magazine posited shrewd but unlikely juxtapositions of celebrities. His "Impossible Interview" for May 1935 paired Dr. Freud, the Viennese analyst whose theories on the human psyche had by then gained widespread acceptance in America, with the film actress Jean Harlow, Hollywood's wise-cracking "Blonde Bombshell." In this satirical swipe at psychoanalysis, a stern and apparently repressed Freud glowers at a radiant, uninhibited Ms. Harlow while the window beyond reveals priapic cacti shimmering in a moonlit landscape of sexual dream imagery.

Edward Hopper. *Night Shadows.* Etching. New York, 1921.
Hopper's work is bracketed by the themes of loneliness and isolation. Here the only sign of animation in an essentially impassive urban landscape is a solitary figure, a diminutive cipher of life, advancing toward a sterile pool of light. During the first two decades of the twentieth century, Americans had been adjusting to the fruits of mechanization; now they were traveling by automobile, going to movies, and relocating in droves from rural to urban America. Hopper's etching subtly questions the rewards and satisfactions for mankind of the modern age.

Merian C. Cooper and Ernest B. Schoedsack. *King Kong.* Cinematographers: Eddie Linden, Vernon Walker, and J. O. Taylor. Screenplay: James Creelman and Ruth Rose. Models: Willis O'Brien. Score: Max Steiner. Cast: Fay Wray, Robert Armstrong, Bruce Cabot. Frame enlargement. RKO Pictures, Los Angeles, 1933. The dark yet romantic side of the city is expressed in this beauty and the beast fantasy. *King Kong* marks an important and enduring boundary between the progressive, science-oriented part of the American psyche and the part clinging fondly to the *terra incognita* of a mythic past. It was an immediate hit, attracting over fifty thousand people on its opening day in New York, the same day that bankruptcy proceedings were initiated against RKO. Kong's death atop the newly completed Empire State Building, the tallest in the world, was not in vain. The studio was saved and the building was immortalized as the skyscraper that came to define every skyscraper on the planet.

Reginald Marsh. *Breadline.* Etching. New York, 1929.

Lines of men, women, and children trailing from soup kitchens and missions were an enduring symbol of hunger and poverty which, while not uncommon amid the relative prosperity of the 1920s, became ubiquitous during the Great Depression. By 1932, the number of unemployed Americans exceeded 10 million. Marsh's reputation as a social realist is largely due to his Depression-era record of America's dispossessed. He made these works in reaction to the tendencies of the media and the government to understate the ravages taking place. Dorothea Lange's first known photograph is of a breadline.

Dorothea Lange. *Leaning on the rail aboard the U.S.A.T. St. Mihiel. First rural rehabilitation colonists.* Gelatin silver print. San Francisco, 1935. Resettlement Administration (RA).

The Resettlement Administration (RA) was not timid about using a variety of methods to help those hit hardest by the economic depression of the 1930s. In May 1935, government photographer Dorothea Lange met the first group of RA colonists in San Francisco as they transferred from the train that had brought them from northern Minnesota to the ship that would take them to their new homes in Matanuska Valley, Alaska. The nineteen photographs she made, selected, cropped, printed, and mounted in a spiral-bound book survive at the Library as an intensely personal record of that encounter.

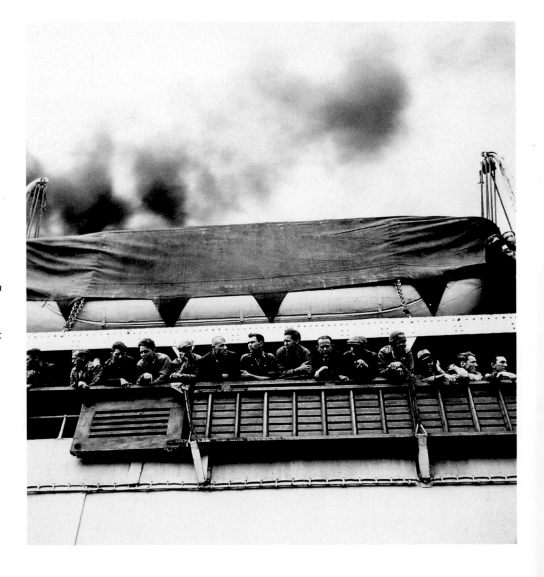

Howard Hawks. *Scarface—The Shame of the Nation.* Cinematographers: Lee Garmes and L. W. O'Connell. Screenplay: Ben Hecht. Score: Adolph Tandler, Gus Arnheim. Cast: Paul Muni, Ann Dvorak, Karen Morley, George Raft. Frame enlargement. RKO Pictures, Los Angeles, 1932.

With the coming of sound in the late 1920s, and the concurrent trend toward social realism, movie censorship became a national issue. To forestall government intervention, the industry created the Hollywood Production Code. *Scarface* was one of the most controversial films of its day, both for what some considered its negative portrayal of Italian immigrants and for its ambivalence toward gangsters—folk heroes to many filmgoers. Director Hawks reshot certain scenes, added a short lecture condemning gang violence and gunplay, and attached a phrase to the title eliminating any question of where Hollywood stood on the issue of crime in America, which had flourished under Prohibition in part because of the mobs who provided bootleg liquor to the popular speakeasies. Here Tony Camonte (Paul Muni) discovers the joy of the Thompson submachine gun. Prohibition was repealed the following year.

Charles Verschuuren. *Your Family Needs Protection Against Syphilis.* Silkscreen. Poster. New York, 1939. Federal Art Project (FAP). Syphilis, a sometimes deadly sexually transmitted disease, had reached epidemic proportions by 1945. During the 1930s, the basic treatment for those affected was a lengthy series of salvarsan infusions alternating with injections of bismuth. Mercury rubs were also given. The Works Progress Administration (WPA) commissioned posters to convey supportive and helpful information in a sensitive manner—without casting guilt or shame. The real cure, penicillin, was discovered in 1928 but was not used to treat syphilis until 1943.

The Federal Art Project (FAP) was an arm of the WPA. Established in 1935, FAP was the major employer of artists during the Great Depression. Its poster division was headed by Richard Floethe, a graduate of the Bauhaus in Germany, who applied fine-art traditions to FAP's mission of alerting the public to cultural and social government programs.

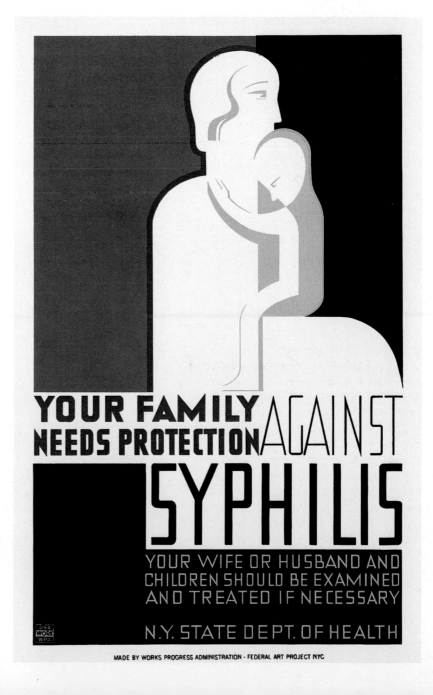

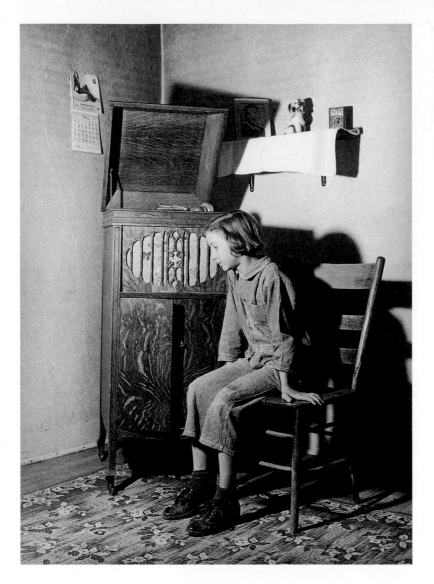

John Vachon. *Daughter of FSA client listening to the phonograph. Crawford County, Illinois, May 1940.* Gelatin silver print. Farm Security Administration (FSA).

Mass production of phonographs and radios was driven by the vigorous post–World War I consumer economy, and helped families in remote areas become less dependent upon resident musical talent and traveling performers. Vachon was a Minnesotan, and his love for the people of the central plains deepened throughout his long career. After his New Deal government work, he joined the staff of *Look,* and returned again and again to photograph his native region.

Geraldine Farrar's Metropolitan Opera farewell. Gelatin silver print. New York, 1922. Among the first opera singers to win wide popularity through sound recordings, the Massachusetts-born Farrar is pictured outside the old Metropolitan Opera House in New York following her farewell performance. The *New York Tribune* reported that she was given "a crown of pearls and emeralds, which she set upon her head, and a golden sceptre." She was America's reigning diva from 1906 until 1922, a virtual cult figure with followers known as "gerryflappers." The first star dressing room in Hollywood was built for her; between 1915 and 1919 she appeared in fourteen silent movies. After retiring at the age of forty, she lived on her estate in Ridgefield, Connecticut, and during her years of seclusion tended what she called her friendship garden, planted with seeds and bulbs sent by many old admirers.

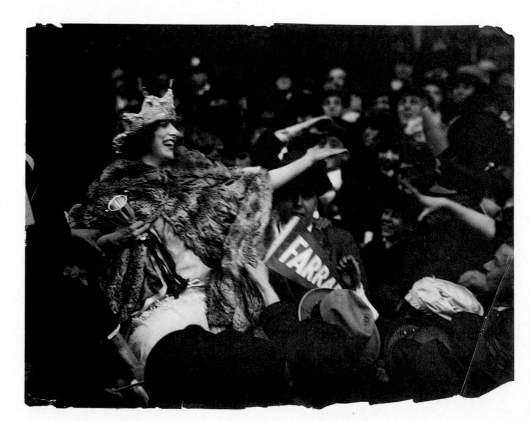

Miguel Covarrubias. *George Burns and Gracie Allen*. Drawing, ink and watercolor. New York, 1928.
Nothing did more to form the modern American sense of humor than vaudeville, which flourished between 1895 and 1925. The stage popularity of vaudevillians Burns and Allen crested in the late 1920s and coincided with the introduction of radio and talking pictures. Radio audiences took immediately to the couple's comedy of verbal misdirection. They were briefly film stars, then made a successful transition to television in 1950 by adroitly adapting their radio show and vaudeville routines, which became a key element in modern situation comedy.

Walt Disney Studios. *Drawings of the character Mickey Mouse shown in thirty-four poses.* Printed proof sheet. Los Angeles, 1936. © Disney Enterprises, Inc.
Animation pioneer Walt Disney recognized the protections afforded to creators by copyright law, as evidenced by the hundreds of registrations he secured after the debut of *Steamboat Willie*, the first cartoon with a fully synchronized soundtrack. In the fall of 1977, Library of Congress researchers discovered in a long-forgotten corner of the Copyright Office more than one hundred model sheets, registered between 1930 and 1945, depicting a whole galaxy of Disney characters. This sheet of Mickey Mouse in various poses captures the essence of his spirit, determination, and wholesomeness.

Ben Shahn. *Omar, on Scott's Run, West Virginia.* Gelatin silver print, October 1935. Resettlement Administration (RA).

These youths are studying the promotional stills for *Hard Rock Harrigan,* a low-budget B movie about a tunnel-digging crew in California. The scenery might have seemed exotic, but the plot would have been familiar to children raised in the severely depressed coal-mining region of the Appalachian Mountains. Activist-artist Shahn had recently taken up photography as a note-taking tool for his printmaking. He produced posters, murals, and exhibits for the RA's Special Skills Division.

Winold Reiss. Project for the Puck Theater, unknown location. Perspective drawing, graphite and colored pencil. New York, c. 1935.

The 1920s and 1930s witnessed the construction of movie theaters in almost every American city, town, and suburb. Intended as a bold and extravagant element of the entertainment experience, these "picture palaces" ranged in size from New York's Roxy, in which 125 ushers served an audience of 6,214, to more modest "mini-palaces" or "deluxe" theaters comparable to this one seating 600 to 1,000. Many featured organs, live orchestras, and elaborate machinery for stage shows, and they fostered the technological development of air-conditioning in order to draw the public year-round. Huge marquees like the Puck's further enhanced the excitement of moviegoing and served as illuminated totems, punctuating and redefining America's Main Streets.

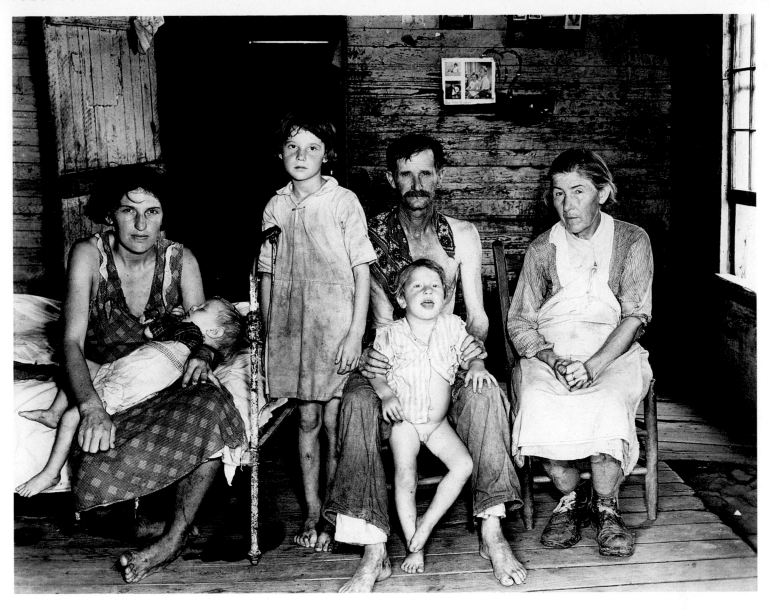

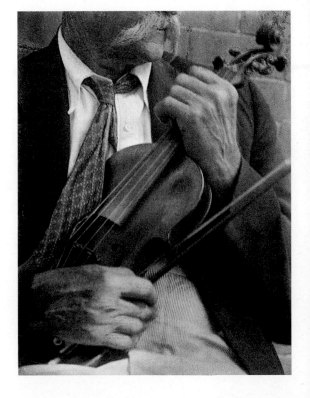

Walker Evans. *Bud Fields and His Family at Home* from *Pictures of the House and Family of an Alabama Cotton Sharecropper,* vol. I. Gelatin silver print. Hale County, Alabama, 1936. Farm Security Administration (FSA). Evans, a preeminent documentarian of the New Deal, took leave from the FSA to work with writer James Agee on a project originally intended for *Fortune* magazine about the devastating effects of economic conditions on a typical family of white tenant farmers. In Hale County, Alabama, the extended Burroughs-Fields-Tengle family lived in a primitive pine-board shack and surrendered one-third of their cotton crop to the landowners. Proudly posing for Evans's large-format 8-x-10-inch-view camera in the parents' bedroom are (from left) Mrs. Fields with baby Lillian; her eight-year-old daughter from a former marriage; Bud Fields, with a kerchief around his neck to hide the evidence of his skin cancer, holding three-year-old William; Mrs. Fields's mother; and, asleep under the bed, their scrawny cat.

This photograph appears in a unique two-volume set of 107 photographs presented by Evans to FSA director Roy Stryker—possibly the first draft of the book *Let Us Now Praise Famous Men,* a classic of the Depression, published in 1941.

Doris Ulmann. James Duff, fiddler. Toned silver print. Hazard, Kentucky, c. 1930. Ulmann, who studied with the well-known photographer Clarence White, was an affluent New Yorker, and many of her sitters were influential Americans; but she was also fascinated by the people and crafts of the rural South. With her assistant John Jacob Niles, who collected, composed, and wrote Appalachian folk music, she made at least seven trips to the southern states between 1928 and 1934. Her images, such as this portrait of James Duff, combined modern forms with soft-focus pictorialist sensibilities.

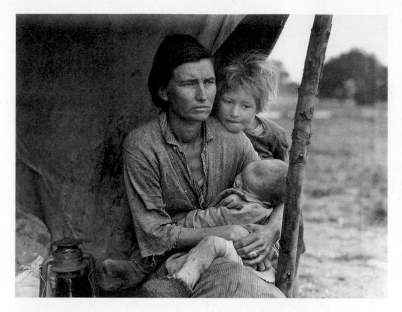

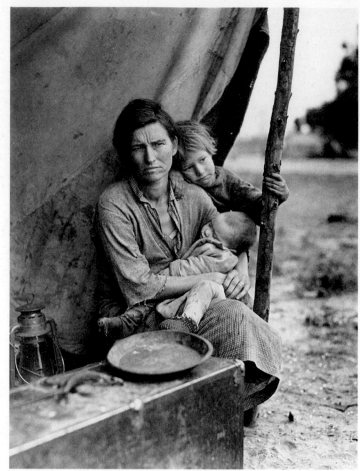

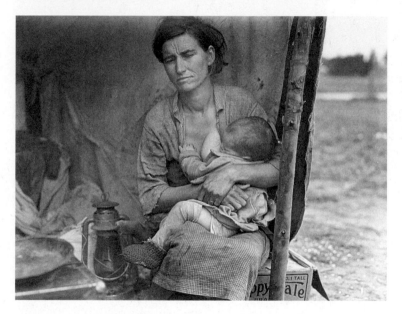

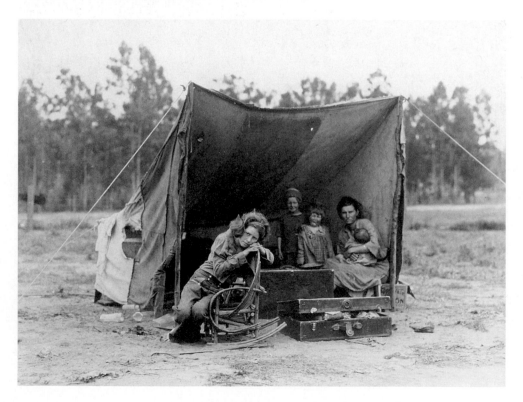

Dorothea Lange. *Migrant Mother.* Gelatin silver prints. Nipomo, California, 1936. Resettlement Administration (RA).

These five RA images are of thirty-two-year-old Florence Thompson, a full-blooded Cherokee from Oklahoma, with her children in a migrant labor camp. Before joining the RA, Lange had been photographing people on the streets near her San Francisco portrait studio who had been displaced by the economic and environmental disasters of the 1930s. Her intensely personal images of the rural poor for the RA were extremely influential. *Migrant Mother,* on the opposite page, is one of the most widely reproduced and familiar photographs in history.

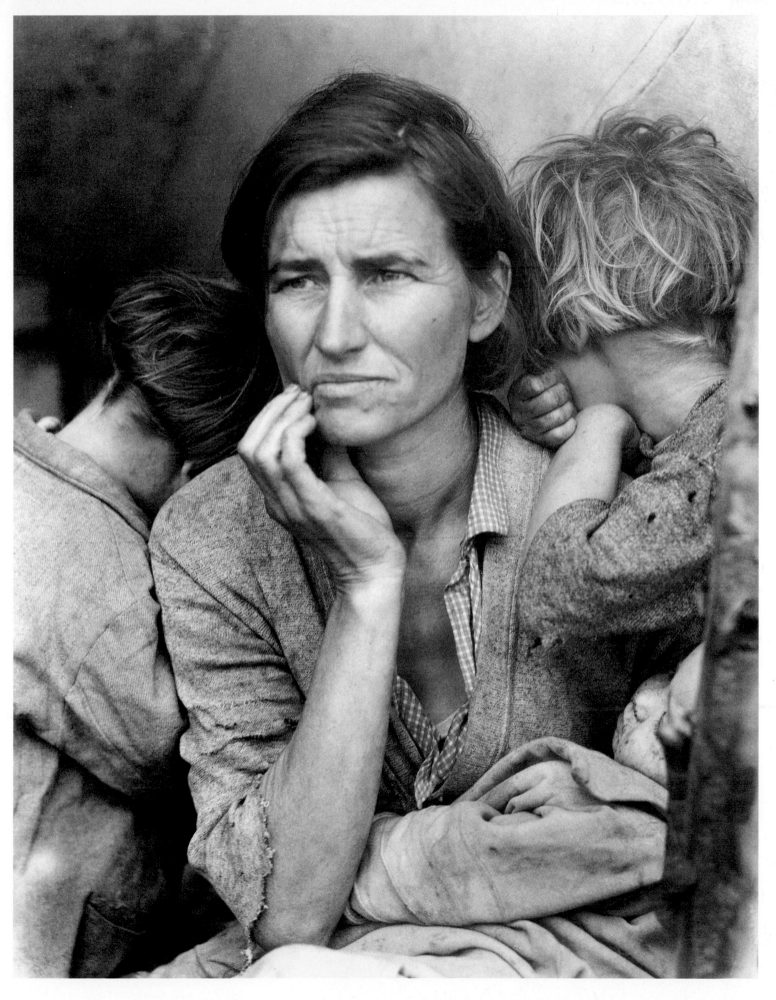

first, and then as the central ribs of strength grew weak, each leaf tilted downward. Then it was June, and the sun shone more fiercely. The brown lines on the corn leaves widened and moved in on the central ribs. The weeds frayed and ~~moved~~ edged back toward their roots. The air was thin and the sky more pale; and every day the earth paled.

In the roads where the teams moved, where the wheels milled the ground and the hooves of the horses beat the ground, the dirt crust broke and the dust formed. Every moving thing lifted the dust into the air; a walking man lifted a ~~cloud~~ thin layer as high as his waist, and a wagon lifted the dust as high as the fence tops, and an automobile boiled a cloud behind it. The dust was long in settling back again.

When June was half gone, the big clouds moved up out of Texas and the gulf, high heavy clouds, rain-heads. The men

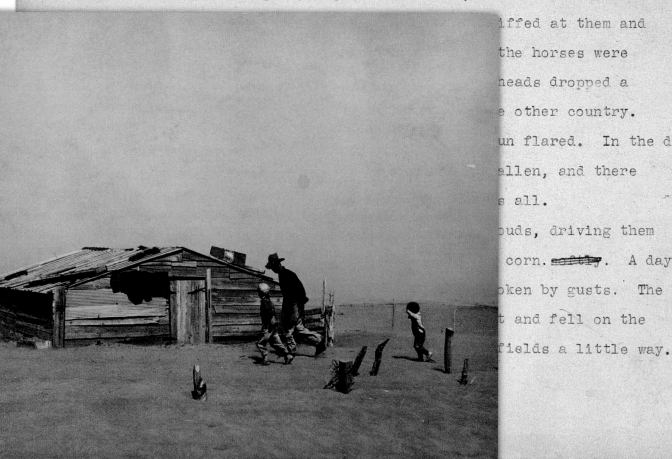

iffed at them and the horses were heads dropped a e other country. un flared. In the dust allen, and there s all. ouds, driving them corn. ~~softly~~. A day oken by gusts. The t and fell on the fields a little way.

Edward Weston. Tomato field, Big Sur. Gelatin silver print. California, 1937.
Broken only by the distant hills, rows and rows of thriving tomato plants, glistening at sunset against rich black dirt, proclaim California's fecundity. Land companies and ranchers developed vast stretches along its coast and valleys and created a mecca for a migrant workforce produced by the Great Depression and dreaming of a stable life. Weston was a pioneer of the Group f/64 California photographers (so-named for the extremely narrow lens-opening needed for their sharp-focus pictures).

Opposite: John Steinbeck. *The Grapes of Wrath.* Typescript with pencil and ink notations. Draft manuscript. Los Gatos, California, 1939.
Steinbeck's fictional saga of the Great Depression traces the migration of an Oklahoma family driven from their home, by drought, dust, and merciless landlords, to California and their struggle to succeed there. It was received as a social document of enormous importance. The typescript, running 751 pages, bears numerous corrections and alterations in the author's hand. The galley proofs contain sometimes quite heated exchanges in the margins between Steinbeck and his editor.

Opposite: Arthur Rothstein. *Farmer and sons walking in the face of a dust storm, Cimarron County, Oklahoma. 1936.* Gelatin silver print (from copy negative, April 1936). Farm Security Administration (FSA).
Rothstein was only one year out of college when he went to the Dust Bowl of Oklahoma, Kansas, and Texas to record the ecological disasters wrought there by drought and wind erosion. In the panhandle of Oklahoma, he took this photograph and recognized that there was something unique about it: "What it did was the kind of thing Roy [Stryker] always talked about—it showed an individual in relation to his environment." While conveying the desolation of the land and the isolation of the people, it also underscores the stalwart attitude of the farmer and his sons as they move against a wind so full of dust the photographer could hardly breathe.

Victor Fleming and King Vidor. *The Wizard of Oz.* Cinematographer: Harold Rosson. Screenplay: Noel Langley, Florence Ryerson, Edgar Allan Woolf. Music: Harold Arlen. Lyrics: E. Y. Harburg. Cast: Judy Garland, Frank Morgan, Ray Bolger, Bert Lahr, Jack Haley, Margaret Hamilton. Frame enlargement. MGM Studios, Culver City, 1939.
In the screen adaptation of America's favorite fable, the magic slippers have changed from silver to ruby red and, more importantly,

Dorothy's adventure has metamorphosed into a dream. According to the critic John Lahr, Bert's son, "Dreaming and destiny were forever linked in the nation's collective unconscious by the Harburg lines 'And the dreams that you dare to dream / Really do come true.'"

A huge media blitz before the film's release assured that the nation was—as MGM phrased it in an ad—"Ozified!"

Rockwell Kent. *Workers of the World, Unite!*
Wood engraving on maple. [New York], 1937.
This icon of labor activism was published on
the cover of *New Masses* on July 20, 1937.
Practicing what he preached, Kent ran for
Congress on the Progressive Party ticket in
1948, and was instrumental in the Supreme
Court ruling against withholding passports
from political dissenters. In the 1920s, Ameri-
can workers remained a relatively impover-
ished and powerless group, but in the 1930s a
powerful trade-union movement emerged as
one of the most important social and political
developments of the decade. In 1937 alone
there were 4,720 strikes—over 80 percent
settled in favor of the unions.

Opposite: Ben D. Glaha. *Rigger on Cableway Headtower During Erection.* Gelatin silver print. Boulder City, Nevada, 1934.
Massive Boulder Dam, built between 1931 and 1936, was one of the outstanding public works projects of the first half of this century, designed to provide hydraulic power, flood management, irrigation, and municipal and industrial water supply. A civil engineering wonder, it controls the Colorado River on the Arizona-Nevada border, and was renamed by Congress in honor of President Hoover in 1947.

Glaha was chief photographer for the Bureau of Reclamation, and an engineer by profession. He understood the challenges faced by the workers, and managed to provide a sense of the massive scale of the dam.

A. V. Kipp. *Panoramic Perspective of the Area Adjacent to Boulder Dam.* Map. Chicago, 1934.
Produced to promote tourism in southern Nevada, northwestern Arizona, and south-western Utah, this perspective rendering highlights the Union Pacific's rail service to Boulder Dam and Las Vegas, as well as the nearby national parks of Grand Canyon, Bryce Canyon, Zion, and Cedar Breaks. Drawn in 1934, this panoramic view focuses on the 726-foot-high dam completed in 1936—the highest concrete-arch dam in the United States—and on 115-mile-long Lake Mead, the largest man-made lake in the western hemisphere. Also visible is Boulder City, the town which was built to house the construction workers for the dam.

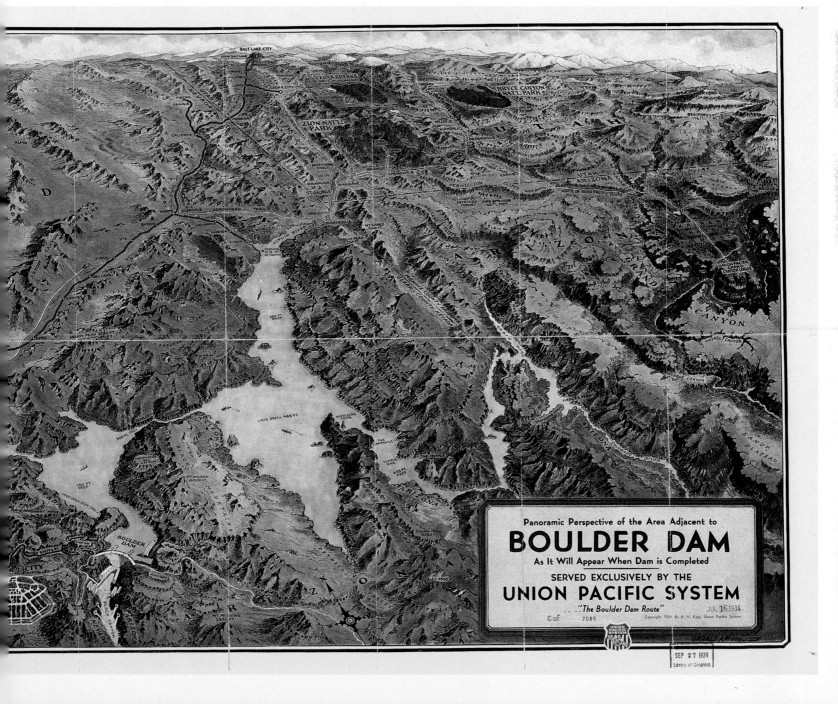

Ralph Steiner. *After Rehearsal.* Gelatin silver print. New York, 1936.
Federal work-relief programs displayed flexibility and imagination in offering assistance. A precursor to the WPA's Federal Theatre Project (FTP), the Group Theatre with its decade of achievements contributed to the government's recognition of the importance of theater to national life. Inspired by the Moscow Art Theatre, the avant-garde acting company introduced America to Stanislavsky's revolutionary methodology—ensemble work rather than star turns, and the truthful playing out of a situation (later termed "method acting" by Lee Strasberg). Pioneer modernist Steiner's dramatic viewpoint shows the Group Theatre's Morris Carnovsky, actor, and Strasberg, founding director, in deep conversation about *The Cast of Clyde Griffiths*, the dramatization of Theodore Dreiser's *American Tragedy.*

FEDERAL · THEATRE · PROJECT
presents
"The EMPEROR JONES"
by EUGENE O'NEILL
WITH RALPH·CHESSE'S MARIONETTES
COLUMBIA
135 · O'FARRELL · OR · 9027
OPENS APRIL·13
RIDE THE WHITE FRONT CARS
Serial No. 771

Federal Theatre Project presents "The Emperor Jones" by Eugene O'Neill. Silkscreen poster. California, 1937–38. Federal Art Project (FAP). As part of the Federal Theatre Project (FTP), Hallie Flanagan created a national federation of theaters offering, at modest ticket prices, plays on current issues, classics, melodramas, comedies, circus performances, vaudeville shows, and local pageants. In the midst of nationwide stagings of all his plays, including this marionette version of *The Emperor Jones,* 1936 Nobel Prize–winner O'Neill commented: "It has a tonic effect on me to think of my own plays being done in places where, without Federal Theatre, they would most certainly never have been produced." By 1939, eight thousand FTP programs had been attended by an estimated 25 million people, many of whom were experiencing live theater for the first time.

IRVING BERLIN

God Bless America
Land that I love
Stand beside her
And guide her
Through the night with a light
From above
From the mountains
To the prairies
To the oceans
White with foam
God Bless America
My home sweet home.

Jerry Berlin

Irving Berlin. "God Bless America." Autograph lyric sheet in ink. Yaphank, Long Island, New York, 1940.

Berlin's songs ranged widely in content from the sophisticated "Cheek to Cheek," composed for Fred Astaire, to the tragic "Supper Time," performed by Ethel Waters as the wife of a lynching victim, to the patriotic and sentimental "God Bless America." Written for his Ziegfeld-style review *Yip, Yip, Yaphank* when he was in the army in 1918, the original lyric ran "Make her victorious on land and foam, God Bless America." Deciding its solemn tone was out of sync with the show, he dropped the number. In 1938, with war again threatening Europe, he revised the song and Kate Smith introduced it on her radio broadcast for Armistice Day, 1938. It was an immediate sensation. Berlin's God Bless America Fund donated the song's considerable royalties to the Boy Scouts and Girl Scouts of America.

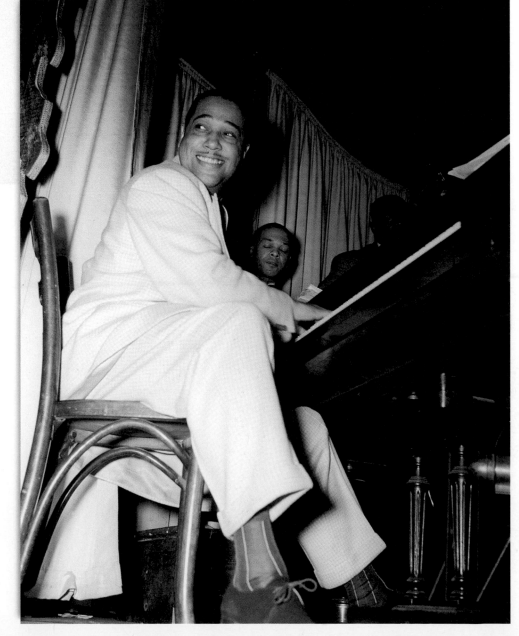

Gordon Parks. *Duke Ellington, orchestra leader, at the Hurricane Club, New York, May 1943.* Gelatin silver print. Office of War Information (OWI).

Ellington was an underappreciated jazz pianist and highly distinguished songwriter whose greatest compositions were short, formally innovative pieces for his band. Musically gifted himself, Parks followed in his idol Ellington's footsteps to New York, but his own ambitions in that field were frustrated. He joined the OWI Historical Section, and covered the city's nightclubs as part of the *Life in America* photo series to garner support for the United States and the Allies through overseas publications. Parks did an extended study of Ellington and each member of his band, some of the greatest performers in jazz and key purveyors of big-band music, which had found universal acceptance in the middle thirties and created the swing era.

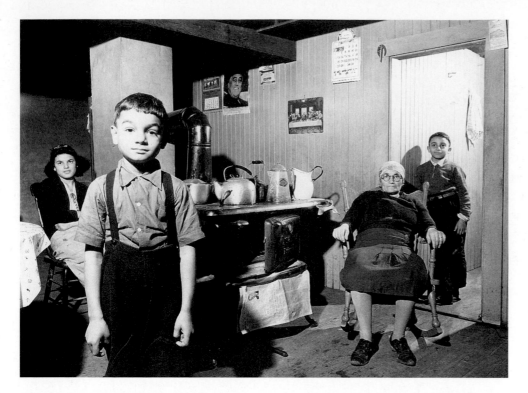

Jack Delano. *The family of Peter V. Andrews, Portuguese.* Gelatin silver print. Falmouth, Massachusetts, December 1940. Farm Security Administration (FSA).

During the prewar mobilization, the FSA's Historical Section was to appeal to allies and neutral nations with benevolent images of the diverse ethnic and religious groups that make up our population, in direct contrast to the intolerance then being shown in Europe. A year out of the Philadelphia Art Academy, Delano toured New England adding photographs of contentment and abundance to the FSA's files.

The Andrews family, proud of just having acquired its first cow, was one of many assisted by the FSA. Only the photograph of President Franklin Roosevelt on the wall makes clear that this home of a distinctively southern European heritage is American.

Marion Post Wolcott. *Members of the Primitive Baptist Church attending a baptismal service which is being held in the creek, Morehead, Kentucky. August 1940.* Gelatin silver print. FSA.

By 1921, American Protestantism was split into two warring camps: the modernists, mostly urban, middle class, and eager to adapt to the teachings of modern science, and the evangelical fundamentalists, largely rural and fighting to preserve traditional faith, creationism, and the centrality of religion in American life. Wolcott traveled alone to isolated, agrarian eastern Kentucky, where she attended such regional social functions as pie suppers, play parties, and square dances. By the 1940s these remnants of English culture had become obsolete in most parts of the world. On August 16, 1940, she wrote the FSA office: "I'm going to get a creek baptizing here tomorrow—I hope there will be no objections. Tried to get permission to take pix inside the church (Baptist) of the annual 'foot washing' service but was unsuccessful."

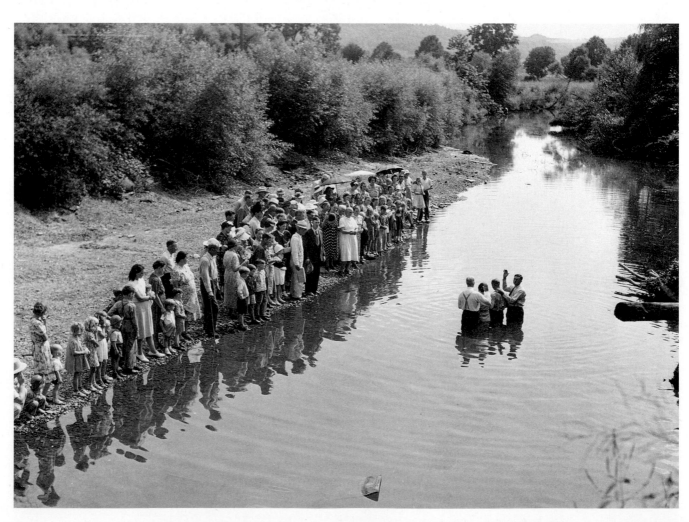

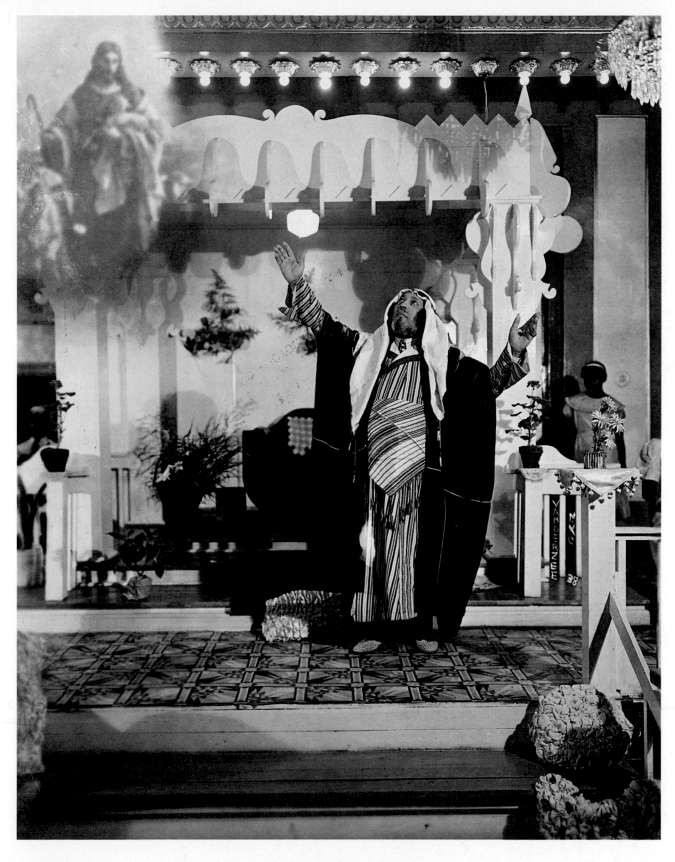

James Van Der Zee. *Daddy Grace, Harlem.*
Gelatin silver print, 1938.
As blacks migrated from the rural South to
the urban North in greater and greater
numbers, they established their own cultural
institutions in many cities. Evangelist Charles
Emmanuel Grace, bishop of the United House
of Prayer for All People, was known as Daddy
Grace to his estimated 3 million followers. He
and his better-known contemporary, Father

Divine, were charismatic leaders of fundamen-
talist religious sects that flourished in the
1920s and 1930s.

James Van Der Zee operated a studio in
Harlem from 1916 to 1968. He photographed
political, religious, and cultural figures as well
as neighborhood life. Drawing on his talent as
a master printer, he inserted an image of
Christ in the upper left corner of this portrait.

Prentiss Taylor. *Scottsboro Limited.* Lithograph. [Washington, D.C.], 1931.
This image appeared on the cover of *Scottsboro Limited,* Langston Hughes's 1932 collection of four poems and a protest play. In 1931, nine black youths had been tried for the rape of two white women in a freight car passing through Alabama. In spite of testimony by doctors that no rape had occurred, and in the absence of adequate legal representation for the accused, there were eight convictions with the death penalty and one mistrial, all in the course of three days. The case became an international cause célèbre. Between 1932 and 1935 the U.S. Supreme Court reversed seven convictions and the Alabama Supreme Court reversed one. In 1937, charges were dropped against four of the nine, and four more were paroled between 1943 and 1946. The last jailed Scottsboro defendant escaped to Michigan in 1948; the state refused to return him to Alabama. This copy of the lithograph is signed with a dedication to Hughes.

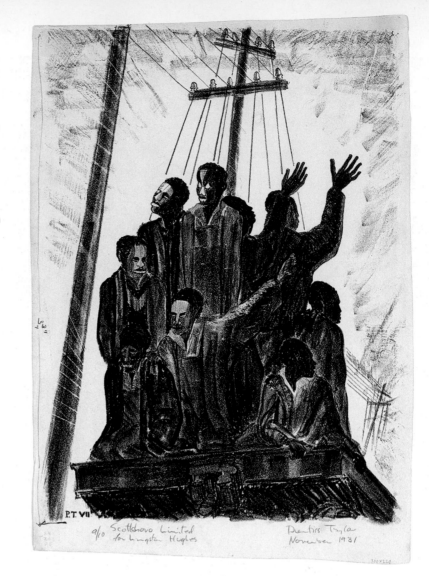

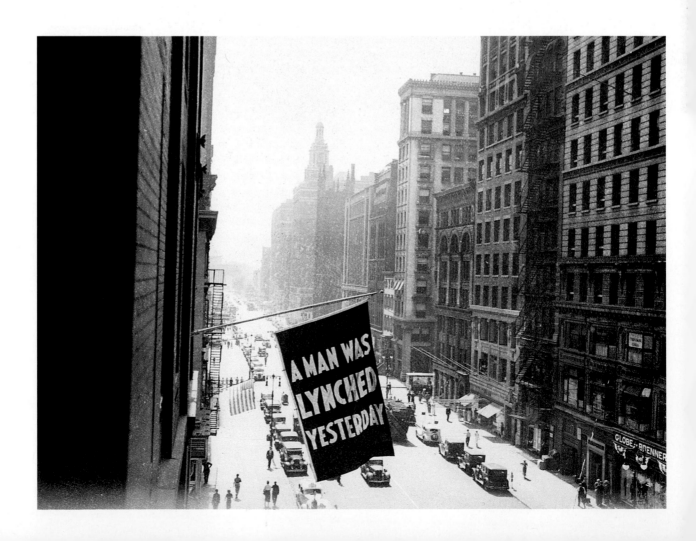

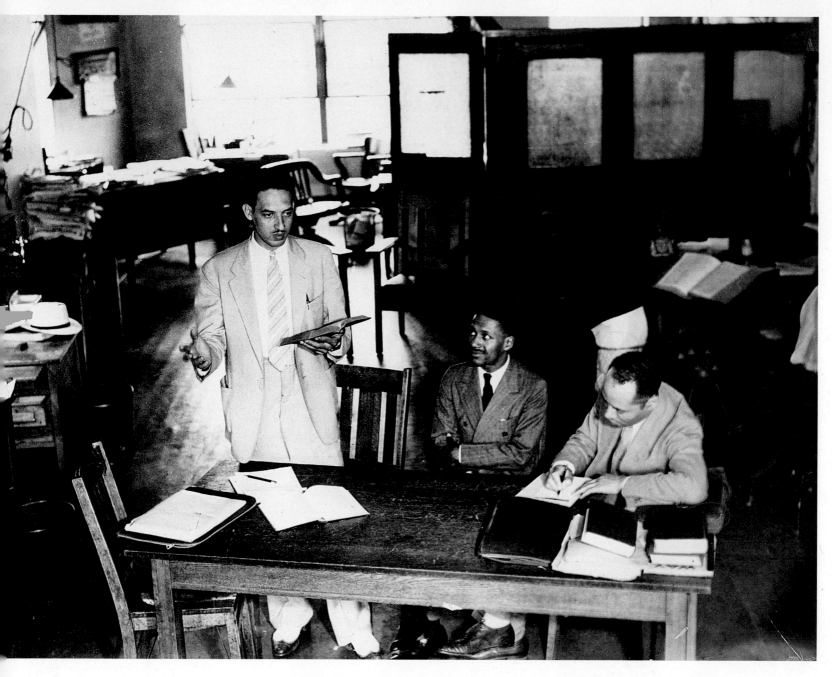

Thurgood Marshall with client Donald Gaines Murray and attorney Charles H. Houston during court proceedings, Maryland. Gelatin silver print, c. 1935.
After graduating at the top of his Howard University law school class, Marshall volunteered his services to the Baltimore branch of the NAACP. One of its goals was to eliminate racial discrimination in schools. In his first

case, Marshall, along with NAACP lawyer Houston, represented Murray, a black graduate of Amherst College who wished to attend the University of Maryland's law school but was refused admittance. They won the case and initiated the modern civil rights movement by fighting racism through the courts. In 1967, Marshall became the nation's first black Supreme Court justice.

Opposite: **Flag, announcing lynching, flown from the window of the NAACP headquarters, New York City. Gelatin silver print, 1936.**
One of the activities of the National Association for the Advancement of Colored People (NAACP) was to monitor and report on injustices against African Americans. In the 1930s a large banner was hung from their New York City office at 69 Fifth Avenue every time a man was lynched, in the hope that public awareness would bring reform. On

September 8, 1936, the banner flew in memory of A. L. McCamy, lynched in Dalton, Georgia, two days earlier. The flag ritual continued until 1938, when the NAACP's landlord, sympathetic to their work but concerned about possible confusion and misinterpretation, threatened to evict the association if it continued to fly the flag. By then, the number of lynchings had dramatically dropped, thanks to the NAACP's campaign.

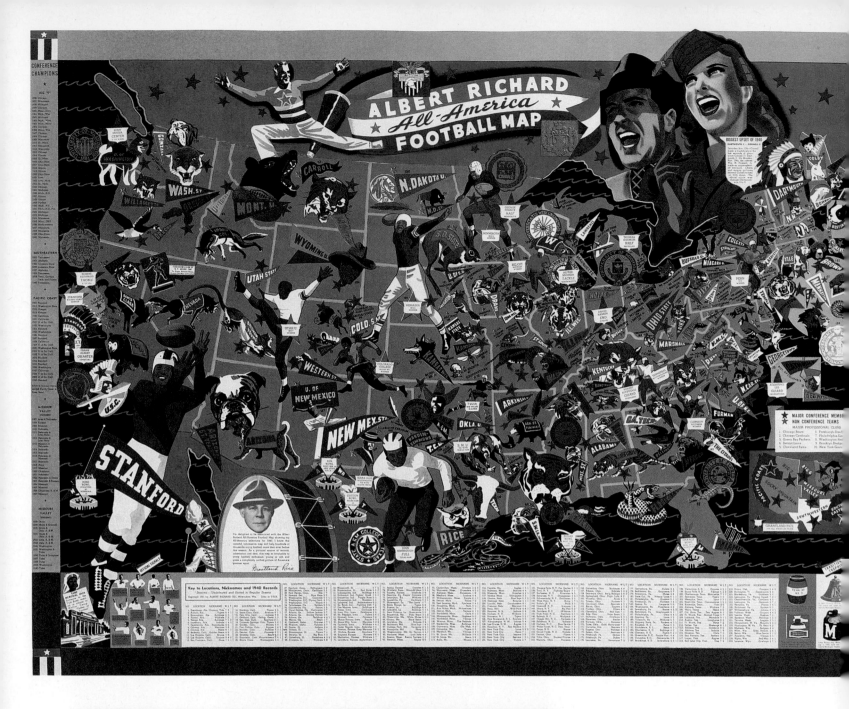

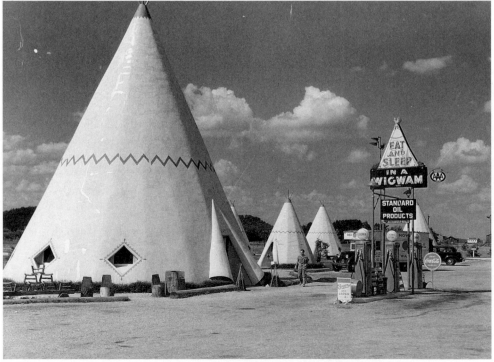

Marion Post Wolcott. *Cabins imitating Indian Tepee, for tourists.* Gelatin silver print. Cave City (vicinity), Kentucky, 1940. Farm Security Administration (FSA).

Many pictures by Wolcott, who grew up in New Jersey and New England, studied in Germany on the eve of World War II, and lived in New York City before joining the FSA staff in 1939, reveal a newcomer's fascination with the South. This motel along Route 31W, south of Cave City, Kentucky, is an example of the distinctively American architectural invention that provided a safe, inexpensive place for entire families to spend the night as they toured the country in their automobiles. Here a full complement of travel facilities is offered—as well as a chance, as the sign says, to "eat and sleep in a wigwam" and gas up for the next day's journey.

Opposite: F. E. Cheesman. *Albert Richard All-America Football Map.* Map. Milwaukee, 1941.
Derived from the nineteenth-century English games of soccer and rugby, American football emerged as an intercollegiate sport in the 1870s, and as a professional sport in the 1890s. This pictorial map demonstrates how popular football had become by the begin- ning of World War II. With a primary emphasis on the collegiate side of the sport, with team nicknames, 1940 season records, and major conference championships, it also documents the major professional clubs—only ten at the time. The map carries the endorsement of the noted sports writer Grantland Rice, and reports his selections for the 1940 All-America team.

Arthur B. Heaton. Project, Blue Bell System hamburger restaurant, Pennsylvania Avenue. Elevation and plan drawing, graphite and colored pencil. Washington, D.C., 1936.
"Fast food" is one of America's more dubious contributions to world culture, and the hamburger reigns as its principal icon. J. Walter Anderson of Wichita, Kansas, probable inventor of the hamburger on a bun in 1916, went on to open the first White Castle restaurant in 1921 and the 115th in 1931. The standardization, cleanliness, economy, and speedy service offered in this new type of eating establishment held enormous appeal for Machine Age Americans. Architect Heaton designed this elegant little pavilion for the "Blue Bell System" and, had this small chain been more successful, Blue Bells rather than Golden Arches might be visible today around the world.

Russell Lee. *Soda Jerk flipping ice cream into a malted milk shaker. Corpus Christi, Texas. February, 1939.* Gelatin silver print. Farm Security Administration (FSA).
The local drugstore with its soda fountain was a central element of small-town life. Its operators, known as soda jerks because of the machine handles they used to concoct their bubbly confections, were colorful entertainers, adding to the fun of serving one of America's favorite foods—ice cream—with flashy maneuvers.

Lee married Texas newspaperwoman Jean Smith early in his FSA career and together they toured the country for years; she chatted with those who were to pose, took field notes, and wrote captions for his photographs.

· FRONT · ELEVATION ·
· SCALE · 1/4" = 1' 0" ·

PLAN OF FRONT
ARTHUR B. HEATON *Architect* · 1211 CONN. AVE.

Frank Capra. *Mr. Smith Goes to Washington.*
Cinematographer: Joseph Walker. Screenplay:
Sidney Buchman. Score: Dimitri Tiomkin. Cast:
James Stewart, Jean Arthur, Claude Rains,
Harry Carey. Frame enlargement. Columbia
Pictures, Hollywood, 1939.
Though condemned by the U.S. Senate for
what was deemed its slanderous depiction of
that institution's members and machinations,
Capra's film was embraced by American and
European audiences as a ringing affirmation
of democratic ideals and the durability of the
American legislative system in the face of
greed, corruption, and totalitarian intent. In
late 1942, the Nazis banned the screening of
English-language films in occupied France,
with the exception of American films already
imported. Throughout France, distributors
chose *Mr. Smith* to be the last American film
seen until war's end. Here the freshman
senator (James Stewart) waxes poetic about
the Capitol Building and the importance of
dreams in a democratic society.

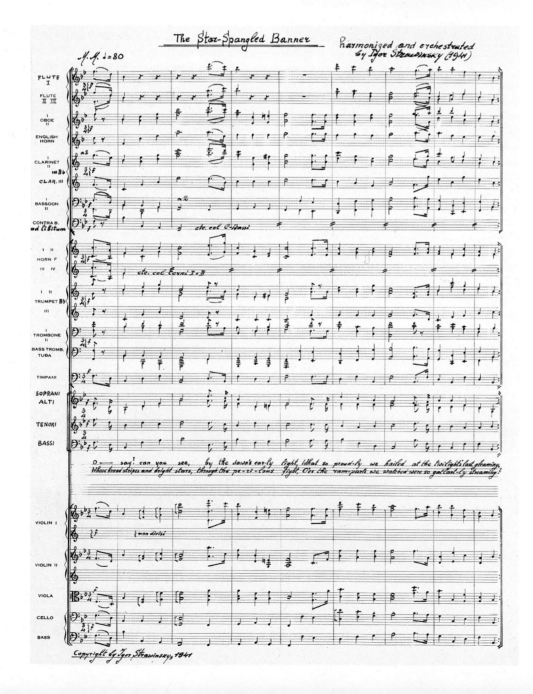

Igor Stravinsky. "The Star-Spangled Banner."
Autograph arrangement for chorus and
orchestra in ink. [Los Angeles], 1941.
The Russian-born master Stravinsky's dedica-
tion of this new arrangement of the national
anthem reads in part: "Searching about for a
vehicle through which I might best express my
gratitude at the prospect of becoming an
American citizen, I chose to harmonize and
orchestrate 'The Star Spangled Banner.'"
Completed on July 4, 1941, it was first per-
formed by the WPA Symphony Orchestra, the
Los Angeles Oratorio Society, and the Los
Angeles WPA Negro Chorus. Then, after a
performance in Boston, police confiscated the
music from the stands because of a Massachu-
setts law forbidding "tampering with national
property."

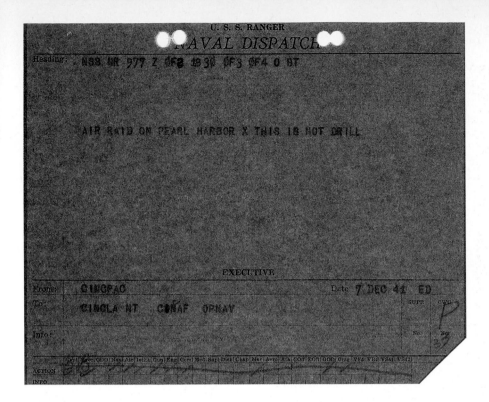

Norman Rockwell. *Save Freedom of Worship—Buy War Bonds.* Offset lithograph. Poster. Washington, D.C., 1943. Office of War Information (OWI).

Franklin Roosevelt enumerated the Four Freedoms—Freedom from Want and Fear, Freedom of Speech and Worship—in a 1941 speech to Congress. Later he stated that "The declaration of the four freedoms . . . is not a promise of a gift, which under certain conditions, the people will receive; it is a declaration of a design which the people themselves may execute." Rockwell, one of America's most beloved artists, intended to donate his painted interpretations of FDR's words to the War Department, but receiving no response, offered them to the *Saturday Evening Post,* where they were published in 1942. Their immense popularity led the OWI to reproduce them as posters in 1943, and more than 2.5 million copies were ultimately printed for the war bond effort.

CINCPAC. *U.S.S. Ranger Naval Dispatch.* December 7, 1941.
On December 7, 1941, Japan launched a surprise air attack on Pearl Harbor, a major naval, military, and air base on Hawaii, and then bombed other U.S. bases in the Philippines. The next day, the United States declared war on Japan. This naval dispatch was received by the U.S.S. *Ranger,* an aircraft carrier that was returning to Norfolk, Virginia, from an ocean patrol when the attack occurred.

Arthur Szyk. *Admiral Yamamoto.* Drawing, ink and pencil. New York, 1941.
Published on the cover of *Time* magazine just two weeks after Pearl Harbor, Szyk's characterization of the man behind the attack blends fear and respect for a brilliant and dangerous adversary in the aftershock of one of this country's greatest military debacles. Polish-born Szyk served the Allies as a cartoonist and became known for his portrayals of the Japanese and the Germans as oafish thugs or mindless killers, very unlike this masterpiece of sophisticated caricature.

William Henry Johnson. *Off To War*. Silkscreen. New York, c. 1942.

Idealism and irony coexist in much of Johnson's work. During World War II he often represented groups of soldiers in training camps, but this piece focuses on one soldier's parting from family and home. It bears the influence both of modern abstraction and of the Harlem-based New Negro Movement, which encouraged African-American creativity driven by its own innate identity and unconstrained by Western traditions. This philosophy was advanced by a constellation of artists and intellectuals, including W. E. B. Du Bois and Zora Neale Hurston, and by the Harmon Foundation.

Raphael Soyer. *Farewell*. Lithograph. [New York], 1943.

During wartime, train stations became particularly poignant terrain for artists. The Russian-born Soyer made this simple, haunting image after observing the crowds of people at New York's Pennsylvania Station bidding farewell to soldiers on their way to war. Soyer had cut his teeth in the 1930s as a WPA artist before successfully submitting this work for the exhibition "America in the War," sponsored by Artists for Victory, Inc. This nonprofit coalition of artists and art organizations proposed to create art that would rally America in support of the war. In October 1943, the exhibition opened simultaneously at twenty-six museums throughout the country.

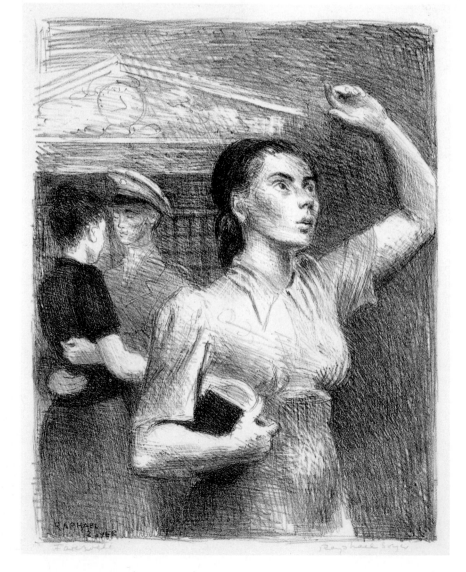

Jolan Gross-Bettelheim. *Home Front.* Litho-
graph. New York, 1942–43.
More than ten thousand printmakers, painters,
sculptors, and designers applied their skills to
the war effort. This Czech-born artist puts a
stylized, industrialist twist on the American icon
Rosie the Riveter: a fleet of defense workers is
rendered as elements of an anthropomorphic
machine. Bettelheim, like Soyer, had worked as
a WPA artist in the thirties, and also contributed
to the 1943 exhibition "America in the War."
Nearly one-third of the participating printmak-
ers were women. The show traveled, for several
years after it opened, to USO centers, army
facilities, and additional museums.

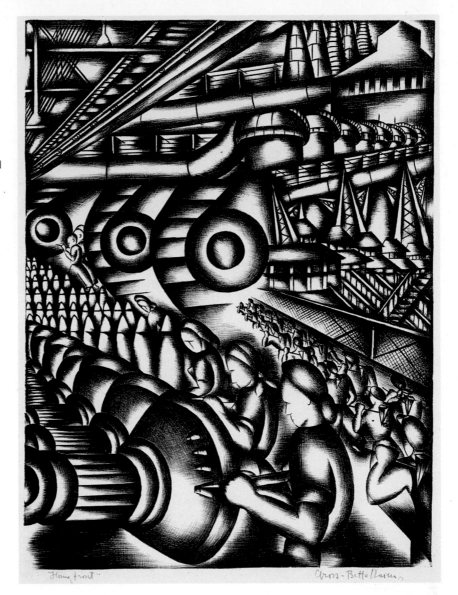

William Wyler. *Memphis Belle.* Cinematogra-
phers: Wyler, William C. Clothier, Harold
Tannenbaum. Frame enlargement. Para-
mount, Hollywood, 1944.
No industry was more essential to the govern-
ment's efforts to prepare the nation for the
hardships of war than the film industry, which
produced a steady flow of home-front enter-
tainments and military training films while
releasing key creative people to the various
military branches. William Wyler was recruited
in 1942 by the Air Force to document the lives
of B-17 crews, and he and his small team were
actually trained as gunners. Filming with
hand-held 16mm cameras began the week
after the first daylight raids over Germany.
Cinematographer Tannenbaum was killed in
action over France, and Wyler was eventually
ordered to stop flying combat missions. The
resulting film focused on the crew of the
Memphis Belle, the first B-17 to complete
twenty-five missions. The government was
leery of homefront reactions to films that
depicted combat dangers accurately, but
President Roosevelt enthusiastically supported
the theatrical release of Wyler's film on April
14, 1944. It stands as one of the greatest
American documentary films of the war.

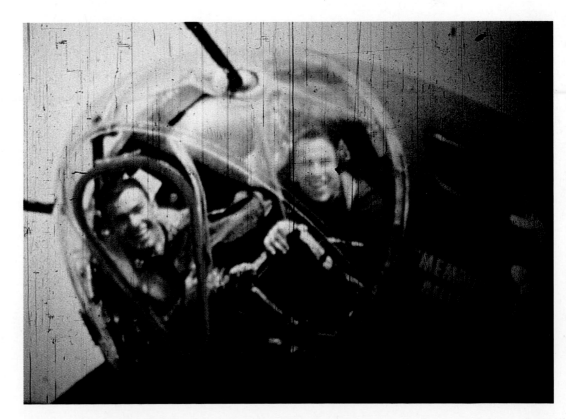

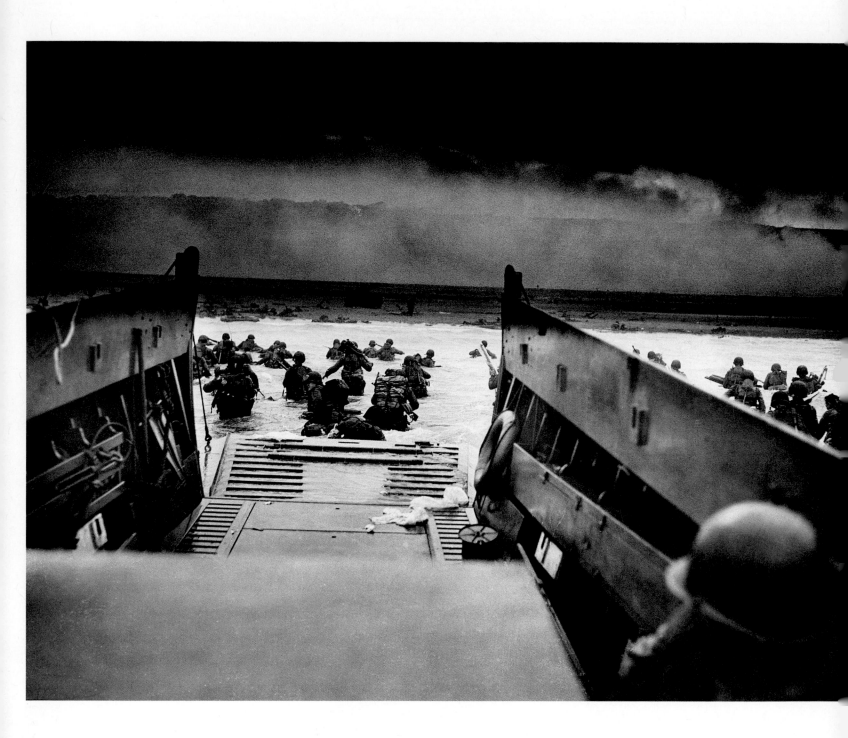

Robert F. Sargent. *Taxi to Hell—and Back.*
Gelatin silver print. Normandy, France, 1944.
U.S. Coast Guard.

The Allied invasion of Normandy on D-Day,
June 6, 1944, was a decisive moment in the
war on the European front. At the end of the
first day, nearly 150,000 Allied troops had
landed along 115 miles of the French coast.
The Americans disembarked from specially
designed Coast Guard barges in waist-high
water, wearing heavy backpacks and carrying
their weapons. Many were killed by German
gunners before they could reach the shore. It
was the largest amphibious assault in history.
After nearly three weeks of intense fighting,
the port of Cherbourg was captured on June
27. The Battle of Normandy ended on August
19 when General Eisenhower ordered U.S.
troops to cross the river Seine. Although
victory seemed close at hand, the Allies still
faced eight months of hard fighting.

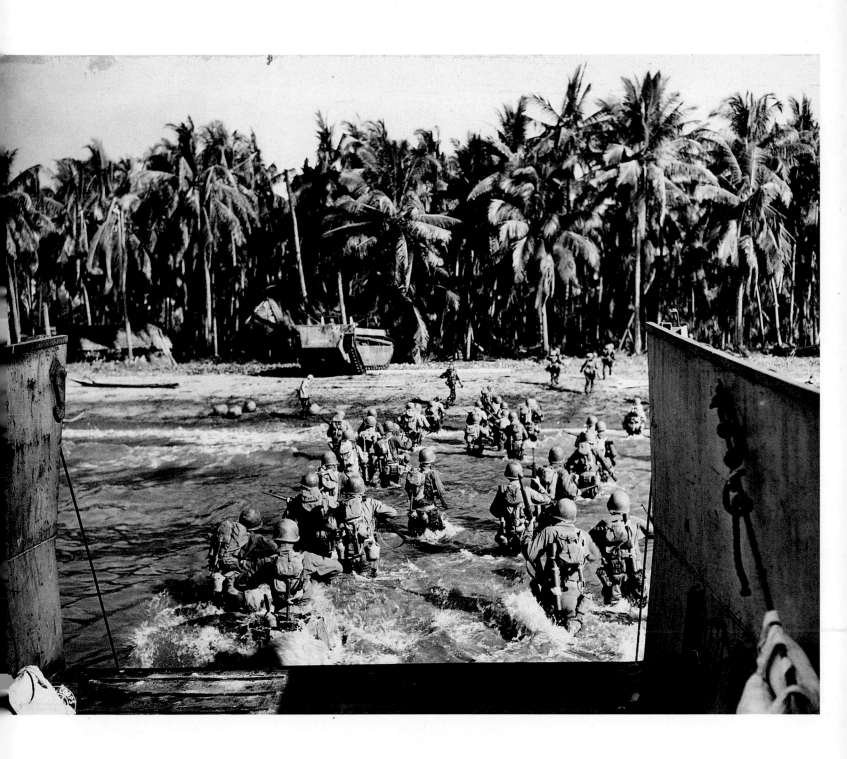

First Troops of the 3rd Battalion, 132nd Infantry, American Division, wade ashore, across heavily mined beaches, during invasion of Cebu island, PI. Gelatin silver print. Philippines, 1945. U.S. Army Signal Corps.

In the days following Pearl Harbor and the Philippine air strikes, Japanese forces destroyed almost half of the U.S. aircraft based on the islands. Manila fell under Japanese control, trapping Philippine and American troops on the Bataan Peninsula and forcing them to surrender on May 6, 1942. General Douglas MacArthur, in command of U.S. Pacific forces, retreated to Australia and vowed: "I shall return." Keeping his promise, he led an invasion on the Philippine island of Leyte in the fall of 1944, a major step in his "island hopping" campaign that by war's end would reach Okinawa at the bottom of the Japanese island chain.

D-Day services in a synagogue on West 23rd Street, New York, NY. June 6, 1944. Gelatin silver print. Office of War Information (OWI). On D-Day, OWI photographers were assigned the topic of public reactions to the Allied landing in France; their work was pooled, so the photographs are unsigned. This service at the Talmud Torah Emunath Israel—a Conservative Jewish congregation in a one-story storefront—appears to be ecumenical, one of many held to provide prayerful support for the Allies. (As early as 1942, many American Jews and others knew of Hitler's Final Solution, the plan to eradicate all Jews and other "undesirables" from Europe—but it was not yet common knowledge.) According to the clock on the back wall, the invasion had been going on for about fourteen hours. Other homefront observances included interludes of silent prayer on street corners at noon, rallies, and blood drives at plasma centers.

Esther Bubley. *Decorating a soldier's grave in one of the Negro sections on Memorial day. May 1943.* Gelatin silver print. Arlington, Virginia. Office of War Information (OWI). One photograph in a portfolio Esther Bubley compiled to convince Roy Stryker to hire her was this documentation of segregation infiltrating burial practices at Arlington National Cemetery. On June 25, 1941, President Franklin Roosevelt issued an Executive Order forbidding racial and religious discrimination in defense work; a week earlier, black leaders had agreed to cancel a scheduled march on Washington on that condition. Occasionally, serious race riots did occur as integration proceeded in the military; but by the end of the war, more than 1 million African Americans had served and many distinguished themselves for bravery. Stryker finally hired Bubley as an OWI staff photographer, but she would hand in her assignments to his successor, Jean Smith Lee. Lee's husband, the photographer Russell Lee, had gone off to military service.

Ansel Adams. Baseball game, Manzanar Relocation Center. Gelatin silver print. Inyo County, California, 1943.
Panic and paranoia concerning an impending Japanese invasion followed the attack at Pearl Harbor. California, Oregon, and Washington were declared strategic areas by the federal government, and persons of Japanese ancestry were ordered evacuated. In the spring of 1942, the War Relocation Authority began placing 110,000 of them in "protective custody." Those forcibly removed from their homes, businesses, and possessions included Japanese immigrants legally forbidden from becoming citizens (Issei), the American-born (Nisei), and children of the American-born (Sansei). Manzanar, in the Owen Valley three hundred miles northeast of Los Angeles in Inyo County, became home to 10,000 of these people, who planted crops in the harsh soil and played baseball, their national game.

Ansel Adams, perhaps the most widely known American photographer today, was struck by "the human story" and published *Born Free and Equal: The Story of Loyal Japanese-Americans* in 1944. Because of the war, the book reached a limited audience. In 1965, Adams gave his Manzanar prints and negatives to the Library of Congress in the hope that the full story would eventually be told.

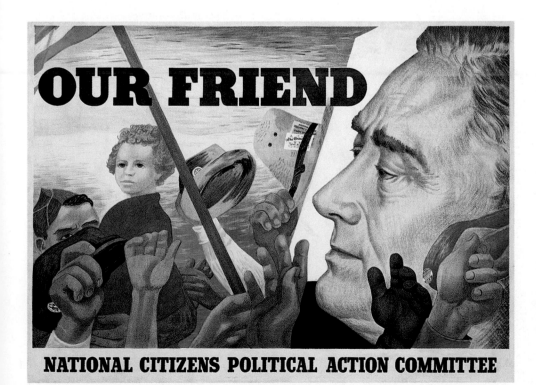

Ben Shahn. *Our Friend. National Citizens Political Action Committee.* Lithograph. Poster. [New York], 1944.
In 1944 Shahn, a painter, printmaker, muralist, and activist, produced a series of posters for the Political Action Committee (PAC) of the Congress of Industrial Organizations (CIO), a branch of organized labor, urging people to "register and vote." This one was published by an arm of PAC formed to elect a progressive president and congress in 1944—specifically, to help propel Franklin Roosevelt into an unprecedented fourth term. It contains political and patriotic symbols, including a child (Shahn's son Jonathan) signifying the nation's future. It did its job.

The Roosevelt Administration had supported organized labor and assured workers the "right to organize and bargain collectively through representation of their own choosing." Recognizing its debt to Roosevelt, the CIO contributed heavily to his campaign in both 1940 and 1944.

<u>Nuclear Reactions and Stability</u>
J. R. Oppenheimer – April 28-1941

<u>Nuclear Reactions</u>

First carried out by use of bombarding particles from natural radioactive substances.

$$N^{14} + He^4 \longrightarrow H^1 + O^{14} \quad (He^4 = \text{natural } \alpha\text{-particle})$$
by Blackett in cloud chamber

$$Be^9 + He^4 = C^{12} + n$$
first source of neutrons – yield small

The γ-rays of Thorium C'' (2.62 MEV)

$$D + \gamma \xrightarrow{\text{(2.18 MEV Binding)}} n + p \quad (\text{Chadwick \& Goldhaber})$$

$$Be^9 + \gamma \longrightarrow n + 2He \quad 1.4 \text{ binding energy.}$$

In general we will want hi-energy particles, especially protons, to get into the nucleus. This can be done at energies less than the culomb barrier energy $\left(E_{cb} \approx \frac{Z^{\bullet} e^2}{(1.45 \times 10^{-13} A^{\frac{1}{3}})^2} \right)$ because of the wave effects which allow the particle to diffract through the barrier. There are often ample nuclear reactions produced by bombarding particles of energy less than the culomb barrier.

J. Robert Oppenheimer. *Nuclear Reactions and Stability.* Pen and ink. [California], April 28, 1941.
After the discovery of nuclear fission in 1939, Oppenheimer began to think about the practical release of nuclear energy. During 1941, but before he assumed charge of the Los Alamos Laboratory that would design and build the first atomic bomb, he grappled with the problem of how to separate uranium-235 (the explosive form of uranium) from the more abundant, natural, and unfissionable uranium-238. The equations on this page refer to English physicist Patrick M. S. Blackett's cloud chamber experiments of the 1920s and to the 1932 discovery of neutrons, which were ejected from beryllium bombarded by alpha particles. Neutrons would prove to be the most useful particles for initiating nuclear reactions.

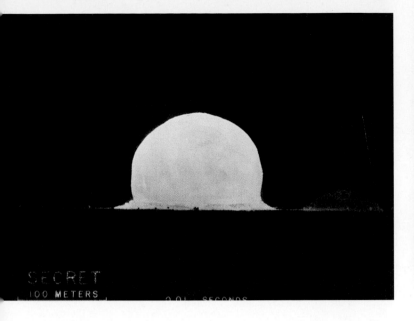

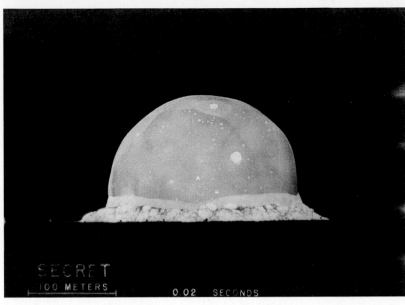

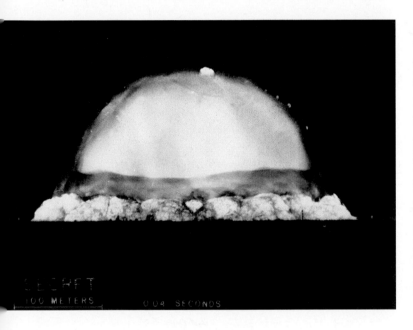

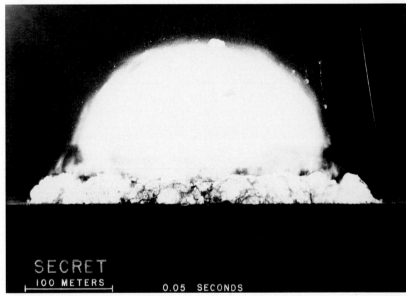

Nuclear explosion, Trinity Test Site, New Mexico, July 16, 1945. Gelatin silver prints.

This sequence of photos was taken six miles from the first nuclear bomb explosion. The blinding fireball awed all who witnessed it. The physicist I. I. Rabi described it as "a vision which was seen with more than the eye." Los Alamos director J. Robert Oppenheimer remembered a line from the Hindu scripture, the Bhagavad Gita—"Now I am become Death, the Destroyer of worlds"—and, as he watched, held tightly to a post to keep himself from falling down. Technically, the Trinity test proved that the complex detonation method by implosion actually worked, and also revealed a highly radioactive dust skirt encircling the blast (first visible in the second sequence photo) that weakened the bomb's power. Trinity planners realized that detonating the "gadget" at a much higher altitude would both diminish the radioactivity and increase the destructive range of the bomb. The Army followed this advice and detonated the bomb 1,870 feet above Hiroshima, with the expected results.

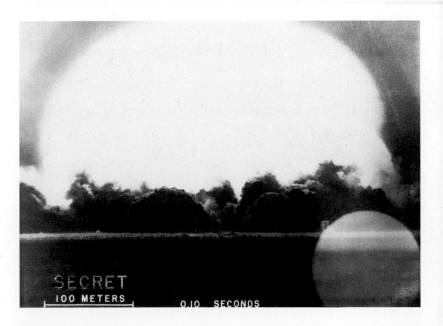

Martha Graham and Erick Hawkins in the premiere of *Appalachian Spring.* Gelatin silver print. Washington, D.C., October 30, 1944. This photograph was taken at the first performance of *Appalachian Spring* in the Library's Coolidge Auditorium on the eightieth birthday of Elizabeth Sprague Coolidge, who had commissioned a score from Aaron Copland to accompany choreography by Martha Graham, America's foremost dance-dramatist. The original drafts of the music bear the title "Ballet for Martha." Copland drew on "Simple Gifts," the Shaker traditional tune, for his work; Graham incorporated characteristic American gestures into her unique dance vocabulary. Together they introduced the vernacular into the fine arts and celebrated what was American, in the spirit that pervaded most of the New Deal arts programs.

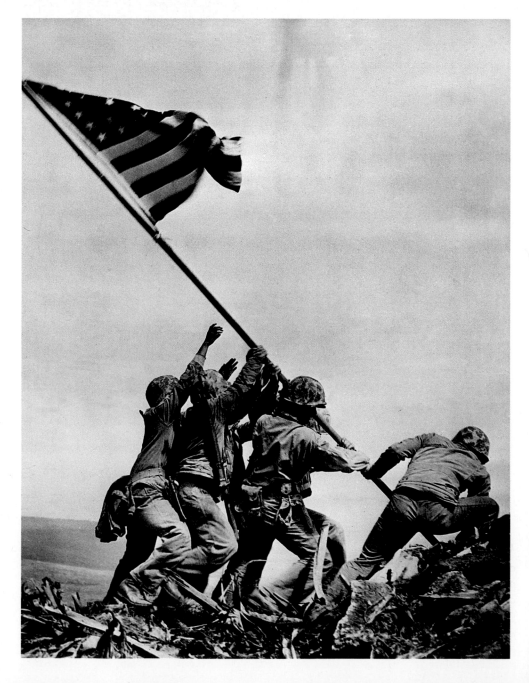

Joe Rosenthal. American Marines raising American flag on Mount Suribachi, Iwo Jima. Gelatin silver print, 1945. Wide World/Associated Press.

Rosenthal's Pulitzer Prize–winning photograph of the six unidentified Americans raising a flag over the Pacific island of Iwo Jima is one of the best-known war photographs ever taken. The Allies invaded the island, more than six hundred miles off the coast of Japan, on February 19, 1945, hoping to establish a staging area for bombers. Rosenthal, a photographer for Associated Press, landed under gunfire three hours after the invasion began. The Marines fought their way to the top of Mount Suribachi on February 23 and raised a small flag. Later that same day, five Marines and a naval medicine corpsman raised this second, larger flag at the summit. Contrary to popular belief, the moment is not staged. In thirty-one days of brutal fighting, 6,821 Americans died, including three of the flag-raisers. Rosenthal inscribed this print to Wyoming's Democratic Senator Joseph O'Mahoney.

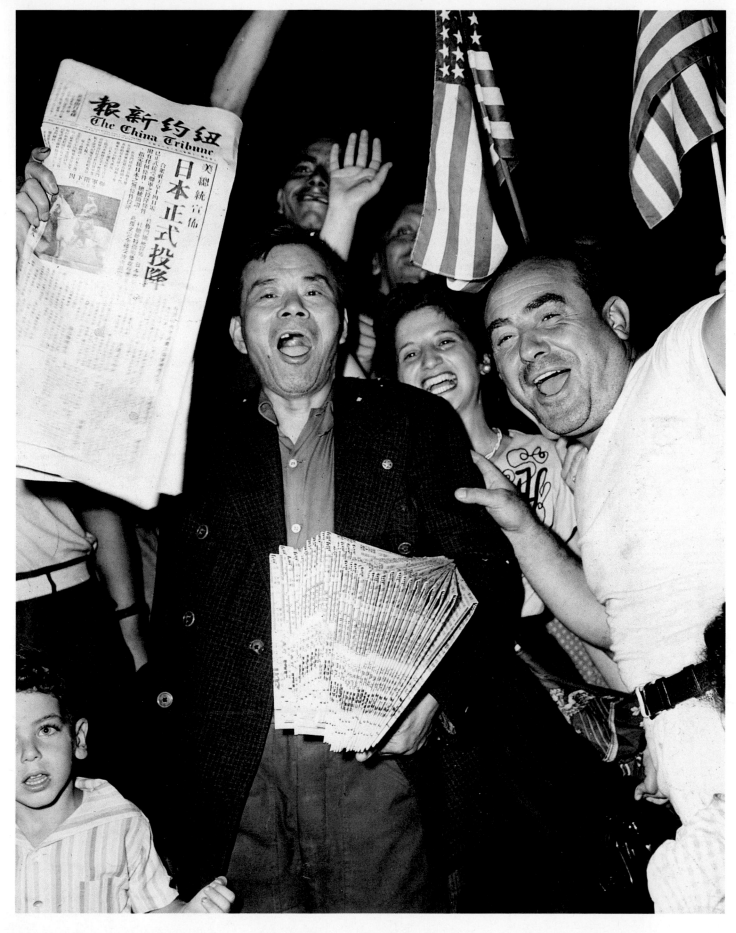

"Read All About It"—A Chinese news vendor cries the latest edition of a Chinese newspaper which "banners" the end of the war, on Mott Street, in the heart of Chinatown. Gelatin silver print. New York, 1945.

Wide World/Associated Press.
Japan officially accepted the Allied demand for unconditional surrender on August 14, 1945. Americans celebrated V-J day on August 15, joyously swarming the streets to wave

flags, throw confetti, blow horns, and display triumphant newspaper headlines such as this. More than 250,000 Americans were killed and more than 600,000 wounded during the war.

Lucinda Ballard. *Dancer.* Costume sketch for *Show Boat.* Gouache drawing, 1946.
This New York revival of the landmark musical was supervised by the librettist Oscar Hammerstein the year after his collaborator Jerome Kern's death. The war provoked a passion for Americana, and *Oklahoma!*, by Hammerstein and Richard Rodgers, had opened on Broadway in 1943, fulfilling the promise of *Show Boat*'s pioneering fusion of drama and song nearly two decades earlier. The American musical evolved from immigrant roots in nineteenth-century vaudeville into an extravagant art form for stage and screen that was embraced around the world.

The Best Years of Our Lives. Offset lithograph. Poster. RKO Pictures, Los Angeles, 1946.
The Best Years of Our Lives, winner of the Oscar for best film of 1946, captured the heartfelt journey of the World War II veteran returning home and sensitively described the emotional hurdles and daily adjustments he faced with loved ones, jobs, self-esteem, and the future. The film's director, William Wyler, served three years of the war as a pilot in the Army Air Force, and Harold Russell, a veteran who had lost both hands, played one of the film's leading characters.

The GI Bill of Rights, enacted in 1944, assured job placement, education and vocational training, unemployment insurance, and loans to veterans toward the purchase of homes, farms, or businesses. One of the lines in the film—"we have no decent place to live"—presages the creation of the first Levittown, a development of two thousand modestly priced units built on Long Island, New York, in 1947. Levittowns soon became the symbol of the future for working-class Americans, and a measurement of their success.

Charles Eames and Eero Saarinen. Preliminary scheme, Case Study House #8, Pacific Palisades, California. Perspective drawing, graphite. [Los Angeles], 1945.

At the end of World War II, *Arts & Architecture* magazine sponsored the Case Study House program in Southern California to prepare for the explosion in new house construction that was expected to accompany the GI Bill and to showcase new structural and cladding materials developed during the war, including metal, plywood, and composites such as plastic.

Designers Charles and Ray Eames collaborated with architect Saarinen and engineer Edgardo Contini on this design for a trussed, cantilevered, steel-framed box called the "Bridge House" projecting from a eucalyptus grove 150 feet above the Pacific. It expresses a final step in the American quest to take possession of the continent, to bridge its hills and divides, and to make dwellings both amenable to modern life and at one with their natural sites. The amended design, constructed in 1948–49, is considered one of the century's great buildings.

Jackson Pollock and Lee Krasner. Christmas card sent to Ray and Charles Eames. Drawing, black ink and colored pencil on red construction paper. East Hampton, Long Island, New York, 1946.

Pollock and his wife Krasner sent this card soon after moving from New York City to more tranquil surroundings in East Hampton, Long Island. The small drawing exhibits his distinctive calligraphy, with color possibly added by her. Nineteen forty-six was an important year in their artistic development. They began to experiment together with "all over" compositions, and he to explore the drip technique, based on Native American sand painting, that would make him a pivotal force in abstract expressionism, the movement that dominated world art after the war and shifted its focus from Europe to America for the first time.

MARK ARTIST'S PROOF RAUSCHENBERG 19

7

THE PURSUIT OF HAPPINESS, 1945–

Early in 1940, Henry Luce, the founder and publisher of *Time* and *Life* magazines, published a short essay called "The American Century," a phrase that soon became a part of the common language. In it, he tried to persuade Americans to intervene in World War II. But he offered as well a broader vision of the nation's destiny—a vision of a great international power actively and creatively shaping the future of the globe.

"What can we say about the American Century?" he asked. It must be "a sharing with all people of our Bill of Rights, our Declaration of Independence, our Constitution, our magnificent industrial products, our technical skills." It must rest on "a system of free enterprise—an economic order compatible with freedom and progress." It must make America "the Good Samaritan of the entire world," offering food and succor to those in need. Most of all, he argued, the American Century must embrace

> a passionate devotion to great American ideals . . . a love of freedom, a feeling for the equality of opportunity, a tradition of self-reliance and independence and also of cooperation. . . . we are the inheritors of all the great principles of Western civilization—above all Justice, the love of Truth, the ideal of charity. . . . It now becomes our time to be the powerhouse from which the ideals spread throughout the world and do their mysterious work of lifting the life of mankind from the level of the beasts to what the Psalmist called a little lower than the angels.

The expansiveness of Luce's predictions, and the somewhat bombastic language in which he presented them, considerably exaggerated the role the United States would accept in the postwar world, and it particularly exaggerated the generosity and idealism it would bring to that role. Americans have always been ambivalent about their relationship with the world, and that ambivalence persisted—and at times even intensified—as the nation moved into its position of global preeminence in the 1940s. But while Luce may have exaggerated, he did not invent. For the United States in the years after World War II—more than in most other eras in its history—did indeed come to see itself as a model for the world, as the organizer of the international system, as an embodiment of the ideals and institutions to which other nations should aspire. The "American Century" as Luce envisioned it may actually have lasted only a few decades, but for a time, at least, the United States considered itself the economic and moral guardian of the aspirations of the globe.

Part of what drove the sense of mission in postwar America was the perilous international climate—the dangerous rivalry between the United States and the Soviet Union. The Cold War began amid the acrimony and mutual incomprehension that accompanied the settlement of the war itself, and rapidly escalated to become the

Robert Rauschenberg. *Mark, postscript to "34 Drawings for Dante's Inferno."* Lithograph. [New York], 1964.
Rauschenberg was in the vanguard of 1960s artists who incorporated mass media imagery into traditional high art. In *Mark,* journalistic photographs and found objects are filtered through a maelstrom of dark, restless brushstrokes, resulting in a kind of reliquary for assorted twentieth-century gods—from sports, technology, politics, and the media themselves. The corner image of President Lyndon B. Johnson, caught midphrase on a glowing television screen, punctuates the lithograph's volley of associations for a society conditioned by broadcast media. Unmistakably embedded in Johnson's televised countenance was the Vietnam War, a nightly fixture in many American homes.

organizing principle of the international scene for the next forty years. The debate over who, or what, was responsible for the coming of the Cold War has raged for decades. But whether rightly or wrongly, both the United States and the Soviet Union became convinced within a few years of the end of World War II that each was a dangerous and irremediable threat to the other. "We have here a political force fanatically committed to the belief that with the United States there can be no permanent modus vivendi"— the diplomat George F. Kennan wrote of the Soviet Union to the State Department in 1946—"that it is desirable and necessary that the internal harmony of our society be disrupted, our traditional way of life be destroyed, the international authority of our state be broken, if Soviet power is to be secure." The purpose of American foreign policy, he helped persuade the nation's leaders, should therefore be to "contain" Soviet power in the hope that one day it might change its shape, or collapse altogether.

Of course, the Cold War did more than shape American foreign policy and commit the nation to an active international role; it also shaped American life at home. It created many fears: fear of Soviet intentions, fear of atomic warfare, fear for the future of capitalism and democracy in the face of competition from the socialist world. Gradually, the Cold War also produced a broad and corrosive fear of communist subversion at home. By the end of the 1940s, many Americans were convinced that their nation, and in particular its government, was infiltrated by communists and radicals; that the threat to the country's future came as much from within its borders as from without; and that the only sensible response to this danger was a concerted effort to root communists out of the major institutions of American life. The crusade against subversion reached its peak—and acquired its most celebrated and reviled champion—in the early 1950s, when a once-obscure senator from Wisconsin, Joseph McCarthy, seized on the issue and made it his own. For four years, McCarthy brawled his way through American politics, making extravagant claims (virtually never supported by serious evidence) and inspiring both passionate devotion—as much for his rough-and-tumble, anti-elitist style as for the substance of his argument—and deep revulsion, until he finally overreached himself and faded quickly from view. But McCarthy merely exploited an issue that others had created. And his highly publicized rampages were always peripheral to the real core of the effort by public and private institutions to expose, discredit, and expel radicals (both real and imagined). Governments, schools, universities, the press, labor unions, businesses, the entertainment industry, the military, the clergy: all joined in the hunt.

"The threat to civil liberties today is the most serious in the history of our country," the American Civil Liberties Union warned at the time. The historian Richard Hof-

John Chase. President Truman wearing General MacArthur's hat. Drawing, pen and ink. New Orleans, 1950.
Six months before President Harry Truman's dramatic recall of General Douglas MacArthur for insubordination during the Korean War, political cartoonist Chase denigrated the president's capacities as military leader with this caricature of the commander in chief dwarfed by his general's outsized hat.

Robert Osborn. *Silence dissenters!* Crayon drawing. New York, c. 1954.
This powerfully conceived and executed image by *The New Republic* cartoonist Osborn expresses a view held by many Americans during the early Cold War era: that their right to free speech was threatened by the national anticommunist campaign.

stadter spoke for many intellectuals and liberals when he expressed a "foreboding" that the Red Scare might "grow until it overwhelms our liberties altogether and plunges us into a totalitarian nightmare." The anticommunist crusade of the early Cold War never reached the dimensions Hofstadter feared. It began to fade (although it never entirely disappeared) only a few years after it began. And it did, in its brief life, reveal a number of cases of genuine subversion. But it also did great damage to many men and women whose only crime had been to embrace unpopular ideas; and it damaged as well the larger fabric of tolerance and respect that Americans liked to believe characterized their culture.

If the Cold War created anxiety and fear, it also produced energy and idealism. It strengthened the sense of mission that has always been a part of American life and helped reinforce both the pride many Americans took in their society and the determination of many others to improve it. There was hardly a social or economic issue that did not find some connection to the Cold War: education, because without good schools the next generation would be unable to compete with the communists; civil rights, because the denial of rights to minorities undermined the nation's ability to represent democratic principles to the world; the welfare state, because it proved that a democratic society could care for its citizens without resorting to socialism; even homeownership, since—as the famous developer of suburbs William Levitt once famously (and only half-facetiously) observed—"No man who owns his own house and lot can be a communist. He has too much to do." Perhaps most of all, the Cold War—and the enormous public investment it demanded in technology, weaponry, and infrastructure—was a powerful factor in sustaining postwar economic growth.

"The remarkable capacity of the United States economy represents the crossing of a great divide in the history of humanity," one economist wrote in the early 1960s, looking back on the extraordinary prosperity of the years since World War II. Nothing in American history—not the industrial expansion of the late nineteenth century, not the boom of the 1920s, not even the explosive growth of the war years themselves—could match the economic surge of the postwar era. Between 1940 and 1965, the Gross National Product (which had held relatively steady in the previous decade) multiplied nearly sevenfold. Average family incomes tripled. Poverty declined by nearly two thirds. "The jobless, distracted and bewildered men of 1933," Hofstadter observed, "have in the course of the years found substantial places in society for themselves, have become homeowners, suburbanites, and solid citizens." Abundance—both the reality of it or the expectation of it—came to define the lives of most, although never all,

Americans and to shape the nation's culture. The doubts about capitalism that had been a staple of social thought in the 1930s now largely disappeared. Fears of a new depression faded in the face of the expanding bounty—and of the promise by Keynesian economists and their followers that new tools of public policy were capable of keeping the economy healthy and growing indefinitely. If the Cold War created an anxiety that fueled many social and political movements, abundance created the confidence and optimism that made new goals seem achievable.

A central assumption of the postwar era, visible throughout much of society, was that America was a middle-class nation and that virtually everyone was now a part of or becoming a part of the middle class. That assumption turned out to be false. But a striking uniformity of images in popular culture—and the growing pervasiveness of that culture—made it possible for many Americans to believe it nonetheless. Television, the most powerful communications vehicle ever invented, not only reached into almost every American home but, for much of the first two decades after its introduction in the late 1940s, conveyed tame, unthreatening messages that reinforced, rather than challenged, the illusion of middle-class homogeneity. Suburbanization, one of the greatest population movements in American history, relocated much of the middle class into self-contained communities physically separated from the diversity and abrasiveness of the city. A voracious appetite for consumer goods among men and women now able to afford them—for everything from processed foods in large, gleaming supermarkets to vacations in the resorts springing up all across the country (among them the family-friendly, corporate theme park of the Walt Disney empire, which opened in Anaheim in 1954)—both drove the economy forward and encouraged more and more people to pursue the material dreams of middle-class life. Greater numbers of men (and significant numbers of women as well) were going to work in large corporate organizations where they were under pressure to embrace conformity and respect hierarchy. That phenomenon was, in fact, one of the most visible targets of social criticism in the 1950s; these organizations produced a social ethic, the sociologist William Whyte once wrote, "which makes morally legitimate the pressures of society against the individual." The middle class was enlarging, to be sure, but it was also becoming both spatially and culturally isolated, its image reverberating upon itself.

America in the 1950s—for all the real material benefits its abundance brought to most people, for all the genuine satisfactions so many men and women took from the improvements in their lives—was not in fact the placid, consensual society that its mass culture implied and that its popular and genial president, the war hero Dwight D.

Eisenhower, attempted to preserve. It was, as it had always been, a nation of extraor-
dinary diversity, of great economic inequality, and of powerful, if at times repressed,
desires. As the nation moved confidently into the 1960s, exhorted by a new, young
president, John F. Kennedy, to help "get the country moving again," forces were al-
ready gathering that would make that decade one of the most eventful and turbulent
in the nation's modern history.

<div align="center">*</div>

"The Sixties": Few terms in recent American history raise such powerful and con-
trasting images. Liberation and libertinism. Reform and revolution. Pacifism and war.
Innovation and desecration. Even thirty years later, the meaning of the 1960s remains
a highly contested issue; yet whatever the disagreements about the meaning of those
years, virtually no one denies their importance.

The 1960s ended in conflict and transformation, but they began with an effort to keep
alive the spirit of stable, moderate progress that the previous decade had established. In
the White House, President Kennedy—elected by one of the slimmest margins in Amer-
ican history—moved cautiously to win support for a relatively modest agenda, which in-
cluded as one of its most important elements a tax cut to stimulate economic growth. On
college campuses, students wore coats and ties or skirts and sweaters, lived in gender-
segregated dormitories, and worried about their grades and their social lives. In the
South, Martin Luther King Jr. and a growing flock of committed African-American ac-
tivists began to confront the regime of segregation and white supremacy with peaceful,
nonviolent protests—protests that, although they evoked violence and brutality from
some southern whites, seemed to most Americans outside the South a reasonable, even
morally unassailable, challenge to blatant injustice. In Vietnam, a small, inconspicuous
group of American advisers was helping the noncommunists in the South to resist a
spreading guerrilla war of which few people in the United States were even aware. The
most jarring features of popular culture were occasional films exploring teenage alien-
ation and sexuality, and the enormous popularity of rock and roll—most vividly symbol-
ized by the Beatles' tumultuous arrival in America for the first time in 1964, four
clean-cut kids with blazers and pageboy haircuts singing simple love songs to screaming
teenagers.

But the apparently containable conflicts of the early 1960s soon broke through their
comfortable boundaries, beginning with the gunshots fired in Dealey Plaza in Dallas on
November 22, 1963, that ended John Kennedy's life and that for many Americans dashed
the golden hopes of the postwar era. In the five years between President Kennedy's death

and the assassinations of his brother Robert and of Martin Luther King Jr. in 1968, the nation experienced a cascade of great public events and profound cultural changes.

The civil rights movement—which reached its interracial peak in August 1963 with a great march on Washington (embraced, and some charged co-opted, by the Kennedy administration)—began within a year to unravel. Distressed by the implacable violence they encountered in the South, many younger civil rights workers rejected nonviolent moderation and called increasingly for a militant (and racially separatist) approach. African Americans in the urban North began to chafe at their own bonds—bonds not so much of legal segregation and disenfranchisement, as in the South, but of social and economic exclusion. Their frustrations produced urban disorders in Harlem, Watts, Detroit, Newark, and elsewhere, and produced as well a new breed of urban black leaders, militant and unbending—one of whom, Malcolm X of the Nation of Islam, ultimately rivaled King himself in the esteem of African-American communities nationwide. By the end of 1965, the civil rights movement had simultaneously triumphed and disintegrated. Congress had passed two epochal civil rights acts: one (in 1964) banning segregation in public accommodations and discrimination in employment; the other (in 1965) guaranteeing blacks the right to vote. But the fissures that had appeared as early as 1963, dividing moderates from militants and white liberals from black activists, had become canyons. A crusade for racial justice initially characterized by confidence, optimism, and broad support now appeared to have turned into a racial crisis. Some Americans believed that the violence and division called for much greater efforts toward equality: affirmative action, the expanding social programs of Lyndon Johnson's Great Society, what a presidential commission called "a commitment to national action—compassionate, massive and sustained, backed by the resources of the most powerful and the richest nation on this earth." Many others believed that the violence and division delegitimized the movement and required a restoration of "law and order."

In Vietnam, what had been a small police action on a remote frontier of the Cold War gradually evolved into a full-scale American military commitment. That commitment lasted for more than seven years, making it the longest war in American history. At its peak, the war engaged the efforts of more than 500,000 American soldiers. It produced unprecedented levels of bombing (more bombs, in fact, than were employed by all sides in all theaters of World War II). It inspired unprecedented feats of modern military technology. And still, there was no end. To the United States government, the war was an effort to preserve a noncommunist "democracy," to defend South Vietnam

Danny Lyon. Atlanta, Georgia. Gelatin silver print, 1963–64.
In 1963 and 1964, Lyon served as staff photographer for the Student Nonviolent Coordinating Committee (SNCC), which was formed in 1960 after the first sit-in by four African-American college students at a North Carolina lunch counter. Such demonstrations spread throughout the South, forcing many merchants to integrate their facilities. Lyon's photo of Taylor Washington—a militant seventeen-year-old high school student active in the Atlanta civil rights movement—yelling out here as he is arrested at Lebs Delicatessen for the eighth time, appeared on the cover of *The Movement,* a picture book produced by SNCC. The photo was then appropriated by the Soviet newspaper *Pravda,* where it was published under the caption "Police Brutality USA."

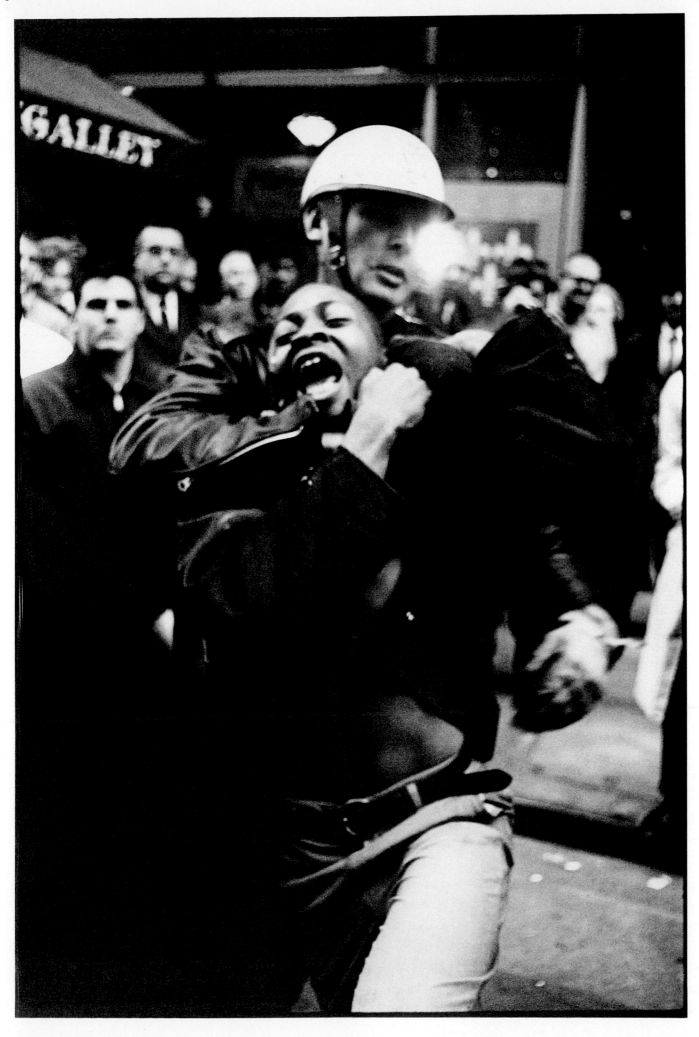

against aggression from the communist North, and to protect America's international reputation as a reliable ally (although to most of the American people it was an unwelcome conflict based on abstract geopolitical principles, one they grudgingly supported for a time but in which they never wholly believed). To the North Vietnamese, and to the many southerners who supported them, it was a war to unite a country that had been artificially divided by the West, a struggle for national destiny and honor. Ho Chi Minh, the revered leader of North Vietnam and the father of postwar Vietnamese nationalism, said early in the war that the Americans thought they could outlast the Vietnamese, wear them down, force them to give in; but that, in fact, it would be the other way around. We have waited over a century, he said, and we can wait some more—five years, ten years, fifty years. "You can kill ten of my men for every one I kill of yours. But even at those odds, you will lose and I will win." It took billions of dollars, years of social and political turmoil in both Indochina and the United States, hundreds of thousands of Vietnamese, and more than 54,000 American lives before the United States learned that Ho Chi Minh was right.

In 1973 the United States and North Vietnam signed a peace treaty that in the end ensured little more than an orderly withdrawal of American forces and a return of prisoners of war. Two years later, brushing aside the demoralized South Vietnamese army, communist forces from the North marched into Saigon, renamed the southern capital Ho Chi Minh City, and—in reuniting their nation under a communist regime—inflicted a substantial and disillusioning defeat on the United States. George Kennan, the reluctant architect of the containment policy in whose name America fought in Vietnam, once called the war "the most disastrous of all America's undertakings over the whole two hundred years of its history." It is, at least, a defensible argument.

<p style="text-align:center">*</p>

The unraveling of the civil rights movement and the collapsing consensus around the Vietnam War intersected with, and reinforced, a series of broad cultural changes in the late 1960s and early 1970s. Those changes grew, to a large degree, out of the attitudes and behavior of the young—the postwar "baby boom" generation coming of age in affluence and optimism, brimming with expectations of personal fulfillment and social progress, disenchanted by the injustices they still saw around them, and frustrated by the impediments they found in the way of their dreams. Some young men and women gravitated to the political left, and gave it for a short time a strength and influence perhaps unprecedented in American history. But the left they created in the 1960s was different from the left of the 1930s and before. It was dominated by students. It was,

Wes Wilson. *The Grateful Dead.* Offset lithograph. Poster. San Francisco, 1967.
Psychedelic rock-music posters were produced in San Francisco from 1966 to 1971 mainly for two concert organizers there, The Family Dog at the Avalon Ballroom and Bill Graham at the Fillmore Auditorium. For his third concert, Graham invited a group he knew as The Warlocks; by performance time their name had been changed to The Grateful Dead. Wilson was one of the first and the greatest of the psychedelic typographers.

on the whole, less concerned with the problems of capitalism than with the problems of culture. Its principal targets were the universities and the restrictions academia continued to place on a generation that had become impatient with any externally imposed limitations. Campus uprisings protested infringements on free speech (at Berkeley in 1964), encroachments on the neighboring community (Columbia in 1968), and at times a set of free-floating grievances that defied any conventional description, as at Harvard in 1969, where striking students—after having been brutally dislodged by police from a university building they had occupied—laid out their eclectic agenda in a widely distributed poster:

strike because you hate cops/strike because your roommate was clubbed/strike to stop expansion/strike to seize control of your life/strike to become more human . . . /strike because there's no poetry in your lectures/strike because classes are a bore/strike for power/strike to smash the corporation/strike to make yourself free/strike to abolish ROTC/strike because they are trying to squeeze the life out of you.

The New Left, as it called itself, was of course deeply involved in the antiwar movement. It was as much involved in the civil rights movement as its mostly white members could be in the face of the increasing separatism of black leaders. But very near its heart, always, was a vision less of a new politics than of a new culture—a culture of personal freedom and individual empowerment. And in that respect, the left was locked in a close embrace with the other great youth movement of the era: the counterculture.

To its many critics, both at the time and since, the counterculture of the 1960s and 1970s was notable chiefly for the outrageous and self-indulgent behavior of many young men and women: for their abandonment of inhibitions about sex and drug use, for their infatuation with rock music, for their long hair and flamboyant clothes, for their apparent lack of conventional ambition, for their deliberate flouting of the values by which their mostly middle-class parents had lived. But the counterculture was also, at least in part, a serious intellectual movement, which rested on a radically new conception of human desire. Those who articulated a rationale for the movement (among them Norman O. Brown, Charles Reich, and Theodore Roszak) called into question the rational, disciplined life of the Enlightenment tradition, a life they believed was hampered by individualism and repression. In its place, they proposed an affirmation of instinctual freedom, physical pleasure, and the full expression of emotion and desire. The younger generation, Roszak argued, was making a noble effort to recapture the meaning of their lives by creating a simpler, more human world—by rejecting the "technocracy" and instead devoting themselves to the unleashing of personal impulses:

The primary project of our counter culture is to proclaim a new heaven and a new earth so vast, so marvelous that the inordinate claims of technical expertise must of necessity withdraw to a subordinate and marginal status in the lives of men.

Not many young Americans were fully committed to either the New Left or the counterculture. But few could escape their influence entirely. And the most important legacy of the late 1960s, therefore, was the gradual reshaping of popular culture in response to some of the radical challenges to it. Television, film, music, art, theater, lit-

erature, poetry: all began to explore new issues, new forms, and new values, sometimes jarringly and subversively, more often in ways that proved reassuring and ultimately co-opting. Equally important, the culture of liberation—a culture inspired by the civil rights movement, but borrowing as well from the impulses and values of the counter-culture—catalyzed powerful new struggles for freedom on the part of many groups who identified their own plights with those of the protesting African Americans and students. Native Americans, Latinos, and Asian Americans all mobilized in various ways for new rights and freedoms. Gay men and lesbians began demanding an end to the discrimination and opprobrium that mainstream society imposed on them.

Most significant of all, perhaps, American women rallied behind a newly powerful feminism inspired in large part by the civil rights movement. "During twelve years of working for a living," the feminist writer Gloria Steinem said in 1970,

> I have experienced much of the legal and social discrimination reserved for women in this country. I have been refused service in public restaurants, ordered out of public gathering places, and turned away from apartment rentals; all for the clearly-stated, sole reason that I am a woman. And all without the legal remedies available to blacks and other minorities.

But feminism drew from many other sources as well: from its own long history stretching back to the early nineteenth century; from the experiences of women in the New Left and the antiwar movement; from the sexual revolution (driven in part by the easy availability of contraceptives); and perhaps above all—as Steinem suggested—from the exposure to discrimination in the workplace and women's sense of thwarted opportunities for personal fulfillment. Some radical feminists sought to create a distinctive and increasingly separate female culture, with its own values and institutions. But most feminists wanted something less radical, if only slightly less jarring to traditional sensibilities: the chance to have careers that were as important, lucrative, and rewarding as those of men; the chance to define themselves not simply as wives, mothers, and helpmates, but as individuals and accomplished professionals. Of all the liberation movements of the 1960s and 1970s, feminism came the closest to achieving its goals—despite bitter opposition—and had perhaps the most far-reaching effect on the patterns of American life.

*

But the bold and often idealistic efforts of mostly younger men and women to redraw the boundaries of conventional politics and conventional values did not go unchallenged. Many, perhaps most, Americans balked at the challenges, resented the taunts

Robert Pryor. Nixon caught in a tape web. Drawing, pen and ink. New York, 1974. President Richard Nixon's resignation on August 9, 1974, in the face of impeachment charges brought by the House Judiciary Committee was hastened by his release of audiotapes that confirmed his complicity in the coverup of a burglary perpetrated by employees of his reelection campaign at Democratic Party headquarters in the Watergate building. Cartoonist and illustrator Pryor has been published in *Time, Harper's, The New York Times,* and other widely read periodicals.

and the flamboyance and the unfamiliarity of the new culture, and chose to defend both the politics and the values they knew. For a moment, in the midst of the turbulence of the late 1960s, something like a real revolution briefly seemed possible to those who hoped for one. But the more important legacy of those years may, in fact, have been not the impact of the left and the counterculture and the drive for liberation—real and lasting as that impact was—but the growth of a powerful and enduring conservative reaction. It was visible first in the presidential campaign of 1968—in which the snarling, right-wing populist George Wallace won a large popular following, thanks to his long record of opposing integration and also to his harsh attacks on "elites" and radicals and what he considered the unholy alliance between them; and in which the more genteel, but in many ways no less conservative, message of Richard Nixon, promising "law and order" and an honorable end to the Vietnam War, ultimately prevailed.

All through the 1970s, as the American economy underwent an escalating series of crises, as the Vietnam War ended in humiliation, as America's standing in the world seemed to erode, and as scandal and failure diminished popular faith in the political system and its leaders, growing numbers of Americans searched for ways to rebuild the tranquil, prosperous, stable society they thought they remembered from the 1950s. Movements emerged to combat feminism, to limit or end affirmative action, to prevent abortions, and to restore "traditional values" to school curricula and popular culture.

A great evangelical revival swept through the American middle class, attracting hundreds of thousands of converts seeking personal salvation and ethical stability. Powerful moneyed interests organized against the expensive welfare state and intrusive state and federal regulation. Intellectuals decried the flagging national will in the struggle against communism and the declining respect for authority. In 1980, finally, these diverse conservative forces coalesced—together with other groups in the electorate unhappy with the anemic record of President Jimmy Carter—to make Ronald Reagan, the former movie actor and California governor, the most conservative president in more than half a century. Reagan promised to restore American greatness by rolling back government, cutting taxes, strengthening the military, and unleashing what he claimed were the artificially suppressed entrepreneurial talents of the people. And while his accomplishments fell far short of his rhetoric, his extraordinary popularity was one of the most striking features of the culture of the 1980s, and helped entrench a series of conservative political and fiscal assumptions that would dominate American public life long after he departed.

<p style="text-align:center">*</p>

As the twentieth century drew to its close, the United States continued to wrestle with the profound changes that had overtaken it in the decades since the heyday of American power and prosperity after World War II. The Cold War, which had done so much to shape the geopolitical order and domestic politics and culture, staggered to a close beginning in 1989 and culminating two years later in the collapse of the Soviet Union. A "new world order," with no discernible shape, began fitfully and uncertainly to emerge.

The American economy, which had bestowed on the postwar generation unprecedented growth and abundance, entered the 1990s on the heels of two decades of erratic growth, rising inequality, and increasing competition from abroad. The United States still had the largest and most productive economy in the world—an economy that greatly rewarded educated men and women capable of excelling in an age of new technologies and highly sophisticated exchanges of information; but an economy that generated fewer jobs and less growth in incomes for ordinary people than it once had; and an economy that inspired much less confidence than it had done in the 1950s and 1960s.

The nation's physical and social landscape was beset by troubles as well: its cities struggling with fiscal stringency; its public schools failing miserably in many communities to provide even minimal educational opportunities for students; its poorest neighborhoods becoming increasingly isolated from the mainstream of American life,

Roger Mertin. Wilson Commons, east facade, University of Rochester. Dye-coupler projection print. Rochester, N.Y., April 30, 1991. Operation Desert Shield became Desert Storm in the winter of 1990, when Congress authorized U.S. participation in the U.N. mission. Many Americans hoped to foreclose a totalitarian regime in the Middle East and erase the "shame" of defeat in Vietnam, but Mertin shows another side of public sentiment. His photograph magnifies a detail from "The Wall" created at Rochester where he teaches photography. It was inspired by the Vietnam Memorial in Washington, D.C., and its hatchmarks represent the Iraqi lives known to have been lost—soldiers and civilians, men, women, and children. The counting stopped at 45,164. The note in the center, dated April 27, 1991, is titled "100,000 and counting" and the students explain: "The numbers of dead and dying are too large and too frightening for any of us to truly comprehend. . . . These deaths are the true nature of war. . . . [These marks] symbolize the human lives we have ended and the humanity we have lost."

dominated by drugs, crime, violence, and profound alienation. The natural landscape of the United States (and of much of the world) was, as a powerful environmental movement made clear, in danger of catastrophic degradation after the rapid and often heedless growth of the industrial era; and a complex (and costly) new web of laws and regulations emerged to try to protect it. The nation's health care system, burdened by its own success in developing expensive new technologies for treating once-incurable diseases, was reeling under towering costs—and under the new scourge of AIDS, the deadly, contagious virus first identified in the early 1980s.

American society—the most diverse amalgam of racial, ethnic, and national groups of any society in history—was straining, as it had done throughout its history, to come to terms with that diversity. A new wave of immigration, the largest in American history, was bringing hundreds of thousands of people to the United States, and along with them the values and customs of hundreds of cultures. Especially prominent were the Latino and Asian populations, enlarging more rapidly than any other. And this new immigration, unlike earlier waves, came at a time of unprecedented assertiveness among ethnic and racial minorities. One result was the rise of the idea of "multiculturalism," the belief that the United States was not a single culture, but many; that it did not derive primarily from western European traditions, but was the product of the mingling of many different sets of values and customs.

Having entered the postwar era suffused with exuberance and innovation and faith in the promise of the future, America approached the century's end as fractured along social, racial, ethnic, economic, gender, and regional lines as it had been in all but a few moments in its history; with a culture so diverse and so contentious that it seemed to lack any coherence or shape; with declining faith in its government, its leaders, and its principal institutions; and with many different visions of the future, which served as sources of both promise and anguish to the various groups who were trying to redefine it to fit their own needs and desires. And yet the United States also remained the wealthiest and most powerful nation in the world; a society with a long history of survival and renewal in the face of conflict, division, and disappointment; a country moving tentatively but rapidly into its uncertain future—searching, as it had since its beginnings, to fulfill its promise as a great democratic experiment in both diversity and union.

* * *

Charles Wilbert White. Return of the soldier.
Drawing, pen and ink. New York, 1946.
Black soldiers returning from World War II
found that their sacrifice and service to the
nation did not guarantee them equal access
to education, jobs, or justice. Even their
physical safety was not assured, as some
survived the war only to be beaten or lynched
for the simple act of wearing their uniform in
public. Reports of such incidents, and his own
commitment to social reform, inspired this
drawing by African-American artist White
who, as a young man, had expressed his desire
to use art as a weapon to "say what I have to
say" and "fight what I resent." President
Truman tried to make lynching a federal
crime, and proposed the first civil rights bill of
the century, but Congress ignored or defeated
his efforts.

Richard Edes Harrison. Illustration for "USSR's
First Atomic Bomb," *Life*, New York, October
1949. Drawing, pen and ink with white and
black paint. Manuscript map.
In 1949, the USSR detonated its first atomic
bomb, heightening tension with the United
States in what became known as the Cold
War. Harrison, one of the foremost journalist-
cartographers of the mid–twentieth century,
worked extensively for *Time, Life,* and *Fortune*
magazines on a freelance basis. His distinctive
style incorporated global perspectives, shaded
relief to represent topography, and unconven-
tional manipulation of projections and
orientations. This typical example captures the
stark reality of the event with basic black and
white tones, and the global perspective
centers on a single cloud of smoke in central
Asia, showing how much of the world can be
affected by the radiation from one isolated
bomb explosion.

"Them!" Offset lithograph. Poster. Warner Bros., Burbank, California, 1954.

This science fiction thriller was directed by Gordon Douglas, with a screenplay by Ted Sherdeman. The title role is played by mutant ants enlarged to house size by lingering radiation from the 1945 test detonation of an atomic bomb in New Mexico's desert. After much mayhem, one of the queen ants makes her home in the sewers of Los Angeles and is challenged by the hero, played by James Whitmore. The film makes clear that the world in the atomic age has opened itself to the unknown. *Them* was the largest-grossing film for Warner Bros. in 1954, and it spawned a host of similar creature features.

Catholic Library Service. *How Communism Works.* Pamphlet. St. Paul, Minnesota, October 1938.

The Truman Doctrine accepted that communism was innately expansionist and had to be contained within the borders Stalin had established in Russia and Eastern Europe. Membership had peaked in the American Communist Party in the mid-1930s, after the United States opened diplomatic relations with the Soviet Union, but the Stalin-Hitler pact of 1939 disillusioned thousands of members. Throughout the 1930s, the Catholic Church was the most active anticommunist force in America. Only its minority status, the long First Amendment tradition, and the separation of church and state weakened its influence. In the late 1940s, during the Cold War, communism became a national obsession.

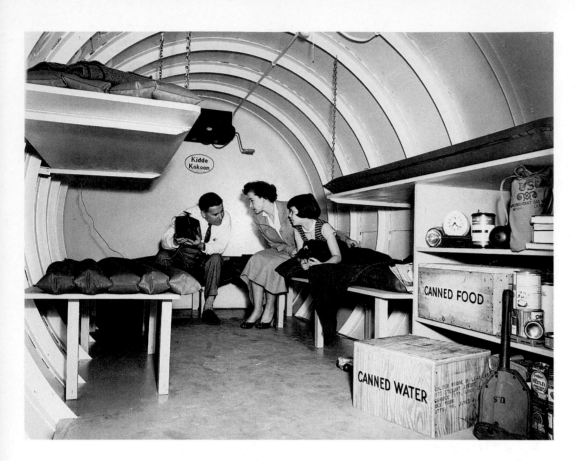

H-Bomb hideaway. Gelatin silver print. Garden City, New York, 1955. United Press International.

In 1950 Einstein wrote that "Radioactive poisoning of the atmosphere and hence annihilation of any life on earth has been brought within the range of technical possibilities. . . . In the end, there beckons more and more clearly general annihilation." The government, however, fostered belief in manageable atomic warfare in spite of the evidence in Japan, and backyard bomb shelters were a 1950s fad. This one could house a small family for up to five days. Standard features included canned food and water, sterno stove, battery-powered radio, chemical toilet, flashlight, blankets, and first-aid kit. During peacetime, the shelter could be used as a spare bedroom, for storage space, or even to cultivate mushrooms.

G. Braunsdorf. Illustration for Associated Press Newsfeature, "Korea—The War That Could Have Set Off World War III." Map. New York, April 9, 1953.

Issued near the end of the Korean War (June 1950–July 1953), this map exemplifies the high degree of generalization and simplification that characterized mid-twentieth-century journalistic cartography. It was distributed along with an accompanying news article in anticipation of imminent peace in Korea, and delineates the major advances and retreats of the North Korean and Chinese forces as well as the United Nations' counterforces. A line along the 38th parallel shows where the opposing armies were deadlocked after truce talks began in July 1951. Warren Bennett, the article's author, wrote: "A bitter, bloody localized conflict, the Korean War has been for almost three years a smoldering spark for World War III, a spark that never burst into flame."

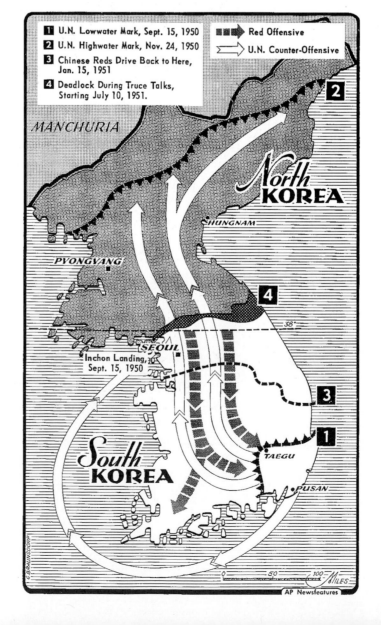

Walt Kelly. Page layout for *The Pogo Stepmother Goose.* Drawing, ink over blue pencil. New York, 1954. In February 1950 Joseph McCarthy, a young Republican senator from Wisconsin seeking political gain for himself and his party, announced that he had a list of known communists in the State Department and caused a national sensation. A Senate investigation did not substantiate his charges, yet his political influence continued to grow. During congressional hearings over the next four years, he spearheaded a movement to "uncover" communists throughout government, destroying many people's careers. In 1954 televised investigations of McCarthy's accusations against the Army exposed 20 million viewers to his intimidating techniques, and badly damaged his public image. Several months later, the Senate censured him. His political demise was as sudden as his rise.

Kelly was the first nationally syndicated comic strip artist to engage in explicit political caricature and commentary, and one of the few to attack McCarthy openly. In May 1953 *Pogo* readers met Simple J. Malarkey, an evil-minded wildcat whose dark, menacing eyebrows and heavy five-o'clock shadow mirrored the features of the junior senator from Wisconsin. In 1954 Malarkey appeared again in *The Pogo Stepmother Goose,* a Kelly parody of the Army-McCarthy hearings based on Lewis Carroll's *Alice's Adventures in Wonderland.*

"After that," continued the Hatter, *"I cut some more bread-and-butter—"*

"But what did the Dormouse say?" one of the jury asked. *"That I can't remember,"* said the Hatter.

"You must remember," remarked the King, *"or I'll have you executed."* The miserable Hatter dropped his teacup and bread-and-butter, and

went down on one knee. *"I'm a poor man, your majesty,"* he began. *"You're a very poor speaker,"* said the King.

Here one of the guinea pigs cheered, and was immediately suppressed by the officers of the court.

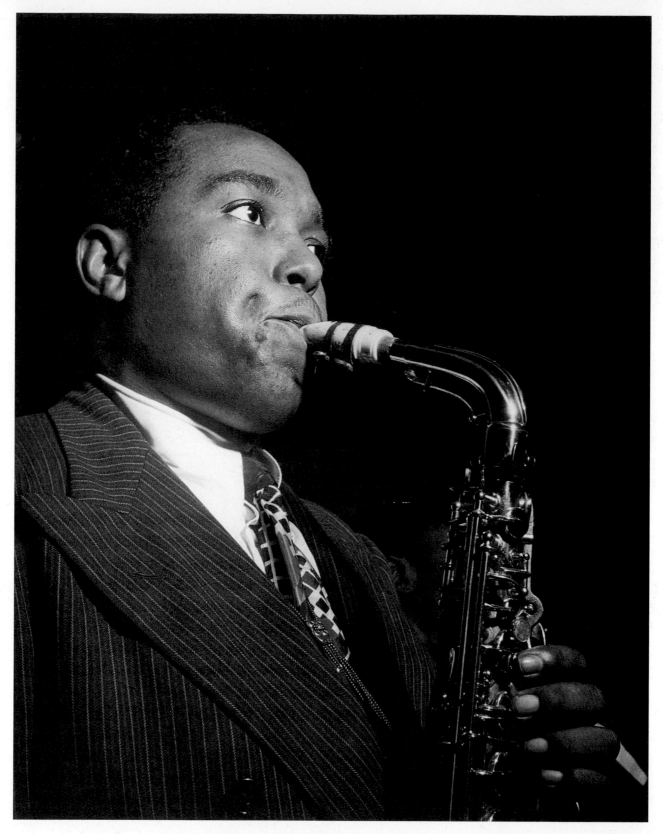

William P. Gottlieb. *Charlie Parker.* Gelatin silver print. Harlem, New York, c. 1947. Alto saxophonist Parker—known as Yardbird, or "Bird" for short—was born and raised in Kansas City, a jazz mecca for a decade from the mid-1920s. In the late 1930s he made his way to New York, where he jammed informally with Dizzy Gillespie and Thelonious Monk at Minton's Play House in Harlem; by the 1940s they had created bebop. Growing out of swing music but much more complex, bebop coined a new musical vocabulary with its chromatic and dissonant harmonies, complex rhythms, and obscured melodies. Its strident, alternative tone—along with the softer, subtler "cool jazz" that followed— spoke to the post–World War II Beat generation. Also a jazz columnist, Gottlieb took photographs for the *Washington Post* and *Down Beat* magazine from the late 1930s to the mid-1950s.

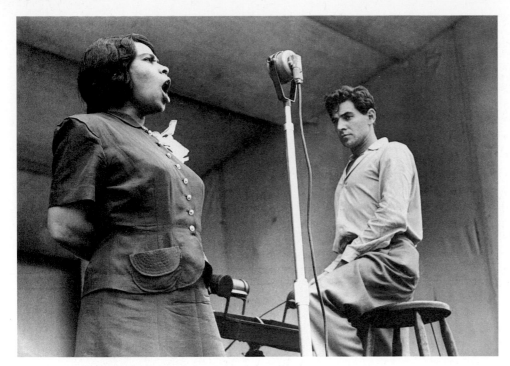

Ruth Orkin. Marian Anderson and Leonard
Bernstein at Lewisohn Stadium. Gelatin silver
print. *New York, June 1947.*
Anderson first appeared with the New York
Philharmonic at the stadium in the summer of
1925 as winner of a contest. By the 1940s the
contralto had an international reputation,
and in 1955 she became the first African
American to sing at the Metropolitan Opera.
Bernstein was named assistant conductor of
the New York Philharmonic in 1943, and in
1958 was appointed its music director, the first
American to hold that position. Besides
working in the classical mode, he composed
some of the finest specimens of popular
musical theater during its golden age, includ-
ing *West Side Story.*

Earl Theisen. Marilyn Monroe. Contemporary
gelatin silver print (from original negative) for
Look magazine. *Hollywood, 1951.*
Monroe is probably remembered as much for
her off-screen life as for her on-screen acting
career. She is the paragon of American female
beauty as codified by the entertainment
industry during the last half of the twentieth
century. Unlike Jean Harlow, who was equal
to men in the 1930s, or Mae West, who was
wittily superior for many decades in a row,
Monroe emerged as a pure sexual object in
the button-down 1950s when popular culture
discouraged women from entering the
professions or holding any paid job at all: a
woman's place was in the perfect home of a
television sitcom. Theisen was *Look's* West
Coast celebrity photographer. His photo was
heavily cropped by the magazine to focus on
Monroe with a gaggle of males in the bushes
eager to "capture" her. Her artistic aspirations
may have been ridiculed by studio chiefs, but
her best work is some of the finest American
screen acting.

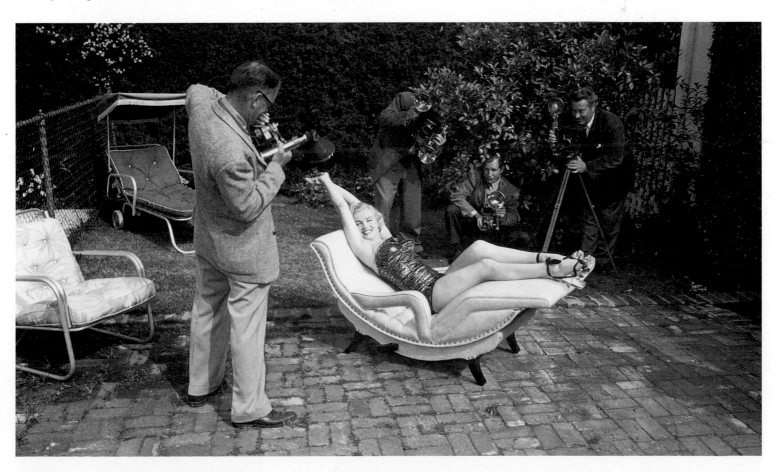

Jennifer Bartlett. *Graceland Mansions.* Pentaptych after Bartlett's five-paneled painting in drypoint, aquatint, screenprint, woodcut, and lithograph. New York, 1978–79.

This work and the painting on which it is based are named after the famous home of rock-and-roll icon Elvis Presley, who died before Bartlett completed the painting. Rather than faithfully portraying the Memphis mansion, Bartlett conceived a series of variations on a rudimentary house form—very like the units of the Levittowns that flourished after World War II. Here she explores the interplay between originality and the generic, order and disorder, literal and figurative language. At the core of the work is the number five: five colors, five media, five times of day, and five approaches to the house.

Elvis Presley. RCA Victor record jacket, 1956. Singer, guitarist, and actor in more than thirty films, Presley leavened his roots in country music with African-American blues, rhythm-and-blues, and gospel music to produce an eclectic and unique sound. "The King" achieved unparalleled success as a recording artist and became a pivotal figure in the history of rock and roll, almost single-handedly defining it as a musical style. Rock's driving rhythms would perfectly express the themes of social and political unrest in the 1960s. This is Elvis's first LP, one of nearly 3 million items in the Library's Recorded Sound archive that contains everything from the first cylinders through radio transcriptions of Army broadcasts to today's compact discs.

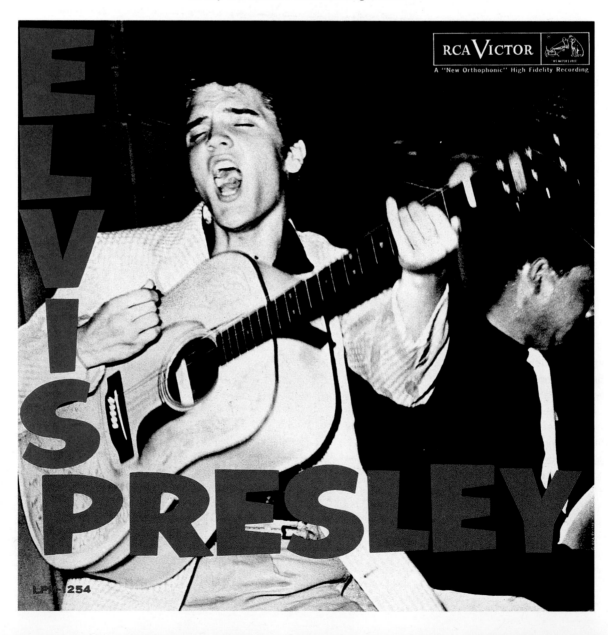

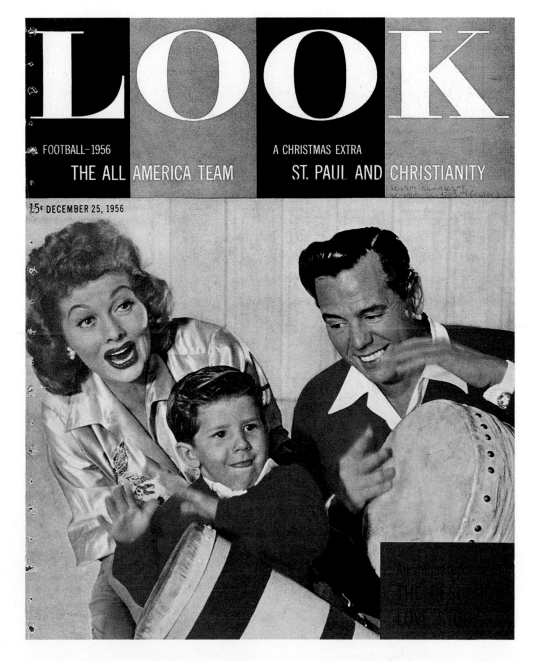

Robert Vose. Front cover illustration for "The Desi-Lucy Love Story." *Look*. New York, December 25, 1956.

Like many other postwar television performers, Lucille Ball successfully drew on the performing arts traditions of vaudeville and burlesque. She and her husband, Desi Arnaz, transformed the way the medium operated by forming their own production company, Desilu, and filming their show (rather than broadcasting live on the East Coast with taped replays the next day on the West Coast). Convinced there would one day be a market for "reruns," these entrepreneurs, not the network, owned their shows. In 1953 their sitcom *I Love Lucy* was the most popular program on television, and its star was required to defend herself before the House Committee on Un-American Activities against charges of Communist party affiliation. Unlike the careers of hundreds of others, hers was not harmed by the allegations.

Gordon Parks. Kenneth Clark testing children's choices of dolls. Gelatin silver print. Harlem, New York, 1947.

Beginning in the late 1930s, sociologists Kenneth and Mamie Clark conducted a series of tests in Washington, D.C., and New York City to determine the effect of racism upon the self-esteem of African-American children. Among other things, children were asked to choose between a white and a brown doll, identical but for skin color; black children who lived or attended schools in segregated settings preferred the white doll, and these findings were duplicated in similar tests conducted by the NAACP in South Carolina and Virginia. Kenneth Clark was primary author of the social science brief that became the basis for the 1954 Supreme Court desegregation decision, *Brown* v. *Board of Education;* it was the first time sociological evidence had influenced a decision of such magnitude. Parks photographed the test situation for a July 1947 *Ebony* magazine article on the opening of the Clarks' Harlem Northside Center for Child Development.

Herbert Matter. *One of Them Had Polio.* Offset lithograph. Poster. New York, 1950.

The polio (poliomyelitis) virus used to strike thousands of children and adults every year, especially during the summer months. In 1937 President Franklin Roosevelt, who had contracted the disease in 1921, established the National Foundation for Infantile Paralysis; its annual March of Dimes campaign supported Jonas Salk's research in the late 1940s. In 1955 Salk developed the vaccine that won him international recognition. The Swiss-born Matter was one of the first to incorporate photography into American advertising. Sponsored by the National Foundation to increase public awareness, this poster suggests that modern science could control the disease (which it did), and that those afflicted could lead normal lives (which they did).

Property of National Screen Service Corp. Licensed for display only in connection with the exhibition of this picture at your theatre. Must be returned immediately thereafter.

Nicholas Ray. *Rebel Without a Cause.* Cinematographer: Ernest Haller. Screenplay: Stewart Stern. Score: Leonard Rosenman. Cast: Natalie Wood, James Dean, Sal Mineo, Jim Backus. Film still matted as lobby card. Warner Bros., Burbank, California, 1955.
Nicholas Ray was in the vanguard of a new generation of directors whose careers began in the late 1940s and who used cinema to articulate the psychosocial problems of post–World War II America. When the first generation of studio heads retired in the

1950s, control was loosened over the mainstream genres of Hollywood melodrama, and Ray was able to make films that focused more on the emotional development of protagonists and less on their actions. His great good fortune in *Rebel* was to cast James Dean, an actor whose Method training, charismatic good looks, and mighty talent fitted him perfectly for the role of a youth in full rebellion against the looming, straitjacket constrictions of 1950s middle-class manhood.

Charles M. Schulz. *"Peanuts."* Drawing, pen and ink. Minneapolis-St. Paul, Minnesota, 1952.
In 1950 Schulz introduced American newspaper readers to the gentle, sheltered, postwar suburban world created, in part, by the highways. In what has become the most popular comic strip ever drawn, lovable loser

Charlie Brown and the unshakable Lucy Van Pelt romp at the helm of a community of kids in which parents, teachers, and other adult authority figures are virtually nonexistent. In *Peanuts,* children become philosophers, offering reflections on human nature with simplicity and wisdom.

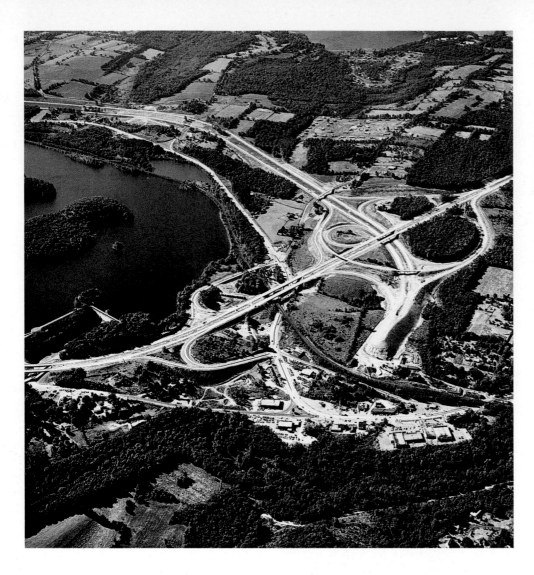

William Garnett. Aerial photograph of highway interchange. Gelatin silver print. California, c. 1968.

In his 1968 book *The American Aesthetic,* Nathaniel Owings wrote, "In the plazas, squares, boulevards and promenades, in the palaces and temples, is displayed the calligraphy of each people's culture, clearly spelling out what they most devoutly serve, sacred or profane." Since the turn of this century, the calligraphy of the continuous ribbons of pavement required by the automobile, so evident in this image, has transformed the surface of our planet. Graceful and now ubiquitous, the first cloverleaf interchange was built in Woodbridge, New Jersey, in 1928. The Federal Highway Act of 1956 financed the forty-one-thousand-mile Interstate and Defense Highways network, one of the greatest construction enterprises in the history of civilization. Owings was a founding partner of Skidmore, Owings & Merrill, the nation's largest, and arguably its most influential, architectural firm during the postwar period. At this time, Garnett developed a singular talent and artistry in aerial photography.

Samuel Gottscho. *Shopping Center.* Modern gelatin silver photoprint (from negative, December l, 1951). Great Neck, Long Island, New York.

Gottscho's documentation of an early and successful example of a new building form—the shopping center—captures much of the appeal that allowed it to eclipse traditional downtown retail centers. First was the ease of parking for an increasingly automobile-centered suburban population. Sheltered, illuminated walkways were welcoming, convenient, and secure. Major "anchor" stores—here Wanamaker's—were carefully placed among smaller retail establishments for a lively marketing mix and to summon the ideal of a clean, elegant, and modern commercial village. Architect Lathrop Douglass designed this and a number of other shopping centers, including in 1968 the huge and influential Tyson's Corner Center in the Virginia suburbs of Washington, D.C., where the protected walkways seen here had evolved into the fully enclosed shopping mall that now dominates retail architecture throughout the world.

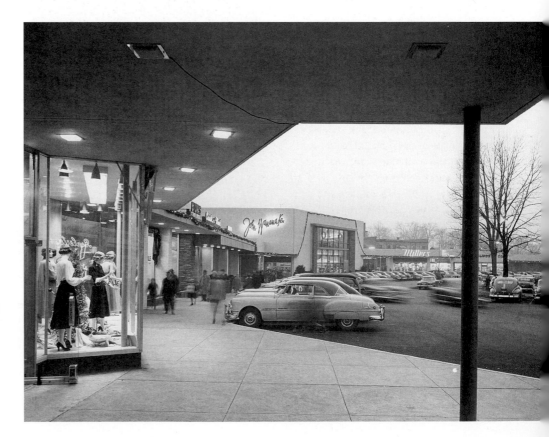

Richard Neutra and Thaddeus Longstreth. Project, Harry Seitchik House, near Philadelphia, Pennsylvania. Drawing, graphite and pastel. Los Angeles, September 1958.
Dissolving the traditional barriers between exterior and interior space and between man and nature was the task of such modern architects as Neutra, who, with his long-time collaborator Longstreth, conceived the house in this lush rendering as a subordinate element of the garden, thus reversing the typical hierarchy. European-trained, Neutra moved in 1925 to Los Angeles where he was influenced by both the climate and lifestyle of Southern California and became a key figure in American architecture. His houses of the 1930s, '40s, and '50s further developed Frank Lloyd Wright's concept of open planning, with strong horizontal wall planes and dramatic cantilevered roof overhangs thrusting into a landscape made ever more visible through floor-to-ceiling windows. This project transplanted the forms and sensibilities of his California modernism to the harsher climate of Pennsylvania.

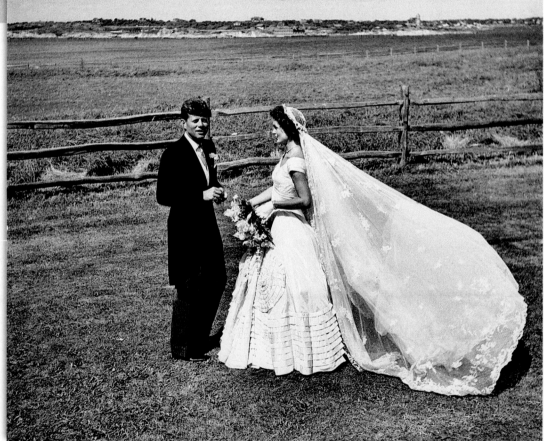

Toni Frissell. Bouvier-Kennedy wedding portrait. Gelatin silver print. Newport, Rhode Island, September 12, 1953.
Few in 1953 could have predicted the cardinal significance of the union of the young Massachusetts senator and Jacqueline Bouvier at the bride's family home at Hammersmith Farm, Newport, Rhode Island. Frissell was a close friend of the bride and her sister, Lee, and although working principally for *Vogue* at the time as a fashion photographer, covered the wedding at the request of *Harper's Bazaar* editor Carmel Snow. Frissell kept the negatives and, when President Kennedy was assassinated, provided most of the wedding pictures published in memorial articles, magazines, and books.

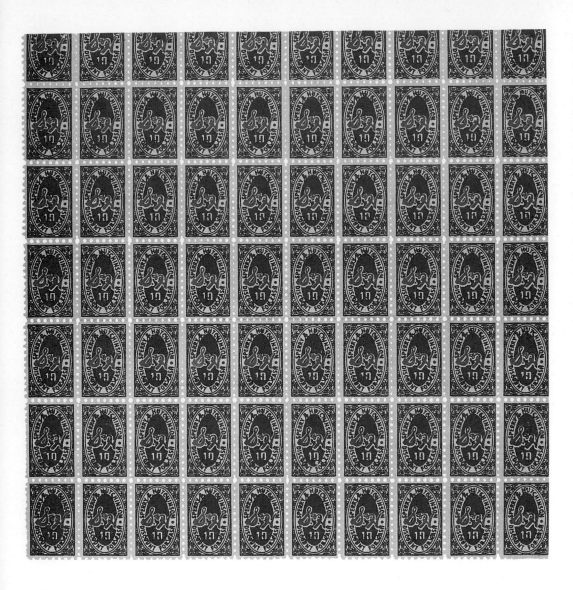

Andy Warhol. S&H Green Stamps. Offset lithograph. Poster. New York, 1965.
S&H Green Stamps were a premium offered by various retailers at the rate of one stamp per ten cents of purchase. Consumers would paste them into booklets, which were redeemable for merchandise from the Sperry and Hutchins catalog. In this poster, the quintessential Pop artist Warhol has transformed an icon of the postwar decades into an ironic comment on consumerism, cash, and middle-class values. In his paintings and prints, he built upon his experience as a commercial graphic artist and borrowed other motifs from popular culture—Campbell's Soup cans, Brillo boxes, and tabloid photos of Jacqueline Kennedy and Marilyn Monroe—enlarging and often duplicating them in a manner evocative of the mechanical repetition of mass culture. Pop Art reasserted the figure in the age of abstract expressionism and invigorated printmaking in the 1960s.

Douglas Sirk. *All That Heaven Allows.* Cinematographer: Russell Metty. Screenplay: Peg Fenwick. Score: Frank Skinner, Joseph Gershenson. Cast: Jane Wyman, Rock Hudson, Agnes Moorehead. Frame enlargements. Universal Pictures, Universal City, 1955.
Sirk was one of the most original Hollywood directors of the 1950s—the most underrated decade of American filmmaking. As with virtually all émigrés in Hollywood, the Dane brought an outsider's perspective to the traditions of American melodrama, putting a highly stylized spin on conventional narratives such as this one about a love affair between a young gardener and a socially prominent widow. He enlarges this narrative into an examination of the emotional numbness of suburban life, and the smug complacency that predominated in some quarters of the nation after World War II. Here, Ron Kirby (Rock Hudson), a man "marching to a different drummer" in the Thoreau tradition, professes his love while Cary Scott (Jane Wyman) wrestles with the choice of her own happiness over the disapproval of her grown children and friends, in the shadowland she has come to inhabit without him.

Opposite:
Felix Frankfurter. Draft of decree implementing the Supreme Court opinion on *Brown* v. *Board of Education.* Typescript with pen and ink notations. Washington, D.C., April 8, 1955.
This key document from the momentous 1954 Supreme Court decision that declared school segregation unconstitutional shows the significant replacement of "forthwith"—proposed by the NAACP lawyers to achieve an accelerated desegregation timetable—with the phrase "with all deliberate speed." Shortly after Frankfurter retired from the Court, he acknowledged that the change had been made because "there were so many blocks preventing an immediate solution of the thing in reality that the best we could look for would be a progression of action." When it became clear that segregationists were using the wording to avoid compliance with *Brown,* the Court began to express reservations about the phrase. In 1964, Justice Hugo Black declared in a desegregation opinion that the "time for mere 'deliberate speed' has run out."

James Karales. Civil rights march, March 1965. Contemporary gelatin silver print (from original gelatin negative). Alabama.

The great reform surge of the Kennedy-Johnson years reflected a new awareness of social problems in America. *Look* magazine photographer Karales, illustrating an article about the role of organized religion in the desegregation campaign, captured a watershed event in the struggle for civil rights: the 1965 march on Montgomery, Alabama, organized to focus national attention on the need for legislation to guarantee voting rights for African Americans. Here, black Americans are joined by many white priests, ministers, nuns, and rabbis in the march from Selma to Montgomery, the Alabama state capital. As a bi-weekly, *Look* explored crucial issues that newspapers and weeklies, with shorter deadlines, could report only in a superficial manner.

CREE # 2

1. The appellees in Nos. 1, 2 and 3, the respondents in No. 4, and the petitioners in No. 5 are permanently enjoined from excluding the appellants in Nos. 1, 2 and 3, the petitioners in No. 4, and the respondents in No. 5 from any public school on the ground of race.

2. The cases are remanded to the respective federal district and state courts for appropriate decrees to carry out the mandate of this Court in the light of the decisions in Brown v. Board of Education, 347 U.S. 483, and Bolling v. Sharpe, 347 U.S. 497.

3. The rights of the appellants in Nos. 1, 2 and 3, the petitioners in No. 4, and the respondents in No. 5 must be given effect immediately where all the relevant considerations controlling a court of equity make it feasible to do so. [Provided that steps toward full compliance with the standards enunciated in Section 4, infra, are undertaken at once by the affected school districts, the admission of a named plaintiff may be delayed for a reasonable period, not to exceed one school cycle of 12 years.]

4. Insofar as reorganization may be necessary in the school districts affected by our judgment and mandate and in other school districts similarly situated, so as to make effective this decree that no student shall be denied admission to any public school because of his race, the respective lower courts are to require that any new or reorganized school districts to be established by local authorities shall be geographically compact, contiguous and non-gerrymandered. And it shall further be made incumbent upon local authorities that within a given school district Negro students be not refused admission to any school where they are situated similarly to white students in respect to (1) distance from school, (2) natural or manmade barriers or hazards, and (3) other relevant educational criteria.

5. On remand, the defendant school districts shall be required to submit with all appropriate speed proposals for compliance to the respective lower courts.

6. Decrees in conformity with this decree shall be prepared and issued forthwith by the lower courts. They may, when deemed by them desirable for the more effective enforcement of this decree, appoint masters to assist them.

7. Periodic compliance reports shall be presented by the defendant school districts to the lower courts and, in due course, transmitted by them to this Court, but the primary duty to insure good faith compliance rests with the lower courts.

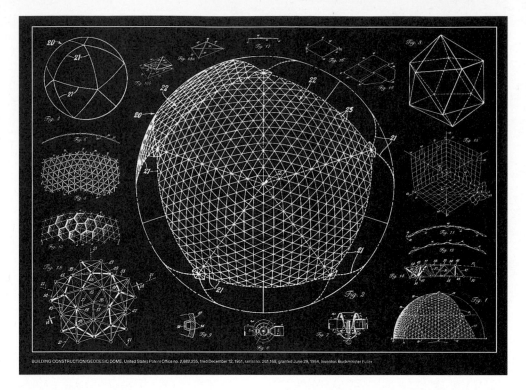

BUILDING CONSTRUCTION/GEODESIC DOME. United States Patent Office no. 2,682,235, filed December 12, 1951, serial no. 261,168, granted June 29, 1954, Inventor: Buckminster Fuller.

Buckminster Fuller. Building Construction/ Geodesic Dome. United States Patent no. 2,682,235, filed December 12, 1951. Screenprint, white ink on transparent film over sheet of blue paper. Cincinnati, 1981.

Few people in history have invented an entirely new method to enclose space. One of the most revolutionary thinkers of this century, Fuller was an architect, engineer, designer, inventor, mathematician, philosopher, author, and teacher concerned with how the science of design could assist in the technological management of our planet, which he dubbed "Spaceship Earth." His geodesic dome was more stable than the world's largest masonry domes, a small fraction of their weight and cost, and buildable at almost any scale. Since 1954 more than 300,000 geodesic domes have been built around the world for myriad purposes, including expositions, arenas, aviaries, and the permanent American base at the South Pole.

Raymond Loewy. Preliminary design for Cornell-Liberty Safety Car for the Cornell Aeronautical Research Laboratory and the Liberty Mutual Life Insurance Company. Drawing, graphite, colored pencil, and ink. September 11, 1956.

Over a period of almost fifty years, Loewy served as a design consultant for several motor companies, most notably Studebaker, where his last product was the widely admired Avanti. Drawing was not Loewy's greatest talent, but this sketch in his own hand demonstrates the kind of analytical and aesthetic acumen that such clients as Cornell University found so valuable. Drawing on his extensive experience in the design and operation of the automobile, he succinctly organizes and focuses the basic elements of the design problem at hand, a "safety car," in order to arrive at a solution for a product that is both attractive and secure.

The New York Times. Front page, Monday, July 21, 1969.

Nothing better illustrated the nation's veneration of scientific expertise in the 1950s than the popular enthusiasm for the American space program, triggered in large part by the Cold War. When the Soviet Union announced in 1957 that it had launched a satellite, *Sputnik,* into outer space, the U.S. government (and much of the populace) reacted with alarm, as if the Soviet achievement was also a massive American failure. In response, there were strenuous efforts to improve scientific education and research.

The USS *Enterprise.* Side elevation for *Star Trek.* Diazoprint. Paramount, Hollywood, August 6, 1979.

Like Robert Fulton's submarine and the Wright Brothers' aircraft, the starship *Enterprise* was intended to take its crew "where no man has gone before." Originally conceived for a television pilot in 1964 by Gene Roddenberry, working with art directors Matt Jefferies and Pato Guzman, the USS *Enterprise* belonged to the fictional United Federation of Planets, dedicated to discovering new worlds and lifeforms. When *Star Trek* first moved to the big screen in 1979, Paramount Pictures copyrighted this design for the *Enterprise,* retrofitted with a pulsed warp 12 drive and a maximum range of ten thousand light-years. *Star Trek* is one of the most successful franchises in entertainment history.

Erik Nitsche. *Convair 880: World's Fastest Jetliner. General Dynamics.* Offset lithograph. Poster. [Lausanne/New York], 1959.

In the 1950s Boeing, Douglas, and Convair competed to design and build practical jet-powered passenger aircraft for postwar commercial use. Purchased by Delta, model 22 or the Convair 880, so named for its cruising speed measured in feet per second, was the fastest of the jetliners (and was finally retired in 1975 as a casualty of the oil crisis). In March 1954 Convair was acquired by the defense giant General Dynamics, whose founder, John H. Hopkins, envisioned the firm as a private national defense service capable of waging the Cold War more effectively by designing and producing an entirely integrated weapons system.

Hopkins hired the Swiss-born Nitsche in 1955 to develop a corporate identity that would convey the company's dedication to peaceful uses of atomic energy. He accomplished this commission with a series of posters titled "Exploration of the Universe."

U.S. Central Intelligence Agency. *South Vietnam.* Map. [Washington, D.C.], 1972.

The Vietnam War (1957–75) was a boon to defense technology firms, such as General Dynamics, whose mutually beneficial relationship with the armed forces became known as the "military-industrial complex," and against whose "unwarranted influence" Eisenhower had warned in his 1961 farewell address. This small-scale reference map is typical of those published by the Central Intelligence Agency. Not intended to show sensitive military information, they are designed and periodically updated for general study and political briefings on geographic regions and countries in which the government has an interest. This one indicates South Vietnam's major topographical features in shaded relief, overlaid by rivers, provincial boundaries, the basic transportation network (roads, railroads, airfields, ports), and major cities and towns. Inset maps focus on economic activity, land utilization and vegetation, administrative divisions and military regions, ethnic groups, and population.

CBS News Special: Hill 943. Reporter: John Lawrence. Frame enlargements. CBS News, New York, 1968.

As America passed from "aid" to "intervention" in Vietnam, TV news audiences came to expect nightly coverage of soldiers and diplomats in this frontline conflict with world communism. A new military machine, the helicopter, not only determined U.S. tactics but allowed TV reporters and crew to hitch-hike to the "hot zones." *Hill 943* was one of many hour-long specials broadcast by the major networks between 1964 and 1972 about how our soldiers lived, fought, and died in Vietnam. Unlike the more controlled film coverage of previous wars, these pulled no punches. The viewer accompanied "Alpha Company" on its deadly mission to take Hill 943, a subsidiary action related to the Battle of Dak To. This daily experience of war—"Are you afraid?" the reporter asked a young soldier under fire—helped fuel the antiwar movement.

Francis Ford Coppola. *Apocalypse Now.* Cinematographer: Vittorio Storaro. Screenplay: John Millius, Francis Ford Coppola. Score: Carmine and Francis Ford Coppola. Cast: Marlon Brando, Martin Sheen, Robert Duvall. Frame enlargements. Zoetrope Studios, San Francisco, 1979.

Just as the American public had difficulty grasping the meaning of the Vietnam War as it was happening, so, too, did the American film community struggle to translate the conflict meaningfully onto the screen for years after its conclusion. *Apocalypse Now* was one of the most successful efforts to represent the moral and emotional dilemmas of those who were directly caught up in it. Coppola seeks meaning on two levels: in the weird reality of jungle warfare as experienced by the combat soldier, and as a parable of how our military establishment lost track of its professed goal. The lower frame shows a helicopter assault by a battalion of the First Air Cavalry that unfolds to the strains of Wagner's "Ride of the Valkyries."

Gordon Parks. Muhammad Ali [after the Henry Cooper fight in London, England]. Gelatin silver print, 1966.

Clearly the parents of Cassius Clay intended him to be a crusader: they named him for the antebellum Kentucky journalist whose home cum newspaper office was packed up and sent North by sixty prominent Lexingtonians angered by his antislavery agitation. Born in Louisville in 1942, Clay rose to fame in the early 1960s as a brilliant boxer. Then he converted to Islam and took the name of Muhammad Ali to signify this new commitment, which involved a vow of nonviolence.

Many viewed his newfound pacifism as a means of avoiding service in the then-raging Vietnam War, or saw his embracing of a "foreign" religion as an affront to American values. In 1966 *Life* magazine sent Parks to do a photo essay on Ali as he prepared for his bout with British boxer Henry Cooper. Years later Parks commented, "There were days when, consumed with bitterness and feeling no one understood his misery, Ali seldom smiled. There was only the terrible glare he stalked his sparring partners with every morning."

Jules Feiffer. *A dance to summer.* Drawing, ink and white-out over pencil on layered paper. New York, 1968.

Feiffer first attracted national attention In October 1956 for an innovative cartoon feature in the pages of the *Village Voice* that combined the instructive impact of political cartoons with the narrative power of comic strips. First called *Sick, Sick, Sick* and later simply *Feiffer*, it was a comic strip for grownups, a vehicle for trenchant soliloquies and dialogues about life, love, power, hypocrisy, violence, and despair. During the 1960s, Feiffer's ruminations on civil rights, relations between the sexes, poverty, the peace movement, the generation gap, and the Vietnam War struck a responsive chord with many Americans.

Howard Brodie. Bobby Seale, bound and gagged at the Chicago Conspiracy Trial. Colored pencil drawing. Chicago, 1969.

In September 1969, Black Panthers co-founder and militant civil rights activist Seale, along with seven other defendants collectively dubbed the "Chicago Seven," went on trial before federal judge Julius Hoffman, on charges of conspiracy to incite riots outside the Democratic Party's national convention in Chicago in August 1968. Seale served as his own defense counsel and provoked angry responses from Hoffman. Finally, on October 29, in an attempt to control Seale's deliberately disruptive behavior and to regain order in his courtroom, Hoffman ordered the defendant bound, gagged, and chained to his chair. Brodie's eyewitness drawing of a muzzled Seale documents this incident, and remains a chilling reminder of the social and racial tensions that marked the era. Eventually, a mistrial was declared, and charges were subsequently dropped against Seale.

Opposite: Maya Ying Lin. Winning design, Vietnam Veterans' Memorial Competition, Washington, D.C. Presentation panel in mixed media on paper, mounted on board. New Haven, Connecticut, 1980 or 1981.
Originally a student project at Yale University's School of Architecture, this design was the winner of one of the largest architectural competitions ever held. In this, her original proposal for a Vietnam Veterans' Memorial, Lin envisioned a highly polished, reflective, 440-foot black granite wall in the shape of a V, on which the nearly fifty-eight thousand names of the American military dead and missing would be inscribed. She believed that "these names, seemingly infinite in number, [would] convey the sense of overwhelming numbers, while unifying these individuals into a whole." Popularly known as "The Wall," this communal gravestone has personalized the war in a way that television could not. It has become a profound national symbol and a point of reference for a new tradition of American memorial structures that name the individual dead, reviving public interest in and support for this building form.

Arnold Skolnick. *Woodstock, 3 Days of Peace and Music—and Love.* Offset lithograph. Poster. New York, 1969.
The Woodstock Art and Music Fair, the largest of the outdoor rock music festivals of the 1960s, was held in August 1969 in Bethel, New York. Over 400,000 people, most between the ages of sixteen and twenty-five, gathered for three miraculously conflict-free days on the rain- and mud-soaked fields of Max Yasgur's farm. The festival has since been enshrined as a symbol of 1960s youth culture. Inseparably mingled with music and political protest against the war in Vietnam and racial discrimination was the youths' rejection of the values and lifestyles of their parents' generation.

Avenge. Offset lithograph. Poster, 1970.
Antiwar sentiment grew as the Vietnam War dragged on, erupting in demonstrations across the nation, especially on college and university campuses. Then President Nixon announced the invasion of Cambodia, Vietnam's neutral neighbor. At Kent State University, students firebombed the ROTC building, and four hundred Ohio National Guardsmen were called in to restore order. On May 4, 1970, after a series of minor disruptions, they sought to clear the campus, which resulted in the shooting deaths of four students and the wounding of ten others. Later, when criminal charges against the Ohio National Guard were dismissed, protests in sympathy with the Kent State victims closed some seven hundred colleges and universities across the United States.

IN MEMORIAM

Trajan Letter Type - 3/4"

Walking through this park-like area, the memorial appears as a rift in the earth - a long, polished black stone wall, emerging from and receding into the earth. Approaching the memorial, the ground slopes gently downward, and the low walls emerging on either side, growing out of the earth, extend and converge at a point below and ahead. Walking into the grassy site contained by the walls of this memorial we can barely make out the carved names upon the memorial's walls. These names, seemingly infinite in number, convey the sense of overwhelming numbers, while unifying these individuals into a whole. For this memorial is meant not as a monument to the individual, but rather as a memorial to the men and women who died during this war, as a whole.

The memorial is composed not as an unchanging monument, but as a moving composition, to be understood as we move into and out of it; the passage itself is gradual, the descent to the origin slow, but it is at the origin that the meaning of this memorial is to be fully understood. At the intersection of these walls, on the right side, at this wall's top is carved the date of the first death. It is followed by the names of those who have died in the war, in chronological order. These names continue on this wall, appearing to recede into the earth at the wall's end. The names resume on the left wall, as the wall emerges from the earth, continuing back to the origin, where the date of the last death is carved, at the bottom of this wall. Thus the war's beginning and end meet; the war is "complete," coming full circle, yet broken by the earth that bounds the angle's open side, and contained within the earth itself. As we turn to leave, we see these walls stretching into the distance, directing us to the Washington Monument to the left and the Lincoln Memorial to the right, thus bringing the Vietnam Memorial into historical context. Thus, we the living are brought to a concrete realization of these deaths.

Brought to a sharp awareness of such a loss, it is up to each individual to resolve or come to terms with this loss. For death is in the end a personal and private matter, and the area contained within this memorial is a quiet place meant for personal reflection and private reckoning. The black granite walls, each 200 feet long, and 10 feet below ground at their lowest point (gradually approaching towards ground level) effectively act as a sound barrier, yet are of such a height and length so as not to appear threatening or enclosing. The actual area is wide and shallow, allowing for a sense of privacy and the sunlight from the memorial's southern exposure along with the grassy park surrounding and within its walls contribute to the serenity of the area. Thus this memorial is for those who have died, and for us to remember them.

The memorial's origin is located approximately at the center of this site; its legs each extending 200 feet towards the Washington Monument and the Lincoln Memorial. The walls, contained on one side by the earth, are 10 feet below ground at their point of origin, gradually ascending to ground level, until they finally recede totally into the earth at their ends. The walls are to be made of a hard, polished black granite, with the names to be carved in a simple Trajan letter, 3/4 inch high, allowing for nine inches in length for each name. The memorial's construction involves recontouring the area within the walls' boundaries so as to provide for an easily accessible site descent, but as much of the site as possible should be left untouched (including trees). The area should be made into a park for all the public to enjoy.

Perspectives Facing North. Approximate Scale: 1"=30' · 1"=2' : 1"=10'

1026

Alfred Hitchcock. *Vertigo*. Cinematographer: Robert Burks. Screenplay: Alex Coppel and Samuel Taylor. Score: Bernard Herrmann. Cast: Kim Novak, James Stewart, Barbara Bel Geddes. Frame enlargement. Universal Pictures, Universal City, 1958.

Most American filmmakers working today have been influenced by Hitchcock. This exploration of romantic obsession and self-annihilation is his darkest, most dreamlike tale of personal identity. Scotty (Stewart) makes Judy (Novak) over physically to resemble the dead woman he loves. Novak later remarked, "I really identified with the story because to me it was saying, 'Please, see who I am. Fall in love with me, not a fantasy.'" In this scene the transformation is complete, and Judy has acquiesced. Hitchcock said, "I wanted her to emerge from that room as a ghost with a green effect so I put a wide sliding glass in front of the camera, blurred at the top when she first appears."

Edward Sorel. *Sic transit Gloria*. Drawing, pen and ink. New York, 1974.

Sorel's drawing was done in response to Gloria Steinem's remark in the *New York Times Magazine* of August 11, 1974, that "Women's obsession with romance is a displacement of their longings for success." As co-founder of the National Women's Political Caucus and co-founder and editor of *Ms.* magazine, as well as through numerous other activities, Gloria Steinem worked to achieve equal rights for women, publicize and promote issues of concern to them, and elevate their role within the nation's economic and political life. Sorel's caustic caricature of Steinem as a female St. George slaying the male dragon with her pen is both a satirical swipe and a measure of respect for the efficacy of her crusading efforts. The feminist movement evolved, within a very few years, from an almost invisible blip in the 1950s and 1960s into one of the most powerful social movements in American history.

Garry Winogrand. *1978 Beverly Hills, California.* Gelatin silver print.

Winogrand's spontaneous photographs combine elements of the snapshot with a discerning eye for situational humor. In his 1975 book *Women Are Beautiful,* he wrote: "Whenever I've seen an attractive woman, I've done my best to photograph her. . . . In the end, the photographs are descriptions of poses or attitudes that give an idea, a hint of their energies." The swift stride of this figure reflects women's fast-paced life in the late twentieth century. By the mid-1970s, nearly half of all married women held jobs, and almost nine-tenths of all women with college degrees were working. The use of the term "Ms." in place of "Mrs." or "Miss" denoted the irrelevance of a woman's marital status in the professional world; however, an Equal Rights Amendment (ERA) to the Constitution, which some feminists had been promoting since the 1920s, died in 1982 when those who feared it would disrupt traditional social patterns blocked ratification.

Lesley Dill. *The Poetic Body: Poem Dress of Circulation.* Lithograph, collage, and letterpress on Japanese silk tissue. 1992.

With a gossamer touch, Dill addresses issues related to the body, gender, and the transience of human life. Riverlike arteries flow downward from the heart, trailed by fragments of poem number 1440 by Emily Dickinson:

> The healed Heart shows its shallow scar
> With confidential moan—
> Not mended by Mortality
> Are Fabrics truly torn—
> To go its convalescent way
> So shameless is to see
> More genuine were Perfidy
> Than such Fidelity

The artist explains, "The poems I choose to use of Emily Dickinson's are the ones that speak about the vulnerability of being human, as well as the bliss and ecstasy of living." Dill's work has roots in a feminist aesthetic that grew out of the women's liberation movement—"femmage," decorative art with significant content. Through grassroots organizations and collaborative activities, women began not only to challenge sexism and discrimination, but to create communities and values of their own. In cities and towns across the country, feminists opened women's bookstores, artists' cooperatives, and coffee shops. They founded shelters for victims of rape and domestic violence, health clinics (and, particularly after *Roe* v. *Wade* in 1973, abortion clinics), and day care centers.

Wayne Thiebaud. Apartment hill. Drypoint on chine collé. San Francisco, 1985.
The vertiginous streetscape of San Francisco and the tendency of the city's inhabitants to build upon any available promontory, however precarious, is the subject here of American painter and printmaker Thiebaud, who recalls the urban tableaux of Edward Hopper. After moving to San Francisco in the early 1970s, his fascination with its topographical extremes became a strong element in his work. By the 1980s, the cities were on the rebound, and the great suburban exodus of the 1950s was being reversed as the young returned in droves.

Star Black. *Hey Yuppie, Search Your Heart.* Wall graffiti. 35mm color slide. East Village, New York, N.Y., 1989.
More than half of all American people of color lived in poverty at the beginning of the 1960s. Televised race riots brought recommendations of massive spending to end abysmal conditions in the ghettos. In her photographs of Lower Manhattan, Black has recorded the most ephemeral sort of political and social protest: graffiti. Beginning in the 1970s, the walls, fences, and doorways of the East Village, SoHo, and Alphabet City in New York, and of similar districts in other American cities, blossomed with stenciled, printed, and spray-painted diatribes on issues from political oppression in El Salvador to racism and abortion. This work protests the dwindling of affordable housing stock for the poor in inner-city areas, brought about in part by "gentrification," the renovation of low-end housing by young urban professionals ("yuppies").

Walter Rosenblum. Street shower, Mullaly Park, South Bronx, New York, 1980. Gold-toned gelatin silver print.
Rosenblum's work displays an empathy for children, an unsinkable optimism, and a capacity for revealing the enduring strength of the human spirit. Himself a child of New York's Lower East Side, he was a highly active member of the Photo League, the vital New York center of documentary photography, where he shared with the great social photographer Lewis Hine a strong sense of moral responsibility for his fellow human beings. He was the most decorated American photographer of World War II, and the "People of the South Bronx" series, to which this photograph belongs, is perhaps his most expressive and meaningful body of work.

John Landis. *Michael Jackson's Thriller.* Cinematographer: Robert Paynter. Screenplay: John Landis, Michael Jackson. Song: Rod Temperton. Cast: Michael Jackson, Ola Ray, Vincent Price (Voice). Frame enlargement. Optimum Productions, Los Angeles, 1983.
Video not only transformed the marketing of entertainment, it also reinvigorated popular traditions, including the most resilient of all genres: the movie musical. Since its heyday in the 1930s, when Fred and Ginger represented the epitome of grace and rhythm, many great hoofers and songsters have kept America spellbound in darkness. With the video revolution in full swing, Jackson set out to make more than a promotional piece for an album; instead of churning out a standard music video, he and his co-producers shot the elaborate production number in 35mm. This short film is both a homage to the classic horror films of the 1930s and a choreographical tour de force that influenced film and video musicals for the next decade and helped to propel sales of Jackson's *Thriller* album to more than 40 million, making it the biggest selling album of all time.

Doonesbury

BY GARRY TRUDEAU

Garry B. Trudeau. *Doonesbury* ("Hmm . . gettin' too late to meet Rick at the grate"). Drawing, ink, pencil, blue pencil, tonal film overlays and white-out, with overlay. New York, 1985.

President Ronald Reagan accumulated more national debt in his eight years in office than all of his predecessors, throughout American history, combined. His administration's answer to the fiscal crisis was further cuts in "discretionary" domestic spending, including many programs aimed at the poorest (and politically weakest) Americans. Reduced subsidies for low-income housing contributed to the radical increase in homelessness that by the late 1980s was plaguing nearly all cities. In this *Doonesbury* sequence the human tragedy of homelessness unfolds before the seemingly impassive facade of the Reagan White House. Trudeau's persistent and provocative commentaries on prominent politicians and controversial social issues have some newspapers printing them on the editorial page rather than in the comics section.

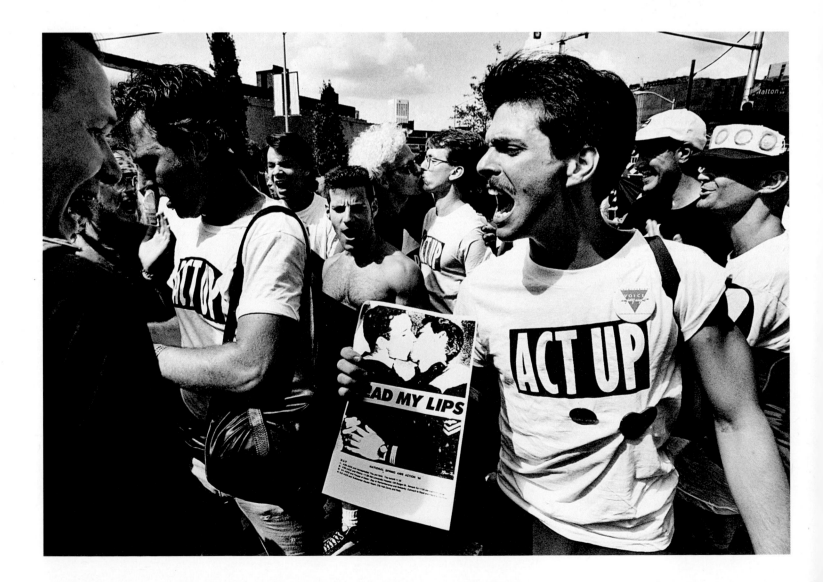

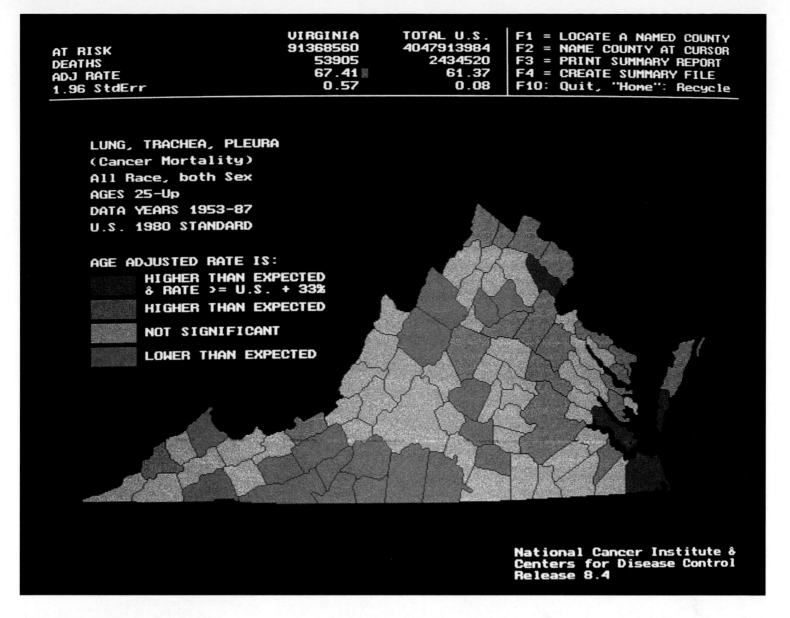

LUNG, TRACHEA, PLEURA
(Cancer Mortality)
All Race, both Sex
AGES 25-Up
DATA YEARS 1953-87
U.S. 1980 STANDARD

AGE ADJUSTED RATE IS:

HIGHER THAN EXPECTED
& RATE >= U.S. + 33%

HIGHER THAN EXPECTED

NOT SIGNIFICANT

LOWER THAN EXPECTED

	VIRGINIA	TOTAL U.S.
AT RISK	91368560	4047913984
DEATHS	53905	2434520
ADJ RATE	67.41	61.37
1.96 StdErr	0.57	0.08

F1 = LOCATE A NAMED COUNTY
F2 = NAME COUNTY AT CURSOR
F3 = PRINT SUMMARY REPORT
F4 = CREATE SUMMARY FILE
F10: Quit, "Home": Recycle

National Cancer Institute &
Centers for Disease Control
Release 8.4

U.S. National Cancer Institute. *State Cancer Control Map and Data Program, Cancer Mortality by Pentad: 1953–1957 to 1982–1987.* Computer screen map, Test Version 8.4. Bethesda, Maryland, February 27, 1992.
A spatially referenced database produced by the National Cancer Institute in collaboration with the Centers for Disease Control and the American Cancer Society allows users to generate maps electronically for each of the fifty states, selecting statistics for thirteen categories of cancer, further clarified by sex, race, and age variables.

This computer display shows the mortality rates for lung, trachea, and pleura cancers in the state of Virginia (all races, both sexes, ages twenty-five and up, for the time period 1953–1987). The resulting map reveals a concentration of "higher than expected" rates in certain regions but does not explain these concentrations, thus defining areas for further research. With numerous studies linking the smoking of tobacco to cancer and heart disease, the use of tobacco became one of the most controversial medical and political issues of the 1990s.

Opposite: William Klein. ACT UP activists at the Democratic National Convention, Atlanta, Georgia. Gelatin silver print, 1988.
Like other presidential conventions, the Democrats' in 1988 offered a highly visible forum for domestic issues, drawing numerous protest and advocacy actions like this one by the AIDS activist group ACT UP seeking increased funding for AIDS (Acquired Immune Deficiency Syndrome) research and equal rights for people testing positive for HIV (Human Immunodeficiency Virus). The gay liberation movement is one of the most controversial challenges to traditional values and assumptions of its time. By the 1990s homosexuals were attaining many of the same milestones that other oppressed minorities had in earlier decades, and the Supreme Court ruled that the government cannot show "animus" toward people based on their sexual orientation, nor make any class of people "a stranger to its laws." Klein, an American expatriate residing in Paris, began photographing in the 1950s, and much of his work exhibits the confrontational style shown here.

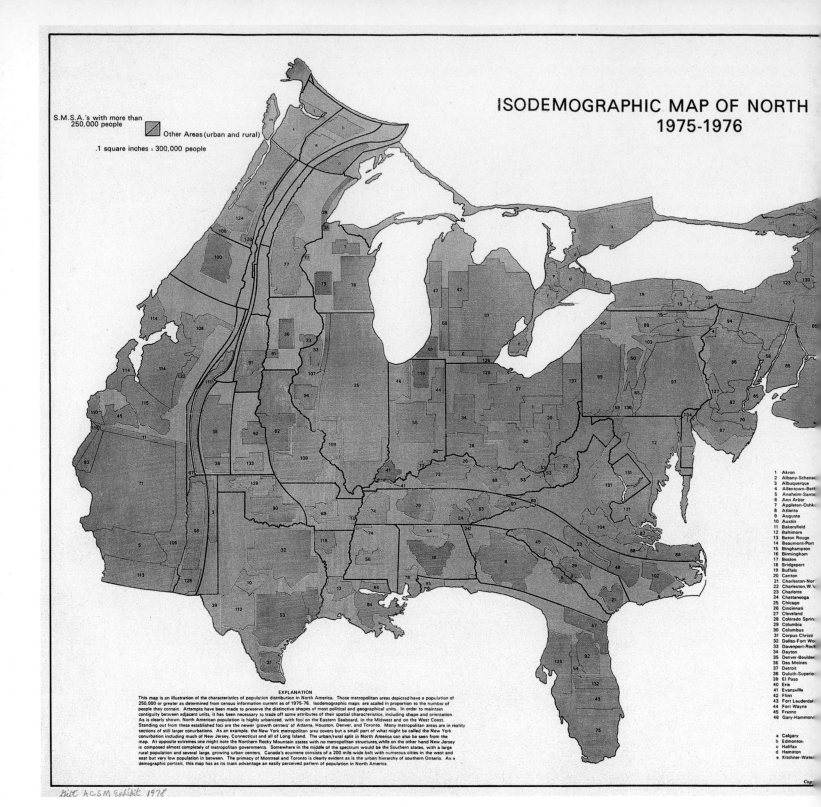

Queen's University, Cartographic Lab. *Isode-mographic Map of North America, 1975–1976.* Map on plastic. Kingston, Ontario, 1978. An award-winning entry in the American Congress on Surveying and Mapping's 1978 map design competition, this cartogram, or map/diagram, distorts geographic areas to reflect the data being mapped. Here states and metropolitan areas (over 250,000 people) are drawn in proportion to the size of their population based on 1975–76 demographic data. The major concentrations are in the urban Northeast, Midwest, and southern California, because a third of Americans live in suburbs. Although there is a large rural population in the Southeast, the rapid growth of Atlanta, Miami, Houston, and Dallas is also evident. The sparse population of the Rocky Mountain and northern Great Plains states is conveyed by their small size and narrow, linear shapes. Most of Canada's population is concentrated in a two-hundred-mile strip along its southern boundary with the United States.

Perhaps the most striking demographic change of the 1970s and 1980s, and the one likely to have the farthest-reaching consequences, was the changing pattern of immigration. In 1965 90 percent of America's immigrants came from Europe; twenty years later, only 10 percent of new arrivals were Europeans, with Hispanics and Asians now dominating the influx.

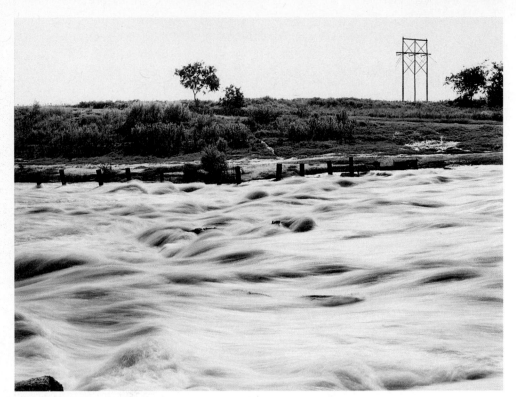

Peter Goin. The Rio Grande, Mexican-American border from *Tracing the Line; A Photographic Survey of the Mexican-American Border.* Gelatin silver print. Reno, Nevada, 1987.
Mexican Americans constitute America's most numerous Hispanic group. The official boundary between Texas and our southern neighbor is the center of the constantly flooding and eroding Rio Grande. Goin's work, the first photographic survey of this two-thousand-mile international boundary, sought to document not only "the geography of the border, but its complexity with respect to line." In this view of the high-water mark between the cities of Brownsville, Texas, and Matamoros, Tamaulipas, power lines belonging to the urban utility system and marking posts near the water's edge underscore the critical role modern development plays in our landscape.

Gregory Nava. *El Norte.* Cinematographer: James Glennon. Screenplay: Gregory Nava, Anna Thomas. Score: The Folkloristas, et al. Cast: Zaide Silvia Gutierrez, David Villalpando. Frame enlargement, Independent Productions/American Playhouse, New York, 1983.
By the mid-1960s Hollywood's studio system had fragmented once and for all. Opportunities opened for a younger generation, including independent filmmakers with an activist view of cinema. A prime example is *El Norte,* which examines the hardships of a brother and sister who emigrate illegally from war-torn Guatemala to find a better life "up north."

Robert Dawson. Missionary church and Paiute boy, Pyramid Lake Indian Reservation, Nevada, Truckee River/Pyramid Lake Project. Gelatin silver prints. Nixon, Nevada, 1991.
In 1906 Derby Dam was built on the Truckee River, diverting a large portion of the river, endangering Pyramid Lake and the Stillwater National Wildlife Preserve, and forcing the Paiutes to wage a ninety-year legal battle for redress. The Truckee River/Pyramid Lake Project was an independent effort begun in 1989 by the Californian Dawson with Peter Goin, a Nevada-based landscape photographer, to examine the competing interests of the rapidly expanding city of Reno-Sparks, Nevada, ranchers from the Fallon-Stillwater area, and the Paiutes during a recent, particularly fractious struggle with a five-year drought. At the far left of this panoramic view is a federally financed Tribal Center—partially completed, vandalized, and never used. In the 1960s, Indians were the least prosperous and least healthy group in the nation.

Opposite: Rachael Romero. *International Workers Day, May 1st Rally, 1 PM Dolores Park*. Linoleum cut. Poster. San Francisco, 1974.

The search for a living wage and civilized working conditions has brought a large migrant labor force to the United States from underdeveloped and war-torn countries. Most of these workers are at the bottom of the socioeconomic scale. This poster calls for those from Latin America and South Africa to attend a May Day rally in San Francisco. California, a magnet for immigrants, has been particularly identified with various protest movements since the student demonstrations of the 1960s and the Chicano-based activism of César Chávez, who formed the first significant farmworkers' union in 1962. Although virtually synonymous with agriculture, many migrants do seek employment in industry. In the 1980s a global redistribution of American industry occurred as conglomerates sidestepped the demands of organized labor and sought much cheaper labor abroad. Many of their new employees emigrated here as well, in search of more fulfilling and financially secure lives.

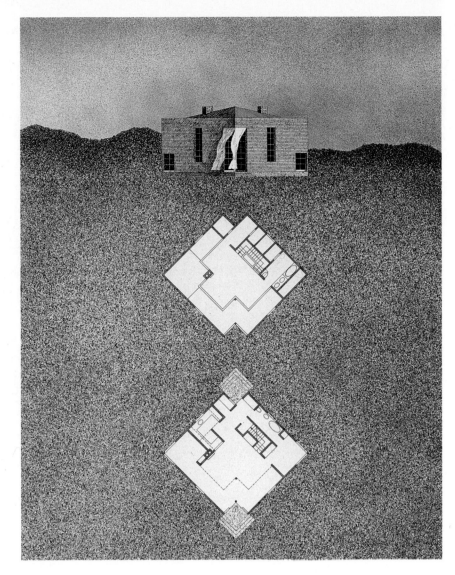

Mark Mack. Project for Rodeino residence, Oakville, California. Perspective and plans. Drawing, airbrush and ink. [San Francisco], 1982.

Austrian by birth and training, Mack, like Richard Neutra before him, came to California and distilled a new architecture from disparate influences—but Mack has relied primarily upon a primitivistic rather than Neutra's modernistic vocabulary. In this design, one of a series of "villas" in the Napa Valley, he went against the current tide of postmodernism in search of elemental forms and a rich, earthy palette that recalled the adobe construction of the region's Hispanic heritage and the work of the Mexican architect Luis Barragan. Mack has been an important figure in developing new conventions for and reviving interest in the art of architectural drawing.

Michael Crummett. Dancers. 35mm color slide. Crow Agency, Montana, 1979.

The Indian Civil Rights movement helped tribes win a series of new legal rights and protections; and in 1968 Congress passed the Indian Civil Rights Act, guaranteeing reservation residents many of the protections accorded other citizens by the Bill of Rights. In 1985 the Supreme Court even upheld Oneida claims to 100,000 acres in upstate New York based on a treaty long forgotten by whites. This noncompetitive group dance at the annual Crow Fair near the Little Bighorn River, where eyeglasses and Adidas coexist with feathers and buckskin, reveals both the persistence of Indian culture and a concurrent participation in contemporary American life.

Crow Fair is one of the largest powwows in the United States. Bringing together members of various tribes, such festivals celebrate and nurture both Crow and Indian identity.

Lucy Long. Christmas show for nursing home residents presented by students at the First Korean School, Silver Spring, Maryland. Gelatin silver print, 1982.

The Immigration Act of 1965 was one of Lyndon Johnson's most important pieces of legislation: it allowed people from all parts of Europe, Asia, and Africa to enter the United States on an equal basis. The concept of "multiculturalism" has emerged out of the cultural pluralism that characterizes a rapidly diversifying America. An estimated 600,000 students attend six thousand ethnic and language schools where young people meet others of the same background and accomplish the transition to their new home. Folklorist Long documented the First Korean School, founded in 1979, for the American Folklife Center and reported that the administrators emphasized the importance of creating good Korean-American citizens.

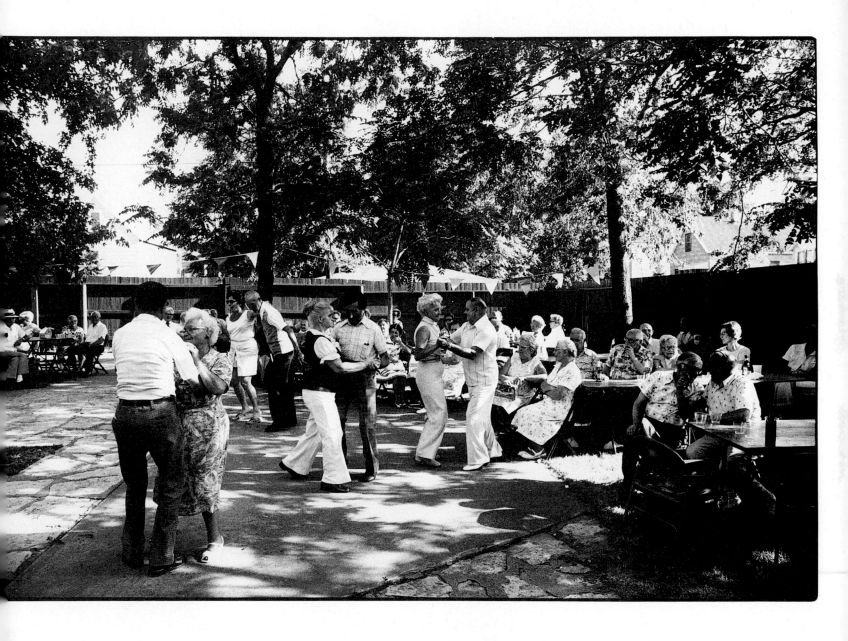

Jonas Dovydenas. Knights of Lithuania picnic, South Campbell Avenue. Gelatin silver print. Chicago, 1977.
Without hearing the hubbub of conversation or the particular strain of music, we are hard-pressed to identify the European-American community picnicking and dancing here. But, by listening, one would soon have discovered that this event was sponsored by the Knights of Lithuania, established by the Roman Catholic church in 1912, partly to stem the loss of national identity among Lithuanian youth.

Like many Eastern European ethnic communities in the United States, Marquette Park and Brighton Park, as well as suburban Cicero, offer a dynamic mix of the descendants of pre-Soviet refugees and those who came during the Soviet era, especially after World War II. Documentary photographer Dovydenas, himself Lithuanian-American, joined sixteen folklorists who documented a wide array of Chicago's ethnic traditions for the Library's American Folklife Center in 1977.

Adelaide de Menil. Danny King's dory and haul-seine net. Gelatin silver print. East Hampton, Long Island, New York, 1985. Independent commercial fishermen have been hard hit by the recreation industry, housing and business development, high-tech corporate fishing fleets, and industrial pollution in spawning grounds. Much like that of farmers, their way of life on the South Fork of New York's Long Island had endured virtually unchanged for centuries, but like the sea itself, it has now become endangered. Thanks to overfishing and poisonous offshore dumping, whole species of sea creatures, such as the cod fish, are also disappearing. The East End Fisheries Project, a photographic survey of more than 130,000 images, was undertaken during the 1980s to document vanishing customs in the villages known collectively as the "Hamptons."

Ezra Stoller. Robert R. McMath Solar Telescope, Kitt Peak Observatory, Pima County, Arizona. Gelatin silver print, 1962.
No one has written more eloquently of this gleaming white observatory, erected in 1962 on an Arizona mountain sacred to the Tohono O'odham (Papago) Indians (and leased by them to the National Science Foundation), than the critic and historian Reyner Banham: "Its huge abstract gesture, like one letter from an unknown Cyclopean alphabet, is silhouetted against an emptiness of air that is almost palpable. . . . It is a supreme product of the culture to which I belong—the culture of scientific inquiry, technological enterprise, and engineering precision." In the 1950s and 1960s many notable architects recognized Stoller's exceptional abilities and commissioned him to make photographic portraits of their works.

Douglas Harp. *Oz ne.* Offset lithograph. Poster. Big Flats, New York, 1993.

A high-energy form of oxygen called ozone in the earth's upper atmosphere protects life on our planet from harmful solar radiation. In 1985 concerns that such man-made chemicals as chlorofluorocarbons (CFCs), used as aerosol propellants and for refrigerants, could be depleting it were confirmed when researchers in England discovered a huge hole in the ozone layer—the size of the continental United States—over Antarctica. By 1997 the hole was twice the size of Europe (from the Atlantic to the Ural Mountains), or 7.7 million square miles. Seasonal ozone depletion occurring over populated areas led to a decision on the part of the American and several European governments to eliminate CFCs by the year 2000.

Harp and Company has won many awards for its innovative design work—especially for creative use of typography. This poster was devised for the Architects, Designers, and Planners for Social Responsibility's 1990 competition.

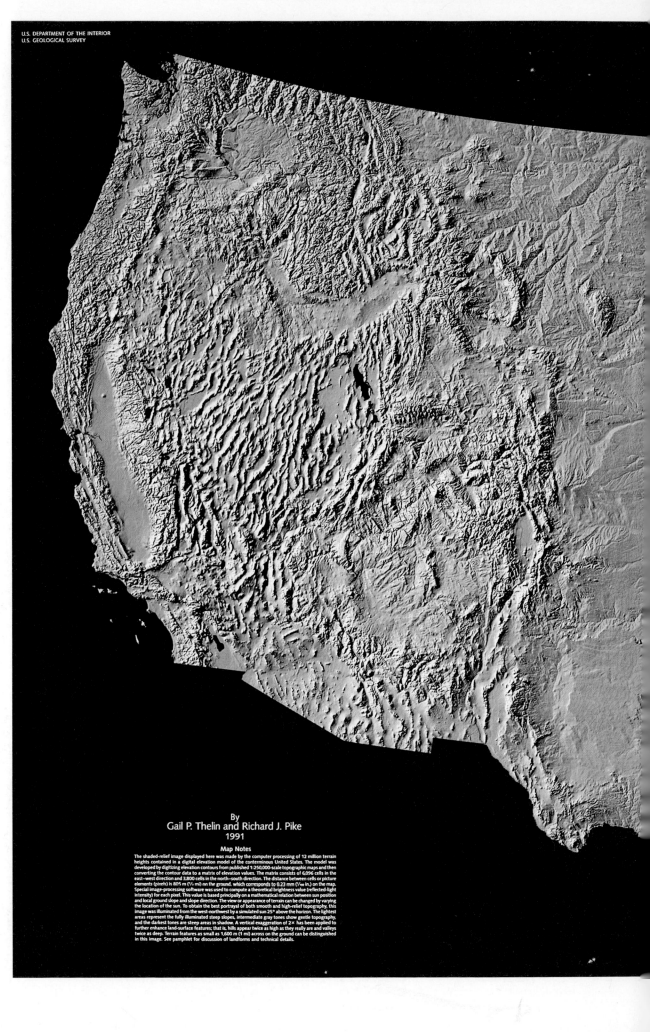

U.S. DEPARTMENT OF THE INTERIOR
U.S. GEOLOGICAL SURVEY

By
Gail P. Thelin and Richard J. Pike
1991

Map Notes

The shaded-relief image displayed here was made by the computer processing of 12 million terrain heights contained in a digital elevation model of the conterminous United States. The model was developed by digitizing elevation contours from published 1:250,000-scale topographic maps and then converting the contour data to a matrix of elevation values. The matrix consists of 6,096 cells in the east–west direction and 3,800 cells in the north–south direction. The distance between cells or picture elements (pixels) is 805 m (½ mi) on the ground, which corresponds to 0.23 mm (¹⁄₁₀₀ in.) on the map. Special image-processing software was used to compute a theoretical brightness value (reflected-light intensity) for each pixel. This value is based principally on a mathematical relation between sun position and local ground slope and slope direction. The view or appearance of terrain can be changed by varying the location of the sun. To obtain the best portrayal of both smooth and high-relief topography, this image was illuminated from the west-northwest by a simulated sun 25° above the horizon. The lightest areas represent the fully illuminated steep slopes, intermediate gray tones show gentle topography, and the darkest tones are steep areas in shadow. A vertical exaggeration of 2× has been applied to further enhance land-surface features; that is, hills appear twice as high as they really are and valleys twice as deep. Terrain features as small as 1,600 m (1 mi) across on the ground can be distinguished in this image. See pamphlet for discussion of landforms and technical details.

Gail P. Thelin and Richard J. Pike. *Landforms and Drainage of the 48 States.* Digital shaded-relief map. U.S. Geological Survey, Reston, Virginia, 1991. Although it has the appearance of an aerial photograph taken on a cloudless day under perfect lighting conditions or perhaps of a sideward-looking radar image, this shaded-relief map was actually generated digitally by a computer using a grid of 12 million spot-elevations, less than a kilometer apart. U.S. Geological Survey cartographers and geologists manipulated the agency's comprehensive topographic database to portray the country's landforms. Totally devoid of vegetation, place names, or human settlement features, the image quite literally reproduces the bedrock stage or physical base on which the drama of American history has unfolded so far.

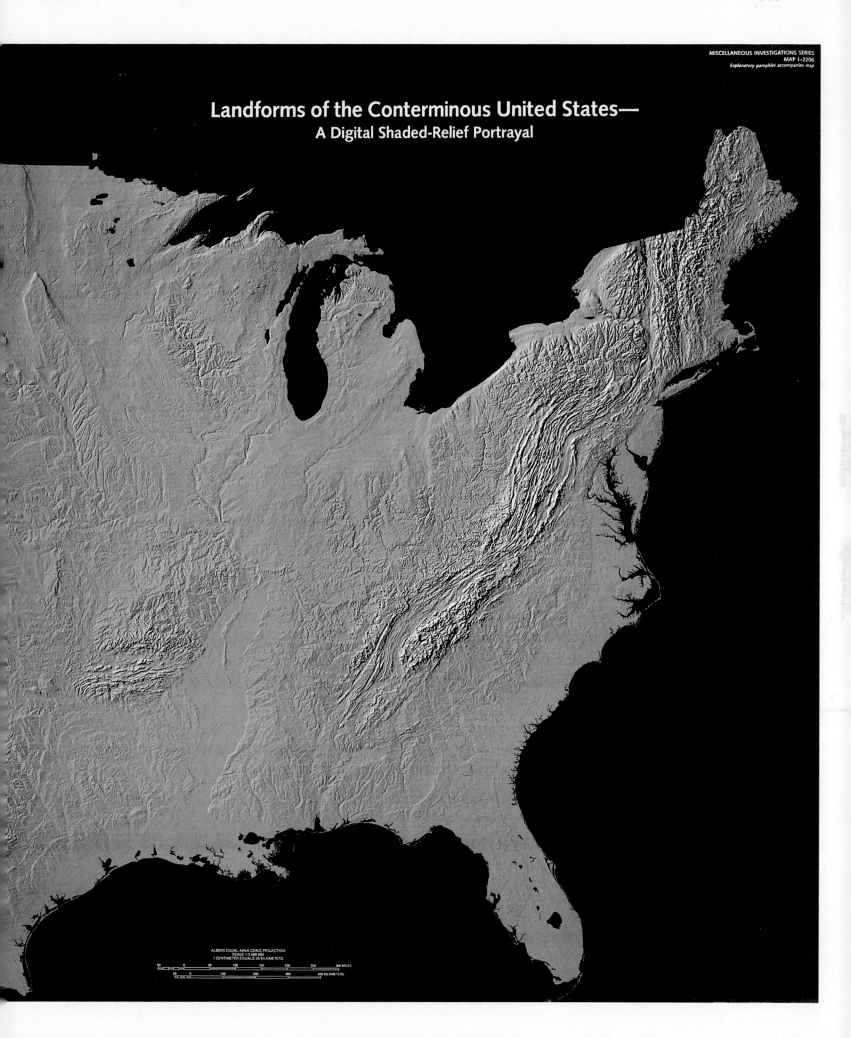

MISCELLANEOUS INVESTIGATIONS SERIES
MAP I–2206
Explanatory pamphlet accompanies map

Landforms of the Conterminous United States—
A Digital Shaded-Relief Portrayal

ALBERS EQUAL-AREA CONIC PROJECTION
SCALE 1:3 500 000
1 CENTIMETER EQUALS 35 KILOMETERS

Walt Whitman

Unidentified boy

Albert Einstein

Unidentified Native American

THE PEOPLE

Unidentified Chinese-American children

Greta Garbo

Francis Benjamin Johnston

Alice Roosevelt Longworth

Booker T. Washington

Carl Van Vechten

Leontyne Price

Unidentified tobacco workers

Helen Keller and Anne Sullivan

Unidentified Sioux

Emily Post

James M. Cain

Barbara Stanwyck

Amiri Baraka

Unidentified U. S. Capitol police officer

Toyo Miyatake

Unidentified garage mechanic

Mrs. F. Lathers

MAKE OUR GARDEN GROW

(CANDIDE <u>sings</u>)

You've been a fool and so have I,
But come and be my wife,
And let us try before we die
To make some sense of life.
We're neither pure nor wise nor good;
 We'll do the best we know;
 We'll build our house, and chop our wood,
 And make our garden grow.
 And make our garden grow.

(CUNEGONDE <u>sings</u>)

I thought the world was sugar-cake,
 For so our master said;
But now I'll teach my hands to bake
 Our loaf of daily bread.

(CANDIDE <u>and</u> CUNEGONDE <u>sing</u>)

We're neither pure nor wise nor good;
 We'll do the best we know;
 We'll build our house, and chop our wood,
 And make our garden grow.
 And make our garden grow.

(SEXTETTE <u>sings</u>)

Let dreamers dream what worlds they please;
 Those Edens can't be found.
 The sweetest flowers, the fairest trees
 Are grown in solid ground.

(ENTIRE COMPANY <u>sings</u>)

We're neither pure nor wise nor good.
 We'll do the best we know.
 We'll build our house, and chop our wood,
 And make our garden grow.
 And make our garden grow.

Richard Wilbur

Robert Cornelius. Self-portrait. Approximate
quarter-plate daguerreotype. Philadelphia,
1839.

CURATORS' STATEMENTS

An American Self-Portrait
BERNARD F. REILLY, JR.

Eyes of the Nation is the product, in part, of the efforts of the present generation of curators and historical specialists who are charged with the care and development of the Library of Congress's special collections holdings. The book, like the collections from which it has been composed, is the outcome of a grand collaboration of almost two centuries' duration between the Library and the American people. In this respect many share authorship of this volume with the curators and Vincent Virga: the photographers, artists, filmmakers, writers, and others who in their own day created these documents; the families, antiquarians, and collectors who preserved them; and the Congress and the people of the United States who supported their safekeeping and service in the world's most comprehensive library. The resulting eclectic assemblage of documents, interwoven with Alan Brinkley's informed historical narrative, constitutes a telling portrait—indeed a self-portrait—of the American people.

Among the many compelling documents comprising this national self-portrait is the earliest photograph of note made in the United States—the self-portrait of Robert Cornelius (opposite, and on the jacket of this book). On a clear afternoon in October 1839, Cornelius stood in the yard of his family's lamp and chandelier manufactory in Philadelphia, working with a camera he had fashioned from a tin box and fitted with a lens from an opera glass. Only nine months earlier Louis-Jacques-Mandé Daguerre had revealed to the French Academy of Sciences in Paris the remarkable new technique he had invented. This technique fixed the image of visible objects on the sensitized silver surface of a metal plate through the action of light. Probably working from an account printed in a scientific journal, Cornelius struggled to

replicate this daguerreotype process.

Cornelius's portrait has an appealingly candid and unrehearsed quality. Its maker was neither a professional artist nor even a scientist but a maker of brass lighting fixtures. Working alone and unable to check his own position through the camera's aperture, Cornelius is off-center in the picture. As he peers into the lens the expression on his face, slight tilt of his head, and crossed arms betray a certain dubiousness—an uncertainty, no doubt, about the success of his experiment. But one might also imagine in his look a larger doubt: about the viability of capturing in visual form human experience and the world around us.

Cornelius's work signaled the dawn of photography in the United States. But the recording of human experience was practiced long before photography. As the walls of the caves at Lascaux attest, the urge to delineate visible reality is far older, and arguably more basic, than the writing of history itself. Even subsequent to the introduction of writing, chroniclers have transcended the limitations of the written word with drawings of the events, places, and people they considered worthy of remembrance, a practice to which this volume bears ample testimony. Drawing has also served more immediate ends, for builders, engineers, and architects, as a medium in which to work out the forms and details of things to be, and to fix these ideas in tangible form.

Since the fourteenth century, drawings and other handmade images have often been reproduced and disseminated as prints. Initially, designs were cut on wood and metal surfaces that were then inked and printed. Refinements ensued as techniques such as etching, aquatint, and lithography were devised to produce a greater range of nuance and effect.

In 1839 Cornelius stood at an important moment in the history of visual representation. Lithography, an inexpensive technique

involving printing from an image drawn on a prepared stone surface, had been recently introduced in the United States on a commercial scale, vastly increasing the capacity to multiply and hence disseminate images. This new technology, in fact, played no small part in the successful presidential campaign of William Henry Harrison, launched only months after Cornelius's photograph. The "Log Cabin campaign," so-called for its central image of the simple, rustic home of the candidate, was a watershed in American electoral history. In a media campaign of unprecedented vulgarity, which was to set a standard for later elections, Harrison's supporters unleashed a torrent of lithographically illustrated song sheets, banners, handbills, and cartoons. The United States was on its way to becoming a visual culture.

While photography was embraced initially as a comparatively automatic means of reproducing optical appearances (the very "pencil of nature," it was called) the medium's persuasive value was soon recognized and exploited. Progressivist social reformers like Jacob Riis and Lewis Hine, the latter working for the National Child Labor Committee (see page 236), used it to disrupt the complacency of middle-class Americans with irrefutable evidence of the squalor of immigrant life and the abusive working conditions endured by unskilled industrial laborers at the turn of the century. Early conservation activists plied legislators with photographs of the natural wonders of Yellowstone and the Yosemite Valley, to persuade them to protect these unspoiled sites from the ravages of mining and the intrusion of urban and industrial development (see Carleton Watkins's Yosemite photograph, page 154).

Because the documents collected in *Eyes of the Nation* were all shaped by the circumstances of their creation and the respective goals of the creators, they should be regarded with the same wariness with which Robert Cornelius confronted his own makeshift

camera in 1839. But while these documents are not always perfectly transparent and reliable, they are always authentic. They speak in a multitude of voices fraught with the values and spirit of their age. These voices are at times strident and crude, at times subtle and eloquent; some are serenely disinterested, others contentiously partisan. The story they tell is in places smooth and harmonious, in others disjointed and contradictory in its details.

Robert Cornelius's self-portrait was donated to the Library of Congress in 1996 by Philadelphia historian and collector Marian Sadtler Carson. Mrs. Carson's act of generosity was preceded by many and similar gifts over the years from other collectors; from presidents, legislators, and various public figures and their families; from members of the creative community; and from countless other individuals and organizations. That within its walls such a record should be assembled not only *for* the people of the United States but also *by* the people is entirely fitting for the national library of a democratic nation.

Bernard F. Reilly, Jr., was Head of the Prints and Photographs Division Curatorial Section in the Library of Congress from 1987 to 1997.

JOHN McDONOUGH
Specialist, Manuscript Division

In offering his personal library for sale to the United States Congress following the destruction of the Congressional Library in the War of 1812, Thomas Jefferson said that there was "no subject to which a Member of Congress may not have occasion to refer." This degree of inclusiveness finds an immediate parallel in the Manuscript Division's collections, where the papers of twenty-three presidents—including George Washington, Thomas Jefferson, James Madison, Andrew Jackson, Abraham Lincoln, Theodore Roosevelt, and Woodrow Wilson—are joined by those of eminent Americans representative of the full range and sweep of our national life. Nor is history from the bottom up neglected, for also present are letters of ordinary soldiers from all our wars, journals kept by emigrants on their long way to the West, logs of whaleships recorded on remote seas, and workaday account books from plantations, shops, and factories. The unfolding panorama is endless.

Few repositories could withstand the surrender of the Constitution, the Declaration of Independence, and papers of the Continental Congress all in one year (as happened following the establishment of the National Archives) and still be ranked as outstanding.

But the collections of the Library of Congress Manuscript Division, now numbering over 50 million items, can claim that distinction. During his tenure as Librarian of Congress (1939–44), poet Archibald MacLeish called the Library's Manuscript Division the institution's "chief jewel," and David C. Mearns, who served the Library for forty-nine years (sixteen as Chief of the Manuscript Division), described it more extravagantly as "an actual Valhalla where the souls of the heroes, reincarnate on paper, foregather and walk again on their ways to glory." Still growing—and examining the new access possibilities presented by the digital age—the Manuscript Division holds materials that comprise a rich resource for scholars, one filled with innumerable revelations of American life.

RONALD E. GRIM
Specialist in Cartographic History
Geography and Map Division

The Geography and Map Division, the primary repository for cartographic materials in the Library of Congress, maintains a collection of 4.25 million map sheets, 53,000 atlases, 700,000 microfilm images, 300 globes, 2,000 terrain models, 1.6 million aerial photographs and remote sensing images, and 1,820 computer files. Geographic coverage includes every country in the world. Temporally, the coverage extends from the end of the fifteenth century to the present. However, the primary emphasis of the collections is the United States and North America during the eighteenth, nineteenth, and twentieth centuries. All scales of information are represented, from small-scale globes and world maps to moderate-scale maps of individual countries and states or provinces to large-scale maps of counties and cities.

Maps, by definition, provide a graphic record of the location and spatial relations of a multitude of features in the world in which we live. Maps not only tell us about the physical landscape but, more important from a historical perspective, the cultural landscape that is the product and accumulation of generations of human action on the physical base.

Printed maps, which first began to appear at the end of the fifteenth century, are available in the Library of Congress's holdings to document the full extent of the European discovery, conquest, and settlement of the Americas. Maps produced during the Renaissance attempted to record accurately, for the first time, the outlines and major geographic features of the newly discovered continents. During the eighteenth and nineteenth

centuries, maps had a more scientific base as measures of latitude and longitude became more precise and trigonometrical surveys were used to produce moderate- to large-scale topographic map and hydrographic chart series. Although the United States government did not complete hydrographic surveys of its coastal waters until the middle of the nineteenth century and only began a comprehensive topographic mapping program by the end of the century, American commercial publishers produced a variety of other maps—including county landownership maps and atlases, panoramic views, and fire insurance maps—that documented the cultural landscape of the nineteenth century.

The first half of the twentieth century saw the introduction of revolutionary mapping techniques starting with the use of aerial photography. By the end of the twentieth century, new mapping technologies included remote-sensing imagery and computer-assisted cartography. This rich cartographic heritage, most of which is documented in the collections of the Geography and Map Division, provides an invaluable resource of spatial perspectives on the historical and geographical development of the United States.

JOHN R. HÉBERT
Senior Specialist in Hispanic Bibliography

The Rare Book and Special Collections Division possesses holdings for nearly all eras and subjects of Western cultural history. Its collection of nearly 5,700 incunabula (books printed before 1501) is the largest such grouping in the Western hemisphere. Items of Americana date from a letter written in 1493 by Christopher Columbus through the present period, and include extensive holdings of western Americana, Confederate publications, and thousands of nineteenth-century pamphlets and titles in popular literature. This outstanding collection of materials on the history of the United States contains numerous contemporary publications describing the initial European contacts within the hemisphere, and within the territory which became the United States specifically. Among the division's more than one hundred separate collections are found the John Boyd Thacher Collection on Columbus and early exploration, the outstanding Lessing J. Rosenwald Collection of illustrated books, the Francis Drake Collection, the Benjamin Franklin Collection, the Henry Harrisse Collection on early exploration and travel, the Joseph Toner Collection on the history of American medicine and historiography, the Wagner-Camp Collection on Western

Americana, and the Walt Whitman Collection. These listed collections serve solely as examples of the vast reserve of materials awaiting those who are engaged in serious study of American cultural topics.

KATHERINE L. BLOOD
Assistant Curator for Fine Prints
Prints and Photographs Division

International in scope, the Fine Print holdings in the Prints and Photographs Division include thirty-five thousand engravings, etchings, woodcuts, lithographs, and silkscreens dating from the fifteenth century to the present day. Strengths include late-nineteenth- to early-twentieth-century American printmakers—encompassing the 1880s etching revival, the Ashcan school, regionalism, American Scene painting, and social realism. Also strong are Old Master prints from the fifteenth to the seventeenth century, chiaroscuro woodcuts from the Italian Renaissance, Impressionist prints, Japanese woodcuts, Works Progress Administration (WPA) prints, Latin American prints, the technique of wood engraving, and lithography from its invention forward. Notable artists include Dürer, da Carpi, Callot, Rembrandt, Hogarth, Goya, Daumier, Senefelder, Toulouse-Lautrec, Cassatt, Whistler, Pennell, Sloan, Beckmann, Kollwitz, Hopper, Johnson, Peterdi, Rauschenberg, and Bearden.

The Library's American fine prints embody our nation's creative vision, while chronicling its historical development. Imagination and creativity were the prisms through which the artists viewed their world, and this personalized commentary is an indispensable ingredient in the American story. The "reading" of prints is an interactive process: it weds the dialogue between each artist and subject with the experience, values, and tastes of the viewer. Like photographers and painters, printmakers speak through their media, making technical and aesthetic choices that determine the tenor of their visual message. For me, these layers of historicity, expression, and artistry are endlessly compelling.

Visual documents provide a lens to see across time; the fine print collection gives a telescopic view, reaching back to the fifteenth century. It is possible to glimpse a Renaissance pageant, an isolated moment on a Colonial American street, or a World War II skirmish. The collection also describes more universal concepts: relationships, emotions, beliefs. This range of narrative expression was produced by both celebrated and little-known artists, each contributing a vital piece to a vast panorama.

A particularly rewarding aspect of my work

is helping researchers to plumb these holdings. It is a joy to see these materials spark intellectual and creative energy among their viewers. Increased access in the digital environment offers an infusion of fresh research potential that is truly dazzling. A primary challenge is to identify now those works that complement the Library's existing strengths and that the growing community of students, artists, scholars, and educators most need. As visual literacy gains importance in our society and in our lives, images accrue power as tools with which to remember, to see (and foresee), and perhaps to understand.

HARRY L. KATZ
Curator, Popular and Applied Graphic Art
Prints and Photographs Division

The Popular and Applied Graphic Arts (P&AGA) collections span four centuries and encompass historical and documentary prints and drawings, political and social caricatures and cartoons, illustrators' drawings, advertising prints and ephemera, and numerous other genres of American and European graphic design. The collections range widely in date and content from early seventeenth-century Dutch political satires to contemporary works by notable American illustrators and editorial cartoonists. Highlights within the collections include the largest collection of American political prints and drawings in existence and the largest collection of historical lithographs printed by the firm of Currier & Ives, perhaps the finest assemblage of British satires in North America, sixteen hundred eyewitness drawings by Civil War sketch artists, more than twenty thousand original cartoon drawings by several generations of leading American cartoonists and illustrators, and extensive runs of rare illustrated periodicals from Europe and the United States. Such ephemeral materials as advertising labels, illustrated sheet-music covers, and banknote engravings are also preserved in these collections.

The P&AGA collections are national in scope, representing graphic work from every region of the country and historic period. They may accurately portray a compelling event in American history or aspect of American culture, represent the creative achievement of a notable artist, or better our understanding of the use of graphic art as a vehicle for political and social commentary.

These rich and varied collections represent a valuable resource for study in three major areas. First, documentary prints and drawings offer unique pictorial evidence of what we did and how we looked and lived in the years

before photography became the prime vehicle for visual documentation. Second, more fanciful literary, advertising, or comic images convey values, ideas, and influences acting upon the popular imagination at any given time in our nation's history. Finally, these collections reflect the technical development of graphic media from simple woodcuts published in small numbers for a limited audience to sophisticated drawings reproduced and disseminated throughout our highly literate society.

As a curator of the national collections, I am challenged and inspired by the responsibility to shape their future growth and make them physically and intellectually accessible to the public. New acquisitions must focus on the needs of Congress, traditional strengths of the Library's collections, and the requirements of present and future researchers. Preservation projects must acknowledge shrinking resources and incorporate new ideas on standardized treatment and storage of large collections. Cataloging initiatives must respond to the changing needs of the scholarly community and rapid advances in electronic digital technology. In the new electronic environment, curators must also become the essential link between original artifacts and their digital surrogates, which may not fully convey physical qualities or historical context. As the Library takes a leading role in all of these issues, my work with the collections affords an extraordinary opportunity to teach and learn.

ELENA G. MILLIE
Curator, Poster Collection
Prints and Photographs Division

The Poster Collection, which numbers approximately 100,000 pieces, covers the entire history of the genre. Holdings range from large woodblock posters of the 1840s to recent computer-generated works. Work by Jules Chéret, Henri de Toulouse-Lautrec, Pierre Bonnard, Lucian Bernhard, Ludwig Hohlwein, Privat Livemont, the Beggarstaff Brothers, Jan Toorop, Will Bradley, and others represent the finest achievements of the early masters of the poster. Trends and movements in modern art are reflected by Art Deco, Jugendstil, Constructivist, and Bauhaus designers. The collection also provides a wealth of material for political movements worldwide, extensive coverage of World Wars I and II, and radical and revolutionary posters from recent decades.

Posters were one of the earliest forms of advertising, but more than that, they are the mirrors of their time. Designed to catch the

eye in order to deliver their message, they turned the streets into public galleries. Underlying the art and the message explicit in the poster itself, is the artist who created it, his or her life and milieu, and the sponsor-advertiser who published it.

It has been my privilege and pleasure to work with the trove of artistic and documentary treasures comprising the Library's Poster Collection and to help it expand in size and scope. Working with the collection has not been dissimilar to archaeology: just as the archaeologist excavates a site, sifting through the layers of artifacts to construct the history of a civilization, I too enjoy extracting the full message from these visual documents. There are always new insights into our past to be discovered. For instance, new printing methods (from woodblock to computer-generated design), the depiction of modern technology (steamships to space shuttles, typewriters to computers), and changes in society (clothing styles, recreational pursuits, diets, and exercises) are well documented by this medium. Social concerns such as crime, housing, health, and quality of life are also reflected, as are political movements, wars, and revolutions. Each has produced countless memorable posters.

Through copyright deposits, purchases, and gift and exchange programs, the Library of Congress has assembled a collection of posters unrivaled anywhere in the world for its breadth, variety, and international character.

C. FORD PEATROSS
Curator, Architecture, Design, and Engineering
Prints and Photographs Division

The Architecture, Design, and Engineering Collections in the Prints and Photographs Division include over 2 million items in multiple formats, including drawings, prints, photographs, and written and printed documentation relating to the history and the development of architecture and engineering, and of three-dimensional design and the associated disciplines of landscape architecture, sculpture, and the decorative arts. Documentation of both the design process and its products is included, with an emphasis on American developments and achievements in the creation of new forms, typologies, and technologies.

Objects speak to us. They tell us of the past, of the hopes, dreams, and accomplishments of their creators. Visual documents relating to the history of architecture, design, and engineering show us how people lived and how they died, how they traveled and how

they worked, how they celebrated and how they mourned, how they succeeded and how they failed. Each print, photograph, and drawing is a rich capsule filled with information concerning the past as it was and as it might have been.

The more one works with visual documents, the easier it becomes to understand the how and the why of their creation, to divine their latent messages, and to communicate them to others. The beauty and important historical associations of many of these documents have a power of their own which can be both integral to and apart from the information they convey. From the wood-truss bridge to the steel-frame skyscraper, along with the submarine and the streamlined locomotive, during the last two centuries America has been at the forefront in the creation of new approaches, materials, technologies, and typologies in the fields of architecture, design, and engineering. The acquisition, conservation, service, and interpretation of the original documents that trace these developments is a special privilege and a unique and ever-expanding education. Frequently one is allowed a glimpse of the spark of genius that bridges the synapse between human thought and activity at its highest level. Ultimately, to collect for the Library of Congress is to share all of this with future generations. It just doesn't get any better than that.

BEVERLY BRANNAN
Curator of Photography
VERNA POSEVER CURTIS
Curator of Photography
CAROL M. JOHNSON
Assistant Curator of Photography
The Photography Collections
Prints and Photographs Division

The Photography Collections at the Library of Congress contain some 13 million prints and negatives, some dating from the invention of photography over 150 years ago. Most of them are documentary in nature, valued for their subject matter: they are significant because of the people, places, objects, events, or styles that they show. Approximately five thousand are classified individually because of the fame of their maker, their aesthetic nature, or the rare or superior technique used to create them, but masterworks can be found among the groups of documentary holdings as well. Three photography curators share responsibilities for this medium. The documentary portion is the focus of Beverly Brannan. The master photographs engage Verna Curtis. Nineteenth-century photography is the specialty of Carol Johnson.

"What was it like in the old days?" is a question I have always wondered about. I remember spending the evenings of my early childhood growing drowsy to the discussion of the day's events in an extended family. We had lived in one place for generations, so the discussions naturally included the history of the individuals or locations involved. I could see in my imagination what the elders talked about. Now I see the world in photographs through my job as custodian of documentary photographs at the Library of Congress.

It is an honor to work with collections amassed by Mathew Brady, Bain News Photo Service, Roy Stryker, and *Look* magazine, as well as the archives of pioneer photojournalists like Toni Frissell. What a privilege to be on hand when Congress provided additional staff to prepare many stored collections for public use, to help make America's visual heritage available to everyone on the Internet, in a format they can use to write their own histories.

Part of my work is to relate photographs to other visual media and texts, recognize new meanings in images already in the collection, and identify niches to fill with the exact object needed to complete a thought or open entire new areas of inquiry. I am mindful of the standards Roy Stryker established when he directed the Farm Security Administration (FSA) photography project that produced those graphic images that make the Great Depression real for us. The photographs represent all American peoples and record everyday life along with some momentous events.

I serve as a bridge between the artist or collector, the Library administration and the collections, and the conservator, the cataloger, and the public. The many circles of kindred spirits I meet enrich my life. I can give deeply to my work knowing the investment will bring rewards rich in ways I can never anticipate.

BB

Abraham Lincoln and his young wife, Mary Todd Lincoln, just before leaving Illinois for Washington and the tragic events of history we know so well; the first photo-documents of the American West in their original volumes produced for the Army Corps of Engineers; the touching visage of the quintessential mother and migrant of the Great Depression—these are a few of the images that are ingrained in the nation's memory. Such images readily enliven our historical imaginations through speedy digital transmission as "virtual artifacts." But it is critical to remember, too, that they have a tangible existence as treasured originals, be they one-of-a-kind daguerreotypes or rare albumen and gelatin silver prints. An important part of the

mission of the Library of Congress is to hold these originals in trust for future generations.

A medium in its infancy and adolescence in the nineteenth century, photography came to its full maturity in the twentieth. At this century's close, it becomes clear that still photography has predominated over the past one hundred years as the most widespread visual medium. Different stylistic schools have emerged, receded, and been replaced by fresh currents; critics and historians have codified the contributions of art- and documentary-movement leaders and followers. As only those with access to such comprehensive holdings as the ones that exist at the Library of Congress can fully understand, many publications have left behind forgotten experts in the medium who offer us that rare combination of mastery of technique and composition with meaningful content.

Curators of the Library's infinitely rich collections, informed with historical hindsight, have the privilege of nurturing objects like those pictured on these pages. Both visual icons and underappreciated masterpieces lend unique meaning to history. As curator of photography at the Library of Congress, I help to make them available while safeguarding them so that they continue to inform and to awe us. VPC

The Prints and Photographs Division Photography Collections are a constant source of visual stimulation. Unknown images are rediscovered daily in the course of answering reference letters, assisting researchers, cataloging photographs, surveying collections to determine their preservation needs, and researching potential acquisitions. Discovering the identity of a previously unknown sitter in a daguerreotype or finding a photograph that fills a gap in our holdings are among the many pleasures associated with curatorial work.

The acquisitions decision-making process requires careful consideration. Our primary aim is to collect images that document American life and culture—the events, landscapes, and people that shape this country. Once we have identified gaps in the collection or a theme around which we wish to collect, the sleuthing begins. We discuss our collecting goals with photographers, collectors, gallery owners, auction houses, and dealers. After examining several bodies of work, the images that are most appropriate for the Library usually stand out. Choosing one photographer's work over another is always difficult. When acquiring work for the collection, we select images that we feel will have long-term research value: images that will retain research interest twenty, fifty, or even one hundred years from now.

We have now entered the digital age. The public can access visual images over the Internet almost effortlessly from their homes. The Library is on the cutting edge of this technology, which allows us to share our images with a much broader public. But all of this would be of little value without the Library's outstanding collection of original photographs—the visual history of American life.

Shaping the nation's photography collections and providing access to its photographic treasures is my idea of the ideal occupation.
 CMJ

JON NEWSOM
Chief, Music Division

Unlike many other divisions of the Library of Congress, the Music Division's holdings are determined by subject rather than by format. Hence these holdings include approximately 8 million books, periodicals, prints, photographs, manuscripts, musical instruments, and other materials relating to music of all types and from all places. We are a microcosm of the Library of Congress.

The core of the collections are the copyright deposits, and the core of these are the American imprints. The greatest portion of these consists of popular music, of which we have a comprehensive collection, documenting the history of America in songs reflecting our changing political and social concerns. In addition, there are a vast number of hymn books from every denomination going back to Colonial times. Yet the scope of our collections is universal. We have original manuscripts from Gregorian chant to modern jazz, books and periodicals in every Roman and Cyrillic alphabet language, printed music from Petrucci to computer-generated scores, violins by Stradivarius and Guarnerius, and more than sixteen hundred wind instruments from a jade *shakuhachi* to a modern gold flute.

The establishment of the Coolidge Foundation in 1925 brought a wealth of contemporary composers' manuscripts to the Music Division through commissions from Barber, Bartók, Britten, Copland, Hindemith, Ravel, Respighi, Schoenberg, and Stravinsky, among others. Manuscripts of many eighteenth- and nineteenth-century masters, from Bach, Mozart, Haydn, and Beethoven to Schubert, Mendelssohn, Brahms, and Wagner were acquired through the Whittall Foundation, which established our resident quartet with the gift of five Strads. The generosity of the families of the Gershwin brothers brought us their papers and a fund to help build our collections relating to the American musical

theater. Manuscripts by film composers, including Korngold, Herrmann, and Raksin, are here. Recently, we received major archival gifts from the families of Irving Berlin and Leonard Bernstein. Not least, we have acquired collections of major jazz musicians from Jelly Roll Morton to Charles Mingus.

Passing our centennial in 1997, we have already made significant acquisitions in dance and theater, thus further expanding our scope so that we are now truly a center for the study of the performing arts.

PATRICK LOUGHNEY
Head, Moving Image Section
Motion Picture, Broadcasting and Recorded Sound Division

The collections of the Motion Picture, Broadcasting and Recorded Sound Division today comprise over 200,000 film prints (35mm and 16mm), more than 125,000 television broadcasts in film and video formats, over 500,000 radio broadcasts, and 1.7 million sound recordings. The collections relating to the history of American film production through the past one hundred years, including the classical Hollywood period, are particularly rich. The division is also noted for its leading role in preserving films by African Americans, particularly those of the pioneer producer/director Oscar Micheaux; the ethnographic films of Margaret Mead and Gregory Bateson; the early exploration films of Osa and Martin Johnson; and films made for Yiddish-language audiences and other minority groups. The Library also has the most widely representative collection of foreign-language films in the world, with particular strengths in German, Japanese, and Italian films of the 1930s and 1940s, British films of the postwar era, and Chinese-language features distributed in America since 1978. One of the Library's largest collections is that of the American Film Institute, totaling more than twenty-eight thousand titles.

The first motion pictures collected by the Library of Congress were received as a copyright deposit from W. K. L. Dickson on October 6, 1893. Dickson, a key assistant to Thomas Edison, was primarily responsible for inventing the first practical motion picture camera (the Kinetograph) and the first peephole viewing machine (the Kinetoscope). From that date to the present, the Library has collected descriptive documentation and other materials relating to virtually every movie copyrighted in the United States.

In May 1942, Librarian of Congress Archibald MacLeish—seeing that movies, radio broadcasts, and recordings in all their

formats constituted essential records of American history—founded the forerunner to the present-day Motion Picture, Broadcasting and Recorded Sound Division. The Library's first two important acquisitions in the 1940s were the film collections of Mary Pickford and the pioneering Chicago distributor George Kleine.

The M/B/RS Division is not only the nation's largest collection of film, television, radio, and recorded sound research materials, it also operates the largest publicly funded complex of laboratories dedicated to the preservation of historical audiovisual formats. Over fifteen thousand theatrical films have been preserved in their original 35mm format since the Library's film preservation laboratory was founded in 1970.

Today, the mission of the M/B/RS Division remains the same as when it was defined by MacLeish at midcentury: to maintain an ongoing collection of motion picture, broadcast, and recorded sound materials that broadly document the history and creativity of the American people.

The Base Ball Collar. Color lithograph, advertising label, 1869.

ACKNOWLEDGMENTS

The Library of Congress is the Everest of libraries. To attempt to scale even its lower slopes without expert guidance is to risk plunging to hubristic death or wending one's way along the well-trod paths at its base. Bernard Reilly, former head curator of the Prints and Photographs Division, thought my idea of a visual history of America culled collaboratively from the Library's various collections a good one; he fought hard to convince the administration of its viability, then led me by the hand into the lives of the curators listed at the front of this book. They took me to the peaks where the very stars themselves were within my grasp. Each of the curators is a national treasure. Without them, the "oculists" of our nation, there would have been nothing unique about this book. I asked them to show me what they loved best, what kept them working with so little recognition, what "stuff" they most treasured: this book is the result of that exercise. They are a passionate crew I have come to love dearly. Their collective genius and daring have given me the greatest, most exhilarating, most profoundly satisfying professional experience of my life. To sit in a room with all of them excitedly "constellating" a chosen image by adding related images to it, or discussing and conjuring visuals for a particular moment in our history, is bliss. Elena Millie, Curator of Posters, kept us all on deadline with a tender ferocity. Our optimistic guardian angel was Margaret Wagner in the Publishing Office; she is a divinely patient woman of manifold gifts, and no one worked harder—from earliest development to final permissions, she always saved the day. Ralph Eubanks, Director of Publishing, tackled the most daunting problems and personalities head on; he is a very brave and very fine boss. My colleagues in the Publishing Office welcomed me warmly, especially Sara Day who managed the copyediting while acting as editorial advisor, and Susan Sharp, a superb sleuth who also was my unflappable WordPerfect crisis diva.

Each division is staffed with specialists, librarians, and researchers who always proved the old adage: If you cast bread upon the waters, it comes back sandwiches. They tirelessly suggested and searched for the most exquisite examples of whatever subject I was exploring; each is acknowledged elsewhere by name, as is the Prints and Photographs Division's processing team led by Helena Zinkham that poured weeks into assuring all items reproduced in the book were properly identified and cataloged. There are dozens of others without whom we could not have met our deadlines. (Marita Clance in the Photoduplication Lab and Jim Higgins, Library of Congress staff photographer, immediately come to mind, along with Ruth Freitag, Len Bruno, Joan Higbee, Clark Evans, Rob Shields, Jim Gilreath, and if I don't stop we'll have three more pages!)

For me, the Library is not only the home of some of the world's most sublime stuff, but also *my* home; I spent three years working here on this dream project for the Rolls-Royce of publishers, Knopf, where our creative and dynamic editor, Jennifer Bernstein, moved several peaks of my rocky prose and kept track of the massive enterprise to make this book all it could be. Andy Hughes said yes to every one of our fantasies—including the gatefold—and masterminded, along with Romeo Enriquez and Larry Flusser, the masterpiece of production we now have for the rest of our lives. Peter A. Andersen's sensitive and gorgeous layouts gave us all an immense and a rather giddy delight; he makes our work look its very best. Kevin Bourke worked a thousand hours to smooth the rough edges of the text. Carol Carson and Archie Ferguson were a joy to work with on the jacket. Jane Friedman, Kathy Hourigan, and Ash Green lavishly gave their support to the project. Martha Kaplan, my agent, tied the whole thing together, and offered wise counsel. It is painful writing these acknowledgments in the past tense. This book isn't over; it's only just being born, and yet I am eager to sit down and hold it in my hands to see what God hath wrought. And I want to thank James McCourt for coming to Washington, D.C., with me. I dedicate my work here to the memory of my parents, Philip (1910–84) and Frances (1916–97).

Vincent Virga

Though the Library of Congress curators named in the front of this volume were, with Vincent Virga, the principal coauthors of the book, *Eyes of the Nation* could not have been completed without the time, energy, and expertise of many other Library of Congress staff members.

In the Prints and Photographs Division: Maricia Battle, Jennifer Brathovde, Donna Collins, Sam Daniel, Sara Duke, DeAnna D. Evans, Jan Grenci, Marilyn Ibach, Tabatha Irving, Mary Ison, Maja Keech, Jeanne Korda, Doris Lee, Jacqueline Manapsal, Tracy Meehleib, John Minichino, Barbara Natanson, Ashley Roach, Sarah Rouse, Woody Woodis, and Helena Zinkham. Special thanks are due to former Prints and Photographs division chief Stephen E. Ostrow and former assistant chief Elizabeth B. Parker.

In the Motion Picture, Broadcasting, and Recorded Sound Division: Larry Applebaum, Arlene Balkansky, Rosemary Hanes, Madeline Matz, Marzella Rhodes, and Brian Taves.

In the Music Division, Patricia Willard and Raymond White. In Conservation: Tom Albro, Linda Steiber, and Heather Wanser. In the Publishing Office: Gloria Baskerville-Holmes, Sara Day, Blaine Marshall, and Margaret Wagner. In the Manuscript Division: Connie Cartledge, Joseph Sullivan, Alice Birney, Len Bruno, Adrienne Cannon, Gerard Gawalt, John Haynes, Marvin Kranz, Janice Ruth, Mary Wolfskill, and John Sellers. In Integrated Support Services: Delores Clipper. In the Copyright Office: Jim Cole and Frank Evina. In

the Geography and Map Division: Jim Flatness. In the Rare Book and Special Collections Division: Clark Evans and Rosemary Plakas. In the National Digital Library: Carl Fleischhauer. In the American Folklife Center: Judith Gray and James Hardin. In the Humanities and Social Sciences Division: David Joseph Kelly. In the Newspaper Section: Bernard Michael. In the Hebraic Section: Peggy Pearlstein. In the Congressional Research Service: Roger Walke.

A number of people outside the Library also contributed to the creation of this book. A special thanks is due to Ed Owen for his painstaking patience in photographing many of the items presented in *Eyes of the Nation.* Thanks also go to: Jean Adams; Mary Street Alinder; Jeffrey Cohen, American Philosophical Society; David Cook; Charles Cooney; Susan Dalton, American Film Institute; Jack Custer, Egregious Steamboat Journal; Keith F. Davis, Fine Arts Program Director, Hallmark Cards, Inc.; Robert Dawson; Jack Delano; Leslie Dill; Kathleen A. Erwin, Curator, Warren and Margot Coville Photographic Collection; Peter Goin; William Gottleib; Sarah Greenough, Curator of Photographs, National Gallery of Art; Anne Hammond; Ed Hill, University of Wisconsin at LaCrosse, Steamboat Archive; George Hobart; Barbara Janowitz, Marion County Historical Society, Ocala, Florida; Richard Longstreth, George Washington University; Danny Lyon; John Magill, Historic New Orleans Collection; Gerald Markowitz; Roger Mertin; Tom Murphy, George Washington University; James F. O'Gorman, Wellesley College; Peter Palmquist; Max Protetch; Robert Rauschenberg; Robert Reid; Andrew Robb; Walter Rosenblum; David Rosner; Pamela Scott; Noel Smith, Graphicstudio; Ted Spencer, National Baseball Hall of Fame and Museum, Inc., Cooperstown, New York; Anne Thomas, Curator of Photographs, National Gallery of Canada; Jennifer A. Watts, Curator of Historical Photographs, Huntington Library; Bob Zeller; Howard Steamboat Museum; Jeffersonville, Indiana, Public Library; Tohono O'odham Reservation, Sells, Arizona.

Library of Congress

INDEX

Italicized page numbers indicate illustrations.

OBJECT LIST AND REPRODUCTION NUMBERS

The following list provides the reproduction numbers for color and black-and-white copies of the objects reproduced in this book. Each entry contains page number, location on page (if necessary), Library of Congress custodial division, and reproduction number(s). Color transparencies are indicated by the prefix LC-USZC4 or LC-USZC2; all other reproduction numbers (e.g. LC-USZ62-XXXX, LC-USW3-XXXX, LC-BHXX-XXXX, etc) indicate black-and-white negatives. Copy color transparencies and black-and-white prints can be ordered directly from the Library's Photoduplication Service, Washington, DC 20540-5230 (telephone 202-707-5640). If a reproduction number is not listed, contact the division cited for further instructions on how to obtain a copy. The Library's general telephone number is 202-707-5000. *Please note*: Special permission has been obtained to include in *Eyes of the Nation* those images whose reproduction numbers are followed by an asterisk; please see individual object captions and p. 399 for credits. Researchers are advised to seek permission before publishing those images marked with asterisks.

Abbreviations for custodial divisions

AFC American Folklife Center
G&M Geography and Map Division
P&P Prints and Photographs Division
MBRS Motion Picture, Broadcasting and Recorded
 Sound Division
MSS Manuscript Division
MUS Music Division
RB Rare Book and Special Collections Division
SER Serials and Government Publications
 Division

Front
first spread: P&P, LC-USZC4-5592. frontispiece: LC-USZC4-1302. opposite copyright page: P&P, LC-USZC4-5585, LCUSZ62-10845. opposite epigraph: top P&P, LC-USZC4-5588; bottom P&P, LC-USZC4-5589. opposite contents: P&P, LC-USZC4-5586, LCUSZ62-14736. opposite preface: RB. following preface: P&P, LC-USZ62-119650. half-title spread: P&P, LC-USZC4-4491.

Chapter One:
ENCOUNTER, 1492–1600
2: RB, LC-USZC4-5267, LC-USZ62-52444. 4: RB, LC-USZC4-5300. 5: RB, LC-USZC4-5268. 6: P&P, LC-USZC4-4710. 7: RB, LC-USZC4-5269. 8: MSS. 10: top RB, LC-USZC4-5272; bottom RB, LC-USZC4-5274. 11: top

MSS; bottom RB, LC-USZC4-5271. 12-13: G&M. 14: top left RB, LC-USZC4-5270; middle right RB, LC-USZC4-5301; bottom RB, LC-USZC4-5302. 15: top RB, LC-USZC4-5303; bottom RB, LC-USZC4-5304. 16-17: G&M. 18: MSS. 19: top RB, LC-USZC4-5306, LC-USZ62-32377; bottom RB, LC-USZC4-5305. 20: G&M. 21: RB, LC-USZC4-5307.

Interlude:
THE GARDEN
22: RB, LC-USZC4-5347. 23: top left RB, LC-USZC4-5348; top right RB, LC-USZC4-5349; bottom RB, LC-USZC4-5350. 24: top left P&P, LC-USZC4-5351; top right RB, LC-USZC4-5353; bottom RB, LC-USZC4-5352. 25: top left RB, LC-USZC4-5354; top right RB, LC-USZC4-5355; bottom RB, LC-USZC4-5357. 26: top left RB, LC-USZC4-5359; top right RB, LC-USZC4-5360; bottom RB, LC-USZC4-5358. 27: RB, LC-USZC4-5356. 28: top left RB, LC-USZC4-5362; top right RB, LC-USZC4-5363; bottom RB, LC-USZC4-5364. 29: top left RB, LC-USZC4-5365; top right RB, LC-USZC4-5367; bottom RB, LC-USZC4-5366*.

Chapter Two:
THE WORLD TURN'D UPSIDE DOWN, 1600–1800
30: RB, LC-USZC4-5308. 33: P&P, LC-USZC4-4597, LC-USZ62-108365. 35: RB, LC-USZC4-5309. 36: P&P, LC-USZC4-4613. 39: P&P, LC-USZC4-4599, LC-USZ62-22385. 41: P&P, LC-USZC4-5179, LC-USZ6-200. 42: RB, LC-USZC4-5310. 46: top G&M; bottom RB, LC-USZC4-5311, LC-USZ62-34018. 47: top G&M; bottom P&P, LC-USZC4-4603, LC-USZ62-114953. 48: top RB, LC-USZC4-5312; bottom G&M. 49: top MSS; bottom P&P, LC-USZC4-4715, LC-USZ62-1912. 50: top RB, LC-USZC4-5313; bottom RB, LC-USZC4-5314, LC-USZ62-49991. 51: top SER, LC-USZC4-5315, LC-USZ62-9701; bottom MSS. 52: top G&M; bottom P&P, LC-USZC4-4596, LC-USZ62-31185-A. 53: top MUS; bottom RB, LC-USZC4-5316, LC-USZ62-40054. 54: top MSS; bottom P&P, LC-USZC4-4617, LC-USZ62-12711. 55: P&P, LC-USZC4-4600, LC-USZ62-35522. 56: top SER, LC-USZC4-5317; bottom P&P, LC-USZC4-4601, LC-USZ62-1523. 57: top P&P, LC-USZC4-4602, LC-USZ62-45181; bottom G&M. 58-59: P&P, LC-USZ C4-3282. 60: MSS. 61: top RB, LC-USZC4-5318, LC-USZ6-862; bottom G&M. 62: top MSS; bottom RB, LC-USZC4-5319, LC-USZ62-39585. 63: G&M. 64-65: G&M. 66: top G&M; bottom P&P, LC-USZC4-4598, LC-USZ62-1531. 67: top MSS; bottom G&M. 68-69: G&M. 70: MSS. 71: top SER, LC-USZC4-5320, LC-USZ62-34260; bottom MSS. 72: top RB, LC-USZC4-5326, LC-USZ62-44000; bottom P&P, LC-USZC4-4612. 73: G&M.

Chapter Three:
WESTWARD THE COURSE OF EMPIRE, 1800–1850
74: MSS. 77: P&P, LC-USZC4-4548, LC-USZ62-94848. 78: P&P, LC-USZC4-1242, LC-USZ62-13253. 79: P&P, LC-USZC4-3878, LC-USZ62-91391. 81: RB, LC-USZC4-5321. 84: top MSS; bottom MSS. 85: G&M. 86: top P&P, LC-USZC4-4547, LC-USZ62-1552; bottom MSS. 87: top P&P, LC-USZC4-47, LC-USZ62-13240; bottom P&P, LC-USZC4-1495, LC-USZ62-3068. 88: RB, LC-USZC4-5322. 89: top P&P, LC-USZC4-4544, LC-USZ62-28114; bottom P&P, LC-USZC4-4561. 90-91: RB, LC-USZC4-5323. 92: top P&P, LC-USZC4-4555, LC-USZ62-1939; bottom MSS. 93: top MUS; bottom G&M. 94: P&P, LC-USZC4-3924, LC-USZ62-3778. 95: top P&P, LC-USZC4-4553, LC-USZ62-1221. bottom P&P, LC-USZC4-2672, LC-USZ62-83676. 96: top P&P, LC-USZC4-3673; bottom P&P, LC-USZC4-4542, LC-USZ62-54414. 97: top left P&P, LC-USZC4-4558; bottom right RB, LC-USZC4-5324. 98: G&M. 99: top RB, LC-USZC4-5325; bottom P&P, LC-USZC4-4565. 100: P&P, LC-USZC4-4564, LC-USZ62-7747. 101: RB, LC-USZC4-5327. 102: top P&P, LC-USZC4-313, LC-USZ62-33557; bottom P&P, LC-USZC4-4554, LC-USZ62-5818. 103: P&P, LC-USZC4-4570, LC-USZ62-58622. 104: G&M. 105: P&P, LC-USZC4-4562, LC-USZ62-765. 106: top RB, LC-USZC4-5328; bottom P&P, LC-USZC4-4543, LC-USZ62-54596. 107: P&P, LC-USZC4-4563. 108: top P&P, LC-USZC4-3670; bottom MSS, LC-USZ62-110375. 109: top RB, LC-USZC4-5329; middle RB, LC-USZC4-5330; bottom P&P, LC-USZC4-4567. 110: top G&M; bottom RB, LC-USZC4-5332. 111: top G&M; bottom RB, LC-USZC4-5333. 112: top P&P, LC-USZC4-4556, LC-USZ62-2550; bottom left P&P, LC-USZC4-4549, LC-USZ62-89832; bottom right MSS. 113: top P&P, LC-USZC4-3596, LC-USZ62-110212; bottom MSS. 114: top RB, LC-USZC4-5331; middle P&P, LC-USZC4-4551, LC-USZ62-4918; bottom P&P, LC-USZC4-4569, LC-USZ62-36094. 115: top P&P, LC-USZC4-2439, LC-USZ62-12457; bottom P&P, LC-USZC4-4559. 116: top P&P, LC-USZC4-4557, LC-USZ62-126; bottom P&P, LC-USZC4-2713. 117: top P&P, LC-USZC4-4552, LC-USZ62-8230; bottom P&P, LC-USZC4-4550, LC-USZ62-1286. 118: P&P, LC-USZC4-2853, LC-USZ62-93402. 119: G&M. 120: top RB, LC-USZC4-5334; bottom RB, LC-USZC4-5335. 121: P&P, LC-USZC4-4568, LC-USZ62-33609.

Interlude:
THE RIVER
122-127: top G&M; 122: middle P&P, LC-USZC4-4900, LC-USZ62-2429; bottom P&P, LC-D401-19395. 123: bottom G&M. 124: middle P&P, LC-USZC4-4904, LC-USZ62-484; bottom P&P, LC-USZC4-4841.

125: bottom P&P, LC-USZC4-4899, LC-USZ62-1032.
126: middle left RB, LC-USZC4-5346; middle right
P&P, LC-USZC4-4902*; bottom left P&P, LC-USZC4-
4907, LC-USZ62-42485; bottom right MUS*. 127:
bottom G&M*.

Chapter Four:
A MORE PERFECT UNION, 1850–1870
128: P&P, LC-USZC4-4574. 130: P&P, LC-USZC4-3944,
LC-USZ6-2041. 131: P&P, LC-USZC4-5009, LC-USZ62-
2606. 135: P&P, LC-USZC4-4583, LC-USZ62-48089.
136: P&P, LC-B8184-2350. 141: P&P, LC-USZ62-28044.
144: top P&P, LC-USZC4-5205; bottom P&P, LC-
USZC4-4575. 145: top P&P, LC-USZC4-2356; bottom
P&P, LC-USZC4-4609, LC-USZ62-41178. 146: top P&P,
LC-USZC4-4588; bottom P&P, LC-USZC4-4594, LC-
USZ62-13275. 147: top P&P, LC-USZC4-3888, LC-
USZ62-110105; bottom P&P, LC-USZC4-4592. 148:
G&M. 149: top LAW, LC-USZC4-5336; bottom LAW,
LC-USZC4-5337. 150: P&P, LC-USZC4-1837, LC-USZ62-
502. 151: top P&P, LC-USZC4-4610, LC-USZ6-2004;
bottom P&P, LC-USZC4-3598, LC-USZ62-106400. 152:
top P&P, LC-USZC4-4607, LC-USZ6-2165; bottom
P&P, LC-USZC4-4545. 153: RB, LC-USZC4-5338. 154:
top P&P, LC-USZC4-4611, LC-USZ62-10208; bottom
P&P, LC-USZC4-4577, LC-USZ62-46909. 155: top MSS;
bottom RB, LC-USZC4-5339. 156: P&P, LC-USZ62-
55591. 157: top MSS; bottom P&P, LC-USZC4-4578.
158-59: P&P, LC-USZC4-922, LC-USZ62-14199. 160:
top P&P, LC-USZC4-4616; 160: bottom P&P, LC-
USZC4-4584, LC-USZ62-10704. 161: top P&P, LC-
USZC4-4571, LC-USZ62-98824; bottom P&P,
LC-USZC4-4608. 162: top P&P, LC-USZC4-4576;
bottom G&M. 163: MSS. 164: top P&P, LC-USZC4-
4618, LC-USZ62-7930; bottom P&P, LC-USZC4-4605.
165: top MSS; bottom P&P, LC-USZC4-4587. 166:
P&P, LC-USZC4-2394, LC-USZ62-157. 167: top P&P,
LC-USZC4-4573, LC-USZ62-14819. 168: MSS. 169:
MSS. 170: top MSS; bottom RB, LC-USZC4-5340, LC-
USZ62-100062. 171: top P&P, LC-USZC4-1005, LC-
USZ62-14372; bottom MSS. 172: top G&M; bottom
P&P, LC-USZC4-4579, LC-USZ62-101396. 173: P&P, LC-
USZC4-4595, LC-B8171-7926. 174: top MSS; bottom
P&P, LC-USZC4-4589, LC-B8184-10054. 175: top P&P,
LC-USZC4-4593, LC-B8171-905; bottom MUS. 176:
RB, LC-USZC4-5341, LC-USZ62-11193. 177: P&P, LC-
USZC4-4591, LC-USZ62-114830. 178: top P&P, LC-
USZC4-4572, LC-USZ62-94553; bottom P&P,
LC-USZC4-4590, LC-USZ62-2589. 179: P&P, LC-USZC4-
2388, LC-USZ62-13637. 180: top P&P, LC-USZC4-948,
LC-USZ62-80408; bottom P&P, LC-USZC4-2342, LC-
USZ62-19443. 181: top P&P, LC-USZC4-2399, LC-
USZ62-36272; bottom RB, LC-USZC4-5342,
LC-USZ62-32498. 182: top P&P, LC-USZC4-4580, LC-
USZ62-20359. 183: P&P, LC-USZC4-4615, LC-USZ62-
7743.

Chapter Five:
YEARNING TO BREATHE FREE,
1870–1920
184: P&P, LC-USZC4-4637. 186: P&P, LC-USZC4-2343,
LC-USZ62-1320. 187: P&P, LC-USZC4-4703, LC-USZ62-
80186. 188: P&P, LC-USZC4-4859, LC-USZ62-19725.
193: P&P, LC-USZ62-116999. 197: P&P, LC-USZC4-
4936. 200: top P&P, LC-USZC4-4860; bottom P&P,
LC-USZC4-4649, LC-USZ62-17356. 201: P&P, LC-
USZC4-4644, LC-USZ62-17946. 202: top P&P, LC-
USZC4-4698, LC-USZ62-107389; bottom P&P,
LC-USZC4-4694, LC-USZ6-106. 203: top P&P, LC-
USZC4-3327, LC-USZ62-83911; bottom P&P, LC-
USZC4-4700, LC-USZ62-71317. 204: P&P,
LC-USZC4-4641, LC-USZ62-39425. 205: top G&M;
bottom P&P, LC-USZC4-4706, LC-USZ62-48354. 206:

P&P, LC-USZC4-4629, LC-USZ62-4536. 208: top P&P,
LC-USZC4-4634, LC-USZ62-64191; bottom MUS. 209:
top P&P, LC-USZC4-3331, LC-USZ62-23314; bottom
P&P, LC-USZC4-4645, LC-USZ62-80511. 210: top P&P,
LC-USZC4-667, LC-USZ62-47409; bottom P&P, LC-
USZC4-3655. 211: top MSS; bottom MBRS, LC-
USZ62-45683. 212: top left MBRS; middle right
MBRS; bottom MBRS. 213: top P&P, LC-USZC4-4861,
LC-USZ62-536; bottom MBRS. 214: top P&P, LC-
USZC4-1102, LC-USZ62-39741; bottom MBRS. 215:
MBRS. 216: top P&P, LC-USZ62-6166-A; bottom
P&P, LC-USZC4-4713, LC-USZ6-18. 217: P&P, LC-
USZC4-4642, LC-USZ62-1048. 218: top P&P, LC-
USZC4-4646, LC-USZ62-10014; bottom P&P,
LC-USZC4-4697, LC-USZ62-112196. 219: top RB, LC-
USZC4-5343; bottom P&P, LC-USZC4-4712. 220-221:
top P&P, LC-USZC4-4625; bottom P&P, LC-USZC4-
4624, LC-USZ62-115247. 222: top: P&P, LC-USZC4-
3126; bottom P&P, LC-USZC4-4635, LC-USZ62-98217.
223: top P&P, LC-USZC4-3126; bottom P&P, LC-
USZC4-4705. 224: top P&P, LC-USZC4-4636; bottom
P&P, LC-USZC4-4640. 225: top P&P, LC-USZC4-4632,
LC-USZ62-11546; bottom P&P, LC-USZC4-4702, LC-
USZ62-104028. 226: top P&P, LC-USZC4-4632, LC-
USZ62-11546; bottom P&P, LC-USZC4-4622. 227-30:
P&P, LC-USZC4-4627. 231-33: P&P, LC-USZC4-4628.
234: P&P, LC-USZC4-4621. 235: top P&P, LC-USZC4-
4699, LC-USZ62-69761; bottom P&P, LC-USZC4-4704,
LC-USZ62-56609. 236: top P&P, LC-USZC4-4691, LC-
USZ62-3514; bottom P&P, LC-USZC4-4695, LC-USZ62-
38564. 237: top P&P, LC-D401-13645; bottom P&P,
LC-USZC4-4626. 238: top P&P, LC-B2-966-15;
bottom MBRS. 239: top P&P, LC-USZC4-2173;
bottom P&P, LC-USZC4-4708, LC-USZ62-92824. 240:
top MBRS; bottom P&P, LC-USZC4-4709. 241: P&P,
LC-USZC4-4647, LC-USZ62-35348. 242: P&P, LC-
USZC4-4633. 243: top P&P, LC-USZC2-567, LC-USZ62-
82853; bottom P&P, LC-USZC4-4696. 244: top MSS;
bottom MSS. 245: top MSS; bottom P&P, LC-
USZC4-4630. 246: top P&P, LC-USZC4-4623, LC-
USZ62-50437; bottom P&P, LC-USZC4-4862,
LC-USZ62-30534. 247: MSS. 248: top P&P, LC-USZC4-
4714, LC-USZ62-94751; bottom P&P, LC-USZC4-4711.
249: G&M.

Interlude:
THE CITY
250: P&P, LC-USF34-43159-D. 251: P&P, LC-USZC4-
4909*. 252: top G&M; bottom G&M. 253: top
G&M; bottom: G&M. 254: top left P&P, LC-USZA1-
1671; top right P&P, LC-USZC4-4906, LC-S35-BT118-
9; bottom P&P, LC-USZC4-4903, LC-USZ62-111306.
255: top P&P, LC-USZC4-3927*; bottom P&P, LC-
USZC4-4901*.

Chapter Six:
RENDEZVOUS WITH DESTINY,
1920–1945
256: P&P, LC-USZC4-4856, LC-USZ62-94257. 258: P&P,
LC-USZC4-4839. 261: P&P, LC-USZC4-5369. 263: P&P,
LC-USZ62-15589. 264: P&P, LC-USZC4-4893*. 265:
P&P, LC-USZ62-94202. 267: P&P, LC-USZC4-4890, LC-
USZ62-90003. 269: P&P, LC-USZC4-4910. 270: P&P,
LC-USW3-34282-C. 272: P&P, LC-USZC4-4736*. 273:
top MBRS*; bottom MBRS*. 274: top P&P, LC-
USZC4-4737*; bottom P&P, LC-USZC4-2379*, LC-
USZ62-100153*. 275: top P&P, LC-USZC4-4727,
LC-USZ62-104203; bottom P&P, LC-USZC4-4719*, LC-
USZ62-2381*. 276: top MBRS*; bottom MBRS*.
277: top P&P, LC-USZC4-4729; bottom P&P, LC-
USZC4-2043*, LC-USZ62-68507*. 278: top P&P, LC-
LY13-1; bottom P&P, LC-USZC4-3307. 279: top P&P,
LC-USZC4-2206*; bottom MUS*. 280: top MBRS*;

bottom P&P, LC-USZC4-4721. 281: top P&P, LC-
USZC4-4718, LC-USZ62-42983; bottom MBRS*. 282:
top P&P, LC-USZC4-4935, LC-USZ62-77891; bottom
P&P, LC-USZC4-3567, LC-USZ62-69101 (note: C4
shows a whole page; Z62 shows lower image). 283:
top left MBRS*; bottom right P&P, LC-USZC4-4725.
284: top P&P, LC-USF34-60994-D; bottom MUS.
285: top P&P, LC-USZC4-4722, LC-USZ62-86033;
bottom COP*. 286: top P&P, LC-USF33-6204-M1;
bottom P&P, LC-USZC4-4842. 287: top P&P, LC-
USZC4-4898, LC-USF342-8147-A; bottom P&P, LC-
USZC4-4724. 288: top left P&P, LC-USF34-T01-9093-C;
top right P&P, LC-USF34-T01-9095-C; middle P&P, LC-
USF34-T01-9097-C; bottom P&P, LC-USF34-T01-9098-
C, LC-USZ62-58355. 289: P&P, LC-USF34-T01-9058-C.
290: top MSS; bottom P&P, LC-USZC4-4840, LC-
USZ62-11491. 291: top P&P, LC-USZC4-4831*, LC-
USZ62-98213*; bottom MBRS*. 292: top right P&P,
LC-USZC4-4838, LC-USZ62-89651; middle left P&P,
LC-USZC4-4917*, LC-USZ62-63874*. 292-3: bottom G&M.
294: top P&P, LC-USZC4-4836*; bottom P&P, LC-
USZC2-1141. 295: top MUS*; bottom P&P, LC-USW3-
23953. 296: top P&P, LC-USF34-42905-D; bottom P&P,
LC-USF34-55314-D. 297: P&P, LC-USZC4-4846*. 298:
top P&P, LC-USZC4-4717*; bottom P&P, LC-USZC4-
4734, LC-USZ62-33793. 299: P&P, LC-USZC4-4733,
LC-USZ62-33790. 300: top G&M; bottom P&P, LC-
USF34-55240-D. 301: top P&P, LC-USF34-32264-D;
bottom P&P, LC-USZC4-5266, LC-USZ62-80423. 302:
top MBRS*; bottom MUS*. 303: top MSS; bottom left
P&P, LC-USZC4-4723, LC-USZ62-115154; bottom right
P&P, LC-USZC4-4837, LC-USZ62-55866. 304: top P&P,
LC-USZC4-4726; bottom P&P, LC-USZC4-4728*, LC-
USZ62-87990*. 305: top P&P, LC-USZ62-87989;
bottom MBRS. 306: P&P, LC-USZC4-4731, LC-USZ62-
15187. 307: P&P, LC-USZC4-4732, LC-USZ62-99499.
308: top P&P, LC-USW3-54042-C; bottom P&P, LC-
USW3-29814-E. 309: top P&P, LC-USZC4-4834; bottom
P&P, LC-USZC4-4730. 310: MSS. 311: MSS. 312: top
MUS; bottom P&P, LC-USZC4-4835*. 313: P&P, LC-
USZC4-4844.* 314: top P&P, LC-USZC4-4845*, LC-
USZ62-102066*; bottom MUS. 315: top left P&P,
LC-USZC4-4716*; bottom right P&P, LC-USZC4-4738*.

Chapter Seven:
THE PURSUIT OF HAPPINESS, 1945–
316: P&P, LC-USZC4-5206*. 318: P&P, LC-USZC4-
4888*, LC-USZ62-69946*. 319: P&P, LC-USZC4-4895*,
LC-USZ62-85958*. 323: P&P, LC-USZC4-4843*. 325:
P&P, LC-USZC4-4864. 328: P&P, LC-USZC4-4887*, LC-
USZ62-84032*. 330: P&P, LC-USZC4-4885*. 332: top
P&P, LC-USZC4-4886*; bottom G&M. 333: top P&P,
LC-USZC4-4881*; bottom RB, LC-USZC4-5344. 334:
top P&P, LC-USZC4-4884*, LC-USZ62-89684*;
bottom G&M. 335: P&P, LC-USZC4-4894*. 336:
P&P.* 337: top MUS*; bottom P&P, LC-L92-51-
AK30, no. 1. 338: top left P&P, LC-USZC4-4919*, LC-
USZ62-76637*; top right P&P, LC-USZC4-4920*,
LC-USZ62-76638*; bottom MUS*. 339: top left P&P,
LC-USZC4-4921*, LC-USZ62-76639*; top middle P&P,
LC-USZC4-4918*, LC-USZ62-76640*; top right P&P,
LC-USZC4-4922*, LC-USZ62-76641*; bottom P&P, LC-
USZC4-4889. 340: top P&P, LC-USZC4-4880; bottom
P&P, LC-USZC4-4866*. 341: top MBRS*; bottom
P&P, LC-USZC4-4867*, LC-USZ62-86785*. 342: top
P&P, LC-USZC4-4854*; bottom P&P, LC-G613-T-
60423-B*. 343: top P&P, LC-USZC4-4857; bottom
P&P, LC-USZC4-4892, LC-F9-02-5309-023-01. 344: top
P&P, LC-USZC4-4891*; bottom MBRS*. 345: top
MSS; bottom P&P, LC-USZC4-4914*. 346: top P&P,
LC-USZC4-4897*; bottom P&P, LC-USZC4-2574, LC-
USZ62-98200. 347: top SER*, LC-USZC4-5345*;
bottom P&P, LC-USZC4-4858. 348: top P&P, LC-
USZC4-4882; bottom G&M. 349: top MBRS*;

bottom MBRS*. 350: P&P.* 351: top P&P, LC-USZC4-4911*; bottom P&P, LC-USZC4-4870*. 352: top P&P, LC-USZC4-1911*, LC-USZ62-96354*; bottom P&P, LC-USZC4-4879, LC-USZ62-96341. 353: P&P, LC-USZC4-4915, LC-USZ62-90338. 354: top MBRS*; bottom P&P, LC-USZC4-4872*. 355: top P&P, LC-USZC4-4873*; bottom P&P, LC-USZC4-5021*. 356: top P&P, LC-USZC4-4869*; bottom P&P, LC-USZC4-5416*. 357: top P&P, LC-USZC4-4876*; bottom MBRS*. 358: top P&P, LC-USZC4-4896*, LC-USZ62-113884*; bottom P&P, LC-USZC4-4877*, LC-USZ62-108765*. 359: G&M. 360: G&M*. 361: top P&P, LC-USZC4-4883*; bottom MBRS*. 362: top P&P, LC-USZC4-4865*; bottom P&P, LC-USZC4-4847*. 363: top P&P, LC-USZC4-4852*; bottom P&P, LC-USZC4-4848. 364: top AFC; bottom AFC. 365: AFC. 366: top P&P, LC-USZC4-4863; bottom P&P, LC-USZC4-4853*. 367: P&P, LC-USZC4-4878. 368-69: G&M.

Interlude:
P E O P L E
370: top left P&P, LC-USZC4-5181; top right P&P, LC-USZC4-4937; bottom left P&P, LC-USZC4-4940; bottom right P&P, LC-USZ62-96452. 371: P&P, LC-USZC4-5265. 372: top left P&P, LC-USZC4-4938; top right P&P, LC-USZ62-47061; bottom left P&P, LC-USZ62-70154; bottom right P&P, LC-J694-2. 373: top left P&P, LC-USZ62-88099; top right P&P, LC-USZ62-114459; bottom left P&P, LC-USF34-41573; bottom right P&P, LC-B5-39969-A. 374: P&P, LC-USZC4-3892. 375: top left P&P, LC-USZC4-5059; top right MSS; bottom left P&P, LC-USZ62-72813; bottom right P&P, LC-USZ62-115116. 376: top left P&P, LC-B5-950055; top right P&P, LC-A351-4-M-77; bottom left P&P, LC-USF342-8075-A; bottom right P&P, LC-B5-34889. 377: MUS.

An American Self-Portrait
378: P&P LC-USZC4-5001, LC-USZ62-4912.

Back
378: P&P, LC-USZC4-5001, LC-USZ6-2174. 384: P&P, LC-USZC4-4283. 399: P&P, LC-USZC4-5591. 400: P&P, LC-USZC4-5587, LCUSZ62-92185.

Special Credits
126: bottom right Published by permission of the Betty Kern Miller Literary Trust. 127: bottom Satellite imagery courtesy of Space Imaging EOSAT. 254: top right © Seagram County Court House Archives, Library of Congress. 255: The Heirs of W. Eugene Smith. 272: Courtesy of Mrs. Doris G. Schleisner. 273: top © The Harold Lloyd Trust, Susanne Lloyd Hayes, Trustee; bottom Courtesy of Paramount Pictures. "Wings" copyright © 1929 by Paramount Pictures. All rights reserved. 274: top Courtesy of The Aaron Siskind Foundation; bottom Courtesy of The Lisette Model Foundation, Inc. 275: bottom Courtesy of DC Moore Gallery, New York. 276: top © 1939 Turner Entertainment Co.; bottom © Courtesy Universal Studios. 277: bottom © Estate of Paul Outerbridge, Jr., G. Ray Hawkins Gallery, Santa Monica. 279: top Copyright © 1997 The Frank Lloyd Wright Foundation, Scottsdale, Arizona. 280: top © 1936 RKO Pictures, Inc. 281: bottom © 1933 RKO Pictures, Inc. 285: bottom © Disney Enterprises, Inc. 290: top From *The Grapes of Wrath* by John Steinbeck. Copyright 1939, renewed © 1967 by John Steinbeck. Used by permission of Viking Penguin, a division of Penguin Books USA Inc. 291: top © 1981 Center for Creative Photography, Arizona Board of Regents; bottom © Turner Entertainment Co. 292: middle left Permission of The Rockwell Kent Legacy. 295: top © copyright 1938, 1939 by Irving Berlin, © copyright renewed 1965, 1966 by Irving Berlin, © copyright assigned to Winthrop Rutherford, Jr., Ann Phipps Sidamon-Eristoff and Theodore R. Jackson as Trustees of the God Bless America Fund. International copyright secured. All rights reserved. 297: © 1997, Donna Mussenden Van Der Zee. 302: top Mr. Smith Goes to Washington © 1939, renewed 1967, Columbia Pictures Industries. All Rights Reserved.

Courtesy Columbia Pictures; bottom © 1941 Mercury Music Corporation. 304: bottom © The Estate of Raphael Soyer and Forum Gallery, New York. 312: bottom Corbis-Bettmann. 313: AP/Wide World Photos. 315: top © Lucia Eames dba Eames Office; bottom © 1997 Pollock-Krasner Foundation/Artists Rights Society (ARS), New York. 323: Courtesy Houk/Friedman Gallery. 332: top Courtesy Heritage Gallery, Los Angeles. 333: top © 1954 Warner Bros. Pictures Inc. 334: top Corbis-Bettmann. 335: © The Ogpi. 337: top Copyright Ruth Orkin, courtesy Ruth Orkin Photo Archive. 338: bottom Courtesy R.C.A. Records; © Elvis Presley's Name, Image and Likeness courtesy of Elvis Presley Enterprises, Inc. 340: Courtesy Gordon Parks. 341: top © 1955 Warner Bros. Pictures, Inc.; bottom PEANUTS reprinted by permission of United Feature Syndicate, Inc. 342: top © William Garnett; bottom Photo by Samuel H. Gottscho. 344: top © 1997 Andy Warhol Foundation for the Visual Arts/ARS, New York; bottom Copyright © 1955 by Universal City Studios, Inc. Courtesy MCA Publishing Rights, a Division of Universal Studios, Inc. All Rights Reserved. 347: top © 1969 by The New York Times Company. Reprinted by permission; bottom Star Trek: Original Series Copyright © 1966 by Paramount Pictures. All Rights Reserved. 351: top Courtesy Jules Feiffer. 352: top © 1970 Warner Bros. Inc. 354: top Copyright © 1958 by Universal City Studios, Inc. Courtesy MCA Publishing Rights, a Division of Universal Studios, Inc. All Rights Reserved. 355: top Courtesy Fraenkel Gallery, San Francisco and © The Estate of Garry Winogrand. 355: bottom Courtesy George Adams Gallery, New York, NY. 357: bottom © Optimum Productions, 1983. 358: top Doonesbury © 1985 G. B. Trudeau. Reprinted with permission of Universal Press Syndicate. All Rights Reserved. 359: U.S. National Cancer Institute. 360: Queen's University, Department of Geology, Kingston, Ontario. 361: bottom Courtesy Mrs. Anna Thomas. 366: bottom Ezra Stoller © Esto. 399: OLIPHANT © UNIVERSAL PRESS SYNDICATE. Reprinted with permission. All rights reserved.

IT'S REVEILLE IN AMERICA!

Pat Oliphant. *It's reveille in America.* Ink drawing. Universal Press Syndicate, 1993.

A NOTE ON THE TYPE

The essay portions of this book are set in Berthold
Bodoni, a version of the type named after the
celebrated Parma printer Giambattista Bodoni
(1740–1813). The caption texts are set in Frutiger, a
sans-serif face originally designed by Adrian Frutiger
(b. 1928) for the new Charles de Gaulle airport.

Composition and color separations by
North Market Street Graphics, Lancaster,
Pennsylvania. Printing and binding by
R. R. Donnelley & Sons, Willard, Ohio

Designed by Peter A. Andersen

W. T. Barnum. *The Tally-Ho.* Photographic
print on card mount, c. 1891.